DELACROIX

Barthélémy Jobert

PRINCETON UNIVERSITY PRESS

© 1997 Editions Gallimard

Original French edition published by Gallimard
5 rue Sébastien-Bottin
75007 Paris

English-language edition published by Princeton University Press
41 William Street
Princeton, New Jersey 08540

In the United Kingdom: Princeton University Press
Chichester, West Sussex
http://pup.princeton.edu

Details on divider pages:
Pages 16–17 (fig. 29), 64–65 (fig. 39), 90–91 (fig. 60), 138–39 (fig. 107),
176–77 (fig. 166), 202–3 (fig. 177), 234–35 (fig. 195)

Translated by Terry Grabar and Alexandra Bonfante-Warren
Design and composition by Barbara Sturman
Printed and bound by Artegrafica, Verona

Printed and bound in Italy
2 4 6 8 10 9 7 5 3 1

Library of Congress Cataloging-in-Publication Data
Jobert, Barthélémy.
[Delacroix. English]
Delacroix / Barthélémy Jobert.
p. cm.
Includes bibliographical references and index.
ISBN 0-691-00418-8 (cl. : alk. paper)
1. Delacroix, Eugène, 1798–1863 — Criticism and interpretation.
I. Delacroix, Eugène, 1798–1863. II. Title.
ND553.D33J5713 1998
759.4—dc21 98-24954
CIP

CONTENTS

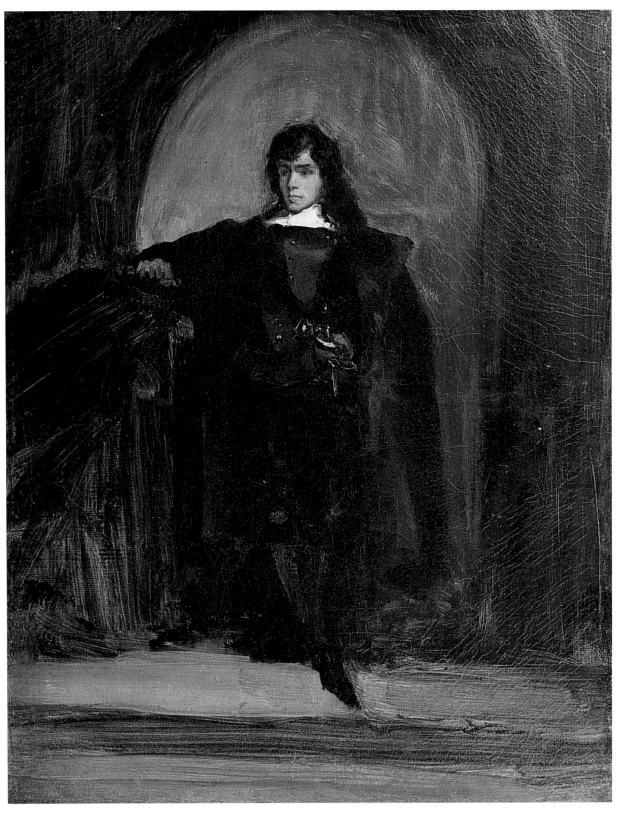

1. *Self-Portrait as Ravenswood*, c. 1821
Oil on canvas, 40.9 × 32.3 cm
Musée du Louvre, Paris

Reconsidering Delacroix

I t is an illustrious name, it is a great name, it is not a well-known name."[1] What Paul Jamot, curator at the Louvre, wrote in 1930 is still true, and the considerable gap between the painter and the public has, since then, increased rather than decreased. The painter, who was born while David was working on the *Sabines* and died when Manet exhibited *Olympia*, appears with time to have been closer to the former than to the latter, despite the numerous artists, from Fantin-Latour and Signac to Cézanne and Picasso, who have claimed descent from him. And it is not certain that his oeuvre, considerable as it is, is known to many in all its richness and diversity. The *Massacres of Chios* and *The Death of Sardanapalus* are paradigmatic of Romanticism, *Women of Algiers in Their Apartment* of Orientalism, and *Liberty Leading the People* has become a veritable republican icon. These four paintings are reproduced everywhere, but are they truly understood? Does one see the Greek war of independence behind *Chios*, Byron in *Sardanapalus*, the Three Glorious Days in *Liberty*? Does one appreciate the complex conditions of the development of the *Women of Algiers*? One could answer that these canvases aspire to the universal: war, love, death, revolution— such is their real subject. And this aspect was not foreign to Delacroix's methods. But it should not make us forget that in their time these paintings called up more precise references, understood by everyone and intended by Delacroix. And they all belong to his first ten years, those when he made himself known, brilliantly, but only to the first quarter of his public career. What of the great paintings done later, from *Medea about to Kill Her Children* to the *Entry of the Crusaders into Constantinople*, and, especially, the ensemble of decorative paintings that occupied him almost constantly upon his return from Morocco in 1832 until 1861, two years before his death? Is one aware that the illustrator of Shakespeare and Byron also painted numerous religious

subjects and that he is, in addition, one of the great engravers and lithographers of his century? Delacroix, despite appearances, is still in purgatory; he remains a new artist, to be discovered.

This is not, however, because he lacks representation in public collections, especially in French museums. Delacroix had experienced such exposure from the time of his first exhibition at the age of twenty-four, when the government acquired *The Barque of Dante*. The French state continued to do the same for practically all his major paintings, whether it had commissioned them or not, with the single exception of the scandalous and sulfurous *Sardanapalus*, which had to wait until 1921. This early exposure on official walls perhaps did a disservice to Delacroix, whose daring and innovations were rapidly forgotten, leaving only an impression of him as the painter of those great big canvases. The fact that some major paintings went to the provinces— sometimes against his wishes, sometimes with his approval—also worked against him. *Greece on the Ruins of Missolonghi* went to Bordeaux, *Medea* to Lille, *The Justice of Trajan* to Rouen, *The Death of Marcus Aurelius* to Lyons, *The Sultan of Morocco* to Toulouse, *Saint Sebastian* to the church in Nantua. The important consequence was that the Louvre had no large works of Delacroix except paintings of romantic inspiration and had none that represented the more classical vein characteristic of his development after 1832, both of which circumstances have altered his image. Additionally, the mural paintings, except for his work at Saint-Sulpice, cannot really be appreciated by the public. The ceiling of the Galerie d'Apollon in the Louvre, obscured, damaged, and practically invisible, awaits restoration; and there is limited access to the decoration of the Palais-Bourbon (l'Assemblée Nationale) and the Palais du Luxembourg (le Sénat), except for the representatives themselves. France has conserved many remarkable groups of works, but this has not benefited Delacroix, whose reputation, on the contrary, has suffered from the dispersion of his work in the rest of the world, where there are only rare instances of substantial collections. Thus this prolific painter is poorly appreciated outside of scholarly circles and learned publications. .

Let us emphasize here a point rarely raised: although in the entire oeuvre of Delacroix only three important losses have occurred—the decoration of the Salon de la Paix at the Hôtel de Ville de Paris, destroyed during the Commune; *Justinian Drafting His Laws* also burned in 1871 in the fire at the Conseil d'Etat in the Palais d'Orsay; and *Cardinal Richelieu Saying Mass*, lost in 1848 when the Palais Royal was sacked— some of his existing paintings, and not unimportant ones, have materially deteriorated

in the course of time. The blame for this sometimes, but not always, belongs to the artist himself, as the testimony of one of his intimate friends, Frédéric Villot, emphasizes: "For his whole life Delacroix was incapable of distinguishing a good canvas from a bad one, a reliable paint from a pernicious or fugitive one. It was above all a question of whether he liked the the grain of the canvas, the nuances of color; if so, any objections you could make to his using them in a work were useless. I experienced this a thousand times. Despite the deterioration that his paintings underwent within a very short time, which saddened him, he could never resolve to abandon the disastrous use of bitumen, or of thick oil that was convenient for him, or to refrain from going back over fresh spots that he wanted to change. The simplest elements of physics, of chemistry, of mathematics in the matter of perspective were unknown to Delacroix, for whom the exact sciences were a closed book, almost antipathetic. . . . Strange thing! Delacroix, so rebellious about any disinterested advice based on scientific facts, was taken in by all the inventions of the paint suppliers, even though he was cruelly punished for it several times. Absorbent and semi-absorbent canvasses, combinations of wax, oil, and essences (which had already so badly served Reynolds), new colors with no solidity, found in him an admirer, if they served an immediate need."[2] One could think that Villot was exaggerating, except that the state of several paintings unhappily confirms his recollections. Problems already appeared during Delacroix's lifetime. Fearing that the cracks (*gerçures*, as he called them) would irremediably damage *The Barque of Dante*, he asked for a "radical repair" in 1859—the removal or replacement of the canvas—which was immediately undertaken but which then necessitated retouching by his own hand.[3] On the other hand, he did nothing when in 1853 the varnishes of the *Massacres of Chios* were removed, even though the operation worried him because of the risk to the painting and especially to the transparency of the shadows.[4] But the work had already "gone yellowish," according to one of his students, Lassalle-Bordes, perhaps because the paints were of poor quality, the artist being unable to afford better at the time. Whatever it was, the painting today appears quite worn in places and has lost much of the brilliance that had so delighted or shocked its first viewers. Unfortunately, it is not the only one: Cézanne told Gasquet that he had seen the *Entry of the Crusaders into Constantinople* (already quite damaged when it was transferred from Versailles to the Louvre) "die, fade, go away" at ten-year intervals.[5] Other paintings, like the *Battle of Nancy* and the *Moroccan Chieftain*, have suffered from the excessive use of bitumen, which has darkened them and led to the

irreparable appearance of a network of cracks in some places. *Boissy d'Anglas* is very difficult to see, and one can no longer find the groups that Delacroix's contemporaries could discern. And it is not only the easel paintings that have suffered: the two hemicycles of the library at the Palais-Bourbon, repaired as early as 1869 and 1874 by one of Delacroix's students, Andrieu, showed worrisome crevices again in 1881, and were in such condition that deposition and transfer to the Louvre was considered. The critic Gustave Geffroy remarked in 1903 that "the paint has not adhered at all points to the smooth surface, it blisters and falls off in big flakes."[6] A new restoration was necessary in 1930, extending to the pendentives, and was executed this time by a student of Andrieu, René Piot. It was even worse at the library of the Luxembourg: leaking caused the cupola, badly glued, to detach itself progressively and finally to fall away entirely in 1868. Additionally, the painted surface itself adhered poorly to the canvas, so that it looked, according to a witness, like a "puff pastry that rose up and detached itself in thousands of little fragments."[7] Andrieu repaired the damage (the extent of his intervention is uncertain). He also intervened at the Louvre, although under less dramatic circumstances. There, too, the ceiling detached itself, but it was realized soon enough that the museum's administration could have the work removed and affixed to a new canvas before reattaching it to the ceiling. The retouching on *Apollo Slays Python* was thus less extensive than at the Palais du Luxembourg and at the Palais-Bourbon. Finally, there was the complete disappearance—caused by humidity and, it seems, by general indifference—of one of the angels done in grisaille in the chapel painted by Delacroix at Saint-Sulpice. Of all the major decorative works that remain, only the Salon du Roi at the Palais-Bourbon seems to have remained in fairly good shape.[8] Of course one should not extrapolate from these incidents any conclusions as to the rest of Delacroix's work—that would be risky or ill-founded—but one should be aware of them. The Delacroix that we see today is not always the one that his contemporaries saw.

What is principally responsible for distancing Delacroix from the contemporary understanding is still his very traditional conception of painting, based on the notion of the subject. For Delacroix, painting is first of all narrative, narrative that rivals writing according to the ancient comparison *ut pictura poesis*. Most of his work thus finds its source in mythology, history, or literature, illustrating themes easily accessible to the cultivated man of the nineteenth century but much less so now. The difficulty increases if one goes beyond the surface to try to understand the creative processes of the artist.

One must first of all deal with a culture that has become distant or even strange to us, and especially recognize that Delacroix assigned to painting a role that is fundamentally different from what it has been for a century: art for art's sake was foreign to him, and the purely formal aspects of his work, which have suffered least from the passage of time, are almost always at the service of the subject and its expression.

Additionally, the very existence of Delacroix has its own importance. It would be easy to turn him into an *artiste maudit*, but this would be to forget that he benefited perhaps more than any other painter of his time from the support of the state; and if he was attacked and disparaged all his life, he also had his champions. He did not flee society; on the contrary, he tried as best he could to know everyone in Paris who figured in the world of artists, scholars, or writers. He regretted the passing of time, but he was also a man of his century, which his painting reflects more often than one might think. Consciously enlisting himself in a tradition inherited from the Renaissance, he was perfectly able to profit from the particular conditions of the artistic life of nineteenth-century France—conditions that toward the end of his life began an evolution that would bring still more radical change.

One can study Delacroix only by taking into account the different aspects of his life and work. If there is a meaning to be observed in his particularly abundant work, it is perhaps less likely to be discovered in a general interpretation—uncertain and controversial because of its breadth—or in the application of a certain systematic code of reading, than in a close analysis of the conditions under which this work was created. Why did Delacroix paint this picture or series? How did he execute it? What was the public reaction, what did the critics say, how did Delacroix react? Such apparently simple questions, which attempt to establish how an artist meets and expresses the sensibility of his era and whether or not he affects it, can lead us to a truly historical reading. I do not object, a priori, to a more aesthetically grounded approach, but the reader will understand that it is not mine. I do not believe that one can take any work completely out of context, and even less so with Delacroix, since his inspiration comes as much from the past as from the half century during which he labored.

One may wish that Delacroix's writings did not immediately interfere with the perception of his works. Delacroix is, of all the great Western artists, perhaps the only one who has left behind such a mass of manuscripts. His journal, which he kept from 1822 until 1824 and from 1847 until his death, is a unique monument of the history of art.[9] It outweighs the rest of his written work, which is not negligible either: a voluminous

correspondence[10] to which new pieces are constantly being added, and articles published during his lifetime in various journals.[11] The study of Delacroix as writer is still an open book; to begin with, there is no truly critical edition that would correct, augment, and complete the irreplaceable but very old work of André Joubin. Still, the available texts supply a solid base, in which one must avoid getting lost.

The paintings, engravings, and drawings of Delacroix profited very early from a scholarly solicitude that mixed admiration with affection and friendship. The first essay by Delacroix's friend, the collector Adolphe Moreau,[12] comes from the critical catalogue of Alfred Robaut and Ernest Chesneau.[13] Its scope and the accuracy of its information made it the essential reference for any work on Delacroix for a century. It was the point of departure for Lee Johnson, whose own catalogue is now the standard.[14] The old but still fundamental work by Loÿs Delteil on the engravings[15] and various publications on the drawings, including the catalogue by Maurice Sérullaz of the magnificent collections in the Louvre, complete the basic scholarly publications.[16] It is worth noting that Delacroix is one of the best and earliest known artists of his time.

Delacroix is also a literary painter, not only because of his journal or because his painting has close ties to literature, but also because of the innumerable written works devoted to him from the time he began to show his work in 1822. They have nourished and fed on each other in a sort of cumulative effort that has finally given his painting a sometimes almost purely textual reality.[17] During his lifetime there appeared memoirs of friends or accounts to which he sometimes lent a hand, and which he never disclaimed either in public or in private. This is notably the case with those of George Sand and Alexandre Dumas. Delacroix's ties with Sand, to which I will return, are well known. Dumas was a friend, an enthusiastic admirer who extracted from Delacroix his firsthand memoirs that he then rearranged in his own style.[18] The details of Dumas's account must be taken with caution, but the whole remains valid, confirmed both by the painter's own writings and those of others. Foremost among these is the book of memoirs by Achille Piron, who knew Delacroix at school, remained one of his intimate friends throughout life, and became executor of his will. He was one of the first to have access to his journal as well as to various other Delacroix manuscripts, including a precious notebook in which the artist had undertaken to gather his recollections. Piron cites it freely, supporting it with precious unpublished witnesses of other youthful friends, in particular Baron Rivet.[19]

The critical discourse that Delacroix inspired as soon as he began to exhibit his work in 1822 is still more considerable and has never stopped. Tied at first to events, that is, essentially to the Salons in which Delacroix participated throughout his life[20] or to the completion of his great decorative works,[21] which themselves form an imposing mass, this discourse extended progressively to the whole of his career. Théophile Thoré, the future William Bürger, was the first to attempt such an analysis, published in *Le Siècle* in 1837.[22] Others followed, notably Baudelaire's *Salon of 1846*[23] and those inspired by the Delacroix retrospective at the time of the Exposition Universelle of 1855, where the articles of Théophile Gautier stand out.[24] The famous work of Théophile Silvestre, *History of Living French and Foreign Artists*, which opens with a magnificent chapter on Delacroix, crowns this first series of published studies.[25] These critiques were all done before his death, and one should add to the list the book of Ernest Chesneau, the future commentator on Robaut, which appeared in 1862.[26] The identity of the various authors, who are among the most perceptive critics of the nineteenth century, would suffice to guarantee the value of these texts.[27] But the writings are even more important because of the relationship that many of the authors had with Delacroix. He understood the influence of the press and, without arranging favorable reviews, was always aware of what was being written about his work: thus he organized veritable press conferences when he completed his different mural paintings.[28] A worldly man, he was introduced into all the Salons and Parisian intellectual circles and was in a position to meet the writers, some of whom for their part sought him out, and he enjoyed talking with them. Of all those we have mentioned, only Chesneau, a late arrival, had few contacts with Delacroix. The four others were among the artist's intimates and benefited from his confidences, from conversations with him, and shared, in varying degrees and to the extent that he permitted it, in his life and his work. The relationship between Baudelaire and Delacroix has been particularly well studied, sometimes from a purely literary angle.[29] But one should not overemphasize this: more than twenty years separated them, and Delacroix was already a famous artist when they met, while Baudelaire had not yet published much at all. Still, if they shared a similar conception of art and of Romanticism, the enthusiastic admiration of the poet for the painter was not really reciprocated, and it seems that Delacroix influenced Baudelaire more than the other way around. Thus Silvestre, who knew Delacroix well, remarked that "Charles Baudelaire, who wrote magnificent pages on him, frightened him a bit with his unconventional, although very innocent, behavior."[30]

Monographs and critical studies thus rely from the beginning on these various sources. Two of the principal works on Delacroix, those of Etienne Moreau-Nélaton and Raymond Escholier, develop a detailed bibliography of the artist based solely on original documents, often cited in extenso.[31] The commemorative exhibition held at the Louvre on the centenary of Delacroix's death in 1963 also followed this method, as is apparent in the catalogue.[32] Other monographs have emphasized in one way or another, the romantic or the dandy, the colorist and the molder of form who anticipates contemporary painting, or the mystic in search of an absolute.[33] Such approches are nonetheless intermingled in a network of references and different sources that, by its very size, discourages synthesis. There is a narrow path between the accumulation of fact and the purely aesthetic analysis disengaged from the contingencies of the historical context. It is this path that I try to follow here, guided above all by chronology. There is an obvious sense to this method: the Delacroix of 1850 is not the Delacroix of 1820 or 1830. This does not of course preclude separating out the principal vectors, beginning with the orientation of his career: the Salon before 1832, followed by the mural paintings, structured his work, of which the major thematic directions developed progressively, with the voyage to Morocco in 1832 being of capital importance. I have thus alternated these two kinds of analysis, following an introductory study more generally dedicated to the man and the painter, seeking above all to introduce the work while at the same time showing the order and logic of it.

To write about Delacroix is necessarily to make choices, first of all among his paintings, engravings, and drawings. One cannot speak of them all, one cannot reproduce them all: a book has limits, and despite his many good intentions, the editor has his constraints. I have thus concentrated the analysis on what mattered most to the artist, his painting (in particular the paintings that he showed at the Salon), and his decorative works, but without omitting engraving and drawing. One will thus find some attention to Delacroix the engraver and lithographer through his most important works—an aspect of his art too often neglected or simply ignored. So far as drawing goes, the selection has been drastic indeed. Delacroix drew regularly on principle and in addition left an enormous mass of sketches and preliminary studies. I raise the question in the first chapter, where I reproduce several of the best known, most attractive, and most representative examples. In exchange I have eliminated drawing from the rest of the work, with the exception of the chapter dedicated to the Moroccan tour, where it is crucial. Even in this case it is impossible to be exhaustive; what I present is an anthol-

ogy, assembling around *The Sultan of Morocco* some studies that permit the reader to understand the place of drawing in the creation of this single painting.[34]

The situation is equally tricky with regard to the texts. I have kept some passages from the *Journal* and various extracts from the correspondence concerning the life, thought, and work of the painter, trying at the same time to show as clearly as possible the extraordinary variety of tones that Delacroix employs and that make him so vivid when one reads his writings. I have done the same for his articles, keeping only three of them—those dedicated to Michelangelo and to Lawrence, and the letter published in *L'Artiste* after his failure in the contest for the Chambre des Députés. There remains everything that has been written on Delacroix. I have favored the documentary aspect and have kept only those texts published during the lifetime of Delacroix, or after his death by those who knew him. Thus I have depended heavily on contemporary writings, including Salon criticism; and, knowing that many of these texts are inaccessible outside of specialized libraries, I have deliberately given long passages, more representative to my way of thinking than short citations taken out of context. I have also deliberately avoided analysis of his critical fortunes over the past century, which is of course interesting for the evolution of the subjective reactions of critics and art historians to his work, and thus rewarding as to our contemporary sensibility, but also likely to occlude the original meaning. Space was lacking for this, and I regret it, but necessity has made a virtue of it.[35] The reader will also quickly realize that I do not place Delacroix in relation to what follows him, but rather to what preceded him. I am suspicious of retrospective analyses, always easy to establish after the fact, but finally having little to do with the artist himself. This also has the advantage of focusing the analysis on Delacroix and his time.

I am not naive enough to believe that these choices are neutral. Without attempting to set Delacroix within a preconceived category, I have especially wanted to present him in all his complexity, with his contradictions, ambiguities, and weaknesses. Beyond chance and beyond the opportunities that mark out his existence, there remains a first principle: a will of iron at the service of a formidable creative power that places him among the very best. "Do not neglect anything that can make you great," Stendhal wrote to him.[36] And he himself noted: "What one asks always of all schools and beyond all differences of appearance, is to touch the soul and the senses, to ennoble the intelligence and illuminate it."[37] This was his aim, his ambition, and perhaps the meaning of his life.

The Man,
the Painter

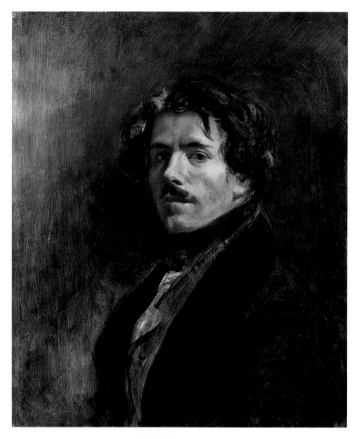

2. *Self-Portrait*, c. 1837
Oil on canvas, 65 × 54.5 cm
Musée du Louvre, Paris

Delacroix painted or drew himself several times during the course of his life, thus bearing witness both to physical changes and to the development of his personality. The more or less rapid sketches[1] are less significant here than the paintings,[2] to which he certainly attributed greater value: he left the most important of them, *Self-Portrait* (fig. 2), to his faithful servant Jenny Le Guillou, stipulating that it should then go to the Louvre.[3] In it, he is sure of himself, a bit sarcastic, fully mature (the canvas was done about 1837, when he was nearing forty). Fifteen years earlier, he had painted himself as Ravenswood (fig. 1), the protagonist of Sir Walter Scott's novel, *The Bride of Lammermoor*, with whom he could then legitimately identify himself. At the beginning of the book, Ravenswood must, after the death of his father and a long legal process, give up his ancestral home to the lawyer, William Ashton. Delacroix, at this time, saw his own future darkening: the family fortune, formerly considerable, was about to fail, and soon he would have only his paintbrushes to rely on for his living. This identification, otherwise attested by a manuscript inscription on the frame, has been rejected by some exegetes in favor of Hamlet or Childe Harold, substituting Shakespeare or Byron for Scott.[4] The fact reveals the fashion in which Delacroix has practically always been perceived. But, after all, the painter is principally responsible for it, since there is no allusion to his profession in this picture, nor, for that matter, in the *Self-Portrait*. The interest is centered on the man, by the biased and ever so romantic identification with the hero of a tragic story. Notice also the evolution from one canvas to the other: it is a long way from the young theatrical character posing as if on a stage—his fiery spirit and audacity

clearly evident—to the mature man, calmer, more assured, more inward, who controls and scrutinizes. The two works have a trait in common, however, in the subject's elegance and pride, a certain detachment, distance, a withdrawal that is found in most of the portraits done during his lifetime. The Member of the Institute drawn by Heim, the worldly man in a suit, his throat generously cravated in white, sketched by Eugène Giraud, leaning against a fireplace along with Musset during a *soirée musicale*, or standing in a salon beside Merimée in a watercolor by Eugène Lami, are from the end of his life, and show the same trait. It is there again in various photographs taken then by Laisné, Petit (fig. 3), Nadar, Durieu, Léger, and Bergeron.[5] Representations of Delacroix where he seems somewhat relaxed are rare, whether it is the artist tormented by spleen and melancholy lithographed by Gigoux (fig. 5), or the friend in a hat who amuses himself by posing as a spiritualist during the first daguerreotype session that he participated in, in 1842 (fig. 4), an example, among others, of the humor he always knew how to use and that should be kept in mind.

In every case, the artist almost disappears behind the man of the world or the grand bourgeois. Delacroix in his youth certainly led a bohemian life. But it was by accident, one might say, and not by choice. His social background was distinguished, his education had reinforced the most refined aspects of his character. Only family ruin forced him to restraint and watchfulness in material things, but he was always conscious of his class. He confided in Baudelaire much later that he was then "given over to the most material vanities of dandyism," saying "laughingly, but not without a certain vainglory, that he had, along with his friend Bonington, worked hard to introduce a taste for English-style shoes and clothes among elegant French youth."[6] To Géricault, with whom he had so many things in common and with whom he shared many ties, it seemed that Delacroix never gave up the prejudices and behavior of the milieu into which he was born. His father, Charles Delacroix (1741–1805), had made a good career as an administrator under the ancien régime in the wake of Turgot, becoming the first assistant to the Comptroller General of Finance. He had then retired to his lands in the Marne. The Revolution had taken up his fate: elected to local office, he had then been a deputy to the Convention, where he voted for the death of the king. As a Member of the Conseil des Anciens

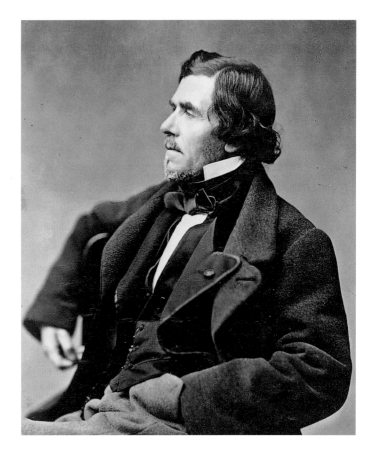

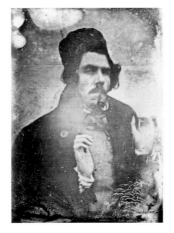 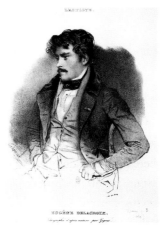

3. Delacroix in 1862
Photograph, 25.5 × 19.5 cm, by Pierre Petit. Bibliothèque Nationale de France, Département des Estampes et de la Photographie, Paris

4. Delacroix in 1842
Daguerreotype taken at Frépillon. Bibliothèque Nationale de France, Département des Estampes et de la Photographie, Paris

5. Delacroix in 1832
Lithograph, 22.8 × 16.8 cm, by Jean Gigoux, published in *L'Artiste*. Bibliothèque Nationale de France, Département des Estampes et de la Photographie, Paris

under the Directory, he was then Minister of Foreign Affairs for eighteen months (1795–97) before being named ambassador to the new Batavian Republic. Rallying to Bonaparte, he was then sent as prefect to two very important posts, first at Marseilles (1800), where he served successfully, and then Bordeaux (1803), where he died.[7] He had married Victoire Oeben (1758–1814), who was related to several of the most celebrated Parisian cabinetmakers of the eighteenth century: Jean-François Oeben, her father; Vandercruse, her grandfather; and Jean-Henry Riesener, her mother's second husband. Three children were born of the union: Charles-Henry (1779–1845), who had a brilliant military career, becoming a general, aide-de-camp of Prince Eugène, with the title of baron, before being retired under the Restoration; Henriette (1780–1827), who married Raymond de Verninac Saint-Maur; and Henry (1784–1807), who, pursuing a military career like that of his brother, was killed at the battle of Friedland. Eugène, born on 26 April 1798, was thus much younger than his brothers and sister.[8] His father, furthermore, had had an operation in September 1797 to remove from his testicles a tumor from which he had suffered for several years and which perhaps made him an unlikely procreator. Charles Delacroix's successor at the Ministry of Foreign Relations (he was in Holland at the time of Eugène's birth) was none other than Talleyrand, and this was enough to instill in historians some doubt as to the paternity of the painter. This question, raised by everyone who deals with Delacroix, seems, however, to be of little importance either from the point of view of Delacroix's career or of his personality.

Partisans of the bastard theory, which identifies him as Talleyrand's son,[9] attribute the brilliant beginning of his career (the state acquired his first paintings, *The Barque of Dante* and the *Massacres of Chios*; and Thiers, Talleyrand's "spiritual son," commissioned his mural paintings), to the powerful hidden protection of his putative father. This is a complete misunderstanding of the conditions of artistic life under the Restoration: the paintings of Delacroix and of other young painters, more or less beginners, were purchased because they had been noticed and because the government wished to support young talent. As to the commissions for decorative works, only the first one depended upon the personal initiative of Thiers; the others were justified by Delacroix's success. It is not necessary to imagine any hidden motive. Thiers appreci-

ated Delacroix: he commissioned a work of which he believed him capable, as he did at the same time from other contemporary painters, without going through the controversial system of the competition, the questionable results of which had just been seen in the decoration of the Meeting Hall at the Chambre des Députés.[10] Delacroix's talent sufficiently explains his success. He seems furthermore never to have had any doubt as to his paternity, and the pages of his journal that speak of his father are full of the greatest admiration for him.[11] If Delacroix never alluded to this question either in his journal or in his correspondence, neither did his contemporaries until very late, and then seldom. Beginning as simple tittle-tattle and fed by the physical resemblance of the aging artist to Talleyrand, the rumor became progressively persistent only after Delacroix's death, through later accounts that fed on each other. It is surely true that the most important thing, finally, is what consequence this dubious paternity could have had for Delacroix's work. And no matter where one looks, there is none, so that would seem to put the question to rest. But, it does seem that Charles Delacroix was indeed Eugène's father. The letters that Charles and his wife exchanged after the birth, basically very tender, permit us to suppose with some reason a premature birth, a hypothesis reinforced by the uncertain health of the painter.[12]

Delacroix was very close to his family. But he lost them early. His father died when he was seven, his mother, whose death overwhelmed him, when he was sixteen.[13] His brother's career was destroyed by the fall of the Empire; he settled at Louroux, near Tours, where Delacroix visited him several times, particularly during 1820 and 1822. As Piron said, Delacroix and his brother "saw each other little during the course of their lives; they loved each other, the family ties never lost their strength; but they were not tied by their education, their minds, or their worlds, so that long intervals passed without their having the occasion to write or visit."[14] The general had married the daughter of an innkeeper in 1822, and Delacroix was sorry to see him surrounded by "brutes and scoundrels."[15] One thinks immediately of *La Rabouilleuse*, where Balzac dramatizes a similar situation. But one should not identify the Bridau brothers with the Delacroix brothers, even if the writer took something from them. It is enough to read the letters, full of affection and tenderness, from the painter to his brother.[16] His relations with his sister Henriette were more

difficult. The year that he was born, she was married to a diplomat of the Revolution (he was Ambassador to Constantinople) and future prefect of the Empire, Raymond de Verninac Saint-Maur. The couple took him in when Victoire Delacroix died, and it seems that living together was not always very peaceful for the brother and sister, especially because such a great difference in age separated them. Delacroix tells his friend Jean-Baptiste Pierret that when he was secretly carrying on with Henriette's cook, she walked in on them "in the middle of my physical and moral tension, at the moment when my shameless desire raised its head and gave me the courage of a demigod . . . the latch was drawn and the disconcerted beauty began to blush. Coldly irritated, my sister made her entry with a dark look, enough to frighten little boys in the street; she was only mad at her stew and was looking for her cook. She was angry, maybe with good reason."[17]

These ancillary loves were unimportant, really, in the face of the confused situation of the family fortune, held jointly by the two brothers and their sister since the death of their mother, and no doubt embittering the character of Henriette de Verninac (she was entirely dependent on it), and straining relations among them.[18] Charles Delacroix had left almost eight hundred thousand francs to his wife, made up mostly of farms in the Ile-de-France and properties in Paris—all purchased when he was a minister under the Directory—as well as a very large claim against his banker, Boucher. In order to assure it, Victoire Delacroix took a mortgage on Boucher's assets, among them the forest of La Boixe, near Angoulême. Boucher had in fact not paid for it and was soon bankrupt and imprisoned. Victoire Delacroix went to court over the forest in order to recuperate her claim and at the same time repay the previous proprietors, since she did not have the necessary

6. *Portrait of Charles de Verninac* (presumed), c. 1826
Oil on canvas, 61.5 × 50.5 cm
Private collection

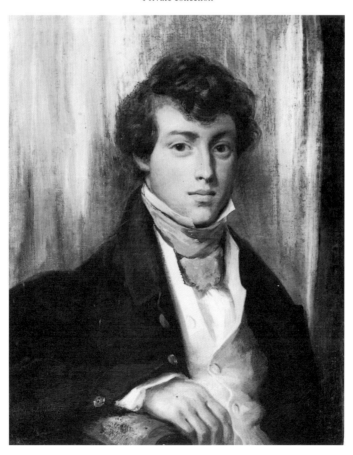

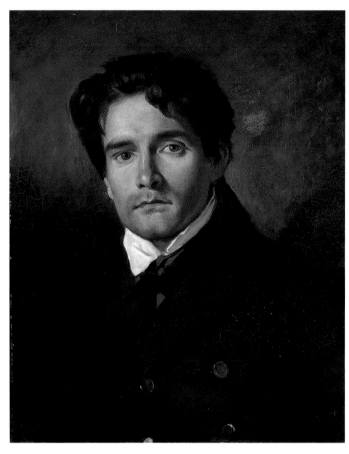

7. *Portrait of Léon Riesener*, 1835
Oil on canvas, 54 × 44 cm
Musée du Louvre, Paris

cash. A very poor manager, she sold off what she had inherited little by little, in order to live. In 1814, all that remained was the mortgaged forest, stuck in the courts, with its revenues not even covering the expenses. The Delacroix children were left practically penniless at her death. They would have to sell the forest to get some capital. The Verninacs, husband and wife, further confused the situation in attempting to rescue what was left. La Boixe was finally sold after the death of Raymond de Verninac in 1822. The price did not cover the debts: nothing was left for the descendants of Charles and Victoire Delacroix. From then on, the general lived on his military pension and a pension from Prince Eugène (he tried in vain to get back into active service, with the help of his brother, under the July Monarchy). Henriette de Verninac fell into financial straits and ended as a lady's companion. As to Delacroix himself, he survived, no doubt with difficulty, a situation that left

him without resources. André Joubin has rightly pointed out that his childhood was marked by increasingly precarious finances that culminated at the moment of his adolescence, when he needed to choose a career. Worry about money was a constant in Delacroix's life during the 1820s, relieved only by his work, his sole source of revenue. Little by little, he created a life of a certain ease, but never equaled the wealth into which he was born. The prices of his paintings were never very high, and he rarely painted for money, even near the end of his life when dealers and admirers came to him much more frequently. The public commissions never paid very well, and he had to subtract a part of the money to buy material and pay his assistants. But he had modest tastes and managed to assure himself a solid bourgeois comfort, never opulence: the only property that he acquired was a house in the country, a modest one in Champrosay, to the southeast of Paris, on the edge of

the forest of Sénart. His friends the Villots had attracted him there, and he rented from 1844 until his landlord sold to him in 1858. He bought the house to avoid moving.[19]

All these problems bothered him less than did their effect on family relations. In a pinch he could only count on himself, his parents gone, his brother and sister distant and at odds with each other (he acted as intermediary between them). His sole close remaining relative was Henriette's only son, Charles de Verninac (fig. 6), five years his junior, to whom he was tenderly attached.[20] When his nephew was alone in Paris as a student at Louis-le-Grand, Delacroix had kept in close touch with him until he returned to his parents in Charente. He came back to live in Paris in 1822, then, after studying law, worked in the *Caisse d'amortissement* before entering the diplomatic service as a vice-consular intern in 1829. Posted first to Malta, then to Chili in 1831, Charles de Verninac was preparing to return to France when he died of yellow fever in New York in May 1834. Delacroix was deeply moved by this loss, "the only remaining member of my sad family who should have been my last friend in the natural order of things, since his age let me think he would see me die," he wrote to his friend Soulier.[21] He found himself alone.

There were, to be sure, a number of cousins on both the maternal and paternal sides, among them Léon Riesener, who was very close to him (fig. 7). He went to spend some time with each of them: at Frépillon, near Montmorency, with his uncle Henri-François Riesener, son of the cabinetmaker, himself a painter; in Normandy, with the Batailles; and then at the Abbey of Valmont, with the Bornots.[22] He also visited more distant relatives, the nephews of his brother-in-law Verninac at Croze, in Corrèze, and the famous lawyer Pierre-Antoine Berryer, whom he saw in Paris and at his chateau in Augerville, near Malesherbes. In his last years, he again took up some of his former relations, including second cousin Auguste Lamey, a judge in Strasbourg. In 1856, he even traveled to the

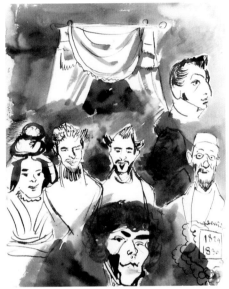

8. *Seven Caricature Heads: New Year's Eve*, 1829–30

Sheet from the Saint-Sylvestre album (the head at bottom is perhaps a self-portrait). Pen and brown ink with brown wash on paper, 24.8 × 19.6 cm. Musée du Louvre, Département des Arts Graphiques, Paris

Argonne, where he met every last one of his relatives who had stayed there.[23] Nevertheless, he remained more or less solitary and never married. He liked women, and his journal and correspondence as well as the memoirs of friends speak of the ardor with which he approached them in his twenties.[24] If Delacroix did not lack delicacy, he was not an ethereal lover either, as is apparent in his confidences to his nephew Charles de Verninac in May 1830, when he was courting his cousin Joséphine de Forget, one of his great passions: "I advanced a little, she retreated, then she advances, then she retreats. Advance, retreat, advance, that isn't all bad . . . because it's nature's way of leading to the divine pleasure that all lovers require, witness the superb Arab stallion that I saw at the stable the day before yesterday. . . . But since in the affair in question I didn't lift a little finger, I neither advance or retreat, I stay in the same place both physically and morally. It's not that there isn't something amusing in this little war of flirtation. Maybe if I got some real favors, I mean palpable ones, I wouldn't return with the same speed and would come down to earth quicker: for *a woman is only a woman, always much like her neighbor deep down*; and the proof that it is the imagination that does everything is that often the most brilliant beauties leave you cold and indifferent."[25] For a long time Delacroix had satisfied his physical needs whenever the occasion permitted—with servants, chambermaids, or models; and he did not avoid fancy parties with Stendhal or Mérimée, who left an account of several of these events. When Delacroix was a little older, he also had worthier relationships, in particular with one of his distant cousins, just mentioned, Joséphine de Forget (daughter of Lavalette, related by her mother to Beauharnais), and with Elisa (the wife of the painter Clement Boulanger, who later married Cavé, the director of the Beaux-Arts under Louis-Philippe).[26] He retained a tender attachment that lasted all his life for the first of his passions, with whom he often dined and with whom he planned various projects. But he thought women frivolous,

and they remained outside of his artistic activity. As Baudelaire pointed out, "Delacroix had made Painting his only muse, his only mistress, his only and sufficient sensual delight. Doubtless he had loved women in the bustling hours of his youth. . . . On this subject, as on many others, the oriental idea took the upper hand vigorously and despotically. He considered 'woman' an art object, a delicious one, and good for raising the spirits, but a disobedient and troubling art object, if one gave her a foothold in the heart, devouring gluttonously one's time and strength."[27]

Delacroix thus found his intimates among his friends. Three of them, friends from childhood and high school, held a special place in his life: Félix Guillemardet, son of one of the colleagues of his father at the Convention, Jean-Baptiste Pierret, and Achille Piron. All three made their careers in administration. (Pierret had thought of becoming a painter and, on the advice of Delacroix, a portraitist, before entering the Ministry of the Interior.) As colorless as they appear to be, and as distant as their world and their occupations were from Delacroix's, they nevertheless were very dear to him. The strong feelings that he had for them when he was twenty did not diminish over time.[28] Delacroix always spoke of their reunions with tender nostalgia, and in particular their annual celebration on New Year's Eve, which they had the habit, long maintained, of spending together, commemorating it by a sketch made in the same album (fig. 8).[29] Charles Soulier, whom he met in Pierre-Narcisse Guérin's atelier, later joined this group, then Frédéric Villot, an engraver by training who attached himself to Delacroix under the Restoration and soon became one of his dearest friends. Villot later said that he had seen Delacroix almost every day between 1827 and 1856, before the door was closed to him by order of the master's housekeeper, Jenny Le Guillou.[30] Relations between the two men had no doubt been strained for several years, since Villot, who was named curator of paintings at the Louvre in 1848, had engaged in some hazardous restorations of which Delacroix had disapproved. (Delacroix was, incidentally, not the only one, and Villot had to leave the post in 1861, and became secretary-general of museums.) More personal questions may also have played a role—Delacroix was very fond of Villot's wife, Pauline.[31] But Villot is doubtless the only friend of Delacroix's youth who had some influence on his work. He taught Delacroix the various processes of engraving. (Soulier, who had

been raised in Great Britain, taught him watercolor.) The continual conversations between the two comrades must have been even more significant, although less obviously so; in any case, this is what we can perceive in Villot's well-known account where he tells how, at the painter's request, he provided the subject of the cupola of the Palais de Luxembourg.[32]

Delacroix did not have such intimate and closely tended relations in the artistic milieu of his time. Among painters, only Géricault and Bonington were close to him; friendship was reinforced in these cases by more professional concerns, both artists representing, for Delacroix, examples to follow, models to imitate. Both of them gave him a great deal, first around 1820, when he was learning his trade, then in the "Romantic years" between 1825 and 1830. Géricault, several years older than Delacroix, was not, strictly speaking, a friend. "Although he received me familiarly," said Delacroix, "the age difference and my admiration for him put me in the position of a respectful student in regard to him. He had been with the same teacher (Pierre-Narcisse Guérin), and when I was starting out, I had already seen him, as a famous painter, do several studies at the studio. He let me see his *Medusa* while he was working on it in a peculiar studio he had near Ternes. The impression that I got of it was so vivid that when I left I ran like a madman all the way to the rue de la Planche, where I was living then."[33] Géricault's premature death in January 1824, when Delacroix was starting on the *Massacres of Chios*, was a hard blow for him: "This morning I got the letter telling me of the death of my poor Géricault. I cannot get used to the idea. Although everyone knew we would lose him soon, it seemed to me that by not thinking about it, one could almost ward off death. She didn't miss her prey, and tomorrow earth will hide the little that remains of him. What a different fate seemed promised by such a strong body, so much fire and imagination! Although he was not exactly my friend, this calamity breaks my heart. It has made me avoid my work, and erase everything that I had done."[34] A short time earlier, Delacroix had gone to visit Géricault when he was very ill. He came back struck by his desperate state, but also "all enthusiastic about his painting: *especially a study of the head of a carabineer*. Just to remember it. It's a milestone. What beautiful studies! What firmness! What superiority!"[35] Even though his financial situation was hardly brilliant, he nevertheless bought almost a thousand francs' worth of works at Géricault's posthumous sale, mostly

copies of the old masters.[36] He always defended and revered the memory of "the admirable Géricault," who had opened the ground that he himself worked. *The Barque of Dante* and the *Massacres of Chios* followed naturally after Géricault's *Cavalry Officer Charging*, the *Wounded Cavalryman Leaving the Fire*, and the *Raft of the "Medusa."* But Géricault's death also prevented emulation from becoming competition, a point not to be forgotten. Let me add that, as Piron emphasizes, Delacroix wrote very little on Géricault. He did not dedicate an article to him as he did to Gros, Prud'hon, and Charlet, whom he particularly admired among contemporary artists. Did his judgment become harsher with time? The reasons that Piron gives, perhaps echoing his conversations with Delacroix, would tend to suggest this.[37] But the question remains open.

Bonington was four years younger than Delacroix. His precociousness brought them together: the two artists were really of the same generation. At the beginning of the 1820s, the two artists belonged to a group of young English and French painters representing the new trends, sharing common interests, working and living more or less together.[38] Among them were the Fielding brothers—Thalès, Copley, and Newton— who were very close to Delacroix, and Bonington, about whom he explained himself much later, in reply to Théophile Thoré. Thoré had asked for firsthand information in order to write a notice on Bonington for the *History of Painters of All Schools.* It is one of the very rare texts in which Delacroix speaks at such length of a contemporary painter. He explains very tactfully how in Bonington, the friend and the artist were inseparable for him: "I knew him well and I always loved him. His cool British manner, which was imperturbable, did not detract from the qualities that made life amiable. When I met him for the first time, I was myself very young and doing studies in the gallery of the Louvre: it was about 1816 or 1817. I saw a tall adolescent in a short coat who was also, very silently, making watercolor studies, mostly of Flemish landscapes. He already had a surprising skill in that medium, which was at the time an English fad. . . . He already had all the charm that is his special merit. In my opinion you can find other modern artists with greater force or exactitude than Bonington, but no one in this modern school, and maybe no one before, had that lightness of handling, which, particularly in watercolor, makes his works like diamonds that flatter and ravish the eye, independently of subject or imitation. . . . I never tire of admiring the marvel-

ous harmony of the effect and the facility of execution; not that he was easily satisfied. On the contrary, he frequently reworked entire bits that were completely finished and seemed marvelous to us; but his skill was such that he instantly found beneath his brush effects as charming as the first. He took advantage of all sorts of details that he had found in the old masters and adjusted them with great skill in these compositions. . . . This detracts nothing from the merit of his works; these details taken alive, so to speak, and which he appropriated (especially costumes), increased the truthfulness of his personages and never felt like pastiche. . . . He was called Richard Parkes Bonington. We all loved him. . . . He died in 1828. How many charming works in such a short career! I learned suddenly that he was attacked by a malady of the chest that took a dangerous turn. He was tall and strong in appearance, and we learned of his death with as much surprise as chagrin. He went to England to die. . . . My dear friend, you have given me the occasion to remember happy times and to honor the memory of a man I loved and admired. I am all the happier for it, in that some have tried to disparage him and he is, to my eyes, very superior to most of those painters who have been favored over him. Keep the balance between my predilections and these attacks. If you wish, credit my old remembrances and my friendship with Bonington for what may be found partial in these notes."[39]

Rare indeed for Delacroix were these privileged encounters where there was an equal sharing, both sentimental and intellectual. "I have two, three, four friends," he wrote in his journal in June 1823. "Oh well, I have to be a different man with each one, or rather to show each one the face that he understands. It is one of the greatest miseries never to be able to be known and felt as a whole person by one man; and when I think of it, I think that this is the worst of life's wounds: it is this inevitable solitude to which the heart is condemned."[40] Hence the importance of his relations with George Sand and especially, through her, with Chopin.[41] Their friendship began just after the writer's break with Musset, during the winter of 1834–35, when Buloz, her editor and the director of the *Revue des Deux-Mondes*, asked Delacroix to make a portrait of her, to be engraved for the subscribers to his periodical. Desperate, she posed with her hair cut short, in men's clothes (fig. 9), trusting in the painter, who must have told her to let herself go, to abandon herself to her grief in order to master it.

There things rested at that time. Delacroix was then preoccupied with Joséphine de Forget. George Sand, with her scandalous life, could not sustain such rivalry. It was only with the beginning of Sand's liaison with Chopin that Delacroix, himself captivated by the composer, truly became attached to her. André Joubin has subtly suggested all the causes for what he calls the lightning bolt that struck the two—a relationship that was perhaps unique in Delacroix's life. They were at one especially about music, not about painting, as we will see later, where the composer felt himself completely lost. A common intelligence, a similarity of character, a certain dandyism also brought them together, as, in another respect, did their health problems and attacks of illness. Delacroix extended to George Sand the friendship that he felt for Chopin and, after their departure for Majorca, began a large portrait of the two lovers. By the light of a lamp on a chimney, George Sand, cigarette in hand, listens to Chopin at the piano. The painting, which Delacroix worked on at the beginning of the summer of 1838, remained unfinished, for unknown reasons, the most likely hypothesis being the difficulty caused by his models' departure for Spain. A drawing allows us to see the composition that Delacroix envisioned (fig. 11). The canvas, which he kept until his death, passed into the hands of his friends the Dutilleux. It was then cut into two separate portraits, where one can still see, particularly in the sketchy treatment of the pianist, the sympathy and admiration Delacroix had for Chopin (figs. 10 and 12). From this time forward (1838), Delacroix frequented George Sand's circle increasingly often, even if he was critical of her political position and social preoccupations—which he was far from sharing. He was not an unconditional admirer of her prose either; nevertheless, their attachment was reciprocal and sincere. She welcomed him at Nohant several times, in 1842, 1843, and then in 1846. The break with Chopin, the Revolution of 1848—during which Sand and Delacroix's opinions were diametrically opposed—then the reestablishment of the Empire and the

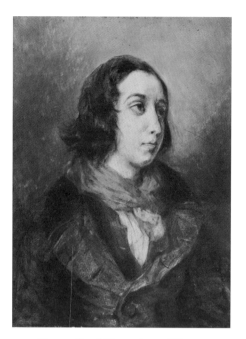

9. *George Sand Dressed as a Man,* 1834
Oil on panel, 26 × 22 cm
Private collection, Paris

more official position occupied by Delacroix, dampened their relationship, as is evident in their correspondence, which became less frequent and less cordial with time. He did thank her warmly, however, on the publication of her *History of My Life* in *La Presse*, with its chapter dedicated to him: "I cannot thank you appropriately or at length; I cannot tell you how I feel, how much tenderness and indulgent goodness there is in this portrait, in this statue that you have sculpted after an original that does not see himself so nobly, even from a closer distance. . . . No one but you would think and speak as you do. *Eh bien!* I swear I am enchanted by what you say because it is you who say it; that I am happy to owe such gratitude to you, it is my soul that thanks you."[42]

In his human relations, Delacroix was really a lively paradox: meditative and loving of solitude, but interested in conversation and curious about the business of his contemporaries, without too many illusions about their value, as many passages of his journal attest, both in youth and in maturity. "One must dine out seldom and work alone in the evening," he wrote in 1824. "I think that high society, or any society, seen from time to time, is less dangerous for progress and the agility of the mind, whatever many so-called artists say, than consorting with them. Vulgarity intrudes at every instant of their conversation; I have to get back to solitude. To living soberly like Plato. How can one conserve enthusiasm for anything when at every instant one has to be available to somebody, when one always needs the society of others. . . . The things that one tries alone are always stronger and purer. Whatever pleasure there is in communicating one's emotion to a friend, there are too many nuances to explain, although each perhaps feels them, but in his own way, which weakens each one's impression."[43]

Still, he was far from being a bear: at the same time that he was making a name for himself through his exhibitions at the Salon beginning in 1822, he was very quickly being introduced into the Parisian salons, in particular the very open and

popular one of the painter Gérard, and that of Cuvier, in the Jardin des Plantes. One can easily imagine that his wit, recognized by all his contemporaries, made him a success. His journal bears witness in any case to continual outings, dinners, suppers, the theater, and the opera, and of course in very different circles. He himself explained this worldly life: "I found a way to work enormously all day long, and, in the evening, I put on silk hose and stayed in the salons until two or three o'clock, or busied myself with distractions that you can imagine. I still ask myself how I could manage all this movement, with a frail constitution. In such a case one has to attribute much of it to the resources of youth that permit excess, because it tends to renew itself again and again, and I stayed young a long time. It was only at the age of about forty-five [in 1842] that a little warning of nature made me understand that I was not immortal, and that I would have to choose between a great and very short life, and a bit more sober career, a little narrower but promising to last a little longer. A serious problem with the larynx, which lasted several years, forced me to more moderation. Since then I give a great deal to my work, and almost nothing to the rest, and I pray to heaven to keep me in this wise direction."[44] If he took care of himself after 1842, Delacroix in reality still went out, but more moderately, as his *Journal* again attests. In forty years he thus met everyone in Paris who was in the arts, literature, or politics. And he did not give up his freedom to judge: he sometimes wrote for himself extremely severe remarks on one person or another. But he was sought after and appreciated by everyone. His world was thus greatly enlarged, and his intellectual interests, quite varied and sustained by his intelligence, found nourishment. The same can be said about his material interests: he did not hesitate to use his relations to get a commission or a position. He was not an intriguer, but he knew how to advance his affairs. For instance, at the beginning of the Second Empire, he thought of profiting by the favor in which Joséphine de Forget found herself by virtue of her family relationships, which was to get himself named to the museums or to the administration of the Gobelins manufacture. But he quickly realized that he had neither the real desire nor the physical capacity for it, and settled for being a member of the municipal council of Paris. He never publicly acknowledged himself as a Bonapartist, but the regime seemed to suit him. Had not his family supported the first Empire? Delacroix was a law-and-order man, and his

reactionary sentiments crystallized with time, especially in 1848, when, at his country house in Champrosay, he took some shots at the June insurgents fleeing the capital. But he never declared or publicized his political opinions during this period when France was changing regimes just about every twenty years. He did not declare himself one way or another, and received commissions from all the governments successively from the Restoration onward. Notwithstanding *Liberty Leading the People* and the *Massacres of Chios*, his work is among the least political of the century, or in any case one of the least committed to the service of any cause, except for Greek independence. His character, as Baudelaire wrote, did not lean that way: "One can say of him, as of Stendhal, that he greatly feared being duped. A skeptic and an aristocrat, he knew passion and the supernatural only in the unavoidable familiarity of the dream. He hated the multitudes and hardly thought of them except as breakers of images, and the violence done to some of his works in 1848 [in fact, only *Cardinal Richelieu Saying Mass*, destroyed in the pillage of the Palais Royal] was not calculated to convert him to the political sentimentalism of our time. . . . The hereditary signs that the eighteenth century left upon his nature seemed borrowed from that distant class of utopians rather than from the extremists— from the class of polite skeptics, conquerors, and survivors who generally are more like Voltaire than Rousseau."[45]

Those who drew near to Delacroix, and there were many, were attracted to a rich and seductive personality, but there were few who could, like Baudelaire, enjoy its multiple facets: "Eugène Delacroix was a curious mixture of skepticism, politeness, dandyism, willpower, cleverness, despotism, and, finally, a kind of special goodness and tenderness that always accompanies genius."[46] It is indisputable that Delacroix was also, and perhaps foremost, a man whose appeal and character were inseparable from his work. "Delacroix, whom we met for the first time shortly after 1830, was then a young man, fragile and elegant, whom you could not forget once you had seen him," wrote Gautier in his *History of Romanticism*. "His pale, sallow complexion, his head of black hair that he kept to the end of his life, his tawny eyes with a catlike expression, under thick brows whose lowest point turned back up, his thin, fine lips, magnificent teeth shaded by a light moustache, his strong, powerful chin marked by strong planes, gave him a wild beauty, strange, exotic, almost unsettling: one would

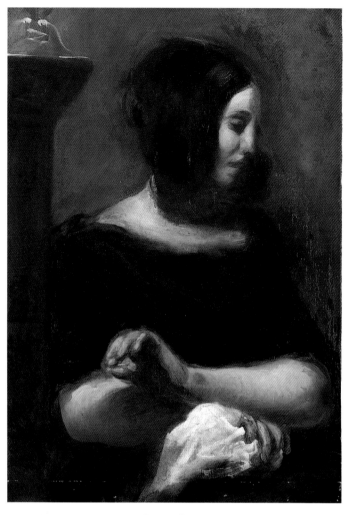

10. *George Sand*, 1838
Oil on canvas, 79 × 57 cm. Ordrupgaardsamlingen, Ordrupgaard

11. *George Sand and Chopin*, 1838
Pencil on buff paper, 12.6 × 14.3 cm. Musée du Louvre,
Département des Arts Graphiques, Paris

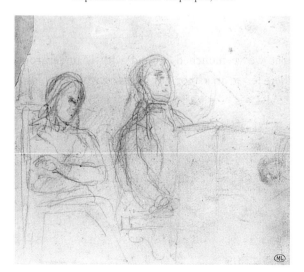

have said an Indian maharajah, educated like a perfect gentleman at Calcutta and now coming in European clothes to soak up Parisian civilization. His nervous, expressive, mobile head sparkled with wit, genius, passion. Some thought that Delacroix resembled Lord Byron. . . . The successes denied to the painter, the man of the world (and Delacroix always was one) obtained easily. No one was more seductive than he when he took the trouble. He could soften the wild look of his mask by a smile full of urbanity. He was soft, velvety, cuddly like one of those tigers whom he excelled in rendering with a supple and formidable grace, and, in the salons, everyone said, 'What a shame that so charming a man does such paintings!'"[47]

The portrait drawn by Silvestre and published during Delacroix's lifetime, reinforces and completes Gautier's: "Delacroix is a violent, sulphurous character but in complete control of himself: he keeps himself perfectly imprisoned in his education as a man of the world. Clever, an attentive listener, he is prompt, sharp, prudent in his replies. He understands life's fencing game, and promptly pierces his man without stepping over the line. . . . His manner is elegant and superbly easy: sober gestures, very expressive, and a golden tongue. He has the skill, the seductive manners, the insinuations, grace, caprices of a woman. His small lively eyes, blinking, buried under the arcade of his black, wild brows; the magnificent abundance of his hair made me think of the etchings of himself that Rembrandt left. . . . His humor is witty and sarcastic rather than joyful. He has a deep and melancholy smile. The square cut of his prominent and uneven jaw, the mobility of his open and quivering nostrils immediately express the strength of his passions and his will. Sometimes he has a proud and intensely cynical look. . . . He is not handsome in a conventional way, and his face shines. All his figures have something of him in them: a pensive and suffering air, but he gives the men enormous muscles because he loves strength and action. His women especially look like him in the nobility, the elegance of their attitudes, the ardor of their temperament, the fatal beauty of their expression. The artist's fragile constitution is supported by the strength of his nerves; he has the resistance and pliability of fine steel. . . . He speaks in a measured way, but, with his impatient attitudes, you can see that he is holding back his impetuousness. He is astonishing in his fiery spirit mixed with sangfroid, and excitement always sparkles in him like a flame."[48]

Another trait completes the picture: fever and illness. His poor health is hard to imagine when one considers the quantity of work that Delacroix left, most of it done without help. The epitaph that Robaut placed at the beginning of his catalogue raisonné, accurate in order of size if not in detail, illuminates this point: "Eugène Delacroix left about nine thousand one hundred forty works, including eight hundred fifty-three paintings; fifteen hundred twenty-five pastels, watercolors, or wash drawings; six thousand six hundred and twenty-nine drawings; twenty four engravings; a hundred and nine lithographs; and more than sixty albums."[49] And among these paintings are a number

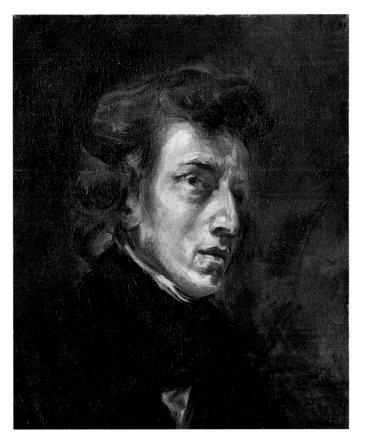

12. *Frédéric Chopin*, 1838
Oil on canvas, 45.7 × 37.5 cm
Musée du Louvre, Paris

of the most important decorative works of his time, sometimes of course executed with collaborators, but always under his constant direction. Now Delacroix, who was not very vigorous by nature, had been affected by illness from his early youth. Traveling in September 1820 from his brother's home at Tours to the family forest in Charente where he intended to spend the rest of his vacation, he imprudently, after a long stretch on foot in the sun, stopped to rest in a hot café where he caught "a cold that quickly turned into a little fever." Sick, he continued on his way, waited a long time at Chatellerault for the diligence to take him to his destination. He finally arrived "with a decided fever" that made him "a match in appearance and a tinder in worth." "It was only yesterday and the day before," he wrote to his brother more than ten days later, "that I began to get some strength back and to think clearly. It was a slow fever that hit me every day: no appetite, boredom, and continual distaste, and such weakness that I had fainting spells when I got up from my chair. Finally I began to

get better thanks to quinine. The fever has let up. The rest will follow. . . ."[50] From then on he periodically suffered from weakness, complicated and aggravated beginning in 1835 by chronic laryngitis.[51] A new and much more serious attack came in March and April 1842. The rest and voluntary seclusion he forced on himself were very difficult: "Hello, dear friend," he wrote to George Sand. "I am bored without seeing you and yet I am still keeping myself in seclusion. So don't come if you want to. Until it gets warm I will doubtless be shaky. I've gotten well five or six times and the imprudence of talking too much and too soon made me ill again. Before wiping off your most serene pen, wipe me off a bit of friendship and memories that will give me patience. My style is drying up from my isolation from good society. I have lived for six weeks with turkeys and dogs and I got along with them pretty well. But all that is not friendship. Alas, my dear friend, latch onto the people you love and who love you. It's a need you feel more with aging. I have had several more losses that I have felt for some time. When everyone that we've loved and that we've munched around with is underground, what is there left to attach to? For me there wouldn't be anything, and I will no doubt pack it in before that."[52] Delacroix wanted to get out, to see people, which was impossible: "Sometimes I am all right, sometimes completely low. I was stupid enough to go out in the evening two or three times and felt nothing but fatigue that influenced the following days. Every time I stay up late, I am worn out for two days and have to spend the evening at my fireside."[53] After six months in the country, he could finally begin to work again in the library of the Palais du Luxembourg. "But I wouldn't yet be strong enough to paint

and I would begin the drawing so as not to lose time; for this illness has set me back greatly," he confided in the architect, Gisors.[54] From then on it ruled his life. He tried several cures: at Eaux-Bonnes in the Pyrenees in 1845, Ems in 1850, Plombières in 1857 and 1858—travel opportunities for him, but also periods of forced inactivity. From time to time he had to rest, interrupting his work for several months—not only easel paintings but also the great decorative paintings—at the end of 1856 and for the first three months of 1858, and at the beginning of 1862. He could, however, always write; and no doubt this state of things was one of the causes for the deepening of his reflections in the last twenty years of his life as it appears in his journal and in the publication of various articles. His work also became more cyclical, accelerating or slowing down depending on his health.

Another important consequence was the increasing withdrawal from Parisian life, of which he had been a notable figure, and which he continued to be, but in retirement. He had always sought solitude to paint. Now he cloistered himself more and more: speaking tired him, and time was, in a way, pressing; everything had to go to his work. "How many days would pass without his being able to make one brush stroke, if his door were open to artists, writers, art lovers lazily strolling from atelier to atelier! . . . Delacroix takes strength from solitude and contemplation; he is at his easel, mysterious and incessant like an alchemist at his furnaces. . . . An artist like that, devoured by the need to produce, finds existence short and is hardly ready to sacrifice it to more interesting relations. According to the poet's expression, he hides his life and expands his spirit. . . . Delacroix trembles like a guilty man every time he hears a visitor's step: the doorbell throws the household into alarm; two housekeepers run to the door, like sentinels aroused by a shot, and defend his orders."[55] One of them was a Bretonne completely devoted to Delacroix, Jenny Le Guillou (fig. 13), who became progressively more and more important in his household. "You could only go in with her approval," Piron wrote, "and most visitors were harshly dismissed. Anybody who talked too much, or especially who made him talk too much, who annoyed him, or who kept him from working, was put under Jenny's ban by Jenny herself, and it was impossible for him to get in. It was hard to know whether, in the general exclusion decided on by Jenny, it was her desire to bolster her influence or her tender concern for her

master's health that took the upper hand; at least she was firmly of the opinion, only too much justified by events, that repose and silence were indispensable to Delacroix's health; people and their demands would prove mortal for him; the least excess would be fatal; the night air, a late evening, or an animated conversation laid him low; he lost his voice and found himself obliged to shut himself in for eight days. . . . Jenny's enlightened devotion, as well as her exercise of a growing authority, assured him a despotic reign. . . . Jenny was not wrong when she said that the love of society would have killed Delacroix several years earlier without her active supervision, her anxious advice. Soon there was no one to balance the account, no will other than his own, and everything in the house bowed before his."[56] Delacroix was satisfied with what could be understood as domestic tyranny. Jenny was the "only being whose heart is mine without reservation,"[57] "half of myself,"[58] and very dear to him, as several passages in his journal indicate.[59] He conversed with her on serious subjects, even if she understood little,[60] and made her visit the Louvre.[61] The barriers that she built around her master, especially during his last years, and the exclusion of old friends, of which she was guilty, gave him a bad reputation. But Jenny did in truth guarantee him the stability and isolation that he needed to work. We are thus indebted to her for many paintings that he otherwise would not have had the strength or simply the time to do.

Delacroix was, as we have often pointed out, a cultivated man. "I have been associated with him for twenty years," George Sand wrote to Silvestre, "and so am happy to be able to say that he deserves to be praised without reservation, because nothing in the life of the man is unworthy of the mission so grandly fulfilled by the master. . . . I probably have nothing to teach you about his constant nobility of character or the honorable fidelity of his friendships. . . . He enjoys equally the various faces of the beautiful, by virtue of his many-faceted intelligence. Delacroix, you might say, is a complete artist. He enjoys and understands music so well that he could probably have been a great musician if he had not chosen to be a great painter. He is no less a judge of literature, and few minds are so enlightened or so clear as his. If his arm or his sight began to tire, he could still dictate beautiful pages that were missing in the history of art, and that will remain as archives for all artists of the future to consult."[62]

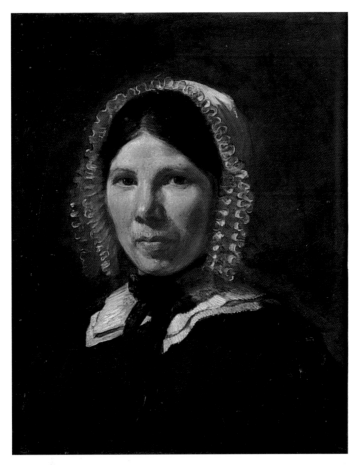

13. *Portrait of Jeanne-Marie Le Guillou*, c. 1840
Oil on canvas, 45.5 × 37.5 cm
Musée du Louvre, Paris

A taste for music came to Delacroix early. In his early child-hood, at Bordeaux, it had been noticed by his sister's music teacher, a former organist.[63] He very soon began to play the guitar and the violin. In 1820, he bought himself a harpsi-chord and played it to distract himself from his troubles.[64] He never stopped going to the opera, to concerts, to musical eve-nings in the salons, as his correspondence and his journals, full of notes on his outings, show. He understood and could enjoy the works themselves (he knew how to analyse them)[65] as well as the quality of the interpretation. In the spring of 1831, he attended Paganini's first Parisian concerts, which were a sen-sation, and probably almost immediately did a small portrait of the artist that perfectly catches, in its sketchlike aspect, the violinist's exceptional virtuosity (fig. 14). In contrast to the painter and lithographer Louis Boulanger, Delacroix does not depend on the romantic legend that surrounded Paganini, the legend of the persecuted genius who made a pact with the devil and perfected his art during his imprisonment for the murder of his mistress. Instead he shows his sickly, almost deathlike, silhouette; he is an apparition, an inspired medium who exists only through his instrument. Delacroix saw in Paganini an example for painters: "You have to be able to render easily [in painting] the thing that you envision," he later confided to Lassalle-Bordes. "Your hand has to acquire great nimbleness, and you can only achieve that by study. Paganini acquired his astonishing skill on the violin only by practicing scales every day for an hour. We need the same exercise [drawing every morning]."[66] Painting, like music, is first and foremost an apprenticeship. Comparing the journal of his youthful years with that of his maturity, we find that the sensibility, curiosity,

and capacity for enthusiasm are not blunted by time: they show rather a tendency to deepen, as if reflection develops his first impressions more and more. Delacroix's taste for music appears also in the short note that he sent to a relative, the musician Dessauer, to ask him to go to hear *The Secret Marriage* of Cimarosa, an admiration for which he shared with Stendhal: "Dear friend, they are giving the *Matrimonio* this evening. Go, standing on your head if you have to. Leave your friends and mistresses, cats and kittens. You will never see such a thing again."[67] Haunted by two arias of *The Abduction from the Seraglio*, he asked his cousin Berryer to have his secretary copy them so that he could learn them by heart.[68] Enflamed by Pauline Viardot in the revival of Gluck's *Orpheus* in 1859, he encourages George Sand to leave Nohant to enjoy what he sees as a true resurrection.[69] He could also be very critical: "Your fury about the literary hacks seems to be at about the same level as mine: it's a vile crew. They think they are the priests of a temple when they are not worthy to be the doormen and, make no mistake, in our century everything is the same way: bombast goes hand in hand with emptiness. Yesterday I saw the opera of this famous Merdi about whom the young German musician whom I saw at your house was so enthusiastic; Verdi or Merdi is all the rage today; they're trotting out all the old castoffs of Rossini, without the ideas: nothing but noise. . . . I thought all the time of your poor Mme Viardot whose destiny, if she wants to live, is to sing the music of those blackguards from now until eternity. Where is Chopin, where is Mozart, where are the priests of the living God, where are you?"[70] Delacroix's musical taste was, in truth, quite classical. He judged Berlioz harshly, as much from the point of view of technique (he "tacks on the chords and fills the intervals any way he can")[71] as from the effect ("this noise is deadly: a heroic mess").[72] He could not forgive his having wanted to free himself from the "eternal laws of taste and logic that rule the arts." "The Berlioz, the Hugos, all these so-called reformers," he

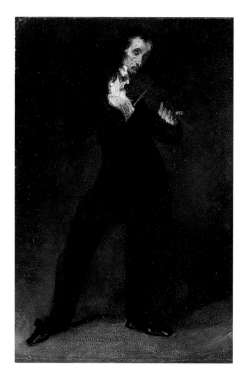

14. *Portrait of Niccolò Paganini*, 1831?
Oil on cardboard, 45 × 30.4 cm
The Phillips Collection, Washington, D.C.

goes on to say, "have not succeeded in abolishing all the ideas we talk about, but they have raised the possibility of doing something other than the true and reasonable. It is the same in politics. You can't get out of the rut without returning to the infancy of society, and the savage state, after successive reforms, is the forced necessity of change."[73] The greatest musician, for Delacroix, was Mozart, whose name is one of those that recurs the most frequently in his journal: "He is really the creator, not of modern art, since there isn't any at present, but of art taken to its height, after which there is nothing more perfect."[74] Weber and Beethoven, too, whose "abrupt novelty" could be striking, remained for him, inferior.[75] Mozart agreed better with Delacroix's temperament: "Delicious music at the home of the agreeable Princess Marcelline [Czartoriska]," he noted in June 1853. "The memory of Mozart's *Fantasia*, a grave piece, almost terrible at times, whose title is much lighter than the piece itself. A sonata of Beethoven, already familiar but admirable. It undoubtedly appealed to me very much, especially to the painful side of the imagination. This man is always sad. Mozart, who is also modern, that is, who is not afraid to touch on the melancholy side of things, like the men of his time . . . , Mozart joins this bit of delicious sadness to the serenity and elegance of a spirit that has the happiness to see also the agreeable side."[76]

It is logical, then, that Cimarosa, Rossini, and Chopin were among his favorite composers. He particularly favored the latter among his contemporaries. Chopin was without question one of those to whom Delacroix felt himself closest, drawn by both sentiment and intelligence, but also by a common conception of art.[77] George Sand, thanks to whom the two men appreciated each other more and more in the second half of the 1830s, finely described this exceptional friendship: "Chopin and Delacroix love each other, one could say tenderly. They are very much alike in character and have the same great qualities of heart and mind. But so far as art goes,

Delacroix understands and adores Chopin. Chopin does not understand Delacroix. He esteems, cherishes, and respects the man; he detests the painter. Delacroix is more varied in his abilities and appreciates music; he knows it and he understands it; he has exquisite taste. He never tires of listening to Chopin; he savors him; he knows him by heart. Chopin accepts this adoration and is touched by it; but when he looks at a picture by his friend, he suffers and cannot find a word to say to him. . . . He has an infinity of wit, sharpness, and malice; but he cannot understand anything about painting or statuary. Michelangelo frightens him. Rubens exasperates him. Everything that seems eccentric to him scandalizes him. . . . It is true that in literature Delacroix's taste is the most classical, formalist."[78] In Chopin, the pianist and composer were one. This brought some exceptional moments at Nohant (fig. 16): "Sometimes in the garden you hear from the half-open window some gusts of music as Chopin works; it mixes with the song of the nightingales and the odor of roses; you see that so far I am not to be pitied," Delacroix wrote to Pierret.[79] One of the reasons for Delacroix's admiration of Chopin, which throws light on the more general conception he formulated on the evolution of the arts, was that the composer both followed and renewed the musical tradition: "But Chopin is a different man than that! 'Look,' I told them, 'how he is a man of his time, how in his art he makes use of the progress that others have made! How he adores Mozart, and how little he resembles him! 'His friend Kwiatkowski often reproached him for his Italian echoes, which, in spite of himself, smell of the modern productions of Bellini, etc. That's a thing that also displeases me a bit. But what charm! And besides, what novelty!"[80] Delacroix accorded a prominent place in the history of music to Chopin: thus he copied in the *Journal*, in February 1851, very long extracts from Liszt's famous article, published in *La Revue de Paris*, in which Liszt

15. *Portrait of Chopin as Dante*, 1843–46? or 1849?
Pencil on paper, 27.1 × 21.1 cm
Musée du Louvre, Département des Arts Graphiques, Paris

predicted a great future for him, all the while developing a close analysis of his art and genius.[81] And Delacroix deliberately represented Chopin as Dante, thus associating the admiration that he felt for the composer and for the writer in a drawing, a souvenir of happy times, signed with the rebus that he had earlier sent to George Sand (fig. 15).[82]

In many different aspects— playing, listening, analysis, and reflection—music was of capital importance in Delacroix's life. It exalted him in his work: "whether he sees, at the theater, Pasta in *Romeo*, Malibran in *Marie Stuart*, Grisi in *Norma*, Cruvelli in *Semiramis*, Alboni in the *Cenerentola*, . . . or whether Mme Viardot teaches him an old aria of Gluck, he will dream of it for weeks, and the result of each of these evenings will be, the next day, a day of productive work where his electrified brush will draw sublime inspiration from the purely musical memory," recalls Adolphe Moreau.[83] In a passage of the *Journal*, Delacroix himself testifies to the help that music could give him in the appreciation or handling of a work: "What I have found, whenever a beautiful painting was before my eyes in a church while religious music was being performed, is that it isn't necessary for it to be so carefully chosen to produce an effect—music no doubt addressing itself to a different part of the imagination, one that is easier to captivate. I remember having seen in this way, with the greatest pleasure, a copy of Prud'hon's *Christ* at Saint-Philippe-du-Roule; I think that it was during the burial of M. de Beauharnais [grandfather of Joséphine de Forget]. Never, certainly, did this composition, which is open to criticism, seem better to me. The sentimental part seemed to disengage itself and arrive on the wings of music. . . . I remember my enthusiasm when I was painting at Saint-Denis du Saint-Sacrement[84] and I heard the music of the services; Sunday was doubly a feast day; I always had a good session on that day."[85] In the same way, the

16. *George Sand's Garden at Nohant*, 1842 or 1843
Oil on canvas, 45.4 × 55.2 cm
The Metropolitan Museum of Art, New York

angel with the rod in *Heliodorus Driven from the Temple*, at Saint-Sulpice, was favored by "that indefinable state of thought into which the sound of the organ playing the *Dies Irae* had plunged me."[86]

Music was so much a part of Delacroix's makeup that it held an essential place in his aesthetic reflections and in his conception of painting. One of the last notes in the *Journal* draws a parallel between the ear and the eye: "The first merit of a painting is to be a feast for the eye. This is not to say that there does not have to be meaning: it is like beautiful verses, all the meaning in the world does not keep it from being bad if it shocks the ear. We say, *have an ear*; not all eyes are fit to appreciate the delights of painting. Many have a false or inert eye; they see the objects literally, but they do not see the exquisite."[87] He says something similar when Maurice Sand asks him to explain the question of reflections and their coloration. "The master painter establishes a comparison between the colors of painting and the sounds of music. Harmony in music, he says, exists not only in the makeup of the chords, but also in their relationships, in their logical succession, in their linking, in what I would call, if needs be, their auditory reflections. Well, painting works the same way! Listen! Give me this blue cushion and this red rug. Let's put them side by side. You see that there where the two colors touch each other, they steal from each other. The red gets tinted with blue, the blue is washed with red, and, in the middle, violet is produced. You can stick in the most violent colors, give them a reflection that ties them together, and they will never be garish. Is nature sober in color? Isn't she overflowing with ferocious oppositions that do not destroy her harmony at all? It's because everything is linked together by reflections. You can claim to eliminate that in painting; you can do it, but there's one little inconvenience: the painting is eliminated too."[88]

Chopin's improvisations likewise come to Delacroix's mind naturally in regard to the discussion in the *Dictionnaire des Beaux-Arts* of the relation of the sketch to the finished work.[89] The painter records for example, in the *Journal* for 1853, a conversation that he had with a music lover, the count Grzymala, coming back from an evening of music: "We spoke of Chopin. He told me that his improvisations were much bolder than his finished compositions. It is the same, no doubt, with a study for a painting compared with the finished picture. No, one doesn't spoil a painting by finishing it! Perhaps there is less room for the imagination than in a sketchy work. One has different impressions of a building that is being built, when its details are not yet indicated, and that same building when it has its complement of ornament and finish. . . . The finished building encloses the imagination within a circle and prevents it from going further. Maybe the sketch of a work is pleasing only because everyone finishes it to his own taste. . . . So the

artist does not spoil the picture by finishing it; only, in giving up the vagueness of the sketch, he shows his personality more clearly, unveiling the whole direction of his talent but also its limits."[90] This shift from music to painting, or from painting to music, is in truth constant with Delacroix. After having seen Courbet's *Bathers*, *Spinner Asleep*, and *Two Wrestlers*, he concluded his analysis by invoking Rossini and Mozart: "Oh, geniuses inspired in all the arts, who draw from things only what is needed to show them to the spirit! What would you say of these pictures?"[91] Often, his reflection is honed by a musical memory. In March 1856, he attended a concert at the Society of Saint Cecilia, where he particularly enjoyed Beethoven's *Eroica* and Cherubini's *Marche du Sacre*. "As for *Preciosa* [an opera of Weber], the heat it gave off, or a brioche that I had eaten before coming, paralyzed my immortal soul, and I slept the whole time." In the evening, pen in hand, he asks himself, thinking of Beethoven, about "the manner in which musicians try to establish unity in their works." Isn't it by the repetition of motifs? Then comes an analysis of the arias of Mozart in *The Magic Flute* and *Don Giovanni*, which leads naturally to a more general reflection on the relationships of the whole and the part, of unity and detail in painting. "These remarks on music make me perceive more particularly how professionals in an art are poor connoisseurs of the art they practice, they do not join to the practice of their art a superiority of mind or fineness of sentiment that the habit of playing an instrument or using a brush cannot give them," he continues. And he extends this to the role of the academies and studios, to the "true sentiment" of fine works and the evolution of taste and fashion. At the end, he returns "to the new sonorities, the combinations of Beethoven; they have become the inheritance or rather the plunder of the lowest beginners."[92] Music is naturally associated with painting everywhere in the *Journal*. In December 1856, Delacroix puts down from memory a passage from the correspondence of Mozart: "Passions, violent or not, should never be expressed to the point of disgust, and music, even in the most horrible situations, *must never hurt the ear, but please and charm it, and consequently remain music*."[93] If we replace the ear with the eye, cannot this remark apply to all of Delacroix's work?

Literature also played a capital role in his life. Delacroix's literary tastes are well known, thanks again to the indications of his journal and to the testimony of his contemporaries. It is Silvestre who has perhaps summarized them best: "And how he loves literature! From time to time he goes to his little house in the country to shut himself in with his books and papers. He is marvelously well read in the historians, poets, and novelists of all countries. He speaks ravishingly of them. He puts the heroic appeal of Corneille above all, along with the perfection and fineness of Racine [and Silvestre adds a note: 'What does Delacroix find in Racine? What he does not have himself: the correctness, the great polish']. Shakespeare charms him by his cunning, strong, and terrible parts; he picks out the happy situations of Byron, but he thinks his heros are braggarts. For the rest, his intelligence, as capricious as gourmandise, goes from Dante to Ariosto as easily as from Shakespeare to Racine. Nineteenth-century phrases bore him."[94] Delacroix was particularly moved by the classics, not only the Greek and Latin authors, but also the writers of the seventeenth and eighteenth centuries, like Racine, Voltaire, or Diderot, whose naturalness seduced him. He did not stop reading them after college: "I studied honorably," he remembered later. "I was one of these good students who understood everything you have to understand and who drew out the real fruit of my studies, without being one of those model schoolboys who collect the laurels at all the prize distributions. . . . I know the ancients, that is to say, I have learned to value them above everything: that is the best result of a good education. I congratulate myself on this in view of the fact that the moderns, in love with themselves, neglect these august examples of intelligence and virtue. It is the shame of our time that the city and the government maintain and encourage colleges whose principle is that one can get along without studying the ancient languages."[95] Delacroix took Horace and Virgil when he went on vacation. "We have to see each other often this winter, read good things," he wrote to Pierret on the occasion of one of his stays in Charente, in the autumn of 1818. "I am completely surprised to find myself weeping over Latin. Reading the ancients tempers us and softens us; they are so true, so pure, and how they penetrate into our thoughts! I want to put down here a little bit of it, badly translated, which will make you want to read the original. I was moved to tears when I found it. There is in these lines [the tenth *Eclogue* of Virgil] an exhaustion, an uneasiness, the disgust of a man who, seeking distraction, throws himself into everything, and who is reminded of his misery by everything. . . . And besides, there are

some not so distant connections with my own situation. That is perhaps what made me seize upon it with such fervor."[96] This intimate familiarity thus goes way back and never ceases to deepen with the years. But paradoxically it does not translate immediately into his painting. Only with maturity did Delacroix feel sufficiently self-assured to try to render with the brush the multiple emotions that reading Ovid or *Jerusalem Delivered* aroused in him. Certain writers whom he loved or read, such as Goethe, Shakespeare, Byron, and Walter Scott, were appropriate for furnishing subjects. Others, no.

Among the latter were literary men with whom he associated all his life, but particularly in his youth. Delacroix knew all the writers of his generation, the "enfants du siècle," who, like him, found their place and made a name for themselves under the Restoration. But paintings inspired by them are very rare. For instance, one would have thought that his relations with Hugo would have been particularly close.[97] In reality, they were so for a rather brief period only, at the end of the 1820s. In those years, Delacroix frequented the romantic *cénacles* of Nodier, participated in debates and in literary battles (but not in the *Hernani* affair), made designs for the costumes of *Amy Robsart*.[98] But the literary excesses of Hugo (or so he judged them) ended by tiring him. For his part, Hugo was far from appreciating Delacroix's paintings. He preferred Boulanger. Each man, guided by his respective taste, judged the other harshly. Thus relations between them were cool in the 1830s. And when Alexandre Dumas, with a mandate from the Duc d'Orléans, wanted to buy Delacroix's *Marino Faliero*, which had not found a buyer in several years, he was careful not to say that the duke wanted to give it to the poet.[99] Hugo's political evolution after 1848, and then his exile following the second of December, while Delacroix seemed on the contrary to profit largely from the new regime, accentuated this estrangement. Even if Hugo, at the end of his life, seemed to have returned to his earlier opinions with regard to Delacroix, the two French masters of Romanticism never did have a true meeting of the minds.

Delacroix does not seem to have appreciated the poets of his time. He said of Musset: "He manages his pen like a chisel; with it he makes gashes in the heart of man and kills him by letting the acid of his poisoned soul run in. Me, I prefer a gaping wound and the living color of blood."[100] This did not prevent him from appreciating the man: one evening, discussing painting as they left a show, they walked, without being able to tear themselves away, from one's door to the other's.[101] It was the same with the prose writers. Alexandre Dumas, who quickly became an enthusiast of Delacroix's painting, met him about 1826, in the studio of the Devéria brothers, one of the centers of Romanticism. The painter and the writer rapidly became friends. Around 1830 they were seeing each other rather frequently. Dumas bought several of Delacroix's paintings and always supported him.[102] On the occasion of the famous ball that he gave during carnival in 1833, Dumas had asked all the young artists that he knew—Delacroix, Louis and Clement Boulanger, Alfred and Tony Johannot, Decamps, Granville, Barye, Ziegler, and Célestin Nanteuil—to decorate the apartment where the fête was to be held. Delacroix was the last to come, the very day of the ball, when all his comrades had finished their work. He was put in front of the panel that that been saved for him. Dumas, of course, recounted the scene: "What do you want me to throw together there—A King Roderick after the battle? [This would be the last Visigothic king of Spain, vanquished, having lost his kingdom, alone on his horse, as described by the poet Emile Deschamp, cited by Delacroix himself] . . . And without taking off his little frock coat that was glued to his body, without rolling up his sleves or his cuffs, without putting on a blouse or jacket, Delacroix began by taking a charcoal; in a few strokes he had sketched the horse, in five or six the chevalier, in seven or eight the landscape, including the dead, dying, and fleeing: then, thinking this sketch adequate, although it was unintelligible to anybody but himself, he took his brushes and began to paint. In an instant then, as if one had torn away a cloth, there appeared first a bleeding rider, injured, wounded all over, almost dragged by his injured horse, wounded and bleeding like him. . . . On the horizon, as far as the eye could see, the field of an unremitting, terrible battle; over all that the sun was setting through an atmosphere thickened with a bloody vapor, a sun like a red shield in a forge; finally, a blue sky blending as it receded into an almost imperceptible tone of green, with several rose-colored clouds like the down of an ibis. All this was marvelous to see: a circle formed around the master, . . . this other Rubens who improvised the composition and the execution at the same time. In two or three hours, the panel was finished" (fig. 17).[103] And, in the evening, Delacroix came costumed as Dante.

Relations between Dumas and Delacroix remained most cordial until the end. Dumas could thus obtain from the painter, as we have seen, firsthand information for his *Memoirs*. Delacroix, for his part, liked to relax with Dumas's novels. But he did not hold them in very high regard beyond their easy, distracting aspect: "I spent the whole day resting and reading in my room. I began the *Monte Cristo*—it is very amusing, except for the interminable dialogues that go on for pages; but once you've read it, you've read nothing,"[104] Or again: "Spent the whole day at home reading the *Chevalier of the Maison Rouge* [*sic*], of Dumas, very amusing and superficial. Always melodrama."[105] Harsh toward Dumas, Delacroix was so, in fact, toward most of contemporary literature, and time only made his judgment less and less favorable: "I am reading the *Memoirs of Balsamo* in the evening. The mixture of parts that show talent with these eternal melodramatic effects sometimes makes you want to throw the book out of the window; and at other moments, curiosity attracts you to these singular books and holds you the whole evening, and you cannot help admiring their verve and a certain degree of imagination they demonstrate even if you cannot admire the author as an artist. There is absolutely no propriety, and they are addressed to a century without modesty and without restraint."[106] "What is Dumas, and almost everybody who writes today, in comparison to a prodigy like Voltaire, for example? By the side of that marvel of lucidity, spark, and simplicity all together, what becomes of this disordered chat, this endless alignment of phrases and of volumes filled with both good and detestable things, without restraint, without law, without sobriety, without consideration for the good sense of the reader! . . . They cannot work, that is to say prune, condense, summarize, put into order. The need to write so many pages is the fatal cause that would undermine still stronger talent. They make money by piling up the volumes; a masterpiece is impossible today."[107]

It was the same with all the writers that he knew. He appreciated them as friendly acquaintances, but enjoyed their work considerably less and, in any case, not without reservations. The admiration that these writers may have had for Delacroix's painting was thus most often unreciprocated. Proprieties were respected in his correspondence, but they were much less so in the *Journal*. Balzac, who had dedicated *The Girl with the Golden Eyes* to him in 1835, sent him, it appears, every one of his novels. Balzac was one of Delacroix's

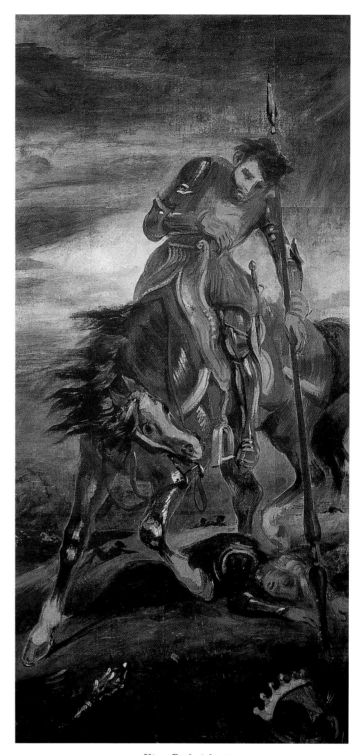

17. *King Roderick*, 1833
Tempera on paper, 192 × 95 cm
Kunsthalle Bremen

defenders. But Delacroix seldom sought his company, congratulating himself, for instance, that he had not come to trouble the days spent at Nohant: "He's a gossip who would have interrupted that nonchalant peace in which I rock myself with great pleasure."[108] And although he copies numerous extracts from *The Human Comedy* into his journal, he accompanies them with biting remarks (or sometimes praises). Thus, apropos of *Ursule Mirouët*, he writes "Always these pictures of pygmies with all the details, whether the character is the principal or only an accessory. In spite of the exaggerated opinion of the merit of Balzac, I persist in finding that his genre, firstly, is false, and then his characters are false too."[109] Even George Sand gets trounced, especially for her theater. It seems finally that, in Delacroix's eyes, only Stendhal combined personal charm, intellectual interest, and stylistic worth. Delacroix and Stendhal formed a veritable band with Mérimée and several other companions such as the British lawyer Sutton Sharpe and Stendhal's doctor, Koreff, coming together periodically in 1830 or therabout for bachelor dinners, which were sometimes augmented by a few young women. Delacroix also met Stendhal in more conventional places like Gérard's salon. His admiration for the talker then extended to the prose writer: "I regard him as the writer who has maybe the most cachet, with the best French that is possible to speak; I mean among the moderns. Nobody tells a story like he does."[110] Stendhal's writing is in effect more in accord with the character of Delacroix, the two men being very similar from this point of view, as Baudelaire and Silvestre were the first to point out.[111]

In literature, Delacroix did not limit himself to critical remarks. He also wrote a great deal. We will skip over his youthful writing, ephemeral essays that present no other interest than that they are by his hand.[112] Of much greater consequence are his articles, the writing of which he had had some difficulty,[113] and, of course, the *Journal*. In this material, a certain talent was recognized, especially by his intimates who, like Silvestre, were familiar with his unedited pages, which he had read to them: "This seductive chat shows the unexpected; there's the originality of Stendhal in his notes written in broken bits; he also has the rough phrases, halting periods, obscure ellipses, all the defects particular to the author of *The Red and the Black* and the *Charterhouse of Parma*. He becomes awkward and timid as soon as he sets himself to stylistic regularity. When he tries for flawlessness, he becomes cold, when he

is naturally so warm, so brilliant. But, as a superior man, he leaves a trace of genius in everything he writes. . . . If he wrote his memoirs, I am sure he would charm the dilettanti."[114] Delacroix was aware of his ability as well as his limits: he was only comfortable with the fragment, the "pensee detachee," as found in Diderot.[115] When François Buloz asked him to write something for the *Revue des Deux-Mondes*, he replied, "As it is impossible for me to set myself to any writing that needs development and a certain length, I could from time to time give you detached fragments of criticism such as you may have seen recently in two issues of *L'Illustration*. They were placed there without my knowledge, although they are indeed mine [these were fragments of the *Journal* first published by Silvestre]. One could call them *letters and critical reflections*. Not being a professional writer, I cannot set aside the necessary time to write a long work. Besides, I find everything that is done, *without exception*, is too long. I would at least like to have the advantage of not being bored for a long time. I think that I put much more vivacity and liveliness into little sallies, where I only write about things that I think I know."[116] Delacroix's writings, although known to some, remained by and large private. Was the painter, in working almost daily in his journal from 1847 until his death, thinking of publication? The only writing that we can be sure about is what he did for his *Dictionnaire des Beaux-Arts*, which he had been thinking about since his election to the Institute. In the tradition of the encyclopedic works of the eighteenth century, he gathered together notes that had been dispersed in his notebooks, reorganized them, developed them, carried his thought farther. But despite several later attempts, he finally abandoned the project. At his death, he left a mass of papers of all kinds and must have known very well that his friends would make every effort to have them made public. He did not forbid it: he was thought to have given Jenny orders to burn a quantity of his notes, but it was Jenny herself who invented this pretext to avoid giving the precious notebooks to Silvestre, whom she did not like. She sent the writings instead to Constant Dutilleux.[117] When he sat down at his work table, was Delacroix aware that he might be read later? Nothing allows us to be certain of the answer. Doubtless not when he records a workshop formula, notes an address, or simply records the use of his time during the day. But it is more likely when he develops his reflections on a certain subject, and when his text takes a clearly more

literary turn. Of course, the resolutions with which he begins his journal demonstrate that he needed to write first of all for himself and with a utilitarian end in view. Thus in 1822 he writes, "I am starting the project that I have so often thought of, writing a journal. What I want the most is not to lose sight of the fact that I write for myself alone; this will keep me true, I hope; I will become better for it. This paper reproaches me for my changes of mind. I begin it in a happy frame of mind."[118] It is with a similar sentiment that he writes in 1847, when he again begins writing regularly, "I am writing this by my fireside, enchanted to have gone and bought this notebook which I am beginning on a happy day. If I can continue to take account of my impressions this way! I will often see what can be gained from putting down impressions and going into them more deeply by recalling them."[119] But his intentions must have evolved in the course of time, along with the mass of his notes, reread and revised endlessly. It is not impossible that he envisaged posthumous publication. He had let Silvestre recopy long passages in 1853. He was thus not against divulging his text, but doubtless only after a preliminary reorganization, which he did not have the time or the desire to do himself. In the reorganization, he would, however, probably have preserved his principal characteristic, the fragmentary aspect—still more noticeable in the constant revision of earlier passages, referrals, annotations, and notes, as well as in the incorporation of citations, sometimes quite long, copied from one author or another.

In what way was this permanent practice of writing (including innumerable letters, sometimes quite long, that Delacroix wrote throughout his entire life) connected to his artistic activity? Let me emphasize from the beginning an essential point: the *Journal* is composed of two well-defined entities, very unequal in form as in depth. Between 1822 and 1824, the young painter jots down his resolutions, notes the important circumstances of his life, confides to paper his emotions and his projects, but in reality offers few developed reflections. Beginning in 1847, and until his death in 1863, while still continuing to record the ephemera of his existence (a precious aspect, and far from negligible for the historian), he goes much deeper into his thoughts and clearly gives them a more problematic turn. The man is older, riper, more experienced, more knowledgeable. He also has more leisure, since illness forces him into seclusion. From this comes a difference of tone, very

noticeable to today's reader, that masks a difference of usage for Delacroix himself. The "first" journal is like a chronicle. The "second" is much more closely tied to his daily artistic creation. The interplay between the practice of his art and reflection, each of which acts on the other, is a trait characteristic of the last fifteen years of Delacroix's life. But one must be careful about systematizing and, above all, about applying his remarks to the body of his work without regard to the context in which he was writing or painting. His ideas change with the passage of time, they crystallize slowly, and the body of doctrine elaborated in his old age, where one often perceives a certain intransigence, ought not always be taken as a key for general reading. Also, Delacroix often contradicted himself from one page to another. One can thus appreciate (and use) the *Journal* in several ways: as an invaluable documentary and factual source, as a selective expression of Delacroix's ideas, but also, more generally, as a broader and more comprehensive expression of a theory of painting and of art.[120] Delacroix was aware that this conjunction of writing and painting (at least as he practiced it) was exceptional: "Reynolds is in this respect a striking example of the truth of this remark, that rarely are men of any age who are gifted with the faculty of producing truly living works are also capable of giving themselves to profound ideas which seem to be the exclusive domain of what is called the philosophic mind, as if action excluded thought or at least limited it."[121] Still, he thought literature inferior to the visual arts and also to music, which he put at the top. According to him, literature could not claim the same unity, the simultaneity of impressions, and consequently the same power of effect. The theme runs throughout the *Journal*, and one finds it like a leitmotif, developed in many passages and under different forms. Thus, in September 1853, he notes after a walk with Champrosay, "It's there that you really feel the impotence of the art of writing. With a brush I can make everyone feel what I have seen, and a description will show nothing to anybody."[122] In a much longer passage, written in October 1850, he says, "Although literature is not my element or I have not yet made it such, when I see this paper filled with little black spots my spirit does not soar as it does at the sight of my picture or even my palette. My palette, freshly arranged and brilliant with contrasting colors, is enough to light up my enthusiasm. For the rest, I am persuaded that if I wrote more often, I would eventually enjoy the same faculty in taking up

the pen. . . . If it wasn't a matter of sewing one thought to other thoughts, I would find myself ready and on the field in an appropriate attitude; but what is so difficult and interferes with the gush of the mind is the business of following a progression, respecting a plan, not getting embroiled in the middle of phrases. You see your picture in the blink of an eye, but you do not see even the entire page, that is, you cannot embrace it with your mind as a whole."[123] For all that, he did not neglect the pen for the brush, far from it; his practice of both was more complementary than contradictory, permanently enriching both the one and the other. And then, didn't he always come back to the painter to explain the painting? Most books on the arts are done by people who are not artists, he notes in the course of elaborating the *Dictionnaire des Beaux-Arts*. From that stem many false notions and judgments made at the mercy of chance and prejudice. I firmly believe that any man who has received a liberal education can speak pertinently of a book, but not of a work of painting or sculpture."[124]

Baudelaire wrote, "It would doubtless be unjust to look for philosophers, poets, or scholars among the artists of the present day; but it would be legitimate to demand of them that they take a little more interest than they do in religion, poetry, and science. Beyond their studios, what do they know? what do they like? what do they express? Now, Eugène Delacroix was, at the same time that he was a painter devoted to his métier, a man of general education, in contrast with other modern artists who, for the most part, are hardly more than illustrious or obscure daubers, sad specialists, old or young; simply workmen, some knowing how to make academic figures, others fruits, others animals. Eugène Delacroix loved everything, knew how to paint everything, and knew how to enjoy all kinds of talents. He was a mind the most open to all ideas and impressions, the most eclectic and impartial sensualist."[125] Reading Baudelaire, one understands how the multiple gifts of Delacroix nourished his painting and how, paradoxically, a work by Delacroix that one would have thought far removed from its century is on the contrary quite close. But why, finally, did he become a painter? It is always easy in retrospect to find the explanation of a vocation in an artist's family background, in the social milieu where he was formed, or in a certain trait of character that manifests itself early. Delacroix is no exception to the rule: one can point to his ma-

ternal line, and insist also on his careful education, his literary and musical aptitudes, so obvious that he may have envisaged making a career of them. All these factors may have played their part. And let us not forget the role of chance and circumstance. In August 1813, the young student was planning to enter the studio of the painter Guérin at the end of his secondary studies. But, if we believe him, this was only to "spend a little time" in order to cultivate "at least a little amateur talent."[126] For that, he would have had to have independent resources, like Géricault, who was also sprung from the prosperous bourgeoisie. But the family fortunes, always in difficulty, dwindled very quickly to severely limited means about 1815–16. He had to work to earn his living. What was he to do? What profession would he choose? Writing to Piron in November 1815, Delacroix shared his indecision: "I write to you with a destable pen and a worse head, as I am seeing double and am angry enough for ten. I have projects; I would like to do something yet . . . nothing presents itself clearly enough. It is chaos, a Capernaum, a dung heap that may grow a few pearls [*sic*]. Pray to heaven that I may be a great man, and that heaven grant it to you. . . . Ortis, Talma, Poussin! That is genius, my friend, those men."[127] This is a precious firsthand testimony coming from one who knew Delacroix well at the time, Piron himself, who recounts Delacroix's hesitations at the moment of deciding for one thing or another. The public career, which his abilities made possible, was forbidden him: this was right at the beginning of the Restoration. His father, a member of the Convention, had voted for the death of the king before serving the Empire as a prefect; his brother was aide-de-camp to Prince Eugène. He was, furthermore, related to Lavalette, director of the postal service during the Hundred Days, whose recent and incredible escape had made the government look ridiculous. What about industry or commerce? This requires not only capital but, especially, aptitude and interest. Delacroix detested mathematics. There remained one possibility: "Give in to his instincts of independence and personal liberty, give free rein to the flights of his imagination, and take up seriously and resolutely a career in the arts." He had already shown, at school, a certain talent in drawing (one of his notebooks has been preserved, in which he caricatures his teachers and friends and lets his imagination run riot).[128] His uncle, the painter Riesener, gave him favorable advice, which, according to Piron, "no doubt influenced

18. *Bouquet of Flowers*
Watercolor, gouache, and pastels, on a black crayon sketch
on gray paper, 65 × 65.4 cm
Musée du Louvre, Département des Arts Graphiques, Paris

the decision that his nephew adopted." But, he continued, "once he had taken this resolution, Delacroix no longer wavered, and we find nothing in his life that could make us think that he ever thought of changing his role. From this moment on, all his willpower, all his faculties, all his ambition belonged to art, as if to a demanding and jealous master who accepts neither weakness nor less than full devotion. He entered Guérin's studio about 1816, and entered it with the firm intention of giving himself up exclusively to painting. Soon after this, his pleasure became a passion, and his young talent became genius."

Guérin, however, appears not to have particularly singled out or pushed the young Delacroix, who remained in his atelier for more than five years. "I do not know whether he noticed that I promised some talent, but he never encouraged me," Delacroix remembered later.[129] This choice nevertheless proved to be judicious. Guérin, one of the principal leaders of French Neoclassicism, was at that time a famous painter. Public, critics, and artists were enthusiastic about *The Return of Marcus Sextus* (1799), *Phaedra and Hippolytus* (1802), *Bonaparte Pardoning the Rebels of Cairo* (1808), and *Andromache and Pyrrhus* (1810). His career prospered under the Restoration

(thus he showed *Dido and Aeneas* in the Salon of 1817). Géricault had studied in Guérin's atelier and returned from time to time. Some of the most gifted artists of the Romantic generation studied with Delacroix under Guérin: Sigalon, Champmartin, Léon Cogniet, Ary Scheffer, Victor Orsel. Although Guérin was firm in his convictions, he was far from rigid in teaching principles or formulas; on the contrary, he gave his students every freedom to develop their personalities, even if he disapproved of their orientation. He gave them at the same time the basis of a solid career.

And it is first of all this basis that Delacroix learned from Guérin. Delacroix was always aware of strictly technical questions, of what one could call the "kitchen" of painting (sometimes he spoke of "sorcery" in regard to shading)[130]—the preparation of canvases, coatings, the fabrication of colors, the use of siccatives, the mixing of oils, and the varnishing of finished works. His writings not only show his constant attention to these problems, but also his experiments and trials, admittedly not always very successful. At least he was aware of his limits in this domain,[131] which he judged to be of the first importance. He sketched out the article "Technique" in his *Dictionnaire des Beaux-Arts* thus: "(Demonstrated palette in hand). The small amount of light that one finds in books on this subject. Adoration of false technique in bad schools. Importance of the real for the perfection of works. It is in the greatest masters that technique is the most perfect in the world: Rubens, Titian, Veronese, the Dutch; their particular care, mixed colors, drying of different layers. (See "Panels"). This tradition altogether lost to the moderns. Bad products, negligence in preparation, canvases, brushes, detestable oils, little care on the part of the artist."[132]

Drawing had a fundamental place in Delacroix's apprenticeship, even before painting.[133] Like all his contemporaries, he worked very often from the live model, from the paintings of the masters, or, more often, from interpretative prints, using the most diverse techniques, including pen, graphite,

19. *Saint Roch*, after Rubens, 1839
Pen, brush, brown wash, and pencil on paper,
49.4 × 34 cm
The Visitors of the Ashmolean Museum, Oxford

charcoal, wash, watercolor, and pastel. We know from the testimony of his student Lassalle-Bordes that he kept the habit of drawing every morning, or in any case as regularly as possible, in the manner of a musician practicing his scales.[134] From this came an extraordinary virtuosity that made him one of the most remarkable draftsmen of the century, the equal of an Ingres or a Degas. "If you are not skillful enough to make a sketch of a man throwing himself out the window, during the time that it takes to fall from the fourth floor to the ground, you will never produce great works," he confided to Baudelaire. And Baudelaire concluded justly, "I discover in this enormous hyperbole the preoccupation of his whole life, which was, we know, to work quickly enough and with enough certainty that none of the intensity of the action or idea could evaporate."[135] Delacroix very quickly acquired the skill that he himself recommended. The drawings relating to his major paintings of the 1820s testify to the assurance that he was far from having when he entered Guérin's studio doing comparatively awkward or hesitant work. His mastery was confirmed in brilliant fashion on the occasion of his voyage in Morocco in 1832, when for six months he did almost nothing but draw.[136] Baudelaire also reports Delacroix's habit of taking up his pencil again after the day's work was finished, even on evenings spent at the homes of friends such as Villot. Then he would develop an idea that had come to him during the day, recalling in a rapid sketch a scene, or a figure that he had seen, or simply copying other artists, but this time from memory. This fact is important: Delacroix was never the prisoner of the model, which only served as the point of departure for his imagination. Whatever happened, "he studied and copied endlessly," notes Piron. "But it was not only the compositions of the masters that he understood and copied this way; he reproduced everything he saw: in the country, at the Jardin des Plantes, everywhere, that is, subjects from history, flowers (fig. 18), and landscapes and animals of every kind. He saw nature in all its aspects, men,

landscapes, animals. He studied this way a great deal, and he has always studied a great deal since. . . . In everything that he has left us, what ought to surprise people who so often have heard it repeated that Delacroix did not know how to draw, is the nobility, the purity, and the correctness of form that shines everywhere in his drawings, whether still lifes, or flowers, or living animals: he found everywhere the seeds of poetry and the elements of beauty."[137]

Study, copy, first thought, preliminary work, the work itself, rapid sketch or minutely worked sheet—his drawing reveals itself under the most multiple aspects and escapes all classification. We should, however, emphasize that this was a matter above all of the "private" part of his activity, if one can say that. He showed only a very few drawings and gave them away rather than sell them. Only his intimates, his friends, students, and artist friends knew the extent of his talent. For the most part these works stayed in effect in their holders, and those that circulated were mostly very finished pieces, particularly watercolors, made popular by Bonington and other English Romantics. Delacroix's skill as a draftsman was really not recognized until the sale after his death. It may be for this reason that there has always been a tendency in the study of his work to give preference to his paintings. It is true that for Delacroix drawing was almost never more than a stage in the development of a picture, and that the evidence shows it was almost always subordinate. Also, many of his drawings are related to a definitive work, whether or not it remained only a project. With Delacroix, the creative process is always founded on drawing, from the vague notation to the final treatment, going through studies of the whole and the details. It would be wrong to imagine a romantic artist who, in the fire of inspiration, took his brushes and threw his ideas up on the canvas or wall with no preparation. This description could apply to only a few sketches or small pictures. For his great historic paintings (the case of the minor genres is noticeably different), Delacroix depends on a work of gradual maturation during which the different elements of the final composition define themselves through drawing. In this he follows the path of the great classical painters, the tradition transmitted in studios since the Renaissance, and he never leaves it. Even effects of color are studied through pastels or watercolor. Nothing in this separates Delacroix from David or Ingres. Still, the drawing has only this utilitarian aspect. Delacroix drew his motifs

again and again, without worrying for the moment what use he would make of them. For him, nature was a dictionary,[138] and he appropriated it to himself naturally, as it were, through drawing, which, rapid as it was, contained the idea that the painter could later develop. "The original drawing of Delacroix is very free," writes Silvestre. "As he sees things quickly and as a whole, that is to say, like sketches, every stroke of the pencil becomes characteristic, generalizing, and above all determines the volume, the projection of bodies, and the direction of their movements."[139]

A large part of Delacroix's drawing was always devoted to copying from the antique or from the great masters (fig. 19). This was, again, one of the essential elements of the traditional formation that he received and from which he never departed. "That was the education of almost all the great masters," he wrote in his journal for the article, "Copy," in his future *Dictionnaire des Beaux-Arts*. "One first learned the manner of his teacher, as an apprentice learns the manner of making a knife, without showing his originality. One then copied all the work of contemporary or earlier artists that came to hand. Painting began by being a simple trade. One was a maker of images as one was a glazier or carpenter. Primitive painters were workmen, more so than us; they learned the trade in a superior way before thinking of making a career. The opposite is true today."[140] So Delacroix copied a great deal, taking either a detail that struck him or the composition of the whole.[141] The utility of copying was twofold: it permitted a closer approach, by imitation, to the art and technique of the model, and at the same time it helped to build up a vocabulary of references. These two aspects are found in Delacroix, and his purchases at the posthumous sale of Géricault, which were for the most part copies from the great masters, are revelatory from this point of view: was not their value enhanced by that of the copyist himself?

In this way Delacroix made the whole western artistic tradition his own. He was able to visit the Musée Napoléon, the site of a prodigious concentration of masterpieces, during his school years. But the pictures and statues that the wars of the Revolution and the Empire had gathered in Paris had been returned to their country of origin under the second Restoration, at the moment that he began to study seriously. Thus Delacroix worked in a Louvre much barer than in earlier years. He still acquired a considerable visual culture. What he

had not seen or could no longer see, he knew by prints, which he always used extensively. Familiar with the collections gathered at the Bibliothèque Nationale, he himself had more than two thousand engravings at his death. He was always interested in new reproductions, and his interest in photography is explained in part by the possibilities that it offered in this direction.[142] On this subject, let me mention that he was not uninterested in engravings drawn from his own works—lithographs, etchings, and woodcuts—that could assure their diffusion. But this does not seem to have been one of his major concerns. The productive association of Delaroche and Henriquel-Dupont—an example of the industrial and financial point of view as well as of the aesthetic relationships between painting and interpretive engraving in the nineteenth century, has no equivalent in Delacroix.

He thus acquired a very extensive culture without always having access to the originals. Having constantly postponed his trip to Italy, Delacroix ended up never going there, and knew the Italians only by their paintings in the Louvre where he worked very often, for instance copying *The Marriage at Cana,* and by paintings in some provincial museums like Rouen, where he particularly admired Veronese's *Saint Barnabas Healing the Sick* (of which he made a watercolor in 1834).[143] The same was true for another of his great models, Rubens, whom he knew only by engravings, except for the pictures that were in Paris. He was not able to see (or see again, since they had been in the Musée Napoléon) the famous Antwerp paintings except during his jaunt to Holland in 1839 and in 1850 when he went to take the waters at Ems. One notes that he never saw some of the great classical ensembles of Rome or Venice, whose influence is nevertheless manifest in his own decorative works. His sensibility and his intelligence sustained an always lively interest: he went to see exhibitions and sales, visited the studios of his colleagues and private collections.[144] Finding himself at Bordeaux to take care of affairs after the death of his brother, he liked to enter churches to discover paintings unknown to him. Aided by his talent at drawing and an unusual visual memory, Delacroix thus was engaged during his whole life in a continuing dialogue with the artists of the past. "You have to see with what subtlety he analyzes the works of the old masters," writes Silvestre, "compares them with his own, and with what ardor he draws out what they have in common. However, his genius inclines to

the traditional glories. He pours out his infinite admiration of Michelangelo, Veronese, Rembrandt, or Correggio; his eyes light up when he speaks of Rubens; he walks then with long steps, stops abruptly, presses you into a corner of his atelier: 'Rubens, Rubens, he's the king of painters; he is great like Homer, and like him he animates everything that he touches.' . . . Delacroix, avid as he is for the exterior refinements of art, goes immediately to its inner character, the soul of the picture. One day I examined with astonishment one of his little copies of Raphael. He had exaggerated the most significant traits of the Italian master, so as to enter more fully into his manner and take account of it. . . . 'I admire Raphael just as much,' Delacroix said to me in a lively manner; 'it is he who raised to the highest point of perfection this brilliant discovery of the Italian genius, the *arabesque of the line.* He is a painter-poet; the other masters are only prose makers. Only he possesses this beauty of contours and of expression united with grace, ideality. . . .' But Delacroix always came back to Rubens's 'coup de lance' [a nickname for the Antwerp *Crucifixion*]; his temperament inclined that way."[145]

Delacroix's personal pantheon was vast. His name is always associated with Rubens, and justly so. But, as Silvestre emphasizes, one cannot insist too much on his predilection for Raphael.[146] He copied the one as much as the other, and the second so perfectly that Ingres, seeing one of his copies when he was visiting their common supplier, Haro, was struck by its beauty. "He was intrigued and wanted to know whose it was," Ernest Chesneau reports. "As they knew his horror of Delacroix's talent, they let him look first and, when he insisted, finally named him. *'The wretch!'* he cried. 'And he does that painting!'"[147] Delacroix's admiration was not, however, limited to the traditionally recognized masters—the Italian painters of the Renaissance, from Raphael and Michelangelo to Titian (fig. 20), Veronese, and Tintoretto, the Flemish and Dutch of the seventeenth century, especially Rubens and Rembrandt, to whom he added, among the upholders of classicism, at least Poussin. He also discovered or attached himself to less revered newer names, opening onto other horizons. The articles that he wrote on various artists reveal this dual orientation, since alongside Raphael, Michelangelo, and Poussin, one finds Gros, Prud'hon, and Charlet. Still more modern is his interest in caricature, and especially English caricature, which he knew and copied very early (fig. 21). Caricature and the grotesque

20. *The Entombment*, after Titian, 1819–21
Oil on canvas, 40 × 55.5 cm
Musée des Beaux-Arts, Lyons

are thus found in a number of his works, more directly in the satiric engravings that he made during his years with Guérin to make some money. Many are indicative of his political inclinations as well as his aesthetics, as they are rather critical toward the Restoration (some were published in opposition journals).[148] Another direction, equally novel at the time, was his admiration for Spanish painting. He appreciated the artists of the Golden Age, whom he knew not only by the paintings in the Louvre but also by those conserved in private Parisian collections, especially the collection of Marshal Soult. Delacroix was one of the first Frenchmen to know directly the painted and engraved work of Goya, by means of his friends the Guillemardets, whose father had been sympathetic to Goya while he was ambassador to Spain. At the home of the Guillemardets, Delacroix could see not only the portrait of their father, today in the Louvre, and some other pictures of the Spanish master, but also, very probably and very early, an example of his "Caprichos" (fig. 22). These were not really known in France and had no real influence until after 1830. Delacroix, whose work of the 1820s shows Goya's mark, is in this sense a true precursor.[149]

He thus knew intimately the life and work of numerous artists. But he seldom used them as subjects for his own work, even though at the time this genre was particularly fashionable; analysis was much more important to him than anecdote. Thus *Michelangelo in His Studio* (fig. 23) is in this respect exceptional. Delacroix, reaching his fifties, saw himself as a meditative Michelangelo, whom he portrayed seated between the *Moses* and the Medici *Madonna*, the sculptor's shears at his feet, the writer's book lying on the floor beside a box of drawings. He did the painting for himself and sold it to a dealer who in turn sold it to Alfred Bruyas, a collector from Montpellier and a friend of Courbet. It was not in any sense a manifesto; Delacroix did not exhibit the painting in Paris. But from the beginning, according to Silvestre, it was understood as an allusion to his own situation; even Michelangelo's scarf brought to mind Delacroix's celebrated one.[150] Is there in this painting a reference any more explicit to the suffering of the creative artist in the face of incomprehension? Perhaps. In any case, from 1830 on, Delacroix more or less consciously projected himself onto Michelangelo, as several passages of the article written for *La Revue de Paris* indicate. "Let those minds

detached from vulgar prejudice mock, if they will, this sublime genius frightened by the judgment of God, wondering before the gates of the tomb if he has used his life well. I see the great Michelangelo in those instants where, his imagination obsessed by Dante's creations or by reading scripture, his hand drew by the light of his lamp some gigantic figures, the effect of which, once felt, never fades. . . . I see him at an advanced hour of the night, struck with fear at the spectacle of his creations, rejoicing in the secret terror that he wanted to awaken in men's souls. . . . I like, again, to imagine him in those moments where, worn out by having been unable to express in painting the sublimity of his ideas, he tried, in the inquietude of his spirit, to call poetry to his aid. It was then the expression of a profound melancholy, or perhaps his agitation, his dread, in thinking of the future life: the regrets of mature age, the fear of the obscure and frightening future."[151] Delacroix, at least at the end of his life, saw no progess in the history of art: "The arts, since the sixteenth century, the point of perfection, show only perpetual decadence. The cause is the change that has occurred in minds and manners rather than the rarity of great artists, for

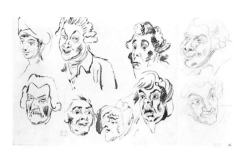

21. *Nine Caricature Heads*, possibly after Thomas Rowlandson, c. 1825
Brush, gray wash, and pencil on paper, 17.2 × 30.2 cm
Musée du Louvre, Département des Arts Graphiques, Paris

22. *Sheet of Studies*, after Goya's *Caprichos*
Pen and brown ink on paper, 22.1 × 18 cm
Fogg Art Museum, Harvard University, Cambridge, Massachusetts

contemporaries. "To which works is it most natural to apply this term [classic]? It is evidently those that seem destined to serve as models, as the rule, in all their parts. I would gladly call classic all those balanced works, those that satisfy the mind not only by their representation of exact or grandiose or striking sentiments and things, but also by their unity and logical order, in a word, by all those qualities that enlarge the impression while leading to simplicity. . . . The school of David is wrongly characterized as the classical school *par excellence*, although it was founded on the imitation of the antique. It is precisely that imitation, often unintelligent and exclusive, that deprives this school of the principal *characteristic* of classical schools that gives them permanence. Instead of penetrating the spirit of antiquity and uniting this study with the study of nature, etc., one sees that it was an echo of a period when one had a fancy for the antique. Although this word *classic* implies beauties of a very high order, one can also say that there are hosts of very beautiful works to which this designation cannot be applied. Many people do not distinguish the idea of coldness from that of the classic. It is true that a good number of

neither the seventeenth century, nor the eighteenth or nineteenth, has lacked them. The general absence of taste, the gradual enrichment of the middle classes, the greater and greater authority of sterile criticism of which the object is to encourage mediocrity and discourage great talents, the inclination of good minds to turn to the useful sciences, the increasing knowledge that frightens away the things of the imagination, all these causes combined have condemned the arts to be more and more subject to the caprice of fashion and to lose all nobility."[152] He also understood the terms *classic* and *romantic* in a very particular sense, not always that of his

artists take themselves for classic because they are cold. For a similar reason, there are others who think they have warmth because they are called romantics. Real warmth touches the emotions of the viewer."[153] A remark by Delacroix, reported by Silvestre, takes on new meaning in this light: "Here [at the beginning of his time with Guérin] the first tendencies of the *romanticism* of which opinion makes me the recognized chief began to show themselves. If you understand my romanticism to mean the free manifestation of my personal impressions, my distance from the examples copied in the schools and my repugnance for academic recipes, I must admit that I am not

only romantic, but I was so at fifteen; I already preferred Prud'hon and Gros to Guérin and Girodet."[154] Delacroix remained fundamentally traditional in spirit, and profoundly anchored in the art of the past.

One cannot count the more or less obvious and conscious references in Delacroix's work, from the woman having her throat cut in the foreground of *The Death of Sardanapalus*, inspired by one of the Nereids of Rubens's *Landing of Maria de' Medici at Marseilles*, to the *Saint Michael* of Saint-Sulpice, almost copied from Raphael, and the figure of Liberty, perhaps derived from the *Venus de Milo*. Even in Delacroix's time, critics proposed such references, and since then research has not stopped. The abundance of possible sources is complicated by Delacroix's universal curiosity. He was interested in all domains, all epochs, and all civilizations, studying the Persian miniatures at the Bibliothèque Nationale as well as Indian or Cambodian figures, to take only two particularly original examples.[155] The ancient or classical models were thus mixed with other more personal sources, medieval, oriental, or exotic. One can therefore reasonably propose as points of departure for *The Death of Sardanapalus*, scholarly publications concerning Etruscan antiquities (he might have been inspired particularly by an engraving representing the bas-relief of a sarcophagus) as well as others on Assyria.[156] The very numerous indications that he left—notebooks, finished sketches with rapid annotations, titles of works, research to do, without counting the more precise mentions found in the rest of his writings, journal, and correspondence combined—have naturally encouraged scholarly inquiry, the results of which have most often been con-

23. *Michelangelo in His Studio,* 1849–50
Oil on canvas, 40 × 32 cm
Musée Fabre, Montpellier

vincing. The accumulation and the variety of possible sources of inspiration perhaps matter less than what they reveal about the creative process for Delacroix. The first idea, the invention, is the artist's alone. But the execution, which uses classical sources (which Delacroix extends quite far) as well as nature, that is, the study of the live model, must fuse these different elements into an original composition. Basing his theory on his personal experience, Delacroix explained this numerous times, for example, when he painted the *Clorinda* in 1854: "The first idea, the sketch, which is rather like the egg or the embryo of the idea, is ordinarily far from being complete; it contains everything, if you will, but you have to free this everything, which is nothing else than reuniting all the parts. What makes the sketch the expression *par excellence* of the idea is not the suppression of details but their complete subordination to the big strokes that have to make the impression. The greatest difficulty thus consists in returning in the picture to this effacement of the details, which, however, make up the composition, the framework of the picture. I do not know whether I am wrong, but I believe that the greatest artists have had to struggle mightily against this difficulty, the most serious one of all. . . . It is here that painters who have an easy and clever touch, who easily make the expressive torso or head, find their triumph turned to confusion. The picture, composed of *related pieces* done with care and placed one beside the other, looks like a masterpiece and the height of skill, as long as it is not finished, meaning as long as the field is not covered; since to finish a painting, for these painters who finish each detail as they put it into the painting, is to have covered the

canvas. In the presence of this work that goes on without obstruction, of these parts that appear all the more interesting for being the only ones to admire, one is involuntarily struck with not very thoughtful astonishment; but when the last touch is given. . . ., one only sees holes or obstructions, no order anywhere. The interest that one felt for each object vanishes in the confusion; what seemed to be an exact and proper treatment becomes dryness itself through the absence of any *sacrifices*. Will you then ask that this quasi-fortuitous reunion of unconnected parts makes the same penetrating and rapid impression of the ideal that the artist is supposed to have glimpsed or caught in the first moment of inspiration? With great artists, the sketch is not a dream, a confused cloud, it is something different from a gathering of barely perceptible lineaments; only great artists start from a fixed point, and it is to this pure expression that it is difficult to return, whether the work is done quickly or not."[157] Delacroix here perfectly sums up his conception of execution, from the original thought to the finished picture. What is missing is the original justification, the ultimate goal of the painting from which all the rest flows. His ideas on the question were formulated in his youth and did not change with time. To be convinced of this, it is enough to bring together three passages of the *Journal* re-edited at a thirty-five-year interval, which develop in analogous terms the role that Delacroix assigns to painting, and in fact to all artistic expression. The first dates from 1822: "When I have made a beautiful picture, I have not written down a thought. That's what they say. How foolish they are! They rob the painting of all its advantages. The writer says almost everything in order to be understood. In painting, he establishes himself like a mysterious bridge between the soul of the personages and that of the spectator. He sees faces, external nature; but he thinks inwardly, the true thought that is common to all men: to which some give body in writing: but in altering its fine essence. Also, vulgar minds are more moved by writers than by musicians or painters. The art of the painter is so much more intimate to the heart of man because it seems more material; for in him, as in external nature, justice is done frankly to that which is finite and that which is infinite, that is, to whatever the soul finds that moves it inwardly in objects that only strike the senses."[158] The second was written in 1850, when Delacroix was preparing an article on the volume published by his friend Elisa Boulanger-Cavé, *Drawing with-out a Teacher*: "'In painting, and especially in the portrait,' says Mme Cavé in her treatise, 'it is mind that speaks to mind, and not science that speaks to science.' This observation, more profound than she perhaps realized herself, is the arraignment of pedantry in execution. I have told myself a hundred times that painting, meaning material painting, was only the pretext, only the bridge between the mind of the painter and that of the viewer. Cold exactitude is not art; ingenious artifice, whether it *pleases* or *expresses*, is art itself. The presumed conscientiousness of most painters is only perfection in the *art of boring*. Those people, if they could, would work on the backs of their paintings with the same scrupulousness. It would be curious to do a treatise on all those falsehoods that can add up to truth."[159] Finally, Delacroix took up and extended all these observations when he was elaborating the *Dictionnaire des Beaux-Arts* in 1857: "To know how to be satisfied. Here is what Lord Byron says: '. . . Experience is indispensable in teaching us all the advantages that we may derive from our instrument, but above all in permitting us to avoid what should not be attempted. The immature man is always ready to rush into senseless attempts, as he tries to make art produce more than it can or more than it should; he does not arrive at even a certain degree of superiority within the limits of his possibilities.' . . . One must not forget that language (and I apply this here to the language of all the arts) is always imperfect. The great writer compensates for this imperfection by the particular turn that he gives to everyday speech. Experience, but especially confidence in his strength, gives to talent the assurance of having done all that could be done. It is only foolish or impotent men who torment themselves with the impossible. The superior man knows when to stop: he knows what it is possible to do."[160]

Delacroix, taking up his brush, put his principles into action and, by constant evaluation of the effect that he sought, tempered whatever anger and fire his execution may have had. His manner of painting, methodical and logical, done in the silence of meditation rather than in the noise of conversation, suggests the atmosphere of the ateliers that he occupied. Not much is known of the one on the Quai Voltaire, formerly occupied by Carle Vernet, where one climbed a hundred and seventeen steps, which made Delacroix say, in what Dumas calls his 'eternal mania for puns': "It's freezing here at a hundred and seventeen degrees!"[161] The one on the rue Notre

Dame de Lorette, to which he was sentimentally very attached, is better known, thanks to an engraving published in 1852 in *L'Illustration*. There was little furniture: a few chairs, tables, and trestles covered with books, papers, drawings, and engravings, overflowing also with portfolios and holders. On the walls, finished paintings (notably *The Death of Marcus Aurelius*) and various casts from the antique. Easels and scaffolding everywhere, with works in progress or finished and framed, waiting for an admirer, a merchant, or a salon. In front of the painter stood a table with paints and a container loaded with prepared palettes and brushes. No disorder or bric-a-brac: the place was entirely devoted to painting and to art. The studio of the Place Fürstenberg, where Delacroix moved to be nearer to Saint-Sulpice when he was weakened by age and illness and was working on his last great ensemble, retains today the same serene and hardworking but comfortable atmosphere: always careful of his throat, he painted in heat suited for a greenhouse of tropical plants.[162]

Delacroix liked to work hard, and alone, but he himself emphasized that regularity came to him only with time, confiding to Silvestre: "How does it happen that at present I am not bored a single instant when I have my brush in my hand? I even find that if my strength allowed it, I would not stop painting except to eat or sleep. Formerly, at the age that is supposedly the age of vigor and imagination, I was stopped at every step and often disgusted; today I no longer hesitate: maturity is complete; the imagination is as fresh, as active as ever, and freed from foolish passions; but the physical strength is lacking, the tired senses demand rest, and yet, what consolation I still find in work!"[163] Baudelaire reports similar words: "'Before, in my youth, I could get to work only when I had the promise of a pleasant evening, music, a ball, any sort of diversion. But today I am no longer like the students; I can work without stopping and without hope of reward. And then,' he added, 'if you knew how lenient hard work makes you and not at all particular about amusements!' . . . The truth," Baudelaire continues, "is that in the last years of his life, everything that one could call pleasure had disappeared, leaving only his work, bitter, exacting, terrible, no longer only a passion but what one could call mania."[164]

Delacroix had the habit of working simultaneously at several pictures, carried along by "moments of vigor and drive that took him at intervals," to use Silvestre's expression. Rarely did he concentrate on a single work, and even then it happened that he would abandon it temporarily, as for example the *Massacres of Chios*. And remember that from 1833 on, decorative work occupied him practically all the time. Sometimes he would leave a composition unfinished and take it up again later, sometimes after several years (this occurred with *The Natchez*, among others). In doing this, Delacroix was not dispersing his energies: he let inspiration act, or rather emotion. Friends and relations who had the privilege of seeing him paint have insisted on the bursts of power that suddenly took him, sometimes in the middle of a session, fits that complemented the regularity toward which he strove, a regularity that was interrupted only by illness and a few rare trips. "The artist has these fits of furious work that turn him yellow and dry him up." Silvestre notes. He takes ten or twelve canvases, turning from one to another by whim; they follow each other on his easel like apparitions in a magic lantern. I found myself one evening at his place about four o'clock: someone asked for a *Christ on the Cross*, which I saw completely sketched out the next morning. Christ, thieves, holy women, the people, soldiers and torturers, everything was done with as much energy as if the picture had been finished; only the scene still took place a little confusedly amid the warm fumes of inspiration."[165] Maxime Du Camp was witness to a similar fever: "I was lying on a divan, and I watched him work. We were quiet and he had forgotten I was there. He was painting a small *Fantasia*. . . . Delacroix was very animated, he breathed noisily; his brush took on a surprising agility. The cavalier's hand got bigger, and bigger, it was already bigger than his head and took on such proportions that I cried out, 'But, my dear sir, what are you doing?' Delacroix gave an agitated little cry, as though I had wakened him with a start; he said to me: 'It is too warm here, I'm going mad.' Then he took his palette knife and took off the hand with one single gesture. He looked wild; mechanically, he made some dabs on the background, as if to calm himself. 'Night is coming,' he said; 'would you like to go out?' A few minutes later, we were walking side by side, without speaking. [A discussion got under way and Delacroix said] 'When I'm doing a painting, I think of another one; then I am carried away by the reverie, as you just saw. It is said that work exhilarates; no, it intoxicates, I know it well.'"[166] The momentum of execution, sometimes more and sometimes less rapid and thought out (Delacroix never hesitated to remove

24. *Sky at Sunset*, 1849?
Pastel on gray paper, 19 × 24 cm
Musée du Louvre,
Département des Arts Graphiques, Paris

and rework), is not in contradiction with long preparatory work. After it, the painter threw himself into the definitive canvas, which he worked as a whole, as Silvestre describes it: "Delacroix begins by sketching his subject in grisaille, in order to establish the general effect simply and quickly. He never amuses himself with painting the picture by successive bits, making a perfect head, arm, hand—what art lovers, those gourmets, call the good morsels; what he wants is the life of the whole, an affecting drama."[167] The objective was to keep the unity of effect as well as the impression of the sketch: "Making a painting is the art of carrying it through from the roughing out to completion. It is a science and an art at the same time; to accomplish it in a truly learned way, long experience is indispensable."[168]

Contemporary critics very quickly characterized his style as lacking in drawing but rich and vigorous in color: Veronese rather than Raphael, Rubens rather than Titian. There is as always some truth in these peremptory assertions. The first point can really only be understood by relation to Ingres and his students, who privileged line and contour in their work. Delacroix himself, without ignoring form, painted essentially volume, and volume in light (as is also indicated, incidentally, in the interest he showed in drawing "by eggs," in the manner

of Géricault and Gros, which he in turn related to sculpture).[169] His remarks on Ingres's *Antiochus and Stratonice*, reported by George Sand, are explicit: "Look! He did well what he could, *le père* Ingres, to be a colorist, and his manner of understanding the thing is altogether comic. . . . He does what he can, *allez!* Only he confuses coloration with color. It is an old god, bourgeois as the devil, and on that matter he doesn't know more than his doorman. Have you noticed that, in the *Stratonice*, there is a very ingenious, very studied, very shimmering luxuriousness of coloration that doesn't produce the least effect of color? There is a mosaic pavement so exact that it would drive a teacher of perspective to despair. From the foreground to the background, there are perhaps a thousand little lozenges, strictly correct as to vanishing point. That does not prevent that pavement from standing straight up like a wall. It gleams like a mirror. You could look at yourself in it to shave: but you wouldn't dare walk on it, unless you were a fly. With just a little true color, his pavement would recede and he wouldn't have needed these thousands of little lines. He did try to put some lights on it. But these are still lights cut to the ruler and compass. You feel like they are there for eternity, and that M. Ingres's sun will never change its position in relation to the earth. . . . He thinks that light is made to embellish: he does not

25. *The Sea at Dieppe*, 1852?
Oil on panel, 35 × 51 cm
Musée du Louvre, Paris

26. *Wild Horse*, or *Frightened Horse Leaving the Water*, 1828
Lithograph (first state of two, before letter), 30.1 × 28 cm
Bibliothèque Nationale de France, Département des Estampes
et de la Photographie, Paris

know that above all it is made to animate. He has studied with very delicate precision the smallest effects of daylight on marbles, gilding, fabrics; he has only forgotten one thing: reflections. Well, yes, reflections! He's never heard of that. He has no idea that in nature everything is reflection and that every color is an exchange of reflections. He has sown little bits of sunlight on all the objects that he put in front of him, you would say they were taken out of a daguerreotype, and there is neither sun, nor light, nor air in all that. . . . Nothing stands out, and consequently nothing exists in this charming picture, a bizarre inanity. Oh! I know very well, I do, what he said to himself. He said: 'I want to do an irreproachable work; I do not only want it to teach and to show; I want it to please. I'm going to fill it with color, oh! but what color, and behold! I am going to astonish my adversaries; they will not have anything more to say now. They will be crushed in every way. Come, students, look carefully: I am going to show you what color is!' And so he starts throwing tones at his subject, after the fact, like you put decoration on a cake after it's baked. He puts red on a coat, lilac on a cushion, green here, blue there; a brilliant red, a springlike green, a heavenly blue. He had the taste to adjust it, and knowledge of costume. He meddled with his hair, his fabrics, the wrappings, an exquisitely fresh lilac, borders, a thousand coquetries of ornament that are very amusing but that lead to nothing so far as color production

goes. The pallid, dull tones of an old wall of Rembrandt are rich in quite a different way from this prodigality of brilliant tones plastered on objects that he will never finally manage to relate to each other by their necessary refections, and that remain raw, separate, cold, garish. Notice that what is garish is always cold!"[170]

Of course there is something of George Sand herself in this long passage. But the words that she attributes to Delacroix are in perfect agreement with his writings, as well as with other testimony of his contemporaries on this subject. As a colorist he was as much a theoretician as a practitioner, and his notes in the *Journal* deal with both the actual fabrication of colors and their arrangement on the canvas.[171] Delacroix, studying his effects long in advance, prepared his palettes with the greatest care. He arranged the different and numerous colors that he anticipated needing in order to have them available when the time came—all the range necessary to render his reflections, halftones, shadows, and lights. In doing this, did he strictly follow preestablished rules? There were such rules, particularly the precise principles that Michel-Eugène Chevreul had published in 1839 in *Of the Law of Simultaneous Contrast of Colors*. Did Delacroix apply them? As a great reader, curious about everything, he knew Chevreul's theories, the evidence shows, even if only second hand (Delacroix seems not to have met Chevreul or discussed them with him). He also knew

27. *Royal Tiger,* 1829
Lithograph (second state of four, before letter), 32.6 × 46.5 cm
Bibliothèque Nationale de France, Département des Estampes et de la Photographie, Paris

28. *Lion of the Atlas,* 1829
Lithograph (second state of four, with letter but before address), 33.1 × 46.6 cm
Bibliothèque Nationale de France, Département des Estampes et de la Photographie, Paris

those of Léonor Mérimée, the writer's father.[172] On his own part, he had constantly reflected on the relationships of colors to each other and their action on each other. His own thought and practice sometimes, but not always, coincided with the ideas of Chevreul, who no doubt partly inspired them. Delacroix constantly reflected on his work, but he was not bound by theories, which also evolved with time. Reflection never constrained him or hindered his spontaneity. He rejoiced in color like no one else, as Maxime Du Camp noted: "As soon as he touched color—abstract color—he was marvelously ingenious. I saw him, one evening, next to a table on which was a basket of skeins of wool. He took the skeins, grouped them, intertwined them, divided them according to shade, and produced extraordinary effects of coloration. I heard him say: 'The most beautiful pictures I have seen are certain Persian carpets.'"[173] We see in this a technique that he progressively refined and that he used a great deal, but never systematically—a technique that he called *flochetage*, in fact a use of colored, broken strokes, almost flakes, that Villot described thus: "Instead of putting the paint exactly in its place, brilliant and pure, he interlaces the tints, breaks them up, and, making the brush behave like a shuttle, tries to form a fabric in which multicolored threads intertwine and intercept each other at every instant."[174] Thus Delacroix arranged color for the sake of color. But it remained for him above all a means of expression. This is indeed the meaning of his celebrated remark: "Color is nothing if it is not appropriate to the subject, and if it does not augment the effect of the picture through its appeal to the imagination."[175]

In effect, Delacroix never abandoned the traditional conception of painting, wherein the subject somehow justifies the picture and the picture is first of all appreciated for the subject (which explains, by the way, the abundance of possible subjects of all origins Delacroix mentioned in the *Journal*, many of which never saw even a beginning). In the notes made for the article on "Subject" in the *Dictionnaire des Beaux-Arts*, the thinking is much more audacious. The notes show the development of three points at three different dates: the importance of the subject, the example of Géricault—who made it disappear as such in his *Anatomical Fragments*, where he represented detached body parts—and finally the question of choice of literary sources made by the painter:

Importance of subject. Subjects from fable always new. Modern subjects difficult to treat without the nude, and with the poverty of costumes. Originality does not always need a subject, etc. The painting of arms and legs in Géricault.

This fragment of Géricault is truly sublime: it proves more than ever that it "is not the serpent or the odious monster, . . . [who, imitated by art, cannot please the eyes"—a passage from Boileau taken from *Art poétique*]. It is the best argument in favor of the Beautiful, as it must be understood. Incorrectness detracts nothing from this fragment . . . Set beside a portrait of David, this painting shows to even greater advantage. One sees in it everything that was always missing in David: this picturesque force, the nerve, the daring that is to painting what the *vis comica* is to the art of the theater. Everything is the same; there is no more interest in the head than in the draperies or the foot.

There are artists who can choose their subjects only from foreign works that lend themselves to vagueness. Our authors are too perfect for us: the imagination of the spectator is tied to the impression of these things so well presented and with such perfect execution. Maybe the English are more comfortable in taking their subjects from Racine or Molière than from Shakespeare and Byron. The more perfect the work that gives the idea of the picture, the less chance a kindred art inspired by it will have of affecting the imagination as strongly. Cervantes, Molière, Racine, etc.[176]

In truth, if Delacroix admires Géricault, who knew how to remove himself from his subject, he remains at the *ut pictura poesis*, whose limits he perhaps sees and feels but in any case does not challenge.

All his painting goes in this direction, as do most of his theoretical reflections, which give priority to imagination and invention, themselves fundamentally classical concepts. The subjects that he treated, at least early in his career, were certainly new, and appeared revolutionary to many. But the proceedings of the painter remained eminently traditional, a characteristic that the era only accentuated: Delacroix appears to us on this point closer to his contemporaries, farther from

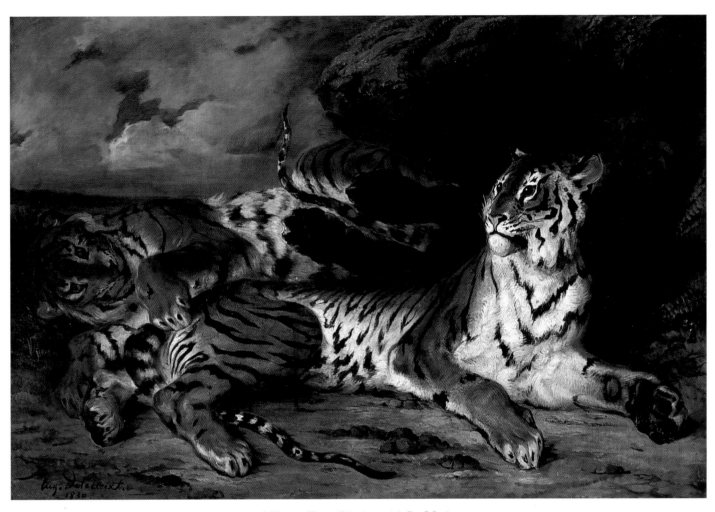

29. *A Young Tiger Playing with Its Mother*, 1830
Exhibited at the Salon of 1831. Oil on canvas, 131 × 194.5 cm
Musée du Louvre, Paris

announcing or anticipating later evolutions. Fundamentally, he does not question one of the dogmas of academic doctrine, the hierarchy of genres, which valued pictures according to the type of subject. History painting was at the summit—mythology, sacred history, history properly speaking, or subjects drawn from literature—exactly because it required of the artist, or so it was thought, the most invention and imagination. It was also the most likely to move the spectator. Portrait, landscape, and still life came after, as the painter in this case had the advantage of the model and of nature. Most of Delacroix's work, however innovative it may have been, thus stems from history painting. Portraits, landscapes, and animals occupy second place, which does not mean an unimportant place, as innumerable and multiple drawings testify. But it is characteristic of Delacroix that he should have remained for the most part at this stage: realism was for him only a stop on the way to creation, and in confining oneself to it one misses, he thought, an essential part of painting. "Marine painters generally do not paint the sea well," he writes. "One can reproach them just as one can the landscapists. They want to show too much science; they make portraits of the waves, as landscapists make portraits of trees, fields, mountains, etc. They are not enough concerned with the effect on the imagination, which the multiplicity of overly circumstantial details, even when they are true, distracts from the principal spectacle, the immensity or the depth, of which a certain art can give an idea."[177]

It is first of all in his drawings that one can measure the talent of Delacroix as a landscapist. His notebooks abound in landscapes sketched during his trips, where, in the most diverse techniques, he demonstrates a very great sensibility (which manifests itself equally in his writings) and where he shows an extraordinary plastic inventiveness (fig. 24). However, he painted very few landscapes as such, and except for *The Banks of the River Sebou* in 1859, he never showed one at the Salon.[178] The popularity of *The Sea at Dieppe* (fig. 25), which seems to anticipate Impressionism in its technique as well as its subject, could easily imply the contrary if the *Journal* were not there to show in what spirit Delacroix painted it. Upon leaving Dieppe, where he had gone to rest for a week, the painter went for a walk on the beach: "I went to pay my last visit to the sea about three o'clock. There was the most beautiful calm, and one of the most beautiful seas that I have ever seen. I could not tear myself away. . . . The soul attaches itself passionately to objects that it is going to leave. It is of this sea that I made a study from memory: the golden sky, boats waiting for the tide to return."[179] If the stylistic analogies are evident, one is finally still far from the rendering of this motif by Monet or Pissarro, and closer to the "memoirs" of Corot. Additionally, the technique of this little panel (another singularity for Delacroix, who preferred to paint on canvas) would bring it closer to the studies drawn at the same moment and in identical circumstances.[180] Delacroix thus did not directly participate in the renewal and transformations of landscape painting that so marked the nineteenth century. He did not work in the genre, but he was nevertheless considered a master thanks to the backgrounds of his history paintings, where the landscape

30. *Count Charles de Mornay and Count Anatole Demidoff,* 1833
Oil on canvas, 78 × 65 cm
Destroyed in 1914 in the fire at the Abbey of Longpont

31. *Count de Mornay's Apartment*, 1832–33
Oil on canvas, 41 × 32.5 cm
Musée du Louvre, Paris

32. *Talma as Nero in "Britannicus,"* 1852–53
Oil on canvas, 92 × 73 cm
Comédie-Française, Paris

not only serves as the frame for the scene but also reinforces its expressiveness. Criticism always brings up this fact, from *The Natchez* to *Ovid among the Scythians*.

The situation is a little different in the case of animal painting. In this instance, Delacroix's reputation rests not only on drawings but also on paintings with lions, tigers, or sometimes horses as the sole subject. As a young man, Delacroix rode horseback. He knew horses well and, early on, from the 1820s, he studied them in drawing and painting at the riding school or at the post office stable.[181] He was following the example of Géricault and Gros, whose influence sometimes is very apparent in his work, as for example in *Wild Horse* (fig. 26). One should, however, note that although Delacroix painted many horsemen, which, incidentally, are almost universally admired, he only rarely painted pictures

where the horse is the principal actor. It is different with his lions and tigers, which succeeded horses as the special subject of his animal studies a little before 1830. He had acquired a thorough knowledge of this motif, working mostly at the Jardin des Plantes beginning in 1828–29, along with the animal sculptor Barye.[182] Hippolyte Taine, on the basis of what Delacroix told him, later gave the story: "They had been given a skinned tiger that they lit with lamps in the evening. Delacroix had drawn it in all positions, trying to understand the workings of the smallest muscle. What struck him most was that the back paw of the lion was a monstrous human arm, but twisted around and reversed. According to him, there are thus, in all human forms, more or less perceptible animal forms to be disentangled, and he added that in pursuing the study of these analogies between animals and man, one dis-

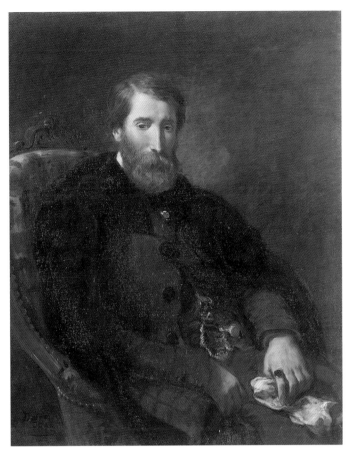

33. *Alfred Bruyas*, 1853
Oil on canvas, 116 × 89 cm
Musée Fabre, Montpellier

covers in the latter more or less perceptible instincts that link his intimate nature to one animal or another."[183] Delacroix's animal painting is, nevertheless, not anthropomorphic like that of the English painter Edwin Landseer, which was very popular in its time. And although Delacroix's work is based on an attentive and meticulous study of the beast, it is not fundamentally realist. It transcends simple description to evoke, by the play of matter and color, the power or character of the animal. Delacroix's sensitivity to purely formal aspects, which the absence of a narrative subject allows, underlies all his animal work up to the *Lion Hunts* of the 1850s. Such sensitivity is present in his first masterpiece in this genre, the monumental *A Young Tiger Playing with Its Mother* (fig. 29) (the canvas, exhibited at the Salon of 1831, measures almost two meters long), as it is in two of his most successful lithographs, done

a bit earlier, *Lion of the Atlas* (fig. 28) and the *Royal Tiger* (fig. 27). After his voyage to Morocco in 1832, he revived this vein and from then on painted the animal alone, often on a small canvas, as well as in combat with man. In his last twenty years, he came back to it more and more often, but he never lost either the evocative force or the plastic beauty of his youthful paintings.

The portrait was one of the most fashionable genres of the nineteenth century, and Delacroix did portraits all his life, the first of which date to 1817–18. He exhibited several in the Salons between 1827 and 1835, the years when he was most active in this genre, in a style influenced, as we will see, by the English, which most often restricts itself to the formula of the bust portrait. With a few exceptions, he did not really try for effects of style. The situation, the social role of the model,

was less important to him than the simple description of the face, the representation of a familiar character with whom he felt sympathy—for most of his portraits were not done on commission but were of members of his family, those close to him, and intimate friends. The exceptions in this gallery include the *Portrait of Louis-Auguste Schwiter,* his only portrait of a standing figure, and the series of winners of the Concours général commissioned by one of his former comrades, Goubaux, for the school of which he was the director. All of these portraits are in many ways characteristic of his romantic years. Three others are even more unusual for Delacroix. The first of them, *Count Charles de Mornay and Count Anatole Demidoff* (fig. 30), exhibited at the Salon of 1833, unfortunately disappeared in 1914. It is known by an old photograph and by one of Delacroix's very rare studies of an interior, *Count de Mornay's Apartment* (fig. 31), which allows us to envision the portrait. The rather small canvas must have been both vigorous and refined in coloring, not only in the decor but also in the clothes of the Count de Mornay, who appears in a rose-colored robe, contrasting with the black suit of Demidoff, who has come for a visit. Delacroix describes a fashionable interior with a minute realism that is almost Dutch (but he rearranged its elements and changed the colors, as shown by a preliminary watercolor probably done on site).[184] He perfectly renders the dandyism of the two elegant men, Mornay the diplomat with whom he had just traveled to Morocco, and the extremely wealthy Demidoff, future husband of Princess Mathilde. This master stroke was, however, never repeated. Another *unicum,* the portrait of *Talma as Nero in "Britannicus"* (fig. 32), commissioned in 1852 for the foyer of the Comédie Française by the administration of the Beaux-Arts. The official nature of the commission and the genre of the actor's portrait, on which Delacroix had to rely (the painting was one of a series divided among various artists), set limits to which he was unaccustomed, at least for a picture of this kind. In his youth, Delacroix had seen Talma act, but perhaps not in *Britannicus,* one of his greatest successes. He admired him greatly, and yet there was another reason behind his devotion: one of his first commissions had been to decorate Talma's dining room. In this painting, Talma bears a close resemblance to a lithograph by Alexandre Colin done from life in 1824 (Talma died in 1826),[185] but the rendering is very personal in the use of reds and crimsons that, as always with Delacroix, reinforce

the dramatic atmosphere. At the intersection of literature, theater, and portraiture, *Talma as Nero* speaks for the skill of its maker who was able, at a distance of thirty years, to testify to one of the successful periods of the French stage.

The last portrait that Delacroix painted, that of the collector from Montpellier, Alfred Bruyas (fig. 33), commissioned by the model in 1853 and thus done a little after *Talma as Nero,* is also unique among Delacroix's works. Delacroix knew Bruyas and, if we are to believe Silvestre, was particularly impressed by his facial appearance, which made him think of Hamlet. The sympathy of the painter for the model comes out not only in the rendering of the head, meditative, melancholy, almost languid, but also in the knowledge with which Delacroix developed a harmony of greens, browns, and blacks that shows particularly well the qualities of the face and hands. The painter in him never lost his prerogatives and always put himself consciously in the line of his predecessors. The reflections that this picture, once finished, inspired and that are recorded in his journal are very illuminating on this point, for they go beyond the analysis of this particular portrait, touching on all his work: "A host of *sacrifices* are necessary for painting to have its full effect, and I think I have made many, but I cannot tolerate the artist's showing himself. There are, however, very beautiful things that are conceived with an overdone sense of effect: such are the works of Rembrandt, and among us, Decamps. This exaggeration is natural to them and not at all shocking. I make this reflection while looking at my portrait of M. Bruyas; Rembrandt would have only shown the head; the hands would have been barely indicated, and the clothes also. Without saying that I prefer the method that shows all the objects according to their importance, since I admire Rembrandt exceedingly, I think I would be awkward if I tried these effects. In this respect I belong to the Italians. Paul Veronese is the *nec plus ultra* of rendering, in all parts of the picture; Rubens is the same, he has perhaps this advantage over the glorious Paolo with very moving subjects, in that he knows how to draw the attention to the principal object by means of certain exaggerations, increasing the forcefulness of the expression. On the other hand, there is something artificial that makes itself felt as much as the sacrifices of Rembrandt, and perhaps more, in the deliberate vagueness that he employs so noticeably in the less important parts of the picture. Neither the one nor the other satisfies me, so far as what concerns me.

34. *Sheet of Seven Antique Medals*, 1825
Lithograph (third state of five, with Engelmann address), 27.5 × 23 cm
Bibliothèque Nationale de France, Département des Estampes
et de la Photographie, Paris

35. *The Blacksmith*, 1833
Aquatint (second state of six, with etched trials and
drypoint notations in margin), 16.1 × 9.7 cm
Bibliothèque Nationale de France, Département des Estampes
et de la Photographie, Paris

I would like—and I think I have noticed this often—that no artifice be felt, and that the interest be pointed out appropriately nevertheless, which, once again, can only be obtained by sacrifices; but it must be infinitely more delicate than in the manner of Rembrandt to satisfy me. My memory of the great painters does not at the moment suggest a perfect model of the perfection that I want."[186]

Reading this passage of the *Journal*, one cannot help recognizing the permanence of the conceptual framework inherited from the Renaissance and the classical age, fixed from his formative years, within which Delacroix painted. He did, of course, enrich this framework in the course of the years by his reading and through his visits, his travels, his experience, and his own works. He never challenged it. This anchorage looks to us, retrospectively, very strong. This was not always the case, at least during his lifetime, when the ways in which he broke with the past were much more apparent than any continuity he might show. There was nothing scandalous, however, about Delacroix's first painted works. It was the same for his prints (it was then that he was learning line-engraving as well as lithography). *The Blacksmith* (fig. 35), a virtuoso little aquatint, evokes the realist painters of the seventeenth century; and the *Sheet of Seven Antique Medals* (fig. 34), little noticed when they were published in 1825 (but popularized when they were reprinted in 1864), are eminently traditional in their subject. It is true that Delacroix, who here shows a great mastery of technique, neglected the usual conventions of this type of scholarly publication, even though he strictly followed his models (in the collections of the Duke de Blacas or of the Bibliothèque Nationale): the medals are shown in a very strong light that intensifies the relief; they are not described as new but as worn by time, and the date of publication also suggests political intentions on the part of the artist.[187]

The essential point is the homage that Delacroix pays to antiquity, seen again in another lithograph of 1825 representing a metope of the Parthenon: he would have seen the Elgin marbles that same year during his stay in London.

As to the paintings done around 1820, they show a gifted student, respectful of his masters, no doubt too much so. *The Virgin of the Harvest* (fig. 37) of 1819, a welcome commission by an acquaintance who was one of the parishioners of the church of Orcemont, near Rambouillet, is a poor imitation of Raphael, especially the *Belle Jardinière*, but introduces a certain movement in Mary's position. *The Virgin of the Sacred Heart* (fig. 38), done two years later, is already much more free and original in its references—Michelangelo and the Bolognese painters of the seventeenth century. The commission had been given to Géricault for the cathedral of Nantes. He passed it on to Delacroix, who devoted several months to the composition, then to the execution: it was his first large format. But it was delivered under the name of Géricault, who received the payment, passing it on, in whole or in part, to the younger man.[188] The picture for some reason soon disappeared, perhaps because its

iconography was judged heterodox (it was refused by the clergy of the cathedral), and was sent to Ajaccio in 1827, where it remained unknown until the 1930s. The decorative works that Delacroix did at this time were equally private: first, the five pictures that he painted during the winter of 1819–20 for M. Lottin de Saint-Germain, on the rue de Nazareth in the Ile de la Cité (destroyed in 1855),[189] then four lunettes that he made for the dining room of the Hôtel de Talma in the rue de la Tour-des-Dames (among them. fig. 36).[190] For these four above-the-door lunettes, the very classical theme of the Seasons had been chosen. Delacroix adapted his paintings to the style of the house and the taste of the proprietor, incorporating diverse antique sources, frescos and sculptures together. Like other paintings done during his years with Guérin, the Seasons demonstrate his talent but are still too close to student work. This makes more forceful his first picture for the Salon, *The Barque of Dante*, of which the strength and originality are not anticipated in the earlier paintings. Delacroix always remained marked by his classical education, but he was not imprisoned by it and was able quite rapidly to free himself.

36. *Spring,* 1821
Lunette for the dining room of the Hôtel de Talma, Paris
Oil on canvas mounted on wood, 42 × 83 cm
Private collection

37. *The Virgin of the Harvest*, 1819
Oil on canvas, 125 × 74 cm
Church, Orcemont (Yvelines)

38. *The Virgin of the Sacred Heart*, 1821
Oil on canvas, 258 × 152 cm
Cathedral, Ajaccio

*From the
Salon of 1822
to the
Salon of 1827:
Leader of
a New School?*

In 1822, Delacroix was unknown to both public and critics. Five years later, he was a famous artist, one of those at the center of the French School, an artist who mattered, even if his works were harshly criticized or severely judged. Three paintings, deliberately planned, had progressively brought him to the fore: *The Barque of Dante*, shown at the Salon of 1822; the *Scenes from the Massacres of Chios* in the Salon of 1824; and, in 1827–28, *The Death of Sardanapalus*. These three paintings have several basic characteristics in common: their format (they are all very large), their genre (they are all history paintings), and their initial conception (none was commissioned; all were done specifically as "Salon paintings," deliberately planned by Delacroix in his role as a veritable "exhibition painter").[1] "I have too much work that I cannot neglect," he wrote to his sister in July 1821. "And on top of that it would really give me pleasure to be able to find the time to do something for the next Salon. These exhibits occur nowadays with such eternal delays, and so far apart from one another, that you could become an old man in between them, and it's good to make yourself a bit better known if you have the chance."[2]

Today it is difficult to imagine what the Salon meant to French artistic life at the beginning of the nineteenth century. This inheritance from the ancien régime—it was originally a show to which only members of the Royal Academy of Painting and Sculpture could contribute—had survived the Revolution more or less intact to continue under the Empire and the Restoration. It was held at the Louvre every two years before the Revolution and more or less regularly until 1833, after which it occurred almost every year. It occupied the Salon Carré (hence its name) and adjacent galleries as needed. Only living artists' works were shown, and, with very occasional exceptions, only works that had not previously been submitted, accepted, or refused by the jury, which was selected by the Academy. The role of the jury and the criteria by which it operated were interminably debated. But the painter, sculptor, or engraver, whatever his or her talent, was thus brought before the public, which was the primary objective of anyone who wanted to have a career in the arts. It was at the Salon, which was almost the only place where the artists of the time regularly exhibited their recent work, that reputations were made or unmade, with the criticism published in connection with the exhibit being, of course, of first importance. Success there not

only meant recognition but it almost certainly guaranteed public and private commissions. David's reputation was established in the course of the Salons preceding the Revolution, and Guérin, Delacroix's teacher, won instant fame in the Salon of 1799 with *The Return of Marcus Sextus*. The position of Gros was largely explicable by the success, in 1804, of *General Bonaparte Visiting the Pesthouse at Jaffa* and, in 1806, *Napoleon on the Battlefield at Eylau*. As to Géricault, the three works that made his reputation were all large paintings exhibited at the Salon but painted on his own initiative, as were Delacroix's works of a few years later: *The Cavalry Officer Charging* of 1812, the *Wounded Cuirassier Leaving the Field of Battle* of 1814, and the *Scene of Shipwreck*, better known as *The Raft of the "Medusa,"* of 1819. Another important feature of the Salon was that it permitted comparison among various living artists, and, for each artist, between the most recent work and those that preceded it. One could thus see the evolution of the individual as well as of the whole school. Delacroix, along with all his contemporaries, was well aware of the exigencies of this special system, which was extended by the opening in 1818 of the Musée du Luxembourg, where the state-owned works of living artists were exhibited. Thus his work was organized during the 1820s with the Salon always in view. A large painting already attracted attention by its sheer size. But if the canvas was a success, it demonstrated the various aspects of the artist's abilities and all the facets of his talent. The choice of genre, history painting, was part of the strategy. A more subtle but equally revealing feature, the composition of Delacroix's entries, reflects a growing assurance and developing ambition.[3] He showed only one canvas at the Salon of 1822, a test case that made him known to the public and noticed by the critics. In 1824, in addition to his main entry, he presented two studies, listed as such in the catalogue (very likely the *Head of a Woman*[4] at the Musée des Beaux-Arts in Orleans and the *Girl Seated in a Cemetery* at the Louvre), as well as a historical scene, *Tasso in the Hospital of Saint Anna*. In the Salon of 1827–28,[5] attention focused on *The Death of Sardanapalus*. But Delacroix also showed *Justinian Drafting His Laws* as well as works in a number of other genres: a painting on a religious subject *(The Agony in the Garden)*, several on historical and literary subjects *(The Execution of the Doge Marino Faliero, Scene from the War between the Turks and Greeks,*[6] *Mephistopheles Appears before Faust, Milton Dictating "Paradise Lost" to His*

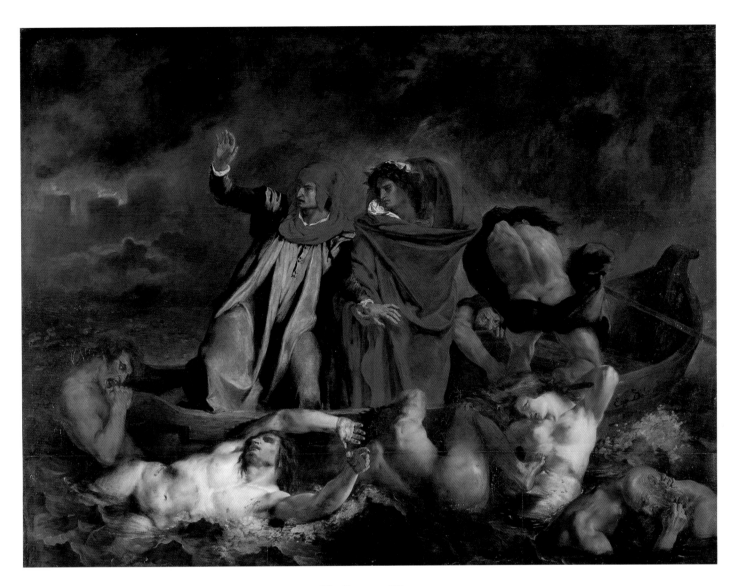

39. *The Barque of Dante*, 1822
Exhibited at the Salon of 1822. Oil on canvas, 189 × 246 cm
Musée du Louvre, Paris

Daughters),[7] some genre scenes (*Young Turk Stroking His Horse*,[8] *A Mortally Wounded Brigand Quenches His Thirst* [fig. 51]), a portrait *(Portrait of Count Demetrius de Palatiano in Suliot Costume)*,[9] an animal painting (*Two English Farm Horses* [fig. 50]), a still life *(Still Life with Lobsters)*, and a study of a head (no doubt the *Portrait of a Woman in a Blue Turban*).[10] The paintings rejected by the jury include: *Portrait of Louis-Auguste Schwiter*, the *Head of an Old Woman*,[11] *Two Horses Fighting in a Meadow*,[12] and *The Combat of the Giaour and Hassan*. By showing these, Delacroix positioned himself as a "complete painter," even if it was his big paintings that gar-

nered most of the attention. The Salon thus had a decisive influence on his activities in these crucial years when he was developing his style. The other exhibitions in which he afterwards participated, and which further enhanced his reputation and his success, were not equally important.[13] The Salon was no less central in the eyes of the critics, who quickly understood Delacroix as one of the leaders of the new Romantic movement that was developing at the same time and in an exactly comparable manner with the painting of large canvases on historical themes—trends that invited contrast with the reigning classicism.[14] One cannot separate Delacroix here

from his contemporaries, most importantly Ingres, whose entries in 1824 *(The Vow of Louis XIII)* and 1827 *(The Apotheosis of Homer)* put him at the head of the group of David's successors. Delacroix's early career is thus from every point of view absolutely dependent upon the particular conditions that governed the artistic life of Paris and that continued almost unchanged during his lifetime, conditions that he never seriously challenged.

In the summer of 1821, Delacroix decided to paint a picture for the Salon of 1822, which was to open in April.[15] For several months he wavered between ideas. Doubtless it is to this time that one should date his research into the subject of the death of Drusus, a subject typical of the neoclassical aesthetic that he explored in notes, drawings, and sketches, as well as in a preliminary study.[16] The painting continued the iconography and theme of the heroic or virtuous death that goes back to the paintings of Poussin, *The Death of Germanicus* and *The Testament of Eudamidas*. It had been more recently illustrated in the paintings of David and Guérin, and Delacroix, in using it, did not show great originality. It would have been more original to take as his subject the war of Greek Independence, of which he was also thinking, as his letter of September 1821 to his friend Soulier, then in Naples, shows: "I am thinking of doing a painting for the next Salon on the subject of the recent wars between the Turks and the Greeks. I think that under the circumstances this would be a way of distinguishing myself, if there is some merit to the execution. Thus I would like for you to send me some views of your Neopolitan countryside, some pocket-size sketches of seasides or very picturesque mountains. I'm sure that would inspire me for the setting of my scene."[17] But finally he decided on a subject taken from Dante's *Inferno*, a work that he had known at least since 1819.[18] The notion of illustrating a particular literary text in a painting was itself entirely conventional. The choice of author was a bit more daring; even if Dante was considered a classic and was known to a wide public, to whom the subject would be easily accessible, it had never before furnished the subject of an important painting by a French artist. Delacroix pondered several passages before finally deciding, then scrupulously followed the original text (Canto VIII of the *Inferno*), as the Salon catalogue indicates: "Dante and Virgil led by Plegias [*sic,* for Phlegias], crossing the lake that surrounds the infernal city of Dis. Sinners cling to the boat, or try to enter it. Dante recog-

nizes Florentines among them." The work was done rapidly: it had to be ready for the opening. "I've been working like a dog every minute for two and a half months," Delacroix wrote to Soulier, who was still in Italy, in mid-April 1822. "In that time I did a fairly big painting that will be in the Salon. I've been determined to make myself stand out this year, and I'm trying my fortune."[19] The painter's feat is not unique in the history of the Salon: Géricault also had painted his *Cavalry Officer* and *Wounded Cuirassier* in a very short time. *The Barque of Dante* (fig. 39) had been painted in one fell swoop, with the ardor of youth and the enthusiasm of throwing oneself into the arena, of facing the public after several years of anonymous apprenticeship and thankless studies. "The best head in my Dante picture was done with great speed and gusto while Pietri read me a canto of Dante that I already knew, but with his accent he gave it such energy that it electrified me. It's the head of the man in back, facing front, who is trying to climb into the boat, having got his arm over the edge," Delacroix recalled many years later.[20]

The painting was a sensation in an exhibition that was short on outstanding works. Guérin, when Delacroix deferentially asked his opinion, gave a very negative critique, as the younger painter himself remembered, even though he recognized that once the painting was submitted to public view, it was noticed by the professors of the School.[21] Much more significant for Delacroix was the flattering approval of Gros. "I idolized Gros's talent, which still is for me at the time of this writing [that is, at the end of his life], and after everything that I have seen, one of the most remarkable in the history of painting. Pure chance led me to meeting Gros, who, learning that I was the painter of the picture in question, complimented me with such unbelievable warmth that for the rest of my life I have been immune to all flattery. He ended by telling me, after bringing out all its merits, that it was a *polished Rubens*. For him, who adored Rubens and who had been brought up in the severe school of David, it was the highest of praise. He asked me if he could do anything for me. I asked him forthwith to let me see his famous paintings of the Empire, which at that time were in the obscurity of his workshop, since they could not be openly exhibited because of the times and because of their subjects. He left me there for four hours, alone or with him, in the middle of his sketches, his preliminary works; in short, he showed me the greatest confidence, and

Gros was a very uneasy and suspicious man."[22] Gros went still further, offering to take him into his atelier: he was sure he could make Delacroix carry off the Prix de Rome and launch him into an official career. Delacroix refused, probably because he wanted to be independent, encouraged in his hopes by the success of his first entry to the Salon. He had, as he himself said, charted a different course.

The Barque of Dante, it is true, had been noticed, if not truly appreciated. One can examine the critiques of two representatives of the traditional aesthetic, Landon and Delécluze (both, incidentally, former students of David), together with the highly favorable text published by Adolphe Thiers in *Le Constitutionnel*. Landon writes, "Seen from far enough away that the strokes are not apparent, this painting, whose color is a bit on the gray side, nevertheless produces a remarkable effect. This is owing to the nature of the composition, which is bold and original. Seen up close, the strokes are so cut up, so incoherent, although not timid, that it is hard to convince oneself that, given the point to which technical talent is achieved in our school, any artist could have adopted such a singular way of working, one to be found at best in some tempera paintings."[23] Delécluze is even clearer: "Forcefulness needs practice. M. Delacroix shows this in his picture of Dante and Virgil: this painting is not a painting; it is, as we say in the workshop, a real mess [*tartouillade*]. However, in the midst of the bizarre objects that the artist wanted to paint, he was forced to make some figures whose contours and color are full of energy; there is talent in the bodies of the damned who are struggling to enter the barque that the two poets are sailing in. We would only observe, for the benefit of this painter, that he must absolutely do a good work for the first Salon [meaning the next one], for one cannot forgive two attempts of this kind."[24] Thiers, for his part, is much more positive, although he still speaks only in generalities: "In my opinion, no painting more clearly reveals the future of a great painter than that of M. Delacroix representing Dante and Virgil in Hell. It is here especially that one sees the spurt of talent, the thrust of nascent superiority that revives the hopes that have been discouraged by the very modest merits of all the rest. . . . Here we have the selfishness of distress, the despair of hell. In this subject, so close to exaggeration, we see nevertheless a severity of taste, an appropriateness of a sort, which relieves the design that harsh but ill-advised judges might accuse of lacking

nobility. The brushwork is free and firm, the color simple and vigorous, although a bit raw. The artist has, in addition to the poetic imagination common to the painter and the writer, that artistic imagination that one could perhaps call the imagination of design, which is completely different from the former. He throws his figures, groups them, manipulates them with the boldness of Michelangelo, and with the richness of Rubens. I do not know what remembrance of great artists grips me in front of this picture; I find this power wild, ardent but natural, which effortlessly yields to its own force. . . . I do not think I am wrong: M. Delacroix has the gift of genius."[25]

The Barque of Dante had thus aroused more astonishment than admiration, and had at least incited a recognition of Delacroix's talent, if not complete conviction. Delacroix had surprised everyone by his choice of a dramatic and terrible subject and by his treatment of it. Beyond his vigorous and visible touch, very different from the smoothness of so many neoclassical paintings (but on this subject one must remember that he retouched the painting during its restoration in 1859), he achieved the chiaroscuro of the scene by using a relatively subdued palette rich in ochers, greens, and yellows, relieved by the burst of red in Dante's hood, the brilliant white of Virgil's toga, and the deep blue of Phlegias's mantle. This set Delacroix apart in a school in which the students and imitators of David still held the uncontested first place. The influences that this beginner claimed were equally innovative: although the classical references were easily spotted (particularly the Belvedere Torso for Phlegias),[26] Delacroix had not, to judge from the evidence, sought inspiration in Poussin and Raphael but in Michelangelo and Rubens, taking from Rubens, for example, the special treatment of drops of water in the *Landing of Maria de' Medici at Marseilles*, reproducing the nuances of the colors of the spectrum as they exist in a rainbow. Géricault's influence was also visible; some people thought until quite late in the century, following Landon's suggestion, that Géricault had worked on the painting, in particular in the foreground.[27] *The Raft of the "Medusa"* had been painted only three years earlier. *The Barque of Dante* showed the same dramatic atmosphere, the same expressive morbidity, which was allied, however, with a relatively classical composition. The two central figures are thus surrounded as it were by a garland of bodies except at the top left where the walls of Dis appear. The figures balance each other, with contrast coming from the expression

of the different personages. The calm and assured beauty of Virgil, the surprise mixed with terror in Dante, the strength of Phlegias, absorbed in his struggle with the elements, all contrast with the despair and abandon of the damned. But the violence conveyed by the actions of the damned, as they attempt to haul themselves into the boat or get a grip on it, hit by the waves, alone or struggling among themselves, remains relatively restrained. Delacroix, for all the boldness that he shows here, remains within limits acceptable to his contemporaries, inasmuch as it is a matter of a first painting in which one can forgive incorrectness and insufficiencies, real or imagined. It is still true that the remarks of Delécluze and Landon inaugurated a

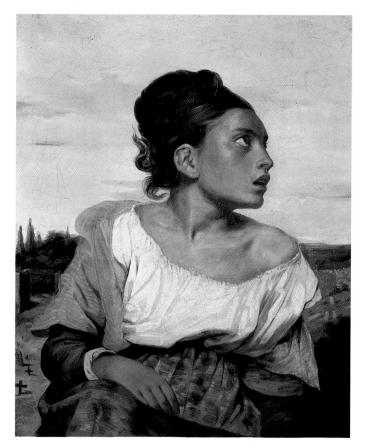

40. *Girl Seated in a Cemetery*, 1824
Exhibited at the Salon of 1824. Oil on canvas, 65.5 × 54.3 cm
Musée du Louvre, Paris

ticularly actresses], but you can only rarely work on it if you want to do something important. I am going to enter into a private charter. I have had a big canvas in my studio for several days, all fresh and virginal; filling it is going to take all the sap that I possess."[31] Still the painting was not begun until January 12.[32] From then on, thanks to the *Journal*, one can follow its progress practically day by day, until its completion a little before the opening of the Salon, which occurred on August 25.[33] Its execution in six months was of an intensity comparable to that of *The Barque of Dante*, even if the subject had been mulled over for a long time. However, it differed in several ways. First of all, Delacroix did not concentrate entirely on this single

critical discourse that endured throughout the painter's career, reinforcing itself from Salon to Salon. Delacroix, finally, could not complain of this first contact with the public, which had responded perfectly to his plan. His painting had been noticed, to the extent that it was quickly purchased by the government for the Luxembourg[28]—an immediate financial relief for the penniless artist and a probable assurance of further commissions or purchases. Delacroix's lucky bet ended in success, relatively speaking, which would now have to be confirmed.

The next Salon was scheduled for the summer of 1824. Delacroix had made his decision a year in advance: "I've decided to do some scenes of the *Massacres of Chios* for the Salon," he noted at the end of May 1823.[29] But it was only at the end of the year that he really went to work: "This week I decided on a composition for *Chios* and almost one for the *Tasso*," he wrote on November 9,[30] and in December he confided to Félix Guillemardet: "It is, alas, a charming subject [women and par-

painting: he worked in December 1823 on the painting that would become *The Natchez* (completed only in 1835), and as early as January 1824, he had made a sketch of *The Agony in the Garden*, commissioned by the Prefect of the Seine, Chabrol, for the church of Saint-Paul-Saint-Louis.[34] In 1824, he executed *Don Quixote in His Library* (completed in April),[35] *The Penance of Jane Shore* (March–April),[36] *A Battlefield, Evening* (begun in June),[37] without counting the paintings more closely related to the *Massacres*, such as *Girl Seated in a Cemetery* (February), *Head of a Woman* (April), and the *Copy of a Portrait of Charles II of Spain* (April–May),[38] to which one can add the group of three portraits of *Aspasie* (fig. 43).[39] *Tasso in the Hospital of Saint Anna*, begun in November 1823, was probably long abandoned and taken up again to be finished after the *Massacres*, since it was only shown in the last days of the Salon. These small- or medium-sized formats are, it is true, not on the same scale as the *Massacres*, which is of much

greater dimensions. Their number, however, is revealing; the big painting did not in the least exclude other activity, which, by the way, could be profitable, relieving him when depression threatened.[40] Delacroix did in fact go through phases of doubt and trial, if not of discouragement, as for example when Riesener, Henri Hugues, and the painter Rouget came to see and criticize the work "at the fussing around moment" [dans le moment du tripotage], when only he could "see something in it."[41] Once Delacroix had determined the composition of the whole, he went from figure to figure, working, effacing, repainting, and getting help in the preparation of the background from Soulier and one of the Fielding brothers, perhaps Thalès.[42] Delacroix had, it seems, obtained permission from the Director of Fine Arts, Count Forbin, to do some retouching at the Louvre itself, a little before the painting was exhibited. The circumstances, rather complicated, came to light in much later and contradictory accounts, particularly those of Villot, Andrieu, and Silvestre.[43] It seems that Delacroix was, in fact, able to return to the canvas once it was already in the Louvre. But the extent of this final retouching is difficult to determine, as is the reason for it. The reworking is traditionally attributed to a revelation Delacroix supposedly received from Constable, who, through the intermediary of his Parisian agent, Arrowsmith, had shown some important pictures at this same Salon, among them *The Hay Wain*. In fact, Delacroix had known Constable for a long time, either by works that some of his friends had brought from England and that had circulated in the studios, or through Arrowsmith himself. The most probable reason, suggested by Lee Johnson, is to be sought rather in the necessity of adapting the picture, which had been executed in a dim studio, to the new conditions of its exhibition.[44] Whatever the final retouching may have been, it shows that Delacroix had taken a new step with the *Massacres of Chios*, which he did with less assurance than he had with *The Barque of Dante*. The hesitations, the steps backward, the experiments and changes in manner that the *Journal* speaks of, unfortunately all too imprecisely, continued on until the moment that the canvas was delivered to the public. The various preliminary drawings, of the whole and of details, went the same way; the big preliminary watercolor conserved in the Louvre differs importantly from the finished picture in the arrangement of groups and especially in the landscape. The *Massacres of Chios* is, more than *The Barque of Dante*, a great

Salon painting, and its execution was delicate and difficult. But one should probably consider another element that was at stake for Delacroix—the consciousness that in this canvas he had progressed in his profession of painting: "I greatly dislike reasonable painting. My disorganized mind must, I see, stir itself up, throw away, try a hundred ways before reaching what has been gnawing at me in each thing. There's an old leaven, a black depth to satisfy. If I have not struggled like a serpent in the hand of a pythoness, I am cold; I have to recognize that and submit to it, and it is a great happiness. Everything good that I have done has been done this way."[45]

The uprising of the Greeks against the Turks went back to 1821, first in Athens and then in the islands. Independence had been declared in 1822, but the Turks quickly recovered and put an end to the revolt of Ali, Pasha of Janina, massacring the population of Chios in April that same year. The island had been liberated by a troop of insurgents from Samos. A Turkish expeditionary force disembarked eight days later and pillaged and burned during more than two months. In the end, fewer than a thousand inhabitants, out of about ninety thousand, survived, the rest having been killed or deported into slavery. This episode, known in the West from accounts of eyewitnesses, aroused profound emotion. Opinion, especially liberal opinion, supported the Greeks for many reasons, both religious and cultural. The bloody savagery of the Ottomans at Chios struck the imagination as did earlier the departure of the inhabitants of Parga when the British sale of their city to the Turks forced them into exile, or as did the suicide of the Suliot women who did not want to fall into slavery. While a philhellenic current progressively overtook France, as well as the rest of Europe, the cause of the rebels seemed more and more endangered. The Turks retook the Morea (1825), and Missolonghi was recaptured, the Greek defenders choosing to blow themselves up rather than surrender (April 1826). The Acropolis of Athens, whose garrison was commanded by a French colonel, Fabvier, fell in its turn (June 1827). The governments of France, England, and Russia, driven to intervention by more and more favorable public opinion, then decided to act, and, when their mediation was refused, destroyed the Turkish fleet at Navarino (October 1827). The Russians invaded Turkey; the sultan finally agreed to negotiate and recognized the independence of Greece (September 1829). It is in this context that Delacroix's work must be placed. He was one of the first

artists to attempt to treat these recent events; we know that he was thinking of a picture on the subject as early as September 1821.[46] That he came to the subject so early sets Delacroix apart, as does the deliberate imprecision of his "Greek subjects," including the first of them, in *Scenes from the Massacres of Chios* (fig. 42). In contrast to a number of his contemporaries, who simply illustrated one incident or another, Delacroix most often situated events only vaguely, without giving them a precise historical or literary source. He did this in the two pictures that he exhibited in the Salons of 1824 and 1827: *Scenes from the Massacres of Chios: Greek Families Awaiting Death or Slavery,* etc. (see the various accounts and the journals of the time) and *Scene from the War between the Turks and Greeks.*[47] In painting contemporary history, Delacroix is not a chronicler. Going beyond contingency and anecdote, he gives history another meaning, permanent, almost eternal. But he also keeps its modern character, combining both old and new. What David sought in classical antiquity, Delacroix found in the Greece of his time. Only Géricault, who had already upset the conventional norms of representation in his *Huntsman* and *Cuirassier,* had, in *The Raft of the "Medusa,"* pushed the limits of the *grand genre* so far. Delacroix admired and revered Géricault, and undoubtedly takes him as a model here, as well as in whatever there is of the classic in the *Massacres of Chios.* The deliberate and audacious choice of illustrating a scene of contemporary history, and of reinventing it even though it sprang from real events, was no doubt dictated by the intended purpose of the painting: Delacroix, a beginner at the Salon of 1822, was now known and sure to arouse the public and to attract the attention of the critics, for good or bad. The

41. Study for the *Massacres of Chios*
Watercolor and pencil on paper, 34 × 30 cm
Musée du Louvre, Département des Arts Graphiques, Paris

subject was not forced; it fit in with profound tendencies of the man and the painter. The *Massacres of Chios* is not a manifesto of inward political engagement, but it should be emphasized that to align oneself with the Greek cause at this date was to place oneself pretty clearly in the liberal camp. But that is not the most important thing. Delacroix had for several years been immersed in the Orientalism typical of his time and milieu: influenced by Gros and probably by Girodet, awakened to the realities of Greece by Monsieur Auguste, one of his painter friends who had gone to Greece and was for him a model and a valuable source, he had also been reading a great deal of Byron. This Orientalism had to translate itself into painting. The *Massacres of Chios* inaugurated a vein in Delacroix that continued to grow and broaden.

The elliptical notations of the Salon catalogue reflect the multiple sources of the painting, of which two are principal. The first and best known, the newspapers, were familiar to all. They guaranteed that the picture would be understood, that the viewer would have immediate access to the scene. But a more detailed analysis reveals a much deeper inquiry on the part of the painter. One of the Frenchmen engaged in the service of the insurgents, a Colonel Voutier, had published his *Memoirs of the Present Greek War* as early as 1823. Delacroix met him right when he was beginning his picture, on 12 January 1824, as his Journal indicates. He reports in it some elements of their conversation that struck him the most: "The Greek soldier who, having defeated his enemy and trampled him, cries enthusiastically, *Zito Eleutheria!* [Vive la liberté!]"[48] Delacroix records also an episode of the siege of Athens in which Voutier, struck by the beauty of the head of a Turk that

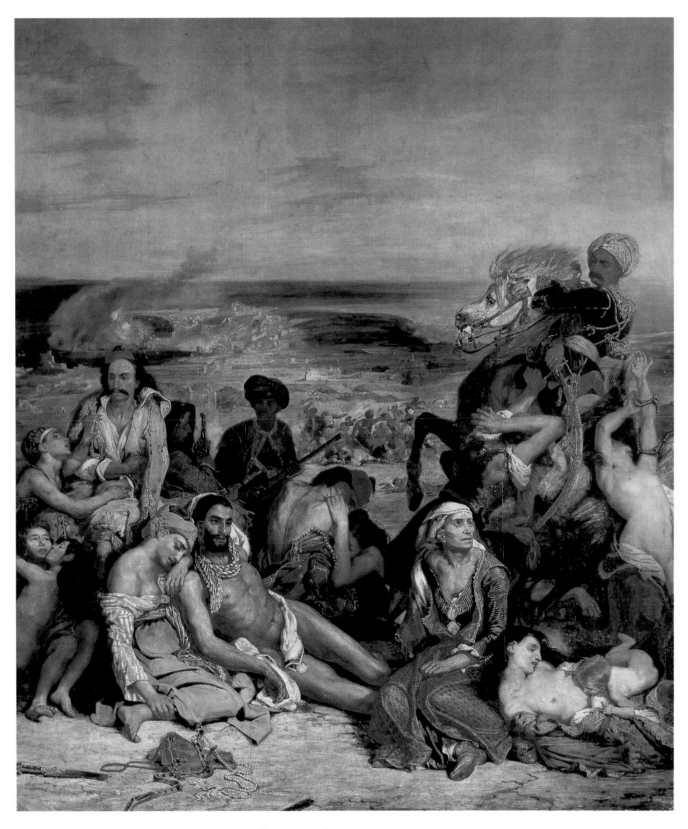

42. *Scenes from the Massacres of Chios*, 1824
Exhibited at the Salon of 1824. Oil on canvas, 417 × 354 cm
Musée du Louvre, Paris

appeared among the battlements, kept a Greek from killing him and goes on to describe the burning of the Turkish fleet in Chios harbor, carried out 18 June 1822 by Canaris and George Pepinis, who personally commanded the assailants. The Turkish admiral, among others, died in the flames, as did another who was carrying the head of a French officer, Balleste, from Candia to Constantinople. Delacroix probably commemorated this glorious counterattack in the left background of his picture; it changed nothing in the tragic course of events, but it saved the honor of Greece. The dead woman in the foreground, whose young child tries to find her nipples, is doubtless an image from Voutier's account.[49] But if one aspect or another of the *Massacres of Chios* derives from Delacroix's interviews with eyewitnesses or from his reading, the invention of most of the groups and their disposition, as well as the choice of the composition, is entirely Delacroix's own (fig. 41).

The influence of Gros's *General Bonaparte Visiting the Pesthouse at Jaffa* is clearly evident in this painting, especially in the use of the nude and of oriental costume, as is that of the great history paintings of the Revolution and the Empire. Delacroix has placed in the foreground, on the same line, a group of Greek prisoners and casualties, without making it possible to determine whether they are dead or dying and not even always whether they are men or women. The figures are grouped two by two except for the old woman who seems, without real hope, to implore the heavens. A broken blade on the ground symbolizes the futility of all resistance. To the left, next to a seated soldier—wounded and rigid with pain, to whom a dazed or dying adolescent clings, two young people embrace. An insurgent, fatally wounded, is wept over by a woman who leans on his shoulder. To the right, one finds the old woman, the dead woman and her child, and a Turk carrying off a woman, attached to his rearing horse, her clothes falling from her. The Turk is unsheathing his sword to get rid of a young man who tries to stop him. This personage is the link to the second plane, where Delacroix has shown the guards, seated in the shade, gun in hand. In the background, clearly lighted, is a huge landscape, loosely treated: the island, the devastated countryside, burned houses, the port, and, in the distance, the nearly black sea. In the center one can distinguish Turks killing the inhabitants with gun or saber, and corpses stretched on the ground. The clarity of the composition is enhanced by the suggestive use of light, which isolates the Turks and clearly separates the three big sections of the work. This clarity is reinforced by the symmetry of the two great pyramidal masses at the right and left, conceived according to different principles: one group of figures piles up around the wounded Greek, the other swirls around the Turkish soldier, which reinforces the opposition between the conquered and the conquerors, between the exhaustion of the one and the cold violence of the other. The opening toward the plane behind them, at the center, does not prevent the linking of the two principal groups, since the wounded man who is stretched out, the couple, and the old woman can also be seen to form an independent group. The arrangement of the figures, perfectly mastered, makes the picture an ensemble of great masses that balance each other and that are also harmoniously composed and balanced in detail. The only apparent movement is that of the soldier at the right, who holds back his horse to stop its movement. Savagery shows itself here not in brutal action, but in the horror of its effects: the "calm grandeur" of the neoclassic is not missing in the prostration of the defeated and the dead.

The picture, which retrospectively appears rather subdued, made a scandal at the Salon and was violently controversial. The principal painters of the School were either lukewarm or frankly hostile. Gérard gave it "the most flattering praise,"[50] all the while saying that its painter was "a man who has run wild."[51] For Gros, it was not the *Massacres of Chios* but the "massacre of painting." Delacroix, encountering him at the Salon and greeting him deferentially, fell victim to the stinging remark, "Monsieur, it is not a question of greeting people, you must still draw well and never confuse bad painting with good." Rivet reports another anecdote that Delacroix liked to tell. Girodet, who was on the jury, had given him his felicitations, "mixing in some severe criticism." "He had noticed the poignant pain of the young mother, dying, whose failing arms could no longer hold her child. 'That is touching and well conceived,' he said, 'but when I approach it, I can no longer see the drawing of the eye, I can hardly distinguish it from the eyelids. Why didn't you finish such an expressive eye?' 'Because I was not sure of not losing the expression that you find striking,' answered Delacroix; 'and if you need to approach it to see the faults, let me beg you to stay at a distance.'"[52]

All the critics emphasized the interest aroused by the canvas, around which crowds continued to gather.[53] But what seemed to be the case for *The Barque of Dante* could not apply to this painting, that it was only a trial: "I think it was with the *Massacres of Chios* that I began to become an object of antipathy for the School, a kind of bugbear," Delacroix remembered, "and I still ask myself how I managed to swim against such a current, how I could have lived and gotten out of the affair without the least intrigue, the least protection; for the praises that a few journals gave me only increased the fury of the respectable professors, who were not slow to respond that I wrote them myself—an enormity that does happen, but that is so contrary to my nature that I have never even insinuated to any journalist that he should say something good about me."[54] The later testimony of Gautier and Dumas is similar: "These horrible scenes, with no academic arrangement hiding the horror, this feverish and convulsive drawing, this violent color, this furious brush roused the indignation of the classicists, whose wigs trembled like Handel's, and were enthusiastically received by the young painters for their strange boldness and their novelty that nothing had presaged. Today [in 1855] the *Massacres of Chios* has become a classic in its turn. At the gallery of the Luxembourg, where it is hung, easels gather around it, it is copied, studied, admired! One cries, 'It is admirable!'[55] and another: 'Good God!' Those of you who belonged to that time, have you forgotten the clamor that arose around this painting, which all at once appeared crude in its composition, violent in its form, and still full of poetry and grace? . . . From that moment on, at twenty-five years old, Delacroix was proclaimed a master, he had a school, not of students, but of disciples, of admirers, of fanatics. A rare thing."[56]

The general context of the exhibition plays a role in this radicalization of minds. The opposition between the Classicists and the Romantics, born first in literary circles, was now reaching painting. Each camp counted its ranks, the painters as well as the critics, and awaited with impatience the opening of the Salon to resolve the quarrel and announce the old school or the new one as the winner.[57] The first lacked a real champion, and had hardly anyone to put forward but Gérard (*Louis XIV Presenting Philippe V as King of Spain, Daphnis and Chloe*). The partisans rallied around Ingres, until then ignored or vilified. His *Vow of Louis XIII*, a skillful synthesis showing

the influence of Raphael and the French seventeenth century, reunited the votes of the classic camp. Similarly, Delacroix became, on his side, the most eminent representative of Romanticism for both partisans and adversaries, who concentrated their criticism on him while sparing other innovators the worst. Thus he suffered from the presence of pictures that were seen to be a happy compromise between the two tendencies that divided the Salon, and in particular one by his contemporary, Xavier Sigalon, his elder by ten years, who, like him, had made an impression in 1822: *Locust, Giving Narcissus the Poison Intended for Brutus, Tries it on a Young Slave*.[58] As Thiers wrote of this, "The artist, whose subject suggests all possible exaggerations of color, line, and expression, has avoided all of them! A minister of Nero, a poisoner, a slave in convulsions, how many follies to commit in order to be terrible, somber, or convulsive! M. Sigalon has committed none. He produces his effect with moderation; he has gone to the end without going a line beyond it. M. Delacroix is far from having the same moderation; his talent is ardent and bold. He is in the first stage of sensibility where one seeks the terrible, in that first irritation where the hatred of calculating results is a failure of reason; he is not ripe yet, but his talent is immense."[59]

In other words, Delacroix's picture was judged not only for itself, but also for what it represented. One of the most determinedly Davidian critics, Chauvin, vilified the "extravagant young men who give off badly directed heat that loses itself in unfortunate attempts, and think they return to natural forms through rendering the ignoble, or find expression only in the grimace and in extravagant gestures." Elsewhere he writes of the "young show-offs" who work in "licentious forms, expressions, and colors," where nature appears only by accident in a corner of the painting, provoking "cries of admiration and hyperboles without end." Of whom was he thinking? Principally Delacroix, for whom he reserves his most cutting remarks, and whom he specifically takes as an example of the opposition between the Classicists and the Romantics: "It is not to arrest the development of our young artists that I am so quick to indicate the steps by which a distinguished painter, the teacher of their teachers [David], led the historical genre to the apogee of its glory; it is rather to establish a necessary point of comparison, which ought to humiliate no one; it is, in short, to avoid the words 'classic' and

43. *Portrait of Aspasie*, c. 1824
Oil on canvas, 81 × 65 cm
Musée Fabre, Montpellier

'romantic', or, if you will, to explain them clearly and precisely. The classic is drawn from *la belle nature*; it touches us, it moves us, it satisfies heart and mind together. The more one studies, the more one discovers its beauties; one leaves it with regret, and returns to it with pleasure. The romantic, on the contrary, has something forced, unnatural, which at first glance shocks the eye and upon examination repels it. The artist, in delirium, uselessly combines atrocious scenes, sheds blood, tears out innards, paints despair and agony. Uselessly again, he obtains partial effects in the midst of a thousand extravagances, and makes people who know nothing about it shout, 'Miracle!' Posterity will never accept such works, and contemporaries of good faith will grow weary of them; they are weary already. Conclusion: I call *Leonidas* and *Philippe V* classic, and the *Massacres of Chios* romantic."[60] The gaze of some was thus already slanted by certain a priori ideas.

"Curses on the barbarian painter whose disordered imagination gives birth only to hideous wounds, contortions, agonies—afraid of not shedding enough blood, of not making enough cripples!" he continues. "The public, at first frightened, . . . passes from the horror of the scene to contempt for the work, understanding that the artist, far from seeking legitimate success, reaching the mind and heart by noble means, has only set himself to strike the senses with vulgar emotions by means of a canvas and some paints. These sorrowful reflections are inspired by the sight of a painting numbered 450, the scene of the *Massacres of Chios*. Of course, one does not know what to blame the most, the amazing naivety of all these throat-cuttings or the more barbarian fashion in which M. Delacroix has presented them, with no regard to proportion, to drawing, to the most usual proprieties of art. If, as I am told, some young painters, seduced by a certain audacity

of the brush, remain in admiration before this butchery, I would tell them frankly: friendship misleads you, compare the *Massacres of Chios* with analogous pictorial subjects; look at Poussin's *Massacre of the Innocents*, or even the *Revolt of Cairo* by M. Girodet; everywhere you will see cunning struggling against force, interesting groups, points of repose—in short, a kind of *peripeteia* within the carnage. But what you will never find is the cold gathering of men, women, and children, dead or ready to breathe their last."[61] Chauvin's imprecations summarize the criticism of the *Massacres of Chios*, bearing principally on the horror of the subject, the weakness of the composition, and the treatment, especially, of color. The first is surprising: is there such a difference between Delacroix and Gros, his most obvious model, the Gros of the *Pesthouse at Jaffa* or of *Napoleon on the Battlefield of Eylau*? Nevertheless, Delacroix was shocking: "The expression—and it is the merit to which the painter seems to have the most pretension—has not succeeded any better. What can be said of these unfortunates, of whom some are absolutely naked and others barely covered with miserable rags, splattered with the blood of their wounds, and whose ignoble features proclaim the artist's system of clearly pronounced ugliness? A singular group who seem to have been assembled for the express purpose of wounding the eye, afflicting the heart, and offending taste."[62] And Delécluze goes farther: "The expression of suffering and despair, rendered by the painter with a care that is tiring for the spectator, certainly proves that M. Delacroix feels deeply and has a natural aptitude for painting his ideas, but does this artist in conscience think that the public is so blasé that you have to offer the representation of such a horrible spectacle to arouse its curiosity? Not only is the disposition of the scene appalling, as anyone can see, but it seems that he took it in hand to make it more hideous yet by the choice of ignoble forms and by the cadaverous tint stretching over the whole picture. Certainly one cannot deny to M. Delacroix truth of invention, vigor of execution, and a true sense of coloring; but I am not at all afraid to assert that in the middle of his hotheaded incorrectness this painter presumes to uglify. . . . True originality and sincere enthusiasm are simpler, and it is impossible that a man like M. Delacroix, who has studied art in a country where there is a museum of antiquities and of pictures such as we possess, should not be aware of the degree

of ugliness that he has spilled into his work."[63] This last remark is interesting; Delacroix is criticized, it seems, for the absence of idealization, for his realism, more than for having painted the dead and the dying.

The question of the composition is another matter entirely. More than the arrangement of the different groups, it was the conception of the whole that was shocking. There is in effect no central episode to which the personages can be related so as to make a hierarchy among them, except in a vague and general way. None of them prevails over the others. Further, each is isolated, without direct, immediate relation to his or her neighbor. The old woman is not concerned that the young woman is being carried off, nor is the seated prisoner involved with the wounded man who is dying at his side. The rupture with one of the essential theoretical foundations inherited from Poussin and Le Brun is thus consummated. This was evident to Delacroix's contemporaries, both adversaries and partisans of the picture. To Landon, who speaks of a "confused assembly," Thiers answers, "It was not necessary to pile up in confusion figures of whom one cannot distinguish either the state or the condition."[64] It was the treatment of the canvas that motivated the most severe criticism. Delacroix varied the management of his brush considerably in various parts, again preferring a very visible touch to the smooth glaze that was prescribed by the rules of Classicism. For example, he multiplied the highlights on some of the clothing, like the old woman's, while the sky is much more broadly treated. This technical choice, a deliberate one and not the fruit of some weakness or inability as some suggested,[65] broke with one of the traditions most honored by the School in recent years, and, as a consequence, accentuated the formal absence of unity in the painting. The same was true for the coloring. If this is difficult to appreciate today, the coloring nevertheless struck all contemporaries by its vigor. Delacroix deliberately employed a large palette, one full of life and still more vivid after the final retouching at the Louvre, according to Andrieu. But he also chose "this fine black, this happy filth" appropriate to corpses. His famous jest, perhaps apocryphal but not unlikely, reported by Dumas, summarizes this ambivalence. To the writer who said, "I didn't know that there was plague at Chios," he replied, "all astonished, with a nervous shudder: 'You have hit the nail on the head, while all the

others have missed. It was in front of the *Pesthouse at Jaffa* that the first idea of my massacre came to me; I didn't take to Gros's palette, only you mustn't say so.'"[66] The essential criticism of the *Massacres of Chios* was, in fact, the use of an incoherent and unrealistic array of colors, of which, however, the richness and variety were emphasized: "In short it was not necessary to throw such colors together, to set so many yellow corpses against so many blue corpses with no other purpose than to establish a great struggle of effects; all that shows an immoderate ambition and not the simple, bare truth that M. Delacroix is tormenting himself to achieve, and to which his fine talent gives him the right to aspire," writes Thiers in concluding an article in which he shows himself nevertheless relatively favorable.[67]

The three other paintings shown by Delacroix did not have the attention-getting large format, and went practically unnoticed. The two studies of heads, preliminary works or works more distantly related to it, are like a muffled echo, offering similar formal effects. The head of the *Girl Seated in a Cemetery* (fig. 40), treated with more precision and more finely than the rest of the picture, thus contrasts, in its smooth and almost varnished finish, with the rougher texture and more apparent touch of the clothing and the landscape. *Tasso in the Hospital of Saint Anna* (fig. 44) was not hung in the Salon except for the very last days of the exhibit, too late to be taken into account by the various critics. One of them, anonymously, commented that "those who put vigor and warmth above everything will find all that in this artist, and with the most original composition," while "those for whom satisfying reason comes first will find that this young man has only a disordered taste, without restraint, and that he is, despite his good qualities, too close to the low and the ignoble."[68] The subject, Tasso incarcerated in the madhouse of Ferrara by order of his protector, Alphonse d'Este, was in style. Byron had published *The Lament of Tasso* in 1817; Goethe's play, *Torquato Tasso*, had been translated into French in 1823. In 1829, Pierret had collaborated in the new translation by Baour-Lormian of *Jerusalem Delivered*. In painting, Fleury-Richard had exhibited *Montaigne Visiting Tasso in Prison* in the Salon of 1822. Delacroix, who had been thinking of this subject for several years (it is in a list of pictures to be done, in a notebook conserved at the Louvre),[69] knew the life and work of Tasso quite well. When he was younger, he had been profoundly

moved by him,[70] and it is not impossible that he more or less consciously projected himself onto this figure, as he did twenty-five years later with Michelangelo, in *Michelangelo in His Studio*. But the implications and personal resonances that one can retrospectively see in the picture mattered less at this date than what was purely romantic about it: an imprisoned poet, his genius persecuted and misunderstood, the madmen, a historical scene, the Renaissance. Delacroix knew what he was doing in sending this little painting (originally he had thought of treating it on a grand scale) to the exhibition: he intentionally put himself in the ranks of the new school.

Although some reactions to Delacroix's work had been violent, his participation in the Salon was not without concrete results. The event had placed him among the artists who counted—as proof that his work was not without merit, he received a second-class medal. "M. Delacroix always has this superiority over the artists of grand paintings that cover the walls of grand rooms: at least the public paid attention to his work," Stendhal noted in his review.[71] The publicity had its consequences: the administration, more liberal than one usually thinks it, was able to discern an original talent that confirmed the hopes it had aroused two years earlier. The government bought *Massacres of Chios*, immediately placing it in the Luxembourg. The purchase price, six thousand francs, was considerably higher than that of *The Barque of Dante* and gave Delacroix a certain financial security: he could from now on reasonably expect official commissions. His name thus appeared in good position on a list drawn up at the same moment, probably by Forbin, for use by the Vicomte de La Rochefoucauld, newly charged with the department of Beaux-Arts in the ministry of the Maison du Roi.[72] Intended to guide his choices, the list said of Delacroix, "His picture of the *Massacres of Chios* promises a great feeling for painting, especially for coloring. To be encouraged." He was recommended for a commission of four thousand francs. In fact, in 1826, he was asked for *Justinian Drafting His Laws*, destined for the Conseil d'Etat. From this time on, Delacroix began to paint directly for the dealers and collectors, and his career took a true jump. As Thiers wrote, "He had proved a great talent, and he had erased all doubts in following the picture of Dante with that of the Greeks."[73]

Three years later, this position was to be compromised by the presentation of *The Death of Sardanapalus* (fig. 46) at the

44. *Tasso in the Hospital of Saint Anna, Ferrara*, 1824
Exhibited at the Salon of 1824. Oil on canvas, 50 × 61 cm
Private collection

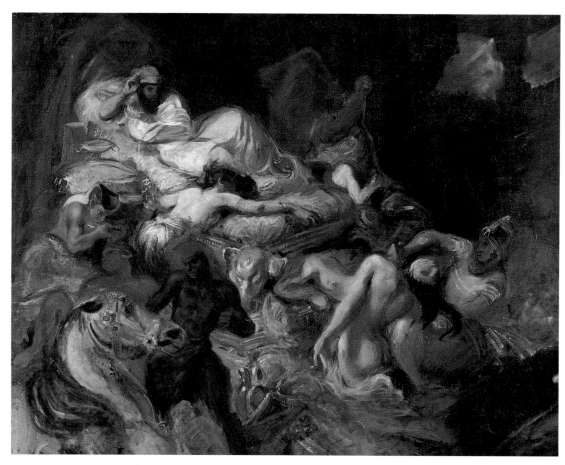

45. Sketch for *The Death of Sardanapalus*, 1826–27
Oil on canvas, 81 × 100 cm
Musée du Louvre, Paris

third installation of the 1827 Salon, provoking an enormous scandal. "I am bored with the whole Salon. They will end by persuading me that I have created a veritable fiasco," Delacroix wrote to Soulier. "However, I am not completely convinced of it. Some say that it is a complete failure; that *The Death of Sardanapalus* is by a romantic, since romantics abound; others say that I am *inganno* [in error], but they would prefer to be wrong than to be right like a thousand others are right, so to speak, and are still damnable from the point of view of soul and imagination. I say they are all idiots, this picture has its qualities and its faults, and if there are some things that I would prefer, there are also a good many others that I am happy to have done and that I wish for them. . . . All this is pitiful and not worth spending a moment on—except for what goes straight to the question of material interest, that is,

cash."[74] Before the opening, he had already been somewhat anxious, as he always was: "I have effectively finished my Massacre number two. But I had to undergo a good deal of tribulation from those asses on the Jury. . . . Just this morning they reopened the Salon. My daub has the best placement of all the entries. So that, success or not, I will be the one to blame. I underwent an abominable experience, arriving in front of it, and I do not wish my eyes upon the excellent public to judge my masterpiece. . . . What an execrable trade that makes one's happiness depend on pure self-esteem! Six months of work end in making me spend the most awful damned days. Anyway, I'm used to these things, and don't be too alarmed for love of me. It's probably like all the other times where the first sight of my damned painting hung beside all the others puts me down completely. It's like an opening night when everybody

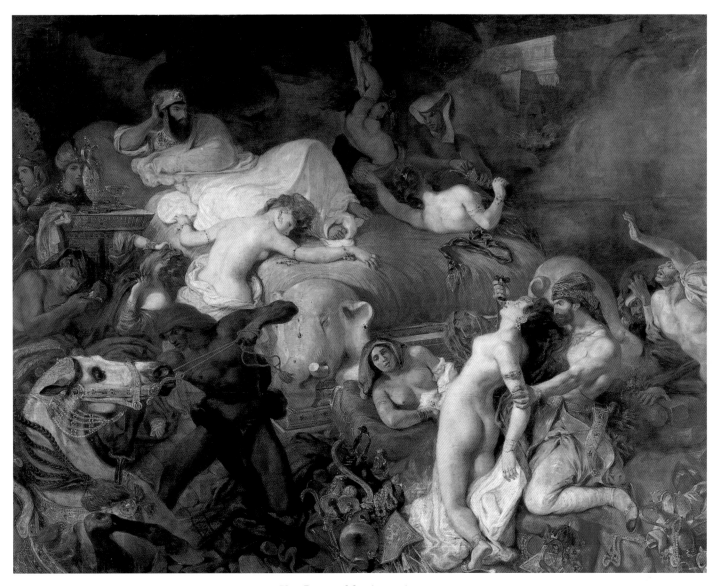

46. *The Death of Sardanapalus,* 1827–28
Exhibited at the Salon of 1827–28. Oil on canvas, 395 × 495 cm
Musée du Louvre, Paris

hisses."[75] His premonitions were accurate: almost no one took up the defense of the picture. This time Delacroix had gone too far: "Until now we have excused rather than condemned the disorderly caprices of this young innovator; we hoped that his hotheaded temperament would become more moderate day by day," writes Vitet. "But here he goes beyond the bounds of independence and originality."[76]

The subject was his own invention entirely, inspired by reading Byron's *Sardanapalus,* published in 1821. According to Rivet, he had been struck by the picturesque aspect of the denouement and had immediately thrown himself into his sketch with this mindset.[77] The scene imagined by Delacroix is certainly different from the end of the play, in which Sardanapalus immolates only himself on a pyre along with his favorite concubine, Myrrha. The painting, however, respects its spirit. Several hypotheses have been proposed to explain the deviation: an adaptation of Byron's work on a Parisian stage, which Delacroix supposedly saw and which specifically inspired him; a particular use of literary sources—Diodorus Siculus, who follows Ctesias in reporting the history of

Sardanapalus (the last king of Nineveh, who died in the ninth century B.C.), or Herodotus and Curtius—by which Delacroix would have enriched the basic givens. No direct and convincing source, if it exists, has been found. The text proposed in the Salon booklet, which appears in the guise of a quotation and which makes various details explicit, is, in all likelihood, by Delacroix himself: "*Death of Sardanapalus.* The refugees are besieged in his palace. . . . Lying on a superb bed, atop an immense pyre, Sardanapalus orders his eunuchs and palace officers to slit the throats of his women, his pages, and even his horses and favorite dogs; none of the objects that served his pleasure should survive him. . . . Aïsheh, a Bactrian woman, will not allow a slave to kill her and hangs herself from the columns supporting the vault. . . . Baleah, Sardanapalus's cupbearer, finally sets fire to the pyre and throws himself in."

Delacroix had put the essentials of his composition in place in a sketch that is today in the Louvre (fig. 45). The subject is arranged on a great diagonal that divides it in two, running from Sardanapalus at top left—calm, stretched on his bed and contemplating the scene—and terminating with Baleah, at the right—announcing the victory of the rebels to his master and at the same time signalling the execution of his orders. The fire is spreading, and smoke already curls at the top of the picture. Behind, one sees the rest of the palace. Aïsheh hangs herself, a slave prepares to kill her companion. On the other side of the bed, women bring the poison. Others kill themselves or have their throats slit, dying or begging for mercy. To the left, a black servant kills a horse, which he restrains by its bridle. The picture, in fact, consists of different juxtaposed groups that Delacroix composed separately, without attempting to tie them to each other: Sardanapalus and the woman stretched out on the bed, her arms extended to the side; Aïsheh, the other concubine, and the servant, Baleah, with his arm tensed, his companion in a reverse movement, hands on head, self-absorbed; the standing woman, nude, whose throat is being cut by a guard; the black man with the horse; the woman who prepares to stab herself with a dagger while her neighbor is in convulsions; and finally the two who appear from behind, bringing poison and weapons. The picture seems all the more saturated in that Delacroix multiplied accumulations of precious objects in the spaces between the figures, without relationship to their immediate environment. The floor disappears almost completely, reinforcing the impression of disequilib-

rium provoked by the perspective of the bed. Delacroix paid little attention to verisimilitude in the arrangement of the personages, as the recollections of the perspectivist Thénot show: "M. Eugène Delacroix asked me to trace for him some monumental lines in . . . *The Death of Sardanapalus*. All the figures were painted, only the architecture remained. All these figures had been drawn from the same point of view and at the same height, without regard to the horizon in the picture or in nature, so that one saw the top of the head when one should have seen the bottom of the chin, and so on for all the other parts of these figures. However, he thought them exactly drawn because they were drawn from nature."[78] Vitet emphasized also what he saw as the unfortunate consequences of the framing adopted by Delacroix: "In truth, the first time one sees this great canvas, one cannot help believing that it has been trimmed down on all four sides, because the flow of action is so badly interrupted by the border. It seems that by adding some feet more in height and width, one would not only recover all the cut-off arms and legs but might manage to understand what is going on. There is no point trying to justify the general composition of the picture: the whole painting is disorder and confusion, and unfortunately the faults reproduce themselves on a smaller scale in almost every detail."[79]

The very distinctive treatment of color exacerbates the whirling impression. Realism gives way to purely formal effects where Delacroix seems to have been carried away as the canvas proceeded, progressively abandoning, from group to group, the original idea of the sketch. Rivet offers these comments: "When he came to the execution of this canvas, the largest he has attempted, when he undertook to paint, from the model, this half-nude slave who throws herself on her master's bed, imploring pity and begging for mercy on her youth and beauty, he let himself be carried away by the seduction of imitation. He put quivering opal and gold on the torso with brilliant reflections, on the shoulders, on the arms of which the sparkling color seems to have made him drunk with enthusiasm. He made here one of the most ravishing studies that could charm the eyes, but he lost the general tone of the picture to keep what he had made so vigorously and happily. Thus, little by little, he modified all the accessories, and the entire scene took on a wholly different effect from what it was first meant to be. Several years later, when he saw the sketch again and I reminded him of the emotions that he had felt, he

said to me: 'Do you know what that proves? That I was only a student; color, that's the phrase, is the style. One is only a writer when one is master of it, and can make it obey one's thought. Today,' he added, 'my palette is no longer what it was. It is perhaps less brilliant, but it no longer goes astray. It is an instrument that plays only what I want it to play.' Moreover, this was his last inherited weakness. It has been clear since then that if you compare the works with the preliminary sketches, that is, the ones that have gone up for sale, you will see how the thought that conceived them has been scrupulously obeyed in the execution."[80] Several sketches in pastel testify to Delacroix's studies of the living model, and, of course, there are other reminiscences, since the woman with her throat cut in the foreground also derives from one of the Nereids of Rubens in the *Landing of Maria de' Medici at Marseilles*.[81] It is nevertheless important to emphasize in Rivet's testimony not so much the "wholly different effect" as the method of the painter, working each fragment separately in autonomous fashion. The different groups use the same range of colors based on whites, reds, and bright golds relieving the greens, browns, and blacks from which they stand out, so that the separate groups offer similar violent contrasts between the darks and the lights. But no unity results from this: light plays indifferently on the various groups. The gaze thus wanders from one piece of the picture to another without being able really to distinguish a principal figure. As in the *Massacres of Chios*, but by different means, Delacroix has again subverted the traditional principles of composition, illustrated in this Salon by Ingres in his *Apotheosis of Homer*. This time the subversion is clearer and more provocative. One can understand why *Sardanapalus* created such a scandal: no one had so scorned well-established customs, the conventions most commonly agreed on, even by Romantics.

When Delécluze drew up his assessment of the Salon, he neatly summed up the issues surrounding *Sardanapalus*: "M. Delacroix's *Sardanapalus* found favor neither with the public nor with the artists. One tried in vain to get at the thoughts entertained by the painter in composing his work; the intelligence of the viewer could not penetrate the subject, the elements of which are isolated, where the eye cannot find its way within the confusion of lines and colors, where the first rules of art seem to have been deliberately violated. *Sardanapalus* is a mistake on the part of the painter. One should go

back to his *Agony in the Garden* to await another work and judge it anew."[82] There was a general panning in which even the artist's partisans participated, criticizing him quite harshly, as did his friend Auguste Jal: "M. Delacroix does not systematically err; it is with all his heart that he painted his *Sardanapalus*. He has worked with passion and feeling, but unfortunately in the delirium of his creation he has been carried beyond all bounds. His very original talent is absent from this canvas done under the inspiration of a great poetic thought. He wanted to compose disorder, and forgot that disorder itself has a logic. He wanted to frighten us with the spectacle of the savage voluptuous pleasure that Sardanapalas's eyes feed on before closing forever, but reason cannot disentangle [the painter's] idea from the chaos within which it is imprisoned. The destruction of so many living beings on the pyre of the most degraded tyrant is a beautiful horror; M. Delacroix feels it; but his hand has betrayed him, and the betrayal is complete. It must be said (and you may imagine what it costs me) that not only does the sum of the faults outweigh the beauties, but that the beauties do not exist. Composition, style, drawing, coloring—I do not want to defend anything."[83] Compared to this, the anonymous remarks of the *Moniteur universel* seem almost favorable: "There is soul, there are new ideas, a frank and bold execution in the *Sardanapalus*: it is Rubens, with his careless drawing, his warm and living color; but what great faults unite to balance against these qualities! Where are we? On what ground is the scene set? Where is this slave trying to take this horse? Such confusion in the foreground! Such an unintelligible mass of objects in the recesses! . . . Bizarre talent that seems to take pleasure in going wrong! Is it any wonder that only a few people find this painting sublime and that almost unanimously the spectators find it ridiculous? There is still time to put a stop to such a career; may M. Delacroix put a salutary brake on his picturesque and poetic imagination, make an effort to acquire a style, consent to draw, make his language equal to his thoughts—this is the desire and the hope of his true friends, who esteem him too much to flatter him."[84]

The blow was all the harder in that the other works that Delacroix had shown since autumn had been rather favorably received, especially *The Agony in the Garden* (fig. 47), *Justinian Drafting His Laws*, and *The Execution of the Doge Marino Faliero*. The first in particular had drawn attention. The idea

of Christ pushing away the angels (who are themselves frightened of the approaching Passion), with the apostles asleep at left, partly cut off, and, in the shadow, the soldiers preparing to arrest Jesus, renewed the traditional iconography. The frank and direct treatment also differed from that of the numerous church paintings commissioned for the Ville de Paris under the Restoration, which, at each Salon, made up most of the religious painting. Yet despite its fresh approach, *The Agony in the Garden* still evoked a more traditional, emotional response, like the work of Murillo, which was very popular at the time. The angels in particular captured the attention of the public and the critics. Louis Vitet, the influential *Globe* journalist,[85] while noting some faults, saw in the work the usual characteristics of the painter, "richness of imagination" and a "fortuitous originality." "It is a charming idea, a completely new idea, that tense and dolorous expression of the three angels who come to announce to their divine master his sad destiny. There is indefinable poetry in these three figures: it is truly inspired. What is especially unique to M. Delacroix, what refreshes this tired subject, is to have given the figures of these angels a less meridional character than the Italian painters, but without falling into the heavy and massive type that the Flemish generally give them: these three figures are almost Ossianic, they are altogether heavenly. . . . M. Delacroix has just proved by this attempt that he has not decided to dedicate his talent exclusively to the cult of the ugly and bizarre. We thank him in the name of art, of which he is doubtless destined to become one of the firmest pillars."[86] Delécluze, who saw in the angels "pretty English misses," recognized "real merit" in *The Agony in the Garden*. "The lines of the composition are simple and grand, and the effect very appropriate to the lugubrious scene that the artist has conceived."[87] *Justinian Drafting His Laws* and *The Execution of the Doge Marino Faliero* enjoyed a somewhat less favorable reception. The first of these (fig. 48), commissioned in 1826 for the third room of the Conseil d'Etat in the Louvre (that of the litigation department), is known only by sketches and the photograph taken in the Delacroix room at the Exposition Universelle of 1855 (fig. 216).[88] A work of very large dimensions (almost four meters high by almost three in breadth), *Justinian* was part of an ensemble of four portraits of legislators decorating the walls (the others were *Charlemagne Presenting His First Capitulars to the Assembly of France* by Ary Scheffer, Marigni's *Moses*, and *Numa Giving the*

Laws to the Romans by Cogniet), which appeared under a ceiling by Drolling *(Triumph of the Law)*. Delacroix, confronting a commission with such an official destination, nevertheless took some latitude in even the choice of subject. Even so, he attempted to be historically exact, as is particularly noticeable in the costume of the emperor. The canvas, executed between *Marino Faliero* and *Sardanapalus*, must have been extremely rich chromatically. "All the Bas-Empire is subsumed in the figure of *Justinian Drafting His Laws*; antique draperies were being succeeded by brocades studded with precious stones, the Asiatic luxury of Constantinople; something subtle and effeminate stole into imperial majesty," Gautier wrote in 1855. And Maxime Du Camp, at the same moment, added, "With all the knowledge of a jeweler in love with his stones, the painter has rendered the precious gems set in enameled gold; with unequaled care he has embroidered the imperial brocades and ornamented the neck of the tunic with precious stones: rubies, emeralds, sapphires, aquamarines, and turquoise, all imitated to the point of illusion."[89] The critics had indeed seen this aspect of the work in 1827, but found it insufficient to excuse what was judged to be a faulty and lax execution.[90] Color also played an important role in *The Execution of the Doge Marino Faliero* (fig. 49), which had already been shown to the public in an exhibition organized at the Galerie Lebrun in 1825 for the benefit of the Greeks. The subject came from Byron: "Marino Faliero, the doge of Venice, having conspired against the Republic at the age of eighty, was condemned to death by the Senate. Leading him to the stone stairway where the doges swore allegiance before taking office, they removed the doge's bonnet and the ducal mantle, and cut off his head. A member of the Council of Ten took the sword that had done the execution, and raising it in the air, said: Justice has punished the traitor. Immediately after the death of the doge, the doors were opened, and the people hurried to see the corpse of the unfortunate Marino Faliero (see the tragedy by Lord Byron)."[91] The painting enjoyed a certain success when it was first shown in public.[92] In it Delacroix demonstrated his usual qualities as a colorist, developed in a manner inspired by contemporary English painters: the work had been done shortly after his return from Great Britain at a time when he was close to Bonington. Bonington, who had been to Venice, perhaps furnished the sketch necessary to render the decoration of the Doges' palace with such accuracy and precision. Delacroix,

47. *The Agony in the Garden*, 1824–27
Exhibited at the Salon of 1827. Oil on canvas, 294 × 362 cm
Church of Saint-Paul-Saint-Louis, Paris

certainly conscious of this English influence, and always inter-
ested in making money, withdrew the picture from the Salon
to send it to London, where it was shown successfully at the
British Institute[93] (Thomas Lawrence even thought of buy-
ing it).[94] The very free treatment and the bold and inventive
composition that emphasizes the bright white emptiness of the
stairway at the center in a sense symbolizes the whole scene,
anticipating the boldness of *Sardanapalus*. It is not surprising
that Delécluze attacked it: "*The Execution of the Doge Marino
Faliero* of M. Delacroix is arranged in a manner that is pictur-

esque but not historical, or, if you prefer, poetic. What receives
all the light, and consequently draws the eye exclusively, is the
stairway of the palace. This artifice, which works very well in
an *interior* of M. Granet, is misplaced in a subject of the sort that
M. Delacroix has chosen. This *painting* is thus only a brilliant
sketch, either because of the fault I have pointed out, or because
of the *laisser-aller* of the drawing and the libertinism of the
brush that reigns here."[95] When Vitet saw the painting at
the benefit exhibition, he was also shocked by the treatment of
the figures, by the realism, or, rather, the lack of idealization.[96]

48. Sketch for *Justinian Drafting His Laws*, 1826
Sketch for the painting exhibited at the Salon of 1827–28 and
destroyed in 1871 in the fire at the Palais d'Orsay, seat of the Conseil d'Etat
Oil on canvas, 55 × 45.5 cm
Musée des Arts Décoratifs, Paris

49. *The Execution of the Doge Marino Faliero*, 1826
Exhibited at the Salon of 1827–28. Oil on canvas, 146.4 × 114.3 cm
The Wallace Collection, London

In many respects, *Marino Faliero* is thus emblematic of Delacroix's most romantic period: in its subject, its treatment, its reception, its fate (it stayed unsold for a long time in the studio before being purchased for a rather high price in 1856). It is perhaps for this reason, in memory of his youth, that Delacroix had a fondness for it, if one is to believe Lassalle-Bordes.[97] However that may be, *Marino Faliero* did no more to reinforce the position of the artist than the other works exhibited at the beginning of the 1827–28 Salon. And it disappeared with them in the tempest brought on by *Sardanapalus*.

Toward the end of his life, Delacroix himself made an assessment of this disaster. "The salons of painting were not annual as they are now. For an ardent and militant man such as I was, it was a great misfortune. I was at the age of vigor and daring and I should have had some minister as bold as I was to take my part, that is, to make me make great works and give me occasions to exhibit them often. The opposite happened. . . . I had had some success at this Salon, which had lasted, I think, six months. That piece [*Sardanapalus*], which arrived last, and which seemed eccentric, aroused indignation,

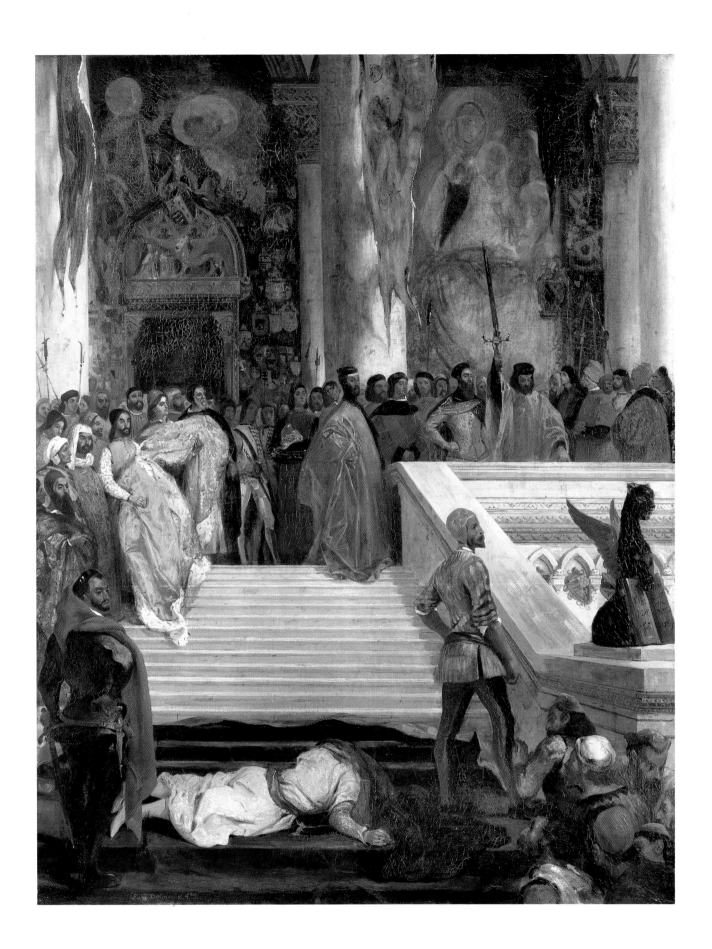

real or pretended, among my friends and my enemies. I became the abomination of painting. No bread or water for me. M. Sosthène de La Rochefoucauld, who was then in charge of Beaux-Arts, called me in one day; and I was thinking, with this invitation, that he was going to give me some good news or at least commission a painting! I enter: like an amiable man, for I have to do him justice—he went about this task gently and as well as he could, for he had no facility to make me understand that I could not possibly be in the right against all the world, and that if I wanted to have a share in the favors of the government, I had better change my manner of painting. At this denouement, I stopped him short by saying that I could not prevent myself from having my own opinion even if the earth and stars were on the other side; and as he was getting ready to attack me with reasoning, I made a great bow and left his cabinet, leaving him more disconcerted than I was. On the contrary, I was enchanted with myself, and from that moment on my *Sardanapalus* seemed to me very superior to what I had thought. The result of this action was deplorable: no more pictures bought, no more commissions for more than five years. . . . You can judge what that meant to me, without speaking of the question of money, such unemployment at a time when I felt capable of covering a whole city with paintings. Not that it cooled my ardor; but I lost a great deal of time on little things, and it was most precious time."[98]

Delacroix dramatizes a bit. It is true that *Sardanapalus* was not bought by the state, as were his previous entries. Sold to the banker John Wilson in 1846, it went to various private collections before finally being sold to the Louvre in 1921 (a first attempt to acquire it, initiated by Thiers, failed in 1873). The painting had very rarely been publicly exhibited before this, not being included either in the Exposition Universelle of 1855 or in the posthumous exhibition of 1864. But the painter was not, as he said, completely eliminated from ministerial favor, since La Rochefoucauld commissioned from him, in August 1828, *The Battle of Nancy* for the Musée des Beaux-Arts of that city. There were also paintings for various members of the royal family, the Duchess de Berry and the Duke d'Orléans, the future Louis-Philippe. Should one further stress this "losing time on little things?" Here again the memories of the painter are biased. At the moment of writing, Delacroix had already done most of his great decorative works, his principal occupation during the second part of his career, after his voyage to Morocco. Why these retrospective regrets about not having obtained these commissions until only a few years after *Sardanapalus*? Useless regrets, in truth, for commissions were practically nonexistent under the Restoration. The years after the Salon of 1827 were in fact far from nonproductive: these are the years of *The Murder of the Bishop of Liège*, of *The Battle of Poitiers*, of *Cardinal Richelieu Saying Mass*, and many paintings of small format. Why then the disenchantment? Perhaps because for the first time the hostility was general, and raised some doubt in Delacroix himself. Perhaps also because *Sardanapalus*, eclipsing his other paintings, symbolized the misunderstanding between the painter, in full possession of his abilities after five years into his career, and a public that only saw in him the most confirmed representative of Romanticism. In spite of everything, Delacroix never repudiated the painting, even making a replica to keep when he finally sold it. Baudelaire only saw it thirty years later, when it was shown at the Galerie Martinet in 1861–62. A generation had passed. But *Sardanapalus* had lost none of its force or magic. On the contrary; they became clearer with time, as Baudelaire writes: "My dreams are often filled with the magnificent forms that move in this vast painting, marvelous as a dream itself. *Sardanapalus* seen again, is youth recaptured. At what a distance back in time does the contemplation of this painting put us! . . . Did ever any painted figure give such a vast idea of the Asiatic despot as this Sardanapalus with his braided black beard, who dies on his pyre, draped in his muslins, in a feminine pose? And all this harem of such brilliant beauty, who could paint it today with such fire, such freshness, such poetic enthusiasm? And all this *sardanapalesque* luxury that shines in the furnishings, in the clothing, in the harness, in the vessels and the jewelry, who? who?"[99]

50. *Two English Farm Horses,* c. 1825
Exhibited at the Salon of 1827–28. Oil on panel, 40.5 × 63.5 cm
Galerie Brame et Lorenceau, Paris

51. *A Mortally Wounded Brigand Quenches His Thirst,* c. 1825
Exhibited at the Salon of 1827–28. Oil on canvas, 32.5 × 40.7 cm
Öffentliche Kunstsammlung, Kunstmuseum Basel

CHAPTER THREE

The Romantic Artist

I found myself, and I still find myself, in a singular position," Delacroix wrote at the end of his life. "Most of those who have taken my part in general were only taking their own in particular; and, fighting for their ideas, if they happened to have any, they turned me into a kind of flag. They enlisted me, willing or not, in the romantic coterie, which means that I was responsible for their idiocies, which greatly added, in people's opinion, to the list of those that I was able to commit myself. I pulled myself out of that with a great moderation in my desires, and by extreme confidence in myself; confidence that is the talisman of youth and that age tends to weaken. By confidence I do not mean blind presumption, which is a ridiculous thing in some talented people, even estimable ones; I never had an exaggerated esteem for what I did; I always saw the faults more clearly than the harshest judges, but I was persuaded that these people did not see the good that was in it."[1] Delacroix never claimed the label "romantic," which he judged too reductive, incapable of expressing the aspect of his work that was profoundly classic, that is, permanent and, to again use his own terms, satisfying to the spirit, "not only by a depiction of feelings and things that is accurate or grandiose or exciting, but rather by unity, logical order—in a word, by all those qualities that augment the impression while bringing simplicity [en amenant la simplicité]."[2] But did he find this expressive naturalness from the beginning? Did he stay as much at the edge of the romantic movement as he implied when he was older? To his contemporaries, he was, on the contrary, in the avant-garde. As Gautier recalled, assembling his memoirs like an old warrior in 1855, "The tail of the Davidian school was then dragging its last coils in the academic dust, and its paintings were nothing but feeble copies of Greek or Roman bas-reliefs. Thus, when The Barque of Dante and the Massacres of Chios appeared, eyes that were accustomed to crepuscular colors were extraordinarily offended by this bold intensity and this superb brilliance. They let out cries like an owl in sunlight, and the most comical outbursts had free rein: art was lost, there were no more sound traditions, the barbarians were at the gates. . . . However, the blow hit home, and each Salon saw fewer paintings of Orestes in the clutches of the Furies, Ajax insulting the gods, Priam appealing to Achilles. Shakespeare, Goethe, Byron, Walter Scott, and the legends of the Middle Ages furnished new themes for the audacious painter who shook off the yoke of the School and listened only to his genius.

No artist more hotheaded, more frenzied, more passionate, ever reproduced the anxieties and aspirations of his time: he shared all its fevers, all its exaltations, and all its despair: the spirit of the nineteenth century throbbed in him and still throbs. You will find in the least of his canvases the reflection of that uncertain flame that formerly burned within us: extinguished, alas! in many, it is in him still living and brilliant."[3]

Delacroix's isolation within the artistic movement of his time became more and more noticeable in the mid 1830s. In his youth it was less so. His personality was then still malleable, ready to assimilate the most diverse influences and adapt itself to the changing conditions of the artistic life in Paris. He certainly found his path: his successive entries in the Salon prove his growing self-assurance. But he was in truth never very close to his contemporaries. Was his career simply a conjunction between his strictly personal evolution and a more general dynamic? Insisting on the clearly marked individualistic side of Delacroix's personality need not prevent our admitting that he could be flexible and that he did react to the milieu in which he worked. In 1831, he sent to the Salon The Young Raphael Meditating in His Studio,[4] Tam o' Shanter, and Cromwell at Windsor Castle; the first painting must have been a deliberate attempt to compete with Ingres, the second with the Vernet of Mazeppa, and the last with Delaroche. Delaroche's Cromwell Contemplating the Cadaver of Charles the First was shown at this same Salon—Delacroix, after a discussion with Paul Huet, did a watercolor on the same subject as this highly controversial painting, attempting to correct its faults.[5] Although Delacroix developed during these years in an increasingly independent vein, he still was never very far from the young school of rebels against Neoclassicism; and it is the equilibrium between the common taste and fashion on the one hand and his special inspiration and feeling on the other—the tension between the group and the individual—that best sums up and characterizes his ideas and his personality, and finally, his contribution to Romanticism.

The relationships that he had during this time with Great Britain, like many artists of his generation, are representative from this point of view.[6] He was then quite close to Bonington, as we have seen, and also to the Fielding brothers, Thalès, Copley, and Newton, watercolorists, painters, engravers, and lithographers, among the most active in the Anglo-French connection that grew on both sides of the Channel. But his

52. *View of London from Greenwich*, 1825
Sheet from the album used by Delacroix during his sojourn in Great Britain.
Watercolor on paper, 14.3 × 23.4 cm
Musée du Louvre, Département des Arts Graphiques, Paris

knowledge of British painting was hardly different from that of the Parisian artistic milieu before his trip to London in 1825. It was based for the most part on innumerable interpretative prints of English paintings, increasingly successful in France, and on the very few works of small format shown in the Salon of 1824—works that had been brought back from England and circulated in the studios—and, finally, watercolors, which were also very much in style. His British friendships, however, and the very Anglophile milieus in which he developed, influenced him more than his contemporaries. To admire the painting from across the Channel was then an act of independence. The work of Lawrence and Constable, David Wilkie and John Martin, in the eyes of the young French painters, represented not so much a model as a path to follow, a breath of air for a School enclosed in overly rigid principles. Delacroix was perfectly aware of it. "Never has a nation seemed more wary of taste," he wrote of the French in 1829 in the notes he made for his article on art criticism ("Des critiques en matière d'art") for *La Revue de Paris*. "Imagine the invasion of the Salon of 1806 by a portrait by Sir Thomas Lawrence. It was hard to digest even in 1824."[7]

The trip that Delacroix made to England during the summer of 1825 allowed him to learn the country directly and to increase his familiarity with British art. Even in principle, this sojourn of several weeks ties him to Romanticism. For his first voyage outside of France, he chose Great Britain over Italy, where young artists traditionally went to complete their formation. It is true that it was easier to cross the Channel than the Alps, easier to go to London than to Venice or Rome, to remove oneself from Paris for a shorter time. He could have reasonably thought that nothing would prevent his going later to make the Italian tour that he had always dreamed of making, as his correspondence makes clear, but he never found either the time or the means, or finally perhaps the true need or the simple will to do it. He decided for the North. Doing this, he turned to the future in preferring the contemporary painters, with their audacity and their quests, to the old masters, as exemplary as they were (and God knows that he revered them), and in electing the metropolis of a country teeming with activity as opposed to the sleeping remains of a glorious past. He rejected nothing that preceded him, but he wanted above all to be an artist of his time whose work reflected contemporary life most fully. This perspective, however, was not peculiar to him. With some variations, including the trip to England, it was shared by most of the young Romantic painters under the Restoration, beginning with the first and most

53. *Two Studies of Armor and Caparison,* 1825
Pencil on paper, 19 × 27.6 cm
Musée du Louvre, Département des Arts Graphiques, Paris

illustrious of them, Géricault, in all probability an example consciously followed by his admirer, Delacroix.

His sojourn lasted three months, from the end of May until August in 1825. He profited from the help of the Fielding brothers, who arranged lodgings for him, and from his friendship with Bonington, who brought him into contact with other French artists there: Poterlet, Enfantin, Eugène Isabey. Thirty years later, Delacroix was to recall for Silvestre, who had questioned him on the subject, this atmosphere, where the group's common work and shared emotions added to the pleasure of discovery: "For the rest, what you are asking is what I take the most pleasure in doing. The period of my life when I saw England and the memory of some friends from then is very sweet to me. Almost all of them are gone. Among the English artists who were good enough to welcome me—all with the greatest kindness, for I was then almost unknown—I think only one is left. Wilkie, Lawrence, the Fieldings, great artists, one especially, *Copley,* in landscape and watercolor. Etty, who died, I think, recently, was very good to me. Not to speak of Bonington, also dead in his prime, who was my comrade, and with whom—as well as with Poterlet, who also died prematurely, a great loss to painting (this one was French)—I spent my life in London in the midst of the enchantments that gave an ardent young man in that country the combination of a thousand masterpieces and the spectacle of an extraordinary civilization."[8] The letters that he wrote from there to his friends in Paris give us more information about his activities.[9] From the beginning of his trip he had been struck by the immense size of London, as well as its luxury, and by the beauty of the banks of the Thames, which he took pleasure in drawing (fig. 52).[10] He ended up appreciating the luminosity and the sun "of a special kind. It is continually a day of eclipse,"[11] he noted, and he understood better through this the specific genre of the English watercolor landscape, of which his friend Soulier had given him an example. "The horses, the carriages, the sidewalks, the parks, the Thames, the boats on the Thames, the borders of the Thames, Richmond and Greenwich, the ships, all that would require volumes of letters and we will talk about it at leisure," he wrote at the beginning of his stay. "This country was just right for your talent. Italy has caused disorder in your shop. I continually find skies, shores, all the effects that come back again and again under your brush."[12] In London, Delacroix, also discovered the English theater, and deepened his knowledge of Shakespeare by attending performances of *Richard III* (with the celebrated Kean in the title role), *The Tempest,* and *Othello.* He did not limit himself to the

54. *Two Studies of a Figure in Greek Costume*
(front and side views), c. 1824–25
Oil on canvas, 35.2 × 46.4 cm. Musée du Louvre, Paris

one playwright, but also saw a show in the manner of Franconi, *The Invasion of Russia by Napoleon*, a theatrical adaptation of Goethe's *Faust*, and, in music, Weber's *Der Freischütz*, in a more complete version than the one that had been done in Paris. In a completely different domain, he was also able to satisfy his taste for things maritime, embarking on an expedition by yacht on the Thames and along the coasts of Essex. But his activities were not all frivolous. He made various sketches for studies, in particular, with Bonington, of the arms conserved in the celebrated collection of Dr. Meyrick (fig. 53). He also visited the permanent exhibition of the paintings of Benjamin West—then one of the best-known English history painters—no doubt the Royal Academy and other exhibits of the kind, and the various studios of artists whom he knew only by reputation.[13] He was received in a friendly way by Etty and Lawrence, to whom he had a letter of introduction, and by Wilkie, whose sketch of *The Preaching of John Knox* he admired, worrying in advance that he would ruin it in the painting. Nothing indicates that he met Constable, to whom his Parisian dealer, Claude Schroth, had recommended him. It is perhaps on this occasion that he acquired one of Constable's sketchbooks, which he himself used afterwards.[14]

The three months spent in Great Britain caused no abrupt changes in Delacroix, nor did they bring about a profound renewal of inspiration. His sensitivity to the Middle Ages and the knowledge he had of it were doubtless deepened, as well as his taste for English literature. But the increased familiarity with contemporary British painting that resulted from this visit was of much greater consequence. Without being blind to the weaknesses and extravagance of the British artists, he appreciated their suppleness, their facility, elegance, and lightness,[15] all of which seemed to him to be lacking in most of his compatriots. These same characteristics are found in his works that are most clearly marked by the English example—those executed in the last years of the Restoration under the influence of the painters whom he had discovered during the spring and summer of 1825. These included Wilkie and Lawrence in addition to those whom he already knew: his watercolorist friends, Bonington, Copley and Thalès Fielding, and especially Constable, an "admirable man," a "veritable reformer," risen "from the rut of former landscapists."[16] Let us note in passing that Turner, whose importance Delacroix would emphasize much later,[17] is not among those artists whom he attempted to meet in England nor among those whom he took as models. The two painters saw each other later in Paris, when Delacroix returned from Morocco and Turner was doing his preliminary

sketches for the illustrations of Scott's *Life of Napoleon*.[18] "He made a mediocre impression on me: he looked like an English farmer, black suit, rather vulgar, big shoes and a hard, cold expression."[19] This was Delacroix's only recollection of that meeting. Like almost all the French of his time, he knew Turner's work really only through prints, and thus had not been able to appreciate it. And Delacroix's painting, especially, had not been influenced by Turner as it was by Constable as early as 1824 in the *Massacres of Chios*, by Lawrence mostly after 1825, and by Bonington throughout all these years.

The example of Thomas Lawrence is the most instructive, for among the British painters it was he who most directly inspired Delacroix. The French painter could have seen Lawrence's work in the Salon of 1824, when the portrait bust of the Duc de Richelieu was displayed (today it is in the Chancellery of the Universities of Paris), and he knew the superb mezzotint engrav-

ings that had popularized the rest of his work. Delacroix was able to study him more closely in London, where Lawrence had received him "very graciously." His admiration for Lawrence, whom he considered an extraordinary portraitist, was then strengthened. He was able to develop this idea a little later in an article he wrote for *La Revue de Paris* on the occasion of the publication in France of the engraving that Samuel Cousins had prepared from Lawrence's *Portrait of Pius VII*, intended for Windsor Castle:[20] "Thanks to Sir Thomas Lawrence and several French painters whose works have appeared brilliantly at our exhibitions, the time has passed when one could seriously ask whether there are painters in England, as one asked some time ago whether there was theater. Many people in France hardly know the name of Reynolds, no more than they would have dared to pronounce the name of Shakespeare eighty years ago. People are hardly aware that while painting was languishing in all of Europe,

55. *Eugène Berny d'Ouville*, 1828
Oil on canvas, 64 × 52 cm (image 61.6 × 50.5 cm)
Philadelphia Museum of Art

56. *Portrait of Louis-Auguste Schwiter*,
1826

Lithograph (single state), 21.9 × 19.4 cm
Bibliothèque Nationale de France, Département
des Estampes et de la Photographie, Paris

57. *Portrait of Charles de Verninac*,
c. 1829

Oil on canvas, 61.2 × 50.2 cm
Private collection

58. *Portrait of Louis-Auguste Schwiter*, 1826–?, 1830
Rejected by the Salon of 1827–28. Oil on canvas, 218 × 143.5 cm
The National Gallery, London

dragging herself along, exhausted and dishonored, on the track of Vanloo and a few geniuses of the same force, a real genius, Reynolds, continued the tradition of the great masters in England. And, it must be said, despite a profound respect for our national glory, he continued it in a manner that has not been surpassed by all that has been done since. Lawrence succeeded to the reputation of Reynolds, his teacher, and, imbued with his traditions, is nonetheless full of originality. In his portrait of Pius VII, as in his best works, one sees that special talent which he is perhaps alone in having to such a high degree, that of rendering in a striking manner the age, the complexion, all the habits of his models. . . . Sir Thomas, who with his immense talent, can do without intrigue, is no less a polite courtier than a great painter. His personages no doubt take from him the noble air and distinguished mien that he knows how to give almost everyone. His talent exudes the uplifting habits of the aristocracy and his familiarity with them. What is most surprising is how he manages so many things; for, despite the apparent facility of his manner, nothing is more conscientious than his work. . . . His paintings, which one would take for improvisations, so vivacious is his touch, are studied with great care, even to scrupulousness, in the imitation of certain characteristic traits; and it is there truly that he excels, and no one has equaled him."[21] Thirty years later, Delacroix's opinion had not fundamentally changed: "My impressions of that period would perhaps be a little modified today [in 1858]. Perhaps I would find in Lawrence an exaggeration of effect that is a bit too reminiscent of the school of Reynolds. But his prodigiously fine drawing, the life he imparts to his women, who seem to be speaking to you, make him a portrait painter superior to Van Dyck himself, whose admirable figures pose tranquilly. The shining eyes, the half-open mouths are admirably caught by Lawrence."[22] Delacroix, however, goes beyond professional considerations. In making open references to Shakespeare, he takes up one of the favorite themes of criticism, the similarity of the English painters to the French Romantics, which had cost him dearly at the Salons of 1824 and 1827. He clearly chooses his camp, and all the more in that the influence of Lawrence becomes patently clear in his activity as a portraitist.

Delacroix did portraits all his life, but it was actually about 1830 that he did most of his work in this genre, and he seems to have put into practice the characteristics that he found in the work of his English model. In the two bust portraits of Charles de Verninac (figs. 6 and 57), the sketchiness of the background and the clothes, brushed large, emphasizes by contrast the more carefully worked face; the model's elegance finds its equivalent in the fluidity of the brush and the subtle agreement of colors. The same is true in the series of portraits commissioned by his former schoolmate at the Lycée Napoléon, Prosper Parfait Goubaux, who in 1820 had founded a private secondary school, the Institution Saint-Victor, which later became Chaptal College. He asked Delacroix to paint each of his student laureates in the *Concours général*. There were ten of them from 1824 to 1834, a series differentiating itself, by virtue of its having been commissioned, from the rest of Delacroix's portraits, which were usually of his intimates and those near to him. Hung in the salon of the school, doubtless until Goubaux's death in 1859, these portraits were afterward dispersed, and some have since disappeared. Those that have been conserved carry an almost palpable mark of Lawrence in the fluidity of their treatment and the expressiveness of the models, shown with evident sympathy (fig. 55).

In the great *Portrait of Louis-Auguste Schwiter* (fig. 58), Delacroix carried even farther his imitation of the English painters who inspired him—Gainsborough, Reynolds, and Lawrence. Schwiter, himself a portraitist, a relative of Pierret from a very good family, was a friend of Delacroix, who no doubt partly projected himself into the image of the elegant and fashionable dandy. Painted for the most part in 1826, rejected by the Salon jury in 1827 (probably because of the noticeably faulty perspective of the balustrade), and then reworked, this monumental portrait is the only full-length one that Delacroix ever did, and by its dimensions, its genre, and its style, it takes on the quality of a manifesto. The placement of the figure, the noble and restrained attitude of the model, the costly luxury apparent in the clothing, and the richness of the discreet vase of flowers combine to make this a very formal portrait. But the formality has a more relaxed, intimate side, felt in the twigs negligently fallen in the foreground and the great landscape behind, perhaps done with the help of Paul Huet. This formal success, then very new to French painting, was to remain unique for Delacroix; it had no direct follow-up, unless perhaps an echo in the lithograph of the same subject, where Schwiter is shown in the manner of an unfinished sketch, characteristic of the Romantic print (fig. 56).

59. *Still Life with Lobsters*, 1826–27
Exhibited at the Salon of 1827–28.
Oil on canvas, 80.5 × 106.5 cm
Musée du Louvre, Paris

Delacroix went back to the bust portrait (except for *Count de Mornay's Apartment* and the unfinished *George Sand and Chopin*). Not until *Talma* and *Alfred Bruyas*, would the English influence be less visible.

It is equally evident in another unique attempt, the *Still Life with Lobsters* (fig. 59) of 1826–27, done for one of Delacroix's relatives, General Coëtlosquet (Delacroix had stayed with him in the summer of 1826, in his château at Beffes in Cher). Equally original in conception and virtuoso in execution, it was, however, hardly noticed at the Salon, eclipsed as it was by his history paintings. It is, nonetheless, a striking work: the picture of the hunt, which occupies most of the space, lets us see a landscape visibly inspired by Constable, where a few hunters in red coats enhance great trails of ochers, yellows, beiges, greens, and blues. The same color contrasts come out in the foreground, in the warm red of the pheasant,

the lobsters, and the Scotch plaid against the browns and blacks of the rabbit, the game bag, and the gun. The little green lizard adds a humorous note as well as a complement to the red, as Lee Johnson has pointed out. The quite visible brush stroke and the smooth and varnished look of certain parts of the picture recall the "English manner" as it was then understood, and the subject itself invokes indirectly the anglophilia of the aristocratic milieus of this epoch. It is possible that the *Still Life with Lobsters*, from this point of view, contains allusions that are less apparent but still real. Lee Johnson thus relates the lobsters, which are after all incongruous in this hunting scene, to the one painted by Wilkie in the foreground of his *Chelsea Pensioners Reading the Gazette of the Battle of Waterloo*, one of his best-known works, much admired by Géricault and which Delacroix could have seen in London in 1825.[23] Nancy Ann Finlay calls attention to the lithograph

60. *Charles VI and Odette de Champdivers,* 1825?
Oil on canvas, 35.5 × 27.5 cm
Courtesy Matthiesen Fine Art, Ltd., London

61. *Louis d'Orléans Showing His Mistress,* 1825–26
Oil on canvas, 35.2 × 26.8 cm
Thyssen-Bornemisza Collection, Madrid

caricatures that Delacroix did in 1820–22, especially *Lobsters at Longchamp*: the lobsters that are trailing behind are associated with the legitimist movement to which the man who commissioned the picture belonged.[24] Without going too far into the real or supposed references and intentions of Delacroix, one can emphasize that both the subject and the techniques of this painting synthesize, like the portraits of the same period, the English influence that was then so strong in his work, including places where one might not a priori expect it. Some annotations on a study sheet for *Mirabeau Confronts the Marquis de Dreux-Brézé* are revelatory: "borrow the engravings of Trumbull and West—the young Moreau—portraits of Reynolds at Dittmer's—ask Mlle Sophie for the English caricatures—id., at the library."[25] To compose a big contemporary historical scene, Delacroix thus sought his models across the Channel

(and even across the Atlantic) in two artists, West and Trumbull, who had painted this kind of subject, nearly absent among the French. As to Reynolds or the collections of caricaturists (which Delacroix could consult, as he indicates, at the Cabinet des Estampes in the Bibliothèque Nationale—one thinks of Gillray and Rowlandson), wouldn't they have given him the modern character that he sought above all else?

This is where the work done in common with Bonington about 1825 is important: imitation or emulation between the two artists is as valuable for style as it is for subject. Delacroix studied the very special execution of his comrade, trying for the smooth effects and near-transparency of watercolor, particularly by using varnish made with copal, the recipe for which he lost, to his regret, after the death of Bonington. But these trials did not stop with technique alone: many themes

are common to the two men, without our being able to deter-
mine exactly from whom they come, thus demonstrating an
identity of interests characteristic of their similar sensibilities.
The drawings made at Meyrick's, in London, are not the only
examples. Other examples are the studies of Greek costumes
done in Paris during the winter of 1825–26 at the home of
their friend Monsieur Auguste or that of the Count of Pala-
tiano, a descendant of a great family of Corfu, who was then
staying in Paris.[26] The count posed for Delacroix and Boning-
ton in the costume of the Greek independence fighters, both
artists later doing his portrait (Delacroix's, shown at the Salon
of 1827, is lost today). The studies of Suliot costumes that
Delacroix left (fig. 54) are exactly comparable to Bonington's,
so much so that for a long time a painting in the Cleveland
Museum of Art, now attributed to Bonington, was thought to
be the *Portrait of Count Demetrius de Palatiano in Suliot Cos-
tume* of the Salon.[27] There are other examples of identical
subjects treated at the same time and in the same orientalizing
vein by both of them, for instance the *Turk Seated on a Sofa
Smoking*.[28] But the similarity really extends to a great part of
Delacroix's work during the two or three years that followed
his return from London.

During this time, he painted a series of small formats,
close to Bonington in style and especially in the conception of
the subjects: he sees history from the point of view of the
diverting episode, gallant or simply picturesque, no longer as
demonstrating exemplary virtue or heroic models. Thus he
represents Henri III at the deathbed of his favorite mistress,
Marie de Clèves, or Henri IV courting Gabrielle d'Estrées.[29]
The lives of these two sovereigns inspired numerous paint-
ings at the time, both in Romantic circles and among artists
who seemed removed from the new trend, particularly Ingres.
This was the "anecdotal genre" or "historical genre," less ele-
vated than traditional history painting, illustrating episodes of
the Middle Ages and Renaissance. This genre offered a seduc-
tive alternative to the "grand siècle" and classical antiquity and
was then in full swing. It was a natural part of the more gen-
eral movement toward the rediscovery of the medieval past
that flowered under the Restoration.[30] Delacroix participated
fully, going to London or Normandy or the Bibliothèque
Royale to find studies that would be useful in his compositions
for painting a true-to-life setting, an authentic costume, a
good likeness—a proceeding common among his comrades,

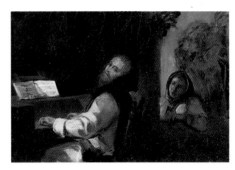

62. *Charles V at the Monastery of Yuste,* 1833
Lithograph (second state of two, after letter), 11.5 × 14.8 cm
Bibliothèque Nationale de France, Département des Estampes et de la
Photographie, Paris

63. *Charles V at the Monastery of Yuste,* 1837
Oil on canvas, 18 × 26 cm. Musée Nationale Eugène Delacroix, Paris

64. *Rabelais,* 1833
Exhibited at the Salon of 1834. Oil on canvas, 186 × 138 cm
Musée des Etats Généraux, Chinon

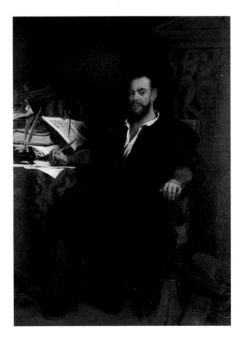

particularly Bonington, with whom he was in direct rivalry. There is thus nothing astonishing in the fact that their work is sometimes extremely similar from the time that their friendship became intimate, about 1824, until 1828 when Bonington died. The relationship is evident in certain subjects, in certain stylistic traits, in composition, and in the imitation of watercolor technique that Delacroix frequently used during this period after the fashion of his British friends. It is also evident in the spirit in which he approaches the small historical paintings of the years 1825–30. This is seen in *Charles VI and Odette de Champdivers* (fig. 60) and *Louis d'Orléans Showing His Mistress* (fig. 61). Charles VI, the mad king, could only be calmed by a few persons, among them his mistress, Odette de Champdivers. This is what Delacroix represents here, showing the servants of the king taking away his sword while he is seeking approbation or comfort from his companion. The subject of *Louis d'Orléans* is found in a work then fashionable by Barante, the *History of the Dukes of Burgundy*, and also in Brantôme's *Lives of Gallant Ladies*, more likely the direct source for the painting. The duke is showing his old chamberlain the nude body of his mistress, who is none other than the latter's wife, but leaves her face hidden. The history of France is summed up in these two paintings as intimate anecdote and picturesque story. This relatively reductive conception is surprising at first in the painter of *Massacres of Chios*, which came only shortly before *Charles VI* and *Louis d'Orléans*. But such a view does not take into full account Delacroix's intentions. These paintings were not meant for the Salon, but for private collections. This explains the facile subjects (he also painted before 1827 a *Charles VII and Agnès Sorel*)[31] and especially the exceptional richness of material and of colors, an extraordinary virtuosity of touch particularly noticeable in *Charles VI*. Delacroix knew how to please, and one cannot help thinking that the commercial appeal of this type of picture was not totally absent from his mind. Buyers existed: the artist, always lacking money and anxious to make a living, did not let the occasion go by, and many of the small format paintings that he did at this period found buyers almost immediately. The "historical genre" was, even so, in line with his own profound tendencies, first because it had ties to literature, which he loved, and in which he found most of his inspiration at this time. But this re-creation of the past was also a way of making it more present and less abstract: the individual matters, and during the

centuries the painter and the spectator identify with him more easily. This is, indeed, what is demonstrated by the painting sent to the Salon in 1833, *Charles V at the Monastery of Yuste*. Shown life-size, the emperor, who has retired after his abdication to live among the monks whose habit he wears, is playing the organ. A young novice at his right listens reverently. Lost, but known through a lithograph by Delacroix himself (fig. 62), the picture invited meditation on the destiny of a former sovereign and, ultimately, on the reality of the greatness of the world. This theme no doubt pleased Delacroix, since he took it up two more times in a smaller format (fig. 63). The melancholy that distinguishes the picture is not at all artificial; it expresses a wholly personal and original emotion. There are, finally, no minor subjects for Delacroix, but rather different means according to the genre, the meaning, and the destination of the work.

At this period, Delacroix found inspiration more frequently in literature than in history, and the subjects that he treated were for the most part a reflection of his reading. However, if he thus placed himself within the traditional framework of history painting and of *ut pictura poesis*, he gave a profoundly different and new version of it by his choice of subject. He used the moderns and his contemporaries rather than the classics, which he knew and loved, deliberately breaking with established tradition. The two writers whom he represented at this epoch were the blind Milton dictating *Paradise Lost* to his daughters and, five years later, *Rabelais* (fig. 64), both of them among the favorite authors of the Romantics.[32] Delacroix never again took any subject from either of them. But these two paintings are nevertheless very suggestive: they testify to the literary taste of the younger generation, defended by Hugo in the *Preface to Cromwell*, which the relatively brutal and vulgar execution of the *Rabelais* expresses in its own way, as Lee Johnson has suggested. Delacroix's originality is all the more evident in that he almost always chose foreign authors. He only occasionally chose French authors, first Chateaubriand, then Hugo, George Sand, and Alexandre Dumas. During the years that concern us here, only Chateaubriand furnished the subject of a painting, important but isolated, *The Natchez* (fig. 65). Delacroix began the painting in 1823 (the idea is noted in the *Journal* in October 1822), but abandoned it when nearly finished for the *Massacres of Chios*. *The Natchez* was taken up and completed at a later date, probably just before it

65. *The Natchez*, 1823–?, 1835
Exhibited at the Salon of 1835.
Oil on canvas, 90.2 × 117 cm
The Metropolitan Museum of Art, New York

was sent to the Salon of 1835.[33] The subject comes from *Atala*, as the Salon booklet indicates: "Fleeing the massacre of their tribe, two young savages go up the Meschacébé Mississippi. During the voyage, the young woman is overtaken by labor pains. The moment is the one where the father holds the newborn in his arms, both of them looking at it tenderly." One must not confuse the characters, nameless in Chateaubriand, with Atala and Chactas, who are the subject of Girodet's famous painting *The Funeral of Atala* (1808), with which Delacroix perhaps wanted to compete on new and different terms. The composition is overall very classical, the central group composed in balanced fashion. But the expressiveness of *The Natchez* depends less on the two principal personages than on the surroundings in which they find themselves. Victor Shoelcher emphasized this in connection with the Salon of 1835: "Nothing is sadder than this immense savannah, through which the river flows slowly and without a murmur; nothing more melancholy than this calm of nature, this air of solitude in which the two living, loving, suffering beings fleeing persecution find themselves," the sadness foreshadowing

the imminent drama of the baby's coming death.[34] *The Natchez* remained without follow-up: Delacroix did not illustrate Chateaubriand again, and completely ignored the young French Romantics in favor of their models or their foreign contemporaries, for the most part German or English.

Four names stand out: Shakespeare, Goethe, Byron, and Scott, because of the importance of the many works they inspired, and also because of what they represented for Delacroix. Shakespeare, whose writing he knew well and admired, and who enjoyed enormous popularity in the circles that Delacroix frequented, furnished at this time the subjects for only a few compositions, one of which is remarkable, the lithograph of *Macbeth and the Witches* (fig. 66), where the dramatic effect is achieved by the work of counterpoint—Delacroix made his whites stand out by using fine scratches on black color uniformly applied in an earlier stage. The vapors of the magic cauldron spread to the upper part of the sheet, encircling Macbeth's figure in a halo, while the three witches, like phantoms, melt into obscurity. Delacroix took up the subject again in oil, directly following a print,[35] and also painted *Desdemona and Emilia*, *King Lear*, *Hamlet Sees the Ghost of His Father*,[36] and *The Capulet Ball*, left unfinished.[37] But Shakespeare only became a favorite source later, toward the middle of the 1830s. In the ten years that preceded, Delacroix definitely preferred Goethe, Byron, and Scott.

Goethe's *Faust* furnished the material for one of the masterpieces of this period—one of Delacroix's most characteristic works—the series of lithographs published in 1828.[38] In 1824, Delacroix had thought of "making compositions" after *Götz von Berlichingen*, a drama by Goethe, which he did not, in fact, approach until later.[39] He finally decided on *Faust*, not through reading the work but through the intermediary of other illustrations and especially a dramatic adaptation that he had seen in London. "I only knew the *Second Faust*," he told Burty in 1862, "and very superficially, until long after my

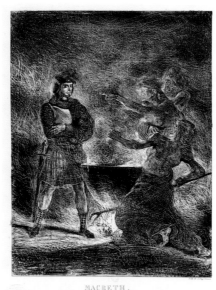

66. *Macbeth and the Witches*, 1825
Lithograph (second state of five, with Engelmann address), 35 × 32.5 cm
Bibliothèque Nationale de France, Département des Estampes et de la Photographie, Paris

plates were made. It seemed to me a poorly digested work and not very interesting from the literary point of view, but one of those that is most appropriate for inspiring a painter, by virtue of the mixture of characters and styles that it includes. If the work had been more popular, I would perhaps have read it. You ask me what gave birth to the idea of the plates on *Faust*. I remember that I saw, about 1821, the compositions of Retzsch, which were rather striking: but it is especially the performance of a dramatic opera of *Faust* that I saw in London in 1825 that pushed me to do something on it. The actor, named Terry, who has left memoirs of the English theater of that time . . . was an accomplished Mephistopheles although he was fat; but that did not interfere with his agility and his satanic character."[40]

Thus in the beginning Delacroix did not have an intimate acquaintance with Goethe's text. He deepened his knowledge, however, by reading the extracts translated by the Count de Saint-Aulaire.[41] He worked under the impression of his theatrical experience, and, in a much vaguer fashion, from the images he had in his head of one of the series of illustrations that *Faust* had inspired: Auguste Retzsch's line engravings in the style of Flaxman, which appeared in 1816 and which he probably knew through lithograph copies. Other cycles were then circulating, like that of Peter Cornelius, the Nazarene, also published in 1816, to which he perhaps alludes in his journal entry of February 1824.[42] But Delacroix, in any event, gave *Faust* a very personal interpretation through his choice of scenes and the rendering of situations, so much did Goethe's drama coincide with the painter's sensibility, at least as it expresses itself in the rest of his works in the second half of the 1820s. The series of seventeen lithographs was done over the course of several years, between 1825 and their publication in the translated edition of A. Stapfer in 1828. They are thus contemporary with the small paintings of the historical genre and with the small paintings on Shakespearean or Byronic subjects like Sardanapalus that they all more or less evoke. It

67. *Mephistopheles Appears before Faust*, 1826–27

Exhibited at the Salon of 1827–28.
Oil on canvas, 46 × 38 cm
The Wallace Collection, London

68. *Mephistopheles Appears before Faust*, 1828

Lithograph (second state of five, after letter, with address of C. Motte), 26 × 21 cm. Bibliothèque Nationale de France, Département des Estampes et de la Photographie, Paris

69. *Mephistopheles in the Air*, 1828

Lithograph (second state of five, with address of Ch. Motte), 27 × 23 cm Bibliothèque Nationale de France, Département des Estampes et de la Photographie, Paris

was a pleasure for Delacroix to depict medieval Germany, and he indulged himself, detailing with care the backgrounds and the costumes. But he was equally touched by the intimate drama of the characters, Faust, Marguerite, Valentine, and especially the omnipresent figure of Mephistopheles, whom he represents flying over the city in the frontispiece of the 1828 edition (fig. 69). Each of the sheets combines different elements in its own fashion, insisting on one aspect or another of a scene, provoking an impression of a succession of ruptures rather than continuity for a viewer who looks at them one after another. By doing this, Delacroix was able to show the essentials of the text by attempting to explain the individuality of the different scenes. Thus, in *Mephistopheles Appears before Faust* (figs. 67 and 68), it is the gestures of both characters that indicate their respective feelings, the astonishment of discovery, the certainty of seduction. The scene takes place in the midst of a pile of bric-a-brac, of which the cumulative effect is certainly picturesque but also indicative of the vain investigations of the scholar. Delacroix repeated this composition,

70. *Faust Attempts to Seduce Marguerite,*
1828

Lithograph (second state of seven, with address
of Ch. Motte), 26.2 × 20.8 cm
Bibliothèque Nationale de France, Département
des Estampes et de la Photographie, Paris

71. *Mephistopheles in the Students'*
Tavern, 1828

Lithograph (second state of six, with address
of Ch. Motte), 27 × 22 cm
Bibliothèque Nationale de France, Département
des Estampes et de la Photographie, Paris

incidentally, in a small format similar to his scenes in the historical genre. The comparison between the lithograph and the oil painting is interesting in that it shows his mastery in the expressive means appropriate to each technique. One may note the contrasts of black and white, and the control of value in the lithograph, as well as the treatment of color in the painting, where the intense reds bring out the black of the clothing within the brown and gold tonality of the ensemble. Also evident is the replacement of the detailed drawing of the different elements in the lithograph by the diversity of the painting's pictorial material. For example, in the oil rendering of the fabrics, the tablecloth is worked by incision with the handle of the brush, as is the cushion of the armchair in part, and the more broadly treated curtain.

Delacroix pushed to extremes the implications of every scene, without consistent attention to good taste or realistic drawing. In *Faust Attempts to Seduce Marguerite* (fig. 70), the grimacing expressions of Faust and Mephistopheles as well as that of Marguerite, who shows her disgust by making a proud, disdainful face, are already in themselves rather extreme. They are reinforced in the almost mannerist drawing of the figures,

stretched and twisted without regard to proportion, especially in Marguerite's waist and Faust's ridiculously spindly legs. It is, incidentally, one of the most restrained sheets. *Marguerite's Ghost Appears to Faust,* for example, offers a whole phantasmagoria of ghosts, monsters, penitents, serpents, and devils typical of the "romantic bazaar." Again, it is a matter of Delacroix testing the public. He is in fact even more exuberant during the preparation of his lithographic stones, making sketches in the margin, sometimes with no direct relationship to the central subject (see, for example, *Mephistopheles Visits Martha* (fig. 72). These proofs with commentary were not intended for sale and only a few copies were printed, which were reserved for the author; they are extremely rare today. They show the state of Delacroix's mind, his mood changes, and, in a way, the mysterious development of his imagination. One can understand a sword in the margin of *Faust's Duel with Valentine,* but why a tiger, a lioness, an elephant, and a combat of knights in *Mephistopheles Visits Martha?* Again, the dark landscape of *Marguerite at the Spinning Wheel* is more evocative than the sword, the head of a horse, and the helmet of *Faust in His Cabinet,* or the barque of *Mephistopheles in the*

72. *Mephistopheles Visits Martha*, 1828
Lithograph (first state of seven, with marginal notations),
24 × 20 cm. Bibliothèque Nationale de France,
Département des Estampes et de la Photographie, Paris

73. *Faust and Mephistopheles on
Sabbath Night*, 1828
Lithograph (first state of five, with marginal notations),
20.5 × 28 cm. Bibliothèque Nationale de France,
Département des Estampes et de la Photographie, Paris

Hartz Mountains. Delacroix was fond of these test proofs. In one of his letters, he expressly asks his editor and printer, Motte, to run a few for him "with the surrounding scribbles."[43] Retrospectively, they significantly increase the dreamlike atmosphere that encompasses the lithographs as a whole.

The series was quite badly received and was a complete commercial failure (as were all of Delacroix's lithographed publications). "Motte was the editor. He had the unfortunate idea of publishing these lithographs with a text that hurt the sales, without speaking of the strangeness of the plates which were the object of some caricatures that increasingly showed me as one of the coryphaei of the *school of the ugly.* Gérard, good academician that he was, complimented me on several drawings, particularly the one of the Cabaret."[44] Like *The Death of Sardanapalus, Faust* in some sense synthesizes Delacroix's romanticism. The public, having panned the one, naturally turned its back on the other. One man, however, was enthusiastic at the sight of a few of the lithographs that had been procured for him: Goethe himself, whose remarks, reported by Eckermann, are all the more exceptional since this is the only case where an author who had inspired Delacroix expresses himself on what the painter drew from his work. The rather long descriptions that Eckermann gives them, probably inspired by Goethe, are also interesting: they show with what care Delacroix's compositions were made, despite their apparent facility, even down to details whose meaning can be understood only by reference to the text (figs. 71 and 73). Eckermann's text is as follows: "[Goethe] put before me a lithograph representing the scenes in which Faust and Mephistopheles, wanting to free Marguerite from prison, pass a gallows as they are riding through the night. Faust is on a black horse that has thrown itself into a triple gallop, evidently

frightened, like his rider, by the ghosts that lurk around the structure. They are going so fast that Faust has trouble staying in the saddle; the wind that hits his face has blown off his cap, which floats far behind, held by two straps attached at his neck. He has turned his anxious face toward Mephistopheles and is listening to what he is saying. Mephistopheles is calmly seated, imperturbable like a superior being. He is not riding a lively steed, for he dislikes whatever has life. Besides, he has no need of it; his will alone carries him as quickly as he wishes. He has a horse simply because one has to imagine him riding; it is enough for him to grab from the first handy pasture a skeleton still held together by skin. This spectral animal is light-colored, almost phosphorescent against the dark background of the night. He has no reins, no saddle; he does not need them either. The supernatural horseman remains calm and nonchalant while he converses with Faust. The wind is powerless against him and his horse: not a hair moves on either." Goethe and Eckermann take "great pleasure" in seeing this "clever composition." "'You have to agree,' says Goethe, 'that we ourselves had not imagined the scene so perfectly.'" Then they turn to another plate, where they see "the wild scene of the drinkers in Auerbach's tavern [the same one that Gérard admired], or rather the quintessence of that scene, at its most dramatic moment, when the spilled wine bursts into flame and the bestiality of the drinkers is unleashed. All is passion and movement, only Mephistopheles retains his usual impassibility. Frenzied blasphemies, cries, curses, the knife that his neighbor has unsheathed, leave him indifferent. Seated on a corner of the table, he balances his legs in the void. His raised finger is enough to extinguish the flames and calm the passions." Then comes the admiring judgment of Goethe, who develops several points: the intrinsic beauty of the print, the intimate and necessary concordance between the poem and the deep feeling of the artist, the value of such illustrations for a better understanding of literary work. "'The more we look at this magnificent image, the more we appreciate the great intelligence of the artist, who has not made two figures alike but expresses in each some aspect of the common action. M. Delacroix,' says Goethe, 'is an artist of elite talent, who has found in *Faust* the food that precisely suits him. The French reproach him for his fieriness; but here, it is exactly right. . . . One sees that Delacroix knows all about life, and that a city like Paris has served as well as one could wish for that. Please

observe that such illustrations would contribute a great deal to the understanding of the poem. The question does not even arise,' says Goethe, 'since the powerful imagination of this artist forces us to rethink the situations as perfectly as he has himself. And if I must admit that in these scenes M. Delacroix has surpassed my own vision, how much more strongly the readers will find all of it alive and superior to what they were imagining!'"[45] The success that Delacroix had achieved in his *Faust* illustrations did not depend on the subject alone, as Goethe well understood, or on its execution, or even on the use of lithography, which was perhaps more appropriate than painting to render the very diverse characters of the original. It came above all from a very intimate communion between the artist and the poem (even though, as we have seen, Delacroix's knowledge of it was partial), such that the illustration ends by surpassing, as the author says, what he himself had imagined. For Delacroix, who never stopped defending the superiority of painting to literature, it is the best of praise.

However representative it may be of Delacroix's romantic decade, the *Faust* series appears nonetheless to be relatively isolated at this period. It stands out not only by the breadth and originality of the enterprise, but also because none of the painted work corresponds to it. The only canvases that Delacroix did during this period that were inspired by Goethe are *Mephistopheles Appears before Faust*, the *Wounded Valentine* in the Neue Pinakothek in Munich,[46] and a lost study, *The Witches' Sabbath*.[47] It were as if the "Faustian" vein had gone entirely into the lithographs. However, the correspondences between them and the rest of his work, whether grouped only by period or by their atmosphere—in turn fantastic, meditative, grotesque, or dramatic—are in reality much closer than one might suppose by judging too quickly on the basis of the origin of their subject matter alone. This is true of one of the themes that strongly appealed to Delacroix during these years, one of the most characteristic themes of Romanticism: the motif of the rider, where the man and his mount, intimately joined, are thrown into a wild, headlong gallop that nothing seems able to arrest. One finds it not so much in *Mazeppa*,[48] which was strongly inspired by Géricault's work (as romantic as it is), as in a much more original subject, *Tam o' Shanter* (fig. 74), which Delacroix painted several times. The subject comes from the eponymous ballad by Robert Burns (1791), which he knew in the original, a "patois very hard to under-

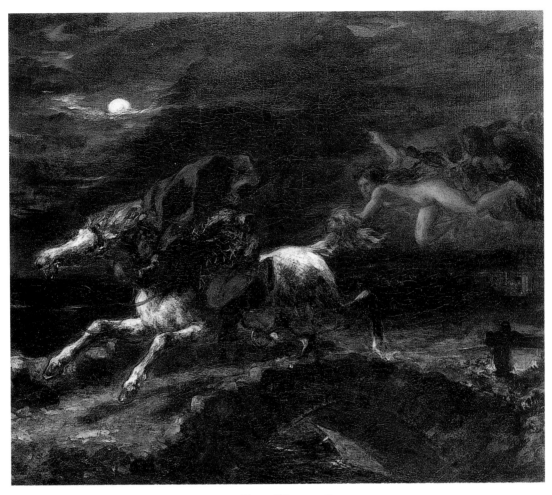

74. *Tam o'Shanter*, 1849
Oil on canvas, 38 × 46 cm
Öffentliche Kunstsammlung, Kunstmuseum Basel

stand, which was explained to me by a native [perhaps one of the Fielding brothers]," he recounted to Feuillet de Conches, who had asked for some explanation about the painting. "Tam o' Shanter is a peasant who loves to forget himself at fairs or in taverns for two reasons," he went on. "The first is that he likes *usquebaugh* [whiskey] too much; the second is that his wife is the most cantankerous person in the world. So one evening, when he is coming back later than usual, he passes by a half-demolished church in which some witches are celebrating the sabbath. He doesn't dare breathe, of course. But, at the sight of a rather young and sprightly witch, more lively than the others, he cannot help crying out, *Bravo, short shirt!* (*Bravo, Cutty Shirt or Short!* I don't vouch for the text). He takes to his heels, or rather his horse's heels, to get to a little

bridge that will shelter him; but the short shirt grabs the tail of his gray horse at the moment that he reaches the bridge, and holds on so hard that the tail comes off in her hand. And there's ten times more than is necessary on this subject."[49] The apparent frivolity of the scene did not prevent Delacroix from treating it three times—in 1825, 1831, and 1849—which suggests its importance to him (he seems to be the only French painter of his time who illustrated the story). In each version, the speed is rendered by rapid brush strokes and by the horizontal elongation of the figures—horse, rider, and witch—in the manner of Géricault in the *Derby at Epsom* and more generally of numerous English sporting prints. Their small size might almost invite us to consider them as humorous pieces if it were not for their repetition and their relationship with

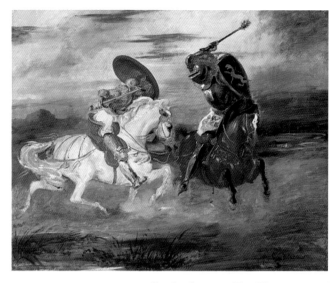

75. *Combat between Two Horsemen in Armor*, c. 1825–30
Oil on canvas, 80.7 × 100 cm. Musée du Louvre, Paris

76. *The Combat of the Giaour and Hassan*, 1827
Lithograph (first state of two, with marginal notations), 36 × 25 cm
Bibliothèque Nationale de France, Département des Estampes et de la Photographie, Paris

77. *The Combat of the Giaour and Hassan*, 1826
Rejected by the Salon of 1827–28. Oil on canvas, 59.6 × 73.4 cm
The Art Institute of Chicago

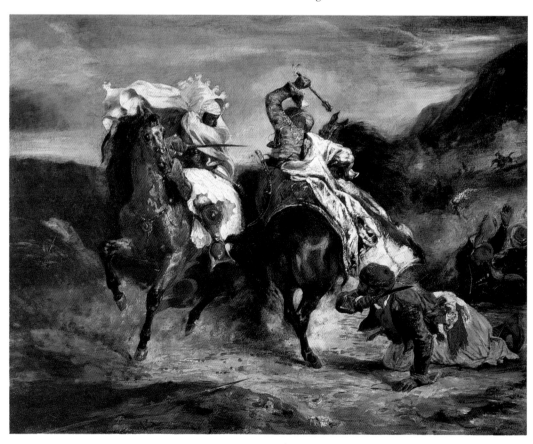

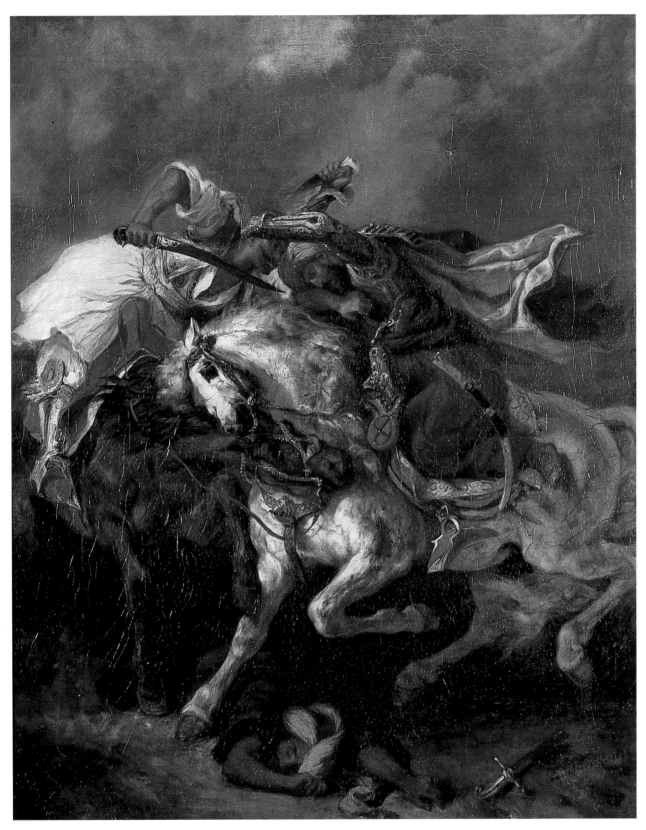

78. *The Combat of the Giaour and Hassan*, 1835
Oil on canvas, 74 × 60 cm
Musée du Petit Palais, Paris

more "serious" or finished works like the *Faust* series, which makes them worthy of more in-depth consideration. In their time, the *Tam o' Shanter* paintings were harshly judged: the Salon version of 1831 was, in the eyes of critics admittedly hostile to Delacroix, a "shapeless daub" or a "revolting folly."[50] Was it in the very reach of such rapidly executed works that Delacroix showed himself an innovator?

More than Goethe, Byron was one of Delacroix's favorite authors, not only for the man he was but because his verses captured the painter's imagination: "How I would like to be a poet!" he wrote in his journal in May 1824. "But at least, do it with painting! Make it naive and daring. What things to do! Do engraving, if painting won't suit, and great pictures. . . . Painting, I have told myself ten thousand times, has advantages that are special to it. The poet is indeed rich: remember, to inflame yourself eternally, some of Byron's passages; they agree with me. The end of *The Bride of Abydos*, the *Death of Selim*, his body tossed by the waves and, above all, his hand lifted up by the wave that has just spent itself on the shore. That is really sublime and it is only his. I feel those things as though they were paintings. The *Death of Hassan*, in *The Giaour*. The giaour contemplating his victim and the imprecations of the Muslim against Hassan's murderer. The description of Hassan's deserted palace. The vultures sharpening their beaks before the combat. The grappling of the struggling warriors. Make one of them who dies biting his enemy's arm. *The Curses of Mazeppa* on those who have tied him to his charger, with the château of Palatin fallen to its foundations."[51] Delacroix was not the first French painter to illustrate Byron: before him, Horace Vernet from 1819, and Géricault at the same time, had drawn or lithographed scenes from *The Corsair* or *The Giaour*. Other poems furnished some of the most popular themes among the French Romantics, particularly *Mazeppa*, which incidentally did not greatly inspire Delacroix. Byron was famous and fashionable under the Restoration, for his life as well as for his works, and for his death among the Greek insurgents at Missolonghi. But Delacroix is different from his contemporaries on account of the strength and importance that Byron's inspiration held for him during this period, an inspiration that continued to the end, with *The Death of Lara* in 1858. Either directly or indirectly, Byron furnished the subject for three of Delacroix's most important compositions: *Tasso in the Hospital of Saint Anna*, *The Execution of the Doge Marino Faliero*, and *The Death of Sardanapalus*. To these works, which he intended specifically for public viewing, should be added the first version of *The Combat of the Giaour and Hassan* of 1826 (fig. 77), shown at the Galerie Lebrun the same year, at the Douai Salon in 1827, again in Paris at the Musée Colbert in 1829, and rejected twice for the Salon, in January 1828. The subject comes from the poem *The Giaour, a Fragment of a Turkish Tale*, published in 1813. The scene is Greece at the end of the seventeenth century. The slave Leila fled the harem of the Turkish pasha, Hassan, to become the lover of a Venetian warrior known only by his pejorative nickname, Giaour, which the Turks give to non-Muslims, especially Christians. Leila, discovered and recaptured, has been punished for her infidelity by being thrown into the sea. The Giaour decides to avenge her, and sets up an ambush for the Pasha and his escort in a narrow pass. He kills him in single combat, then meditates over the lifeless corpse of his enemy. Delacroix boldly traced his composition, making the two horsemen confront each other, one seen from three-quarter face, the other from the back in relation to the spectator. He was able to balance the composition by placing the man with a dagger at the right (one sees beyond, in the smoke and powder, the rest of the combat). The brilliance of the vivid colors is reinforced by the vigor of the brush, a very visible touch, and the contrasts of pictorial matter characteristic of this period. The evocative power of the scene comes not only from the subject—the fiery struggle between the two enemies—but from the energy of the painter, which the spectator can see and feel. This poem inspired Delacroix throughout his career. In 1829, he painted a small *Giaour Contemplating the Dead Hassan*,[52] in 1834–35, *The Giaour's Confession*,[53] and in 1849, *The Giaour Pursuing the Ravishers of His Mistress*.[54] Twice he returned to the moment of the combat: in a lithograph done about 1827 (fig. 76), in which the Giaour tramples the conquered Hassan under his horse's hooves, and in the canvas sent to the Salon of 1835 (fig. 78), in which he concentrates on the fight of Hassan, the Giaour, and their horses. The two adversaries are seen here in profile, in a much tighter frame, where they occupy most of the composition. But, as in 1826, the expressiveness comes in great part from the richness of the material and the color (in a golden tonality clearly different from the blue-green of the 1826 painting in Chicago). The theme of the Giaour, it seems, particularly intrigued Delacroix

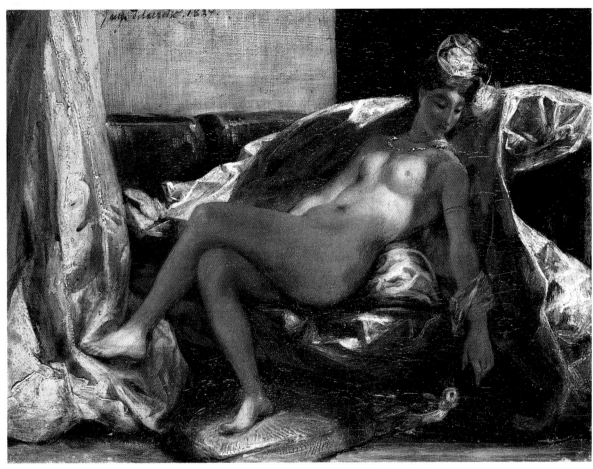

79. *Woman with Parrot*, 1827
Oil on canvas, 24.5 × 32.5 cm. Musée des Beaux-Arts, Lyons

80. *Female Nude Reclining on a Divan*, c. 1825–26?
Oil on canvas, 25.9 × 33.2 cm. Musée du Louvre, Paris

81. *An Odalisque*, c. 1827–28
Oil on canvas, 37.8 × 46.4 cm. Fitzwilliam Museum, Cambridge

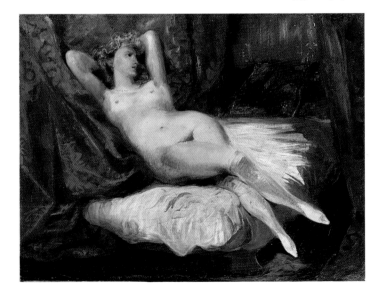

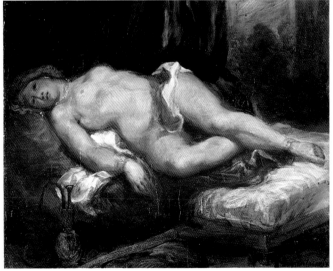

82. *Rebecca and the Wounded Ivanhoe,* 1823
Oil on canvas, 64.7 × 54.2 cm
Private collection

Identifications have been proposed for these women, one model or another whose relationship with Delacroix at times went beyond the strictly professional. The essential is not, however, to investigate the biographical considerations. The sensuality of these bodies offered to view is certainly evident and goes beyond the simple sympathy of the painter for his model. But it also goes beyond mere remembrance, so much has Delacroix achieved a type in these little pictures. A few accessories, a divan, a fur, cushions, and a vase recall the Orient for two of the three, while the bed and the valet of the third suggest the Middle Ages. The white stockings, the string of pearls, and the coiffure of the fourth suggest, rather, a Parisian woman involved in an amorous adventure. The principal thing, however, is not the direct expression of the voluptuousness of the subject but the pleasure of the painter. Delacroix multiplies the harmony of his colors, subtly marries bold and subtle tones, red and blue-green in *An Odalisque,* yellow, red, and blue in *Woman with Parrot;* ties together the white of the stockings and the bed with the beige of the body in *Female Nude Reclining on a Divan.* The light plays subtly on the flesh, making it vibrate delicately. There is no question that he had in mind his beloved Venetian painters of the sixteenth century with whom he directly competes here in the rendering of life and purely pictorial virtuosity. Was he looking for a comparison with his contemporaries, Ingres in particular, of whom one cannot help thinking? He is far from those dreamy women of the *Grand Odalisque* or the *Bather of Valpinçon* in format, genre, and, of course, form. Here, as in the Greek or Turkish paintings and as in the Byron illustrations, Delacroix shows himself to be above all a painter: the subject never disappears but is transcended, as it were, by its formal expression.

Byron had found in Delacroix one of his best translators into painting. But he was far from the only one. The same is true for another of the favorite authors of the period, Sir Walter Scott, whom the other Romantics repeatedly illustrated.[56] The impact of Scott's historical novels—set in both France and England from the twelfth to the fifteenth centuries and in Scotland in the seventeenth and eighteenth centuries—was considerable between 1820 and 1830, touching all the arts. During these years, Scott's novels represented three-quarters of all English novels and a third of all novels published in France. Delacroix illustrated Scott beginning in 1823, with his

around 1830. An expression of his own sensibility (one could compare it with the *Combat between Two Horsemen in Armor* [fig. 75]), it was also representative of many aspects of the Romantic school: in its source—a contemporary English poem; in the subject itself—a dramatic combat caused by a fateful love that ends in the death of the victim and the confrontation of two men who echo the struggle of their mounts; and in the exoticism of the scene, which evokes at the same time the struggle for Greek independence. The scenes that Delacroix drew from Byron are thus directly related to all the orientalizing paintings of the period, but also, more loosely, to the female nudes of the years 1825–28: *Female Nude Reclining on a Divan* of 1825–26 (fig. 80), the *Woman with Parrot* of 1827 (fig. 79), and *An Odalisque* of 1827–28 (fig. 81), with which *Lady and Her Valet* naturally belongs— it probably illustrates a passage of Brantôme's *Lives of Gallant Ladies,* but the subject is, after all, rather secondary.[55]

83. *Quentin Durward and le Balafré*, c. 1828–29
Oil on canvas, 40.5 × 32.4 cm
Musée des Beaux-Arts, Caen, deposited by the Musée du Louvre, Paris

84. *Cromwell at Windsor Castle*, c. 1828–30
Exhibited at the Salon of 1831. Oil on canvas, 34.8 × 27.2 cm
Private collection, Switzerland

small *Rebecca and the Wounded Ivanhoe* (fig. 82), a painting that he thought "execrable" but that was soon bought by an admirer of the new school, Coutan. Coutan was ready to "take others": are we to conclude that Delacroix turned to this type of subject only for monetary reasons, producing a kind of painting that was easily marketed? One should not neglect either the fact that *Rebecca and Ivanhoe* belongs, by its subject and its handling, to the troubadour genre that was then very much in style and to which Delacroix was far from a total stranger. But from the beginning it was the purely literary qualities of Scott that seduced him, above all an "astonishing perfume of reality" that, as Delacroix would later recall, surprised all the world when the novels appeared.[57] The writer had the art of expressing contemporary sensibility through the personages and situations of the past, which he brought to life with a picturesque intensity. Delacroix was touched like everyone else without, however, being duped, at least at the

end of his life, by the relatively artificial, fabricated character of Scott's works. On this point his journal contains some harsh evaluations, written at a time when he could think with detachment and at a distance from the enthusiasms of his youth. "After painting certain details that are surprising in their evident naiveté, like the exact names of people, strange usages, etc. you have to come down to a more or less fantastic story that destroys the illusion," he writes in 1853 after having read some Russian novels. "Instead of painting a true picture under the names of Damon and Alceste, you make a novel like other novels, which seems to be more because of the search for illusion just in the secondary details. All of Walter Scott is like that. The apparent novelty contributed more to his success than all his imagination, and what has aged his works and places them below the famous ones that I cited [*Voltaire, Don Quixote, Gil Blas*] is precisely this abuse of truth in the details."[58] Scott is mentioned here, incidentally, less for himself

than because he is typical of the writers of his time: "What makes modern literature inferior is the pretense of showing everything," Delacroix continues; "the whole disappears, drowned in the details, and the result is boredom. In some novels, like Cooper's, for example, you have to read a volume of conversation and description to find an interesting passage; this defect seriously damages the works of Walter Scott and makes it very hard to read them; also, the mind languishes in the midst of this monotony and emptiness where the author seems to take pleasure in talking to himself. Painting is lucky to ask only a glance to attract and capture."[59] In other words, one can make a good painting even of bad literature, novels that, to use Delacroix's own terms, taste cannot accept as accomplished works.

85. Sketch for *The Murder of the Bishop of Liège*, 1827
Oil on canvas, 60 × 72.5 cm
Musée des Beaux-Arts, Lyons

That he was enthusiastic about Scott very early on is not in doubt, as is shown not only in *Rebecca and Ivanhoe* but also in the *Self-Portrait as Ravenswood* (fig. 1) painted about 1821. In 1824, he painted a *Leicester* (now lost), probably inspired by *Kenilworth*. But one really has to wait until the end of the 1820s before he gives all his energy to this material, at first with two small formats, *Quentin Durward and le Balafré* (fig. 83) and *Cromwell at Windsor Castle* (fig. 84). Delacroix perhaps painted Cromwell, drawn from *Woodstock*, under the influence of a theatrical adaptation: "Having by chance turned over a portrait of Charles I, [Cromwell] falls into a profound mediation at the sight; he forgets he has a witness who is watching; it is a spy of the Royalist party who has obtained access to him."[60] The other painting represents an episode from *Quentin Durward*, one of Scott's most popular novels. The young hero, coming from his native country to enlist in the Scotch guard of Louis XI, stops in the tavern called *La Fleur de Lys*, near Plessis-lès-Tours. He learns from his uncle, Ludovic Leslie, called *le Balafré* and already a member of the guard, that all his relatives have died in the struggle that pits them against the Ogilvie clan. Leslie gives a gold chain to his cutler to have masses said for the repose of their souls. Delacroix follows the original text rather closely, concentrating his effects, in very simple compositions, on the gestures more than on the expressions per se of the different personages, and using a richly colored harmony based on browns, golds, and bright reds. The last painting of Delacroix inspired by Scott is *The Murder of the Bishop of Liège* (fig. 86),[61] which, although it presents some formal similarities to these last two, is spectacular in another way. It represents another episode from *Quentin Durward*. William de la Marck, called the Boar of Ardennes, "has captured the château of the Bishop of Liège with the aid of the Liégeois rebels. In the middle of an orgy in the great room, seated on the pontifical throne, he has the bishop brought before him, clothed derisively in his sacred habit, and has the bishop's throat cut in his presence."[62] Painted with the same vitality as *Marino Faliero* and *Sardanapalus*, it is one of Delacroix's works that most clearly manifests the Romantic character. By its subject, it in effect synthesizes literary inspiration and the rediscovery of the Middle Ages. The choice of the moment to be represented is characteristic also: the violent action here reaches its paroxysm, increasing the dramatic intensity of the scene. There is perhaps a certain desire to shock: painting a bishop in the process of getting his throat cut, even under the pretext of literature, could appear rather scandalous in the reign of the devout Charles X (the chapter from which the scene comes is entitled "The Orgy"), not to speak of the other personages— the milling crowd evokes the revolutionary populace that Delacroix would represent a little later in *Boissy d'Anglas at the National Convention*. "Who would have thought that one could paint rumor and tumult? Movement, possibly, but this small canvas shouts, screams, and blasphemes; it is as though one hears hundreds of words and the obscene songs of this drunken

86. *The Murder of the Bishop of Liège,* 1829
Exhibited at the Salon of 1831. Oil on canvas, 91 × 116 cm
Musée du Louvre, Paris

rabble floating above the table in the bloody vapor of the frenzied lanterns. What a band of outlaws! What fierce getups! What colorful poses! What bloody and jovial bestiality! How it swarms and squeals, how it blazes and stinks!"[63] The terms that Gautier uses are in themselves enough to demonstrate how very far we are from the traditional canons of the ideal and of classical beauty that Delacroix seems to delight in not following. Topping it off, the very aspect of the canvas is closer to the sketch than to the finished picture as it was then understood. "Why is it that M. Eugène Delacroix has not been free to develop this admirable and magnificent composition on the same scale as Rubens's *Les Enfers* or Paul Veronese's *Wedding*? Then, no doubt, we would not have had to reproach the singular caprices, the bizarre inequality of the execution that are so disagreeably striking in this painting," Gustave Planche wrote, on the occasion of the Salon of 1831. "It seems that discouragement and constraint stopped him by fits and starts, that he took up and put down his work like a child who tosses away his toys after amusing himself with them. Several heads in the foreground are less finished, less advanced than others on the second or third plane. Let us hope that, some day, popular attention and admiration will permit him to enlarge and complete it for the galleries of the Luxembourg, this sketch so cleverly and boldly invented."[64] For all of this, the picture was still recognized as an exceptional work, and its merits were pointed out by many people, including the students and zealous admirers of David.[65] Delacroix's style was, in fact, beginning to impose itself, if not to win all the votes: "Twenty years ago the . . . *Bishop of Liège* would have been a pretty sketch; now it is a painting," noted the anonymous critic of the *National* when the canvas was shown in 1830 at the Musée Colbert.[66] In 1855, Gautier best defined the in-between state in which it remained: "Less finished than a painting, more finished than a sketch, *The Murder of the Bishop of Liège* was left by the painter at that supreme moment when one more stroke of the brush would have ruined everything."[67]

Delacroix had in fact taken much care in its execution, much more in any case than might be suggested by its appearance, with its vigorous touch and the apparent rapidity of the brush strokes. The sketch (fig. 85), conserved in the Musée de Lyons (which differs from the finished painting particularly in the orientation of the setting), illustrated his early idea: it was to make a great scene in chiaroscuro, illuminated almost solely by the white stretch of tablecloth around which the composition is organized. It is based on two diagonal axes, the table and the crowd of drinkers on one side, and, on the other, a line that begins with the soldiers at left, passes by the bishop and his assassins and ends with William de la Marck standing before the throne. The vault is like an echo in the sketch, but it follows the orientation of the table in the painting. However, it is not with the setting that Delacroix took the most trouble. Villot, in a lively and well-known text, traced the steps of the work: "Delacroix made very important modifications to the sketch and had great difficulty realizing the effect that he had conceived for this scene. He several times abandoned a work that did not satisfy him. Finally, he decided definitively; the man standing, seen from the back, at left, gave him great trouble and he did him over seven or eight times. As to the white tablecloth, it was, according to him, the main point of the picture. One evening, drawing at the home of his friend Villot [himself], he said to him: 'Tomorrow I attack this cursed tablecloth, which is going to be Austerlitz or Waterloo. Come to my studio at the end of the day.' M. V[illot] was on time for the rendez-vous. Delacroix, dressed in a short red flannel blouse, palette in hand, opened the door and said with an inexpressibly fine smile, pinching his lips and nodding his head: 'Eh bien! mon cher, it's Austerlitz; you are going to see.' In fact, the tablecloth flamed out and illuminated his bloody orgy. 'I am saved,' Delacroix added, 'the rest doesn't worry me; I am going to get at the architecture, I will change my first arrangement and for the framework of the vault I will get my inspiration from the sketches that I made at the Palais de Justice in Rouen.'"[68] (He also followed the studies of the great hall of Westminster Castle and the costumes of the Meyrick collection that he had done in England in 1825.) The exceptional success of *The Murder of the Bishop of Liège* comes, however, less from the tablecloth itself than from the mastery that Delacroix demonstrated in rendering the setting: the vault appears progressively to the spectator, who, little by little, thanks to the reflections, distinguishes the details of the architecture as though the eyes accustomed themselves to the half-light. The effect is identical in a slightly later work, the *Interior of a Dominican Convent in Madrid* (fig. 87). Taken from the Gothic novel by Robert Maturin, *Melmoth the Wanderer*, published in 1820 and translated into French the following year, its subject was doubtless rather obscure for Delacroix's

87. *Interior of a Dominican Convent in Madrid*, also called *Honorable Amends*, 1831
Exhibited at the Salon of 1834. Oil on canvas, 130 × 163 cm
Philadelphia Museum of Art

contemporaries. "A young man from a great family, forced to take vows, is led to the bishop, who is visiting the convent, and is overwhelmingly mistreated in his presence," reads the handbook of the 1835 Salon, where the painting, finished in 1831, was exhibited. Thirty years later, it had become incomprehensible. "I thank you again for your kind article and want to tell you that your poetic instinct has as usual served you well in divining the subject of the picture so foolishly but legendarily baptized *Honorable Amends*," Delacroix wrote to Gautier in 1860. "Opening the catalogue of the Salon where it was shown should have been enough. The subject is taken from *Melmoth*, which you no doubt admire as much as I do, from the sublime story of the Spaniard imprisoned in a convent. He is dragged before the bishop on broken glass, sharp points, etc. etc., to be whipped and then lowered into the infamous dungeon, where they put his mistress with him. Then comes the scene where, before they both died of hunger, the lover ate a piece of his adored mistress: the story does not say what piece. I did not think I should choose that moment."[69] Proof that, even caught up in the Romantic movement, Delacroix could restrain himself and stay within certain limits. . . . It seems that, more than the subject, it is the rendering of the architecture that interested him. (Planche noted, with justification, in 1834, that "very probably the figures were added after the architecture and this is why they look like a useless veneer."[70]) The painter also took great liberties with the original text: nothing suggests Spain or Madrid, where the scene is supposed to have taken place. The bishop is seated on his throne, whereas in *Melmoth* the unfortunate hero is brought to him at the altar. Finally, Delacroix painted not the

Jesuits of the book, but Dominicans, whose white robes offered better contrast with the darkness of the room, and suggested the Inquisition. *Melmoth* is indeed an interior that competes with those of Granet, then popular, as Gautier commented: "The *Dominican Convent in Madrid* introduces us to an interior of such beauty that we rank it above all that M. Granet has done, for the gravity and melancholy of the color; since the figures are more alive, more animated than the ivory and ebony models that M. Granet plants among the ink-colored walls of his subterraneans and his churches."[71] Corot was not mistaken about it. Visiting Rouen with Robaut, who recounts the anecdote, he sat down with him in a waiting hall (the *salle des pas perdus*) of the Palais de Justice. "He was silent there for a moment, his eyes raised to the high vaults of sculpted wood, when all of a sudden he cried out, 'What a man! What a man!' He was seeing again in his mind the picture of the *Honorable Amends* that we had admired together some days before in the Durand-Ruel galleries. For him the room was nothing, Delacroix was everything, although he had done nothing but be inspired by the characters of *Melmoth*."[72]

Just as Delacroix continued after the *Massacres of Chios* to paint historical subjects, the battles for Greek independence or various well-known episodes of the history of France, so his literary inspiration continued. History, especially the history of France, is, however, one of the basic fundamentals of the Romantic movement and of romantic feeling. In Delacroix's work history is far from secondary, but it occupies all the same a place apart, as though he had come to it mostly through literature, approaching the topic itself with a certain reluctance. Although Delacroix considered the life of Napoleon "the epic of our century for all the arts,"[73] he never treated it directly, except in a little picture of 1824, *A Battlefield, Evening,* which he kept in his studio all his life (it figures in the posthumous sale).[74] (He did occasionally consider other treatments of Napoleon's life, planning, for example, to do *The Arrival of Napoleon at the Egyptian Army* or *The Farewells at Fontainebleau* in 1824.)[75] In the manner of Géricault, whose influence on *A Battlefield, Evening* is undeniable, Delacroix uses two dead horses and a wounded soldier to evoke the end of the Napoleonic epic, and perhaps more precisely the battles around Paris. But the painting is an exception in his work. It should also be remembered that most of his great historical subjects were commissioned: *The Battle of Nancy* for the Musée de Nancy, *The Battle of Poitiers* for the Duchess de Berry, *Cardinal Richelieu Saying Mass in the Chapel of the Palais-Royal* for the gallery of the Palais-Royal, *The Battle of Taillebourg* for Versailles, as was the *Entry of the Crusaders into Constantinople.* *Mirabeau Confronts the Marquis de Dreux-Brézé,* and *Boissy d'Anglas at the National Convention* were competition paintings. *The Justice of Trajan* grows from a literary inspiration (Dante) more than a historical one, as does *The Execution of the Doge Marino Faliero,* and *Justinian Drafting His Laws* was from the beginning intended for the Conseil d'Etat. On his own initiative, Delacroix undertook only three paintings in this genre: the *Scenes from the Massacres of Chios, Greece on the Ruins of Missolonghi,* and *Liberty Leading the People,* all done in his youth, and all inspired by history, which he otherwise practically disdained during the rest of his career, even though it furnished so many subjects for other French painters.

The only event of his time that truly attracted his interest (putting aside the exceptional circumstances of *Liberty Leading the People*) was the struggle of the Greeks against the Turks, and it furnished only one single painting of important size after the *Massacres of Chios*: the allegory of *Greece on the Ruins of Missolonghi.* Otherwise, Delacroix never again painted *en grand* the realities of the War of Greek Independence. He continued to think of it, however, and it is one of the essential threads of his orientalist vein before his 1832 voyage to Morocco, along with Byronic themes and more picturesque subjects: the *Turk Seated on a Sofa Smoking, An Odalisque,* and other *Studies of a Figure in Greek Costume.* It is thus that *A Turkish Officer Killed in the Mountains* came to be known as a *Hassan Killed by the Giaour.*[76] Delacroix is certainly very close to Byron in this last painting (the clothing of the officer is in part what is described in the poem), but the village burning in the background indicates the true meaning of the picture. His continuing enthusiasm for the Greek struggle never stopped translating itself into his work. Thus, in April 1824, in the midst of doing *Massacres of Chios,* he thinks of a "great sketch of *Botzaris: The Turks, Astonished and Surprised, Throw Themselves at Each Other,*" a subject to which several sketches are related, studies or projects more or less finished, among them a watercolor that is today in the Louvre (fig. 88).[77] But the only finished one is a *Scene from the War between the Turks and Greeks,*[78] a vague scene that makes no allusion to any exact historical event but contents itself with showing the Greek

combatants, a horseman at a gallop, and another, whose horse has been killed, raising his gun to his shoulder. The canvas, little noticed at the Salon of 1827–28, lacks ambition, if not totally, at least of the kind that breathes in *Massacres of Chios* or *Greece on the Ruins of Missolonghi*; it suggests that Delacroix had to use a more-or-less obvious allegory to represent contemporary history. In any case, it would be thirty years before he again seriously took up these different subjects.

88. *Scene of Battle between Greeks and Turks*, 1823–24?
Watercolor and pencil on paper, 33.7 × 52.3 cm
Musée du Louvre, Département des Arts Graphiques, Paris

For lack of subjects in his own time, Delacroix tackled the history of France directly, three times, at the end of the 1820s, with *Cardinal Richelieu Saying Mass in the Chapel of the Palais-Royal; The Battle of Nancy; Death of Charles the Bold; Duke of Burgundy;* and *The Battle of Poitiers.* There is no literary pretext here, but instead well-known episodes or personages, and paintings destined above all to retrace or commemorate them. Even though these paintings have some analogies with and formal resemblance to the small scenes of the literary or historical genre, each conveys a different spirit, for example, in regard to common documentary sources: the Middle Ages as depicted in *The Murder of the Bishop of Liège* is not the same as that in *The Battle of Nancy.* The circumstances in which these works were done are also rather special: they were all commissioned, and even if they correspond in many respects to themes that Delacroix was then developing, he did not undertake them on his own initiative. In this they are indicative of his inclusion in the Parisian art market. Just as the small formats had, in part, a commercial objective, these paintings offer proof that Delacroix was henceforth among the artists who mattered in Paris, and they invalidate the rash judgment that would turn him into an *artist maudit.* From this point of view, the failure of *The Death of Sardanapalus* did not have real consequences, and his prestigious official commissions did not dry up after 1828; on the contrary, they increased.

The duke of Orléans, for instance, asked him for a large composition for the Palais-Royal. Anxious to recapture the artistic luster that his residence had known before the Revolution and the dispersion of the former paintings of the Orléans collection, he had undertaken to decorate one of the principal galleries, which served as a ballroom, with paintings commissioned from contemporary artists retracing the great episodes of the history of the palace from the time of Richelieu until the nineteenth century. The duke's librarian, Vatout, in the *Lithographic History of the Palais-Royal*, which reproduces all the commissioned paintings, makes explicit the subject assigned to Delacroix: "Following the example of the Cardinal of Lorraine, [Richelieu] had guards whose orders were not only to accompany him into the Louvre but not even to leave him even at the altar, and thus to mix the odor of cannon powder with the odor of incense and other secret perfumes."[79] The Salon booklet of 1831, where the canvas was presented, explains the scene more precisely: "The Cardinal de Richelieu in his chapel in the Palais-Royal. He says mass surrounded by the company of his guards, muskets shouldered and fuses lit." The canvas was very large (it measured more than two meters high). It unfortunately disappeared during the Revolution of 1848 in the pillage of the palace, in the course of which the pictures of the gallery were destroyed, cut up, or burned. It is known now only through the lithograph by Jourdy published in Vatout's history (fig. 89), through a sketch and preliminary drawings, and through a small variant, perhaps another preliminary idea for the definitive painting, which was purchased in 1846 by one of Delacroix's students, Mme Rang-Babout (fig. 90). He treated the imposed subject with exactitude, precision, and verisimilitude in the faces, costumes, and setting, but no documents exist to enlighten us on the development of the commission. Had there been any discussion on the subject? Were the destination of the picture and its definitive emplacement taken into account? Was Delacroix aware of the rest of the program? We do not know. *Cardinal Richelieu Saying Mass* was in any case rather coolly

89. *Cardinal Richelieu
Saying Mass in the Chapel
of the Palais-Royal*
Lithograph, 34.8 × 24.4 cm,
by A. Jourdy after
Delacroix's canvas, published in
J. Vatout, *Histoire lithographiée du
Palais-Royal* (Paris, 1845)
Bibliothèque Nationale de France,
Département des Estampes et
de la Photographie, Paris

90. *Cardinal Richelieu
Saying Mass*, 1828?
Variant of the canvas
destroyed in 1848 in the pillage
of the Palais-Royal
Oil on canvas, 40 × 32.4 cm
Galerie Claude Bernard,
New York and Paris

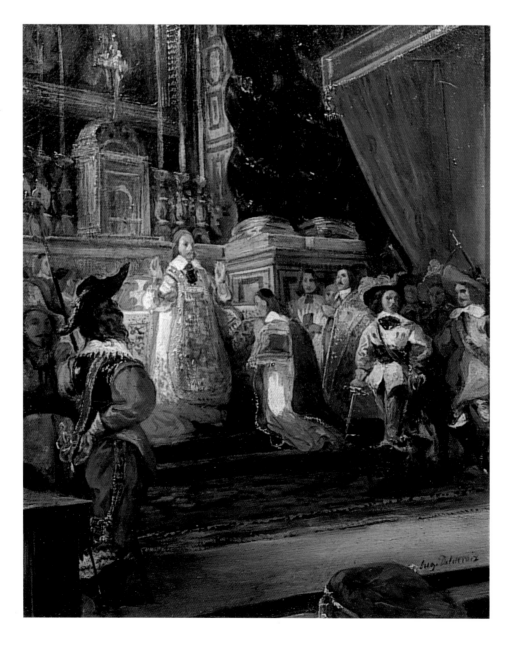

received at the Salon of 1831. "There is nothing original in it, nothing bold: even the expression, that part of art in which M. Delacroix has often shown himself superior, is here a cold nullity," said *Le Moniteur Universel*. "The arrangement is sensible and calm in effect. . . . A happily imagined episode or an accidental circumstance would have . . . broken this monotony."[80] Only the coloration found mercy in the critics' eyes. It is difficult to make any judgment on a painting that has disappeared and that the lithograph only partially renders. Delacroix took pains with the painting (we do not know when it was commissioned, but it was finished, doubtless in three months, in the autumn of 1828),[81] and Louis-Philippe was content with it. Was the painter constrained in painting such a relatively insignificant subject? It is comparable, after all, to his small genre paintings. But *Richelieu* was a large format, and the imposed theme, picturesque and stirring as it was, lacked at first view any nobility or monumentality. Delacroix surmounted this difficulty skillfully by giving his personages a very theatrical pose, particularly noticeable in the halberdier at the center and in the group with the page at left. He was also intent on rendering the detail of a sumptuous setting in which even the arms of the cardinal were included, the material and color of his garments adding to the richness found in the carpet and cushions of the prie-dieu, which also emphasizes the diagonal on which the painting is constructed. Perhaps a bit neglected because of its early disappearance, and easily grouped with the commissioned paintings, it should not after all be considered as lacking in interest.

Another history painting had been commissioned at the same time as *Richelieu*, but by the Ministry of the Interior. The Ministry had decided to commemorate Charles X's visit to Lorraine, to take place in September 1828, by bestowing upon the Musée des Beaux-Arts de Nancy a painting from the king. The commission, ordered in the month of August, was given to Delacroix; it appeared, finally, that the administration was not at all hostile toward him after the emotion aroused by *The Death of Sardanapalus*. "The Minister of the Interior, by all reports an amiable man [Martignac], has commissioned a picture for the museum of the city of Nancy, representing *The Death of Charles the Bold*, a great libertine by nature," Delacroix wrote to Soulier at the beginning of October. And, to Guillemardet: "The Minister of the Interior has commissioned a painting on a subject that suits me exactly, the death of Charles

the Bold. I'm counting on you to lend your archaeological knowledge on this subject."[82] Delacroix himself had selected the theme that he was to treat from the proposals of the Royal Society of Sciences, Arts, and Letters of Nancy, which had suggested three possibilities: the Duke of Lorraine ordering that honors be rendered to the remains of Charles the Bold, the discovery of his half-devoured body after the battle, and the episode that he finally chose, described in the booklet of the 1834 Salon: "Battle of Nancy, death of the Duke of Burgundy, Charles the Bold, 5 January 1477. The duke, embittered by his last disasters, fought recklessly, in snow up to his shins and in such icy weather that he lost his cavalry. He himself, mired in a pond, was killed by a horseman from Lorraine at the moment that he was attempting to get out."

It is easy to understand what may have pleased Delacroix in such an episode, both dramatic and picturesque. But he was also aware of the constraints inherent in such a commission and particularly of the historical accuracy that would be demanded. The subject was popular in Lorraine and timely since interest had been revived under the Empire by a whole series of works, poems, competitions, and subscriptions. It was imperative that the painter not deviate too much from the well-known facts. Delacroix, who had never neglected this aspect in his other paintings, thus made a special effort at documentation. He asked Schwiter, through his intermediary Pierret, to bring him from Nancy "as many views as he can of different parts of the chapel and of the locale [meaning the place] where Charles the Bold was killed."[83] The chapel, which figures in the sketch that Delacroix was ready to submit as early as February 1829 to La Rochefoucauld (fig. 93), still Superintendent of the Beaux-Arts, has disappeared in the finished painting (fig. 94). This change, the most notable one, perhaps came about because the painter had judged his information to be insufficient. He had numerous written sources to situate his subject: the chroniclers of the epoch, particularly Philippe de Commynes, and later historians, from Dom Calmet to the recent *History of the Dukes of Burgundy* by Barante (1826), not counting the more literary texts, including one by Scott, *Anne of Geierstein*, which had just appeared in translation as *La Mort du Téméraire*. The studies of arms that he had accumulated for several years also introduced an element of authenticity. But the Salon of 1834, where the painting was finally exhibited (its completion seems to have been delayed by the fall of the

91. Sketch for *The Battle of Poitiers*, 1829
Oil on canvas, 52.8 × 64.8 cm. The Walters Art Gallery, Baltimore

92. *The Battle of Poitiers*, 1830
Oil on canvas, 114 × 146 cm. Musée du Louvre, Paris

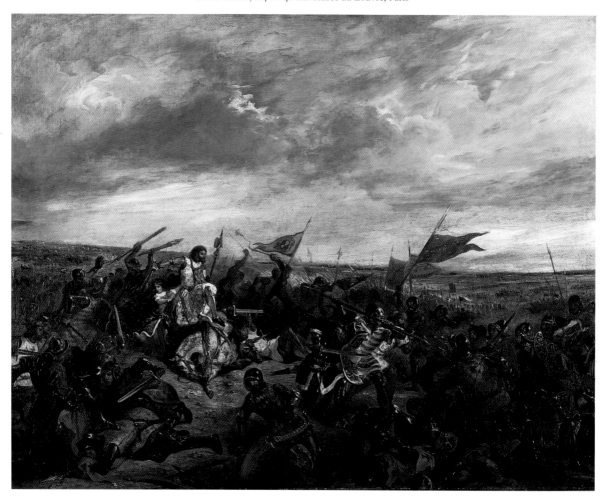

93. Sketch for *The Battle of Nancy*, 1828–29
Oil on canvas, 47 × 68 cm. Ny Carlsberg Glyptotek, Copenhagen

94. *The Battle of Nancy, Death of Charles the Bold,*
Duke of Burgundy, 1831
Exhibited at the Salon of 1834. Oil on canvas, 239 × 359 cm. Musée des Beaux-Arts, Nancy

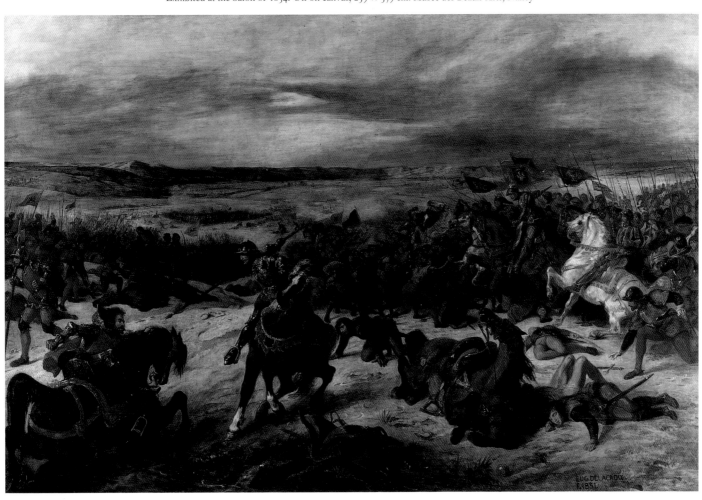

Bourbons and then the painter's voyage to Morocco), brought no recompense for his efforts. Much of the criticism was concerned with the liberties that Delacroix had taken with history. He was blamed for not having reconstructed the exact circumstances of the death of the Bold, pictured here in the middle of the combatants when in reality he was killed alone, away from the battle. The presence on the canvas of his two principal adversaries—Charles at the bottom left, and Duke René of Lorraine in the midst of his cavalry at the right (recognizable by the ornament at the top of his helmet)—was also questioned. The unlikeliness of a scene in which the duke was to be killed without the intervention of his troops, assembled around him, was also pointed out. The critics misunderstood the intentions of the painter, who without any doubt rightly wanted to represent the two camps in the presence of their chiefs in order to grasp better the historical reality, and they took no account of the very large size of the format, which made it impossible to hold to the single figure of the Duke of Burgundy and which required a multitude of figures. In fact, Delacroix had made a true and new battle picture. In a great landscape of snow that recalls the field in Gros's *Napoleon on the Battlefield of Eylau* (as the white horse is perhaps reminiscent of the *Battle of Nazareth*), the two armies meet in the middle distance: to the left the Burgundians, to the right the Lorrainese. The foreground is occupied by several isolated groups. On one side lie the wounded or dead around a downed horse; on the other, the Sire de Bauzemont prepares to thrust his lance into Charles the Bold, disarmed, losing his helmet, almost dismounted, his horse struggling in the icy water. Delacroix's audacity was to report this central episode in one of the corners of the painting, accentuating still more the disequilibrium of Charles and the movement that his adversary is about to make. It should be noticed that Duke René de Lorraine, in the background, symbolically repeats almost the same gesture against an infantryman who threatens him. In the melee that occupies the center of the painting, where the Burgundians on foot try to stop the Lorrainese cavalry, the painter multiplied the picturesque episodes that give life to the battle: a soldier picks up an abandoned weapon, wounded men try to get out of the way but are not strong enough to walk, a crossbowman draws and is about to shoot his bolt, hidden behind the cadaver of a horse, some archers watch the fight, a man runs away; one sees the beginnings of the coming defeat. This juxtaposition, while not altogether likely, nevertheless renders the spirit and truth of a battle. The spectator, before entering into the individual details of the confrontation, with all that it contains of greatness and of misery, sees first the masses, and a single engagement that sybolically recapitulates the scene. The lances of the Lorrainese cavalry, vertical at the right of the picture, slant progressively beginning with the standards, and prolong themselves into the single weapon of Bauzemont, whose gesture is, from every point of view, at the center of the composition. Delacroix had distributed notes of vivid color among the figures, but they have disappeared today because of his use of bitumen (the yellowing is due to the varnishes). A contemporary copy in the Musée Lorrain in Nancy allows us, if we forget about its mediocre aesthetic quality, better to discern Delacroix's intentions. The gaze should have been drawn to the group consisting of Bauzemont and Charles the Bold by vivid touches, notably on the carpet of the duke's saddle and on the escutcheon decorating the breast of his adversary's horse.[84] Although this aspect escapes us today, we should recognize that by its composition alone, the expression of the figures, the force and life that come from the details as well as from the ensemble, *The Battle of Nancy* is indeed one of Delacroix's masterpieces.

If he took several years to finish *The Battle of Nancy*, after having executed most of its composition in a few months, he did finish another battle scene much more rapidly. Of small format, and exactly its contemporary, is *The Battle of Poitiers* (fig. 92). Commissioned in 1829 by the Duchess de Berry, daughter-in-law of Charles X and mother of the heir presumptive (the future Count de Chambord), the painting was finished just before the revolution of 1830. The duchess, who had not paid for it, took it with her into exile and sold it. Delacroix got the painting back, under circumstances that remain unclear, and kept it a short time before reselling it. It was publicly exhibited only in 1855, at the Exposition Universelle, where it was not much noticed. Passing then into various private collections, it reached the Louvre rather late, in 1931. Always eclipsed by better-known or more popular works, it is one of the least familiar paintings of Delacroix. Wrongly so, for, as in *The Battle of Nancy* and later in *The Battle of Taillebourg*, he was able to show war in its timeless aspects while reconstructing the particular details of a specific, dated, historical event. The Battle of Poitiers, fought on 19 September 1356

against the English, is one of the great French disasters of the Hundred Years' War. The king, John the Good, was made prisoner after a heroic struggle, which Delacroix represents here: the sovereign faces the final assault of his enemies, aided by his faithful men and his son, the future Duke of Burgundy, Philippe the Bold, who assists him with his famous "Father, watch the right! Father, watch the left!" The duchess had commissioned the subject at the same time as *Quentin Durward and le Balafré*, discussed earlier. It shows once again the general taste for the Middle Ages, of which the duchess was one of the most active champions, but it also has perhaps a certain political slant, in that it demonstrates the courage of the French king. Should we also see in it a reminder of the recent struggle against the English, or even an allusion to the situation in France in 1829–30?[85] That is doubtless going too far, and these implications seem to be irrelevant to the painting, even if the duchess was aware of them—which is questionable— or if Delacroix was—which is not at all certain. Comparing the painting with the sketch (fig. 91) makes Delacroix's design evident. The sky, which occupied only the upper third of the sketch, takes up half of the finished canvas. It is cloudier and also darker; the artist has preferred an expressive harmony of yellows, beiges, and very light ochers to the original blues and whites. He has chosen a harmony that is perhaps more eloquent and evocative of the whole, in preference to a violent contrast of colors of which the interest would have been purely formal. He has lowered and slanted the horizon line, reinforcing the general movement and the dynamics of the combat—from the king at top left, to the wounded soldier at bottom right—passing by the group of three foot soldiers in the center. The banners, raised in disorder against the sky, accentuate the impression of confusion. From the sketch to the painting, Delacroix also refined the attitudes of the figures; for example, young Philippe appears less assured. The spectator is much closer to the action than in *The Battle of Nancy*. The king, who attracts the eye by virtue of his white clothing and the dead white horse against which he leans, is almost encircled. The English are at his right and his left, and only the shield of three lords pressed close together separates him from them in front. At first view, the two camps are relatively indistinct (some combatants are even interlaced in furious hand-to-hand fighting), but little by little one distinguishes between them. As in *The Battle of Nancy*, the ardor

and intensity of the struggle are first conveyed in individual instances before characterizing the collective. The turbulence of the figures is echoed in the blacks, browns, golds, and reds that are scattered over the whole of the lower half of the canvas. One wonders whether the requirements of the commission weighed less heavily on Delacroix than they did in his other battle scene, even though he took the same care to be exact in the minutely studied costumes and armaments. His mastery seems to be firmer here as he integrates into a coherent and expressive whole the particular episodes that compose it.

These paintings naturally belong with the "medieval" work that Delacroix did during the second half of the 1820s, being distinguished only by the historicity of their subjects. But all the same, he did not entirely escape into the past after the *Massacres of Chios*. In addition to the Orientalist paintings that directly or indirectly refer to contemporary events in Greece, one large format painting continues in the same vein, at the same time that it prepares the way for *Liberty Leading the People*. Traditionally called *Greece Expiring on the Ruins of Missolonghi*, after Robaut, it had been given a slightly different title by Delacroix: *Greece on the Ruins of Missolonghi* (fig. 95). The painter always insisted on its specific genre, allegory.[86] For him it was a new and original direction in the representation of history, which until then he had always approached through narrative and description.

Why did Delacroix passionately dedicate himself to a second homage to the Greeks in their fight for independence? The fall of Missolonghi, which was finally captured by Turkish forces in 1825, after several successive sieges beginning in 1822, had aroused public opinion; and for Delacroix the news rang with much more personal resonance: Byron had died there the year before. Nothing, however, suggests that he did this big painting under the shock of the news. The work is perfectly controlled and planned out. Delacroix, in confronting a very special branch of history painting, thought for a long time about his subject and how to treat it, as is shown by a series of sketches in an album that is today in the Louvre.[87] The original idea of a young woman personifying Greece was susceptible to numerous variations in detail: the painting could be vertical or horizontal, the attitude and expression of the principal figure could be more or less static, she could be standing or kneeling, surrounded by people or alone. One notebook sheet with some sketches of heads and boots carries

the following annotations: "The patriarch fallen on his knees, dying [an allusion to the execution of the patriarch of the Eastern Church, Gregory V, on Easter Day 1821, which had revolted Western opinion]—A workman soldier covered with sheepskin—Vultures and scavenging dogs—Flaming debris pushed to the shore." A veritable sorting of ideas seems to have taken place. In the end Delacroix arrived at his definitive composition, vibrating with contained intensity, in which Greece—a young woman in national costume—presents herself, palms out, chest half bared. In the middle distance, at the right, is a Turkish soldier posing triumphantly. The arm of a corpse buried under the rubble in the foreground evokes the struggle that has just ended, as does the blood still running on the stone at bottom center. There is nothing overdone or declamatory; one finds only the calm grandeur appropriate to allegory, the expressiveness coming as much from the treatment of color and the management of the brush as from the subject. The tones are somber, the range voluntarily muted, as in the costume of the Turk. The rare bright tints make the central figure of Greece stand out with her white cap heightened with rose, her white robe, the white lining of her cloak, and the blue-gray of her trousers. Delacroix avoided the tedium of a palette composed of somber colors by heightening it with more lively, still restrained tones: the orange of the Turkish soldier's turban and belt, the red in the foreground on the dead man's sleeve and on Greece's slippers, and the gold embroidery of her cloak. The variations in handling reinforce the subtlety of the color, as they did in the *Massacres of Chios.* One need only study the astonishing spot of blood on the stone to grasp Delacroix's talent in the almost impressionistic rendering of matter and to understand why this realism could be shocking.

Greece on the Ruins of Missolonghi aroused a certain interest when it was shown at the Galérie Lebrun in 1826, at the exhibition held to benefit the Greek insurgents. But it was, it seems, a mostly negative reaction. One of the rare critics to have expressed himself on the painting was Boutard, who wrote in the *Journal des Débats,* "Talent is evident, struggling in a singular manner with the systematic vagaries and disordered technique of the artist, as one sees gleams of reason, sometimes even strokes of genius, showing through the deplorable discourse of insanity."[88] Hugo showed himself much more positive without, however, completely understanding

the artist's intent. In his review he limits himself to a very general interpretation: "M. Delacroix has just delivered to their [the critics'] ill humor and to the heightened attention of an enlightened public a new canvas in which one again finds to a great degree all the qualities of this young and already great colorist. It is Greece on the ruins of Missolonghi. We do not like allegories; but this one is profoundly interesting. This woman, who is Greece, is so beautiful in attitude and expression! This triumphant Egyptian, these severed heads, these stones stained with blood, all of it has something so pathetic! And then there is such knowledge and art in M. Delacroix's daring! His brush is so broad, so proud, and especially so true!"[89] The painting was misunderstood until its purchase by the Musée des Beaux-Arts of Bordeaux in 1851; although it was exhibited many times between 1826 and 1830 (for example, in England in 1828, but never in the Salon), it did not find a buyer. In Delacroix's mind, it was no doubt intended for a public collection, as were *The Barque of Dante, Massacres of Chios,* and *The Death of Sardanapalus.* But no connoisseur was found who could be seduced by this moving figure of a woman that, in its realism, renewed and modernized the already disused genre of allegory. It is not certain that this figure is fully appreciated in just measure today.

Greece on the Ruins of Missolonghi is also an essential step toward *The 28 July.* To use the exact title that Delacroix gave the painting, *Liberty Leading the People* (fig. 96) was no doubt his most famous and popular work.[90] There is yet again a certain ambiguity concerning the intentions of the painter in treating this subject, a question posed here with much greater acuity than in the rest of his work. One can make infinite glosses and propose literary or philosophical analyses without much risk of being proved wrong. One can find in one picture or another the expression of Delacroix's love of women, or his attraction to death, or his flight into the past or into a more-or-less inaccessible elsewhere, in a word, the expression of his rich sensibility. In the case of *Liberty Leading the People,* the question is reduced to fundamentals: the canvas is obviously symbolic and clearly charged with meaning; how then does it reflect the political opinions of Delacroix? He painted it at exactly the time of the Three Glorious Days, between October and December 1830,[91] and the title he gave the work invites us to place it in precise historical context, or at least to identify its beginnings.

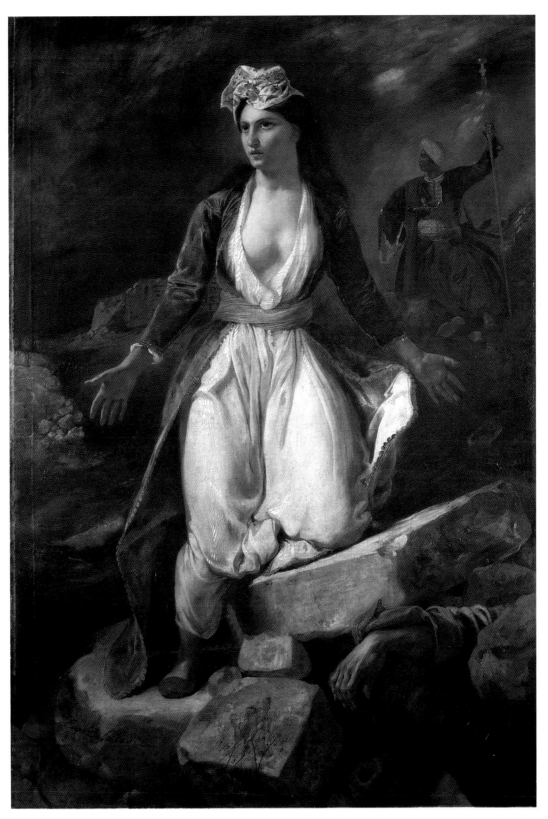

95. *Greece on the Ruins of Missolonghi,* 1826
Oil on canvas, 209 × 147 cm
Musée des Beaux-Arts, Bordeaux

Two sources inform us about the painter's reaction to these events. The memoirs of Alexandre Dumas, to be used cautiously as always, have often been cited: "When I saw Delacroix near the Pont d'Arcole on 27 July, he pointed out a few of these men that one only sees in times of revolution, who were sharpening their weapons on the pavement, one had a saber, the other a foil. Delacroix was terribly afraid, I tell you, and showed his fear in most energetic fashion. But when Delacroix saw the tricolor flag floating above Notre Dame, when he recognized—he, a fanatic of the Empire, whose father was prefect under the Empire of the two most important cities of France, whose brother, having been promoted to general, was wounded on five or six battlefields, whose second brother had been killed at Friedland—when he recognized, we have said —he, the fanatic of the Empire—the standard of the Empire, ah! *ma foi*, he did not restrain himself! Enthusiasm replaced fear, and he glorified the people, who at first had frightened him."[92] Delacroix's correspondence fills in Dumas's description without contradicting it: "What do you think of these events?" he wrote on 17 August 1830 to his nephew Charles de Verninac at his post in Malta. "Isn't it the century of unbelievable things: we who have seen it cannot believe it. . . . For three days we have been in the middle of shooting and gunshots, for there is fighting everywhere. The simple pedestrian like me has exactly as much chance of being shot, neither more nor less, as these improvised heroes who march against the enemy with bits of iron attached to a broomstick handle. Up to now things are going the best way possible. Everybody who has any sense hopes that the promoters of the republic will agree to stand at ease."[93] And to his brother Charles, a little later, in October, he writes: "The spleen is going away, thanks to work. I have undertaken a modern subject, *A Barricade* . . . and if I have not fought for the country, at least I will paint for her. This has put me in a good mood."[94] Pierre Gaudibert, in an article published on the occasion of the centenary exhibitions in 1963, has shown how, in 1830, it was possible to confuse Republicanism and Bonapartism, a confusion that was no longer possible after 1848, the moment when Delacroix's opinions became more firmly "rightist."[95] Probably frightened by the beginnings of the uprising, he was then convinced by the turn of events and the accession of Louis-Philippe. The stabilization of the situation, the consolidation of a constitutional monarchy reintegrating the acquisitions of the Revolution and especially of the Empire, were satisfactory in every way. After the fact, Delacroix favored the July Revolution. Probably he neither expected it nor hoped for it, as critical as he had been of the Bourbons in his caricatures, which go back, it is true, to 1818–22. His friendships were liberal, but he had no complaints regarding the regime, which had bought his major paintings and had just commissioned others. *Liberty Leading the People* retrospectively explains his sentiments, while reconstructing the momentum that was then shared by many. As Dumas's lively passage indicates, the painting "has a great quality: it lives the life of 1830, it breathes an atmosphere charged with saltpeter, it teems under the July sun. . . . These are real paving stones, real boys, real men of the people, real blood; and the soldiers, how well they are killed! look at the cavalryman in the corner. . . . That Liberty is not at all the classic Liberty; it is a young woman of the people, one of those who fight not to be *tutoyée*, outraged, violated by the great lords."[96]

What Delacroix painted is first of all a scene of riot, in the most realist manner. It does not, however, occur in an exactly identifiable context, as Charles Lenormant understood: "Is it not a real tour de force to have painted at a distance of five months a Barricade that is true, beautiful, and poetic all at once? Delacroix seems to me to have perfectly understood the matter from a perspective as short as our own; he has not tried to paint the barricade at a particular crossing, which would provoke someone to demand an account of the paving stones or a forgotten bullet. An open scene, a cloud of smoke through which the towers of Notre Dame, in the distance, designate very generally the city where the great Revolution has taken place, dispensing with all topographical explanation; the actors on the scene are the same ones that one saw everywhere and that one does not recall having precisely met anywhere."[97] The characteristic clothing of the different personages immediately identifies them as belonging to a certain type of rioter.[98] Thus, in the three men at the left, there are three precise categories of worker: the factory worker (the man with the saber); the artisan, foreman, or chief of a workshop, higher up in the social hierarchy (the man with the gun, often considered a bourgeois or a student); and the worker from the country, probably employed in the building trade (the man kneeling at Liberty's feet). In the background, one recognizes the cocked hat of a *polytechnicien*, whose school distinguished itself in the

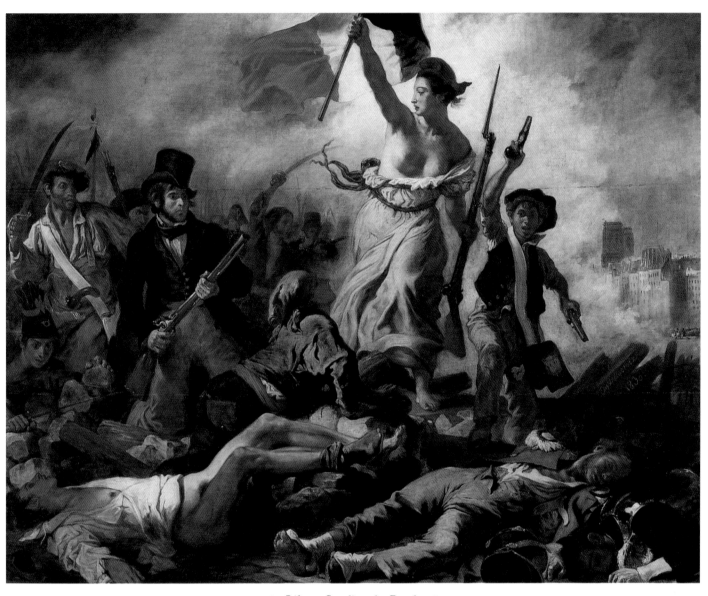

96. *Liberty Leading the People,* 1830
Exhibited at the Salon of 1831. Oil on canvas, 260 × 325 cm
Musée du Louvre, Paris

uprising. The two dead soldiers at right, a Swiss guard and a cavalryman, belong to regiments of the royal guard that had fought the insurrection. The bits of uniform and the weapons (including the one recovered by the revolutionaries) are perfectly identifiable and are painted with the greatest exactitude. As for the setting, particularly Notre Dame (of which the silhouette is easily recognizable and from which waves the tricolor), the angle of vision that Delacroix adopted—with the cathedral seen from the left bank and hidden by houses on the quay—was completely impossible at the time. He has rearranged the setting to suit his convenience without losing the necessary verisimilitude.

Liberty Leading the People is a realist painting, including even those figures who are the most emblematic, Liberty herself and the urchin who accompanies her. He is often identified with Gavroche, but in fact the character was born more than twenty years after the painting was done. Delacroix created an archetypal image to which Hugo would give a literary equivalent in *Les Misérables*.[99] As for Liberty, she is first of all, to use Lenormant's terms again, "a young, strong, brilliant woman, dressed like one of the people, but shining with an unknown light, odd, however, in the nudity of her shoulders, the bonnet on her head, the standard that moves in her hand. This woman, whom many people would think for a moment is one of their acquaintances, so much is she of our time and place—this woman is none other than the Liberty of the people. No doubt someone will complain about the appearance of this allegory; as for me, I found it so living, so true, so tied to the subject it poetically subsumes that I could not help deciding in favor of M. Delacroix."[100] The artist may have been inspired by more precise sources: a poem by Auguste Barbier celebrating Liberty as "a strong woman with powerful breasts" or the memory of an episode of the July days known through an anonymous handbill describing a young laundress in her apron, who, finding her brother dead, fires on the Swiss guard before being killed herself by a lancer. Delacroix may also have been thinking of a painting by Le Barbier, *Jeanne Hachette at the Siege of Beauvais*, done in 1778 (lost at Beauvais in 1940). Various antique models (Lee Johnson suggests the *Venus de Milo*) and modern ones (in particular Raphael) are equally possible. All of these fade before a new and original creation in which the real and the ideal are indissolubly united. The head seen in profile, as on a medallion, the bared torso, the red bonnet (brighter before Delacroix progressively muted it),[101] the determined and deliberate gesture, the tricolor flag—they transform the woman of the people into the figure of Liberty. The composition of the canvas also accentuates her symbolic character. She stands out as the summit of a pyramidal structure solidly resting on the cadavers in the foreground, souvenirs of Gros and David (the half-nude man at left recalls the traditional academic figure called "Hector" in the ateliers, somewhat subverted by the stocking that he is still wearing). Her relatively static position is not incompatible with the diagonal movement, which makes the entire work more dynamic. The warm tonality of the whole also emphasizes the figure of Liberty, who stands against a background of clouds, subtly recalling the three colors of the flag, the single vivid note of the canvas.

The painting was understood in various ways when it was shown at the Salon of 1831.[102] The realistic representation of the rabble (Heinrich Heine even spoke of "heads from the Court of Assizes")[103] shocked most of the critics, although political opinion was not a determining influence: leftist or rightist tendencies were less important than aesthetic presuppositions. The figure of Liberty was called working class, a fishwife, a whore. Some critics did recognize Delacroix's daring in reworking and renewing the traditional iconography. Thoré, revisiting the painting in 1837, praised it for having modernized sacred pictorial conventions and for adapting them to modern times: for him, *Liberty Leading the People* "is both history and allegory. Is this a young woman of the people? Is it the spirit of liberty? It is both; it is, if you will, liberty incarnate in a young woman. True allegory should have this quality, of being at the same time a living type and a symbol, as opposed to the old pagan allegories that are no longer anything but dead forms. We cannot adopt these banal mythological allegories, which no longer represent the idea for which they were created. The Greek Minerva is no longer the modern myth of wisdom. It seems to us that the things of contemporary civilization, like those of ancient civilization, can best be personified in living and original forms. . . . Here again, M. Delacroix is the first to employ a new allegorical language."[104]

The canvas, which won the cross of the Legion of Honor for the painter, was bought at the Salon by the Minister of the Interior and immediately placed in the Palais du Luxembourg.[105]

But its fate during the whole of the nineteenth century reveals the scandalous and subversive charge that it seemed to raise against conservative governments. The painting was taken down from the wall in 1832, when the republican opposition was becoming increasingly violent and when the July Monarchy was turning in a less and less liberal direction. Finally it was returned to Delacroix himself, no doubt in 1839, when his friend Cavé was Director of Fine Arts. The work was requested of him again after the revolution of 1848. Thoré suggested at that time that the painter make a companion piece, *Equality on the February Barricades*, and that the two be hung together in the Palais-Bourbon. The matter was settled by reinstating the painting once considered dangerous at the Luxembourg, where it remained until its disappearance into storage in 1850, when the director of the national museums, Jeanron, was replaced by a protégé of the Prince-President, Nieuwerkerke. Delacroix wanted *Liberty Leading the People* to be included in the Exposition Universelle of 1855 in the retrospective that was dedicated to him. He addressed a request to Prince Napoleon, who was in charge of the artistic section, and justified himself in these terms: "This work, which represents a fact of history, did not seem to the former government proper to be shown to a generation that is far from having repudiated the consequences of that event. It has seemed to me that under a powerful government, itself borne of a great national manifestation, this painting could be removed from oblivion."[106] Nieuwerkerke was of a completely different opinion: "I hope you have been kind enough to transmit to His Royal Highness the important reasons that, from my point of view, argue against the exhibition of a painting representing liberty in a red bonnet at the top of a barricade and French soldiers trampled under the feet of the riot [he had first written, 'the populace']."[107] The canvas was finally presented to the Exposition after a decision made by Napoleon III himself, according to Dumas.[108] But it was not reinstated at the Luxembourg until 1861, then it was moved to the Louvre in 1874. The political meaning of *Liberty Leading the People* was evident to contemporaries and to the painter himself. It was reinforced in a way by the iconographical slippage of the figure of the Republic, with which Liberty was finally confused.[109] Thus the extraordinary fate of this painting is explained, unique for Delacroix and probably for all of French painting.[110] Its exceptional popularity was symbolized by its

use on the hundred-franc bill in 1979, and on a postage stamp in 1982.[111] But even then, some were offended by Liberty's bare breasts.

Delacroix thus saw his work escape him, taking on a deeper meaning than he had probably thought of. But one ought not to neglect what the painting meant from a strictly stylistic point of view. *Liberty Leading the People* stands out not only for its theme, but also for its return to Classicism, not only in its use of allegory but also in its composition. The paintings that Delacroix sent to the Salon of 1831 included some that were clearly more romantic: *Cromwell at Windsor Castle, Cardinal Richelieu Saying Mass in the Chapel of the Palais-Royal*, and especially *Tam o' Shanter* and *The Murder of the Bishop of Liège*. With *Liberty*, however, one senses the affirmation of a less fiery vein, one that is more reflective, almost more sensible. This is confirmed in two history paintings that occupied Delacroix at the beginning of 1831: *Mirabeau Confronts the Marquis de Dreux-Brézé* and *Boissy d'Anglas at the National Convention*. In September 1830, Guizot, now Minister of the Interior, had announced a competition for the decoration of the meeting room at the Chambre des Députés. At the center of the wall behind the presidential rostrum there was to be *The Royal Session of 9 August 1830, where the King Louis-Philippe I accepts the Constitutional Charter*. At the left, another painting was to show *The Session of the Constituent Assembly of 23 June 1789, when Mirabeau replies to the master of ceremonies [the marquis of Dreux-Brézé] who urges the assembly to dissolve: "Go tell your master that we are here by the order of the people, and that we will leave only under the power of bayonets."* At right, a pendant was to show *Boissy d'Anglas, President of the National Convention, saluting the head of the Deputy Féraud that the rebels of 1 Prairial, year IV, present to him as a menace*.[112] Guizot had chosen the subjects himself, selecting them "exclusively from our legislative history during the French Revolution. The deputies, and the country that is anxious to hear them, need to see examples of motifs that connect them to constitutional institutions." Hence, the choice of the vow taken by Louis-Philippe, a dignified close to "the series of events to which we owe our political guarantees," and of the two other scenes, which represent the two principal duties of the deputies: "the resistance to despotism and the resistance to sedition." For the first time in his career (and it was to be the only one), Delacroix was confronted with a rigorous iconographic program

97. Preliminary sketch for *Mirabeau Confronts the Marquis de Dreux-Brézé*, 1830–31
Oil on canvas, 68.2 × 81.7 cm
Musée du Louvre, Paris

requiring historical exactitude—since the events were recent enough that eyewitnesses were still living—and an ideological content that necessarily affected the composition. In addition, one must consider the principle of competition, to which Guizot had been led by strictly ideological reasons (he would have preferred to give the commissions to the painters whom he considered the masters of the French School, Ingres, Gérard, and Delaroche). These factors posed many new constraints for Delacroix. There was also the prestige inherent in the place for which the paintings were intended, and perhaps also the challenge of winning. He decided to do the *Mirabeau* and *Boissy d'Anglas*. The sketches were due respectively on 1 February and 1 March. Busy with preparing for the Salon, he and twenty other painters asked for a delay, which was refused. In each case Delacroix was among the artists selected from all the competitors for the final choice, but in the end he did not win. Alexander Hesse got the *Mirabeau*, and Vinchon the *Boissy d'Anglas*.

The results of the competition (Coutan won for the *Vow of Louis-Philippe*) caused a stir in the artistic world. Delacroix, at the request of the director of *L'Artiste*, who had favored him, gave his opinion in a letter published in the review. The principle of competition, he said, seems to be the fairest and most democratic. Still, it is imperative to find independent, impartial, honest juries, and to define the objective of the competition. Is it a matter of "finding talent above all, or only of obtaining works with enough acceptable qualities so as not to be shocking in the spot that they are going to occupy?" The artist must restrain his inspiration in order to please: "Shut up in an atelier, inspired by his work and full of that sincere faith that alone produces masterpieces, if he happens by chance to think about the stage where he is to play a part or the judges who are waiting for him, his force dries up immediately. He glances sadly at his work. . . . He becomes then his own judge and executioner. He changes it, he spoils it, he wears himself out; he wants to civilize himself and polish himself so as not to displease." In short, competitions encourage mediocrity and destroy innovation, so greatly is the chosen subject deflowered by thirty or forty other attempts. "The arts were better off before they became an administrative thing," Delacroix concluded. "When Leo X wanted to have his palace painted, he did not ask his Minister of the Interior to find him the most worthy painter: he simply chose Raphael because his talent pleased him; or, maybe, because he liked him."[113] This plea for the artist's independence and for arbitrary choice on the part of the commissioner found many resonances in the personal

98. *Mirabeau Confronts the Marquis de Dreux-Brézé*, 1831
Sketch presented for the competition for the Chambre des Députés
Oil on panel, 77 × 101 cm
Ny Carlsberg Glyptotek, Copenhagen

situation of Delacroix, who never again entered a competition. But beginning in 1833, Delacroix obtained from the government an exceptional series of commissions for great decorative works for various prestigious public edifices—the Palais-Bourbon, the Chamber des Pairs, the Louvre, the Hôtel de Ville in Paris—allowing him great liberty in most cases in the choice of subject and the execution of the programs. His failure of 1830 had from this point of view no follow-up.

But what about his paintings? Were they as weak and impersonal as one would think after having read his opinion? Far from it, and that is probably the reason for his failure in the competition. *Mirabeau Confronts the Marquis de Dreux-Brézé* (fig. 98) is the more sober of the two projects. One must not confuse the definitive sketch, entered in the competition, with the preliminary one (fig. 97), all energy and liberty, where Delacroix places the large masses of the composition. There are not many changes from the one to the other: general darkening of the background, which emphasizes the light row of heads of the deputies lined up to support Mirabeau (Bailly is recognizable beside him), suppression of a *roi d'armes* behind Dreux-Brézé so that the throne of Louis XVI appears, and modification of the seats at the right—the armchairs (which Delacroix thought were reserved for the nobility) becoming

benches, more in conformity with the historical truth (the room had been scrupulously restored from engravings of the time). The confrontation of the two men thus acquired its symbolic weight. Discussing their respective sketches with Chenavard in 1854 (Chenavard's is in the Musée Carnavalet), Delacroix insisted on this: "I told him that an absolute truth can give an impression contrary to truth, at least the truth that art should suggest; and, thinking it through, the exaggeration that brings out the parts that are important and ought be striking is completely logical; you have to lead the mind to that. On the subject of Mirabeau at the Versailles protest, I told him that Mirabeau and the Assembly ought to be on one side and the king's envoy all alone on the other. His design, which shows balanced and organized groups, in various poses, the men talking among themselves in a natural manner, is well-arranged for the eye and follows the rules of composition; but the mind absolutely does not see it as the Assemblée Nationale protesting against M. de Brézé's injunction. The emotion that animates a whole assembly as it animates a single man must be expressed absolutely. Logic requires that Mirabeau be at their head and that the others gather behind him, attentive to what is happening: all minds, like that of the spectator, are intent on the event. . . . The arrival of M. de Brézé

was perhaps not announced in such a way as to find the Assembly united in a single group to receive and confront him; but the painter can't otherwise express this idea of resistance: the isolation of the figure of Brézé is essential. . . . In this very characteristic scene where the throne is on one side and the people on the other, [Chenavard] puts Mirabeau by chance on the same side as the throne, where, another inconvenience, workers are going up to tear down the draperies. The throne has to be isolated too, as abandoned as it was then, morally, by everyone and by opinion, and especially it is essential that opinion stand face to face with it."[114] Delacroix gives us here his conception of the representation of history, which does not differ fundamentally from the ideas that he develops elsewhere on the illustration of literary texts. Notice that the faults that he finds in Chenavard exist equally in the winning painting, by Hesse, which does present, however, numerous portraits. But would Delacroix's sketch, expressive in its mid-size format, have been as effective if enlarged (the completed paintings were to be about five by six meters)?

The second composition, *Boissy d'Anglas at the National Convention* (fig. 99), certainly would have been. At the time, it aroused enthusiasm among Delacroix's usual supporters. The painter Louis Boulanger, a close friend of Hugo and a friend of Delacroix, took up his pen to defend it in *L'Artiste*. "My painter is Delacroix. . . . *That* is alive, it moves, whirls, quickens the flow of blood in your arteries. . . . It is the accent of nature grasped in all that is most intimate, most unexpected—precious qualities that alone reveal the great painter, but unfortunately too often reveal him to only a few."[115] Silvestre is equally sensitive to the rendition of the scene: "The people rush like an angry river into the rooms of the National Convention. Walls, stairways, and galleries crack and reel; workmen, clubbists, and bums climb over each other, breaking their limbs; the representatives are immobilized; the president fearlessly contemplates Féraud's bleeding head, presented to him on the end of a pike, and the knitters leaning from the top of the balconies break into thunderous applause. A rare day painfully pierces the room above the teeming heads; dust raised by the trampling floats in eddies in this stormy atmosphere, shot through with the livid light of bayonets."[116]

Greatly darkened and less visible today, Delacroix's sketch, which caught the event at its dramatic climax, at the moment when Féraud's head is presented on the end of a pike to Boissy d'Anglas, who rises in horror, has not lost much of its force, unless in the details of the figures. The riot extends from the top of the benches, at the left, to the tribune of the president, at the right. Boissy d'Anglas, alone, standing, under the flags, hat in hand, is at the top of a rising pyramidal mass that opposes the descending pyramid of the people of Paris. A few courageous but isolated individuals, grouped to the right of the canvas, resist the undifferentiated mob. Compared with Vinchon's painting (in the Musée des Beaux-Arts in Tours), Delacroix's sketch, combining expressiveness with historical truth, wins with no possible dispute, and one can with good reason regret that he did not execute it in a large format.

Mirabeau and *Boissy d'Anglas*, as paintings that reconcile imposed restraints with Delacroix's personal fire, are somewhat extraneous to or distant from the rest of his work. But they mark a turning point, or at least a clear change, in his artistic development. Delacroix had been straining in two different directions: toward an increasingly exacerbated Romanticism, and toward a more controlled painting where classical discipline was evident. The first direction runs from *Faust* and *The Death of Sardanapalus* through the *The Combat of the Giaour and Hassan*, *The Murder of the Bishop of Liège*, *The Battle of Nancy*, and *The Battle of Poitiers*. The second begins with *The Barque of Dante* and *Scenes from the Massacres of Chios*. By way of *Greece on the Ruins of Missolonghi*, this other direction gives us *Liberty Leading the People* and, as an appendix, *Mirabeau Confronts the Marquis de Dreux-Brézé* and *Boissy d'Anglas at the National Convention*. The rapid succession and almost simultaneous execution of important works that are very different from one another suggest that around 1830 their author was undergoing, if not doubt, at least the search for a synthesis. Delacroix seemed to find himself at an impasse in trying to fuse contradictory elements. It was then that a fortuitous event occurred that was to have definite consequences for his further evolution; at the end of 1831, he was offered the chance to go to Morocco. The voyage would opportunely reshape the course of his work.

99. *Boissy d'Anglas at the National Convention*, 1831
Sketch presented for the competition for the Chambre des Députés
Oil on canvas, 79 × 104 cm
Musée des Beaux-Arts, Bordeaux

CHAPTER FOUR

The Voyage
to Morocco

Can one imagine Delacroix without the *Women of Algiers in Their Apartment*, the *Jewish Wedding in Morocco*, or *The Sultan of Morocco*? Moroccan subjects make up a major part of his work, whether they are done in painting, watercolor, lithography, or etching, or whether they are depicted in sketches and drawings done during his sojourn in North Africa, in notebooks or on loose sheets, rarely mounted, less known but equally seductive. His place in the history of French nineteenth-century painting cannot be assessed without a consideration of his role in the Orientalist movement; it of course existed before him, but he gave Orientalism an entirely new and very personal impulse, as did Horace Vernet and Decamps. The six months that he spent in North Africa, when he was invited to accompany Count Charles de Mornay, ambassador extraordinary from Louis-Philippe to the ruler of Morocco, were a formative experience. Before this trip, Delacroix knew the East only secondhand. He knew the Turkey and Egypt of Gros, Girodet, and Monsieur Auguste, and had gathered impressions of the land and its customs from the stories of voyagers. Of course, he also knew Byron's poems and was familiar with the various objects, weapons, and clothing that friends and relations had brought back from Greece and the Middle East. He had relied on these things, as well as on his characteristic attentive study of the prints available in the studios, at the dealers, or in the cabinet of the Bibliothèque Royale, to produce the work in his Greek vein that was at once imaginary and realistic. After the Moroccan trip, he relied on lived experience, on deeply felt personal impressions. There is a clear break, as much thematic as stylistic, and the influence of these few months is considerable, touching all his work.[1]

From his letters and journal, it does not seem that he was particularly eager to visit the other side of the Mediterranean. Only Italy attracted him, always a hope, always postponed. More generally, Delacroix was not, on his own, a great traveler. His trips to the country, in France, were always based on family or friendly relations, or dictated by strictly medical reasons. With the exception of Normandy in his youth, he almost never explored a region in search of unfamiliar motifs. And the only trips that he undertook outside of France, from the London visit of 1825 to the cure at Ems in 1850, most of them relatively short, were undertaken at the suggestion of friends or doctors. The Moroccan trip was very exceptional. It was, however, the result of mere chance. Delacroix was able to take advantage of an unsought opportunity that offered itself. The preparation for it was hurried; he had hardly a month between making the decision and the beginning of the voyage.

The conquest of Algeria, which the government of Louis-Philippe had pursued after the taking of Algiers in July 1830, had led to rather serious contentions with neighboring Morocco. It was decided to send an ambassador to the chief sovereign in order to resolve the differences between the two countries: to obtain the return of three French ships taken by the Algerians and kept in Moroccan ports, to regulate commercial questions, and to settle between the two countries the frontier of the new colony. The head of the mission had been appointed in mid-October 1831, with orders to proceed to Morocco as early as possible. Mornay, a dandy, a social leader, and the lover of the famous actress Mlle Mars, had certain apprehensions about this assignment. In addition to his servants, He was to have only two companions; an interpreter named by the administration, Antoine Desgranges, and an assistant in charge of the mail, François Ferrary. The prospect of long months away from Paris had nothing delightful about it for him. He had the idea of adding an artist so as to make the trip more agreeable. Partly by chance, more by social connections, the role fell to Delacroix, whom de Mornay had not known before. We have Mlle Mars to thank for the reasons and circumstances of this choice. Telling one of her friends about the departure of the embassy, after a New Year's Eve meal with Mornay and his traveling companion, for the voyage, she spoke of the latter: "Eugène Lacroix [*sic*], a young painter with wit, talent, worldliness, and an excellent character," she said, "which is not to be despised if you have to spend four or five months together and probably suffer some privations, for the trip is not easy or agreeable in all respects, and resolution is necessary; it is Duponchel who introduced them. Charles definitely did not want to go alone and I understand it; he first thought of the younger Isabey, the son, but he had been to Algeria and he refused, not tempted by curiosity; then I asked Duponchel to find someone among his artist acquaintances who would be happy to make the trip, and the thing was arranged to the great satisfaction of both parties. The government gave its permission, and our diplomat has gone in good and amiable company."[2] Duponchel was an old acquaintance of Delacroix, as were Armand and Edouard Bertin, sons of the founder and manager of the *Journal des Débats*. The two broth-

ers undertook to "attach" ["*accrocher*"] (this is their own term) Delacroix to Mornay.[3] It was not so much as a painter, but rather as a connoisseur of music, an opera lover, an ornament of the salons and brilliant conversationalist, that Delacroix was chosen. The two men must have understood each other perfectly. Delacroix, informing Duponchel about how things were going with the mission while the embassy was at Tangiers, thanked him for having introduced him to Mornay: "He is everything you said, and more. Every day I grow closer to him. One could not wish for a better traveling companion in any respects."[4] As to Mornay, he made almost no reference to Delacroix in his official correspondence, only a note in a letter to the French vice-consul in Tangier, Delaporte, while the embassy was en route for Meknès. Here he writes that "the whole caravan is in good health, the foolishness of the painter is tolerable and his good humor makes for good company."[5] Relations between the two men were to remain cordial well beyond the time spent together in Morocco. They were spoiled, however, when for financial reasons the diplomat sold paintings that Delacroix had given him or advanced to him, one of which Mornay had never even paid for.[6]

Delacroix had very little time to prepare for the voyage.[7] The minister had accepted his joining the embassy on condition that he pay for his food on the ship that was to take them from Toulon to Tangier, and, once there, assume all the costs of the sojourn. On 1 January 1832, at three o'clock in the morning, after spending New Year's Eve with Mlle Mars, Mornay and Delacroix set off for Toulon. The rest of the expedition joined them in early January. On the eleventh, the frigate *La Perle*, on which they embarked, cast off its moorings, bound for Africa.

The various stops on Delacroix's trip to North Africa are particularly well known. The many historians who have retraced them have had, as always, the benefit not only of his writings—in this case, the correspondence that he exchanged

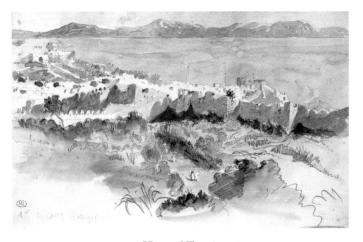

100. *View of Tangier*, 1832
Sheet from one of the Moroccan albums. Watercolor and pencil on paper, 19.3 × 12.7 cm. Musée du Louvre, Département des Arts Graphiques, Paris

with his friends and relations in France—but also his travel notes, rapidly jotted in his notebooks or more carefully edited, as well as the multitude of drawings done on the spot, often labeled with a few words or phrases. This source is obviously precious both for the events he lived through and especially, as we will see, for our better understanding of the importance of the Moroccan experience in his artistic and aesthetic development. In addition, there are reports and official correspondence conserved in France and abroad: Mornay's embassy interested the European chancelleries, which were kept informed by their local representatives. These various sources together allow us to follow Delacroix day by day, and even sometimes hour by hour.[8]

La Perle, after a voyage made difficult by an often stormy sea, stopped on 21 January at Algeciras. The Spaniards feared infection by the cholera then raging in France, so that replenishing their stores had to be negotiated with the authorities. Delacroix was able to accompany the sailors who were sent ashore for provisions, and so got a vivid impression of this first contact with Spanish soil, as he wrote shortly afterwards to Pierret: "I hoped to disembark both at Gibraltar, which is two steps away, as well as at Algeciras, but an inflexible quarantine prevented me. I did, however, touch the ground with the men who were sent for provisions. I saw the grave Spaniards dressed *à la Figaro* surround us with pistols, fearing infection, and throw us beans, salads, chickens, etc., and take our money, which we left on the sand of the shore, without giving it a vinegar bath. For me that was one of the most lively feelings of pleasure, to find myself transported, without having touched land anywhere else, to this picturesque country; to see their houses, the mantles that everyone wears, from the greatest rogues to the children of beggars, etc. All Goya throbbed around me. That was for a very short time."[9] This first contact was to be renewed a few months later. For now, Delacroix reembarked *La Perle*, which dropped anchor at

Tangier on 24 January (fig. 100). The French vice-consul, Jacques-Denis Delaporte, went on board to arrange the protocol for the reception of the mission. It landed the next morning, welcomed first by a delegation of foreign consuls, then the pasha of Tangier, Sidi Larabi Saïdi, the customs officer, Sidi Ettayeb Biaz, as well as the city's principal Moroccans. After a second formal reception the following day at the Casbah, Mornay, assisted by Delaporte and the dragoman of the French consulate, a Jew, Abraham Benchimol—carried on negotiations with the pasha and his administrator. These talks were necessary preliminaries to the ultimate objective of the voyage, the meeting with the sultan himself. The beginning of Ramadan on 4 February was one more reason for delaying the embassy at Tangier, as was the death, at the end of February, of one of the sultan's brothers. Delacroix thus stayed in Tangier until the beginning of March, about six weeks in all. He spent them in the midst of the diplomatic milieu, a separate community united by its identity but shaken periodically by various incidents and quarrels over precedence, in which, in any case, he took no part. He frequently visited the home of the British representative, Sir Drummond Hay, with whom he shared a love of horses, and whose wife had a certain talent as a watercolorist. But most of his day was devoted to the discovery of the city and its surroundings. Benchimol put him in touch with his relatives in the important Jewish community, which furnished abundant material for sketches and notations, in particular when he

was able to attend the marriage of one of the interpreter's children on 21 February.[10] Delacroix thus was put into contact with a civilization, a people whose customs very few artists had known before him, and which he could not have imagined before his departure from Paris (figs. 101–104). He experienced from the first moment the astonishment of discovery: "I have now arrived at Tangier. I have just walked through the city. I am dizzy with what I have seen," he wrote to Pierret almost as soon as he landed. "I do not want to let the mail go by, which goes to Gibraltar very shortly, without letting you know of my astonishment at everything I have seen. We disembarked in the middle of the strangest people. The pasha of the city received us with his soldiers all around. I would have to have twenty arms and forty-eight hours a day to give any idea of all that. The Jews are admirable. I am afraid that it will be difficult to do anything besides paint them: they are the pearls of Eden. Our reception was one of the most brilliant for the place. They regaled us with the most bizarre military music. At this moment I am like a man who is dreaming and seeing things that he's afraid will disappear."[11] He approaches this "really new and plentifully picturesque" country first of all as an artist.[12] A good part of his time in Tangier was to consist of making sketch after sketch, drawing in pencil, ink, and watercolor the places, the men, the most striking scenes that he could find. The country, the climate, the luminosity inspired him, and his routines were apparently well established after barely two weeks, in spite of

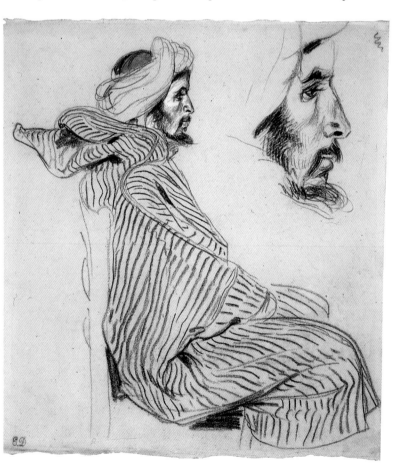

101. *Study of a Seated Arab*, 1832
Black crayon with red and white chalk on paper, 31 × 27.4 cm
The British Museum, London

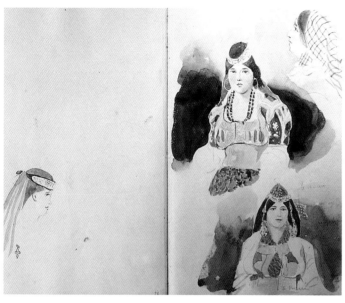

102. *Studies of Jewish Women,* 1832

Two sheets from one of the Moroccan albums. Watercolor and pencil
on paper, each 19.5 × 12.5 cm. Musée Condé, Chantilly

103. *Studies of Architecture,* 1832

Two sheets from one of the Moroccan albums. Watercolor and pencil
on paper, each 19.5 × 12.5 cm. Musée Condé, Chantilly

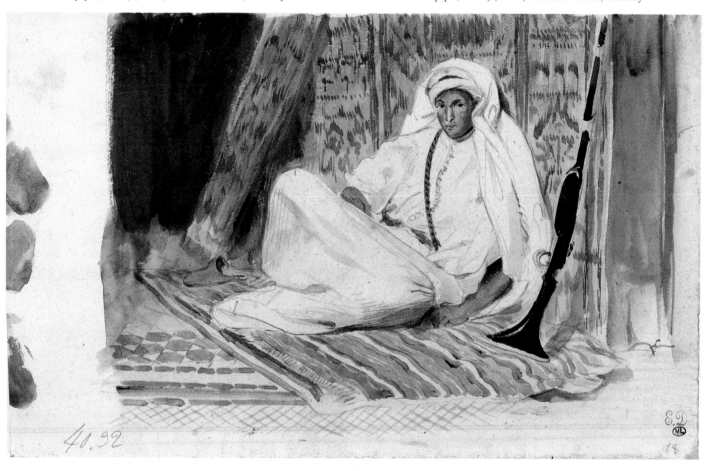

104. *Young Arab in His Apartment,* 1832

Watercolor and pencil on paper (at left, Delacroix's watercolor testing), 19 × 29.8 cm
Musée du Louvre, Département des Arts Graphiques, Paris

105. *Study of Arabs on Horseback,* 1832
Watercolor and pencil on paper, 15.5 × 21.6 cm
Nationalmuseum, Stockholm

his being European and despite the difficulties of an artist's life in Muslim countries. He writes: "I am really in a very curious country. My health is good, I am only a little worried about my eyes. Although the sun is not very strong yet, the brilliance and the reverberations of the houses all painted white tires me greatly. Little by little I adapt myself to the habits of the country, so as to manage to draw many of these Moorish figures easily. They are very prejudiced against the beautiful art of painting, but a few pieces of silver here and there appease their scruples. I go riding outside of town, which gives me infinite pleasure, and I have delicious moments of idleness in a garden at the gates of the city, under a profusion of flowering orange trees covered with fruit. In the midst of this vigorous nature, I feel sensations that I felt in my childhood. Maybe the confused memory of the sun of the Midi, which I saw as a very young child, awakens in me. Everything I will be able to do will be very little in comparison with what there is to be done here. Sometimes my arms give up on me, and I am sure that I will take away only a shadow."[13] He explained this feeling of relative powerlessness in the face of so much novelty a little later to the famous and influential marine painter Théodore Gudin, when the mission was preparing to leave for Meknès: "You, who have so well understood their character, will, I hope, be pleased to learn what joy I find in the midst of a people who are so different in many ways from other Muslim peoples. I have been surprised above all by the simplicity of their dress, and at the same time by the variety that they are able to give to the arrangement of the few pieces that make up their wardrobe. It is still too early in the season for me to be able to judge the full beauty of the country. We have been here for about a month, and we are all leaving for Meknès, where the emperor is now, and where he's supposed to receive us with all kinds of Moorish politeness, gun salutes, horse races, etc. You can imagine my admiration: you are the man best suited to appreciate such striking spectacles. Right now, I really pity artists gifted with some imagination who will never have an idea of the marvels of grace and beauty in these fresh and sublime natures."[14] Delacroix expresses similar ideas the same day in a letter to Duponchel. He insists on the quality and originality of the clothing and architecture of the Moroccans and emphasizes the picturesque quality of the country: "The costume is very uniform and very simple; however, the way it is adjusted gives it a beauty and nobility that is astonishing. I hope to bring back enough sketches to give an idea of the bearing of these men. And I will also bring back in the original most of the pieces of their dress. I will happily ruin myself to do that, and for the pleasure that you will have in seeing them. Then one has to weep at the impossibility of giving an idea of the charming details of the painting of their houses and the charming proportions of their architecture. . . . The Jews are very well, too, and their costume is very picturesque. I have been to several of their ceremonies; there are paintings to be made at every street corner. I have to admit that we do not have here any boulevards,

106. *Study of a Harnessed Mule,* 1832
Watercolor and pencil on paper, 12 × 18.6 cm
Musée du Louvre, Département des Arts Graphiques, Paris

nor the opera, nor anything that resembles it. The rue Vivienne is a collection of huts like those of the madmen of Bicètre, in which grave Moors in hoods like those of the Carthusians are piled together in the middle of rancid grease and six-month-old butter that they sell to people. All that doesn't smell like amber or benzoin, but I am not here for the pleasure of the senses; and the pure love of beauty makes up for a lot of inconveniences."[15]

The order finally arrived from the sultan, and the embassy started for Meknès on 5 March (figs. 105 and 106). Benchimol had joined them, along with his nephew and other members of the family, profiting from the escort furnished by the Moroccan authorities; the roads were not always safe, and an attack was to be feared. On muleback, they all started out, accompanied by horsemen sent by the emperor, under the order of the kaid Mohammed ben-Abou. Ettayeb Biaz made the trip also, responsible for the safe passage of the Frenchmen. To accommodate the Europeans, the trip was made in short stops, permitting Delacroix a closer contact with the Moroccan population in the villages they passed, and it afforded the opportunity for new experiences. On 6 March, he attended his first fantasia, given on the occasion of their passing into the province of Larache, when the brother of the pasha came to relieve Larabi Saïdi with four hundred horsemen. On 15 March, the caravan reached Meknès (figs. 107 and 108).

Delacroix's impressions during the fifteen days or so that he spent in the Moroccan capital must doubtless have been very different from what he had experienced in Tangier. The trip toward the south had prepared him for it; he found himself, once there, in another atmosphere ("it's furiously African at present," he wrote to Pierret upon arrival),[16] with a population less accustomed to Europeans, and especially with the presence of the sultan. Their entry was solemn, in the midst of a great concourse of people (convoked by imperial order). The embassy, escorted by soldiers, musicians, and standard bearers, made a circuit of the town "in an extremely deafening racket," in which the sound of musettes and drums was mixed with the noise of cavalry and infantry volleys,[17] and then was conducted to the guesthouse, where it was to remain in isolation until the imperial audience, for reasons of protocol but especially of security (due to a delegation of Algerians having arrived at Meknès during Ramadan, there was fear of an unfortunate incident that would interrupt negotiations). The French delegation stayed cloistered there for eight days, a week that was a bit painful, according to Delacroix, who pined for news from France.[18] "Being always in one another's company, we are less disposed to gaiety, and the hours seem quite long, although the house we are in has very curious Moorish architecture, like all the palaces of Granada you have seen in engravings. But I find that the sensations wear out after a while, and the picturesque so blinds your eyes at every step that you end up by becoming insensitive to it."[19] Finally, on 22 March, the solemn audience with the emperor took place, followed by a tour of the apartments within the palace, an exceptional mark of favor. Delacroix, who seems to have been

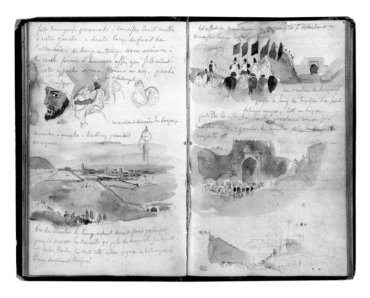

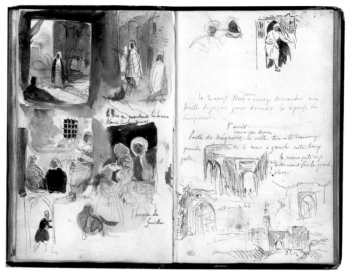

107. *Arrival at Meknès*, 1832
Two sheets from one of the Moroccan albums.
Watercolor on paper, each 19.3 × 12.7 cm. Musée du Louvre,
Département des Arts Graphiques, Paris

108. *At Meknès*, 1832
Two sheets from one of the Moroccan albums. Watercolor,
pen and brown ink, and brown wash on paper, each 19.3 × 12.7 cm
Musée du Louvre, Département des Arts Graphiques, Paris

particularly interested in Moorish architecture, which he constantly compares with that of Andalusia, found it "as curious as can be."[20] The next day, he was able to begin to see Meknès (fig. 108), but without the same freedom of movement as at Tangier: "I informed you in my last letter that we have had the audience with the emperor. We were supposed to have permission to walk in the town from that moment on, but it is a permission of which I am the only one among my companions to have taken advantage. . . . The clothes and appearance of a Christian are antipathetic to these people, to the point that one must always be escorted by soldiers, which has not prevented two or three quarrels that could be extremely disagreeable because of our position as envoys. Every time I go out, I am surrounded by an enormous band of curious people who don't spare me their insults, dog—infidel, foreigner, etc.—and who push each other to get close and make a face under my nose. You can't imagine how I itch to get angry, and it takes all my eagerness to see things to make me expose myself to this villainy. I've spent most of my time here extremely bored because it has been impossible to be seen drawing from nature, even a tumbledown house; even going up on the terrace exposes you to stones or gunshots. The Moors are extremely jealous, and the women usually go to the roof terraces to get some fresh air or to see each other."[21] The sultan, attentive to his guests, arranged for the embassy to visit his stud farm and

zoo, and one evening sent them his personal musicians, three Jews from Mogador. During this time, negotiations went forward: they were concluded on 4 April when an open letter from Abd el-Rahman was sent via Mornay to Louis-Philippe, settling all the problems between France and Morocco. The embassy then was able to start home, furnished with gifts from the sultan, including a lion, a tiger, two ostriches, two gazelles, an antelope, and a "kind of hart,"[22] and, finally, four stallions for the king of France (each member of the delegation, including Delacroix, also received a horse from the emperor). Leaving on 5 April, they reached Tangier on the twelfth. There, a new delay was necessary: the letter received at Meknès had to be approved by Paris, then sealed by the sultan. So they fell back into the life they had led during the month of February, punctuated by visits to diplomats and to the notables of the town. It was broken by an expedition to Spain, thanks to *La Perle*, which had returned to Africa, and which took Mornay, Desgranges, and Delacroix on board on 10 May and landed them at Cadiz on the sixteenth after a week of quarantine. They stayed a couple of weeks.[23]

There are two ways of understanding Delacroix's Spanish escapade: as the discovery of a country of which he already knew certain notable works, the lived confirmation of what he had seen and felt in Velasquez and Goya, or indeed as the prolongation of his Moroccan trip. The two points of view are

valid and complementary. Spain was a destination dear to the Romantics, the picturesque country that Delacroix had glimpsed at Algeciras at the beginning of his voyage, the country of bullfights and women in mantillas, which he got to know less superficially at Cadiz and then at Seville (where he stayed alone from 22 to 28 May), visiting monuments, convents, and churches. But the months that he had just spent in Africa of course

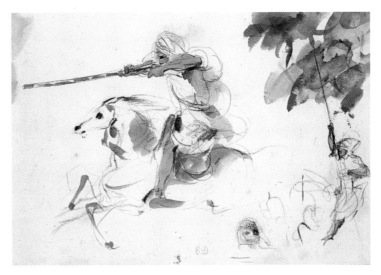

109. *Arab Horseman Practicing a Charge*, 1832
Pencil and watercolor on paper, 20 × 30 cm
Private collection, Australia

Algeria, where it stopped a few days, from the twenty-fifth to the twenty-eighth. It was here that Delacroix's famous visit to a harem took place. He had not been able to visit the interior of a Muslim home in Morocco, and he renewed his attempts in Algiers, then a French possession, where he no doubt thought it would be easier. It was the chief engineer of the port, Poirel, who, when asked, put him in contact with one of his assistants who, it seems, had

led him to emphasize the Moorish element of Andalusia, just as the image of Spain was, as we have seen, an a priori part of his view of Morocco. This is what we see in his account to Pierret, the only important record of his Spanish weeks, along with a few jottings in his notebooks and some twenty drawings, dispersed today.[24] "I have returned from Spain, where I spent a few weeks: I saw Cadiz, Seville, etc. In this short time, I have lived twenty times more than in several months in Paris. I am very glad to have been able to get an idea of this country. At our age, when one misses an occasion like that, it doesn't come again. I found in Spain everything that I had left among the Moors. Nothing has changed but the religion; the fanaticism, incidentally, is the same. I saw the beautiful Spanish women, who live up to their reputation. The mantilla is the most gracious thing in the world. Monks of all colors, Andalusian costumes, etc. Churches and a whole civilization like it was three hundred years ago."[25]

Delacroix was to spend still another week in Tangier before reembarking for France (on his return from Spain, Mornay had found an emissary of the sultan at Tangier, with the signed letter of agreement). No doubt Delacroix sold the horse that Abd el-Rahman had given him, and was able to buy the things he had promised himself, Moroccan clothing and objects that he brought back to France, for himself and as gifts for his friends. *La Perle* left for France on 10 June by way of Oran, where it stayed from the thirteenth to the nineteenth, and

been a former pirate for the dey. The following account of the episode has been handed down: "Secrecy was promised on both sides. The woman, warned by her husband, dressed herself in her richest costumes and waited, seated on a divan. Algerian women are thought by the Orientals to be the most beautiful on the Barbary coast. They know how to bring out their beauty by rich fabrics of silk and velvet, embroidered in gold. . . . When, after traversing some dark corridor, one penetrates the part that is reserved for them, the eye is really blinded by the vivid light, the fresh faces of the women and children appearing suddenly amid this mass of silk and gold. For a painter, that is a moment of fascination and strange happiness. Delacroix's impression was like that, and he transmitted it in his painting, the *Women of Algiers*. The wife of the former rais of the bey [*sic*] was very pretty, and M. Poirel told me that Delacroix was almost drunk with the sight that he had before his eyes. After the wonderment came the work, and then conversation. Delacroix wanted to know everything about this life that was mysterious and new for him. The former rais acted as an interpreter. He had great difficulty in following all his overexcited, agitated thoughts. From time to time, Delacroix cried, 'It's beautiful! It's like Homer's time! The woman in the gynoecium took care of her children, spun wool, and embroidered the most marvelous fabrics. This is woman as I understand her!'"[26] This is an account told in retrospect, as one must keep in mind: Cournault and Poirel, who were familiar with

the *Women of Algiers* or other orientalizing paintings of Delacroix at the time they wrote, and who were remembering relatively distant events, have perhaps somewhat enlivened their recollections about the wonderment and fever of the painter. But the account remains not unlikely, including the exclamations attributed to Delacroix, which are, as we will see, amply confirmed by what he wrote. This novel experience for a European artist, unique in its circumstances, enriched the other impressions that the painter had felt in Morocco. It was the ultimate episode of a voyage of which the consequences were to be of major importance.

Returning to France, Delacroix brought with him an abundant written and illustrated documentation of his voyage, most often done, to use Philippe Burty's language, "on the pommel of his saddle or in an Arab tent, in the streets of Meknès or in the palace of Abd el-Rahman."[27] He had been supplied with everything he needed for working during the trip; in fact, he had painted only a little, just two canvases according to tradition, both for the vice-consul, Delaporte: the portrait of his wife,[28] and a small *Arab Horseman Practicing a Charge*,[29] a forerunner of the numerous *Fantasia* scenes that he afterwards painted. All his work, in fact, consisted of notations, in writing or drawing, closely linked, about what he saw. For this he used at least seven notebooks of different sizes as well as innumerable separate sheets, all of which he kept until his death, when they were dispersed at the posthumous sale.[30] Four notebooks remained intact,[31] the others disappeared or, more likely, were cut apart. In any event, we have today an imposing mass of documentation that informs us of the daily life of the painter, his discoveries, and his impressions. It consists of more or less rapid notations, which he sometimes went back to complete in the quiet of the evening, or at a later time, as for example during the quarantine at Toulon. Delacroix doubtless did them in the first place to preserve his first impressions at the discovery of an unknown country. Was it his intention to construct a repertory, a vocabulary that he could later use? Probably, but the utilitarian character of his work appears only retrospectively and remains secondary. At the time, it was a question of keeping a more or less exact record, true to the spirit. From this comes the diversity of Moroccan drawings, done in pen, charcoal, graphite, sanguine, sometimes highlighted with watercolor, rapidly sketched, or, on the contrary, carefully worked, sometimes with a few indications of colors or situations. In other cases, the writing is more essential (as in describing the reception of the embassy by Abd el-Rahman). Delacroix had very likely imagined, before his departure for Africa, that when he returned he would write an account of his travels, illustrated with engravings or lithographs.[32] Such publications were popular in the first half of the nineteenth century and could make a good profit. The letters written from Morocco, intended to be read and commented on in groups of his friends to whom he addressed them, give an idea of how he might have developed the project. But the only written piece of any importance on Morocco is the article for the *Magasin pittoresque* of 1842, on the occasion of the publication of a wood engraving after the *Jewish Wedding in Morocco* in the Louvre, where he limits himself to a long description of the ceremony. Once back in France, it is largely through images that Delacroix transmits his experience, the notebooks and Moroccan drawings showing their usefulness as much for reviving first impressions as for supplying the basic documentation on which to base a realistic description for the seduction of the Parisian population. "I spend part of my time working, with pleasure, and another considerable part in just living; but the idea of this Salon that I had to miss, as they said, never crosses my mind; I am even sure that the large quantity of rather curious information that I will bring home from here will not do me much good. Far away from the country where I am now, it will be like trees torn from their native ground; my mind will forget these impressions, and I will not stoop to showing only imperfectly and coldly the living, striking sublimity that runs in the streets here and assassinates you with its reality."[33] In the letters written by Delacroix at the beginning of his travels, one rather often finds this idea that, once back in France, he will not be able to reconstruct the impressions that he has experienced, that he will lack the necessary technical resources. Add to that the separation between Africa and Europe, not only in culture but in light and color. This contradiction between the multitude of studies done on site and their apparent uselessness was, in fact, resolved by the painter's work itself. By the accumulation of numerous and repeated notations, by concentration on certain subjects, on certain types that impressed him most, Delacroix gave his "Moroccan" works what at the beginning of his trip he thought he never could: an exact rendering of reality in the smallest details, like the original effect that it had on him and that it was his vocation to transmit.

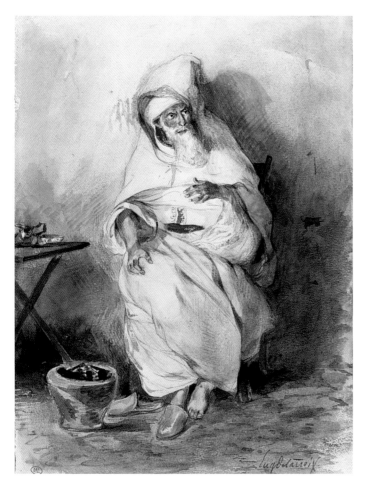

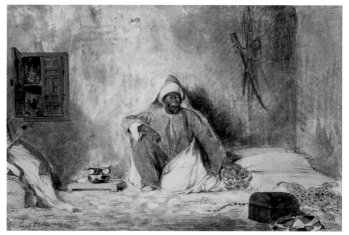

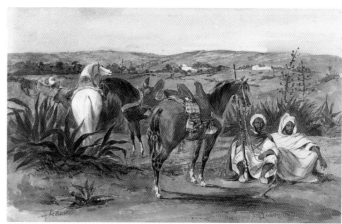

The days that he spent in quarantine in Toulon on their return, in July 1832, were certainly important in giving him time to become aware of the real weight of what he had just lived and experienced. From one of his letters, we know that he profited from the forced seclusion to draw,[34] but what work he did then is not known precisely: organizing his folders, going back to his drawings to finish them, perhaps by adding color according to the indications written on site, or undertaking more elaborate works? Tradition says that it was at this time that he did a series of watercolors that he offered to Mornay, to thank him. It was an album of eighteen drawings, dispersed in a public sale in 1877, which is particularly interesting for an analysis of the sources of the Orientalist streak in Delacroix after his visit to Morocco. The watercolor series is the first work of importance that he did not on site but in France, although still anchored in the reality of Africa as experienced by the members of the embassy. The Mornay album included portraits—Abd el-Rahman, Abraham Benchimol, his wife

110. *Amin Bias, Minister of Finance to the Sultan of Morocco*, 1832
Watercolor and pencil on paper, 23.4 × 16.6 cm. Musée du Louvre, Département des Arts Graphiques, Paris

111. *A Kaid, Military Chieftain, in His House*, 1832
Watercolor and pencil on paper, 15.4 × 20.7 cm. Private collection

112. *Arab Horsemen Resting Near Tangier*, 1832
Watercolor, pencil, and gouache on paper, 16.7 × 26.5 cm. Fine Arts Museums, Achenbach Foundation for Graphic Arts, San Francisco

and daughters depicted together on one page, the kaid Mohammed ben-Abou, and Amin Bias, Minister of Finance and of Foreign Affairs (fig. 110)—and landscapes or clearly identified scenes corresponding to stages of the mission—*Camp at the Town of Aliassar-el-Kebir, View of the City and Harbor of Tangier, Arab Horsemen Resting Near Tangier* (fig. 112), *Fantasia at Meknès, The Fanatics of Tangier* (fig. 121), *Negroes Dancing in*

the Street at Tangier, Soldiers Asleep, Traveling Players. A last group represents different Moroccan types: *A Moorish Woman with Her Servant on the Riverbank*, *A Moor and His Wife on Their Terrace*, *A Negro Slave Going for Water*, *Arabs at a Market*, *Coulouglis and Arab Seated at the Door of a House* [a Coulouglis is the son of a Turk and a Moorish woman], and *A Kaid, Military Chieftain, in His House* (fig. 111). Delacroix did not wish to give a minute account of the vicissitudes of the mission, nor a chronicle. Knowing the different stops of the voyage, one can place each sheet at an exact moment. But note that the arrival of *La Perle* at the port of Tangier is not among these scenes, nor is the reception by Moroccan authorities. The trip to Meknès is evoked twice—in one of its picturesque circumstances (the fantasia), the most important episode—(but the reception by Abd el-Rahman is not given such treatment, nor is the visit to the palace, gardens, and imperial menagerie. There is no chronological order at the heart of the series. The portraits themselves (except for Abd el-Rahman) can also be considered as types: *The Wife and Daughter of Abraham Benchimol* is clearly very close in its composition to the different versions of the *Jewish Woman of Morocco*, which Delacroix did later: a seated figure, whose isolation makes the costume stand out. Nor does anything indicate what Amin Bias's function was (the sheet representing Benchimol is lost). The principal characteristic of the Mornay album, which sets down certain Moroccan themes that Delacroix later revisited, was precisely to disengage the themes from their immediate context within the journey that had just ended. It shows a deliberate distancing, along with an obvious concern for exactitude and realism, which were to be, in fact, the mark of all his Orientalist subjects.

Delacroix did not immediately deliver a big Moroccan painting to the Parisian public. He contented himself with showing several watercolors at the Salon of 1833: *Interior of a Guardhouse of Moorish Soldiers*, *Jewish Family*, *Costumes of Morocco*, and *Costumes of the Kingdom of Morocco*. It was only in 1834 that he did *A Street in Meknès* (fig. 113) and especially the *Women of Algiers in Their Apartment* (fig. 116), where the contribution of his voyage to Africa is actualized.

Like many of his important works, this last painting was not the result of a commission but of the artist's own initiative, and its large dimensions mark it as obviously intended for exhibition. It is not so clearly a manifesto as *Scenes from the Massacres of Chios* or *The Death of Sardanapalus*, but the evidence shows that it is indeed a painting in which the painter affirms his principles and gives his vision of Orientalism at a time when, in France, this current was taking a new turn provoked by the recent conquest of Algeria. We have already seen the circumstances under which Delacroix was able, once he had returned to France, to paint Muslim women in their most intimate interior, a place normally forbidden to Europeans. But if the finished canvas derives from the sketches done on site, it does not scrupulously transcribe what the painter saw in Algiers, as Elie Lambert has shown.[35] In addition to the studies done on the trip, there was another series of preparatory studies, done in the studio in Paris, using a European model and the clothing and documents brought back from Africa,[36] by means of which the process of transformation was achieved, ending in the final subtle equilibrium (figs. 114 and 115). Each of the three seated women derives from an Algerian model (their names are even known, thanks to Delacroix's notations on the drawings). But their clothes and jewels have been redistributed so as to make a gradation, from right to left, from the simplest clothing to the richest and most complicated. The black servant who, at the right of the picture, draws a curtain to display the harem to the spectator, is, it appears, a complete invention of the artist, since she figures in none of the drawings done in Algiers. Delacroix could of course have seen her in North Africa, but this addition to the original scene appears not to have been dictated by considerations of a strictly realist kind. This figure simply adds to the exoticism of the painting, the verisimilitude of which she increases in the eyes of a spectator familiar with descriptions of Turkish harems. She is thus a part of the tradition of European painting since the Renaissance, tying the work to the great Venetian masters, in particular Veronese. As to the setting, if it shows what Delacroix could have studied at Algiers, it has also undergone modifications, particularly in the source of light, which comes from the left in the painting instead of the right, as in the original drawing. Are these liberties in the painter's use of sources surprising? It is, after all, only the normal procedure of an artist concerned for the plastic aspect of his work. The interest here lies in the minute precision with which Delacroix has painted the costumes of these women, the background of the scene, and the different objects offered to the viewer—the narghile, basket, slippers, carpets, and cushions.

The almost purely documentary aspect has been carried so far that the painting served as the basis for an exhibit of the clothing of Algerian women at the period of the French conquest, in the museum of ethnography in Algiers in the 1930s. This shows to what extent Delacroix has remained very realistic, as did the other orientalizing painters and engravers of his time, wanting to describe exactly what they had experienced or discovered during their voyages to Africa or the East. But the concern for realism is combined, in Delacroix, with purely formal concerns. The *Women of Algiers* shows, in fact, a unity in the treatment of light, which, in the details, reveals a range of colors much more varied than the general tonality would at first glance lead one to suppose. Each of the four figures has its own harmony: red, blue, and black for the servant; rose, white, green, and orange for the woman holding the stem of the narghile; blue, red, and ocher for her seated companion; red, white, brown, and gold for the one partially reclining at left. The patterns of the rugs, the cushions, and the tiles of the foreground are pretexts for combinations just as refined as those, of another kind, on the wall and curtain of the background, left in shadow. The rendition of the light on the various materials takes precedence over the color alliances; the vibration of the curtain contrasts with the flat tone of the tiled floor, the reflections of the mirror with those of the dishes and the objects in the niche and cupboard. Notice also the red of the doors, which relieves the array of browns, somber greens, and ochers in this part of the canvas. All of Delacroix's talent goes into the general harmony that arises from the individual elements. On this point, the effects of the composition should not be underestimated: in placing his four figures almost on the same line, in giving much more detail to the front of the scene than to the background, in concentrating attention on the lower half without, however, falling into artifice and monotony—thanks to the standing figure of the servant—he leads us to appreciate the whole as much as the detail, to contemplate the scene in its totality before letting our eyes turn successively to each of the figures. The direction of the gaze of the four figures, going from one to another, explicitly invites us to move

113. *A Street in Meknès*, 1832
Exhibited at the Salon of 1834. Oil on canvas, 46.3 × 64.5 cm
Albright-Knox Gallery, Buffalo

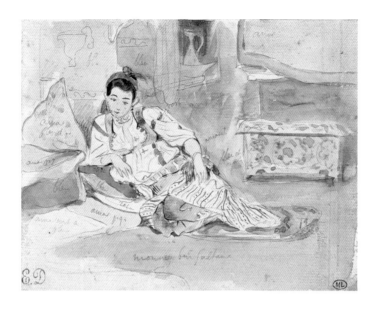

114. *Arab Woman Seated on Cushions,* 1832?
Probably executed during the stay in Algiers.
Watercolor and pencil on paper, 10.7 × 13.8 cm
Musée du Louvre, Département des Arts Graphiques, Paris

115. *Two Seated Arab Women,* 1832?
Probably executed during the stay in Algiers.
Watercolor and pencil on paper, 10.7 × 13.8 cm
Musée du Louvre, Département des Arts Graphiques, Paris

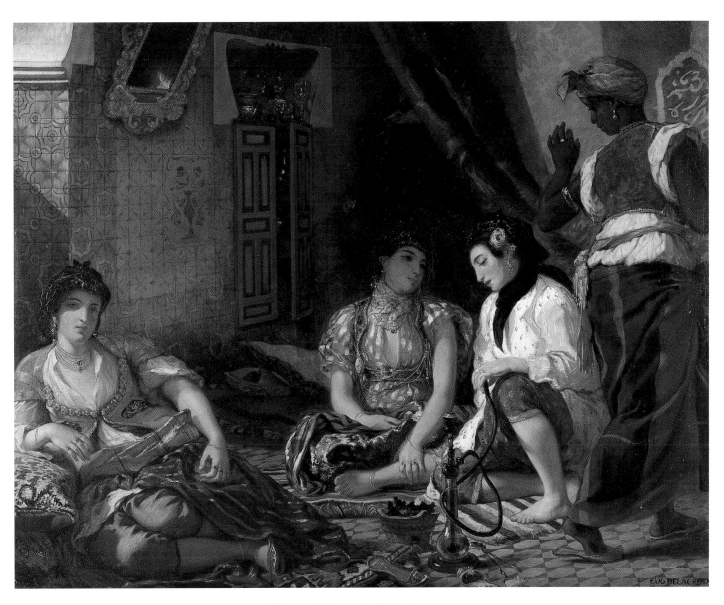

116. *Women of Algiers in Their Apartment*, 1834
Exhibited at the Salon of 1834. Oil on canvas, 180 × 229 cm
Musée du Louvre, Paris

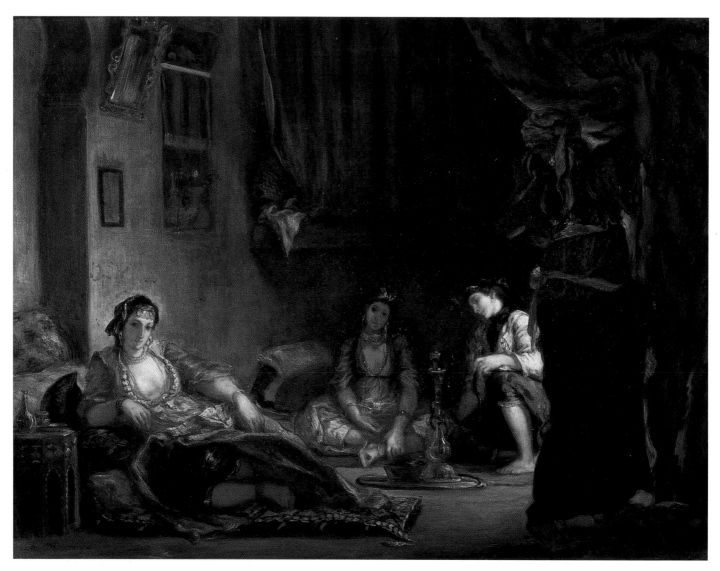

117. *Women of Algiers in Their Apartment*, 1847–49
Exhibited at the Salon of 1849. Oil on canvas, 84 × 111 cm
Musée Fabre, Montpellier

toward the figure at left, and finishes outside the canvas, directed toward the spectator. It is not only the still life of the foreground that invites us to wander from harmony to harmony, with the slippers tossed down as if by chance next to the narghile and the basket sitting on a bit of carpet, to discover contrasts and consonances: the composition would be ineffective except for what Delacroix has been able to do with the rendering of light, particularly noticeable on the flesh. This is what Cézanne felt when he said to Gasquet: "We are all there in this Delacroix. When I speak of the joy of color for color's sake, this is what I mean. . . . These pale pinks, these stuffy cushions, this slipper, all this limpidity, I don't know how, it enters your eye like a glass of wine going down your throat, and you are immediately intoxicated. One doesn't know how, but one feels lighter. These nuances lighten and purify. . . . And it is all filled up. Colors run into each other, like silks. Everything is sewn together, worked as a whole. And it is because of this that it works. It is the first time that anyone has painted volume since the great masters. And with Delacroix, there's nothing to say; he has something, a fever that you don't find among the older painters. It's the happy fever of convalescence, I think. For him painting comes from marasmus, from

the Carracci malady. He is knocking up against David. He paints by irisation. . . . And then he is convinced that the sun exists and that one can wipe one's brushes in it, do one's laundry. He knows how to differentiate. . . . A silk is a fabric, and a face is flesh. The same sun, the same emotion caresses them, but differently. He knows how to put a fabric on the Negress's thigh that has a different odor from the Georgian's perfumed culottes, and it is in his colors that he knows it and does it. He makes contrast. All these peppery nuances, look, with all their violence, the clear harmony that they give. And he has a sense of the human being, of life in movement, of warmth. Everything moves. Everything shimmers. The light! . . ."[37]

The impression given by the forms and by the management of color finally counts for more than the strict documentary representation of the *Women of Algiers*. Criticism, when the canvas was shown at the Salon, oscillated between these two poles, with the most perspicacious critics, for example Gustave Planche, recognizing how far Delacroix had gone beyond his original subject: "The figures and the setting of this painting are prodigiously rich and harmonious. The color everywhere is brilliant and pure, but never crude and clashing. . . . This canvas is, in my opinion, the most brilliant triumph that M. Delacroix has ever reached. To interest the viewer by virtue of the painting, reduced to its own resources—without the support of a subject that can be interpreted in a thousand ways and that often distracts the eye of superficial spectators, who are busy judging the painting according to their dreams or conjectures—is a difficult task, and M. Delacroix has fulfilled it. In 1831, when he so happily framed historical reality in allegory, his pictorial power did not act on only the minds of the curious. The imagination regularly aided the skill of the brush. In the *Women of Algiers*, there is nothing of the kind; it is painting and nothing more, frank, vigorous painting, vigorously pronounced, with a Venetian boldness, which, however, owes nothing to the masters whom it recalls."[38] Charles Blanc, in his obituary of the painter in 1864, also emphasized this quality, insisting on the fact that it is only possible because of the indefinite character of the subject: "It is in this painting that Delacroix displayed all the resources of an art that he turned into magic. And first, just as there is here no principal figure, so there is no dominant color. The painter, wanting to give an idea of oriental life, represents the women of the harem like pretty things, beautiful jewels in a case. These are,

in effect, beings without thought, who live the same life as the flowers. The painter was thus free to set out all the treasures of his palette on this occasion, and he had almost complete freedom in the choice of color, being able to introduce as he saw fit accessories, fabrics, details of costume and decoration that he needed for his harmony. His painting being in a way purely descriptive—since he only had to express the richness of the interior of a seraglio, that is, its brilliance, its opulence, and its coolness in a warm country—he has used all his means of coloration to achieve a maximum of splendor and intensity, bringing them into the most perfect and calm harmony by balancing all these strengths."[39]

This painterly quality is even more pronounced in the second version of the *Women of Algiers*, done some fifteen years later, in 1847–48 (fig. 117). In a small format, Delacroix made important modifications to his first picture: the light comes from the right; the setting, from the floor to the background, has been simplified; and a few objects have disappeared (the slippers, the tongs), or been moved (the narghile, the basket), or been added (the table on the left). The four figures are placed differently: the servant and the woman on the left in the foreground, the two other women in the middle distance. The wall and the curtain at the back are also more clearly shown. The lighting is much more accentuated: the relative obscurity of the first plane contrasts with the vivid clarity of the second, as though the spectator were facing a stage, its curtain being drawn by the servant. Interest is thus concentrated on the figures, who are bathed in a much warmer tonality obtained by a particular technique that we know about, thanks to the *Journal*.[40] It seems that Delacroix varnished his sketch, then painted over it before giving it another coat of varnish, the result being the greater unity of coloration in his painting. Perhaps there is here an influence of Correggio, as Bruyas suggests, emphasizing that the artist was "obsessed" with that painter at the time that he was doing the second version of the *Women of Algiers*.[41] But if the handling has changed, the effect of the picture remains quite similar, however with a decided primacy given to the plastic aspects, as is often the case when Delacroix returns later to subjects that he has already treated.

The same conjunction of exact description with a distancing achieved by formal means is found again in two other canvases that Delacroix showed in 1838 and 1841 respectively, *The Fanatics of Tangier* (fig. 122), and the *Jewish Wedding in*

Morocco (fig. 120). The two paintings, of comparable format, large but not as large as the Louvre's *Women of Algiers*, may possibly have been worked on at the same time. The *Jewish Wedding*, commissioned by the Marquis de Maison (who finally refused it), was very probably begun in 1837.[42] If so, that would make the similarity of the two works with regard to Delacroix's treatment of events witnessed in Morocco only more striking. We have seen that he had participated in a Jewish wedding during his stay at Tangier. The same is true for the scene of the fanatics, which he saw with Mornay through the shutters of a closed window, lying in the top story of a house at Tangier or at Meknès.[43] In neither case is the subject immediately comprehensible to the spectator. The Salon catalogue gives circumstantial clarifications for each of them. Thus, for the *Fanatics:* "These fanatics are called Yssaouïs, after Ben Yssa, their founder. At certain times, they gather outside the towns; and working themselves up by prayer and by frenetic cries, they enter into a veritable ecstasy, and then spread out into the streets and give themselves up to a thousand contortions and often to dangerous acts." And, for the *Jewish Wedding:* "Moors and Jews are mixed. The bride is enclosed in the interior apartments while rejoicing goes on in the rest of the house. The important Moors give money to the musicians, who play without stopping day and night; only the women dance, which they do one by one, to the applause of the assembly." As a witness of the two episodes, Delacroix had his sketches, done in Tangier, for the *Jewish Wedding* (figs. 118, 119) and, for the *Fanatics*, a more rapid drawing done after he had seen the event and when it was still fresh in his mind, which was later reworked in one of the watercolors of the Mornay album (fig. 121).[44] For the *Women of Algiers*, Delacroix bases his work on the notations of his

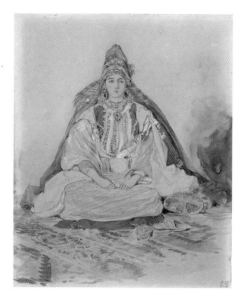

118. *A Courtyard in Tangier*, or *House of the Jewish Wedding*, 1832
Watercolor and pencil on paper, 20.7 × 29.4 cm
Musée du Louvre, Département des Arts Graphiques, Paris

119. *Jewish Bride in Tangier*, 1832
Watercolor and pencil on paper, 28.8 × 23.7 cm
Musée du Louvre, Département des Arts Graphiques, Paris

visual memories, as he does for the *Jewish Wedding*, a description of which was written in Morocco in one of his notebooks (it is a "continuous" text with some little sketches of details from various places): "The Jewish wedding. Moors and Jews, at the entry. The two musicians. The violinist; thumb in air, the underside of the other hand very shaded, light behind, the haik around his head transparent in places; white sleeves, shadow behind. The violinist; seated on his heels and on the gelabia. The body of the guitar on the player's knee; very dark near the waist, red vest with brown notes, blue behind the neck. Shirt sleeves turned back up to the biceps; green paneling beside him; a wart on the neck, short nose. Beside the violin, a pretty Jewish woman; vest, sleeves, gold and aramanthine. She is silhouetted partly against the door, partly against the wall. Closer, an older woman with a great deal of white that almost entirely hides her. Shadows full of reflections; white in the shadows. A pillar stands out darkly in front. The women at left arranged like flower pots. White and gold dominate, and their yellow handkerchiefs. Child on the ground in front. Beside the guitarist, the Jew who plays the tambourine. His face is a dark silhouette, hiding part of the hand of the guitarist. The bottom of his head outlined against the wall. A bit of gelabia under the guitarist. In front of him, legs crossed, a young Jew who holds a plate. Gray garment. Leaning on his shoulder a young Jewish child about ten years old. Against the door of the stairway Prisciada; violet neckerchief on her head and under the neck. Jews seated on the steps, partly seen through the door, strong light on the nose, one standing on the stairs; a cast shadow, with reflections, standing out against the wall, light yellow reflection. Above, Jews leaning over. One at left, bareheaded, very dark, silhouetted against the wall lit by the sun. In the

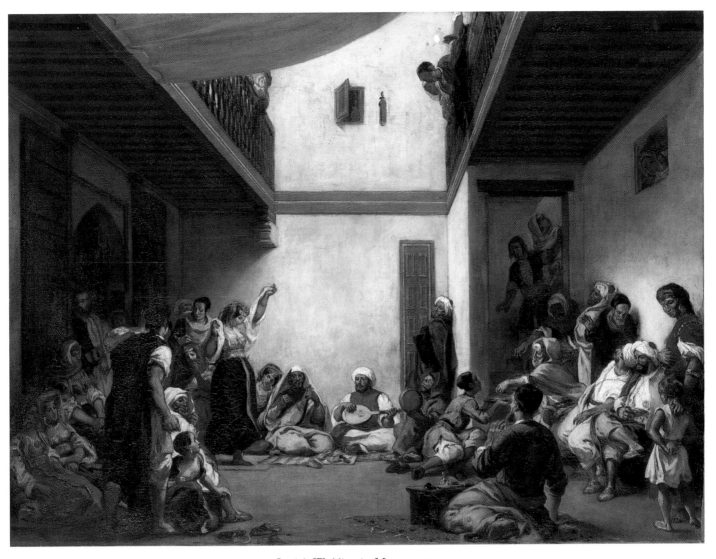

120. *Jewish Wedding in Morocco,* 1837?–41
Exhibited at the Salon of 1841. Oil on canvas, 105 × 140.5 cm
Musée du Louvre, Paris

corner, the old Moor with his crooked beard: shaggy haïk, turban low on his forehead, gray beard against the white. The other Moor, shorter nose, very male, prominent turban. One foot out of his slipper, sailor's vest and sleeves *idem*. On the ground, in front, the old Jew playing the tambourine; an old handkerchief on the ground, one sees the black skullcap. Torn gelabia; one sees the garment torn at the neck. Women in the shadow near the door, full of reflections."[45]

In the painting, Delacroix followed his notes almost to the letter, modifying certain details (the foreground pillar, which would have unbalanced the composition, has been removed, as has the child leaning on the Jew who holds the plate; the old man seen from the back in the foreground no longer plays the tambourine, the musicians being concentrated at the back). From this comes the exactitude of the scene, as much in the whole as in detail.

For *The Fanatics of Tangier*, there are no comparable drawings or textual sources: Delacroix did not report this very special scene either in his notebooks or in his correspondence, or, later, in his *Journal*. Except for the very rapid sketch in the Louvre, the point of departure for the composition is the watercolor given to Mornay, which one may reasonably suppose to be quite close to the scene that the two of them experienced together. The composition is similar the *Jewish Wedding*: in a rather narrow street, in the middle of a crowd, are the disciples of the marabout Sidi ibn Isa, founder of the sixteenth-century sect of the Isawa, with a horseman at right, a flag above him. The street appears narrower in the painting: Delacroix has suppressed the escaping crowds of the watercolor, near a city gate at the right and toward another street in the center. He has also made some changes in the spectators in the foreground: on the right he gives the two standing Arabs more room, their calmness contrasting with the frenzy of the Issawa, and adds a man, seen from behind, to the group of children watching the cortege. Delacroix thus links all the figures to each other. On the left, the running urchin turns back, accentuating the diagonal movement. The spectators are also better detailed and their attitudes differentiated. Another group has been added on the roof of the house in the center of the street (it had been on the left before), and vegetation has been added on the terraces. Finally, the framing is larger; the figures are proportionally less important in the canvas than in the watercolor, and the importance of the sky and the setting is also reinforced.

Although Delacroix kept the documentary sources of his work in both *The Fanatics* and the *Jewish Wedding*, he nevertheless modified them for reasons that were above all stylistic. The effects of the changes are readily apparent: they are aimed at a better differentiation of the groups (both paintings include several dozen personages), and at the same time they accentuate the color contrasts. The *Jewish Wedding* is thus built around a well of light that brings out the colors of the musicians' and spectators' costumes, either by silhouetting them against a white wall or in letting them melt into the half-light or shadow. A few spots of color highlight the whole: the reds of the musician at the back and of the two women on either side, the blues or greens on the spectator seated on the left and on the man who, in front of the stairs, reaches out with his coin. The green of the woodwork allows Delacroix to break the monotony of the white walls that vibrate with sun. The canopy stretched above the courtyard also introduces a break in the luminosity, differentiating the right and left parts in the foreground of the painting, the background being lighted uniformly and very brightly. In *The Fanatics*, the artist's choices are even clearer, where three colored bands are superimposed: the blue sky, the white walls, and the many-colored crowd in which we see different tones of beige, white, ocher, brown, red, and green. The changes that Delacroix made also permitted him to break the monotony of the two upper zones. As Gustave Planche pointed out when the painting was

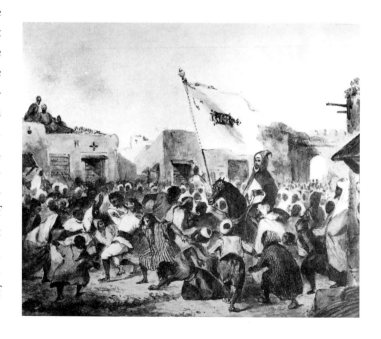

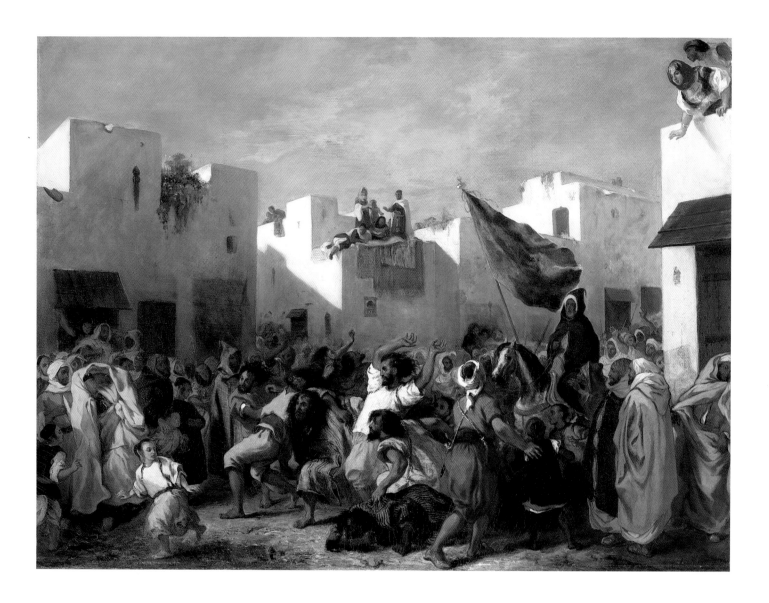

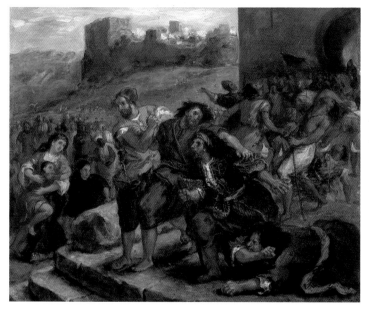

122. *The Fanatics of Tangier*, 1838
Exhibited at the Salon of 1838. Oil on canvas, 97.8 × 131.3 cm
The Minneapolis Institute of Arts

123. *The Fanatics of Tangier*, 1857
Oil on canvas, 46.7 × 56.4 cm
Museum of Fine Arts of Ontario, Toronto

OPPOSITE

121. *The Fanatics of Tangier*, 1832
From the album done for the Count de Mornay.
Watercolor on paper, approx. 20 × 23 cm
Present location unknown

shown in the Salon, "*The Fanatics of Tangier* offers the eye an ensemble of really delicious colors, the walls crowned with spectators, the turbans of the crowd that presses around the fanatics, composing masses full of richness and variety."[46] Gautier, when the canvas was again shown to the public at the Exposition Universelle in 1855, emphasized that the effect derives finally less from the chosen subject than from the way in which it was handled: "If we had not ourselves seen the Issawa doing their strange exercises, rolling on live embers, eating snakes, breaking glass, eating fire, slashing their bodies, and quivering down on the ground like galvanized frogs, we might have perhaps taxed *The Fanatics of Tangier* with exaggeration. . . . There is an unbelievable turbulence of movement in this canvas, a ferocity of brush that no one has surpassed, and especially a warm coloration, transparent and light, the charm of which tempers the horrible and repugnant aspects of the subject."[47] Criticism approached the *Jewish Wedding* in the same way, going beyond the subject to emphasize the rendering of the light and the richness of the painter's palette. Gautier writes in 1855, "The color of this picture is sober, sleepy, tranquil despite its richness, and it makes us feel that outside, on the chalk-white terraces, sun rains down, blinding, implacable, and torrid."[48]

The same principles hold for the largest painting that Delacroix based on his Moroccan experience. *The Sultan of Morocco and His Entourage* (fig. 124) is an imposing painting, as much by its format (slightly smaller than the *Scenes from the Massacres of Chios*) as by the monumentality of the figures that compose it.[49] At the insistence of Cailleux, director of the Royal Museums, Delacroix wrote for the Salon catalogue of 1845 a long note explaining the memorable scene of 22 March 1832: "The painting reproduces exactly the ceremonial of an audience at which the author was present in March 1832, when he accompanied the extraordinary mission of the king to Morocco. At the right of the emperor are two of his ministers; the nearer of them is Muchtar, who was his favorite; the other is Amyn Bias, administrator of customs. The personage closer to the front, turning his back to the spectator, is the kaid Mohammed ben-Abou, one of the most important military chiefs, whose name figured in the last war and in the negotiations. The emperor, remarkably mulatto, wears pearl prayer beads rolled around his arm; he is mounted on a Barbary horse of great size, as horses of that breed usually are. At his left is

a page, whose job is to wave a bit of cloth from time to time to keep insects away. Only the sultan is mounted. The armed soldiers whom one sees behind are cavalrymen who have dismounted. They are lined up next to each other, never two men deep, and when they are on horseback, they have the same way of marching and fighting, that is, in a line or a demicircle, with the standards in front."

Delacroix made only a rapid ink sketch of the ceremony, either during it or shortly thereafter (fig. 126), and took some rapid notes: "Out of a mean gate with no ornament first came, at short intervals, little groups of eight to ten black soldiers in pointed hats, who lined up at right and left. Then two men carrying lances. Great resemblance to Louis-Philippe, but younger, with a thick beard, medium brown. Fine burnoose almost closed in front. A haik underneath on the upper part of the chest and almost entirely covering his thighs and legs. White chaplet with blue silk around his right arm, of which one saw very little. Silver stirrups. Yellow slippers that hung loose in back. Harness and saddle, rose colored and gold. Gray horse, his mane cropped. A parasol with unpainted handle, a little ball of gold at the end; red on top, in sections [*à compartiment*], red and green underneath."[50] Here again Delacroix introduces several changes from the original scene: the gate is his invention, even if it recalls the one he had seen on arriving at Meknès. It is not a gate of the royal palace, and the walls evoke the ramparts of the capital rather than the enclosure of the palace. The slight modifications in the horse's mane and the stirrups are inconsequential. The parasol has been simplified. Delacroix kept the two colors but arranged them differently, not *à compartiment* but green on top and red underneath, accentuating the contrast with the brilliant blue of the sky.

Drawings and preliminary studies are particularly numerous for this painting (figs. 127, 128), and it is difficult to put them in chronological order. One cannot, in fact, divide them, as Elie Lambert proposed, into those done in Africa, those begun in Morocco and finished at Toulon, and those finally done in France, insofar as more than ten years passed between the event and the finished picture that records it. The only reliable indication that we have comes from the existence of a sketch in the museum at Dijon. It is very free in its handling, a first idea that Delacroix certainly executed not long after his return, thus around 1833 (fig. 125). The scene is arranged in a format longer than it is high, incorporating among others the

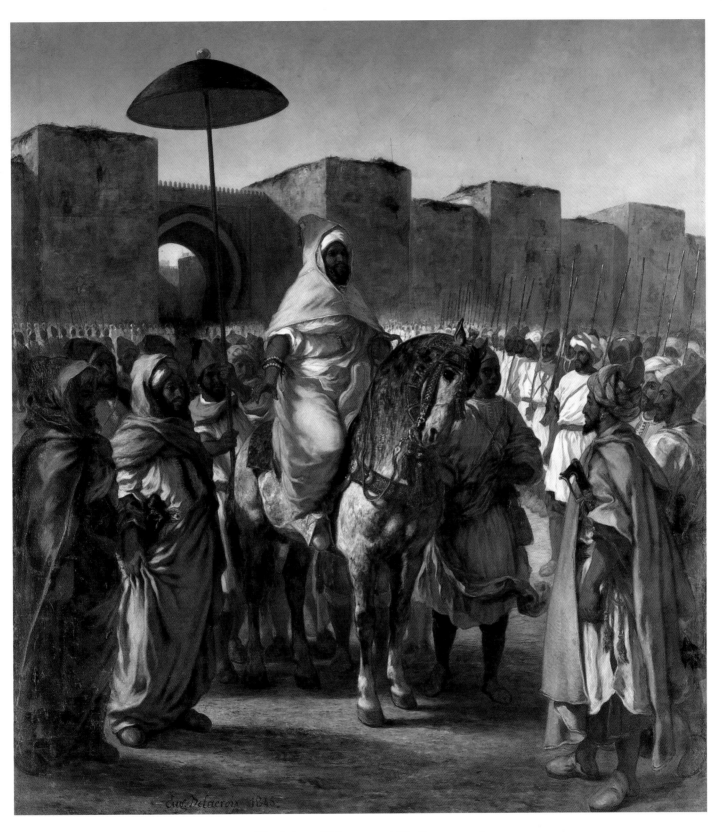

124. *The Sultan of Morocco and His Entourage,* 1845
Exhibited at the Salon of 1845. Oil on canvas, 384 × 343 cm
Musée des Augustins, Toulouse

two principal personages of the French mission, Benchimol, in white, and Mornay, in the dress of an ambassador. It is thus possible to divide the preliminary drawings into two groups corresponding either to the first idea of the painter or to the final painting. The elimination of the two protagonists on the French side of the audience is explained less by stylistic than by historic reasons, and by the time that elapsed between the mission and the execution of the painting. The negotiations conducted by Mornay had been crowned by success and had been followed in Paris by an informed public. There was really no need of long explanations to enable the viewer to identify the different personages. Ten years later it was a different story. Mornay's diplomatic career had gone in a different direction, and the political situation had also changed profoundly. The conflict with the Moroccans had started up again. There had been battles (to which the notice in the catalogue alludes) and new negotiations had been undertaken. This explains the disappearance of Mornay and Benchimol: it was now difficult, if not impossible, to commemorate an episode that had fallen into oblivion and become incomprehensible in view of the recent diplomatic changes. Interest in Abd el-Rahman and Morocco had, however, been revived by those same changes. Delacroix's choice of the vertical format, which concentrates attention on the sultan and those near to him, makes sense in light of these considerations. The canvas loses its anecdotal character and becomes a monumental portrait. We do not know why Delacroix did not paint this major episode of his voyage to Morocco immediately, but waited several years before taking it up. Yet the result is a work emblematic of his Orientalist vein, in its elaboration, in the relation of the treatment to the subject, in the formal composition, and in the relationship of the palette of colors to the general luminous tonality.

125. Sketch for *The Sultan of Morocco*, 1832–33
Oil on canvas, 31 × 40 cm
Musée des Beaux-Arts, Dijon

The similarities to the *Women of Algiers* are striking in all these respects, even though the colors are less delicately handled. (*The Sultan of Morocco* is an outdoor scene, where the light is more vivid.) More frankly arranged, the colors are no less vibrant—as, for example, on the ground—or subtly mixed—as in the horse's covering (one critic, Alphonse, saw *bleu chiné*). The harmonies are as subtle in the figure of Abd el-Rahman, the rose and blue of the saddle playing against the yellow and white of his garment, the reds and blues of the harness against the horse's mane. The costumes of the soldiers and attendants allow very vivid bursts of color: green, blue, yellow, and red, within the general tonality of ochers, whites, and browns in the mass of personages, who are contrasted against the two great masses of the ocher walls and the blue sky above them. The parasol, finally, echoes the walls in the green of its top and the lower part of the central group in its red. According to Charles Blanc, it was the crucial element of the painting: he spoke of the general effect as an "effect similar to that which nature presents when you see a field of ripe grain on the horizon, and then the two colors, azure and yellow, come together in the green of a field or a bouquet of trees." He added: "The blond and golden tone of the rampart and the blue of the sparkling sky, after making their brilliant contrast, affirmed and consummated their alliance in a green parasol that shaded the figure of the sultan, and this parasol was the key to the whole painting, while the spectator only saw it as a piece of ethnographical information or the remembrance of a local truth."[51] But all these bursts of color do no damage to the atmosphere of the whole. Delacroix, according to Lasalle-Bordes, aimed specifically at this effect by means of a special technique borrowed from Veronese. He "sketched out his big canvases with tempera paints, which allowed a quicker preparation.

126. *Reception of the Embassy of Count de Mornay by the Sultan of Morocco,* 1832
Two sheets from one of the Moroccan albums, describing the reception by the Sultan. Pen and brown ink on paper, 19.3 × 12.7 cm
Musée du Louvre, Département des Arts Graphiques, Paris

127. Study for *The Sultan of Morocco,* 1832?
Brush and gray wash with gouache on bluish paper, 14.7 × 20 cm. Musée du Louvre, Département des Arts Graphiques, Paris

128. Study for *The Sultan of Morocco,* 1845?
Black crayon and pencil on paper, 59.8 × 49.7 cm
The Metropolitan Museum of Art, New York

OPPOSITE

129. *Encampment of Arab Mule Drivers*, c. 1839
Rejected by the Salon of 1839.
Oil on canvas, 38.1 × 46.3 cm
Milwaukee Art Museum

130. *Moroccan Chieftain Receiving Tribute*, 1837
Exhibited at the Salon of 1838.
Oil on canvas, 98 × 126 cm
Musée des Beaux-Arts, Nantes

131. *Guard-Room at Meknès*, 1846
Exhibited at the Salon of 1847.
Oil on canvas, 65.3 × 54.2 cm
Von der Heydt Museum, Wuppertal

132. *Arab Players*, 1848
Exhibited at the Salon of 1848.
Oil on canvas, 96 × 130 cm
Musée des Beaux-Arts, Tours

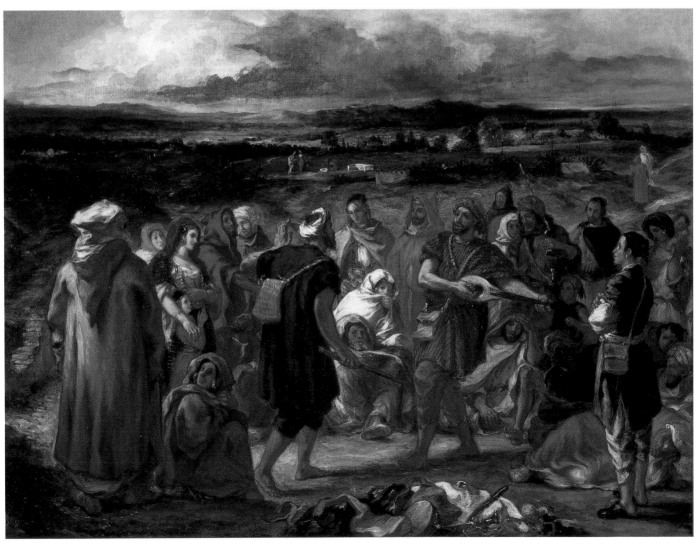

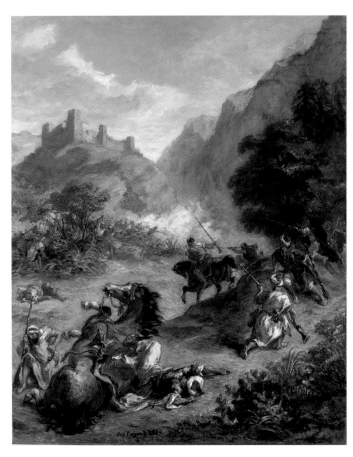

133. *Arabs Skirmishing in the Mountains,* 1863
Oil on canvas, 92.4 × 74.6 cm
National Gallery of Art, Washington, D.C.

134. *The Banks of the River Sebou,* 1858
Exhibited at the Salon of 1859. Oil on canvas, 48.9 × 59.7 cm
Artemis Group, London

This sketch made, he covered the whole surface with oil that fixed the colors, but also reduced the clarity considerably; which gave them that demi-tint that I was just speaking of, which he highlighted with light colors for the parts in the light, and with vigorous contours for the shade. I saw Delacroix sketch in tempera the picture of the emperor of Morocco on horseback. . . . The great colorist had thrown a brilliant note onto this canvas. The sketch, full of verve, was magnificent. . . . When he gave it a coat of oil, everything went crashing down; but he wasn't a bit worried; and then, he painted and repainted his canvas, which, when it was finished, made me regret the loss of the sketch that was so extraordinarily rich in delicious tones."[52]

Lasalle-Bordes may have thought the brilliant colors had disappeared, but some other critics did not think so, although the painting suffered from being hung at the Salon opposite Horace Vernet's *Abd el-Kader Taking Smalah* and between Philippoteaux's *Battle of Rivoli* and Schnetz's *The Sacking of Aquileia,* whose vivid, crude colors killed the harmony of its nuances. Delacroix was blamed for being too somber. Nevertheless, certain Salon visitors, more attentive than others, were able to perceive what Delacroix had undertaken. Thus wrote Thoré: "The general color is so harmonious that this brilliant and varied painting appears somber at first glance. It is the incomparable talent of M. Eugène Delacroix to be able to marry the richest and most diverse nuances, like musicians who run over the whole range of sound. This time the painter of the *Massacres of Chios* will not be reproached for having twisted his personages and exaggerated their movements. All these figures are calm and noble, as is appropriate for tranquil Orientals. Delacroix has reached a supreme point in art, magnificence and grandeur in simplicity."[53] Baudelaire, whose first Salon this was, found the most exact and most perceptive words: "Has anyone, at any time, ever used such a musical coquetry? Was Veronese ever more magical? Has anyone ever sung more capricious melodies on a canvas? made a more prodigious harmony of new, unknown, delicate, charming colors? We call on anyone who knows his old Louvre;—show us a painting of a great colorist in which the color has as much spirit as in M. Delacroix's. We know that we will be understood by only a few, but that is enough. This painting is so harmonious, despite the splendor of its tones, that it becomes gray—gray like nature—gray like the atmosphere of summer, when

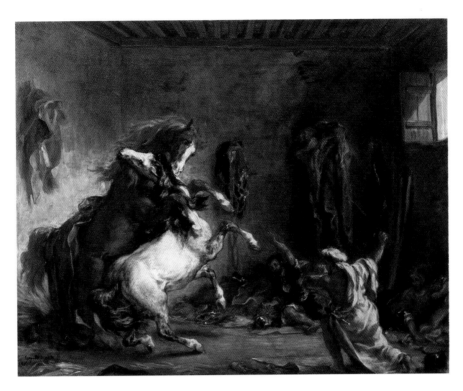

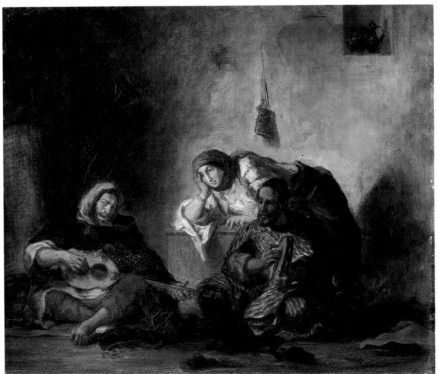

135. *Arab Horses Fighting in a Stable*, 1860
Oil on canvas, 64.6 × 81 cm
Musée d'Orsay, Paris

136. *Jewish Musicians from Mogador*, c. 1843–46?
Exhibited at the Salon of 1847. Oil on canvas, 46 × 55.5 cm
Musée du Louvre, Paris

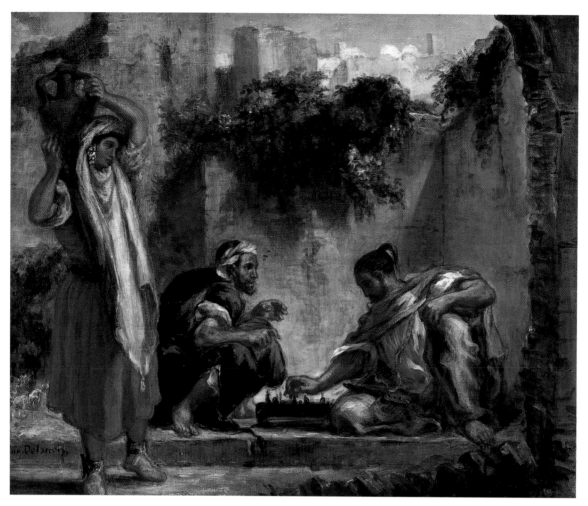

137. *Arabs Playing Chess*, 1847–48
Oil on canvas, 46 × 55.5 cm
National Gallery of Scotland, Edinburgh

the sun stretches like a twilight of dust over every object. But one does not see it at first glance—its neighbors overwhelm it. The composition is excellent—it has something unexpected because it is true and natural."[54]

Delacroix painted Moroccan subjects until the end of his life: the *Arabs Skirmishing in the Mountains* (fig. 133), was sold to the dealer Tedesco on 12 April 1863, only a few months after the painter's death. In all, there are more than thirty paintings that, over a thirty-year period, compose the Orientalist strain of his work. Like the *Women of Algiers*, *The Fanatics of Tangier*, the *Jewish Wedding*, or *The Sultan of Morocco*, most are tied to known episodes of the voyage of 1832, to manuscript notes or sketches done on site: the *Clash of Arab Horsemen* thus recalls a scene that Delacroix had experienced during one of

his outings with Drummond Hay and that he reported in a letter to Pierret.[55] Similarly inspired is the *Arab Horses Fighting in a Stable* (fig. 135). The *Moroccan Chieftain Receiving Tribute* (fig. 130) evokes the offering of milk that was made to the travelers during their trek toward Meknès. The latter also inspired *Moroccan Troops Fording a River*, *The Banks of the River Sebou* (fig. 134), and the two versions of the *Encampment of Arab Mule Drivers* (fig. 129). The *Guard-Room at Meknès* (fig. 131) was observed by the painter during his stay in the capital, as were the musicians who furnished the subject matter for *Arab Players* (fig. 132) and *Jewish Musicians from Mogador* (fig. 136). There is not always a direct relationship: another important group of Delacroix's Orientalist paintings avoids anecdote, concentrating on one or a few figures, often caught

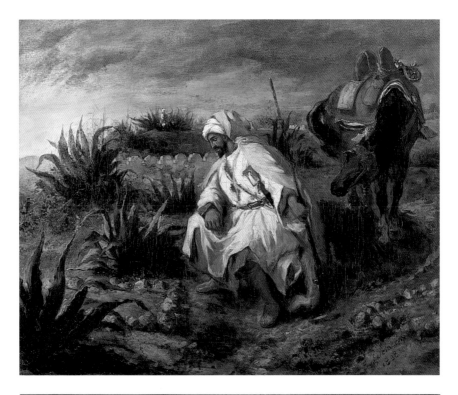

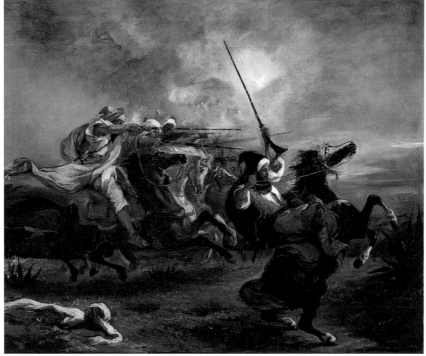

138. *Arab Soldier by a Grave*, 1838
Rejected by the Salon of 1839. Oil on canvas, 47.3 × 56.2 cm
Hiroshima Museum of Art

139. *Arab Cavalry Practicing a Charge*, 1832
Oil on canvas, 60 × 73.2 cm
Musée Fabre, Montpellier

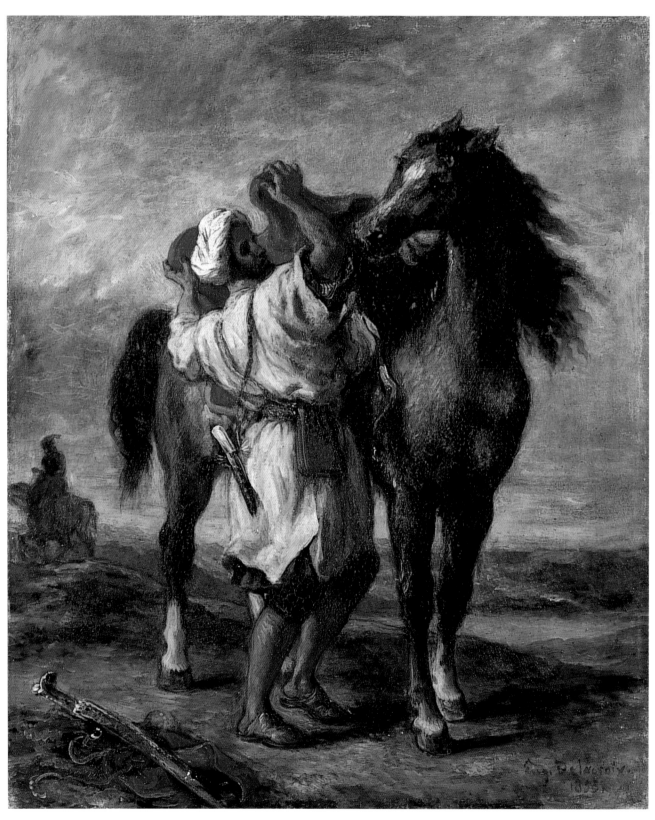

140. *Arab Saddling His Horse*, 1855
Oil on canvas, 56 × 47 cm
The Hermitage Museum, Saint Petersburg

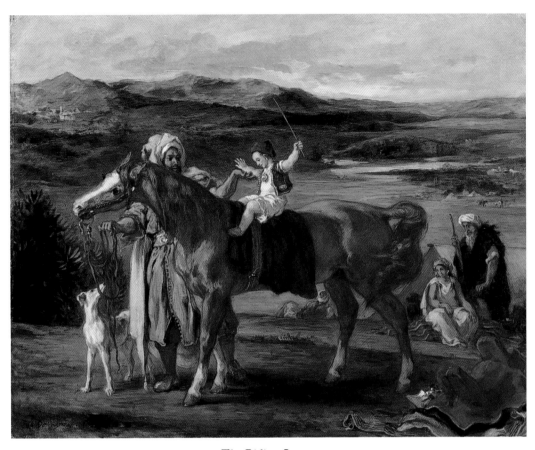

141. *The Riding Lesson,* 1854
Exhibited at the Exposition Universelle of 1855. Oil on canvas, 64 × 81 cm
Private collection, United States

in a static moment that, even in works of small format, aims at giving them permanence and monumentality. These include the *Arab Soldier by a Grave* (it is Mohammed ben-Abou) (fig. 138), *Arabs Playing Chess* (fig. 137), *Arab Saddling His Horse* (fig. 140), and the passersby of *A Street in Meknès.* The subject of certain canvases, like *Moroccans Hunting a Lion,* and some versions of *Arabs Skirmishing* (fig. 133), and even *The Riding Lesson* (fig. 141) are, it is true, more picturesque in character. But it is always a pretext; Delacroix's Orientalist paintings are never simple chronicles, in contrast to the works of many of his contemporaries like Decamps and Horace Vernet. The way that he conceived the *View of Tangier from the Seashore* (fig. 142) reveals how he had distanced himself from the reality with which he had rubbed shoulders for six months. The landscape that is the setting of the scene comes from a drawing done on site, followed very closely. But the group of Arabs pulling a boat onto the beach was, if we

believe Chesnau (who tells the story in Robaut's catalogue), a recollection of a vacation in Normandy. Walking with his cousin Bornot near Fécamp, Delacroix supposedly saw a group of sailors, men and women, trying in vain to haul a small craft up on to the shore. The two men went to help them, and Delacroix, in the water, the task achieved, said, "I've found a good subject for a painting." If the canvas shows no sign of this fusion of such different sources of inspiration, it is no doubt because the subject, landscape or genre scene, becomes secondary, and because the worth of the work lies essentially in its formal qualities: the harmony of blues and deep greens of the sea and the hill, against which the ramparts and white roofs of Tangier appear, and a delicate counterpoint afforded by the blue sky highlighted by the clouds, white, gray, and pink, in contrast to the severity of the dark tones. At the same time that the scene is anchored in the North African reality, it is distanced from it by the primacy given to the plastic expression,

especially to color. When Delacroix returns to certain themes at intervals of several years, as he frequently does near the end of his career, it becomes clear that he is less attached to retracing the Moroccan memories in exact detail than in painting that which only begins with them (fig. 123). He is never far from reality, but he attains it by other means, those of the true artist. Thus he wrote in 1853: "*Still on the use of the model and imitation*. Jean-Jacques said correctly that one paints the charms of liberty better when one is in chains, and one describes a pleasant countryside better when one lives weighed down in a city where one only sees the sky through a dormer window among the chimneys. When I am right there, with my nose in the landscape, surrounded by trees and charming places, my landscape is heavy, overworked, maybe truer in detail but not true to the subject. . . . I only began to do something acceptable, on my voyage to Africa, when I forgot the little details and instead remembered in my paintings only the striking and poetic; until then, I was pursued by the love of exactitude, which most people take for truth."[56]

Although Delacroix had already painted the Orient before he went to Morocco (for the nineteenth-century painter, the term covered the eastern Mediterranean as well as North Africa), he had done it only through the imagination. After 1832, as was often pointed out in his own time, he painted from what he had seen and lived. But one must not reduce the results of his sojourn only to the development of a more realistic Orientalist vein. The consequences of those six months go much farther than that. The first and most obvious consequence is the increased clarity and richness of his palette, a more sophisticated use of color, and, generally, the luminous harmony that results from this. Problems of coloration were certainly not absent from Delacroix's consciousness before 1832, but his great paintings were constructed more around composition and the relationship of the different figures to each other. The *Women of Algiers in Their Apartment* is a different matter. Its display in the Louvre between the *Scenes from the Massacres of Chios* and *The Death of Sardanapalus* adequately demonstrates the extent of the change provoked by the trip to Morocco. Delacroix seems to have abandoned the somewhat artificial and theatrical character of the earlier works and to have become more natural, truer, thanks to the judicious use of colors that are suddenly more luxurious. The Moroccan trip is of first importance in this, in several ways. The greater

luminosity of Africa clearly struck the painter, who only knew the much more tempered contrasts of the North and had only a vague memory of his early childhood in the Midi. He wrote to Villot: "If you have a few months to lose some day, come to the Barbary coast, you will see a nature that is always hidden in our countries, you will feel the most precious and rare influence of the sun that gives everything a penetrating life."[57] Additional evidence of the painter's preoccupation with this is found, curiously, in the black and white prints that he did on Moroccan subjects. Instead of the straight lithography that he had used for the *Sheet of Seven Antique Medals* (fig. 34) and the *Faust* series (figs. 67–73), or the aquatint of his first attempts at line engraving, he turned to aquafortis, which emphasized the contrasts—(as in the *Arabs of Oran*, the *Clash of Moorish Horsemen*, the *Jewish Woman of Algiers* (figs. 143, 144, and 146), or *The Kaid Mohammed ben-Abou*—or to pen autography, a lithographic process that gives a much more pronounced line than the usual technique, as in *Mule Drivers of Tetouan* (fig. 145), *Women of Tangier Hanging Laundry*, or *Costumes of Morocco*. He could thus show the luminous oppositions more clearly in the sheets that, incidentally, often are based on painted compositions or watercolors. This preoccupation came to fruition only with daily work, done on site, not only preserving the memory of a different and picturesque reality, but especially—manuscript notes on his drawings and in his notebooks convince us—transcribing in detail the colors that enlivened it, bright colors, many of them, that could be found in watercolor. Delacroix thus analyzed day by day the more general atmosphere in which he bathed. This slow and progressive impregnation gave him, little by little, the confidence that allowed him to conquer the feeling of powerlessness that has been mentioned in the face of the Moroccan reality. It is thus that the trip to Africa developed an essential part of his pictorial technique, the consequences manifesting themselves not only in the Orientalist paintings but also in the rest of his production.

Another civilization, another light, other colors—Morocco was indeed all that for him. But it completed his formation by revealing to him the truth and the real value of the antique model. Like all the artists of his generation, Delacroix possessed a deep knowledge of it. The classical formation that he received under Guérin had begun, as was the tradition, with studying the basics, that is, drawing from Greek and Roman

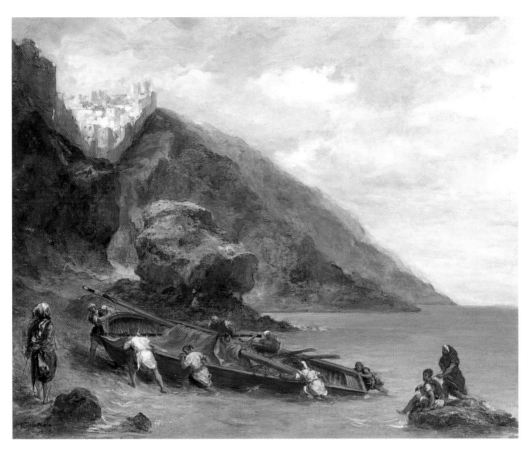

142. *View of Tangier from the Seashore*, 1858
Oil on canvas, 81.1 × 99.8 cm
The Minneapolis Institute of Arts

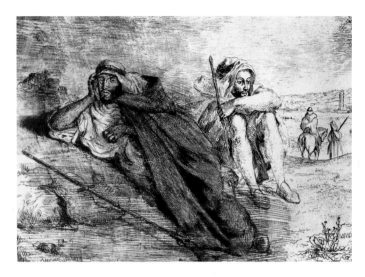

statuary, either directly, from works conserved in France, or from casts for the others. He had been able to admire, if not already study, the fabulous collection of ancient art in the Musée Napoléon, which was dispersed after the fall of the Empire, and he had seen in London the Parthenon marbles that Lord Elgin had brought from Greece. This knowledge increased his sincere and deep admiration; he kept casts from the antique in his studio on the rue Notre-Dame-de-Lorette and had others as decoration outside the one in the place Fürstenberg. In this he was no different from his contemporaries, who shared this natural reverence for the antique model. But, with regard to practical consequences, it was another matter. It was partly against the sclerosis brought on by a too insistent imitation of this model and the preponderance of mythology and Greek and Roman history in the choice of subjects that the Romantics struggled, Delacroix chiefly. All his work, from *The Barque of Dante* on, even when the mark of the antique was evident here or there, aimed toward freeing himself from it; the voyage to Morocco had the opposite effect. It is true that it was no longer a matter of an archaeological antiquity, known only from its remains, with the coldness and whiteness of its marble statues, the antiquity of David and his students up to Ingres, but another antiquity—living, real, and vibrant with light.

To understand how Delacroix found Rome and Greece in Africa, one must once again turn to the letters that he wrote to his friends. "It is a perfect place for painters. The economists and the Saint-Simonians would have a lot to criticize in regard to the rights of man and equality before the law, but beauty abounds; not the much-praised beauty of fashionable paintings. The heroes of David and company would make a sad figure with their rose-colored limbs next to these sons of the sun: but on the other hand, the antique costume is worn better there, I dare say," he writes to Villot.[58] And, the same day, he develops this idea for Pierret, his most intimate correspondent: "Imagine, my friend, what it is to see Catos, Brutuses, lying in the sun, walking in the streets, and mending their old slippers; these people here only own one covering, in which they walk, sleep, and are buried; they seem as satisfied as Cicero must have been with his curule chair. I tell you, you can never believe what I tell you, because it will be so far from the truth and nobility of these natures. Yesterday a peasant passed by here, who was rigged out like you see here [a small sketch]. Farther on, here is a turning where the day before yesterday I gave twenty sous to a vile Moor. All in white like Roman senators and the Greeks at the feast of Athena."[59]

Later, at Meknès, he wrote in a similar vein to Bertin: "The picturesque abounds here. At each step there are pictures already made that would give twenty generations of painters fortune and glory. You think you are in Rome or Athens, minus the atticism; but the mantles, the togas, and a thousand of the most antique coincidences. A rascal that mends a shoe for a few sous has the robe and bearing of Brutus or Cato of Utica."[60]

Finally, it is near the end of his voyage that he takes up the same ideas again for Auguste Jal, the journalist and art critic: "Beauty runs in the streets: it is hopeless there, and painting, or rather the mania for painting, appears to be the greatest of

MULETIERS DE TETUAN

follies. You have seen Algiers, and you have an idea of nature in these regions. Here, there is something still simpler and more primitive; there is less Turkish alloy; Romans and Greeks are here at my door; I have laughed heartily at David's Greeks, except of course for his sublime brush. I now know them; the marbles are truth itself, but you have to know how to read, and our poor moderns have only seen hieroglyphics. If the school of painting persists in always proposing as subjects for the young infants of the Muse the family of Priam and Atreus, I am convinced, and you will agree, that it would be infinitely better for them to be sent as ship's boys to the Barbary coast on the first boat, than to wear out the classical earth of Rome any longer. Rome is no longer in Rome."[61]

The idea that the Orient offers a living and authentic antiquity to the traveler, which had been perpetuated for centuries, became widespread in France under the Restoration because of the philhellenic movement. It was not unique to Delacroix; a number of his contemporaries shared it, including many of the painters. Horace Vernet, who discovered Algeria a little while after Delacroix, in 1833, had a similar experience and expressed himself on the subject in terms quite close to Delacroix's.[62] What Delacroix experienced remains profoundly original, because it was totally personal. The discovery of a living antiquity meant simply a possible synthesis between the classical formation that he had received, and that he had never relinquished, and the romanticism of his youth, a synthesis that already foreshadows *Liberty Leading the People*. All his further production follows from this, beginning with the Greek or

Roman subjects that he had almost never attempted previously, at least in the monumental format of the great Salon paintings like *Medea about to Kill Her Children*, *The Justice of Trajan*, and *The Death of Marcus Aurelius*, not to speak of the decorative works of the Luxembourg or the Palais-Bourbon. The voyage to Morocco liberated Delacroix from the impasse in which an exacerbated romanticism had threatened to imprison him. If this trip was fruitful on the formal plan, it was equally important spiritually. At his return, Delacroix was in full possession of renewed and reaffirmed abilities. From Tangier to Meknès, from Seville to Algiers, he had stored up new subjects and expanded his technique. But above all, he returned to France with the fundamental idea that he was from now on truly the keeper of the classical tradition.

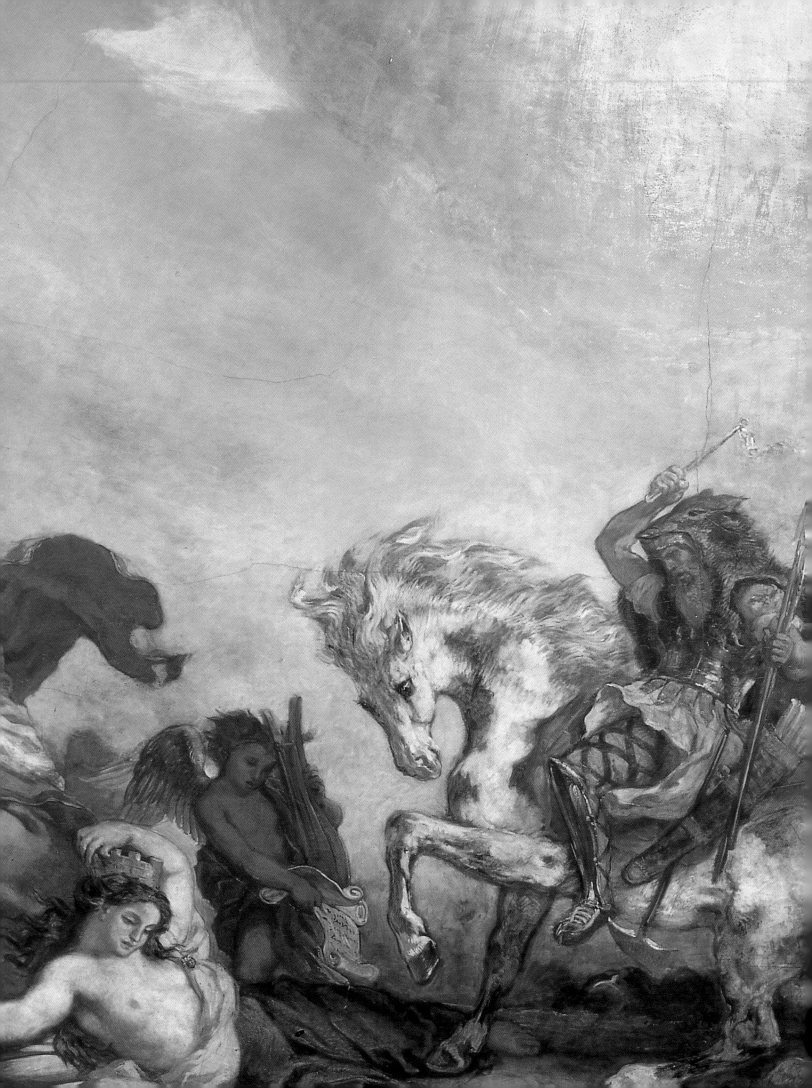

The Great Decorative Works: The Palais-Bourbon

Before the trip to Morocco, the rhythm of Delacroix's activity had been determined by his submissions to the Salon. After 1832, his activity was structured around a series of great decorative projects: the Salon du Roi (1833–37) and the library (1838–47) in the Palais-Bourbon, the library of the Chambre des Pairs in the Palais du Luxembourg (1841–46), *The Lamentation* in Saint-Denis-du-Saint-Sacrement (1843–44), the ceiling in the Louvre's Galerie d'Apollon (1850–51), the Salon de la Paix in the Hôtel de Ville de Paris (1852–54), and the Chapelle des Saintes-Anges in Saint-Sulpice (1849–61).[1] Delacroix, of course, did not always work intensely and continuously on all these projects from the time he received the commissions until they were completed, nor did he work on these to the exclusion of other projects. For example, he continued to send important paintings to the Salon: *Women of Algiers in Their Apartment* (1834), *Saint Sebastian Tended by the Holy Women* (1836), *The Battle of Taillebourg* (1837), *Medea about to Kill Her Children* (1838), *The Justice of Trajan* (1840), *Entry of the Crusaders into Constantinople* (1841), *The Sultan of Morocco and His Entourage* (1845), and *Lion Hunt* (1855), to name only the large-format paintings. In addition, his monumental paintings were done collaboratively: except in the case of the Salon du Roi, he called upon assistants trained in the studio he had established in 1838 for that purpose. The contribution of these assistants, which generally consisted of setting the works in place, should not be overstated. Delacroix's achievement over thirty years is impressive indeed, especially for one limited by illness beginning in 1841–42. The constant commitment required by these monumental paintings, as well as Delacroix's stated desire to realize "great walls," suggest that these paintings represent the chief axis of the second part of his career. These works are less well known than his other paintings, less accessible, and perhaps also harder to grasp, for they are often "programmed" paintings. And yet, because of the subjects they treat, the constraints they imposed, and their often original techniques, they brought a fundamentally new dimension to Delacroix's oeuvre.

Delacroix officially received the commission to decorate the Salon du Roi[2] in the Palais-Bourbon on 2 September 1833; the departmental order had been approved two days earlier.[3] In fact, he had been notified semi-officially at least three months previously: in a letter of 30 May to François Cavé, head of the division of Literature, Science, and Art of the Ministry of the Interior, Delacroix asked that care be taken to have "the ceiling of the room that I am to paint"[4] properly prepared against humidity. In June he told Lelong, the architect of the Chambre des Députés, that he did not plan to begin work immediately, so as not to compromise the project by painting on a too-fresh ground.[5] In early July, he began "to make charcoal drawings on the wall" after the scaffolding was in place. "All beginnings are beautiful," he wrote Guillemardet, "where you pay the price is in the final giving birth."[6] Thus, both the overall program and the various subjects that it comprised were established by that time. A bureaucratic delay in carrying out the minister's orders would explain why Delacroix, unofficially informed beforehand, had begun to think about the execution of the work before receiving administrative notification. Another reason lay in the circumstances of the commission, which Delacroix specified only in his journal, reported by Piron: "M. Thiers is the only man in a position to be useful to me who has helped me in my career. . . . It is he, who, as Minister of the Interior, gave me the Salon du Roi in the Palais-Bourbon. He did it despite the charitable advice of my enemies, and even of my friends, who seemed to compete with one another to tell him that it would be doing me a disservice because I knew nothing about monumental painting, and that I would dishonor any walls I might paint." Elsewhere in his journal he described how he received the official commissions: "It was after 1830 that Thiers's friendship won me the Salon du Roi. This work, which was rather successful, even among the purists, led other ministers to give me similar projects in various monuments. I did not enjoy the favor of the king, who didn't understand my painting at all. The two or three paintings he had me do for Versailles were given me because they really were being given to everyone, but I was far from being numbered among the most favored. I owe to a few friends who have been in power now and then the opportunities that I have had to show what I could do."[7]

Thiers's role in having the Salon du Roi assigned to Delacroix thus appears to have been crucial. His gesture was significant in two ways: it was the first important mural decoration in the new Chambre des Députés—which was still being built (the construction would be completed only some years later). It was also one of the first government commissions for decorative painting, a genre that would receive more consistent attention and continuous support in the following years. The

147. *Plan of the Chambre des Députés, in the Palais-Bourbon,
Paris, in 1840, after the works of Jules de Joly*

The orientation is north-south. Around the semi-circular Salle des Séances are
(left) the Salle des Pas-Perdus; (center left) the Salon du Roi, or Salon Delacroix;
(center) the entrance hall, or Salle Louis-Philippe; (center right) the Salon
des Distributions, or Salon Abel de Pujol; and (right) the Salle des Conférences.
The library is at the far right, its main entrance at the end of the various
communicating halls that run east-west along the main courtyard.
From Jules de Joly, *Plans, coupes, élévations et détails de la restauration de la
Chambre des Députés . . .* (Paris, 1840), plate 8

choice of Delacroix, a controversial artist, could have been polemical, and not without reason. Other artists—Ingres, Delaroche, Horace Vernet, Eugène Devéria, and Sigalon— were qualified (from various points of view) for so prestigious an endeavor, and in fact they later received government favors. Except for Ingres, however, none of them really had a reputation for large-scale decorative projects. Like Delacroix, albeit less regularly than he, they had had noteworthy paintings in the Salon. There was actually nothing to indicate that any one of them would either succeed or fail at the task, and this meant that the final selection, left to the minister himself, was necessarily arbitrary to some extent. What might have prompted Thiers's choice? In his articles, he had supported Delacroix since the painter's early days, in 1822 and 1824; when Thiers

achieved a position of influence, he was able to act on his longtime admiration (which, it should be recalled, extended to most of the painters of the younger Romantic generation). Perhaps Thiers wished to compensate for the failure of *Mirabeau* and *Boissy d'Anglas at the National Convention* so that the enlightened choice of a single individual might cancel out the compromise of a competition. For his part, Delacroix seemed more disciplined in his later works. So the experiment could be attempted, especially because the initial commission was quite modest, just four ceiling coffers. And in the end, the painter's success amply justified the minister's expectations.

The Salon du Roi, or Salle du Trône, emerged from the renovations and expansions undertaken in the Palais-Bourbon by the architect Jules de Joly (fig. 147), following the palace's

148. The Salon Abel de Pujol, formerly Salon des Distributions, in the Palais-Bourbon

149. The Salon Delacroix, formerly the Salon du Roi, in the Palais-Bourbon

purchase by the French state in 1827. Joly renovated the assembly room, creating around it a series of larger and smaller rooms and a library. The Salon du Roi (fig. 149) was built for the monarch's throne, where he would sit to receive the respects of the nation's representatives before the opening of the official sessions. The room is square and open on three sides: to the hall leading to the assembly room; to the building's grand entry hall, today the Salle Casimir-Perier; and to the hall between the Salon and the vestibule that opens to the court and garden of the nearby Hôtel de Lassay, today the Salle des Quatre Colonnes. Delacroix, working with the architect, was to be solely responsible for the decoration of the hall. In its original state, the room was poorly adapted to decorative painting; the symmetrical Salon des Distributions, today the Salon Abel de Pujol, gives an idea of how it was (fig. 148). Delacroix almost immediately requested modifications, as he explained much later, in 1848, in his journal: "The *salon du Roi* or *salle du trône* was ill-suited for painting. It is a large, square room, with both real and sham windows that leave only narrow piers between them. Above the archivolts there extended a wide frieze that, at the time, did not leave any space to be filled on this side. They were able to eliminate this frieze, so as to join it to the cornice by making it shallower. That left, between the archivolts and above them, enough space for important subjects related to one another and occupying the circumference of the room without interruption. Light enters from three windows overlooking a gallery that in turn opens onto the main courtyard: the light is thus dimmed because of the gallery, which serves as a hall. In the middle of the ceiling is a circular opening, which also lets some light in,[8] but the light only strikes the sides, since the ceiling is flat and appears even darker because of the light-filled lantern that draws the eye, at the expense of the paintings around it."[9] Delacroix was even more explicit in an 1836 letter to the Minister of the Interior in which he requested an increase in his grant because of changes to the original program: "The decoration of the Salon du Roi in the Chambre des Députés in its original layout, was far from presenting the complication that it displays today, and to which I was brought in order to make the best of the spaces. According to the first plan, only the ceiling coffers and the piers between the windows were to be painted. The long frieze bracketed by figures, which now takes up the area above the arches, was all added. These figures, by their number and importance, more than doubled the work and entailed a considerable expenditure of time. In the original arrangement, there was, below the moldings supporting the ceiling, a stringcourse that left an inadequate space that could be filled only with purely decorative trimming. At that point, the organization of the room was deemed to offer only a heavy, graceless appearance, made worse by the extreme thinness resulting from the four figures isolated on the ceiling. It was suggested that the ceiling be torn down entirely and replaced with another, in

which the painting would fit better and more appropriately to the purpose of the room. I then asked that, instead of this tearing down and subsequent rebuilding, only the string-course, which weighed down the windows and doors, be eliminated. . . . But in the new plan, that which had been for the painter only a minor detail became the principal part of the whole project, since the frieze comprises no fewer than sixty to seventy more and less elaborated figures. I confess that I felt rewarded—for an expenditure of time so excessively beyond what I had anticipated and even the minister's own specifications—in the satisfaction of making the overall decoration more complete."[10]

Delacroix's purpose for the alterations he obtained is clear: by extending the surface available to be painted—previously limited to the ceiling—he was emphasizing color and downplaying the purely architectural elements, while at the same time and by the same token compensating for the inadequate illumination. Moreover, a painted frieze that ran along all four walls and which served a similar function further unified the room. The same held true for the areas opened up between the doors and windows, which were also given over to the artist. Delacroix's concerns, motivated primarily by the distribution of light, were very much those of a decorator: his goal was not to adapt the walls to a preexisting program, but to create a truly pictorial space, with the painter either enhancing or correcting the architectural effects within an original overall creation.

To do this, Delacroix conceived a chromatic progression that became increasingly rich as it rose upward. The piers were executed in grisaille, to look like sculpture and to coexist peaceably with architectural surroundings they could not have defeated. The tones of the frieze are deliberately subdued so as to set off the richness of the ceiling coffers. In addition, the contrast with the gilt moldings is much greater in the ceiling than at the height of the frieze. The furnishings had been planned with the general effect in mind: light muslin curtains on the windows, but furniture opulent enough to balance the gilding and frescoes. Unfortunately, the appointments that were installed after the decoration was completed disrupted the harmony. In 1848, Delacroix complained that the windows were draped in very bright red velvet curtains, which cut off some of the light. Likewise, partitions were installed in the gallery overlooking the courtyard. "The only practicable opening was thus the ceiling lantern, which gives entirely too little

150. *Leda and the Swan*, 1834
Fresco formerly in the Abbaye de Valmont, 67 × 88 cm
Musée National Eugène Delacroix, Paris

light. This cutting off the light from the windows and these heavy draperies, in an even heavier, more overwhelming shade, were quite a blow to the paintings on the frieze, which had been intentionally weighted, by sacrificing their colors, so as to set off those of the ceiling. To add the finishing touch, the immense carpet that covers the floor was composed of the loudest, most disastrous colors imaginable."[11]

The choice of techniques derived directly from the room's architecture. The ceiling coffers were painted in oil on canvases that were then remounted. For the frieze and the piers, however, Delacroix used an original process, painting directly on the wall with a combination of oil and virgin wax so as to obtain a matte effect like that of distemper. This allowed him to avoid the unwanted reflections that might have resulted from using on the walls the same technique he employed on the ceiling, where this problem, because of the particular lighting in the room, did not exist. He had also considered fresco painting, with which he experimented during his vacation in Valmont in the summer of 1834, when he had made his final decision.[12] He frescoed three overdoors (today in the Musée Delacroix), the only frescoes he ever painted. They were small, the subjects purely classical and decorative, and their sole purpose was to permit him to understand the practical conditions required by the technique. Shortly after the first attempt (probably *Anacreon and a Girl*), he wrote Villot: "I said that I have done nothing; I was wrong. Maybe I have done more

than I thought, for I tried some frescoes. My cousin had a bit of wall prepared with suitable colors, and in a few hours I made a small painting in this manner, which is fairly new to me, but which I believe I could apply acceptably if the opportunity arose. It is more convenient than distemper: the difficulty arises especially in finishing and rounding the shapes properly: but I believe the change that occurs in the colors is less than with distemper. Otherwise, it takes a very long time to dry, and four or five days after being done, I am not yet sure that the colors have regained their brightness. I confess that I would be singularly encouraged to try something in this manner if I could do it seriously and on a large scale. I believe the process is simpler than it is made out to be. Besides, it might mean making a tour of Italy to see a few old plaster-mashers to complete one's education."[13] After a second experiment, *Leda and the Swan* (fig. 150) and *Bacchus with a Tiger,* which may be considered pendants, he clarified and refined his ideas in another letter to Villot: "I have made a second try at a fresco, where I have had more patience and which came out better. You are right, my nature doesn't seem to go with painted cartoons, and that is the only drawback. But these are the advantages: the need to do everything at once excites the putto quite differently than does lazy oil painting. Besides, it has always been my bad luck to change in the retouching what came out in the first impulse. As you know, one's effort increases with the difficulty. Any rebellious material excites me to conquer it; an easy conquest excites less enthusiasm. Speaking of which, I can think of certain Spanish painters who painted straight off, primarily Zurbarán, whom I believe you do not know. The overall harmony loses by this, I believe. But there is something penetrating that is lacking in your beloved Venetians. Only, when one is as lazy as I am, I would never have the heart to leave a flaw that detracts from the whole, so long as I was able to retouch it. So that is one of the advantages of fresco painting. Also, if one has to, one can tolerate a certain discord among the parts, and I maintain that only then can one develop all the *ideal*, are you following me, of which great painting is capable, or rather I would admit that the two manners are two different, equally beautiful arts, but with totally opposite requirements. I will expound on this for you further, for this small attempt has led me, *regretfully*, to acknowledge that it was brazen of me to do oil painting without much consulting nature, which fresco painting avoids rather than includes.

Understand if you can."[14] If, in the end Delacroix decided against fresco painting the Salon du Roi, it was apparently because of these two characteristics of the medium: that pentimenti are impossible and that the colors change as they dry, making it more delicate and more difficult to control the range of colors, which was essential to his decorative program. Instead, he decided to use encaustic, a technique that he had learned from Reynolds, and that, in his particular case, is known to us from statements by his students Pierre Andrieu and Gustave Lassalle-Bordes.[15] He used wax dissolved in turpentine, mixing this previously prepared, quick-drying cream into his paints as he laid them down. The encaustic gave a matte appearance similar to that of fresco painting while retaining the variety of colors and shades of oil paints; this allowed him to use oil paints in the same room without introducing too great a dissonance. Another important effect was that the resulting work was both sturdy and permanent. After experimenting with and mastering this technique in the Salon du Roi, Delacroix would apply it in nearly all his other great decorative works.

Once the material problems were resolved, there still remained the essential question of the subjects to be treated. The ministry apparently did not give specific instructions in the matter, leaving the artist perfect freedom. Delacroix discussed the matter at length with Villot—who, as we have seen, was very involved in the choice of technique—working out with him the themes and the iconography, as he would later do for the libraries of the Palais du Luxembourg and the Palais-Bourbon.[16] He finally settled on a decoration consisting entirely of allegorical figures related to the room's purpose.[17] The four parts of the frieze correspond to the four rectangular coffers of the ceiling, while a different program was developed on the piers.

Justice is depicted on the coffer over the alcove occupied by the throne (fig. 151): "This is the attribute of supreme power and the chief connection of human society. In the painting, she reaches her scepter out over women, old men, etc." The frieze (fig. 152) shows related subjects: to the left of the alcove "Truth, Prudence, etc., help an old man who is writing the laws; Meditation labors over the texts; the peoples rest beneath the aegis of the laws that protect them. On the other side, three old men sit on a magistrates' bench. Might, standing, represented as a nearly nude young woman, leaning on the club,

151. *Justice*
Coffer of the ceiling of the Salon du Roi in the Palais-Bourbon.
Oil on canvas, 140 × 380 cm
Palais-Bourbon, Paris

152. The *Justice* wall
Frieze with *Justice, The Mediterranean,* and *The Ocean*
Oil and wax on plaster, 260 × 1100 cm, 300 × 122 cm,
and 300 × 118.5 cm, respectively
Palais-Bourbon, Paris

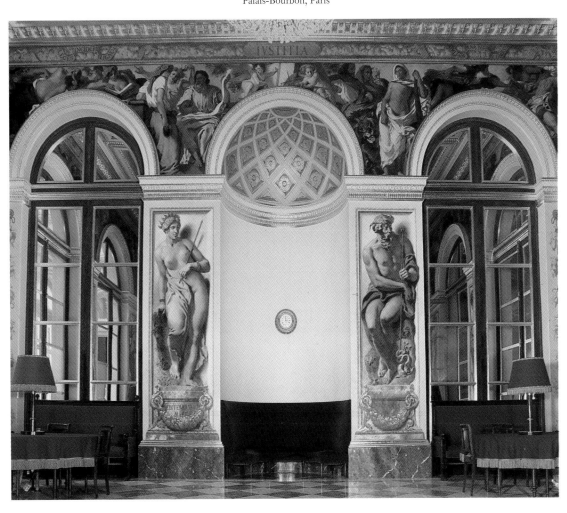

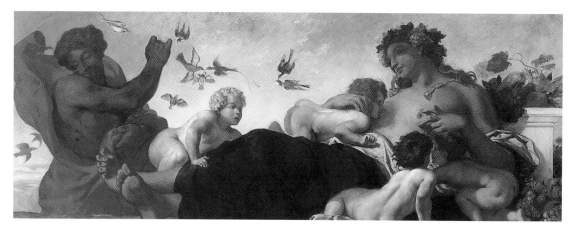

153. *Agriculture*
Coffer of the ceiling of the Salon du Roi in the Palais-Bourbon.
Oil on canvas, 140 × 380 cm
Palais-Bourbon, Paris

154. The *Agriculture* wall
Frieze with *Agriculture, The Garonne,* and *The Saône*
Oil and wax on plaster, 260 × 1100 cm, 300 × 110 cm,
and 300 × 110 cm, respectively
Palais-Bourbon, Paris

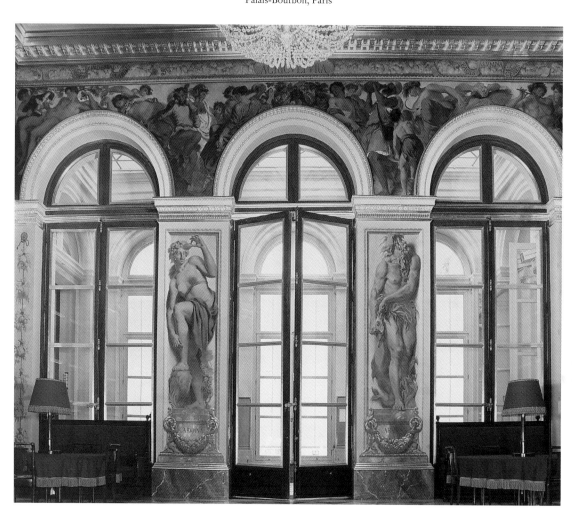

with a quivering lion at her feet, is the natural support of their decisions, and, farther on, an avenging putto who appears to be executing their orders goes to seize in their lairs the robbers and sacrilegious persons who are busy hiding and stealing away with vessels, riches, etc." Agriculture is the theme on the side adjoining the hall leading to the courtyard. In the coffer (fig. 153), "she is nursing babies, who press themselves to her tan breast. A laborer is busy sowing"; variegated birds fly about in the sky. "In the corresponding frieze [fig. 154], on one side, the grape-pickers, fauns, and followers of Bacchus celebrate this autumn festival. On the other side, the harvests: a robust peasant carries to his lips a vase handed him by women and children. A sleeping harvester is stretched out on sheaves; farther on, retired into the shadows, a young man crowned with ivy plays the flute." Delacroix illustrated Industry and Commerce symmetrical to Agriculture. "The principal image [fig 155], which occupies the ceiling, is characterized by details such as bales of goods, anchors, etc. A putto leaning on a trident represents the importance of the merchant marine. Another spirit, winged and holding a caduceus, symbolizes the speed of transactions. Above the archivolts [fig. 156] can be seen, on the left, Negroes bearing goods, exchanging ivory, gold dust, dates, etc., for our commodities. Ocean nymphs and sea gods, bearing pearls and corals from the sea, watch as sailors embark, represented by children wreathing with flowers the prow of a ship. On the right, silk looms, throwsters, women bringing the cocoons in baskets, and other people picking them off the very mulberry branches." Last is War, on the side of the main entrance. "Agriculture and Commerce provide the elements of life in the things that are produced or exchanged; Justice preserves the safety of the relations between the individuals of a State. War is the means of protection against attacks from without. In the last coffer [fig. 157], the figure of War is represented by a woman lying down, wearing a helmet, her breast covered by her aegis, and holding flags. Weeping women flee, turning back one last time to gaze upon the face of father or husband, who has fallen in the defense of his country. The corresponding subjects, occupying the lower portion of the wall [fig. 158], are, on one side [on the left], the sorrows of war: women taken away as slaves, casting despairing glances to heaven, for they cannot raise, to call it to witness, their weak arms heavy with bonds. . . . Warriors attach their armor once more and hurl themselves forward to

the sound of the trumpet. On the other side is portrayed the making of arms and arsenals full of swords, shields, and catapults. Blacksmiths inflate their bellows and make the iron glow red; others sharpen swords or hammer out helmets and breastplates on anvils."

The cornice between the frieze and the ceiling is painted in grisaille to look like stone, with garlands of flowers and fruit, cartouches in the middle, and gilded banderoles on either side, on which are inscribed in Latin the subjects of the panels and various maxims, respectively. Some of the latter are abbreviated passages from ancient authors: *Leges incidere ligno* (to engrave the laws in wood) and *Culpam paena premit* comes (the punishment accompanies the crime), for Justice, and *Plenis spumat* (it foams up abundantly) and *Pacis alumna Ceres* (Ceres is the daughter of Peace), for Agriculture, come from Horace, Virgil, and Ovid.[18] *Indi dona maris* (the gifts of the Indian Ocean) and *Fuso stamina torta levi* (threads spun by a smooth spindle), for Industry, and, for War, *Invisa matribus arma* (arms hateful to mothers) and *Gladios incude parante* (beating the blades on the anvil), however, appear to be by Delacroix (or Villot, or another of his friends). The four corners of the ceiling are given over to four figures of children, who bear emblems also related to the principal allegories: Minerva's owl for wisdom; Hercules' club for Might; the sculptor's chisel, hammer, and compass for the Arts; a basket of flowers and a shepherd's crook for the last putto, who represents Fertility. As Delacroix wrote: "Because they are small, these figures of children stand in contrast with the large subjects and contribute to the ceiling as a whole." In certain cases, they support the adjacent allegories, especially Justice, but their chief role clearly is to provide a plastic connection among the four large coffers. There is a similar scheme around the glass-enclosed cupola, from which a chandelier hangs today. In each sconcheon, Delacroix placed two heads or masks in blue grisaille against gilt branches; these not only form a natural frame around the central oculus, but also are symmetrically related to the four figures that they extend. Very bright blue ribbons set off the gold that is lavished throughout the ceiling's elements, whether sculpted or strictly decorative, and keep the ceiling from becoming overwhelming.

Thus, the conception of the upper portion of the room was very rigorously and logically worked out, according to a specific program that excluded the lower portion, which was

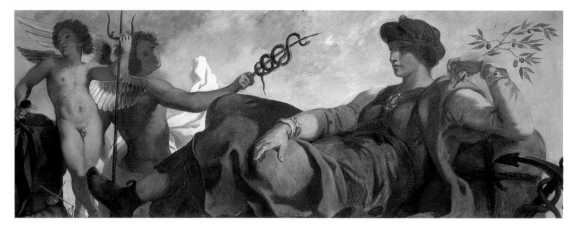

155. *Industry*
Coffer of the ceiling of the Salon du Roi in the Palais-Bourbon.
Oil on canvas, 140 × 380 cm
Palais-Bourbon, Paris

156. The *Industry* wall
Frieze with *Industry, The Loire,* and *The Rhine*
Oil and wax on plaster, 260 × 1100 cm, 300 × 108.5 cm,
and 300 × 110 cm, respectively
Palais-Bourbon, Paris

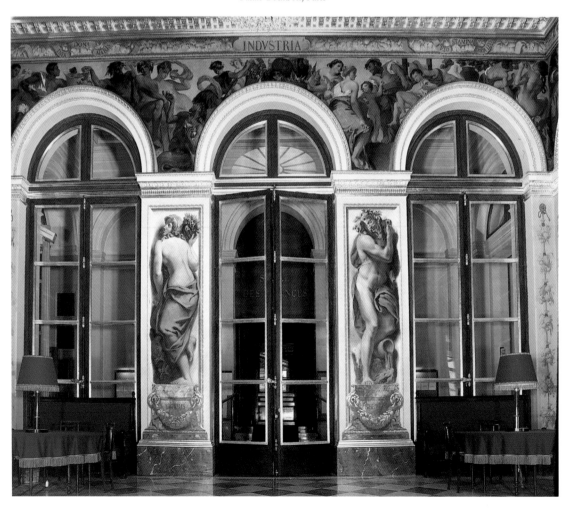

157. *War*
Coffer of the ceiling of the Salon du Roi in the Palais-Bourbon.
Oil on canvas, 140 ×380 cm
Palais-Bourbon, Paris

158. The *War* wall
Frieze with *War, The Seine,* and *The Rhône*
Oil and wax on plaster, 260 ×100 cm, 300 ×115 cm,
and 300 ×117 cm, respectively
Palais-Bourbon, Paris

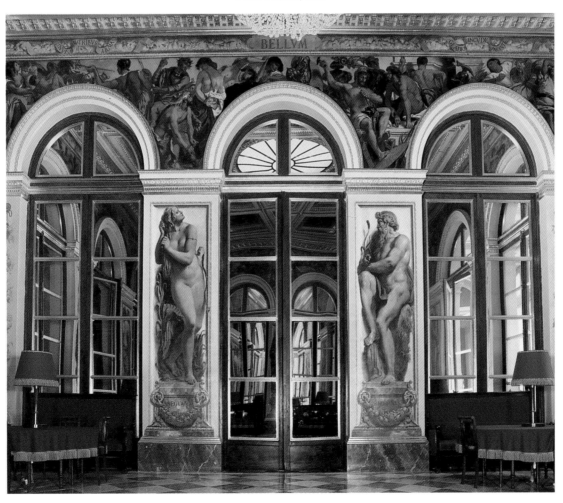

planned to be more decorative. Delacroix wrote: "There were represented in the high piers between the windows and doors, the most important rivers of France painted in grisaille [*The Loire* and *The Rhine* below *Industry*; *The Seine* and *The Rhône* below *War*; *The Garonne* and *The Saône* below *Agriculture*]. There were, too, the [Atlantic] Ocean and the Mediterranean, which naturally frame our country, and which are depicted on either side of the throne, at the end of the room. These figures, much larger than life-size, are in subdued tones, so as not to attract the gaze." Yet, the present-day yellow and blue highlights contradict this text and most descriptions contemporary with Delacroix's. Are these by the painter? Might he have decided, once the Salon was finally open, that the piers were too faint, compared with the friezes and ceiling, and did he then brighten them? The 1991–92 restorations did not resolve the question of original additions or later interventions. Delacroix retouched nearly all of his great decorative projects after they were finished, in order to improve the relations between the parts, in the actual light of the site, since some of the elements were painted in his studio. In the Salon du Roi, however, once the ceiling was in place, he worked constantly on site. Perhaps still unsure of himself in this first such endeavor and more sensitive to criticism, he may have retouched certain areas after a period of reflection; the question remains open. In any event, in the purely ornamental sections—notably the fake marble pedestals and corner piers decorated with trophies of fruits—Delacroix was assisted by specialists, in particular his friend Eugène Cicéri.

The Salon was gradually unveiled as each section was finished, so that the first reviews appeared in 1836, before the grisailles were finished. The reaction, however, was unanimous: in his first attempt at decorative painting, Delacroix had triumphed. Many, like Théophile Gautier, emphasized how he had made the most of a difficult architectural situation: "At first glance it seemed impossible to compose the decoration of such a room with the necessary brightness and unity. The forced scattering of the figures into several areas separated by masonry elements provided a singular hindrance to the general effect and to a tonal harmony. . . . The paintings in the throne room are true masterpieces of ingenious composition and felicitous symmetry; were it not that the dreary taste of the architecture spoils the illusion, one might believe oneself, seeing these cheerful and luminous paintings, in a Renaissance

hall, decorated by some artist summoned from Florence, Primaticcio or master Rosso, so elegant and supple is the style, so royal in appearance are these beautiful allegorical women, nude or caressed by light draperies, and so accustomed to magnificence, unlike the dazed figures smeared by modern artists in the palaces of monarchs or public buildings."[19] This point is the one that most often recurs: with the Salon du Roi, Delacroix was well within the tradition of decorative painting—as exhibited chiefly by the Renaissance masters, especially the Venetians—yet remained original: "It will henceforth be impossible to deny this eminent artist's grace and high style. Those . . . who insist that this artist has none of the intelligence of the great Italian masters have today lost the argument. *Women of Algiers* and *Saint Sebastian* had already proved to those with eyes to see that M. Delacroix was not locked into the Flemish school, that he appreciated Veronese and Titian as much as Rubens and Rembrandt; the Salon du Roi will confirm beliefs that were hitherto but inferences. For our part, though our beliefs in this matter were fully formed, we rejoice to see all doubts victoriously resolved by the Salon du Roi; for these new paintings by M. Delacroix not only provide a series, an ensemble of fine works, but they also contain a lesson that will not remain unfruitful. They teach that truly lively, truly original talents become renewed and broadened by the variety of tasks that they either set themselves or accept. For talents of this order, the circle within which their will unfolds is ceaseless expanding. They cross every epoch and every school with impunity; they never lose their own nature; they can live intimately with Rubens and Veronese, Titian and Raphael, without becoming Flemish, Venetian, or Roman. Every aspect of tradition that they study and penetrate, far from dulling their will, encourages them and spurs them to battle; and though they may have spent their best years in the picturesque expression of passion, when they wish to take on beauty directly, to set themselves beautiful lines and contours as their single supreme goal, they have only to will it and it is so. . . . We have been long accustomed to seeing him new in new things; in the Salon du Roi, he proved himself new in treating an antique theme."[20] Gustave Planche accurately assessed the major step forward that the Salon du Roi represented in Delacroix's aesthetic evolution. His choice of a coffered ceiling—not so much imposed upon him as assumed by him—and his considered decision to imitate sculpture on the frieze and piers

were derived from sixteenth-century Italian models and from Fontainebleau.[21] They implied a return to the sources of European monumental painting, to the origins of its development in France. Delacroix knew the history of art too well to be unaware of this, and a number of references have been proposed for the overall composition as well as for certain specific figures considered independently.[22] But what could have been mere quotation or simple imitation became part of a creation that was both original and personal, from the definition of the iconography to the execution of the different parts of the decoration and the way they were integrated into a whole that was both ideal and formal.

The point has been abundantly made that the balance that is achieved in the Salon du Roi is due primarily to the balance of the colors. But the role played in the overall harmony by the draftsmanship of the various figures—taken individually and as parts of the whole—merits attention as well. Each part was imagined both separately and together with the others, permitting multiple readings, level by level, from the piers to the frieze to the ceiling, and panel by panel. We know from the preparatory drawings that have been preserved[23] that Delacroix from the beginning had intended to integrate the allegorical figures into the architectural decoration. The ceiling's structure virtually dictated that the figures be lying down, with a few accompanying figures and explanatory attributes. They correspond to one another around the central lunette yet do not repeat one another; the attitude of *Justice*, for example, is markedly original. The series of rivers and seas is similarly organized. Once he had determined their general appearance (false statues on pedestals), asserting the verticality of the piers, Delacroix was able to vary a number of elements, such as the arrangement (frontal, dorsal, or in profile), the orientation (toward the center or outward), and even the gaze, which is never exactly the same. Delacroix also composed the figures in pairs: *The Seine* and *The Rhône*, for example, frame the main entrance, across from *The Mediterranean* and *The Ocean*, on either side of the throne (the recent restorations showed that in an earlier version the latter looked toward the alcove).

Neither the ceiling nor the piers would have the decorative value they do, however, were it not for the frieze. The Salon du Roi offers only planar surfaces, so that the dynamic possibilities open to Delacroix were limited. The frieze, which in its wider sections emphasizes vertical movement, also shows a horizontal movement. The junction between *Industry* and *War*, for example, is created by a piece of pink clothing that overflows naturally from one into the other. Yet Delacroix privileged the walls as such, no doubt taking into account the likeliest position of the viewer, who would examine each of the room's four quarters in turn. Each stringcourse was, in fact, designed to relate both to the two piers below and to the archivolts of the openings in the lower section. This allows us to identify three successive parts or episodes there (as Delacroix did in his description), just as we can single out the different standing figures: Might and her lion, the captive and her conqueror, Bacchus, the grape-picker, and the ironsmith. Each is arranged so as to either echo or oppose the curve of the lunette below it, like the stretched-out figures above them, but, again, there is no repetition. Delacroix varied the attitudes sufficiently to avoid monotony and incorporated rhythm and movement into an overall quality of stasis that emphasizes the main lines of the architecture through a subtle play of balance between the whole and the part.

It is evident that this formal success—the result of a thorough study, revealed in the great many preparatory sketches, drawings of the overall composition and of its parts, and watercolor tests for the colors—marked an important stage in the development of Delacroix's art. After taking on the problems of a major decorative project alone, or nearly so, he was recognized as one of the masters of monumental painting, just when the genre was undergoing an important rebirth in France after more than a century. The Salon du Roi stands out perhaps even more by its iconography, which was new for him at that time, and which remains unique in his oeuvre. It was, in effect, the only time that, with such breadth, he used figures that were allegorical in the most classical sense, that is, employing the language of attribute and attitude, especially in the piers and ceiling, and reducing anecdote to a minimum in the frieze. Initially, *Liberty Leading the People* showed a scene with barricades. Here, Might is simply a woman leaning on a club, accompanied by a lion. The processions of the grape-pickers, the conquered, the blacksmith, and the cocoon-gatherers refer to no specific historical or mythological episode, nor to any specifically French trait. The antique costumes are in keeping with this desire for permanence. Never before had Delacroix gone so far into abstract allegory, nor would he do so again. On the contrary, his other great decorative works were all constructed

around mythological and historical subjects, except for the ceiling of the Salon de la Paix in the Hôtel de Ville, where the other elements depict ancient gods and the labors of Hercules. Thus, for his first project in the very specific genre of decorative painting, Delacroix used the most traditional of vocabularies, at the time the least familiar to him, as if seeking to prove that he could compete with his models on their own classical terms.

As soon as he had completed the Salon du Roi, Delacroix began to campaign for a new commission. "I am lobbying in two or three directions, not one of which will pan out, in order to get a few feet of wall to paint, which will probably bring in no more than I have already earned, but which will satisfy the need to work large, which becomes overwhelming once one has tasted of it," he wrote Rivet as early as February 1838.[24] His aim, in fact, was nothing less than the majority of the new rooms in the Chambre des Députés, as evidenced in a journal entry in which he detailed his plans for three of them, the Salle des Pas-Perdus, the Salon des Conférences, and the library (since the only room not mentioned, the Salon des Distributions, was identical to the Salon du Roi, we may infer that Delacroix had in mind a similar decoration, were it to be assigned to him).[25] For each of these, he drew up a general direction, which he then developed into either specific ancient or modern historical subjects or figures of famous men. The Salle des Pas-Perdus, or "great entrance hall," was thus "dedicated to expressing the power of France, especially its civilizing influence." The ceiling would be filled with *The Defeat of the Moors,* whom Charles Martel stopped in the plain of Poitiers, just as they were at the heart of France and about to overturn our nation. . . . The coving would be divided into six main paintings, separated by symbolic figures acting as caryatids and representing the peoples subject to our arms or civilized by our laws. The paintings would be spaced and framed by painted architectural ornaments relating them to the ceiling. These subjects, drawn also from the great deeds of our history, would tend less toward the representation of achievements glorious only for our arms than toward that of actions that extend the moral influence of France." These subjects would be *Charlemagne's Empire, The Conquest of Italy by Charles VIII, Clovis at Tolbiacum, Louis XVI Receiving the Allegiance of the Doge of Genoa, Egypt Brought into Subjection,* and *The Conquest of Algeria.* Delacroix's explanations erase the

subjects' apparent disparity: each one marks an essential moment in the civilization of France, in the political or artistic domain. They also left open the possibility, "if the necessary funds were to be granted," of depicting "a few great acts of our history" on the walls facing the windows.

The program proposed for the Salle des Conférences turned to ancient history in order to represent in the covings "acts of patriotism and of devotion to the laws drawn from ancient history": *Lycurgus Appearing Alone before a Furious Revolt of the Lacedaemonean People, Cincinnatus at His Plow, The Funeral of Phocion, The Senators of Rome during the Siege of Rome by the Gauls.* The paintings would alternate allegorical figures painted in grisaille to look like sculpture, "representing symbols and allegories referring to each subject," such as Law, Civil Courage, and Eloquence. The decoration of the library, divided into five small cupolas and closed at each end by a half-dome, would be more specifically consecrated to the arts and letters. The two half-domes "would present acts that honored letters or philosophy": *The Crowning of Petrarch by the Senate and People of Rome at the Capitol* and *Phaedo,* in which "Socrates, surrounded by Plato and the philosophers who study with him, talks with them about the immortality of the soul." For *Theology, Saint John Chrysostom, Saint Jerome, Saint Basil,* and *Saint Augustine,* identified by various attributes, "winged figures representing Divine Love, Faith, Patience, and Meditation" would connect the four-figure composition; for *History and Philosophy, Pythagoras, Descartes, Tacitus,* and *Thucydides,* "two figures symbolizing history and philosophy flying among these famous men"; for *Science,* "Galileo, in irons, assigning their various revolutions to the celestial spheres. Aristotle describes the various kingdoms of nature. Newton, deep in meditation, holds the apple that gave him his first notion of gravity. Archimedes, entirely absorbed in solving his problem, does not see the barbarian preparing to kill him"; for *The Arts,* "Raphael, Michelangelo, Rubens, Poussin. These four great artists, considered the most illustrious modern artists, would be depicted as follows: Raphael, holding his pencils, would lean upon a divine figure representing *Grace.* Michelangelo, whose design it was, would hold the model of the cupola of Saint Peter's, and would be surrounded by four small spirits representing *Painting, Sculpture, Architecture,* and *Poetry.* Rubens, holding his shining palette and borne by a winged lion. Poussin, with the antique torso and his painting of Eudamidas near him";

finally, for *Poetry*, blind Homer, "his eagle soaring above his head, holding in his talons his imperishable laurel wreath"; Virgil seated, holding his tablet, and at his feet Rome and the she-wolf nursing Romulus and Remus; "Dante raised from earth by the emblematic figure of Beatrice and aspiring to the eternal spheres, whose splendor dazzles his mortal eyes"; and "Ariosto, surrounded by the trophies of knighthood, takes his lute and prepares to sing."

Delacroix was making very clear distinctions between the decorations of the various rooms according to their purposes. He was also breaking with the exclusively allegorical language of the Salon du Roi in order to propose more anecdotal subjects, which had also sometimes been the subjects of famous paintings, such as Claude Guy Hallé's *Allegiance of the Doge of Genoa*, Poussin's *Funeral of Phocion*, and David's *Death of Socrates*. Others belonged to the iconography favored by the neoclassical artists, such as *Blind Homer*, *Lycurgus*, and *Cincinnatus at His Plow*. Still others were in line with the new trends in history painting, especially *Charlemagne*, *Charles VIII*, *Egypt Brought into Subjection*, and *The Conquest of Algeria*, and the portraits of modern artists and scientists, subjects often treated by Delacroix's contemporaries. His proposals—in particular, those for the Louvre and the new Musée de l'Histoire de France in Versailles—sometimes coincided, to the letter as well as in the spirit, with the choices of Louis-Philippe and his government. He was, paradoxically, less innovative in the latter project than in the very classical Salon du Roi, although he exhibited a similar concern for the harmony necessary between the decoration and its architectural framework. He wrote about the Salle des Pas-Perdus, for example: "It must be noted that the choice of subjects is limited by the layout of the site. For example, the

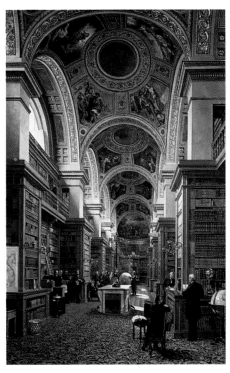

159. The library of the Palais-Bourbon, view at the height of the half-domes

160. The library of the Chambre des Députés in the Palais-Bourbon, 1884
Oil on canvas, 138 × 100 cm, by Victor Navlet
Palais-Bourbon, Paris

ceiling of the Grand Salon, which is very narrow and very long, could only be occupied by a subject such as a battle." And he closed his journal as follows: "In an undertaking of this kind, the preparatory studies are those that concern one most, because one must adapt the subjects to the designated place and make the calculations required by the dimensions of the figures and their foreshortening, given the curvatures of the ceilings and the covings." From this standpoint, the project proposed to the administration displays a definite continuity with his previous work.

In the end, Delacroix was retained only for the library, actually the most important of the rooms that remained to be decorated. Thiers had just left the government, and this time his influence had not been able to overcome the latent and overt hostility in official circles, in particular at the Institute, three members of which had divided among themselves the rest of the program: Horace Vernet, in the Salle des Pas-Perdus; Alexandre Abel de Pujol, in the Salon des Distributions; and François-Joseph Heim in the Salle des Conférences. Their work gives us a yardstick for Delacroix's aptitude and talent in the area of decorative painting: Abel de Pujol merely painted the ceiling coffers in grisaille, so that the painting is very discreetly in keeping with the architecture of the room. It is dignified, inorganic, and cold, compared to its counterpart, the Salon du Roi. Vernet developed in the ceiling assigned to him a modern allegory of Peace, with factory chimneys, a locomotive, and a steamboat.[26] His allegory has not aged as well as the classical processions of Delacroix, who had elected a traditional, proven language, made fresh by an innovative formal handling. Heim, in the covings of the Salle des Conférences, was the one who came closest to what he had planned: historical scenes are embedded

161. The *Science* cupola
(clockwise from lower left) *Hippocrates Refuses the Gifts of the King of Persia*, 1841?;
Archimedes Killed by the Soldier, 1841; *Aristotle Describes the Animals Sent by Alexander*, 1841;
The Death of Pliny the Elder, 1841
Oil on canvas, each 221 × 291 cm. Palais-Bourbon, Paris

in a painted trompe l'oeil architectural and ornamental decoration, with allegorical figures and medallions of illustrious men. In the end, although Delacroix's overall program had been rejected, the library was the lion's share of the project. And it was the library upon which he had principally set his sights, if one may judge from his memoir: "These projects would represent a series of works that could be undertaken at the same time, under a single direction, and without taking much more time, because of the help available from the cooperation of intelligent students. Experience has shown that each part and the whole may be done this way, but if the works were to be divided up, I would point out that since the decoration of the library was planned first, I had, at the invitation of M. Thiers, considered how it might best be approached. I made a series of studies on the subjects I have just set forth. Thus, it would be more than mere preference on my part: the work would be accomplished the sooner because of this previous preparation." He was notified of the commission on 31 August 1838. Despite his "previous preparation" and the "cooperation of intelligent students," which Delacroix

hastened to put into effect, his work was not soon accomplished: it would take more than nine years. The 1840 commission to decorate the library of the Chambre des Pairs in the Palais du Luxembourg and another, in 1848, for a *Lamentation* for the church of Saint-Denis-du-Saint-Sacrement, slowed the work at the Assemblée Nationale; illnesses in 1841 and especially in 1842 interrupted it entirely. The complexity of the undertaking should also be taken into account: the interior arrangement of the library was very different from that of the Salon du Roi.

The library's layout is, in fact, much more original: it is a long gallery, forty-two by ten meters, bracketed by two half-domes and divided into five bays by transverse arches (see figs. 159, 160). The lower sections of the walls and the areas accessible from the walkways that run along both sides are lined with shelves. The painted decoration, therefore, is relegated to the upper section, the two half-domes, and the cupolas over the bays, which receive light from great arched bay windows on both sides. As Lee Johnson pointed out, no model was imposed upon Delacroix this time; he had to find a truly

162. The *History and Philosophy* cupola
(clockwise from lower left) *The Death of Seneca,* 1841?; *Socrates and His Genius,* 1841–42;
The Chaldean Shepherds: Inventors of Astronomy, 1841?; *Herodotus Consults the Magi,* 1841?
Oil on canvas, each 221 × 291 cm
Palais-Bourbon, Paris

163. The *Legislation and Eloquence* cupola
(clockwise from lower left) *Cicero Accuses Verres,* 1884; *Demosthenes Declaiming by
the Seashore,* 1845; *Lycurgus Consults the Pythia,* 1843; *Numa and Egeria,* 1843–44
Oil on canvas, each 221 × 291 cm
Palais-Bourbon, Paris

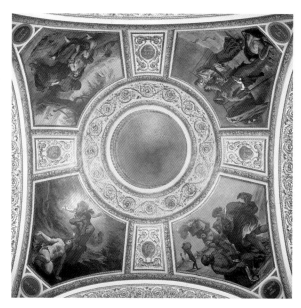

164. The *Theology* cupola
(clockwise from lower left) *Adam and Eve*, 1845; *The Babylonian Captivity*, 1843–45;
John the Baptist Beheaded, 1843–44?; *The Tribute Money*, 1843
Oil on canvas, each 221 × 291 cm
Palais-Bourbon, Paris

personal solution to a problem without precedents. He could not alter the physical constraints, as he had before; the only flexibility in this respect lay in the internal disposition of the cupolas, which could be treated as single blocks, separated by pendentives—either rectangular or trapezoidal—and either set apart with figures, or not. Delacroix hesitated between several formulas before committing to the solution he finally put in place: four trapezoidal pendentives, separated by painted ornaments, foliated scrolls, and grotesque masks. At the same time, however, he had considered the most important aspect of the library, that is, the conception of the program, which would then direct the execution. In September 1838, he was resting in Valmont; he wrote Villot asking for his help: "You know the place; be good enough in your moments of leisure to rack your brains about how one might best approach it: five cupolas and two half-domes at each end. The subjects that I have thought of all have drawbacks, and if I come across a better idea, which I think very possible, I'll take it. They are pendentives, as you know [here, there is a drawing of their layout]. It would take a fruitful idea, not too real, not too much allegory, in short, something for everyone."[27]

The explanation for the subjects he finally selected was given by Delacroix himself in 1848, in an account he sent to Thoré, and that Thoré quoted in his review in *Le Constitutionnel*.[28] He made a complete distinction between the two half-domes, on the one hand, and the twenty paintings in the five cupolas, on the other. The latter "relate to philosophy, history, and natural history, to legislation, eloquence, literature, poetry, and even theology. They refer to all the categories adopted by all libraries, without following their exact classifications." The first of the five cupolas, beginning at the southern end, is dedicated to Science (fig. 161), with the subjects of the four pendentives being respectively *Hippocrates Refuses the Gifts of the King of Persia*, *Archimedes Killed by the Soldier*, *Aristotle Describes the Animals Sent by Alexander*, *The Death of Pliny the Elder*. The next cupola is dedicated to History and Philosophy (fig. 162): *The Death of Seneca*, *Socrates and His Genius*, *The Chaldean Shepherds: Inventors of Astronomy*, and *Herodotus Consults the Magi*. The main entrance to the library is in the middle bay, naturally dedicated to Legislation and Eloquence (fig. 163): *Cicero Accuses Verres*, *Demosthenes Declaiming by the Seashore*, *Lycurgus Consults the Pythia*, and *Numa and Egeria*. Next is Theology (fig. 164), with two subjects from the Old Testament, *Adam and Eve* and *The Babylonian Captivity*, and

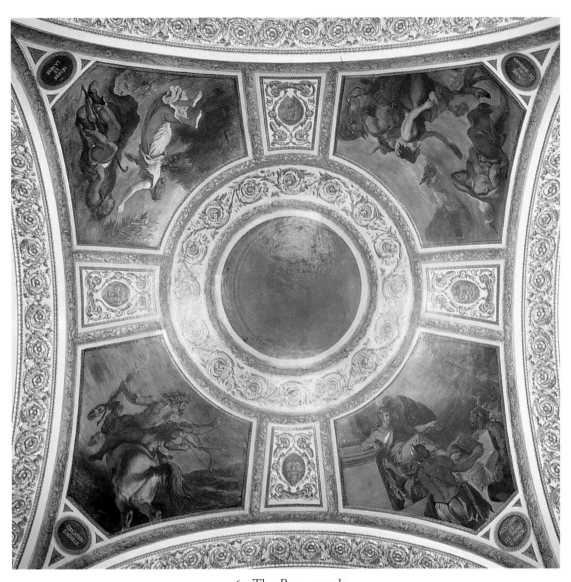

165. The *Poetry* cupola
(clockwise from lower left) *The Education of Achilles*, 1845?; *Hesiod and the Muse*, 1845?;
Ovid among the Scythians, 1844; *Alexander and Homer's Poems*, 1844–45?

Oil on canvas, each 221 × 291 cm
Palais-Bourbon, Paris

two from the New Testament, *John the Baptist Beheaded* and *The Tribute Money*. The last cupola illustrates Poetry (fig. 165): *The Education of Achilles, Hesiod and the Muse, Ovid among the Scythians,* and *Alexander and Homer's Poems.*

In the south half-dome, Delacroix painted *Orpheus Civilizes the Greeks* (fig. 167). "He is surrounded by hunters covered in the skins of lions and bears. These simple men stop, astonished. Their women approach with their children. Yoked oxen plow furrows in this antique soil, by lakes and on mountainsides still covered with mysterious shadows. Retired in crude shelters, old men and wilder and more timid men contemplate the divine stranger. The Centaurs stop at the sight of him and return to the heart of the forests. The Naiads, the Rivers, are amazed amid their reeds, while the two goddesses of the Arts and of Peace, fertile sheaf-laden Ceres and Pallas holding an olive branch, cross the azure sky and descend to earth to the enchanter's voice." The north half-dome corresponds to this one, with *Attila and His Hordes Overrun Italy and the Arts* (fig. 166). "Eloquence weeps, as the Arts flee before the wild steed of the king of the Huns. Flames and slaughter mark the passage of these savage warriors, descending from the mountains like a torrent. At their approach, the timid inhabitants abandon the countrysides and cities, and, felled in their flight by arrow and lance, water with their blood the land that nurtured them."

Neither the criteria by which Delacroix had chosen these various subjects nor their logical connection seems to have been immediately obvious to his contemporaries: "I have not, so far, very clearly identified the mysterious correlation that must exist among the different subjects: I hope that it will be revealed to me when the canvas still covering the two half-domes drops," wrote Louis de Ronchaud in 1847, in a study on monumental painting in France. "Then the work may be judged as a whole and in its details. The influence of literature on life's grandeur and dignity, even on the beauty of death, and the power of these to civilize; the respect that the heroes bore for the poets and the philosophers; and the phenomena of divination and inspiration, embodied in a few great men, and causing them to be looked upon as in touch with a mysterious power, appear to have concerned M. Delacroix."[29] Three months later, when the decoration could be seen in its entirety, Clément de Ris expressed similar reservations in an article that was otherwise extremely favorable and flattering: "The

artist was able to overcome the difficulty presented by the fragmentation of the pendentives, and to use it to prove once again to what extent he takes the qualities of harmony that he possesses. Yet, while we acknowledge the talent that blazes in each pendentive considered separately, we will make a comment on the subject, which, though the expression of a personal point of view, will nevertheless have, we hope, some value. We think that it would have been more suitable to make the pendentives serve as historical links between the half-domes, and to have chosen the subjects in such a way as to lead the viewer's mind through a series of great historical deeds from Orpheus, one of the founders of the Greek civilization, to Attila, who destroyed that civilization; this approach—of having the two end subjects explain each other—would have made the relation between the two immediately evident and given to the whole a unity that seems to us to be lacking."[30] It may have been that the grandeur of the concept of such a cycle had initially disconcerted the critics. Not only do the later reviews not echo these first reservations, but on the contrary, they point out the logical connection among the different parts: "The high-mindedness, richness, and propriety of the idea in the decorative paintings in the library of the legislature are of an order and a value all their own: they are the measure of all that a rare spirit made painter can accomplish in that realm. To discover and compose such a decoration in the library required nothing less than the most extensive and the keenest literary intelligence, joined to the surest, deepest artistic touch. M. Delacroix resolved this problem effortlessly. . . . The two immense half-domes and the five small cupolas of the library unfurl the entire history of ancient genius and civilization. The two half-domes, the opposing, circular ends of the balcony, are like the two poles of this history, depicting the beginning of the Greek age and the end of the Roman age. . . . Beneath the five painted cupolas . . . are neither ages nor chronological sequence, but the great programs, the noble spheres of this history, layered and radiating outward. . . . One of these spheres shines in each cupola, represented on the four sides by its most brilliant points, and these are four paintings in pendentive, where each special genius is dramatically summarized in its most sublime representatives or works."[31] "[The paintings of the Palais-Bourbon] unfurl, between Orpheus and Attila, between the dawn and the twilight of the ancient world, the entire history of its civilization and its genius. This

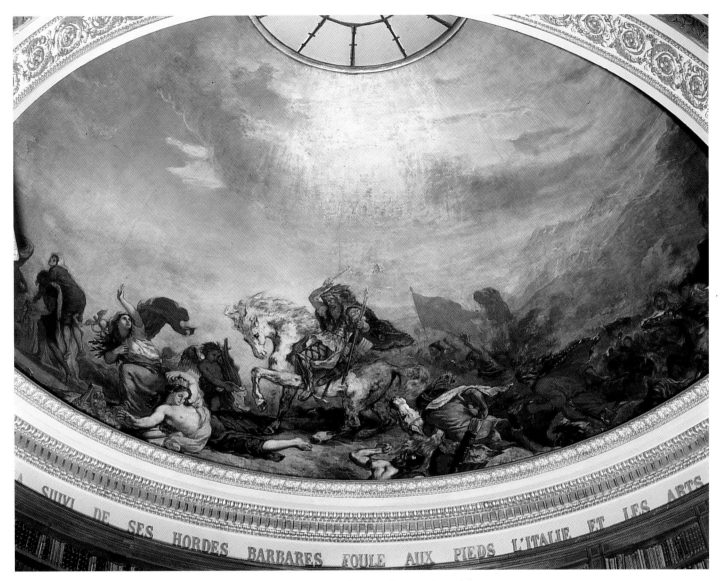

166. *Attila and His Hordes Overrun Italy and the Arts,* 1843–47
Oil and wax on plaster, 735 × 1098 cm
Palais-Bourbon, Paris

history does not follow its chronological order: the conception is nobler, and the program more vast. . . . It is a poem, by turns Greek, Roman, biblical, and Oriental, where all ideas are conceived and all images linked, despite differences of times and races, and whose every symbol is personified with a historical insightfulness worthy of the painterly imagination."[32]

The final iconographic program unquestionably corresponded to a specific theme: the overall meaning—the birth and death of ancient civilization—is given by the two half-domes. By eliminating the modern subjects that he had origi-

nally planned to introduce in the cupolas, Delacroix reinforced their relation to the main idea, while leaving them autonomous to some extent, since they are articulated along another thematic axis, the organizations of libraries. There are, therefore, several possible readings, depending upon whether one is looking to interpret the content of the overall decoration, focusing upon the half-domes and the bays, or considering the latter singly or in combination. It is understandable that certain critics might have been somewhat disoriented upon discovering a decoration that was so original, ambitious, universal in

its implication, and unlike that in any other library.[33] Delacroix himself, however, seemingly did not determine the details of the project from the beginning. Historians have long assumed that he drew upon a specific source and that the overall mapping had to some degree preceded its execution; this is the premise underlying George L. Hersey's analysis in particular.[34] According to Hersey, Delacroix was inspired by Giambattista Vico's *Scienza nuova seconda*, published in 1744, and by Vico's theory of the development of civilizations through a series of ages, first that of the gods, then that of heroes, and finally that of humanity. It seems to be the case that once Delacroix had settled upon the general idea for his decoration—most likely decided or refined in conversations with Villot—he only defined the subjects for the cupolas during the course of the execution. This is Anita Hopmans's hypothesis, which she developed in reviewing all the available documents and relying especially on a meticulous reading of notes made in the margins of certain preparatory studies.[35] Delacroix would have associated information he came upon by chance in his readings of the moment with the method of classification suggested for libraries by Charles Brunet in his *Manuel du libraire et de l'amateur des livres*, published in 1810 and the basis for Delacroix's choices for the cupolas. Hopmans has rightly pointed out that this approach was in marked contrast with that of his contemporaries, including, and especially, the other artists working in the Palais-Bourbon, but it was also unique in his own work as a decorative painter. Completing the commission was of primary importance: he had to get started in order to demonstrate to an ever-impatient administration that he was on the job and that the payments he was requesting on account were justified. The delays that held up the execution of the decoration thus had their advantages in that they allowed Delacroix to perfect his program, giving it all its cohesion and logic. Its universality should not obscure its very personal quality. As I have said, the theme of the Salon du Roi stands apart from the rest of his body of work, but this is not true of the library. He would repeat certain subjects, such as *Alexander and Homer's Poems* in the Palais du Luxembourg, or *Ovid among the Scythians* in a painting exhibited in the Salon of 1859, but the connection lies rather in the broader idea of the development of humanity and civilization. It is a cliché to note that *Attila* recalls *Chios*, *Sardanapalus*, and *Entry of the Crusaders into Constantinople*, but the death of

Archimedes, killed by a common soldier, or that of Seneca, opening his veins at the command of Nero, his pupil, all partake of a similar dramatic concept of life and history that exists in the painter's writings as well.[36] Delacroix was also exploring a more serene theme during this same period in the Palais du Luxembourg. The library of the chamber was not an anonymous decoration, no anomaly in his career: as an extension of the Salon du Roi, it illustrates the renewal and broadening of Delacroix's inspiration following his trip to Morocco. Never before had he painted so many subjects taken from the Bible or Greek and Roman history, let alone on such a scale. Thenceforth these would comprise most of his work, though without breaking with his previous production.

As noted earlier, the execution stretched over nearly ten years.[37] He appears to have been occupied in planning and studies during 1839. The September 1840 commission for the library in the Chambre des Pairs also caused delays. Shortly after, having established his program, Delacroix decided the composition of the first pair of cupolas, *Science* and *History and Philosophy*. The collaborators he had recruited for the purpose worked on these under his direction over the course of the year 1841. The other decorative projects in the Palais-Bourbon were nearing completion at the time, and the Minister of the Interior inquired about the progress of the library and when it would be finished. "To that," Delacroix wrote George Sand, "I did not reply, for I knew no more than he of the matter. That is how one gets out of a situation without committing oneself."[38] The progress of the works at the Luxembourg, to which he gave priority, and the laryngitis that weakened him during almost all of 1842, also slowed the project. Official reports, newspaper articles, and various correspondence allow us to understand how things stood with the library in 1843: by April, only eight pendentives (or two complete cupolas) had been completed. Delacroix was promising to finish eight more by December and was tracing the composition of Orpheus (the painted sketches for the two half-domes had been finished shortly before). This time, technical difficulties intervened. The pendentives were supposed to be painted in his studio, in oil on canvas, and then mounted on-site. The half-domes, however, also in oil on canvas, were to be done on-site, the supports having been previously attached. The first eight pendentives were set in place over the course of the year 1843. They were deemed too dark, by Delacroix as well, who had

not really been able to gauge their effect because he had not been able to work on-site.[39] In January 1844, Louis de Planet, a pupil and collaborator of Delacroix, noted: "He finds the pendentives placed in the library a bit dark; when they are all in place, he will have to brighten them a great deal. . . . His idea is to establish the two half-domes as two sources of light, and the pendentives as softer half-tones. He would have preferred, had he had permanent scaffolding, to do them on-site."[40] But worse was to happen. After finishing the painted sketches of the two half-domes at the beginning of the year, Delacroix had started on Orpheus, but the summer heat buckled the wood and iron of the construction, and a crack developed. The preparatory canvas had to be removed so that the wall might be repaired, and Delacroix decided to paint the two half-domes with a wax-based mixture like the one he had used in the Salon du Roi.[41] Working from below without being able to judge the accuracy of the composition only added to the difficulties of the endeavor: "It would be very important for me to be able to see the two half-domes without so much of the scaffolding being in the way, in order to judge whether our figures are placed right," he requested of Joly in July 1844. "I fear several errors and I am truly going on guesswork."[42] The other pendentives, on which the pupils had been working almost constantly, were finished in July 1845 and set in place that autumn. They still had to be retouched, and the half-domes had yet to be completed. A year later, however, the Assembly treasurers were once more complaining to the Minister of the Interior that the library was unfinished. Delacroix worked intensively on Attila and Orpheus during all of 1847, and in late December he invited his intimates to see the entire completed project.[43]

Delacroix, under pressure from the administration, ill, involved in other projects, hampered by technical problems, and working in fits and starts, had nonetheless succeeded in endowing his decoration with a genuine unity that was all the more remarkable because this was the first time he had worked in collaboration. He had, we have seen, occasionally been assisted before, by Charles Soulier and one of the Fielding brothers for the landscape in Scenes from the Massacres of Chios, and by Paul Huet for the background of Schwiter's portrait. With the library of the Palais-Bourbon, Delacroix inaugurated a practice that was completely different and new to him, opening a studio in late 1838. There, pupils trained for the painter's trade under his direction, and he chose assistants from among them to help him with the vast decorations that he could not have accomplished alone. Some thirty more or less well-known pupils attended his studio: Maurice Sand; Degas's friend Evariste de Valerne; and Mme Rang-Babut, who went on to establish herself at La Rochelle.[44] Some were more talented than others, but by and large they had indifferent careers. Three of them in particular, Gustave Lassalle-Bordes, Louis de Planet, and Pierre Andrieu, worked closely with him, at the Palais-Bourbon (Lassalle-Bordes and Planet); at the Luxembourg and Saint-Denis-du-Saint-Sacrement (Lassalle-Bordes); and at the Louvre, Hôtel de Ville, and Saint-Sulpice (Andrieu). Relations between master and pupils appear to have been attentively cordial on his side and respectfully admiring on theirs, yet the relationship with Lassalle-Bordes and Planet ended in a quarrel, for reasons that are unclear. Andrieu's story became somewhat murky after Delacroix's death, when some of the student's work appeared for sale under the master's name.[45] Lassalle-Bordes described his collaboration in detail in a letter sent to Philippe Burty, who published it,[46] but his recollections, reported long after the fact and laced with bitterness and resentment, should be taken with a grain of salt. For example, he and Planet sometimes contradict each other, but we have the latter's journal, in which he made daily entries at the time, and which is far more reliable.[47] By comparing notes, however, we also get a very clear idea of what Delacroix expected from his assistants and what their participation was. The concept was the master's alone, as is also proven by the many drawn and painted studies of the whole and of details, in which he established the composition. The pupil squared the study onto the canvas that would later be remounted and executed the grisaille and the dessous (that is, the base), all under Delacroix's direction and constant supervision: he advised, corrected, modified, recommended a certain model for a certain figure, gave technical instructions, and helped make up the palettes. At some stage of the preparations, he stepped in to finish the painting. "In my kind of painting," he explained to Planet, who reported the conversation, "it is impossible for my collaborator to finish something in such a way that I need not change anything. I am sure that he could treat the subject with a great deal of talent, but for him to do it as I see it, he would have to be another me. Because my painting is all about feeling, the only way to

help me is to prepare the work so as to leave me the possibility of changing, modifying, if the desire so takes me."[48] If one further considers the changes that Delacroix made to the composition and the colors once the paintings were off the scaffolding and in place, as well as his final retouching, then the reasons for the overall harmony become clear.

This harmony is due primarily to the integration of painting and architecture and to the studied effect of luminosity. The compositions of the two half-domes correspond—in both, most of the figures are grouped toward the bottom—but so do the tonalities, with the upper two-thirds occupied by landscapes and skies done in intense blues and greens. The cupolas echo these compositions, with the central oculi opening onto a false but identical sky. The role of the painted ornamentation, the foliated scrolls, garlands, grotesque masks, and the medallions with the titles, is equally important: these details clearly frame, identify, and separate the pendentives, while at the same time introducing into each cupola a spatial unity reinforced by their repetition, from bay to bay, developed also in the stuccoes of the arches and openings and the gilded moldings of the cornice and piers. The space derives its dynamism, though, from the composition of the pendentives. Delacroix focused each scene upon a limited number of figures, having originally conceived these scenes, including details of decorations and accessories, as so many separate paintings, taking their individual shapes into account even in his first drawings. Their final arrangement was no less studied: it negotiated several possibilities: individually, as pendants, in groups of four, and within the library's principal axis. These various aspects were only achieved in stages; in this sense, the last three cupolas (*Legislation and Eloquence*, *Theology*, and *Poetry*) are more successful than the first two, although the ceiling's rhythm is in no way marred because of this. Delacroix was able to vary the composition of the pendentives wonderfully, bringing freshness to a traditional theme, either by taking advantage of the formal constraints (*Adam and Eve*), or by inventing different effects for similar subjects (*Hesiod and the Muse*, *Numa and Egeria*, and *Socrates and His Genius*). The quality of the execution is equal to the vastness of the program: "From the first glance, from one half-dome to the other,

the length of the library, the rich expanse and the brilliant pictorial intensity seizes you and amazes you. The five staggered cupolas and their perspective pendentives outdo one another in splendor, and the entire architectural decoration, modeled on Louis XIV, if not the Renaissance, lavishes a display of painting, a feast of colors, that intoxicates the eyes. Yet, here, color is more than merely the wealth of a palette or the vigors and softnesses that are its polychrome sensuality and material art, so to speak: above all, it has a unique gift of expression, a deep appropriateness and sympathetic accord with each subject, the liveliest local truthfulness and the noblest idealism; in a word, all the spirituality and the greatest power of its art. . . . When color is understood and treated in this way, it does more than irresistibly attract the eye, it also strikes the mind and penetrates the soul. It is a language with a tone for every idea, a music with a mood for every emotion. And just so, as we have recently seen, in the numerous paintings of the Legislature library, does it give each subject its moral tint and poetic light, to each painting its pictorial property."[49]

With the library of the Palais-Bourbon (the library in the Palais du Luxembourg having been completed shortly before), Delacroix established himself once and for all as a great decorative painter, entering a tradition inherited from the Renaissance and the Grand Siècle, but without renouncing any of his originality. After Delacroix's death, Paul de Saint-Victor wrote: "Never has monumental painting reached such heights. A marvelous brightness reigns throughout this profusion of scenes and images; thoughts shine through forms, symbols are revealed at first glance, each subject characterizes an aspect of genius or dramatizes an epoch with the clarity of language. But what analysis cannot convey is the effect that the execution brings to these inspired compositions, the poetic light in which it bathes them, the local truthfulness with which it stamps them. One could say that color, in these great paintings, is but the splendor of the idea. It takes on the color of every century, suits every person, runs through every mood of imagination and character . . . everywhere masterly and deep, integrated into the scene, incorporated into the figures, finding the tone for each type and the chord for each emotion."[50]

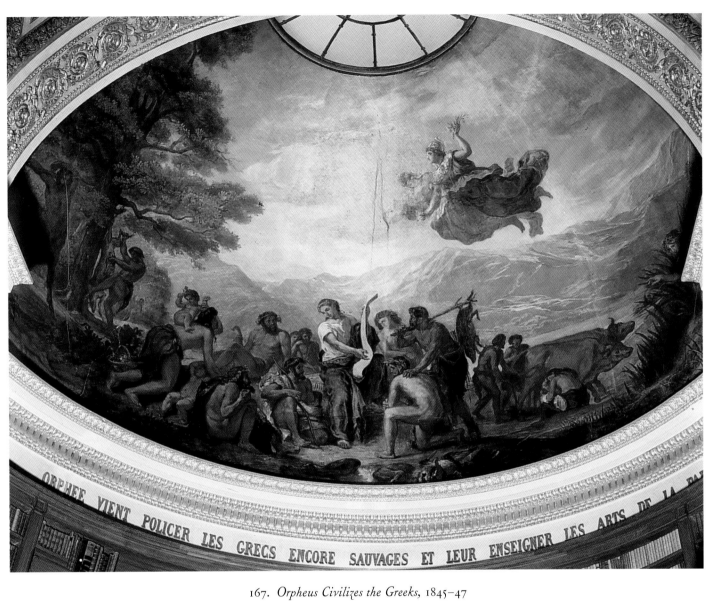

167. *Orpheus Civilizes the Greeks*, 1845–47

Oil and wax on plaster, 735 × 1098 cm

Palais-Bourbon, Paris

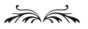

The Great Decorative Works: From the Palais du Luxembourg to Saint-Sulpice

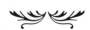

During the July Monarchy and the Restoration, the Palais du Luxembourg was the seat of the Chambre des Pairs. Like the Palais-Bourbon, from 1836 to 1845, it underwent substantial reconstruction, under the direction of the architect Alphonse de Gisors, resulting in its present configuration. By 1840, a group of rooms, including the assembly hall, had been completed on the second floor of the south part of the building, as had a vast gallery on the facade that would be the library (figs. 168, 169). Delacroix immediately applied for a commission. Thiers had just returned to his position; Rémusat, the Minister of the Interior, had nothing against him; the architect favored him; but the controversy then surrounding his *Justice of Trajan* militated against him.[1] "It is a beautiful site, and I would be sorry to lose the opportunity," he wrote. In the end, Delacroix was not commissioned to decorate the entire library, but only the central section, a cupola, and its pendentives, which he had, in fact, accepted earlier.[2] His cousin Léon Riesener and Camille Roqueplan would divide between them the ceilings of the two adjacent rooms, that is, six flat coffers each.

The library of the Palais du Luxembourg is laid out very differently than that of the Palais-Bourbon; its ceilings are lower, and it is better lit by a series of large bays overlooking the garden. The opposite wall, covered with shelves, is blind. Thus, while the exposure provides a great deal of light, that lighting is uneven. The project was all the more challenging in that the middle window is not only below the cupola, but set into a recess in the thickness of the wall that corresponds to the projection of the pavilion. This means that a significant part of the composition is always in half-light. The half-dome that decorates the recess poses a similar problem, because it is lit from below. The painter also had to take into account the

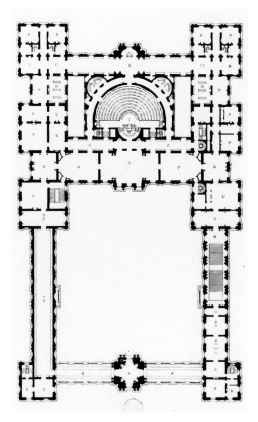

168. Plan of the second floor of the Palais du Luxembourg, Paris, in 1845, after the works of Alphonse de Gisors

The orientation is north-south. The library is at the top center, between the semi-circular Salle des Séances and the garden.
From Alphonse de Gisors, *Le Palais du Luxembourg . . . 1615–1845* (Paris, 1847)

position of the cupola itself, which may be seen as a whole, but which may also be approached from four separate sides. Entering from the assembly hall, one perceives a part of the cupola at the same time and along the same axis as the half-dome (as well as the garden, as far as the observatory in the distance). Here, there is not enough room to back up, because only a narrow hallway separates the assembly hall from the library. A second section is revealed by turning and facing the part that opposite the first, and which is also the best lit. Entering from the adjacent rooms at either end, in which case the cupola is revealed successively, one quarter at a time. The choice of subjects for both the cupola and the half-dome was left up to Delacroix (subject to approval, of course), and was to take these several factors into account. The project was, therefore, in its own way, as problematic as the Salon du Roi had been, and as the library of the Palais-Bourbon was.

Delacroix's initial solution seems to have been analogous to the one he applied in the Palais-Bourbon. That is, he planned to divide the cupola into four vertical segments, or else into eight, each with a separate subject, such as the falls of Icarus and Phaeton, or Perseus slaying the Gorgon.[3] But this would have meant losing the architectural unity and the sky effect, because the lack of space would have required the figures to be pushed to the top. A single subject was better, as Delacroix himself remarked in a note on a preparatory drawing that posited a division into four parts: "propose only subjects drawn from Homer—make it all into a kind of apotheosis in honor of the greatest of poets."[4] At this point, he had also noted for the half-dome the subject of *Dante and the Spirits of the Great*. How did the latter come to be painted in the cupola? On this point we have Villot's crucial testimony, which merits being quoted at length.[5] Villot described Delacroix as ceaselessly searching, thinking,

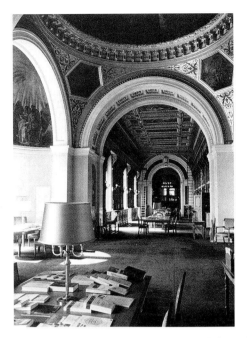
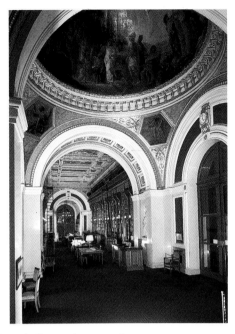

169. The library of the Palais du Luxembourg today

In the center is the cupola painted by Delacroix (fig. 170), to its left, the Alexander half-dome
(fig. 175). Two of the hexagonal pendentives are visible. The garden is to the left.

discussing, trying, before arriving at his final overall theme. Having found it, he would repeat the process, this time in drawings, until he discovered the composition that would best join idea and form in the expression best suited to the place.

"One evening, Delacroix came to visit and announced joyously that he had just received the commission for the paintings in the cupola in question, as well as for those in the half-dome over the window. He was delighted, but very much in a quandary because he did not know what to paint. There had to be a *pictorial connection,* those were his words, between the cupola and the half-dome. In such situations, before getting down to the task, Delacroix—who was, as I have said, very meticulous and very logical—would hesitate for a long time, and we would confer endlessly. If he already had an idea, he usually did not tell me; he would quiz me, make me draft plans, cover sheet upon sheet with daubs, and hunt through the Greek and Latin classics for axioms or passages applicable to the situation. Finally, we had to turn the material over every which way and talk for days and nights on end. That was what happened when he decorated the king's waiting room and the library of the Legislature. But this time, unusually, we were not condemned to hard labor, to these ex-

cruciating studies. The evening he came to tell us the news, he found me reading Dante's *Inferno,* and no sooner had he asked his inevitable question under the circumstances—What should I put there?—than I told him I had just the thing: two wonderful subjects that go naturally together. Then I read him the part where Dante recounts his arrival in the Elysian Fields, and how he was received by Horace, Ovid, Lucan, and Homer. . . . After reflecting on the various episodes that could work within the composition, episodes that allowed the introduction of women and men, nude and draped; animals; and a magnificent landscape, I suggested for the half-dome Alexander ordering Homer's works to be placed in a coffer of gold. He seemed to be instantly intrigued by the grandeur and richness of the scene, for he did not raise his usual objections to what I had proposed, and, after a moment's silence, asked me to lay out the overall groupings on a sheet of blue paper that I had before me. This was one of his habits; of course his inexhaustibly fertile imagination had no need of help from me, for he was quite certain that fertility would never fail him, but he was pleased to see how someone else in his place would go about it, what mistakes such a one would make that would be important to avoid, and finally the felicitous variations that were

possible to conceive in a roughly sketched theme. In short, it was a sort of experiment *in anima vili* that he was pleased frequently to practice. I still have the drawing, and needless to say Delacroix used none of it. The day after our exchange, he set to work, which meant piling up sketch upon sketch, composition upon composition. Then, once he had chosen the principal scene and the episodes, he began making painted studies. I remember that he was greatly worried lest the figures in the cupola, while of course following the curve of the vault, appear to be bending over rather than standing perfectly upright. He made a number of sketches in order to resolve this important problem, because he meant to paint in his studio as many as possible of the different parts that would join together to make the cupola, and he would have found it infinitely disagreeable to have to start the whole thing over again because the figures had fallen and hit him in the face. He was only able to find the contrivance to be used in the case after much trial and error and by using a miniature model of a vault in wood or cardboard. And still, if memory serves, despite all his precautions, he had to correct some movements on-site that were not entirely satisfying from below."

This text has the undeniable ring of authenticity and also correlates with other reports, in particular that of Lasalle-Bordes, which confirmed that the figures had to be altered because they had initially been placed too high; Delacroix, working from a scaffold, had misjudged the effect of the cornice.[6] Yet Villot's part in the final choice should not be overestimated: it seems to have consisted chiefly in stimulating a thought conceived earlier and independently of him. Delacroix had been familiar with *The Divine Comedy* and an admirer of Dante from his youth; his first submission to the Salon was inspired by him. Villot's suggestion was falling on eminently receptive ground, and it is not surprising that Delacroix took it immediately, especially since the figures and the two chosen scenes perfectly suited the decoration of a library: remember that Delacroix was at the same time laboring over the program of the library of the Palais-Bourbon. He still had to shape the project, develop it, and inscribe it within the architectural frame of the Palais du Luxembourg. The interest of Villot's memories here lies less in his personal role (someone else certainly could have filled it) than in what it reveals about Delacroix's creation: it did not emerge full-blown, but rather in response to—and reaction against—other proposals. And, in a way,

this demonstrates his relationship to the masters and to tradition. The more and less explicit recollections and references, whether plastic or literary, that are nearly always present in his work, are more than mere quotations. They are the painting's necessary foundations, from which he would develop a body of work that was both closely connected to the humanist tradition and perfectly independent of it.

Delacroix himself very precisely described the subjects he treated in the Luxembourg cupola.[7] His plan proved, if proof were needed, that, here, as in all his monumental paintings, his conception of the subject was inseparable from the specific architecture of the place. But this explanation may go beyond the mere identification of the figures. The viewer, following the painter's directions, sees the cupola as a whole, then each group, and finally focuses on the individual figures, with the text in a sense directing the viewer's gaze.

"The cupola of the library shows the limbo described by Dante in the fourth canto of his *Inferno*. It is a kind of Elysium, inhabited by those great men who did not receive the grace of baptism. *'Their honourable fame on earth, / Resounding in their mortal life, has gained them / Grace in heaven, and this distinction here.'* These words, taken from the poem, are inscribed on a cartouche held aloft by two winged children who point to the subject. The phrase carried by an eagle in another part of the sky completes the explanation, reading: 'Thus did my mortal eyes see congregate / The great disciples of that lord of song / Who like an eagle soars above the rest' [fig. 170].

"The composition is arranged in four sections or main groups. The first, which is the most important and, as it were, the center of the painting, is across from the window overlooking the garden [fig. 171]. It represents Homer leaning on a scepter, accompanied by the poets Ovid, Statius, and Horace. He welcomes Dante, who is brought to him by Virgil. A divine spring issues from the earth at his feet, and the water of this Hippocrene is collected by a young child, who seems to offer it in a golden cup to the Florentine, the last one introduced to this illustrious company. To one side and in front, Achilles, sitting by his shield and close to the group dominated by the author of the *Iliad;* on the other, Pyrrhus, dressed in his armor, and Hannibal, the latter standing, gazing toward the part of the painting where we see the Romans.

"Turning to the left, we find the second group, which is that of the illustrious Greeks [fig. 172]. Alexander, leaning on

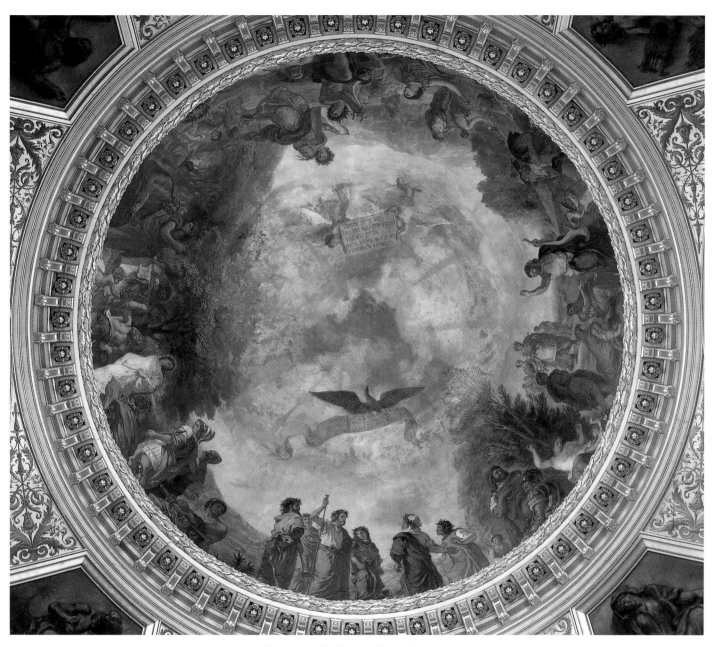

170. *Dante and the Spirits of the Great*, 1841–45
Oil on remounted canvas, 680 cm diameter
Palais du Luxembourg, Paris

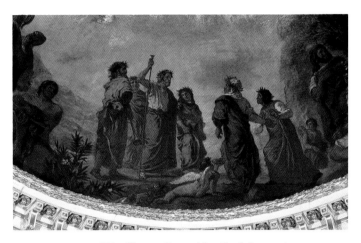

171. *The Homer Group* (detail of fig. 170)

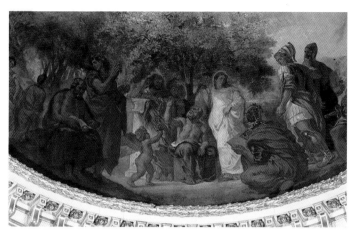

172. *The Greek Group* (detail of fig. 170)

the shoulder of his master, Aristotle, turns toward the painter Apelles, seated before him as if preparing to capture his features. Aspasia, wrapped in white drapery; Plato, leaning on a cippus; behind him, Alcibiades, wearing a helmet; and some figures in the shade of a grove of laurels and orange trees surround Socrates, who talks familiarly with them. A winged spirit presents the latter with a palm frond, symbol of the oracle who had proclaimed him wisest of mortals. In front and in shadow, Xenophon, crowned with a wreath of flowers and turned toward Demosthenes, who holds a scroll on his knees.

"The third side or section shows Orpheus, poet of the heroic age, seated holding his lyre [fig. 173]. The Muse, who flies beside him, appears to be dictating divine songs to him. Hesiod, stretched out near him, gathers from his lips the mythological traditions of Greece, and Sappho of Lesbos offers them inspired tablets. An attentive panther stretches out at their feet. Behind these figures, and in a smiling meadow, we see other privileged shades wander and rest. Young women gather flowers on the banks of a stream that meanders through these pleasant places, and woodland animals approach timidly to drink there.

"The fourth side is that of the Romans [fig. 174]. Porcia, seated near Marcus Aurelius, points to a vessel containing the burning coals that were the instrument of her death. Cato of Utica, addressing his daughter and the wise emperor, holds in his hand Plato's famous treatise.[8] His sword rests on the ground, its point at his entrails. To the left of this group, we can glimpse Trajan in the shade of a great laurel, and, on a knoll farther away, Caesar, dressed for war, carrying a globe and a sword, and, near him, Cicero and a few Roman figures. Two nymphs, one of them entirely nude and lying on an urn, the other seated under the laurel and playing with a child, occupy the front of this part of the painting. The right side shows, in the foreground, Cincinnatus, leaning on his spade and wearing rustic garb. He smiles at a young child, who has taken his helmet and appears to be the genius of Rome, inviting him to take up arms."

Delacroix's account mentions neither the pendentives of the cupola nor, what is stranger, the half-dome, even though it was related, but he explained this elsewhere.[9] The four pendentives represent, on the side facing the garden, *Eloquence*, with the features of "a man of a certain age addressing a multitude," and *Poetry*, "a young woman holding a lyre"; on the opposite side, *Theology*, or "Saint Jerome in the desert"; and *Philosophy*, "a man surrounded by attributes and animals of every kingdom." And in the half-dome (fig. 175): "Following the Battle of Arbela, the Macedonian soldiers found a priceless gold coffer among the Persian spoils. Alexander ordered that it be used to hold the poems of Homer. He is represented seated on a raised chair on the battlefield. At his feet are captives leading children, and satraps in the attitudes of suppliants. Victory, wings spread, crowns the conqueror. Behind the group of figures that bears the coffer, a ruined chariot and the battlefield in the distance."[10]

It is the overall program, which recalls the approach to the two Palais-Bourbon half-domes of the same period, that gives

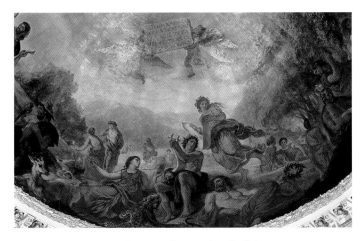

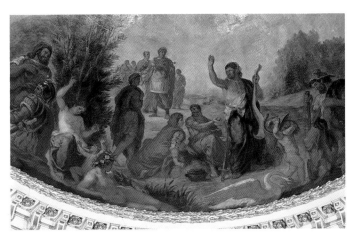

173. *The Orpheus Group* (detail of fig. 170) 174. *The Roman Group* (detail of fig. 170)

the cupola its distinctively decorative dimension. The figures, which are immediately above the cornice, are dressed in bright colors—shades of red, blue, green, white, ocher, and orange—that answer one another and, along with the flesh tones, produce a harmony of warmth and clarity. The figures stand out in a continuous circle against a background landscape done in greens and blues, the center occupied entirely by the cloud-filled, equally intense sky. The arrangement of figures and scenery is perfectly integrated into the space; not only does it accompany the architecture seamlessly, it even develops a certain illusionism in the way it opens to an imaginary sky, in the tradition inherited from the Italians of the late seventeenth and eighteenth centuries. Yet Delacroix was careful neither to treat the center uniformly nor to leave it empty: hence the eagle and the two putti. Certainly they are assigned to carry the banderole and inscription, in order to give the meaning of the scene, but they also serve to fill the space in the center, and to weight upward the two main groups, those of Homer and Orpheus. The other two groups, those of the illustrious Romans and Greeks, require less such balancing because they can be seen from farther away: the viewer gradually discovers them from the library's two wings. Each group is constructed separately around a central figure—Orpheus, Sappho, and Cato of Utica. The sole exception is the figure of Homer, built along a subtly rising diagonal that begins at the curve of the cornice, and goes from Dante and Virgil to the four classical poets. The play of attitudes and gazes that connects the different figures mitigates their apparently static

quality, as does the perspective created by the middle grounds, especially in the Roman group, which opens onto a meadow and hills, whereas Homer's group stands out against the sky, the Greeks against a grove, and Orpheus's group against mountains. The children and nymphs play a similar role, softening any excessive austerity the subject might connote. Like all the other figures, these may be considered not only from a decorative standpoint, but also in light of their relationship to Dante's text, illustrated and elaborated by Delacroix, who added elements of his own invention. The figure of Hannibal is a perfect example of this: it acts as a framing element at the right of the Homer group, along with the figures of Pyrrhus and the nymph playing with a child (which recalls *The Cumaean Sibyl*, exhibited at the Salon of 1845), but also participates in the next group, that of the Romans, so that Hannibal's gaze brings in additional meaning, with the reference to the Punic Wars.

The half-dome (fig. 175) displays an analogous, albeit denser arrangement. Here, Delacroix had to take into account a further difficulty: the window's lunette. His solution was to divide the painting in three, with Alexander and the conquered folk on the right, the conquering Macedonians on the left, and, in the middle, as if resting on the cornice, the spoils, above which Victory hovers. He thereby skillfully designed a pyramid, which echoes the shape of the half-dome and aligns Alexander with Homer's poems, that is, the principal subject. The composition may also be analyzed from a more dynamic point of view. Everything converges toward Alexander: the

Persian group does so in an obvious way; the Greeks, thanks to Victory and the palm trees that add an exotic note but, most importantly, emphasize the right-hand side. The connection with the cupola is as much a function of meaning as of shape, with one blue-green sky frankly echoing the other. The gold on the cornices, moldings, and pendentives—its richness and lavishness accentuate the chromatism, as does the white of the arches—further unites the two spaces.

The execution proceeded somewhat faster than that of the decoration of the Palais-Bourbon, a very similar project, but encountered the same kinds of setbacks: illness, overwork, pressure from the administration—in this case, the Great Referendary of the Chamber, the duc Decazes. In February 1841, six months after receiving the commission, Delacroix had not yet submitted the final sketches of his compositions. They were ready that May, and in June he was on-site and at work with Lasalle-Bordes as his assistant. In fact, Delacroix could only work effectively in summer and autumn, the only time the lighting was adequate and the place accessible. He finished the preliminary sketch for the cupola in November but had to interrupt work during the winter for health reasons. Modifications to the scaffolding made it difficult to resume the project, but a greater obstacle was presented by certain peers, who in 1842 objected to the work in progress. It appears that Delacroix was not so much their target as Riesener's ceilings, which were then beginning to be installed.[11] Riesener's choice of allegorical language was severely criticized, one of the paintings, *Philosophy Lifts the Veil Enveloping Nature*, was removed, and it was proposed to replace Delacroix's half-dome and pendentives with an architectural decoration of coffers. Delacroix was able to keep the half-dome but was obliged to reduce the pendentives to their present expression, that is, grisaille figures within hexagons surrounded by foliated scrolls. He took advantage of the summer sun to return to work, beginning in July, in competition with the Chambre des Députés. In early 1843, the cupola, closed to the public, was well underway, and the half-dome was drafted. Delacroix could only make progress between sessions: in this way, he advanced the cupola during the summer of 1843 and again beginning in May 1844. He wore himself down, but without completing the project, as he had hoped: "Because I forced myself to work on it too long in the dark, my eyes were in very bad shape for six weeks, and I have not yet regained the use of

them as before. I must absolutely have broad daylight; to tell the truth, it would not take very long: except that at this time of year, and with the distance from the Luxembourg [he had just moved to the Right Bank], not to mention the cold, it would be impossible," he wrote Gisors in December.[12] The cupola was finally completed following his stint of the summer of 1845. That left the half-dome, which was finished in December 1846. Thus, the project took Delacroix five years, although during the same period he was working at the Palais-Bourbon, and in a few months during 1843–44 had painted *The Lamentation* in Saint-Denis-du-Saint-Sacrement, as well as easel paintings and submissions to the Salon, especially that of 1845. Nevertheless, his work in the Palais du Luxembourg appears to have been, all things considered, orderly, regular, and consistent.

The result was received with universal praise. Articles had been written as early as October 1845, which worried Delacroix: something would be judged that was "unresolved," that should really not have been shown until it had reached its "effective point," that is, was finished.[13] The first articles appeared in February 1846, the rest came out periodically over the next year.[14] Contrary to what Delacroix might have thought, this spread over time turned out to be in his favor: "There is, in the lives of the glorious masters, a supreme moment in which their talent, filled with passion and wisdom, condenses, so to speak its different qualities, and sums them up in a single privileged work, a final, chosen form, in which all its creator's thought has been poured. . . . There comes a time in which, like one of those naive medieval laborers, working to earn his mastership, we call upon all of our resources, and in this way each of us makes our masterpiece on Earth. Having arrived at this decisive moment, M. Delacroix has just made his, or such is the public acclaim; such is the sentiment that was tossed into the crowd a year ago by a few sympathetic writers, and now seems to have made its way, winning over the general opinion."[15]

Several themes recur from critic to critic. As with Delacroix's other monumental paintings, critical emphasis was on his masterly solutions to the technical problems of adapting his work to an architectural context, in this case, to the composition of a cupola, which, in Thoré's words, "requires very specific combinations of lines, shifts of planes, and plays of effects," unlike half-domes, friezes, pediments, and ceiling frescoes,

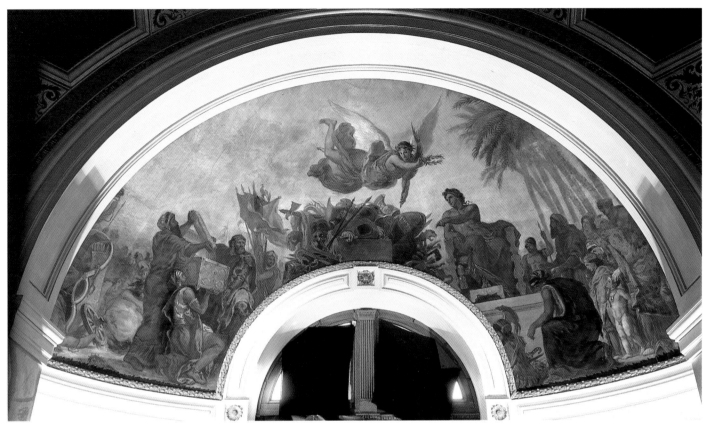

175. *Alexander Preserves Homer's Poems*, 1846
Oil on remounted canvas, 680 cm diameter
Palais du Luxembourg, Paris

where "the composition is almost the same as in an ordinary painting."[16] Such attention to the strictly decorative aspect implied a true science of the arrangement of masses: "What impressed us equally was the extreme skill with which all the heroes are grouped. While they appear to be scattered, beneath the dense shadows of the myrtles and on the meadow's green knolls, they are in fact obeying the imperious rule of the group and are connected to one another by an effect of light, a trick of colors, a knowledgeable accident of the terrain, and almost always, too, by the governing idea."[17] Beyond that, there was the principal theme, "wonderfully chosen for a library,"[18] which held the viewer's attention, and above all the manner in which that theme was treated. The peace that it inspired made it a watershed in the painter's known oeuvre. "Greek antiquity has proved a beneficial inspiration to M. Delacroix. . . . A calm has descended upon this impatient nature, this restless hand."[19] A number of ancient references were

posited as Delacroix's inspirations:[20] a Roman statue in the Louvre, then believed to be a portrait of Demosthenes; a bas-relief in the British Museum, *The Apotheosis of Homer*, for Sappho; and the Ludovisi Mars for Achilles. Homer, Marcus Aurelius, and Aristotle were taken from well-known, widespread models, which made it easier for viewers to identify them: "All the figures that he placed in Limbo (for Dante named but a few of the shades that it was granted him to see) have distinct personalities in human memory. M. Delacroix was careful to leave them those personalities, so that one's mind greets most of them as easily recognizable friends. Moreover, from his earliest works, M. Delacroix has always had a deep feeling for the civilizations of all times and countries. Of the modern painters, it is he who revealed the Orient to us, for example, under its most vivid and real aspect; whenever he has treated historical subjects, he has brought to the interpretation of the past a reporter's insight."[21] Even more than his works

at the Palais-Bourbon, or his *Medea* of 1838 (fig. 200), Delacroix's achievement at the Luxembourg demonstrated how grounded his art was in the legacy of antiquity, in subject matter as much as in any specific reference. Yet, however close he appeared to be to the classical camp, he retained his originality, above all as a colorist, as Théophile Gautier elaborated: "The antique, as Eugène Delacroix understands it, has all the novelty of the unexpected; nothing is younger or newer than the Greek and Roman interpreted in this way. In these subjects, where misunderstood imitation of statues and bas-reliefs introduces dryness and immobility, our artist is able to be supple, luxurious, and colored; he causes sunlight to play on marble, and brings the crimson of life back into the veins of the past; he flexes, twists, gives motion to those inflexible contours, rendering them as undulating as flames; the fixed gesture relaxes, the muscle quivers, the nerve vibrates, the fiber palpitates; he places a gleam in the white eye, a red grain in the closed nostril, a breath between sealed lips; he widens all the openings in the antique mask to let modern life shine through. Until now we have had only the outline of antiquity, he gives us its color. . . . Many people deny M. Delacroix's gift of beauty in art. This is because it is usually held to consist of a clear, clean line, with no blurring and scrupulously trimmed; it can, however, come from color as much as from the drawing. The cupola of the library of the Chambre des Pairs is a striking example of this: the impression of beauty is as vivid beneath this dome as beneath M. Ingres's ceiling [*The Apotheosis of Homer* in the Louvre]. Yet, nothing in M. Delacroix's painting resembles the Apollo Belvederes and Venuses de' Medicis, the normal types of beauty, according to the usual ideas, but there are elegant tones and combinations and contrasts of nuances full of style, rendering the ideal just as well as any line, however pure. . . . And so the sight of M. Delacroix's cupola conveys a harmonious, limpid, serene impression, as before the purest and most classical masterpieces. Everything seems noble, elegant, poetic; the exclamation 'How beautiful!' comes naturally to your lips. He has the style of color, the beauty of tone, the poetry of effect. You may not find in this painting those thin cameo profiles that look so well on pins, but you will see living heads, flesh made satiny with life and gilded with light."[22]

In fact, the vigor of the colors and the luminous harmony in the two principal compositions were especially commented upon: "Through the magic of its palette, this painting illuminates itself; the tones receive no light, they give it," Gautier also wrote.[23] "In the Luxembourg cupola, M. Delacroix's triumph over M. de Gisors's miserliness may be considered a true tour de force. The painter was obliged, so to speak, to create the light he needed to illuminate his figures. He had to seek in the tones of the draperies and in the nuance of the sky the rays that the architect had denied him. The struggle was hard, but the painter emerged victorious from this pitched battle: he transformed shadow into light."[24] Paul Mantz was among those who took their thoughts on this point furthest; he compared the effects of the cupola with those Delacroix had strived for in *Jewish Wedding in Morocco* (fig. 120), where he "had enveloped his figures in a transparent half-tone, a veritable prodigy of finesse and lightness," attenuating the sun-warmed ray on pavement and walls "in an utterly exact graduation." He found this same skill in the Luxembourg, "all the more considerable in that it is applied on a larger scale," in particular in the chiaroscuro of Aspasia and Socrates, and the two nymphs opposite them. "The landscape that runs around the cupola, especially behind Orpheus and Sappho, owes its depth and reality in the distances principally to this sapient distribution of light. Everything appears radiant, because the half-tones are as light as those in Veronese: M. Delacroix knows as well as he that light has its own perspective, as do color and line."[25]

In the Palais du Luxembourg, Delacroix achieved a perfect unity of subject matter with its plastic expression. What the Salon du Roi had foreshadowed, corroborated by what had been revealed in the library of the Chambre des Députés, was confirmed here: Delacroix was incontestably one of the greatest monumental painters of his time, if not the greatest, and in any case he renewed a genre that had been in disuse in France for more than a century. At the same time, his work in the Luxembourg demonstrated his capacity to renew himself: "M. Delacroix's genius is essentially complex: he embraces every horizon where the human soul might go astray. In the long history of art, in which every painter translates the emotion of his time, M. Delacroix excellently represents and personifies the painful thought that torments our century. . . . This is the aspect of his talent that we have most often been permitted to see, but his talent can also be clothed in tenderness and poetry; when he wishes it so, it has seductiveness, charm, and an indescribable something that makes us dream

and forget. . . . In this instance, it has pleased the artist to paint a work that is all tranquility and serene sweetness, a calm, fresh ceiling for a library, that silent dwelling where the spirits of those who are no longer with us keep watch. . . . As for the painting itself—its color, poetic sentiment, light, and composition—I say without hesitation that M. Delacroix has never gone further, and that certain qualities that he had not hitherto revealed completely blaze in the cupola, with an unforeseen splendor and perfection."[26] In the end, the originality of the works in the Chambre des Pairs resides in their transcending the mere rendering of their subjects. As Thoré wrote: "seeing this majestic, simple painting, as with anything great, this calm, mysterious landscape, one feels in one's soul an ineffable serenity and an eager aspiration toward the ideal; one is transported above illusory realities, to the only world in which the soul finds satisfaction in poetry. Thus, M. Delacroix has attained the goal of his art, which is, according to us, to inspire feelings and not to formulate abstract ideas."[27]

By the end of 1847, the two projects that had engaged Delacroix for nearly ten years were finished. As early as January of that year, however, he had been talking with Gisors about painting the decoration of the grand staircase of the Luxembourg.[28] In March, he was jotting down possible subjects, "scenes of the Revolution and the Empire with allegorical figures": *The Nation Leading Its Volunteers, Glory Crowning Napoleon, Africa Conquered, Our Soldiers Throw Themselves into the Sea to Take Possession of It*, as well as *Egypt Subjected by Napoleon's Genius*, and *The Battle of Isly*, "treated poetically."[29] The project did not materialize (the staircase has no paintings), but proves Delacroix's desire to continue along a now-familiar path. At this same time, a commission to paint the transepts of Saint-Sulpice was under discussion. That assignment, too, fell through (it was given to Emile Signol in 1876),[30] and it would be another two years before he was commissioned to paint the Chapelle des Saints-Anges. The execu-

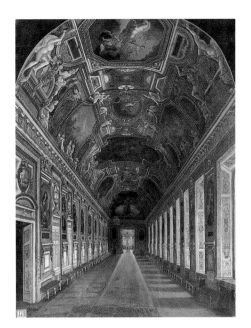

176. The Galerie d'Apollon in the Louvre after Duban's restorations
Oil on canvas by Pierre de Castelneau, second half of the nineteenth century
Musée du Louvre, Paris

tion of these murals would take until 1861, because Delacroix was committed to two others: the ceiling of the Galerie d'Apollon in the Louvre and the decoration of the Salon de la Paix in the Hôtel de Ville de Paris.

The Louvre commission was part of a vast restoration program undertaken by the republican government shortly after the fall of the July Monarchy;[31] the architect Félix Duban had been assigned to direct the project.[32] The work began with the section most urgently requiring attention, the wing with the Petite Galerie, whose second floor comprised the Galerie d'Apollon.[33] Left unfinished in the seventeenth century, it had severely deteriorated. Now that it had been structurally rehabilitated, the next stage was the restoration or replacement of its elements—its stuccoes, woodwork, and ornamental sculpture (1849–50). The painted decoration, part of it originally by Charles Le Brun, part by various other painters between 1769 and 1781, was to be restored at the same time. Two of the ceiling compartments were missing, and the central, most important element and a tympanum at one end of the gallery had never been painted. Duban suggested assigning them to Delacroix, Charles-Louis Müller, and Joseph Guichard. Through Villot, Delacroix had been aware of Duban's plans since April 1849,[34] but he was not officially notified of the commission until March 1850.

"This is a very important work, which will be set in the most beautiful place in the world, beside beautiful compositions by Lebrun. You see how slippery the footing is and how one must hold on."[35] Delacroix was perfectly aware of the difficulty of the task he was being asked to perform. No longer was it a question of creating from start to finish an original decoration in contemporary architecture, but rather of integrating a work into a predetermined program and a preexisting space, both of them a century and a half old. He would be competing with one of the greatest masters of the French school, who had also been its greatest decorative painter: the example of Versailles, foreshadowed by the Galerie d'Apollon,

was more than proof enough of this. Delacroix would have to do more than merely follow tradition; he had to incorporate himself directly into it. The iconography of the Galerie d'Apollon, liberally inspired by the Palazzo Farnese's Carracci gallery, was complex (see fig. 176). The north tympanum, at the entrance end, depicted *The Triumph of Neptune and Amphitrite (The Waters)*; the south tympanum, *The Triumph of Cybele (The Earth)*. Between them, four octagonal or oval compartments marked the four times of day, beginning at the south end: *Aurora on Her Chariot; Castor, or the Morning Star; Evening (Morpheus, Father of Monsters)*; and *Diana, or Night*. Le Brun had painted the south tympanum and three of the compartments, *Aurora, Evening,* and *Night. Castor* had been painted in 1781 by Antoine Renou, and the four compartments around the middle one, *The Seasons,* dated to the same period.[36] Stucco figures along the cornice depicted the Muses, the signs of the zodiac, and the parts of the world. Paintings of grotesques, medallions painted on the theme of the months, and flowered garlands completed the decoration. The lighting, which comes essentially from a series of windows facing east over the Infanta's Garden and the Seine, is less important here than the abundance and wealth of the various elements, with the paintings bringing the only note of color into a primarily white and gold harmony. It had been decided to restore and finish the gallery according to Le Brun's original plan, and Müller and Guichard referred to his compositions, which were known from etchings of the period. Delacroix, however, was given much more freedom, because no drawings by Le Brun survived or were known, although it was known that a *Triumph of Apollo* had been planned. Initially, Delacroix had considered *Horses of the Sun Unharnessed by the Sea Nymphs,* which he had been thinking of since 1847.[37] He then contemplated *Apollo Slays Python,* a subject drawn from Book I of Ovid's

177. Final sketch for *Apollo Slays Python* 1850
Oil on canvas, with pastel (?) highlights, 137.5 × 102 cm
Musées Royaux des Beaux-Arts de Belgique, Brussels

Metamorphoses that was perfectly in keeping with the gallery's other compositions. The episode takes place after the flood that Jupiter has sent down upon the Earth to punish humanity for its violence and crimes. As the waters recede at the sun's first light, strange life forms appear, such as the serpent Python, which strikes terror into the survivors: "Consider / the Python, that huge serpent that struck fear in the hearts / of those newly created men. With what possible purpose / would the earth produce from itself a monstrosity like that? / But there it of course was, coiling its scaly length / around whole mountainsides as if it would swallow them up. / The archer god, Apollo, whose accustomed targets were deer / or now and again a chamois, emptied his whole quiver / into this dreadful beast, whose blood and venom mixed / as they seethed into the ground."[38] Starting from this brief passage, Delacroix elaborated his final subject, and gave the following description of it in an explanatory sheet attached to the invitations sent to friends and critics when the ceiling (fig. 178) was completed: "Mounted on his chariot, the god has already fired some of his shafts; Diana, his sister, flying behind him, offers him her quiver. Pierced by the arrows of the god of heat and life, the bleeding monster writhes, exhaling, in a flaming vapor, the last of his life and impotent rage. The waters of the Flood are beginning to dry up, leaving on mountain peaks the bodies of men and animals, which they drag with them. The gods have become incensed at seeing the earth abandoned to deformed monsters. They have armed themselves like Apollo; Minerva and Mercury rush to exterminate them, until the eternal wisdom repopulates the solitude of the universe. Hercules smashes them with his club; Vulcan, the god of fire, chases night and foul vapors, as Boreas and the Zephyrs blow the waters dry and disperse the last clouds. The nymphs of rivers and streams have found their reed beds once

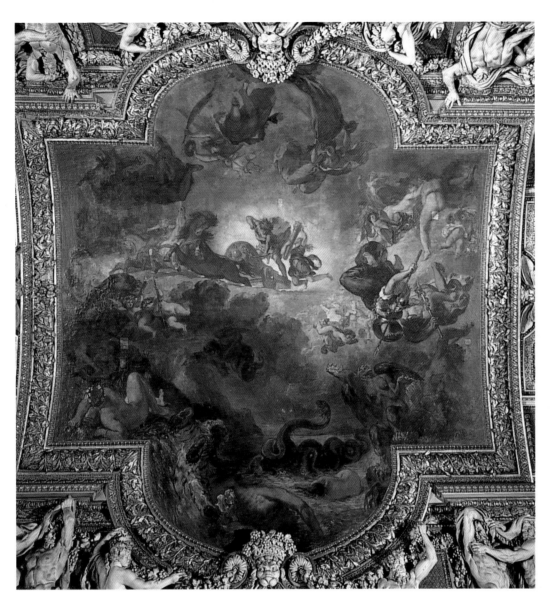

178. *Apollo Slays Python,* 1850–51
Oil on remounted canvas, 800 × 750 cm
Musée du Louvre, Galerie d'Apollon, Paris

more and their urn still soiled with mud and debris. The more timid divinities [Juno, Venus, and Ceres above Minerva and Mercury] watch the battle between the gods and the elements from a distance. Meanwhile, from the highest heaven, Victory descends to crown Apollo, and Iris, the messenger of the gods, unfurls her scarf on the breeze, as a symbol of the triumph of light over darkness and the rebellion of the waters."[39]

In illustrating a mythological episode, Delacroix could not have been more in keeping with the classical tradition: *Apollo Slays Python* is unique in his career from every standpoint. While preserving his trademark qualities, especially his extraordinary inventiveness (the massing of figures and groups is almost entirely his creation), it is perfectly integrated into the rest of the gallery. Delacroix somewhat modified Le Brun's original idea, of course: the earlier artist's *Triumph of Apollo* had also been meant to glorify Louis XIV (the "kneeling blandishments" that Gustave Planche congratulated Delacroix on avoiding).[40] Yet, he remained in the spirit of the Grand Siècle without erring on the side of pastiche. The multiplication of the figures, which are so many high points, is in a similar vein. He set his imagination free to achieve the "deformed monsters" and the stunning arrow-pierced Python, while rigorously respecting the traditional iconography, such as Mercury's attributes and the horses of the Sun, the colors of whose trappings symbolizing the four seasons and the four times of day (while working on it, Delacroix had discussed it with Delaporte, who had come to see him).[41] As personal and original as it may be, *Apollo Slays Python* also perfectly fulfilled its mandate.

The painting's success owes much to the treatment. Delacroix finalized the composition soon after being notified of the commission, and worked intensively at the sketch between April and June of 1850 (fig. 177). The very few changes in the final painting appear in the lower part. As he wrote Dutilleux in April 1851: "[The hard work involved in my ceiling] is even more than I had anticipated. The need to do it in sections keeps my mind continually frustrated about what can't be seen, and no matter how careful I have been to make my ideas precise in the sketch, the need to enlarge it requires differences that mean constant adjustments. But the pleasure of working on an object like this makes up for the hardship and the tiredness, and, since I am feeling quite well, I hope this will not drag on too long. I have covered most of it, and the upper part

is done, except maybe for light retouchings that will be suggested when I see it altogether."[42]

This time Delacroix worked rapidly, with no real interruptions, assisted by Andrieu, in the studio of Charles Séchan, a set decorator who had also restored the gallery's paneling. By September 1850, there was a cartoon of the composition, but the final canvas, furnished by Etienne-François Haro, had still to be put in place. Delacroix was on the jury of the Salon, and his obligations in that regard kept him from the task until January, but from then on he worked continuously.[43] He had hoped to be finished within two months, in time for the inauguration of the new rooms by the Prince-President (it took place on 5 June), but, exhausted, he did not complete the studio work until August. When the paint was dry, the canvas was set in place at the beginning of October. "What I am finishing now is a big deal for me: they are waiting for me out there, to decide once and for all if I am a painter or a dauber. . . . The setting-in went without a hitch: it is a masterpiece all by itself. As for the painting, which, over the six months and more that I have been working on it, I only saw the day they moved part of the scaffolding, none of my little calculations was wrong: the only retouchings are trifling. People are amazed that the painting fit perfectly, as if it were made for its spot: since it didn't make itself, people would be less amazed if they knew the precautions I took. You know what the smallest details can often cost."[44]

Apollo Slays Python (which, unlike his other decorative works, Delacroix painted in oil, so that it would conform better with the rest of the gallery) was realized in a single impetus, enthusiastically, as he himself said. The task was neither easy nor without risk. Although not a new one for him, it differed in a number of ways from anything he had previously undertaken, if only because of the shape of the ceiling. These problems undoubtedly contributed significantly to the fervor he demonstrated. He wrote in his journal in June 1850: "I was saying to myself, as I looked at my ceiling composition, which I have only liked since yesterday, because of the changes I made in the sky with pastel, that a good painting, exactly like a good dish, is made up of the same elements as a bad one: the artist does everything. How many magnificent compositions would be nothing without the great cook's grain of salt! This power of the *je ne sais quoi* is amazing in Rubens; what his

temperament, his *vis poetica*, brings to a composition, without his appearing to change it, is marvelous. It is nothing but the knack in the style; the manner is everything, the background means little by comparison."[45] The reference to Rubens was not a chance one: his influence is, in fact, more marked in *Apollo Slays Python* than in the earlier monumental paintings. In July and August, that is, after finishing the sketch, Delacroix passed through Belgium on his trip to Ems. There he saw many of Rubens's works, including *The Raising of the Cross* in Antwerp: "More freedom, albeit with academic brushwork, in the middle painting, but completely free and his natural self once more, in the lateral panel with the horse, which is better than anything. It made me think better of Géricault, who intuited that power, and is by no means inferior. The painting may be less skillful in *The Raising of the Cross*, but it must be admitted that the impression is maybe more gigantic and nobler than in his masterpieces. He was imbued with sublime works; one cannot say that he was imitative. He had that hallmark, and the others within him. How different from the Carracci! If one thinks of them, one can see that he did not imitate, he was always Rubens. That will be useful for my ceiling. I felt that way when I started. Did I owe it to others as well? Frequent exposure to Michelangelo took generation after generation of painters beyond themselves."[46] *Apollo Slays Python* can reasonably be compared with the masters: it is above all a work into which Delacroix may have put even more of himself than those of the Palais-Bourbon and the Palais du Luxembourg.

The reviews, almost unanimously favorable, analyzed these two themes: only a small minority of articles were opposed to the work, and the influential figures who wrote about the ceiling, from Delécluze to Gustave Planche, expressed a few reservations at most. Delacroix was confirming his capacities as a monumental decorator and painter, in his choice of subject, overall conception, and execution of the parts—which his talent as a colorist magnified. "We know that when we look at one of M. Delacroix's paintings we must pass lightly over the details and concentrate especially on the whole and on the idea," wrote Delécluze, for example. "Now, the placement of a ceiling painting forces the viewer to focus on it only rapidly and at intervals; this is one reason why M. Delacroix's composition so well fulfills the conditions necessary for success

in this kind of painting. All these figures wandering throughout the airy spaces—their appearance thereby subject to the laws of perspective, which almost no one knows—allowed the artist to employ a great freedom in the drawing, with no fear of verification; then, because the use of foreshortening was unavoidable, the painter could sometimes be slippery about the precision of forms without even the most educated or scrupulous observers being able to indicate exactly which pieces were missing and which were too much."[47] Charles Tillot's remarks are more interesting because he identifies the difficulties peculiar to decorative painting: "Except for the Old Masters, few artists have managed it; to be convinced, one need only glance at the works excuted in the French and Egyptian museums [that is, within the Louvre], and on the grand staircase of the Louvre. Some are from the brushes of remarkable artists, yet none are free of a flaw that has long been noted, that of being entirely unsuited to their pupose. We do not except here either the work of M. Ingres [*The Apotheosis of Homer*], or that of M. Cogniet [*The Egyptian Expedition under the Orders of Bonaparte*]. . . . Their figures, laid out with head and feet on the same horizontal line, appear to stand away from the wall and about to fall onto the viewer's head. In a word, to use a term borrowed from artists, their figures do not 'ceil.' This term, which seems to us to describe perfectly the ability that figures on a ceiling have to act and circulate freely, while remaining vertical, can be applied to M. Delacroix's paintings; he has been able to meet the requirements of this kind of work, which his special attainments and boldness render him more qualified than any other to perform. There he has shown himself to be what he truly is: both painter and poet at once. This last work reveals nothing new about this so prolific and so various talent, but it does show him from all the standpoints at once that we had been privileged to witness in turn; it summarizes his entire life's work. Here, the painter is by turns elegant and severe, soft and brilliant, correct and as passionate as in the *Massacres of Chios*, *The Barque of Dante*, and the *Entry of the Crusaders into Constantinople*, and never has he deployed the resources of his dazzling palette with such profusion."[48]

Today, it is a questionable matter to make a statement about the overall tonality and coloring of the work, which is much darkened and, as mentioned earlier, in very poor

condition. Nevertheless, they are visibly different from those of his previous paintings, and the sensation is completely other: before Delacroix seems to have been inspired chiefly by the Venetian school, and by Veronese in particular, whereas here he has set himself in the line of Rubens and, above all, Le Brun. This apparent break was undoubtedly more evident when the painting was unveiled, even though Delacroix had deliberately achieved a chiaroscuro effect—a first for him in his decorative painting. One can still make out the blue-green of the sky, set off by the clouds, but not its contrast with the mountain landscape. Yet, certain parts still allow a glimpse of the refinement of his palette, which married subtle details and harmonious masses such as Apollo, Iris, and Victory, and Mercury and Minerva. One can more easily appreciate the great variety of the drawing of the different figures, with the foreshortenings noted by Delécluze, in particular in the lower section, where the nymph tumbles over her urn, the tiger hurtles into the waters, and the monsters are massacred by the gods. Delacroix's virtuosity in the excution is not superfluous; it is what gives the composition its dynamism. This composition is organized first along a major axis, with Apollo, haloed with sunlight, in the middle; it begins with Iris and Victory and ends at the lower section, where the monsters are spread out around the serpent Python. The groups develop along parallel lines on either side, while developing two diagonals, one from the nymph in the lower left toward the "timid divinities" in the upper right, and the other from Vulcan to Hercules, emphasized by the horses, the clouds, and the monster killed by Minerva. She divides the whole into two zones of light—the left one darker than the one on the right—whereas Apollo, in the middle of the ceiling and thus of the gallery, radiates light over the entire scene as well. Everything contributes to reinforcing the dramatic effect and explaining the subject—a battle in which light overcomes darkness, good overcomes evil, and civilization overcomes the state of nature—without ever losing sight of the strictly decorative aspect.

Should one go further and see in *Apollo Slays Python* an allegory for Delacroix himself, his work, and his ongoing struggle? As Lee Johnson has rightly noted, the idea occurred to certain critics at the time; he reports Auguste Vacquerie's words as follows: "Assigned to paint the triumph of light—he who has caused light to triumph in the French school—he was sure to win. He, the painter of the sun, was in his element."[49]

It is less certain that Delacroix cleverly insinuated either himself or allusions to contemporary political and social developments into the battle of the god of the arts.[50] If a personal involvement on the part of the artist is to be sought in this commissioned work, it might lie rather in its destination, the "most beautiful place in the world," not only one of the few seventeenth-century galleries surviving in Paris, but one that was at the heart of one of the greatest museums of the period, the Louvre, a veritable treasure house of the artistic glories of the past. Delacroix had the good fortune to enter it during his lifetime, and with a major work. He could not let the opportunity pass and, for a few months, he gave his all, so as to make his mark, and leave behind him a deathless work.

The success of *Apollo Slays Python* apparently surprised even Delacroix. It behooved him to take advantage of it, and by the time the ceiling was being set in place he was already seeking another commission for a monumental painting.[51] In the following months he obtained one for a room in the new Hôtel de Ville;[52] it would be his last decorative painting project in a public building. It is also the only one that no longer exists: it was destroyed when the building was burned down during the Commune in 1871, a fire all the more regrettable because it also destroyed the preparatory works that were kept there, as well as the archival documents that would have made it possible to reconstruct the chronology more accurately.

The Hôtel de Ville had been restored and expanded by the architects Etienne Godde and Jean-Baptiste Lesueur between 1837 and 1842. On the second floor of the new constructions, on the rue Lobau at the back of the building, was a long gallery, the Galerie des Fêtes, which opened into a salon at either end: the Salon de la Paix (during the July Monarchy, the Salon Louis-Philippe) at the north end, and the Salon de l'Empereur at the south end (fig. 179). Delacroix was assigned the former, Ingres the latter, and Henri Lehman the Galerie des Fêtes. They had to work quickly: the interiors had not been finished at the same time as the construction, owing to a lack of funding. Now the honor of the new imperial regime was at stake, a regime that was apparently much stricter on this point than the preceding governments: "I have a set and immovable deadline," Delacroix wrote George Sand, "so I am furious and living happily at the same time."[53] As with the Galerie d'Apollon, he would wear himself out over two years in order to finish on time. He was to paint eleven lunettes that

179. The second floor of the Hôtel de Ville de Paris in 1842,
after the works of Etienne Godde and Lean-Baptiste Lesueur

The orientation is east-west. On either side of the Galerie des Fêtes (top center)
are (left) the Salon de la Paix, decorated by Delacroix, and (right) the Salon de
l'Empereur, decorated by Ingres.
From Victor Calliat, *Le Nouvel Hôtel de Ville de Paris* (Paris, 1856)

would decorate the area above the cornice; a round central painting, about five meters in diameter, on the ceiling; and eight panels around it. All the elements would be painted on canvas in the studio (Delacroix would again use oil-and-wax-based paint), and then remounted on-site. The sketch for the middle ceiling painting was completed in February 1852. Delacroix, with the help of Andrieu and another assistant Louis Boulangé, then began the finished painting, which progressed rapidly, while working simultaneously on the lunettes. In September, he made what he thought would be a final push before the compositions were set in place and he had made the inevitable on-site retouchings, without which he believed no decorative work could be considered finished. No one was allowed to enter, beginning with the prefect, who was turned away by Haro, standing guard.[54] He was immediately satisfied by the overall effect: "All my calculations relative to the proportion and grace of the overall composition are accurate, and I am delighted with this part of the work. The dark areas that are due to the room itself, and so were to be expected to this degree, will, I hope, be easily corrected."[55] In his own words, however, the task was "gigantic."[56] He had miscalculated the amount of light in the room and was therefore obliged to rework the tonality of all the compositions. The proportions of certain figures seemed intolerable to him.[57] His disappoint-

ment was considerable: "The room in which my paintings have been installed is the darkest imaginable: I had to do so much reworking on-site that the vexation of not being able to finish on time and of my excessive efforts have made me ill. . . . I have worked far too hard this year, the second in a row, and see what a difference time makes; ten years ago, I would have not only have eaten up this job, but I would have been on time. In one's youth, one is always sure of oneself; later on, you have to deal with rheumatism, or, rather, with inconstant fortune."[58] Discouraged as he was, and anxious to send something to the Salon of 1853, Delacroix was also delayed by the festivities in honor of the marriage of Napoleon III.[59] He did not resume work until June, and worked alone all that summer in discomfort and heat. In the autumn, Andrieu joined him, assisting him until the work was finally completed, in mid-February 1854. The retouchings were far from cosmetic: the Salon de la Paix was executed in two stages, with as much work being done on-site as had been done earlier in his studio. Yet, today there is really no way to tell, because we have only some sketches, preparatory drawings, and etchings made at the time, either after the works themselves, or after drawings by Andrieu. No contemporary photograph of the Salon de la Paix has turned up so far, though there are views of the Galerie des Fêtes and the Salon de l'Empereur that allow us to imagine the

180. Lunettes of the Salon de la Paix in the Hôtel de Ville de Paris

181. Central ceiling panel of the Salon de la Paix in the Hôtel de Ville de Paris

Etchings after Delacroix's compositions (destroyed by fire in 1871), executed after Pierre Andrieu's drawings and published in Marius Vachon, *L'Ancien Hôtel de Ville de Paris, 1533–1871* (Paris, 1882)

182. Ceiling panels of the Salon de la Paix in the Hôtel de Ville de Paris

Etchings by Sellier after Roguet's drawings, published in Victor Calliat, *L'Hôtel de Ville de Paris* (Paris, 1856)

richness of the decoration into which Delacroix's compositions were incorporated. The orientation of the ceiling and the arrangement of the panels and lunettes are still a matter of conjecture, as is the ornamentation of the room.

The iconographic program must have represented a compromise between Delacroix and the administration authorities, but we cannot assign their respective contributions. The middle of the ceiling was occupied by a large allegory, *Peace Descends to Earth*, which we can visualize, thanks to the sketch and etchings of the period (figs. 181, 182, 183). "The subject of the main ceiling is the earth weeping, raising her eyes to heaven to plead for an end to her sorrows. Indeed, Cybele, the august mother, has sometimes very wicked sons, who bloody her robe and cover her with smoking ruins; but the time of trial is over; a soldier stamps out the torch of the fire with his iron heel; groups of relatives and pairs of friends separated by civil discord find one another and embrace; others, less fortunate, piously gather the piteous victims. Above, in an azure sky gilded with light, out of which clouds race, the last traces of the tempest swept away by a powerful gust, Peace appears, serene and radiant, restoring abundance and the sacred choir of the Muses, no longer fugitives; Ceres, crowned with heads of grain and leaning on her golden sheaf, nevermore to be

183. *Peace Descends to Earth*, 1852
Sketch for the ceiling of the Salon de la Paix in the Hôtel de Ville de Paris
Oil on canvas, 77.7 cm diameter
Musée Carnavalet, Paris

184. *Hercules Rescues Hesione*, 1852
Sketch for one of the lunettes of the Salon de la Paix in the
Hôtel de Ville de Paris, which was destroyed by fire in 1871
Oil on canvas, 24.5 × 47.5 cm
Ordrupgaard Samlingen, Ordrupgaard

trampled by the brazen hooves of warhorses, rejects ruthless Mars and the pygmies who rejoice in public calamities; Discord, wounded by this luminous tranquility, flees like a nocturnal bird surprised by daylight and seeks to hide in the shadows of the abyss, while from his throne on high, Jupiter, with the same gesture with which he blasted the Titans, threatens also the maleficent divinities who hate the peace of men."[60] The eight panels depict the beneficent divinities friendly to Peace: Ceres, Bacchus, Venus, Mercury (fig. 188), Neptune "calming the waves raised by the recent storm" (fig. 186), Minerva (fig. 187), Clio (fig. 185), and Mars enchained. Finally, "eleven subjects, drawn from the life of Hercules, form a kind of frieze around the room that is interrupted by the window bays and the chimney's monumental height [fig. 180]. Rather than chronological order, the compositions obey the conventions of juxtaposition and contrast: Hercules, exposed after his birth, is collected by Minerva, who takes him to Juno. When the sturdy baby takes the goddess's breast, the Milky Way spurts out. Farther on, he brings Alcestis back from the Underworld and returns her to Admetus, her husband; he kills the Centaur, one of the last of the monstrous creations; he enchains Nereus, god of the Sea, to force him to reveal the secrets of the future; he secures the girdle of Hippolyta, queen of the Amazons—an easier triumph; he smothers Antaeus, despite the vain attempts of Earth, the Titan's mother, to help him; he rescues Hesione, daughter of Laomedon, exposed to be devoured by a sea monster, like Andromeda and Angelica [fig. 184]; he skins the Nemean lion so as to wear its pelt; he carries upon his robust shoulder the Erymanthian Boar, which he caught alive as it ran. In another frame, situated between Vice and Virtue, at that crossroads where life forks like Pythagoras's Y, he unhesitatingly follows the austere guide who leads to glory through travails and dangers. The last painting shows Hercules arrived at the ends of the earth and resting by the famous pillars, the boundary posts of the world, beyond which lies the green, immense Ocean, with its unknown solitudes." The decorative effect of the lunettes was successful, the relationship of the subjects to the theme developed in the ceiling, less so, at first glance, even though Gautier deemed it "as lively to the mind as to the eyes." In his view, Hercules was "the knight errant, the righter of wrongs in the world of legend; he subjugated the forces of disorder and rebellion, finished off the hybrid Chimera that survived the cataclysm of the floods, killed the bandits, and, placing his invincible muscles at the service of the weak, he prepared for the reign of Peace."

185. *Clio*, 1852
Oil on canvas, 19.5 × 37.3 cm
W. M. Brady & Co., New York

186. *Neptune Calms
the Waves*, 1852
Oil on canvas, 19.5 × 37.5 cm
Musée du Petit Palais, Paris

187. *Minerva*, 1852
Oil on canvas, 19.5 × 37.5 cm
Musée du Petit Palais, Paris

188. *Mercury*, 1852
Oil on canvas, 19.5 × 37.5 cm
Musée du Petit Palais, Paris

Sketches for the ceiling of
the Salon de la Paix in the
Hôtel de Ville de Paris, which
was destroyed by fire in 1871

189. *The Lamentation*, 1844
Oil and wax on plaster, 355 × 475 cm
Church of Saint-Denis-du-Saint-Sacrement, Paris

The overall tone of the decoration, which Delacroix lightened in the course of the execution, must have been especially vigorous, to judge by his remarks and sketches and Andrieu's preparatory works.[61] There were two reasons for this: insufficient light, and an opulent decoration with a great deal of gilt. According to Gautier, the new brilliance of the massive garland around the middle ceiling, for example, rather damaged the harmony. The blue background of the main composition was supposed to be echoed in that of the lunettes, whereas the figures on the ceiling panels apparently stood out against a darker background (see figs. 184–188). The coloring of each part must have been just as carefully adjusted: Clément de Ris especially admired *Hercules at Cadiz*, *Hercules Crushes Antaeus*, *Hercules and Alcestis*, *Hercules and Cacus*, and Gautier, *Bacchus*: "Among these figures, all of them well characterized and skillfully shaped, [Bacchus] is distinguished by the poetry of the colors: the blood of the bunch of grapes circulates like a divine purple in his beautiful body, sunken down beneath the vine branches; a pink half-tint flutters about him like the reflection of a crystal cup filled with nectar and pierced by a ray of sunlight."[62] Delacroix himself recognized in the central panel "the true color harmony that reigns between the figures and the azure sky that serves as their background." He went on to say: "It is painted music, in which one picks out no single melody, but which pleases the eye with a series of chords as skilled as they are graceful."[63]

The critics were, if possible, even more of one mind in recognizing the worth of the Salon de la Paix. Clément de Ris, for example, expressed the general opinion when he wrote: "The great modern colorist has never shown himself more full of youth, life, strength, and power, with a nobler artistic sentiment, a more complete understanding of decoration as it was understood by his forebears, the painters of Venice and Antwerp. The ceiling of the Galerie d'Apollon, which had set the seal on M. Delacroix's glory, now has a no less worthy pendant."[64] His success was all the more brilliant because

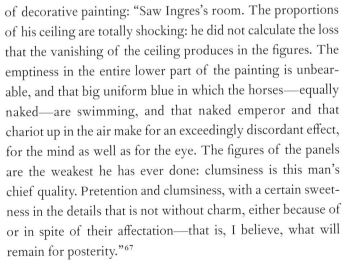

190. Chapelle des Saints-Anges,
Church of Saint-Sulpice, Paris

Delacroix here was in direct competition with Ingres. The latter had painted only the ceiling of the Salon de l'Empereur (which suggests that Delacroix painted the lunettes of the Salon de la Paix on his own initiative, as he did the frieze of the Salon du Roi, and for similar reasons).[65] Like the Louvre's *Apotheosis of Homer*—but unlike Delacroix's *Peace Descends to Earth*—Ingres's *Apotheosis of Napoleon* failed to take into account the painting's final placement. The emperor on his chariot stood out like a cameo against a uniform blue background. The canvas was surrounded by works representing the most important cities conquered by Napoleon, executed by his pupils from their master's drawings. The two rooms could not have been more different, and the critics who launched into the inevitable comparison between the two masters had to emphasize how difficult, if not impossible, it was to do so, since the two artists had followed opposite systems. They praised them both equally,[66] a preview of the judgment made a year later, when they both exhibited at the 1855 Exposition Universelle. Delacroix's comments on the subject are perhaps more interesting, implicitly revealing, as they do, the goals he had pursued and how he had thought about the problem of decorative painting: "Saw Ingres's room. The proportions of his ceiling are totally shocking: he did not calculate the loss that the vanishing of the ceiling produces in the figures. The emptiness in the entire lower part of the painting is unbearable, and that big uniform blue in which the horses—equally naked—are swimming, and that naked emperor and that chariot up in the air make for an exceedingly discordant effect, for the mind as well as for the eye. The figures of the panels are the weakest he has ever done: clumsiness is this man's chief quality. Pretention and clumsiness, with a certain sweetness in the details that is not without charm, either because of or in spite of their affectation—that is, I believe, what will remain for posterity."[67]

In the return to monumental painting that took place during Louis-Philippe's reign, Delacroix was unique both in his

aesthetic choices and in the purpose of his works: practically all his works were intended for public buildings; he thus found himself excluded from one of the great enterprises of the time, the decoration of religious buildings. The Chapelle des Saints-Anges in Saint-Sulpice occupies a very special place in his career: it was the last of his efforts of this kind, and one of his final works; because he threw all his energy into it, it took on the value of a testament. It is not exceptional iconographically, however: Delacroix had been painting religious subjects since *The Virgin of the Harvest* (fig. 37) and *The Virgin of the Sacred Heart* (fig. 38).[68] Nor was it really a first, since in 1843–44 he had executed a very large mural for the church of Saint-Denis-du-Saint-Sacrement in the Marais in Paris.[69]

He received this commission from the prefect of the Seine, Claude-Philibert, comte de Rambuteau, in June 1840, when he was in the middle of his work at the Luxembourg and the Palais-Bourbon. The commission had been intended originally for the painter Joseph Nicolas Robert-Fleury, who "not feeling inclined to do it," had proposed his friend Delacroix to take his place. Varcollier, head of the fine arts division at the prefecture, who was not yet "tamed" to painting, "disdainfully consented," while the prefect, no admirer of Delacroix, made difficulties about it.[70] The site was unpromising. Saint-Denis-du-Saint-Sacrement, a neo-Greek church built from plans by Godde and completed in 1835, comprises a nave and two aisles, with neither transept nor side chapels. A chapel at either end of each aisle is lit by a large side bay. The murals were to fill the upper half of the walls, above the altars. Delacroix was assigned the Chapelle de la Vierge, on the right aisle, adjoining the chancel, and after several attempts, decided on *The Lamentation* (fig. 189). It was more than two years before he set to work in earnest, submitting his sketch to Varcollier in February 1843. At that time, he traded sites with Joseph Désiré Court, the painter commissioned to do the Chapelle Saint Geneviève, at the other end of the aisle; this meant reversing the composition because of the change in lighting. The reasons for the change are still unclear: the priest, preferring a more pleasant subject near the chancel, may have been responsible. After the wall was prepared, Lassalle-Bordes was given charge of the grisaille, while the painting was done in oil and wax, but in a gold frame, thus creating the illusion of a painting hung on the line. *The Lamentation* was finished in six months, but when it came time for the public viewing,

Delacroix was dissatisfied: "When I finished, I resolved to show it in its newness to a few people. . . . I was away briefly, the scaffolding and partition were taken down because of a misunderstanding, and so the painting suddenly fell into the public eye. For my part, I was so dissatisfied with the effect, because the chapel is so dim, that I resolved to abandon it to its fate just as it was. But since you wish to see it, take your kindness further and go see it only when the weather is somewhat clear and in the morning. That is your only chance of seeing it."[71]

According to Planet, Delacroix spared no experiment with color in his attempts to brighten the composition, but despite his efforts he was unable to achieve the results he had attained in his other monumental paintings, and it would only be the advent of electric lighting that would do him justice. The critics' reception was rather favorable (except for a heinous—and anonymous—article in the *Journal des Artistes*, a publication that opposed the Romantic painters on principle): swayed by the composition's originality, with the Virgin's arms outstretched as if on a cross (inspired by Rosso Fiorentino); its monumentality; the expressive vigor of the colors, which suffuse a scene of grief with sorrow and melancholy; the humanity of the protagonists; and its realism, as well as the poetry it exudes, they were all aware that, with it, Delacroix was introducing something new to religious iconography. "E. Delacroix is universal," Baudelaire would write some time later. "He has done genre paintings full of intimacy, and history paintings full of grandeur. He alone, perhaps, in our skeptical century, has conceived religious paintings that were neither empty nor cold, like competition paintings, nor pedantic, mystical, or neo-Christian, like those by all those philosophers of art who turn religion into a show of archaic lore, and believe that unless they know every primitive symbol and tradition, they cannot play the religious note and make it sing. It is easily understood, if only one considers that Delacroix is, like all the great masters, a wonderful mixture of knowledge—that is, a complete painter—and naïveté—that is, a complete man."[72]

Despite its success, this experiment, which broke with so many deep-rooted traditions and habits, might have remained one of a kind. As we have seen, there had been a possibility, in 1847, of commissioning Delacroix to do the transepts of Saint-Sulpice, but nothing came of it. Two years later, political circumstances had changed and were now in his favor.[73]

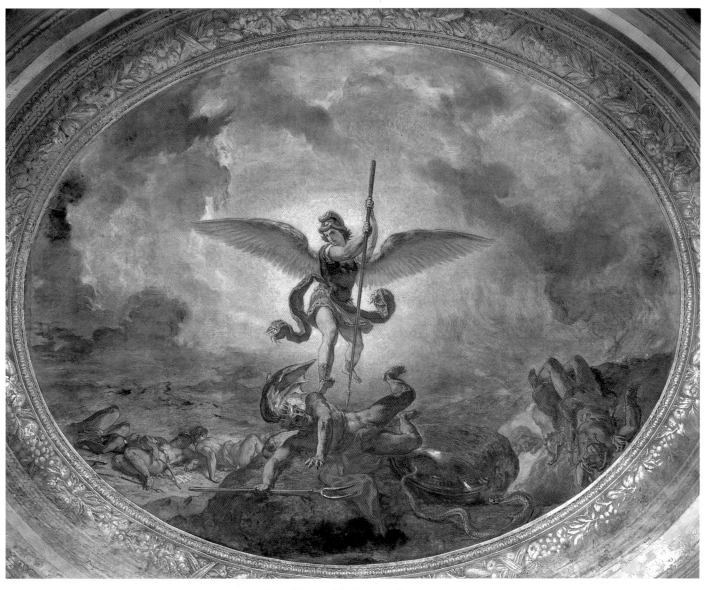

191. *Saint Michael Defeats the Devil*, 1856–61
Vault of the Chapelle des Saints-Anges. Oil and wax on canvas attached to the vault, 441 × 575 cm
Church of Saint-Sulpice, Paris

One of his friends, the critic Charles Blanc, brother of the republican Louis Blanc, had been named director of fine arts at the Ministry of the Interior, following the February Revolution. He supported the painter's application, and in April 1849 Delacroix was commissioned to decorate one of the side chapels, the first on the right after the main portal (fig. 190).[74] Administrative vagueness had led Delacroix to believe he was assigned the chapel with the baptismal fonts (on the left, below the north spire); he began work on his subjects with that in mind, but had to abandon his initial program when he realized that his was the Chapelle des Saints-Anges. He had to decorate a very flattened cupola, four pendentives, and two large, facing panels. For once, the lighting did not pose any particular problem, coming in, as it did, from the south through a large window left clear, and from the north, indirectly from the higher reaches of the nave. Delacroix, seconded by the ecclesiastical authorities, elected to depict, on the ceiling, *Saint Michael Defeats the Devil* (fig. 191); in the pendentives, in grisaille, four angels bearing symbolic objects as described in the Apocalypse (a palm and a votive flame, a harp, a censer, and the Book of Life); and, on the two panels, *Heliodorus Driven from the Temple* (fig. 193) and *Jacob Wrestling with the Angel* (fig. 192). The first episode is from the third chapter of the Second Book of Maccabees: Seleucus IV Philopator wants to seize the riches in the Temple of Jerusalem and sends Heliodorus to do the deed. "Having presented himself with his guards to take the treasure away, he is suddenly knocked down by an unknown horseman: at the same time, two heavenly messengers throw themselves upon him, and beat him furiously with rods, until he is cast out of the sacred precinct."[75] At the top of the stairs are the high priest Onias and other Jews, terrified by the sacrilege and its punishment. The story of Jacob and the Angel is recounted in Genesis:[76] "Jacob accompanied the flocks and other gifts with which he hoped to assuage the anger of his brother Esau. A stranger appeared to him, stopping him and starting a bitter quarrel with him, which ended only when Jacob, touched on the tendon of his thigh by his adversary, was reduced to helplessness. This struggle is seen by the holy books as symbolizing the trials that God sometimes sends his chosen ones."

The drawn and painted sketches (which also served to obtain his clients' approval) were done fairly quickly, before the summer of 1850, but the execution on-site (again, in oil and wax and directly on the wall, except for the ceiling, which was to be on remounted canvas) was delayed by the works underway at the Louvre and then at the Hôtel de Ville. The four pendentives were drafted in April 1852, but the bulk of the work was not begun until June 1854. Delacroix, who had been enthusiastic at the beginning, gradually came to have second thoughts, and started everything over in the summer of 1855, which did not prevent him from noting, in March 1856: "Disappointment. I insisted on working too long last year. I did too much of it from a mistaken premise."[77] Assisted by Andrieu and Boulangé (responsible for the painted ornamentation), he nevertheless made progress on all the panels at once. His health problems forced him to interrupt work for more than eighteen months, until mid-1858, when he returned to the job, making as much of an all-out effort as his strength would allow, until it was finished, in July–August 1861. His rhythm here was the same as in most of his other large monumental projects: the original idea took shape quickly, as the compositions were defined and the sketches prepared, but the execution itself, in fits and starts, delayed either by other undertakings or by health problems, took longer. "A few years ago, I was not frightened by these efforts; I have a wonderful enthusiasm, more perhaps than what I used to bring to them, but I have to contend more with tiredness," he confided to his cousin Auguste Lamey in June 1860.[78] The Delacroix of Saint-Sulpice was a man who, beginning to feel his age and increasingly weakened by illness, required long periods of rest. In the last years of his life, he was obsessed with completing the Chapelle des Saints-Anges: he worked on it exclusively whenever he had the material and physical resources, and organized his life around it. His return to the Left Bank, to the rue de Fürstenberg, for example, was principally motivated by his need to be closer to this privileged work site. In order to rest, at the end of the summer of 1860, he was obliged to live in Champrosay, where he maintained a monklike discipline—he would later speak of "a carriage-horse backbreaker,"[79] "living out of the world," and "galley-slave work"[80]—he rose at five-thirty in order to catch the first train, was at the chapel for four hours in the morning, and returned during the day, "trying not to stay too long at work, despite the tremendous enthusiasm I have for it"; once back home, a little outdoor exercise, supper, and early to bed.[81] Other times, he was barely able to direct Andrieu's brush.[82] His correspondence and his journal attest

to this determination to finish, especially noticeable in the last years, after his illness of 1856–57, a determination that came from his deepest self: the deliberate choice made by a painter who gives himself utterly to the work. "I began this year by working on my church project as usual; the only visits I made were by calling-card, which do not disturb me at all, and I worked all day long; what a happy life! What a heavenly reward for my so-called isolation! . . . To tell the truth, painting worries me and torments me in a thousand ways, like the most demanding mistress; for four months, I have been flying at first light, and I run to this thrilling work, as if to the feet of the most cherished mistress; what from a distance looked easy to overcome presents horrible, incessant difficulties. But how is it that this eternal battle, rather than getting me down, picks me up, rather than discouraging me, consoles me and fills my moments when I have left it? What a happy reward for what the best years took with them; noble instant of the capacities of the old age that already besieges me on every side, yet allows me enough strength to overcome the pains of the body and the afflictions of the soul!"[83]

This continual and very personal struggle, too easily symbolized by Jacob's own, and the fact that this was also one of Delacroix's last important works, have led modern critics to interpret the chapel, and *Jacob Wrestling with the Angel* in particular, as a spiritual and artistic testament, and as a synthesis of his career. Barrès's famous words attest to this,[84] representing an entire historiographical current that has continued to the present day:[85] "Crowning autobiographical page, summary of the experience of a great life, deathbed testament inscribed by this aging artist on the wall of the Angels. It is full of that Church music and luminous harmony wherein, late in life, a true man brings his entire life together. . . . Taking *page* in its broadest meaning, is this mural-testament to genius not the concrete response to the counsel of the Father of the Church to the artist, to the writer, as much as to the scholar? . . . when your face bows in death, let it fall upon a noble page." This was not, however, his contemporaries' interpretation, and it should be noted further on this subject that those critics favorable to Delacroix tended to prefer *Heliodorus* to *Jacob Wrestling with the Angel*. The debate centered around his iconographic choices as much as on any purely aesthetic questions. There was no lack of references, especially in the cases of *Saint Michael* and *Heliodorus,* subjects that Raphael had treated in

one of the Louvre's most famous paintings and in one of the Vatican stanze. Delacroix had been able to free himself in *Heliodorus,* less so in *Saint Michael,* which the critics—with the notable exception of Gautier—considered quite weak, and which received less attention than the two large mural panels. The layout of the chapel, in fact, particularly emphasizes the latter, while visitors are not drawn directly to look at the vault. In the end, the decorative unity depends essentially upon these, far more than on the compositions taken as a whole.

Various sources besides Raphael have been proposed, more or less persuasively:[86] Jean Duvet's engraving of the Apocalypse, published in 1561 and known to have been consulted by Delacroix in the earliest planning stage;[87] various other old prints; a bronze bas-relief panel in the Church of Monte Sant'Angelo, in Gargano, Italy, known from an etching;[88] Titian's *Death of Saint Peter Martyr,* of which Delacroix owned a copy made by Géricault, for *Jacob Wrestling with the Angel;* various books on Persia, Turkey, and Palestine, archaeological travels and studies for the *Heliodorus* decoration. But the references remain secondary, unlike in his *Saint Michael,* which is too obviously inspired by Raphael, a model from whom, for once, Delacroix could not or would not free himself. His originality is evident on several levels, principally, and quite subtly, in the relationship between the two panels, which are comparable in overall theme but opposite in subject: the one, an exterior scene taking place in a vast landscape, in natural light, in the dawn's gloaming; the other, a violent chiaroscuro inside a building, where he contrived several areas of light—behind Onias, at the top of the stairs, and just below the landing; on the one hand, nature, the life of caravans and flocks, water, mountains, and trees; on the other, the city, the opulence of the architecture, the costumes, and the Temple treasure spilled over the steps. Finally, in *Jacob Wrestling with the Angel,* the scene is reduced to two characters, aside from Jacob's servants, who are merely extras. There are more than twenty figures in *Heliodorus,* five of them major: the angels, Heliodorus, and Onias. This painting also differs from the much more simply arranged *Jacob* in the complexity of its composition (partly repeating that of *The Execution of the Doge Marino Faliero* [fig. 49]),[89] with its many instances of foreshortening. Yet there are connections: the trees, in a way, correspond to the column, as do the pile of arms and clothing to the precious objects opposite, and though the general

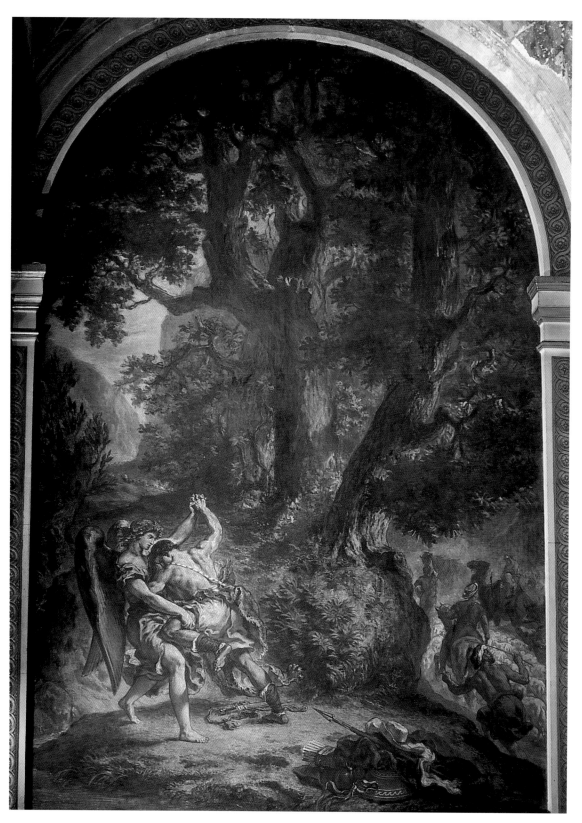

192. *Jacob Wrestling with the Angel*, 1855?–61
Oil and wax on plaster, 751 × 485 cm
Church of Saint-Sulpice, Paris

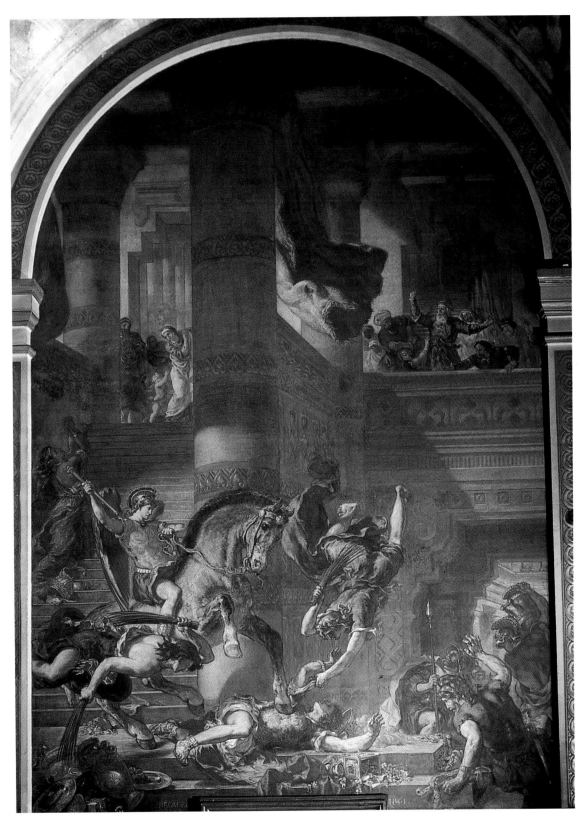

193. *Heliodorus Driven from the Temple*, 1861
Oil and wax on plaster, 75 × 485 cm
Church of Saint-Sulpice, Paris

tonality of each is different, the colors are equally rich and varied in both.

The colors have been a particular object of study, both by Delacroix's contemporaries and after his death.[90] Delacroix's talent as a colorist was virtually a cliché in the reviews of his time, which naturally pointed out the degree to which *Heliodorus* and, to a lesser extent, *Jacob* exhibited the master's recognized ability in this area: "Light everywhere, even in the shadows, the darkness brightened, to reverse the terms of chiaroscuro, delightful local color."[91] This analysis was later taken much further, beginning with Paul Signac, who contrived to explicate Delacroix's handling of color: he would have reached his maturity precisely in Saint-Sulpice, practicing at that time the divisionism of pure color in his technique of "flochetage."[92] However correct this theory may be in part, a close, detailed study of the painting is enough to prove that it goes too far. The same is true of another series of analyses, based upon Andrieu's recollections in particular,[93] which held that Delacroix applied his theory of complementary colors systematically: "In combining his palette, Delacroix intended to derive, from the mixture of adjacent colors, neutral tones with which the brighter colors would harmonize. He always contrasted light and shadow, the half-tint and its reflection. Example: *violet* shadow, *yellow* highlight; *red* local color, *blue-gray* half-tint, taking his cue from the local color, situated between the half-tint and the highlight, the local color that would throw everything off if it were not exactly right." It is quite true that Delacroix painted specific areas and details of his panels this way, and this was immediately given as proof. But this practice was far from being as systematic as some claimed, and the same is true of his use of flochetage, which is itself contradicted by the brushwork, which is very obvious in some places, as in the foreground in *Jacob* or the highlights on the jewels and gold in *Heliodorus*. However true in part, these various analyses do not jibe with what we know of his working method, which was reasoned and rational, but also impulsive, passionate, and instinctual.

Rather, it is the iconographic treatment of their subjects that perhaps makes the two major compositions in Saint-Sulpice unique, and suggests something about Delacroix's originality in the realm of religious painting. *Heliodorus* seems to belong with his earlier works, and, more broadly, with those of the Old Masters, especially the Venetians, as was im-

mediately obvious to his contemporaries. Although *Heliodorus* is more personal than many other efforts of the period, in the end, it is closer to them than the far more unusual *Jacob*. As Thoré noted: "There are only two figures, life-size and enlaced in a group that statuary could reproduce. The caravan is inconsequential and is but an accessory, drowning in the river in the gully. The landscape predominates, and M. Delacroix, who is a landscapist of rare ability, has also taken pleasure in painting one of the greatest pieces of nature that anyone of any school has ever dared do."[94] The composition also pivots around the clump of trees in the middle (as that of *Heliodorus* does around the column), a formal echo of the struggle between Jacob and the Angel, and an iteration of studies Delacroix made in the woods at Sénart.[95] The religious theme recedes before the simple, realistic depiction of nature, and the dust of the caravan winding into the distance. There is a boldness that sets Delacroix apart from his contemporaries, a Delacroix who is outside all the theoretical discussions informing the decorative religious painting then undergoing a significant rebirth, a Delacroix equally far from those who claimed to rediscover the fervor of ancient times by imitating medieval and Renaissance models.[96] He disassociated himself from them by the very relationship of his compositions to the architecture: they fill the frame assigned to them, neither referring to nor inspired by any tradition, and this gives them a startlingly modern look, resulting from more than the vigorous brushwork. This boldness was understood by some, violently opposed by others (the discussions about the Saint-Sulpice paintings were more heated than those about any other of Delacroix's monumental paintings). How important was any of this to the painter? Here is his assessment of the opening of the chapel: "Neither the minister nor the prefect visited me, nor Nieuwerkerke, nor anyone from court nor other persons of rank, despite my invitations. As for the 'Institute people,' very few came; on the other hand, many artists came. It is true that not many people were in Paris. All in all, I'm happy; everyone assured me that I was not yet dead."[97]

When Delacroix began the Salon du Roi, he was in his mid-thirties. When the Chapelle des Saints-Anges was completed, he was over sixty. In 1833, monumental and decorative painting was just beginning to be revived in France. Around 1860, it was once again a specific genre and practice within history painting.[98] At the end of the Restoration, the only

recent works that could be cited were the ceilings in the Louvre, where *The Apotheosis of Homer* shone most brilliantly; those in the Bourse (grisailles by Abel de Pujol); and Gros's cupola in the Pantheon (evidently Girodet's paintings in Compiègne were not as well known as they deserved to be). The situation was very different at the beginning of the Second Empire, when a great number of public buildings, both civil and religious, were decorated with frescoes or mural paintings, some of which became as well known as the great Salon paintings that had hitherto established the reputations of artists. Among these were Delaroche's half-dome in the Ecole des Beaux-Arts, Chassériau's staircase in the Cour des Comptes, Périn and Orsel's works in Notre-Dame-de-Lorette, Flandrin's in Saint-Germain-des-Prés—and all of Delacroix's. The fact that he produced such works regularly, beginning in 1833, ought not obscure either his own development or the parallel development of his contemporaries. Delacroix was part of a more general European movement, within which he proved himself to be one of the most active of the French painters. Ingres, the perpetual rival with whom he was always compared, could have entered this company only with *The Apotheosis of Homer*, the ceiling of the Salon de l'Empereur in the Louvre, and his unfinished *Golden Age* at Dampierre—his pupils, however, defined one of the prevailing currents of monumental painting. Delacroix never trained a school, and his first creations, in the Palais-Bourbon and the Palais du Luxembourg which might have been very influential in that way, were not easily accessible to the public after their inauguration. By the time he finished *Apollo Slays Python*, the situation was even more immutable. Too, he kept himself apart from the theoretical discussions on the subject that were stirring up the artistic circles of the time. In the end, he remained alone and isolated, recognized but without any real influence, a situation all the more curious in that he was one of the few who deliberately situated himself within the continuum of the French tradition of decorative painting, illustrated most notably by Le Brun. Indeed, regardless of the circumstances of each commission, the layout of the site, the definition of the program, and the difficulties of execution, he consistently followed the few simple principles that had governed works at Fontainebleau, Paris, and Versailles in the sixteenth and seventeenth centuries: the painting must suit, serve, and enhance the architecture, and reveal the dynamics of the space into which it is intimately incorporated. In this, his gifts, especially for color, served him well. But painted decoration, by virtue of its subject matter, brings in an additional dimension as well: that of the mind. Delacroix never abdicated his painterly qualities in his monumental works: by the nobility of his themes, and the ideas he developed within them, those works easily sustain comparison with his easel paintings. Combining as they do the "feast for the eye" and the satisfaction of the intelligence, they number among his major works.

1833–63:
Thirty Years in the
Public Eye

After his return from Morocco, Delacroix concentrated mainly on the large decorative projects, but the general public still identified him only with his submissions to the Salons. This can be explained in part by the brief period during which visitors were allowed in to see his work at the Palais-Bourbon and the Palais du Luxembourg—which constituted most of his output during the July Monarchy. After this brief period, and because no engravings were made of these paintings, the works may as well have disappeared, surviving solely in the writings of critics. The case of his *Lamentation* (fig. 189) in Saint-Denis-du-Saint-Sacrement was somewhat different, but that work was more like a framed, wall-hung painting, without the scope of either the Salon du Roi or the libraries of the Palais-Bourbon and the Palais du Luxembourg. Both *Apollo Slays Python* and the compositions of Saint-Sulpice were late works, and so did not radically change the image people had of Delacroix during his lifetime. This image remained defined by his public exhibitions, that is, essentially, by his submissions to the Salons, in which he participated fairly regularly until 1859. Moreover, the sequence of his submissions lacked the logic of his earlier years: Delacroix seems to have worked on them intermittently, whenever the decorative projects, which continued to be his priority, allowed him to. His health, which was becoming increasingly delicate, must be taken into account, too, and this at times slowed his activity considerably, especially after his serious laryngitis of April 1842, which caused his absence from the Salon in 1842, 1843, and 1844, and again, during the Empire, in 1852 and 1857. Otherwise, he was always represented there until 1859, sometimes by an extensive submission of small- and medium-format works. What is most surprising is that he found the time and energy to continue painting large canvases for the Salon, the last being *The Lion Hunt* of 1855—certainly because he knew that was where his audience was, and where in the end his reputation was made. Although painted for the occasion, his submissions, whether organized around one large painting or made up of a group of smaller paintings, nevertheless exhibit a marked internal cohesiveness. They reflect the temporary directions of his work, as well as demonstrating in a more ongoing way the variety of genres of which he was capable.

In 1833, Delacroix presented *Charles V at the Monastery of Yuste*, and with it only three Moroccan watercolors and three portraits, *Count Charles de Mornay and Count Anatole Demidoff*, *Doctor François-Marie Desmaisons*, and one of Auguste Petit de Beauverger, a Goubaux portrait.[1] The Moroccan subjects made their true debut the following year, with *Women of Algiers in Their Apartment*, which was flanked by *A Street in Meknès* and major works that exemplified his production of the preceding years, *The Battle of Nancy*, *Interior of a Dominican Convent in Madrid*, and *Rabelais*.[2] His submission of 1835 was even more eclectic: a religious painting, *Christ on the Cross;* two literary subjects, one from Chateaubriand, *The Natchez*, and one from Byron, *The Prisoner of Chillon;* along with *Arabs of Oran* and his portrait of Félix Guillemardet.[3] With *The Prisoner of Chillon* (fig. 194), Delacroix was continuing in his Romantic vein. Byron, in the eponymous poem, had been inspired by a real person, François Bonnivard of Geneva, who in the sixteenth century had opposed the bishop of Geneva and the duke of Savoy; the latter imprisoned Bonnivard for six years in the Château de Chillon, on the banks of Lake Geneva. In his poem, Byron compared Bonnivard, a symbol of republican freedom, with the celebrated Ugolino. He describes him as locked up in his cell with his two young brothers, whom he helplessly watches waste away and die. In any case, the public seems to have connected Delacroix's painting only with the poem, without reading any political significance into it. The painter selected the moment, corresponding to Byron's eighth canto, when only one of Bonnivard's brothers is still alive; the other is buried in the castle keep. Since there is no latitude for picturesque effects, such as those allowed by poems like *The Giaour*, the expressiveness depends essentially upon plastic means reduced to a limited palette, since the scene is set in a dark place. Delacroix, whose visible and very energetic brushstroke is itself a transposition from Byron's text, concentrated on the figure of Bonnivard pulling desperately on his chain, and on his reaching arm, which stretches the body and leg in a gesture both impotent and passionate, and which, in his raised hand, also says something about brotherly love. Some understood the implication, others did not. Critics reached opposite conclusions about the relationship between the image and the original text: "M. Delacroix was not afraid to attempt the translation of this intimate, complex scene by using a single face. He tried to render all, and rendered little," wrote Henri Trianon,[4] for example. On the other hand, *L'Artiste*, always favorable to Delacroix, recalled Byron's poem, then concluded: "M. Eugène Delacroix, too, an easily impressionable soul,

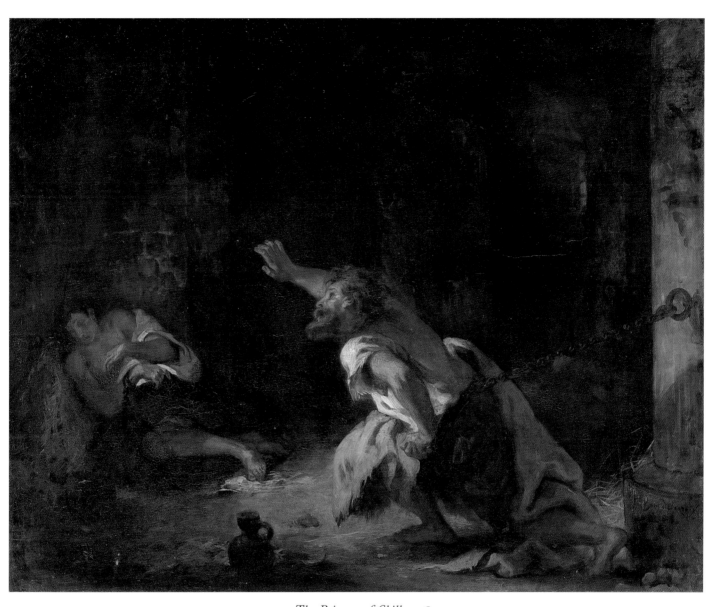

194. *The Prisoner of Chillon*, 1834
Exhibited at the Salon of 1835. Oil on canvas, 73.4 × 92.4 cm
Musée du Louvre, Paris

becomes readily impassioned by poets' verses; he listens to them and understands them, and, having understood them, imagines that he can toss them, still living and as he sees them, onto the canvas.... One has but to reread the poem to see how little the poet left for the painter to invent. . . . And that is M. Eugène Delacroix's painting, in a word. Lord Byron drew it, M. Eugène Delacroix added the color. It is a good drawing, for a poet's drawing, but the colors are indubitably those of a good painter. M. Delacroix understood and rendered every detail of these beautiful verses. The figure of the wretched man who tries to lunge toward his brother and stretches his body to break his chain, is typical of Byron's energy. Indeed, nothing from Byron is missing from this painting, neither the Gothic pillars, nor the chain attached to the iron ring, nor the straying ray of light that casts its sorrowful color on the black and massive columns. The painting is complete; it is unquestionably a great and fine work."[5] It is worth mentioning that the painting had been purchased before the Salon, by the heir to the throne, the duc d'Orléans, who supported the younger artists as well as the more established ones, and so counted the Romantics among his protégés.[6] The Salon brochure mentioned the canvas's owner; for Delacroix, it was one more prestigious acknowledgment. As for *The Prisoner of Chillon*, inscribed as it was in the line of his previous works, it was hardly a surprise. *Christ on the Cross* (fig. 196), the first religious painting exhibited by the artist since *The Agony in the Garden* (fig. 47) in the Salon of 1827, was a different case. At first it was hung badly, then, benefiting from better exhibition conditions, the very large picture was generally well received, despite the usual remarks about Delacroix's faulty drawing and the work's overly sketchy quality. "I would have qualms about passing over *Christ on the Cross* in silence," wrote Pillet in *Le Moniteur Universel*. "The first glance is unkind to this painting, or rather this draft, although it is more advanced than other productions by its author. . . . At first, I saw only the crude blues and reds, much too intense for colors that the dark clouds in the sky should have both muted and harmonized.... I was shocked by the gross inaccuracy of several figures. . . . Yet, returning to this work of Delacroix's, I congratulated myself on not having given way to my initial prejudice. . . . I recognized an extremely touching intention in the Mary and Saint John group, that episode moved me deeply; I was happy to discover in the composition as a whole that unity of action and

interest that some Romantics decry."[7] *Christ on the Cross* is chiefly interesting in retrospect: with this painting, Delacroix finally returned to the religious subjects that he had rarely treated earlier, in fact almost totally ignored after *The Agony in the Garden*. From this standpoint, the 1835 Salon painting of the Crucifixion is of paramount importance—although the public of the time could not be expected to foresee later developments on the basis of this one painting. The Minister of the Interior purchased *Christ on the Cross* immediately after the Salon, at the request of Vigier, the deputy from Morbihan, who asked for grants from the State after every exhibition, and the painting was sent to Vannes.

With the notable exception of *Women of Algiers*, no one painting really stands out from the groups that Delacroix presented between 1833 and 1835, when he seemed to be in a rut. As the anonymous critic of *Le Constitutionnel* remarked about the Salon of 1835: "M. Delacroix has long excited lively admiration and lively antipathies; it must be noted that today the admiration is cooling, while those antipathies are subsiding into a kind of indifference. Why is this? It is probably because his supporters are losing patience after so often going into raptures based on hopes that every year defers, contemplating some worthy pieces of talent that refuse to progress and fill the gaps; because his detractors have become disarmed by the artist's inflexibility and immobility. . . . The three paintings that M. Delacroix gives us this year [the article discusses only *Christ on the Cross*, *The Prisoner of Chillon*, and *The Natchez*] seem done expressly to increase this twofold lassitude, on the part of adversaries and friends alike."[8]

Was Delacroix aware of these criticisms? Was he too absorbed by the Salon du Roi to produce more? Whatever the case, in 1836 and 1837, he exhibited only one painting each year, both of them large, however: *Saint Sebastian Tended by the Holy Women* in 1836[9] and *The Battle of Taillebourg* in 1837. With them, he was returning to the tradition of large Salon paintings, and both works indeed seemed perfect for the Salon: the first, which Delacroix had painted on his own initiative, was purchased by the State—as *The Barque of Dante*, *Scenes from the Massacres of Chios*, *Liberty Leading the People*, and *Christ on the Cross* had been—and was sent to the church in Nantua. Louis-Philippe had commissioned the second for the Galerie des Batailles at Versailles, where it was immediately sent.

The familiar subject of *Saint Sebastian Tended by the Holy Women* (fig. 195) required no special explanation. The Salon brochure simply pointed out the moment that Delacroix had chosen: "Following his martyrdom, the saint has been abandoned at the foot of a tree to which his tormentors tied him. As the soldiers move off, holy women prepare to do their pious duty by him. One pulls out the arrows that pierce him." Given a prominent position in the Salon Carré, the painting was very favorably received, largely because of the new direction it represented, as Gustave Planche elaborated: "M. Eugène Delacroix's *Saint Sebastian* will stymie much conjecturing. Those who have been following assiduously all the works undertaken and completed by this author for fourteen years will be surprised by this most recent transformation of an adventurous and innovative mind. While decorating a room in the Chambre des Députés—which we have not seen, but which, if we may believe [the word of] privileged witnesses, is unlike any of his previous works—M. Delacroix found the time to make a great religious painting. His tireless activity reveals the seriousness of his love for art. . . . This year's color obviously brings to mind Titian's use of color; last year's *Mary Magdalen at the Foot of the Cross* recalled Rubens; in 1834, *Women of Algiers* recalled Veronese. How does M. Delacroix, with tireless perseverance, manage imitation and originality at the same time? How does he reproduce by turns the Flemish and Venetian styles, while maintaining the individuality and ineffable stamp of his thought? Why is it that, among the Venetians, he sometimes chooses Veronese and sometimes Titian? Is it not his uncommon desire to do his work well? Are we not obliged to believe that M. Delacroix, sincere in each of his works, in good faith in each of the imaginative works he creates, is never complacent, but always seeking a new manner, as if what he had hitherto found was nothing? Is this not the natural conclusion that arises in the presence of this artist's works, so manifold and so diverse?"[10] In subject and style, Delacroix appeared to be returning to the great classical tradition (a viewpoint that might have had more substance if the jury had not rejected *Hamlet and Horatio in the Graveyard* [fig. 238]). Traces of his work in the Salon du Roi were perceived in these paintings, quite rightly, and *Saint Sebastian* is very like it in composition, colors, and its atmosphere of calm grandeur. The composition is very simple. The saint, in half-light, occupies the picture's foreground, behind him are the women, and, in the background, below but in full light, is the group of departing Roman soldiers. Each of the three main characters is captured in an either noble or cautious attitude, including the fainting Saint Sebastian, who has collapsed after his torture. The woman who tends him (nothing allows us to identify her specifically as Saint Irene, his sister) draws an arrow from his body with tender delicacy. Her companion, on the right, who conceals a jar of ointment in her mantle and turns to watch the soldiers, connects the two parts of the painting, the Christians and the pagans, shadow and light, the relatively muted range of colors in the foreground and the bolder colors in the middle ground: the red of her mantle alone goes with the browns and greens in the lower part and also emphasizes the contrasting blue-green of the sky, just as, in response, the saint's red mantle on the left does the same against the ground and the vegetation. The probable influence of Michelangelo and Rubens that was later pointed out (his contemporaries most often compared him to the Venetians, especially Titian) is less a matter of specific references to this sculpture or that painting than of the reserve that Delacroix derived from them. Nor did he deny himself a certain virtuosity, as in the foreshortened perspective of Saint Sebastian's body, for example, and the glinting light on the armor in the foreground, both of which establish a transition toward the viewer, an effect he would use in many compositions, up to and including *Jacob Wrestling with the Angel*. The face, half-lit and in profile, of the woman on the left recalls that of *Liberty*, and prefigures, more closely, his *Medea* of 1838. In general, Delacroix seems not to have been concerned with directly expressing any specific religious sentiment, which here is completely absent. His purely stylistic preoccupations, which are distinctly more evident, would seem to have destined the painting for a museum rather than for the church where it was sent. "The grace of gesture and movement, the grandeur of draftsmanship and style, and the inspiration of both invention and execution rank this figure with the most perfect offerings in this genre from the Italian schools of old," *L'Artiste* concluded, without worrying overmuch about any possible Christian meaning the picture might have.[11]

Having brought classicism to his *Saint Sebastian* and having enjoyed success shortly afterward with the finished Salon du Roi, Delacroix found himself in a new position. The Romantic painter appeared to have settled down, making him a

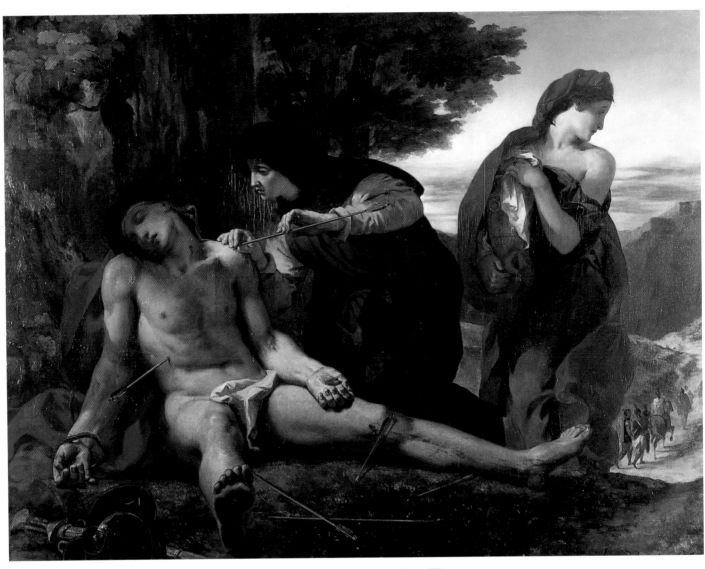

195. *Saint Sebastian Tended by the Holy Women*, 1836
Exhibited at the Salon of 1836. Oil on canvas, 215 × 280 cm
Church of Saint-Michel, Nantua

196. *Christ on the Cross*, 1835
Exhibited at the Salon of 1835. Oil on canvas, 182 × 135 cm
Musée de la Cohue, Vannes

197. Sketch for *The Battle of Taillebourg*, 1834–35
Oil on canvas, 53 × 66.5 cm
Musée du Louvre, Paris

logical candidate, in February 1837, for the Academy seat left vacant by Gérard's death. From this standpoint, the list of works he took "the liberty to ask the Academy to be so good as to recall" is very significant: *The Barque of Dante, Scenes from the Massacres of Chios, The Agony in the Garden, The Execution of the Doge Marino Faliero, Liberty Leading the People, Women of Algiers in their Apartment, Saint Sebastian Tended by the Holy Women,* and the paintings in the Salon du Roi in the Chambre des Députés.[12] Conspicuously, there are no Romantic works represented, neither *The Battle of Nancy, The Battle of Poitiers, The Murder of the Bishop of Liège,* nor, of course, *The Death of Sardanapalus.* Nevertheless, the Institute's antagonism was still alive and well, and in the end they elected Schnetz.

Delacroix returned to the Middle Ages with his submission to the next Salon, *The Battle of Taillebourg* (fig. 198), although it should be noted that he had received the commission to paint it in 1834 and made his sketch of the final composition that same year (fig. 197). He then had to adapt the dimensions of the work to its final placement (according to legend, the architect for the galerie, Fontaine, cut a sixty-five-centimeter band around the painting for this purpose after it was completed, but the story is incontrovertibly a fabrication), and worked on it until July 1836. "I have interrupted *The Battle* [of Taillebourg] for several reasons," he explained to

Villot at the time. "First, I was very glad to let my ideas rest, for fear of spoiling it, and then it is so dreadfully hot in my studio that it is almost impossible to work. I started *Medea,* which is coming along; we shall see."[13] Delacroix very probably went back to *Taillebourg* in the autumn of 1836, and labored on it until the opening of the Salon, in March 1837. But the information in his letter to Villot is of twofold interest: we ought not consider *Saint Sebastian, Taillebourg,* and *Medea* as a sequence, but rather as a group that the artist was gradually advancing simultaneously.

Taillebourg had been commissioned for Versailles's Galerie des Batailles, which epitomized the philosophy of the Musée de l'Histoire de France, created by Louis-Philippe.[14] The episode that Delacroix painted took place on 21 July 1242: "Driven by his fervor, King Saint Louis crosses the Taillebourg Bridge over the Charente, which is guarded by the English army. With almost no one behind him, he is dangerously engaged, having knocked over the first posted guards, who had tried to withstand his advance. The French, rushing after him, harm themselves by their very haste, and are hindered by the crowded conditions of the passage. Many of them swim across the river to come to the king's aid. Their efforts are at last crowned with success. Not only is the king freed, but he wins all the honors of this brilliant engagement, which has very

198. *The Battle of Taillebourg,* 1837
Exhibited at the Salon of 1837. Oil on canvas, 485 × 555 cm
Musée National du Château, Versailles

important consequences."[15] The subject, perfectly suited to the gallery, in which the history of France was narrated in a series of battles representing the country's evolution from its beginnings, was also quite new in the iconography of Saint Louis (for example, the subject had not been treated in the series of paintings on the monarch's life commissioned late in the reign of Louis XV for the chapel of the military school in Paris). The episode was familiar, appearing in chronicles of the period such as Joinville's, and in every history of France since then. The difficulty Delacroix faced lay more in the genre itself, and in the requirement that the painting fit within a group, than in any problems of historical accuracy (to which he was always particularly committed). A comparison with the sketch in the Louvre shows that Delacroix changed the composition significantly because of the architectural constraints of the gallery. The artist had originally imagined a more horizontal composition, and the bridge, on the right side of the painting, was more prominent, and Saint Louis was alighting on the riverbank. Obliged to cut the arch of the bridge, Delacroix organized his painting along a great diagonal axis, this time, in the direction of the bridge, but keeping the water of the river in the lower part of the picture. He thereby increased the painting's expressive power and set off Saint Louis better, but downplayed the relationship of river and bridge. The tighter frame around the figures (the surroundings are much more apparent in the sketch) is also due, at least in part, to the necessity that the different paintings in the gallery work together. Those commissioned by Louis-Philippe (the group also included older works) were exhibited together and hung in the Salon Carré. Delacroix's painting stood out from those of his confreres, which were more sober and orderly, not to mention more banal. "Extreme curiosity makes one stop in front of M. Delacroix's large painting . . . and already this composition, with its undeniable boldness and originality, has become the subject of lively controversy within the Salon itself," Pillet observed in *Le Moniteur*.[16] Delacroix's usual detractors, such as Delécluze, found the composition confused, identified errors of perspective and drawing, and lingered over details like the figure of Saint Louis, which Louis Viardot considered too effeminate.[17] Others, however, were enthusiastic about the painting itself, to begin with, but then also compared it with the other battles commissioned for Versailles: "What a difference between *The Battle of Taillebourg*

and all the others on the same line in the large room. Only M. Delacroix painted men fighting, the others just painted writhing mannequins."[18] Delacroix was obviously the right painter; the theme, masterfully treated and rendered, suited his temperament very well: "Once Eugène Delacroix has hurled himself into the arena, he cannot stop himself; he walks, runs, flies. Is there a battle? He is the first into the fray, where his swordstrokes are the greatest; he loves noise and movement; war cries, the groans of the dying, the whinnying of horses, the sound of the torrent washing away the corpses; that is his joy! No painter in the world identifies himself with the subject of his painting more than Eugène Delacroix: he behaves like a zealot, with a zealot's conviction, but also a zealot's violence. . . . Finally, a real battle! This time, people are fighting, killing each other, wounding each other, dying, winning: it is a terrifying jumble of swords, standards, horses, soldiers, captains, Frenchmen, and Englishmen."[19] Gustave Planche takes the same line, although his analysis is more rigorous: "M. Delacroix's *Battle of Taillebourg* is a very worthy work, and marks a new step forward in the artist's career. It is an immense machine, skillfully and vigorously driven; the composition is full of verve and ardor, those fighting attack each other and defend themselves, instead of looking at each other. There are blows struck and blood shed, horsemen unseated and trampled by the horses' hooves: it is a fine, true battle, one that no one today except M. Delacroix could paint. Nowhere has its creator more felicitously employed the eminent qualities that distinguish him; nowhere has he displayed more animation and energy. Each group taken singly awakens and captures one's attention, and the artist has been able to form a bloody fray of all the groups together. . . . It is a stunning page. The colors of this painting are brilliant and refined, and the tonality is flawless. The heads are as well done as the attitudes, and are rendered with scrupulous care. The artist obviously rejoiced in his work, his excitement growing as he went along. . . . *The Battle of Taillebourg*, we fear, will be the only battle in Versailles, the only one that will not recall Franconi's circus maneuvers."[20] Planche was quite correct in emphasizing the colors and Delacroix's artful arrangement of the groups. The viewer immediately identifies Saint Louis, in the middle of the composition, by the blue of his clothing, the white of his horse, and the red of the enemy he is trampling (an intentional tricolor?). The king is particularly highlighted, since two other

199. *The Finale of "Don Giovanni,"* 1824
Exhibited at the Salon of 1838. Oil on canvas, 55.9 × 45.7 cm
Private collection

areas of light color visually establish a diagonal: the white of
the rearing horse, in the upper right, and the gray-blue of the
fallen horse, in the lower left. Thus organized overall, the
scene develops through the details of each individual engage-
ment. *The Battle of Taillebourg*, the third and last medieval
battle that Delacroix ever painted, and the largest, iterates the
aesthetic qualities of *Nancy* and *Poitiers*, while at the same
time rendering the picturesque quality of a period and the epic
spirit of the story. Whereas *Saint Sebastian* signaled a notice-
able evolution in Delacroix's work, *Taillebourg* is closer to the
earlier paintings.

The Salon of 1838 marked a new phase; Delacroix's entries
that year were as numerous as they were important. The key
piece was *Medea about to Kill Her Children* (fig. 200), which
created a sensation; it evidenced antiquity as the artist's new
source of inspiration and a style that, like *Saint Sebastian*, dis-
played what Delacroix had learned in the Salon du Roi, now

finished: "I am grateful to M. Delacroix for having treated an
antique subject this year; not only is his *Medea* a beautiful and
important work, full of spirit and ardor, in brilliant colors re-
calling the highest period of the Venetian schools, but it also
reveals in its author an increasingly definite predilection for
painting's ideal side. . . . This is unarguably a picture of un-
usual merit, perhaps the finest M. Delacroix has ever done,"
wrote Gustave Planche in *Revue du XIXe siècle*. "One finds in
it all the qualities that he developed first in the decoration of
the Salon du Roi, and then in the Chambre des Députés, and
these qualities are associated, in his *Medea*, with the energy and
the dramatic expression that the artist so ardently pursued in his
earlier works, and that laid the first foundations of his fame."[21]
Surrounding *Medea* were three paintings of Moroccan subjects,
two of them, *The Fanatics of Tangier* and *Moroccan Chieftain
Recieving Tribute*, very significant, and *A Courtyard in Mo-
rocco*.[22] In addition, there was *The Finale of "Don Giovanni"*

(fig. 199), which might have been the painting exhibited at the Galerie Lebrun in 1826 to benefit the Greeks, but which, in any case, went unnoticed by the critics.[23] *Medea about to Kill Her Children*, however, created a great stir. For the first time in his career, Delacroix had treated a subject from Greek mythology in a large painting. Two years after *Saint Sebastian*, this represented a development that seemed obvious to the public, but less so to historians, who are aware of the reality of the dates: as we have seen, Delacroix had been thinking about the theme of *Medea* since at least 1824,[24] and had conceived of it when he was working on *The Battle of Taillebourg*. The Salon brochure cites no specific source, merely noting succinctly: "The fury of Medea. She is pursued and about to kill her two children." The legend of Medea had been told by many ancient authors, including Euripides and Ovid, and was certainly known to an educated audience. Jason, the leader of the Argonauts, abandoned Medea after she helped him take the Golden Fleece from her father, the king of Colchis. She took her revenge by sending a poisoned tunic to her rival, the daughter of King Creon, whom Jason wanted to marry. Medea fled, then, maddened, killed her two children by Jason. Few artists before Delacroix had dared portray such an episode. He, however, chose the most dramatic moment, when Medea, about to be overtaken, and holding her two children in her arms, dagger in hand, is about to perform her irrevocable act.

What accounts for the painting's expressive power, noted by all Delacroix's contemporaries? First of all, of course, Delacroix elected to suggest rather than show, rightly limiting his skillfully elliptical narration to three principal figures, who occupy almost all the pictorial space. The presence of the pursuers is indicated only by Medea's abruptly suspended movement as she penetrates into a grotto, descending toward the right, but turning back toward the outside, on the left. There is, too, Delacroix's ambiguous representation of the mother's attitude (is she protecting her children, or on the contrary preparing to slaughter them?), and the slight compositional contrivance whereby the little boy on the right kneels conveniently on a rock. This allows Delacroix subtly to balance his group, constructed as a pyramid around Medea, toward whom everything converges. The upper part of her face, however, is in half-light—a bold stroke that endows her with even more intensity and accentuates the scene's dramatic aspect, but that was sometimes misunderstood: "The painting's appearance is

gripping," wrote another unnamed critic, "one is deeply moved by this deranged mother, with her haggard eye, pale face, dry, livid mouth, palpitating flesh, and burdened breast. There is a marvelous animation in the three figures, and a vigor in the colors and drawing that astonishes, touches, and erases the one reproach that one might make M. Eugène Delacroix, for the shadow brought over the upper part of Medea's face."[25] Delacroix reinforced the focus on the single group by using a severely limited range of colors, deployed with almost brutal simplicity, compared with the refinements of *Women of Algiers*. For example, the bodies' pallor, balanced by Medea's clothing, which is pink on the side, and red and a nearly black blue-violet in front, stands out against a background of dark browns and greens, with a very few lighter tones—the blue of the sky, and the ocher of the soil.

"M. Delacroix did well to select an antique subject, for he has found in this subject an opportunity to paint the nude," Gustave Planche noted,[26] the two nude children, and Medea's nude torso, which recalls *Liberty Leading the People* and evokes *Greece on the Ruins of Missolonghi*. But the classical quality of *Medea about to Kill Her Children* is due less to these traditional elements—the subject and the nudity—than to Delacroix's approach, which was consciously to create a type. The juxtaposition of the picture and the Moroccan subjects gives it additional significance, even though the coincidence was, it seems, fortuitous. Here, Delacroix was reconciling and synthesizing the various directions of his work since *Liberty Leading the People*. Is that why he gave it particular importance? Deeply disappointed when the State purchased it to send to the Lille Musée des Beaux-Arts, he did everything possible to have it exhibited at the Luxembourg, where it would have joined *The Barque of Dante* and *Scenes from the Massacres of Chios* (*Liberty Leading the People* was deinstalled at the time). He was thereby ranking *Medea* among these last paintings, and valued it more than the works that had already been sent to the provinces, such as *Christ on the Cross* and *Saint Sebastian*. He was able to keep *Medea about to Kill Her Children* in Paris for only a year,[27] and regretted the departure of a painting that had so powerfully struck its viewers' imaginations. As George Sand wrote him: "I would prefer not to leave without saying good-bye, and talking with you about *Medea*, which is a magnificent, superb, heart-rending thing: you are really quite a *dauber*!"[28]

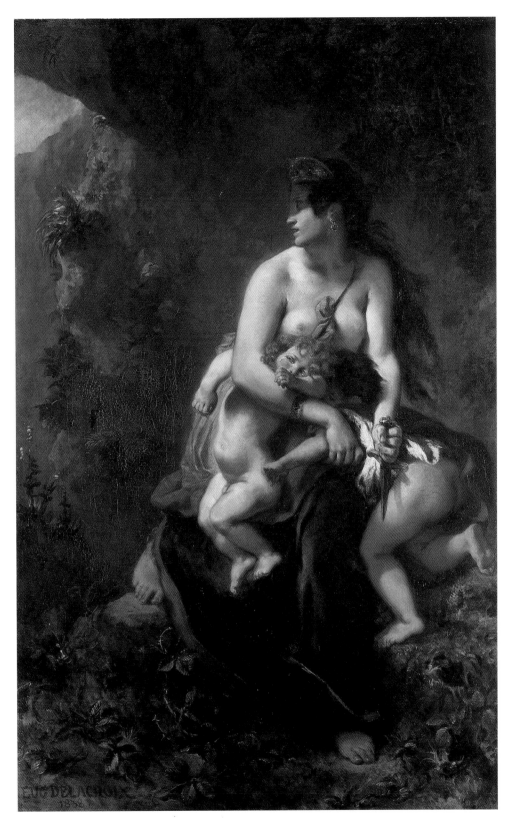

200. *Medea about to Kill Her Children*, 1838

Exhibited at the Salon of 1838. Oil on canvas, 260 × 165 cm

Musée des Beaux-Arts, Lille

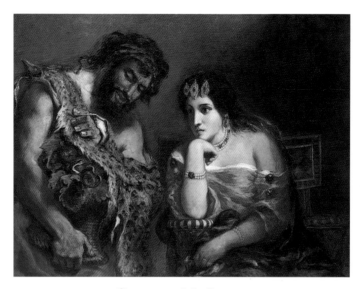

201. *Cleopatra and the Peasant*, 1838
Exhibited at the Salon of 1839. Oil on canvas, 98. × 122.7 cm
Ackland Memorial Art Center, Chapel Hill, North Carolina

Despite his success, Delacroix still found himself confronted by the antagonism of the academic camp, including the Institute and the Salon jury. Their hostility, while not increasing, took different forms as the painter became more and more appreciated by a group of critics and a segment of the public. Since Delacroix had undeniably become one of the masters of the French school, why block official honors and conduct guerrilla warfare against him at the Salon? This discrepancy became increasingly obvious in the latter half of the 1830s. Delacroix had given proof of Classicism, with the Salon du Roi, *Saint Sebastian*, and *Medea*. Nevertheless, he was again defeated at the Institute when he presented himself for the second time, in February 1838. Furthermore, three of his paintings, including the second version of *Tasso in the Hospital of Saint Anna, Ferrara* (fig. 263), were rejected at the Salon of 1839.[29] This time, Delacroix himself protested the injustice and inconsistency of the jury, whom he claimed had accepted works they had rejected the year before (he was, in fact, confusing the various versions of *Hamlet and Horatio in the Graveyard*). The only works to make it past the gate were *Cleopatra and the Peasant* (fig. 201) and the second version of *Hamlet* (fig. 237), now in the Louvre, which was very favorably received by most of the critics and was later purchased by the duc d'Orléans.

Both of the subjects that Delacroix treated were from Shakespeare, *Hamlet and Horatio in the Graveyard*, obviously so, *Cleopatra* somewhat less obviously. But Shakespeare is who Delacroix had in mind when he was composing his painting, as he would write George Sand a few years later.[30] Nevertheless, he gave no specific reference in the brochure: "Cleopatra. This queen, wishing to avoid the shame of being subjected to the triumph of Octavius Caesar, who was keeping her under close watch for fear of an extreme solution, had a farmer admitted who brought her an asp concealed in a basket of figs." The painting's genre is somewhat influenced by this: it could as easily be a historical scene as a specific reference to a literary text, in this case, act 5, scene 2 of *Antony and Cleopatra*. Perhaps reluctant to look like an illustrator of Shakespeare, Delacroix allowed ambiguity to conceal this point (some critics pointed to Plutarch as the source). The call of the theater, however—to which he was always so visibly close and which so often extended into his work—is the most evident. In criticizing Cleopatra's attitude, Merimée, for example, referred to directorial conventions, which would have required her to rise halfway from her chair upon seeing the serpent.[31] Delacroix might have here portrayed the celebrated tragic actor Rachel, who in the same period had posed for *The Cumaean Sibyl*.[32] Finally, it is essentially a juxtaposition of the beautiful and the grotesque—extended, in a sense, to the hanging of the painting itself, which was exhibited at the Salon above Decamps's *Turkish Café*—that brings the painting closer to Shakespeare.

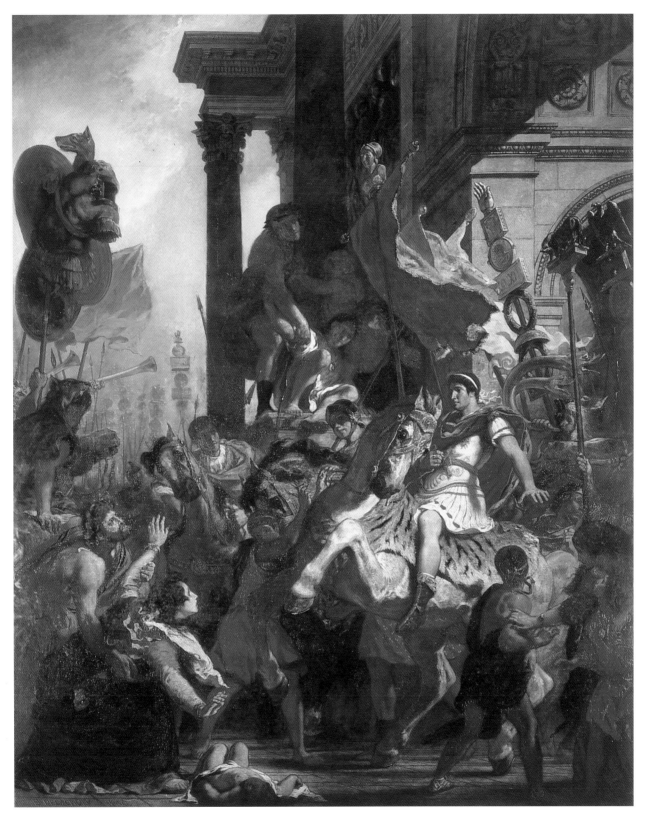

202. *The Justice of Trajan*, 1840
Exhibited at the Salon of 1840. Oil on canvas, 490 × 390 cm
Musée des Beaux-Arts, Rouen

The queen's calm, white face, for example, contrasts violently with the farmer's, which is brown and common. Cleopatra's dreamy, meditative attitude—to which the viewer's gaze is immediately directed, since the painting has only the two figures and no setting besides the chair—was variously received. So was the treatment of the clothing, which Delacroix, with undisguised pleasure, made brilliant: orange with gold highlights and dark blue for Cleopatra's dress, and green, red, and black-flecked brown for the farmer, as well as the gleam of the gold, pearls, and precious stones of the queen's jewelry. Yet, the painting received fairly little attention from the critics, especially compared with the other work that Delacroix showed, *Hamlet and Horatio in the Graveyard*, which was very successful. This subject was more immediate, and easier, too, in that it offered numerous possibilities in the expressions of the various figures. "The little Hamlet is a chef-d'oeuvre worthy of the most highly regarded masters. . . . The expression on his face is sublime in its sorrowful concentration: it somewhat recalls the poetic features of M. Liszt's inspired physiognomy. . . . There exists a singular contrast between Hamlet's disturbed expression and the farmer's careless one. The latter has never reflected upon the mystery of death, nor the mystery of life, which ceaselessly harass Hamlet's thoughts. The interest of this painting lies chiefly in this ingeniously true-to-life opposition. And how the execution bears out this somber philosophy! How sad the sky is, how veiled in fat, heavy, purplish-blue clouds; on the horizon, a greenish band intersected with tones as gray as the ashes of a funeral-pyre. The color scale is fascinatingly strange."[33]

Both *Cleopatra and the Peasant* and *Hamlet and Horatio in the Graveyard* are quite small. Was Delacroix, at the next Salon, seeking to make his mark with a large new history painting? Was this canvas merely a calling card for the works that were then being assigned at the Luxembourg?[34] We do not know exactly why he went with the conception and execution of *The Justice of Trajan* (fig. 202), the only painting he exhibited in 1840. It is difficult, however, not to see it as a response to the jury's severity of the previous year. And yet there was a rumor at the time that the painting was accepted only by a majority vote, and after a second round.[35] A large painting of a subject from Roman history (albeit via Dante), *The Justice of Trajan*, given its author's mindset, was probably intended to show up the inanity of the academic critics by triumphing on their own

ground. If he believed he was about to silence the controversies once and for all, he was mistaken: the painting caused a sensation, and was a main topic of discussion among the public.[36] But it also aroused a great deal of criticism, with the artist's partisans and opponents once more taking up their positions with their customary brio and the usual arguments. Most people, including some of Delacroix's detractors, remarked upon the harmonious beauty of the colors, evoking the great Venetian painters, especially Veronese. Gustave Planche, who favored Delacroix, as he almost always did, gave a useful summary of the debates: "M. Eugène Delacroix's *Justice of Trajan* is the finest painting of this year's Salon. It is easy to see several errors of draftsmanship in this work, but these mistakes are amply compensated by a multitude of first-rate qualities. The middle and backgrounds of *The Justice of Trajan* recall the most brilliant canvases of the Venetian school. The architecture is conceived and rendered with a breadth, simplicity, and harmony that awaken in every mind the memory of *The Wedding at Cana*. . . . One need not be very knowledgeable to notice the errors of draftsmanship to be found in the foreground of this work; one need not be very perceptive to see the faults in Trajan's horse; but to assemble all the parts that make up this painting, to create this watching, listening crowd, [the artist] must be endowed with the rarest abilities, and must have received from heaven what schools will never teach—grandeur and energy. The flaws are always the same, but the beauties are countless and of the highest order. In this canvas, there is not one childish effect, not one petty combination; this is frank, bold painting, which ought to be admired because it is beautiful, and because works of this quality are not counted by the hundreds these days."[37]

The works that Delacroix exhibited at the following Salon, in 1841, clearly demonstrate the importance he gave the event. Despite his being fully occupied at the Luxembourg and the Chambre, he managed to find time to execute three paintings in very different genres, but all very ambitious, the *Entry of the Crusaders into Constantinople*, *The Shipwreck of Don Juan*, and *Jewish Wedding in Morocco*. The *Entry of the Crusaders* (figs. 203 to 205) was unarguably the key piece of his submission, by its dimensions as by its destination, since it was to appear in Versailles, in the Salle des Croisades. If we may believe Riesener's memoirs, the painter had received from Cailleux, director of the Musées Royaux, the direction to do a painting "that didn't

look like a Delacroix."[38] Like *The Battle of Taillebourg*, the *Entry of the Crusaders into Constantinople* was to be integrated—this time, in neo-Gothic surroundings—into a group of paintings assigned to various artists. It was also meant to trace the Christians' struggle against the infidels. The program, therefore, was quite specific. But Delacroix was able to go beyond it and remain entirely personal in what would be his last large-format painting dedicated to medieval history. The very simple subject represented an episode during the fourth crusade: the taking of Constantinople by the Crusaders in 1204. "Baldwin, the count of Flanders, commanded the French, who had charged from the land side, while the old doge Dandolo, leading the Venetians, who had come by sea, attacked the port. The principal leaders go throughout the various quarters of the city, and the weeping families intercept them to plead for mercy."[39] The painting's theme resembles that of *Scenes from the Massacres of Chios*, as does its organization into two distinct planes. In front, are the leaders of the Crusaders; at their head is Baldwin, the count of Flanders and future emperor, his horse trampling the standards and arms of the conquered. Among the knights behind him, the old doge Dandolo can be identified, while the three other knights are probably the other leaders of the crusade, the marquis Boniface of Montferrat, the count of Champagne, and the count of Blois. A soldier brings them a prisoner. Two groups of Byzantines, one on the right and one on the left, beg for mercy: on one side, two women, one of them half-naked and prostrate, holding up her dead or fainted companion, on the other, an old man who tries to protect his daughter and toward whom a young boy is turned. Further to the left, a woman lies on the steps of a palace. Held by a soldier, another old man comes out; his mysterious identity provoked questions on the part of several critics, who were not satisfied by the answer: was he the old blind emperor Isaac Comnenus, freed by the Crusaders; his brother Alexis, who had usurped the throne; or just a priest? Delacroix was very loose with specific details, but the pyramidal composition of the principal figures emphasizes the main action—the Crusaders' victory and the Byzantines' distress. Behind and below, the background of the scene appears: Constantinople being pillaged, the Golden Horn, and the Bosphorus, beneath a cloudy sky made darker by the fires. The contrast between the two parts of the painting, which are already very distinctly separated by their compositions, is accentuated by the differ-ence in luminosity and by their very atmosphere. With the direct representation of violence relegated to the background, the principal scene focuses upon the consequences of the action and is very restrained.

The painting's reception was even more restrained. Besides the now commonplace criticisms, Delacroix was uncharacteristically accused of having deliberately darkened his palette, of not displaying his universally acknowledged talent for color. The anonymous critic for *Le Constitutionnel* wrote: "We will pass over the careless drawing, the strangled and confused composition, the forced attitudes, and the usual gleams from M. Delacroix's brush, but the color itself, so brilliant and powerful in its contrasts, has become dull and muddy. Gray tints and muddy tones have taken the place of the lively, contrasting colors of his palette, where rainbows seemed to have run. The handsome Istanbul sky . . . is laden with a heavy layer of grayish clouds that darken the entire painting. As for the execution, it seems to be impossible to hold the opinion that is not excessive in one direction or the other. In the entire painting, not one contour is firm, not one line is frankly distinct from another, and there are mistakes of anatomy and drawing, albeit, we will agree to believe, deliberate mistakes on the master's part."[40] Even Gautier deplored a color scale that was "muted and calm." "Given the statement of the subject, one expects a flood of splendors, streams of light, all the riot of color of the Orient, for one imagines Constantinople to be nothing but a dazzling whiteness between two immutable blues. M. Eugène Delacroix, who would have found it so easy to achieve this ideal, has elected an overcast, almost northern weather."[41] In short, the overall tonality was unexpected. As for the details, the richness of the effects in the *Entry of the Crusaders into Constantinople* was as great as in Delacroix's other large paintings. We can see it, for example, in the two foreground groups of Byzantines, even if the canvas is in poor condition and has become noticeably darker with time. G. Laviron offers this commentary: "What a skillful harmony of colors, what a vigorous effect, how marvelously distributed are the refined and delicate nuances and energetic oppositions, how each figure is in its ground, how one strolls in the space amid all that. But also, what disjointed drawing, what incoherent composition! . . . This entire painting has an odd look, an accidental quality not completely justified by the nature of the subject the artist has chosen to represent. . . . In a word, the

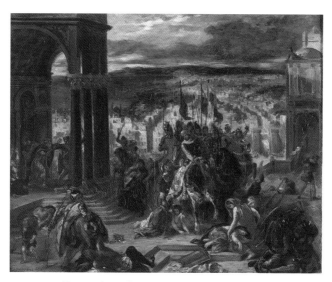

203. *Entry of the Crusaders into Constantinople*, 1852
Oil on canvas, 81.5 × 105 cm
Musée du Louvre, Paris

entire painting, despite the immense talent that M. Delacroix has expended on it, is more a historical fantasy than a history painting in any strict sense of the word."[42] This last remark is all the more intriguing because Delacroix had pursued the same precision and verisimilitude that he had always sought in treating historical subjects. Yet the spirit of the *Entry of the Crusaders into Constantinople* is different than that of the battle paintings *Nancy*, *Poitiers*, and *Taillebourg*, and not only because the combat is not the principal subject. Delacroix was able to give his latest subject a universal breadth, as he had done twenty years earlier in *Scenes from the Massacres of Chios*. Most of the participants in it are anonymous—even Baldwin of Flanders does not really stand out among his companions. The effects of war, the death of men, the despair of the old, the dishonor of women, are of all times and places. The painter's gaze invites the viewer to meditate upon the grandeur and harshness of history. As Baudelaire wrote in 1855, when the painting was exhibited again, at the Exposition Universelle, "the painting of the *Crusaders* is so profoundly penetrating, subject matter aside, by virtue of its stormy and mournful harmony! What a sky and what a sea! Everything is tumultuous and calm, as in the wake of a great event. The city, spreading out behind the *Crusaders* who have just crossed it, extends out with marvelous truthfulness. And everywhere those shimmering, flowing draperies, unfurling and flapping their lumi-

nous folds in the transparent air! Everywhere the restless, bustling crowd, the tumult of arms, the pomp of costumes, the emphatic truth of gesture in life's great circumstances! The beauty of these two paintings [the *Entry of the Crusaders* and *The Justice of Trajan*] is essentially Shakespearean. For no one since Shakespeare has excelled like Delacroix in melting drama and reverie into a mysterious unity."[43]

The reviews of the Salon of 1841 were more of one mind in praising the qualities of two other paintings by Delacroix, *Jewish Wedding in Morocco* (fig. 120) and especially *A Shipwreck*, today called *The Shipwreck of Don Juan* (fig. 207). The latter painting was exhibited with no other information, but viewers recognized in the overall work the source of Delacroix's inspiration, the second canto of Byron's poem *Don Juan*.[44] When the shipwrecked Don Juan and his companions run out of food, they organize a lottery to determine who will be sacrificed. Don Juan's tutor is chosen. In this painting, Delacroix was obviously referring to *The Raft of the "Medusa,"* not only in the scene itself but also in the deliberately vague title, which recalled the one Géricault gave his work at the Salon of 1819: *Shipwreck Scene*. There was no mistaking it, and one of the more insightful critics, Eugène Pelletan, was the first to compare the two works, incidentally pointing out how much the painting's expressiveness, as with the *Entry of the Crusaders into Constantinople*, owes to the handling of the color: "The

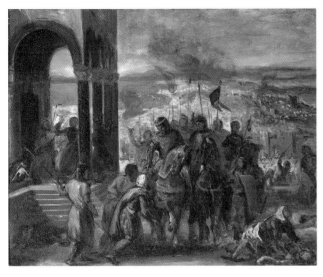

204. Sketch for *Entry of the Crusaders
into Constantinople*, c. 1839–40
Oil on canvas, 33 × 41 cm
Musée Condé, Chantilly

205. *Entry of the Crusaders into
Constantinople*, 1840
Exhibited at the Salon of 1841.
Oil on canvas, 410 × 498 cm
Musée du Louvre, Paris

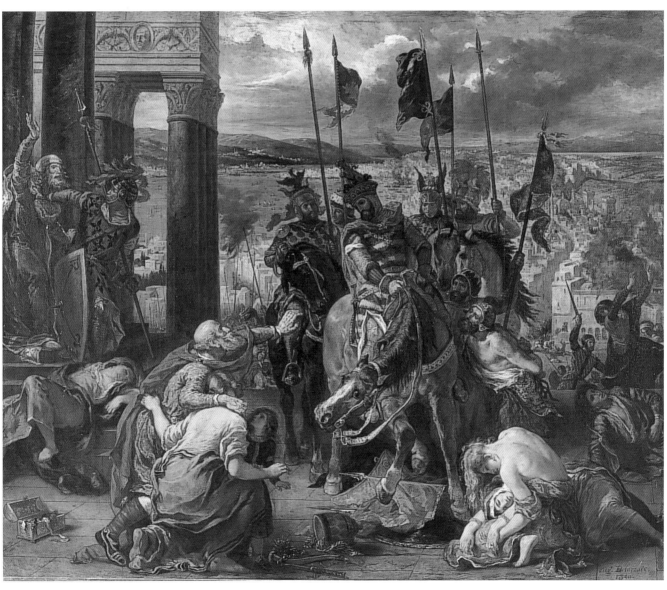

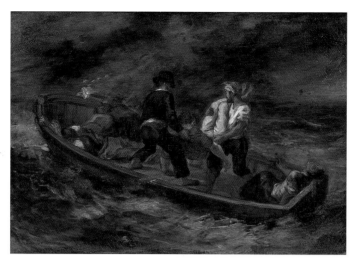

206. *Castaways in a Ship's Boat*, 1840–47?
Exhibited at the Salon of 1847. Oil on canvas, 36 × 57 cm
Pushkin Museum, Moscow

ability to create a funereal harmony, the dramatic part of color, has never been taken further than in this painting. The heavy tones of the sky and the greenish tones of the sea translate the desolation of the shipwreck wonderfully. The waters are solid, which is rare in seascapes; they suggest the ocean's depths. Their tint and movement are understood and rendered with wonderful truthfulness. The drawing is ample, and, in the man seen from the back, full of fine feeling. One must unhesitatingly proclaim this the most completely beautiful canvas by this painter. He has a depth in his feeling for drama that Géricault, in a similar subject, seems to us not to have attained."[45] Nevertheless, even the enthusiasts retained the prejudices against the painter that by now were received ideas. Laviron, for example, writes: "It gives a horrible, gripping, frightening impression; looking at this painting, one feels painfully moved . . . , but beware of changing position or taking a step forward, for at the first movement, the enchantment is broken, the illusion ceases, and you perceive nothing but a coarse and shapeless sketch on the same canvas where just now you admired a composition so deeply felt and rendered with such passionate energy: confusion and chaos dominate this frenzied composition."[46]

Thus, in less than ten years, Delacroix showed an exceptional series of outstanding paintings, whose implications, while less historically significant than those of the paintings of his youth, were nonetheless considerable. The evolution of his inspiration was noticeable in the religious paintings, on the

one hand, with *Christ on the Cross* and *Saint Sebastian Tended by the Holy Women*, and in the history paintings, on the other, with *Medea about to Kill Her Children* and *The Justice of Trajan*, in which the artist was testing himself with the most classical subjects, those of Greco-Roman antiquity. At the same time, he was delving deeper—with themes that were more familiar to him, but with a similar concern for renewal—into history, and more specifically the Middle Ages, as in *The Battle of Taillebourg* and the *Entry of the Crusaders into Constantinople*, and in the illustration of his favorite authors: Shakespeare (*Hamlet and Horatio in the Graveyard*, *Cleopatra and the Peasant*), Byron (*The Shipwreck of Don Juan*), and Sir Walter Scott (*The Knight and the Hermit of Copmanhurst*). The paintings of Moroccan subjects (among which *Women of Algiers in Their Apartment*, *The Fanatics of Tangier*, *Moroccan Chieftain Receiving Tribute*, and *Jewish Wedding in Morocco* stand out) combine both aspects: they fit within the current of the "Greco-Turkish" works predating 1832, and at the same time they made Delacroix one of the principal practitioners of the Orientalism then in full swing, and one of the most original. The variety and timelessness of his submissions placed him in the first rank (let us remember that Ingres no longer showed at the Salon, following the failure of his *Martyrdom of Saint Symphorian* of 1834). But that was not sufficient to disarm his enemies once and for all, as evidenced by the failure of his various applications for the Institute (a third, in February 1839, had the same

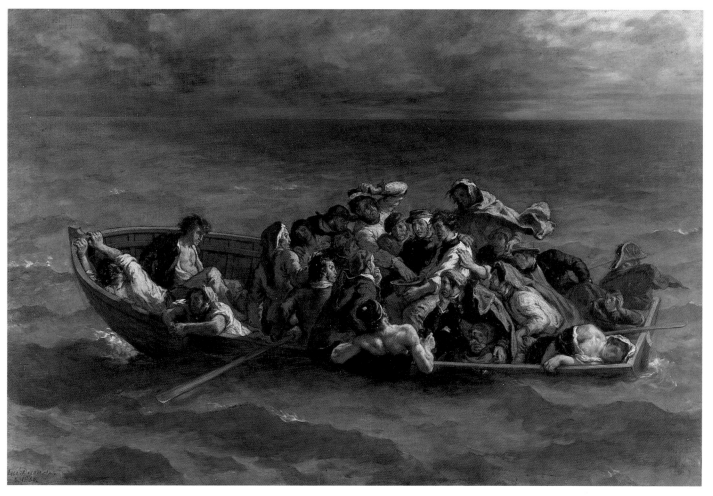

207. *The Shipwreck of Don Juan*, 1840
Exhibited at the Salon of 1841. Oil on canvas, 135 × 196 cm
Musée du Louvre, Paris

outcome as the first two). The obvious assurance, maturity, and fullness of his large paintings from 1835 to 1840 still, in the eyes of some, did not manage to erase the scandal of *Scenes from the Massacres of Chios* and *The Death of Sardanapalus*.

Delacroix's submission of 1845, after a four-year absence, was especially important. He manifested a very marked classicizing bent—the subjects that he treated did not themselves have Romantic connotations. They were from the New Testament (*Mary Magdalen in the Wilderness* [fig. 208]; the jury had rejected the first version of *The Education of the Virgin* [fig. 255]), ancient history (*The Death of Marcus Aurelius* [fig. 210]), and the classical tradition (*The Cumaean Sibyl* [fig. 209]). Although more contemporary, *The Sultan of Morocco and His Entourage* (fig. 124), despite its picturesque exoti-

cism, in reality belongs with the large formal portraits. In his return to the art scene, Delacroix, approaching fifty, displayed an undiminished vigor. Baudelaire was able to open this Salon with a fanfare, a decisive assertion, the first he ever published on the artist: "M. Delacroix is decidedly the most original painter of ancient or modern times. . . . Thanks to the belated justice of time, which cools resentments, excessive admiration, and ill will, and slowly carries every obstacle away to the tomb, we no longer live in the days when M. Delacroix caused the *arriéristes* to cross themselves, or was a rallying symbol for any opposition, intelligent or otherwise; those 'good old days' are gone. M. Delacroix will always be somewhat controversial, just enough to add the odd lightning bolt to his halo. And so much the better! He has the right to remain forever young: he,

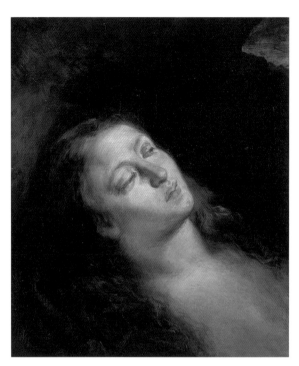

208. *Mary Magdalen in the Wilderness,*
about 1843–45
Exhibited at the Salon of 1845.
Oil on canvas, 55.5 × 45 cm
Musée National Eugène-Delacroix, Paris

at least, has not betrayed us, nor lied to us, like some of the ungrateful idols we have taken into our pantheons. M. Delacroix does not yet belong to the Academy, but he is a member in spirit; he has long since said everything he had to in order to be the first—it is understood. All that remains—the miraculous tour de force of a genius who continually seeks the new—is for him to proceed along the high road on which he has always walked."[47]

In a letter to Thoré written shortly before the opening of the Salon, Delacroix mentioned as important paintings only *The Sultan of Morocco* and *The Death of Marcus Aurelius*,[48] the subject of which was described as follows in the brochure: "Commodus had already manifested his perverse inclinations; in a dying voice, the Emperor commends his son's youth to a few friends—philosophers and Stoics like himself—but their dejected attitudes express only too clearly the futility of his recommendations and their mournful presentiments about the future of the Roman Empire." Delacroix had begun the painting two years earlier, in May 1843, and then Planet had worked on it according to his instructions. Delacroix returned to the

work in January 1844, finally finishing it that autumn.[49] He took his imitations of the great models further in *The Death of Marcus Aurelius* than in any other work. The Neoclassical painters had very often treated the theme of heroic or exemplary death. Many of them had more or less closely followed two famous paintings by Poussin, *The Testament of Eudamidas* and *The Death of Germanicus*, which here Delacroix has also borrowed from; however, he has moved the bed slightly so as to place it on the diagonal and abandoned the draperies, trophies of arms, and columns that were common in his predecessors' works, in favor of an architectural setting. But it was almost pastiche, and the critics pointed out the painting's similarities, not only to Poussin but also to Greuze and David: "*The Death of Marcus Aurelius* is composed almost like David's *Death of Socrates*. . . . An odd comparison between the two leaders of schools that would seem to be at art's antipodes. But, really, M. Eugène Delacroix's Romans are just like David's Greeks. They have more humanity, so to speak. . . . The overall effect of the composition inspires meditation and respect. It is not a requirement, in representing these great scenes of the

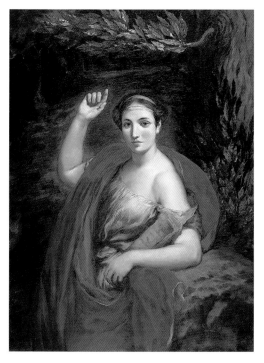

209. *The Cumaean Sibyl*, 1838?
Exhibited at the Salon of 1845.
Oil on canvas, 130.5 × 98 cm
Wildenstein & Co., New York

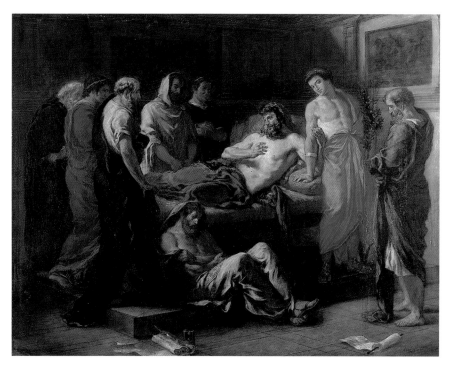

210. *The Death of Marcus Aurelius*, 1843–44
Exhibited at the Salon of 1845.
Oil on canvas, 256 × 337.5 cm
Musée des Beaux-Arts, Lyons

ancient world, to be cold and stilted."[50] Delacroix was also criticized for not having treated his subject with the appropriate nobility. To tell the truth, only Baudelaire enthusiastically and unreservedly defended this "splendid, magnificent, sublime, misunderstood" painting, from the standpoints of the expressive contrast between red and green, and of the drawing and the modeling, both of which Delacroix executed as a colorist. Delacroix, however, did not very much care for *Marcus Aurelius*, preferring to have the State buy *The Sultan of Morocco* and send it to the Musée de Toulouse.[51] *The Cumaean Sibyl*, indicating "at the heart of the dark forest, the golden bough, won by the most noble and the favorites of the Gods,"[52] also divided the public. *Mary Magdalen in the Wilderness* evoked more praise, but, all things considered, it was more a rendering of an expressive head than a true history painting. *The Sultan of Morocco* was not the success Delacroix had expected. Thus, he had reason to be disappointed. He had either to resign himself to being understood by only a few or else to betray himself, as he wrote Thoré, when he thanked him for his articles: "Are there really, in the arts, languages so difficult to understand that the majority never manages to be able to see? Must one absolutely be or not be a certain way, under pain of not being at all? I am noticing after twenty years that those are the alternatives between which I am driven. I did not believe myself to be so indecipherable and must be doubly grateful to those who are not disgusted by my puzzles. After so many attempts, I confine myself to wishing only that the coldness of the greater number may not manage to win over as well the small number of people of taste of whom you spoke and who often are those who make reputations."[53]

For the next three years, he produced only small-format works, but in a relatively varied range of subjects. His 1846 submission consisted entirely of subjects from literature: *The Abduction of Rebecca* (fig. 232), inspired by Sir Walter Scott; *Romeo Bids Juliet Farewell* (fig. 244), by Shakespeare; and *Marguerite in Church*, by Goethe. His 1847 entry had a more Moroccan tinge, with Delacroix presenting *Guard-Room at Meknès* (fig. 131), *Jewish Musicians from Mogador* (fig. 136), an *Odalisque*,[54] and *Arab Cavalry Practicing a Charge*, the last version of his "dust race," and a new version of *Christ on the Cross*

and *Castaways in a Ship's Boat* (fig. 206), an avatar of his *Don Juan* exhibited in 1841 (fig. 207). These genres all reappeared the following year, in *The Death of Valentine* (fig. 227), a new illustration of *Faust*, which was very well received by the critics, and *The Death of Lara* (fig. 233), inspired by Byron's poem, and in two more important and larger paintings, *The Arab Players* (fig. 132), and *The Lamentation* (fig. 250), a return to the theme of the pietà. In addition, Delacroix—for the first time since his youth —exhibited paintings with animal subjects: *Lion Mauling a Dead Arab* (fig. 212) and *Lion Devouring a Goat*.[55] After 1845, instead of producing very large works and historical subjects, he would

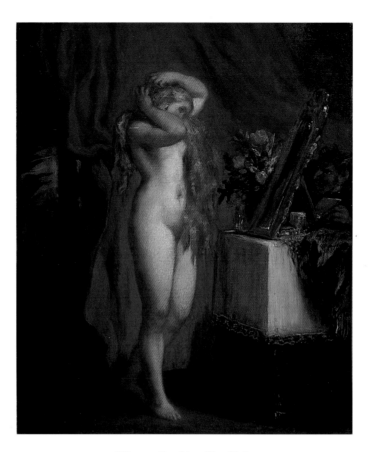

211. *Woman Combing Her Hair*, 1850
Exhibited at the Salon of 1850–51.
Oil on canvas, 46 × 38 cm
Private collection

henceforth keep to smaller paintings. There were two main reasons for this: the onus of his decorative works and his increasingly poor health. Yet, it would be a mistake to consider these as minor works, or to believe that with them Delacroix was merely making an appearance. He thought highly enough of the smaller paintings to show them publicly, and to display them at the extremely important event that the Salon still was. Their importance was of a different order, however, than that of the large works of previous years. Delacroix's intention was no longer to command attention, silence the critics, or please either members of the Academy or administrators in a position to commission work, but simply to continue, with a certain detachment, the dialogue he had initiated with the public more than twenty years earlier. One can feel the hour of reckoning approach, as his Romanticism recedes. This was the spirit that moved Baudelaire in his *Salon de 1846*, when, after giving his famous definition and expounding upon it—"Romanticism is precisely neither in the choice of subjects nor in the exact

truth, but in the manner of feeling"—he gave an overview of the painter. His long text yields insightful analyses, and a few sentences that summarize Delacroix's career as it could be interpreted at the time and that simultaneously shed light on how he was sometimes perceived: "Romanticism and color bring me straight to EUGÈNE DELACROIX. I do not know whether he is proud of his Romantic quality, but this is his place, because most of the public has long—in fact, since his first work—considered him the leader of the *modern* school. . . . They have so far been unjust toward Eugène Delacroix. The critics have been either harsh toward or ignorant about him; with a few exceptions, even their praise must often have been offensive to him. Generally, and for most people, the name Eugène Delacroix conjures up vague notions of ill-directed fervor, turbulence, adventurous inspiration, even confusion; and, in the opinion of those gentlemen who make up most of the public, chance—that honest and obliging servant of genius—plays an important part in his more felicitous compositions." Baudelaire also put an end to the wrong-headed comparison between Delacroix and Hugo: "Eugène Delacroix and Victor Hugo have often been compared. Here, the Romantic poet, so there must be the painter. This need to find counterparts and similarities among the different arts at all costs often leads to strange blunders, and this one, too, proves how poorly people have understood. The comparison surely must have distressed Eugène Delacroix, perhaps both of them. . . . The parallel has remained in the banal domain of received ideas, and those two tired old ideas still clutter many weak minds. We must be done with this rhetorical foolishness once and for all. . . . M. Victor Hugo . . . is

a workman who is more adroit than inventive, a laborer who is more correct than creative."[56] As Romanticism became history, Delacroix became classical.

The Revolution of 1830 had inspired *Liberty Leading the People*. That of 1848 left him initially indifferent, then on his guard, then increasingly disapproving, even hostile, as events unfolded. The paintings that he presented at the Salon of 1849 partly reflected his attitude, and they surprised his contemporaries. For Delacroix went beyond his usual subjects, even though he exhibited the second version of *Women of Algiers*, probably an older painting, made before his trip to Morocco; *Syrian Arab with His Horse;*[57] and *Othello and Desdemona* (fig. 245). He was attempting flower paintings for the first time and in a large format, a genre that was new for him on that scale. Their unique position in his oeuvre and the admiring surprise that they occasioned among the public and the critics when they appeared at the Salon merit some attention.[58]

The flower paintings of 1848–49 (figs. 213–215) were not the first that he had done in this genre, but their large dimensions are evidence that they were painted in a very particular state of mind. Delacroix, who, before launching into the large compositions, had been working on many studies of flowers since autumn, explained himself on the subject in a long letter to Dutilleux, written as he was finishing the paintings in February 1849. Dutilleux had called his attention to two older flower paintings by an unknown artist. Delacroix thanked him, then went on to analyze them, before describing his own method and objectives: "They are full of talent: the brushstroke especially is astonishing; their only flaw seems to me to be that fault common to nearly all of this kind of work, when done by special men: the concern for detail, taken so far,

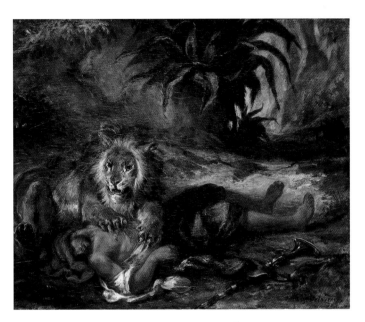

212. *Lion Mauling a Dead Arab*, 1847
Exhibited at the Salon of 1848.
Oil on canvas, 54 × 65 cm
Nasjonalgalleriet, Oslo

harms the whole somewhat. . . . Since, in the course of execution, the artist proceeded less by large local areas of lines and colors than by an extreme attention to expressing the individual parts, the objects that in the painting serve in a sense as background to each of these details, which are too conscientiously set off, eventually disappear, and nothing remains except this scattering, which harms the effect somewhat. . . . With no particular idea in mind, I took the entirely opposite tack . . . and subordinated the details to the whole as much as I was able. I also wanted to avoid somewhat the kind of stereotype that seems to condemn every flower painter to do the same vase with the same columns or the same extravagant draperies acting as background or *repoussoir*. I tried to do bits of nature, as they appear in gardens, except bringing together within the same frame and in a somewhat plausible manner the greatest variety of flowers. . . . If they are finished on time and as I want them, I will probably place them in the Salon. There are five, no more no less."[59] Of these five paintings, Delacroix, in the end presented only two of the four that were finished. He was dissatisfied with the other two, and their effect. "I had glimpsed my paintings the day that I returned to the Salon for the placement, and they made a poor impression on me," he wrote Riesener in early June 1849, in a letter that clearly expresses his concerns about the paintings he exhibited. "If you would be so kind, during my absence, for I am very ill, and it takes it out of me to attend to this matter, if you would be so kind, I say, to do as you did for yourself, and to do me the favor of having the two weakest withdrawn, unless you see some way to have them placed to their advantage. But I do not at all insist upon this. I even think that, all things considered, it is better to withdraw them entirely. I had no intention of retouching them, and they will remain as they are.

What is odd is that, in my studio, they were as bright as the others."[60] As for the fifth, he completed it and presented it along with the first two at the Exposition Universelle of 1855. He sold none of the five paintings, which remained in his studio until the posthumous sale, where their reappearance provoked a new outpouring of praise. The critics had particularly appreciated them in 1849, pointing out Delacroix's originality in so specific a genre, but one that seemed made for him and his talent as a colorist: "It is quite simply a riot of the palette, a feast of colors given to the eyes," wrote Gautier. "What is praiseworthy in these two canvases as well, besides the quality of the tone, is the style imprinted upon the flowers, which [by the other painters] are usually treated purely botanically, with no concern for their bearing, style, features, or character. Each flower has its particular expression, they are gay, sad, silent, noisy, brash, modest, chaste, lascivious, outgoing or contained, gentle or fierce, enervating or soothing; they have their special attitudes, their own flirtatiousness and vanity, all things that the vulgar, detail-ridden flower painters do not render."[61] Considered in the context of the exhibitions in which Delacroix participated, the flower paintings stand out from every point of view: aside from Gautier, the critics were essentially moved by the painting alone and the painter's virtuosity. It was one of the very few times that the subject of the painting appeared inessential, and so one may isolate them within the artist's body of work, as did Timothy Clark, who sees in them "Delacroix's response to the events of revolution—a deliberate, grand withdrawal to a world of private sensation, a world of traditional, painterly problems."[62]

In the following years, Delacroix returned to his usual themes, but with a marked tendency toward religious subjects. Although in 1850–51, he presented a "light" painting, *Woman Combing Her Hair* (fig. 211)—in reality a magnificent female nude, which despite its very small size attracted the critics' attention and evoked their admiration, as did *The Giaour Pursu-*

213. *A Vase of Flowers on a Console,* 1848–50

Exhibited at the Exposition Universelle of 1855.
Oil on canvas, 135 × 102 cm
Musée Ingres, Montauban

ing the Ravishers of His Mistress, another illustration of Byron, and *Lady Macbeth Sleepwalking*—he also exhibited *The Raising of Lazarus* (fig. 258) and *The Good Samaritan*. In 1853, two of his three paintings were religious subjects, *Saint Stephen Borne Away by His Disciples* (fig. 253) and *The Supper at Emmaus* (fig. 251). The third, *African Pirates Abducting a Young Woman* (fig. 217), displays a unique reference within one of his common themes, since it is partly inspired by "Chanson des pirates" from the *Orientales*, making it one of the few intersections between Hugo and Delacroix in the latter's painting. The source was not indicated, however, whether because the poet's name was considered politically too dangerous or daring at the time that the painting was exhibited, or because Delacroix, who went far afield from the original text, simply saw no reason to mention it.[63] No one thought to make the connection, and the work remained merely a Romantic invention embroidered on Moroccan memories.[64]

The Exposition Universelle of 1855 marked the final turning point in Delacroix's career—and one of the most important stages, when he was finally acknowledged by every authority.[65] The second event of this kind, following that of London in 1851, this Exposition differed from the first chiefly because there was an art section, the section's organization having been assigned to, among others, a commission directed by the emperor's cousin, Prince Napoleon, on which Delacroix served. The goal was to demonstrate both the power of the imperial regime and France's superiority over the other Western nations, especially Great Britain. The "scepter of the arts," to borrow an expression current at the time, had to go to France, of course, but everything was still to be done to bring that about. It was thus decided to replace the Salon with an international exhibition of painting, sculpture, and engraving. Each country would be represented by a selection of its living artists, who would field works from their entire careers. This was the key difference. The Exposition des Beaux-Arts

214. *A Basket of Fruit in a Flower Garden*, 1848–49
Exhibited at the Salon of 1849. Oil on canvas, 108.4 × 143.3 cm
John G. Johnson Collection at the Philadelphia Museum of Art

215. *A Basket of Flowers Overturned in a Park*, 1848–49
Exhibited at the Salon of 1849. Oil on canvas, 107.3 × 142 cm
The Metropolitan Museum of Art, New York

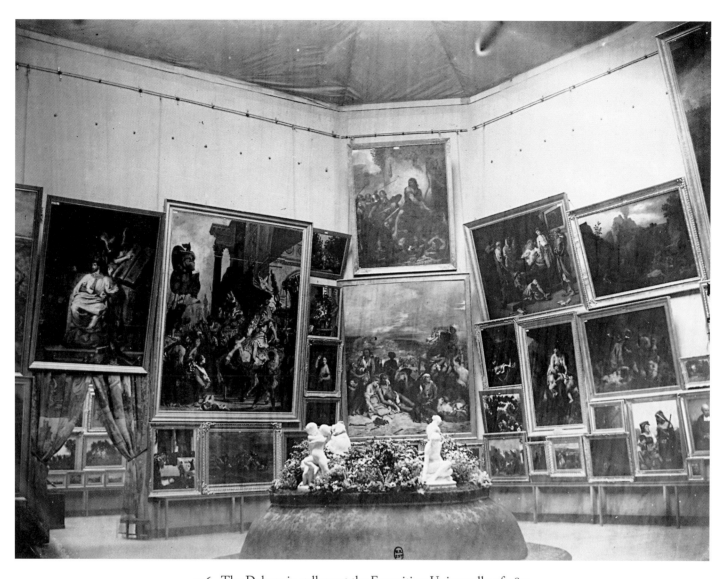

216. The Delacroix gallery at the Exposition Universelle of 1855

Photograph taken during the exhibition. The following works can be clearly identified (from the left):
Justinian Drafting His Laws, The Justice of Trajan, The Execution of the Doge Marino Faliero,
The Shipwreck of Don Juan, The Cumaean Sibyl, Scenes from the Massacres of Chios, The Lamentation,
The Fanatics of Tangier, The Death of Marcus Aurelius, Medea about to Kill Her Children, and
The Barque of Dante. Delacroix's works are interspersed with those of other artists.

(which took place at the specially modified Palais de l'Industrie, on avenue Montaigne, and not at the Louvre, which had not housed the Salons since 1849, anyway) therefore had the dual function of a retrospective Salon. The organizers, wishing to emphasize the great names of the French school, had decided to feature—in the number of works they would be entitled to send and in the way and place their works would be hung— four painters considered the greatest contemporary artists: Ingres, Horace Vernet, Decamps, and Delacroix. The latter was still somewhat the poor relation of Ingres, to whom all Delacroix's requests were passed. Unlike his principal rival, who demanded and obtained a gallery of his own, Delacroix had to settle for exhibiting among the other French artists, despite his objections: "The possibility had been held out to me of having a place in the galleries that are *entirely* given over to MM. Ingres and Vernet," he wrote Frédéric de Mercey, head of the fine arts section of the Ministry of the Interior. "Age and talent have privileges that I am far from challenging. But I myself am neither a young man nor unknown. I hope I have not brought out large paintings from the provinces, at great inconvenience and cost to exhibit them here in an unfavorable light. Furthermore, I would hope that the collectors who were all so kind as to place their paintings at my disposal, despite the lengthy duration of the exhibition and the risks of the place, could see them placed with some honor."[66]

Delacroix's paintings made up an extraordinary retrospective (fig. 216). The group of his most important works—save perhaps *The Death of Sardanapalus*, with its lingering scent of sulphur—thirty-five paintings in all, were together for the first time. His youth was represented by *The Barque of Dante*, *Scenes from the Massacres of Chios*, *Tasso in the Hospital of Saint Anna*, *Justinian Drafting His Laws*, *The Agony in the Garden*, *The Execution of the Doge Marino Faliero*, and a *Head of an Old Woman*, the only work that had not been shown at the Salon.[67] The key works executed about 1830 were gathered around *Liberty Leading the People*: *The Battle of Poitiers*, *The Murder of the Bishop of Liège*, *Boissy d'Anglas at the National Convention*, *The Prisoner of Chillon*, and *The Combat of the Giaour and Hassan* of 1835. From among the Moroccan paintings, Delacroix selected the first version of *Women of Algiers in Their Apartment*, *The Fanatics of Tangier*, *Jewish Wedding in Morocco*, and a very recent work, *The Riding Lesson*. The large paintings done between 1835 and 1840 were also there: *Medea*

217. *African Pirates Abducting a Young Woman*, 1852
Exhibited at the Salon of 1853.
Oil on canvas, 65 × 81 cm
Musée du Louvre, Paris

218. *The Two Foscari*, 1855
Presented at the Exposition Universelle of 1855.
Oil on canvas, 93 × 132 cm
Musée Condé, Chantilly

about to Kill Her Children, The Justice of Trajan, the *Entry of the Crusaders into Constantinople, The Death of Marcus Aurelius,* as well as *The Shipwreck of Don Juan, Mary Magdalen in the Wilderness, The Cumaean Sibyl,* the *Christ on the Cross* of 1847, the *Lamentation* of 1848, *The Death of Valentine, Romeo Bids Juliet Farewell,* and *Romeo Lifts Juliet from the Capulet Tomb* (this was the first time that Delacroix exhibited this painting, now lost).[68] Recent works completed the retrospective: three of the five flower paintings of 1848–49 and two paintings only just executed, which the public was viewing for the first time, *The Two Foscari* (fig. 218) and *The Lion Hunt* (fig. 219). The former was inspired by Byron's play (and perhaps also by Verdi's opera, which played in Paris in 1846, shortly before Delacroix began his painting). Rather than illustrate a specific scene, Delacroix had combined several elements, inventing the moment he selected: "The doge, Foscari, must hear the reading of the sentence of his son, Jacques Foscari. The latter, accused of dealings with the Republic's enemies, is condemned to permanent exile, after being subjected to torture. He turns toward his father, just as his wife, who has burst into the room for an instant, rushes to bid him farewell."[69] Delacroix had begun the painting in February 1847, then seems to have abandoned it shortly afterward, finding himself unable to resolve the problems of perspective that he detected. He only returned to the work in 1854, intending it for the Exposition, and at that time was helped by Dauzats, who apparently drew the principal lines of the setting for him.[70] *The Two Foscari,* one of Delacroix's last works inspired by Byron, was extremely well received at the Exposition. However representative it may be of Delacroix's work of the 1850s, the painting belongs within a distant context created by two much earlier works, *The Murder of the Bishop of Liège* and *Interior of a Dominican Convent in Madrid:* the same choice of a literary source, the same dramatic atmosphere, and a similar composition, with a large architectural setting. The difference lies mainly in the look of the brushstroke, which is more controlled and less passionate in *The Two Foscari,* and in the very subtle handling of the color. The range of color, which is very extensive in the details—for example, in the carpet and all the group around the doge—is no longer limited to browns and reds. The result is a softer overall harmony, which replaced the fairly harsh chiaroscuro. Jacques Foscari, his wife, and the judge appear to be in high contrast, but this results from a great variety in the

blues and greens, highlighted with very bright beige-whites and a very intense red. The painting's expressive power still resides largely in its color, which perhaps became more refined over time.

On the occasion of the Exposition, the State had commissioned Delacroix to paint a large canvas, leaving the subject up to him. He chose the *Lion Hunt,* thereby giving shape, in an important work, to the renewed interest he had displayed in animal painting since the late 1840s, while at the same time paying rather heavy-handed homage to Rubens's *Hunts.* Delacroix knew these works through Soutman's prints, which he discussed at some length in his *Journal,* deeming the structure more crucial to the success of the work than the rendering of detail, and so giving us a key to a possible reading of his own painting: "The effect of the principal lines on a composition is immense. I have before me Rubens's *Hunts;* one among others, the one *for lions.* . . . The rearing horses and bristling manes, a thousand props, the detached shields and twisted bridles, all made in order to strike the imagination. But the whole is confused, the eye does not know where to focus, there is a feeling of dreadful chaos; it seems that art did not sufficiently govern it, increasing by a prudent distribution, or by sacrifices, the effect of so many brilliant inventions. On the other hand, in *The Hippopotamus Hunt,* the details do not show the same imaginative effort. . . . If described, this painting would seem in every way inferior to the preceding one; yet by the way in which the groups are arranged, or rather the one and only group that makes up the painting as a whole, the imagination receives a shock, which recurs each time one looks at it; but in *The Lion Hunt,* it is always cast into the same uncertainty of the lines."[71] Movement and variety, together with the painting's unity—for Delacroix, these were, ultimately, the essential qualities to be sought in Rubens. After his usual drawn studies, Delacroix established the composition in a large and energetic painted sketch (fig. 220), which quite clearly conveys the effect he was seeking to achieve with color and the arrangement of the groups, and which remains the only complete evidence of his work. The final painting, which was sent to the Musée des Beaux-Arts in Bordeaux following the Exposition, was seriously damaged in a fire at the Bordeaux city hall in 1870; the upper third especially was damaged. The Stockholm Nationalmuseum's *Lion Hunt* (fig. 221), finished in 1856 but begun before the large painting and possibly

submitted to the authorities as the sketch to be accepted, displays slight variations in the detail. Along with the copy made by Andrieu, it permits us to imagine the 1855 *Lion Hunt* quite accurately. In an exhibition in which opinion proved to be quite favorable to Delacroix, most of the critics violently attacked its composition, color, and facture. Two reviews exemplify the vigor of their criticism: "If . . . the reconciliation of order and movement is the necessary condition for any truly beautiful work of art, *The Lion Hunt* possesses none of the elements of beauty. Its almost incomprehensible composition hints at two men and a horse on the left-hand side, upside down beneath a lion that rather clumsily attacks a rider mounted on a fiery horse, another horseman aims his lance at a lion clinging to his horse's hindquarters. All of M. Delacroix's usual qualities are missing in this strange confusion. Neither men nor animals act; they affect stiff, unreal poses. The color is brilliant, but garish, and this chaos of red, green, yellow, and purple tones, all with the same value, makes the *Lion Hunt* look like a tapestry."[72] "This painting defies criticism," Maxime Du Camp wrote, "it is a vast, colored word puzzle in which it is impossible to find the word. It is a strange jumble of horses falling down piecemeal, horsemen attacking heraldic lions with daggers, and deformed date-sellers crawling on their knees. Here, color reaches its highest level of extravagance. This is almost raving madness, even harmony is neglected, for all the tones have similar values."[73] Delacroix was surely not insensitive to these criticisms, particularly those concerning the overall composition, which he visibly reworked in two subsequent versions, of 1858 (fig. 223) and 1861 (fig. 222). The elements are virtually the same—hand-to-hand combat between a man and a lion; two horsemen, one of whom is himself attacked; and hunters on foot, one killed and one wounded on the ground. But the arrangement is very different: the groups are farther apart than in the large painting of 1855, in which everyone is inextricably mixed together, and the general movement is brighter and more emphatic.

Despite this momentary rebuff, Delacroix came out of the Exposition Universelle, his first retrospective, all the greater. "It is a consoling thought," wrote Gautier, "to see how the day of reckoning arrives for those gallant, proud talents who in their love of art have not begged the crowd's approval. . . . A contemporary posterity forms quickly around these manly natures, first made up of a few pupils, two or three critics, and a small number of admirers, a sort of mysterious coterie that has penetrated the secret of their genius and comprehends the meaning of their works, which are ridiculed or misunderstood by the common people; then the coterie takes in a few adepts, soon joined by newcomers; the circle widens year by year, to comprise the entire public, and the master that was once insulted is saluted by unanimous acclaim. Such has been the life of M. Eugène Delacroix: for a quarter of a century, his name has been surrounded by a deafening tumult of abuse, diatribes, ridicule, and extremely violent controversy; now the dust of battle has settled, and the master, long treated like a zealot and a lunatic, appears radiant in the brilliance of a serene and henceforth unarguable glory."[74]

One delayed but direct consequence was Delacroix's election to the Institute. After his three defeats in 1838–39, he presented himself unsuccessfully twice in 1849, then again in 1851 and 1853. Presenting himself for the eighth time, in November 1856, he was finally elected the following 10 January. But he had no illusions about this "grand business." The election came too late to allow him to carry any weight in the development of the arts, in particular on teaching, as he explained to Dutilleux, who had congratulated him: "It was done quite openly, and that compounds the win in the eyes of the public. You say, quite rightly, that twenty years ago this success would have given me an entirely different pleasure; I would have had a chance, in that case, to be more useful than what I can be now in the present circumstances. I would have had time to become a professor at the École des Beaux-Arts: there, I could have had some influence. In any case, I am not of the opinion of some people, friends and otherwise, who suggested that I would do better to withdraw. There is more conceit than real self-esteem in staying in one's tent: besides, this way, I am consistent with my past record, since once I made up my mind, I continued to present myself."[75]

Increasingly weak and preoccupied with his work at Saint-Sulpice, Delacroix sent nothing to the Salons after the Exposition Universelle. When his health improved, he exhibited again in 1859, after taking special care with his submission: "I have achieved a true tour de force in finishing my pictures for the Salon," he declared in April to Dutilleux with satisfaction. "I have no fewer than *eight*. You are well aware that I am not a man who improvises something in such a situation: they are all at the point where the difficulties seem to have been overcome.

OPPOSITE (COUNTERCLOCKWISE)

221. *The Lion Hunt,* 1855 or 1856
Oil on canvas, 56.5 × 73.5 cm
Nationalmuseum, Stockholm

222. *The Lion Hunt,* 1861
Oil on canvas, 76.3 × 98.2 cm
The Art Institute of Chicago

223. *The Lion Hunt,* 1858
Oil on canvas, 90 × 116.5 cm
Museum of Fine Arts, Boston

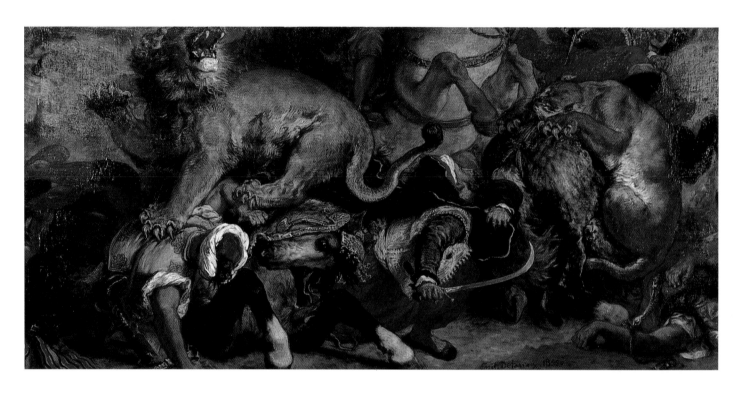

219. *The Lion Hunt,* 1855
Exhibited at the Exposition Universelle of 1855;
damaged in a fire at the Hôtel de Ville
de Bordeaux in 1870
Oil on canvas, 175 × 359 cm
(originally 270 × 359 cm)
Musée des Beaux-Arts, Bordeaux

220. Sketch for *The Lion Hunt,* 1854
Oil on canvas, 86 × 115 cm
Musée d'Orsay, Paris

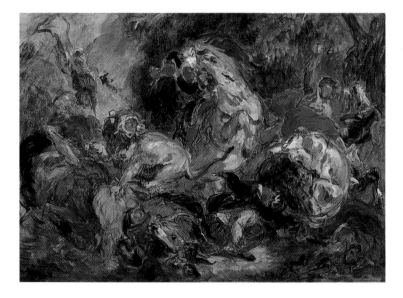

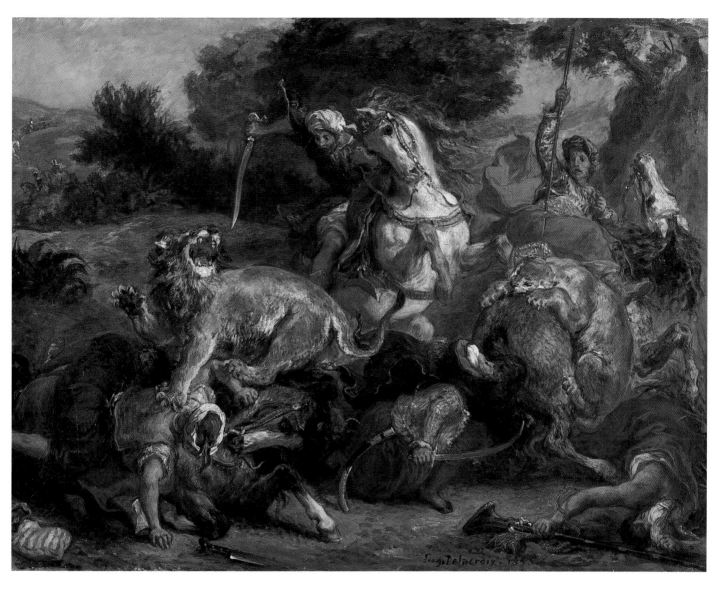

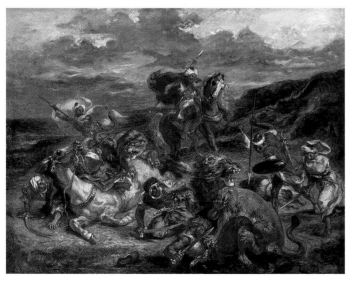

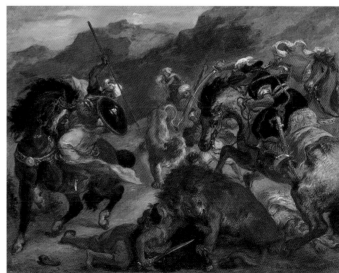

Yet I encountered some I had not expected: it is very, very difficult to apply the finishing touches. The danger consists in reaching the point where you can no longer usefully alter anything, and I am the alteration man."[76] Delacroix presented three religious subjects, *The Road to Calvary* (fig. 259), *The Entombment* (fig. 257), and *Saint Sebastian Tended by the Holy Women* (fig. 254); three literary subjects, *Erminia and the Shepherds* (fig. 248) from Tasso's *Jerusalem Delivered*, *The Abduction of Rebecca* (fig. 231) from Sir Walter Scott, and the final version of *Hamlet and Horatio in the Graveyard* (fig. 235); a Moroccan landscape, *The Banks of the River Sebou* (fig. 134); and a historical painting, *Ovid among the Scythians* (fig. 224). In this last painting, he was returning to a subject he had already treated in the library of the Palais-Bourbon (fig. 165): "Some study him curiously, others welcome him after their fashion and offer him wild fruits, mare's milk, etc."[77] All the characters are arranged in the lower half of the picture, with Ovid reclining on the left, and the Scythians around him; one of them milks a black mare in the foreground. In the upper half, a magnificent landscape—lake, hills, and a chain of mountains in the distance—spreads out beneath a blue sky across which float clouds. Thus, *Ovid Among the Scythians*, a historical painting, is also something of a historical landscape. And, indeed, the landscape was unanimously praised, no doubt because the audience was bothered by the rest of the painting—especially the overemphasized mare, described by critics as "the odd she-horse," "twin of the Trojan horse."[78]

In a Salon that was in general judged severely, Delacroix did not have the success he had perhaps taken for granted.[79] He received the respect due his age and position, but his works were not understood. *The Banks of the River Sebou*, for example, was harshly criticized. Maxime Du Camp spoke of "a spectacle of unpardonable decadence," and suggested that Delacroix "return to the literary works that he loves and to the music for which he was assuredly born."[80] It evidently looked like a step backward: "I heartily thank you for cheering me up a little about the result of these poor paintings that I almost regret exhibiting," Delacroix wrote Paul Huet. "Besides, I should be used to this result from nearly all my exhibitions. Either because my paintings are compared with the others, or for any other reason, such as the absence of varnish, etc., there is always a sort of hesitation to approve of them even among my friends or those who are used to my painting: all the more so among people who go only by word of mouth, or who prefer the newly varnished, loud tones of brand-new paintings best of all."[81] We sense here a man more disillusioned than hurt. He was more than sixty years old, and was working desperately to finish the Chapelle des Saints-Anges. This failure would be the last, for Delacroix would nevermore exhibit at the Salon, either because he could not find the time to finish painting for the event or because he considered the effort pointless.[82] He stayed before the public: his paintings appeared in other exhibitions, notably the benefit for the Artists' Relief Fund in 1860. His older works were being sold at auction, and dealers and collectors were commissioning new ones. His completion of Saint-Sulpice still kept him within the circle of active painters, in a certain sense, but he was no longer directed by the institution around which he had organized himself, year by year, for four decades.

As we have seen, the weight of specific circumstances makes it difficult to assign a logic to the sequence of Delacroix's submissions from 1833 to 1859. If there is one, it is an intimate reflection of the direction of his work, including the evolution brought about by the large decorative paintings. Stylistically and thematically, as before his trip to Morocco, the paintings that Delacroix exhibited are windows onto the broad directions of his activity.

After *Liberty Leading the People* in 1830, Delacroix almost never painted history again, except in the large works and those in the Luxembourg and the Palais-Bourbon. As his production grew, the small and medium-size historical subjects became increasingly rare, eventually representing only a tiny proportion of his work. Another notable difference from the years of his youth, was the spirit in which he approached the representation of history, which became for him less informed by literary references. One unmistakable sign was that he began to treat only ancient subjects, like those he had done in the library of the Chambre. In the 1830s, he had painted a small-size *Hippocrates Refuses the Gifts of the King of Persia*, a traditional, well-known subject that he would repeat in the *Science* cupola, and which Girodet had treated earlier, in 1792, in a famous painting emblematic of Neoclassicism, popularized through engravings, and against which Delacroix would inevitably and consciously have measured himself. The work, now lost,[83] is known only from an old reproduction, which suffices to demonstrate how Delacroix distanced himself from

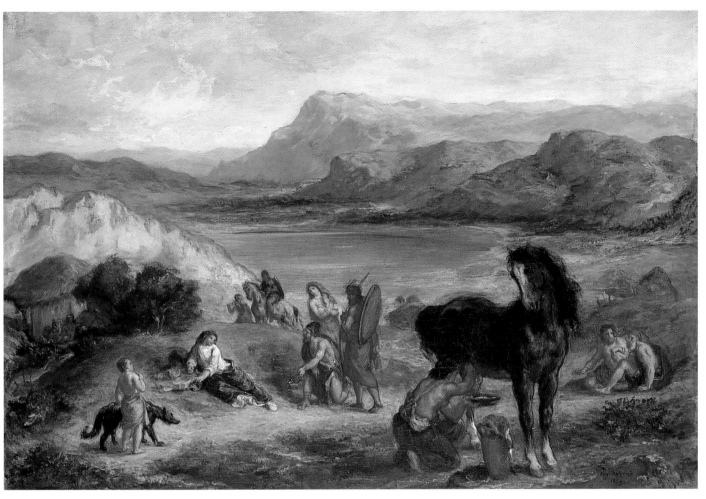

224. *Ovid among the Scythians*, 1859
Exhibited at the Salon of 1859. Oil on canvas, 88 × 130 cm
The National Gallery, London

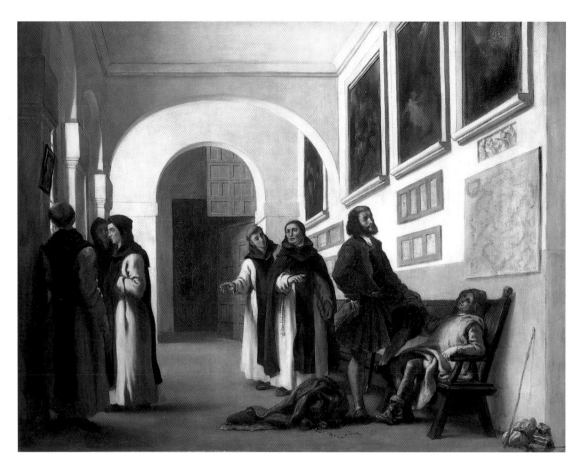

225. *Christopher Columbus at the Monastery of La Rabida*, 1838
Oil on canvas, 90.5 × 118.4 cm
The National Gallery of Art, Washington, D.C.

Girodet's work through a composition that is much livelier than that of his illustrious predecessor, who had organized his painting to look like a bas-relief frieze. *Lycurgus Consults the Pythia*, datable to 1842–43 and today in Ann Arbor, is even more closely related to his elaboration of the decoration of the Palais-Bourbon library, for which it was probably a sort of exploratory study. Delacroix later repeated several of his pendentives, adapting them to a rectangular format; one of them, among the strictly historical subjects, is *Archimedes Killed by a Roman Soldier*, painted around 1846. The tendency that is manifest in the large paintings and decorative works extends to the smaller easel paintings, executed for friends and collectors: Delacroix was approaching history either more as epic or, the reverse, more meditatively, but in both cases, he was moving away from the descriptive, picturesque manner that had characterized his Troubadour paintings of the mid-1820s. Yet

there are traces of these in two unrelated works painted in 1838, commissioned by Prince Demidoff for his palazzo in San Donato, near Florence (they remained unknown to their contemporaries until they were sold in 1870), and depicting two episodes in the life of Christopher Columbus, a fashionable subject at that time. Works by Washington Irving, Alexander von Humboldt, and Alphonse de Lamartine had brought Columbus into the public consciousness, and the figure of a great man, misunderstood and persecuted, was popular in Romantic circles: Delacroix was not alone in painting him. The first of his paintings, its setting vaguely inspired by a sketch he made during his Spanish escapade of 1832, was *Christopher Columbus at the Monastery of La Rabida* (fig. 225). The scene is described in the sales catalogue: "Seven years before the discovery of America, near the small port of Palos, in Andalusia, two foreigners traveling on foot, dusty, their faces bathed in

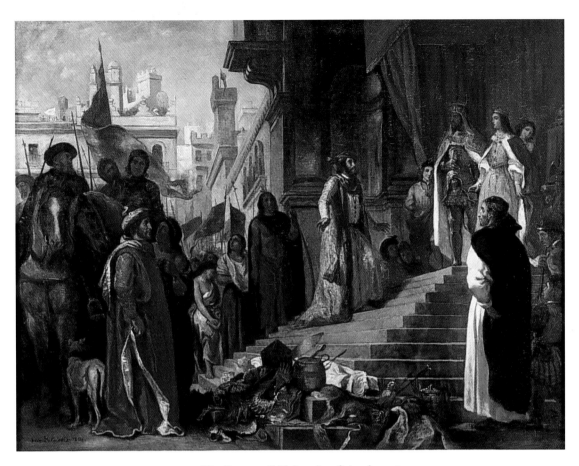

226. *The Return of Christopher Columbus*, 1839
Oil on canvas, 85 × 115.5 cm
The Toledo Museum of Art, Toledo, Ohio

sweat, appeared at the door of the small monastery of Santa Maria in Rabida. The two foreigners were Christopher Columbus and his son Diego. The prior, Don Juan de Marchena, came down to talk with them. This prior, a man of great heart and learning, became Columbus's friend, and supported him in his difficult undertaking." In the second, *The Return of Christopher Columbus* (fig. 226), he brings the Catholic monarchs the riches won in his first expedition to the New World. "Columbus made a state entrance into Barcelona; the entire city came out to meet him; he walked among the Indians that he had brought back and who wore the costumes of their country. Gold, gems, and other rare things were borne before him in open baskets and plates. Ferdinand and Isabella awaited him seated on their thrones, and when he appeared, amid his entourage, the Catholic rulers arose."[84] Alone among his paintings, these two were conceived as pendants. The spareness

and austerity of the former are in contrast to the latter's richness and ostentation; the counterpart of meditation and isolation are success and public acknowledgment. The standing monk on the right in *The Return of Christopher Columbus* connects the two episodes and recalls the role of intermediary that the prior played in introducing Columbus to the monarchs. There is anecdote here, as well as a distant literary reference, but they do not determine the painting's chief effect. For Delacroix, history was no longer simply a theater, it was also an object of meditation, except in the large paintings executed for the Salon or a museum. He ceased making small paintings of historical subjects not only because a passing fashion was ending, but because of a more intimate and interior development.

The case of the literary subjects was entirely different. Delacroix continued to paint these prolifically, repeating and

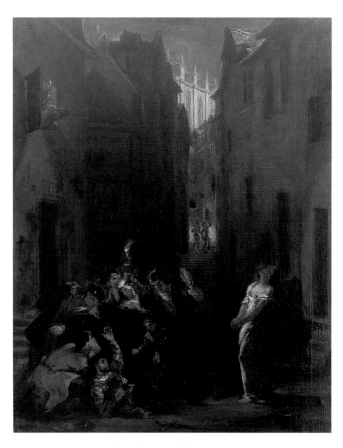

227. *The Death of Valentine,* 1847
Exhibited at the Salon of 1848. Oil on canvas, 82 × 65 cm
Kunsthalle, Bremen

developing the references of his youth, while extending them in meaningful ways. Goethe, Byron, Scott, and, Shakespeare were still his favorite authors. But at long intervals that became shorter toward the end of the artist's life, there also appeared Ariosto, Tasso, and the ancient tradition. Nevertheless, Delacroix remains, first and foremost, the incomparable illustrator of the Romantic authors, and thereby risked a certain discrepancy with respect to the direction in which the taste of collectors and critics was developing. Is this why he abandoned a series of lithographs, like the one he made for *Faust,* meant to illustrate another of Goethe's plays, *Goetz of Berlichingen*? Between 1836 and 1843, he had done seven, working on them at the same time as the *Hamlet* lithographs. Perhaps he considered simultaneous publication too much of a financial risk. Perhaps also, he anticipated an unfavorable reaction from the public, to whom such subjects might appear old-fashioned. Goethe's play had been translated and published in French in

1823. From 1824, Delacroix had been thinking of doing something with it, at the same time that he was considering *Faust,* as he looked at Cornelius's and Retzsch's engravings.[85] He was still thinking about it a few years later, around 1827, when he sketched seven subjects from *Goetz* on a notebook sheet.[86] This was a project from his youth to which he returned after some ten years. The action of *Goetz of Berlichingen* takes place during the period that Delacroix had chosen to illustrate *Faust.* The principal protagonist, a historical figure, a late fifteenth-century German knight, fights to keep the privileges threatened by the Emperor Maximilian. Certain prints from the second series, therefore, distantly recall the first one, such as *Brother Martin Clasping Goetz's Iron Hand* (fig. 229). But the line has become simpler, the realism greater. The framing is tighter around the figures, leaving less room for the setting. Here again, Delacroix abandoned picturesqueness and mannerism in order to focus interest on the figures alone, avoiding

the distraction of the setting, to develop a personal set of themes: doesn't *Weislingen Captured by Goetz's Men* recall the various versions of *The Combat of the Giaour and the Hassan*, one version of which (fig. 230) is exactly contemporary? Yet the other prints of *Goetz* lack the expressive power of the contemporary lithographs of *Hamlet*, as if Delacroix, seeking to achieve some distance from the descriptive letter of the text, had not found in Goethe the same philosophical depth as in Shakespeare. He did not, however, forsake Goethe: in 1848–49, for example, he painted *Goetz of Berlichingen Writes His Memoirs*, and at his death he left *The Wounded Goetz Taken in by the Gypsies*. The most significant painting from the play, *Weislingen Captured by Goetz's Men* (fig. 228), of 1853, in which he repeated and modified the earlier lithograph, is situated chronologically between the two paintings. The group consisting of Weislingen and the men of arms who are seizing him is nearly identical to the group featured in the other two paintings, but the foot soldier holding the horse, with his gesture, opens the composition to the left and to the ambush taking place below. The lithograph was constructed around a central mass, while the painting develops around a diagonal axis that accentuates the sense of imbalance. The setting in the painting, which is almost absent from the lithograph, also divides the scene cleanly in two, with the dark green tree on the right contrasting with the very pale blues of the sky on the left. The bright colors contribute to the impression of a melee in the central group. But in the end, the painting, despite its late date, is not as removed as one might think from the *Faust* lithographs, in particular in the excessive torsion of the knight on the right and the exaggerated camber of his horse's very thin neck: on this point, Delacroix did not become more restrained with time. Thus, one ought not be surprised by the criticisms that, at the Salon of 1846, greeted *Marguerite in Church*,[87] which virtually duplicated the lithograph of 1828. Though usually well disposed toward Delacroix, Planche remarked that "to give this well-conceived composition all the value, beauty, and interest that it deserves, the drawing of Marguerite would have to be corrected, the left thigh shortened, the face given some elegance, the hands corrected, the body thickened, and all given proper form; in short, what is indicated should be written, what has been begun should be completed, what is sketched should be painted."[88] *The Death of Valentine* (fig. 227), on the other hand, was extremely well received at the Salon of 1848.

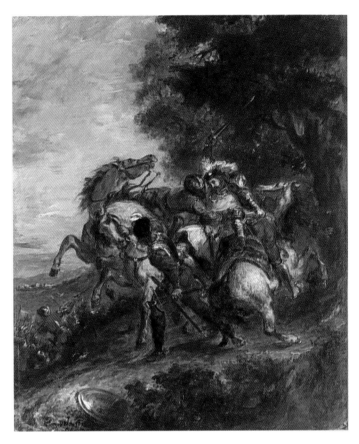

228. *Weislingen Captured by Goetz's Men*, 1853
Oil on canvas, 73.3 × 59.3 cm
The Saint Louis Art Museum

229. *Brother Martin Clasping Goetz's Iron Hand*, 1836
Lithograph (second of two states), 25.5 × 19.5 cm
Bibliothèque Nationale de France, Département des
Estampes et de la Photographie, Paris

230. *Weislingen Captured by Goetz's Men*, 1836
Lithograph (second of four states, after remarks were
removed and before letter), 30.5 × 27 cm
Bibliothèque Nationale de France, Département des
Estampes et de la Photographie, Paris

Delacroix, who had painted the small picture the year before, had already treated the subject in his lithographs of 1828: "Valentine, Marguerite's brother, mortally wounded by Faust, is surrounded by neighbors, who press around him. Marguerite, who, like the others, has run to him, stops, overcome by her dying brother's curses. In the painting's background, we see Faust and Mephistopheles fleeing."[89] But whereas in the lithographs Faust and Mephistopheles occupy a prominent place—both in the duel scene itself and in their flight, where they appear in the foreground, while the summarily sketched Valentine expires behind them—in the painting they are merely two silhouettes set off simply by the narrow corridor between the houses. Valentine and Marguerite are in the foreground, she, isolated completely on the right, he, surrounded by the crowd of neighbors on the left. Delacroix, who seemed to be distancing himself from the works of his youth by emphasizing a different figure, was, paradoxically, returning to a composition that was much closer to Cornelius's engraving of the same subject, and that was one of the possible sources of the 1828 lithograph. Nevertheless, his capacity for renewal was noticed, which could explain the critics' reversals. They especially appreciated the solitary, despairing figure of Marguerite, and were assuredly sensitive to the painting's expressiveness, despite its small size. This last painting inspired by Goethe sums up Delacroix's attitude toward the German poet in the second part of his career: a connection still heartfelt, but tempered by a certain distance.

The same is true of Sir Walter Scott, whom Delacroix also abandoned almost entirely, and through a similar process. After a few lithographs executed around 1830—*The Bride of Lamermoor, Steenie,* and several others from *Ivanhoe,* including *Richard and Wamba, Fronte-Boeuf and the Jew,* and *Fronte-Boeuf and the Witch*—he left the works that had so inspired him, only to return much later, in 1846, with another episode from *Ivanhoe, The Abduction of Rebecca* (fig. 232): the castle of Fronte-Boeuf has been taken by the troops of the Black

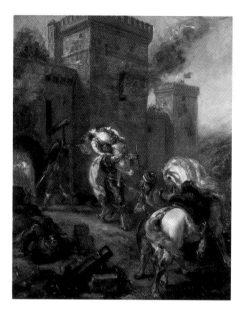

231. *The Abduction of Rebecca,* 1858
Exhibited at the Salon of 1859.
Oil on canvas, 105 × 81.5 cm
Musée du Louvre, Paris

Knight and Locksley, that is, Richard I and Robin Hood. Rebecca, abducted by the orders of the Templar Boisguilbert, who had long coveted her, is shown in the hands of two of his African slaves, who are to take her away from the battle. The painting's reception at the Salon was lukewarm. Delacroix was criticized, for example, for flaws in the drawing, the painting's too unfinished look, and Rebecca's lack of expression: "The two Africans undeniably emanate fierce energy and ruthless cruelty, but the limbs, bodies, and faces of the two slaves are barely indicated. The horse on which Rebecca is about to be placed is drawn, or rather, indicated, with so much confusion, that it can express neither terror nor prayer. As for her body, it is impossible to divine it beneath her clothing. Not only is this composition not painted in the serious meaning of the word, it is not even located."[90] It is true that Delacroix's usual energetically vigorous brushstrokes are here even more accentuated, as is often the case in the small- and medium-size works of his last twenty years. The painting is nevertheless skillfully constructed, rendering the subject particularly clear. In the foreground, Boisguilbert's African slaves are tying Rebecca to a rearing horse that bears a curious resemblance to the various Romantic *Mazeppas.* Boisguilbert is below on the right, while in the background the castle of Fronte-Boeuf, captured by storm, is burning. The figures stand out against a blue, green, and brown background, which gives the painting quite a lively overall tonality, with Boisguilbert's white mantle contrasting with the Africans' darker clothing, and the red of the saddle bringing in the necessary counterpoint. As for the scene's movement, is it not rendered by the opposing directions of the two horses, their rearing postures, the torsion of the two black men, and the swooning Rebecca's body, extended by the twisting path climbing toward the castle and the wreathing smoke of the blaze? Delacroix was able to render both the episode's swift brutality and the secondary, marginal value of the taking of the castle. Returning to the same subject ten years later, however, in a painting begun in 1856, finished in 1858,

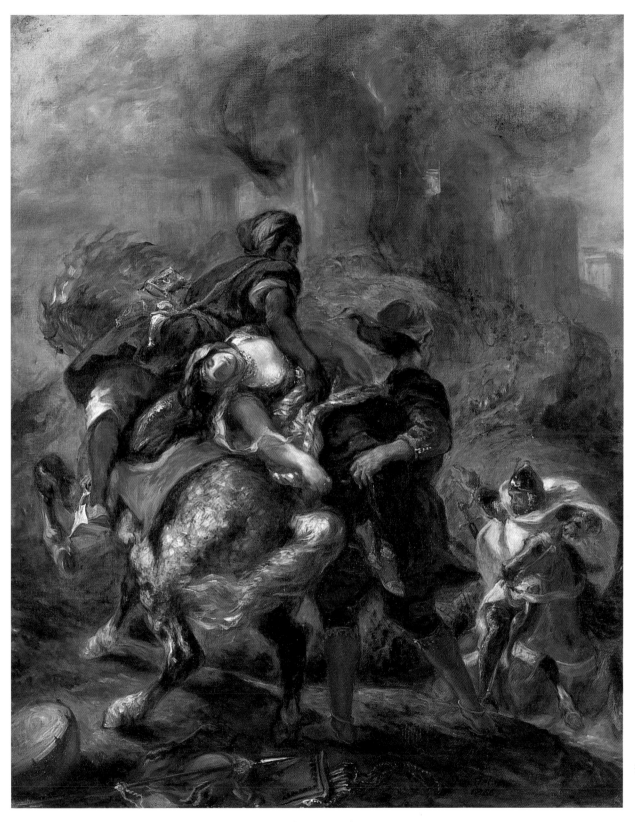

232. *The Abduction of Rebecca*, 1846
Exhibited at the Salon of 1846. Oil on canvas, 100 × 82 cm
The Metropolitan Museum of Art, New York

and exhibited at the Salon of 1859 (fig. 231), he radically changed the disposition of the various elements, this time choosing to represent Rebecca's abduction directly by Bois-guilbert. The scene takes place close to the castle, and, very simplified, is structured around a curve that connects the four figures. The overall tonality has also been modified, with the bright colors standing out like so many flashes of light against a much more emphatic brown background, instead of mixing harmoniously into one another. Thus, everything works together to enhance the dramatic atmosphere of the subject, yet the painting had few defenders; it was, again, seen as a draft, rather than as a finished composition. *Ivanhoe* seems to have particularly captivated Delacroix. In 1838, he once more painted *Rebecca and the Wounded Ivanhoe*—a subject that he had already treated in his youth—and indicated on a page of his journal more than twenty paintings to be done, all from the novel.[91] During the same period, he considered organizing individual, as yet unpublished, lithographs into various collections, dedicated to Goethe on the one hand, and Scott and Byron on the other, adding to the prints he had already done "those that are merely planned and do not pretend to a similar kind of execution." Although Delacroix's enthusiasm for Goethe, and even more for Sir Walter Scott, had somewhat cooled over time, these authors nevertheless remained a constant reference in the twilight of his life.

His admiration for Byron, however—a privileged source of inspiration—remained undiminished. In addition to *The Prisoner of Chillon* and the various versions of *The Combat of the Giaour and Hassan*, Delacroix executed works on other episodes of the same poem and several paintings inspired by *Lara* and *The Bride of Abydos*. Before 1840, Delacroix produced the second *Combat of the Giaour and Hassan* and *The Giaour's Confession*, a small painting that belonged to George Sand and in which the hero, having retired many years before to a monastery to atone for Hassan's death, tells his story on his deathbed. In 1847–48, another poem of Byron's provided him with the subject of *The Death of Lara* (fig. 233). Count Lara, returned from exile with his page, Khaled, has led a revolt against his cousin Otho. After waging a final, desperate battle against him, Lara falls, pierced by an arrow, and dies in the arms of his page, who is, in reality, a woman. Thoré expressed his admiration for the qualities that Delacroix had been able to demonstrate in such small dimensions: "Lara

seems as gigantic as a statue by Michelangelo, because of the quality of the shapes. Over him bends his page, hair all undone—his mistress—an angel whose soul is already passing through visible matter to soar toward the sky. The landscape is sublime in its grandeur, and the sky harmonizes perfectly with this moral storm."[92] The poem is more than illustrated, it is transcribed into the plastic language of painting, which gives it a sensual equivalent. Byron was Delacroix's point of departure, but the artist went beyond the letter of the text, seeking to render, in his own medium, Byron's very spirit, with which he felt close sympathy. He would return to Byron more and more frequently: in 1849, in *The Giaour Pursuing the Ravishers of His Mistress* ("he reaches the shore, quivering because he cannot hurl himself after the boat that is taking them away"),[93] then in *The Bride of Abydos*, from the poem that would provide subjects for four paintings.[94] Yet again, Delacroix put into concrete form an admiration and projects that dated from his youth. Zuleika, whom her father, the old pasha Giaffir, had promised to an old man, has fallen violently in love with Selim, with whom she has been raised. She flees the harem with him, and, in a cavern by the sea, he reveals to her that he is the leader of a band of pirates, who await only his signal, a pistol shot. As Giaffir and his men approach in pursuit of the fugitives, Selim shoots. But Selim's men cannot help him, and he is killed by Giaffir; Zuleika, in turn, dies of sorrow. Delacroix chose the most dramatic moment, when everything is suspended. Giaffir is approaching, Selim prepares to defend himself and hopes that his friends will come quickly to his aid. Love merges with the expectation of the fray and of death. The artist returned to this composition a little later, this time in a vertical, not horizontal, format, and continued research into another painting, executed in 1852–53. The two lovers are more closely joined, embraced by the curve of the scimitar. The last version, painted in 1857 (fig. 234), presents the most successful composition: the middle group is virtually identical, but is even better encircled, due to changes in the rocky landscape, now set off against the sky. Delacroix also employed a less uniform, more skillful color harmony, by contrasting warm and cool tints. One year later, he painted his last work inspired by Byron, a second version of *The Death of Lara*. Lara and his page are less prominently positioned than in the first version, since Delacroix has instead developed the landscape, now far wilder and markedly diluting the scene's

233. *The Death of Lara,* 1858
Second version of the theme treated for the Salon of 1848.
Oil on canvas, 61.5 × 50 cm
Private collection

234. *The Bride of Abydos,* 1857
Oil on canvas, 47 × 38 cm
The Kimbell Museum of Art, Fort Worth

tragic atmosphere, here relatively downplayed. *Lara* was the last of the series of paintings—uninterrupted for more than thirty years—whose subjects he had taken from Byron. But while he had remained faithful to this source of inspiration, which had been so important to him since the 1820s, another writer now took the lead: Shakespeare.

The compositions taken from Shakespeare occupy a special place in the body of Delacroix's work, if only by virtue of their number—nearly twenty paintings between 1835 and 1859; a series of sixteen lithographs from *Hamlet*, executed between 1834 and 1843; and a few individual prints. The chronology is significant as well: Delacroix illustrated Shakespeare essentially during the second half of his career, after his trip to Morocco. Finally, we should note that only some of the plays captured his interest: *Hamlet, Othello, Romeo and Juliet*, and *Macbeth*. Over the course of the period, *Hamlet* supplied material for nine paintings, *Romeo and Juliet* for four. One could even legitimately speak of identification, so obsessed was Delacroix with the figure of Hamlet between 1835 and 1859. Yet, such a description of Delacroix's state of mind should be more nuanced, in keeping with the opinions on Shakespeare that he expressed in many passages of his journal. The sincere and lively admiration Delacroix felt for him—going back to his youth, when, like all the Romantics, he had enthusiastically promoted him[95]—was a deeply considered one. For Delacroix, Shakespeare had been first and foremost the painter of life, life that was real because it was multifaceted: "I thought of all that inexhaustible variety of nature, ever consistent with itself, ever various, taking on the most diverse forms using the same means," he noted during a stay in Augerville. "The idea of the old Shakespeare immediately came to my mind, he who creates with everything that comes to hand. Each character, placed in a given circumstance, appears to him all of a piece, with its own nature and face. With the same human given, he adds or subtracts, he modifies his material and makes you men that he has invented, but who are real. . . . That is one of the surest marks of genius. Molière is like that, Cervantes is like that. Rossini, with his alloys, is like that. If he differs from these men, it is in a more nonchalant execution. Through a peculiarity that one rarely finds in men of genius, he has formulas, habitual patchworks that extend his manner, always obviously his own, but not stamped with the seal of power and truth. As for his fertility, it is inexhaustible, and where he has

wished to be, he is real and ideal at the same time."[96] Like all great artists, he reveals to humankind reality: "Shakespeare is very refined. By painting with great depth certain feelings that the ancients ignored, or of which they were even unaware, he discovered a whole little world of feelings that are, in all men and all times, in a state of confusion, and that seemed destined never to see the light of day, to be analyzed, until a particularly gifted genius brought his torch into the secret corners of our souls."[97] However, in a conversation with his childhood friend Professor Philarète Chasles, Delacroix agreed that Shakespeare was less an artist than a philosopher: "He does not seek unity, the summary, the type, as artists do, he takes a quality: it is something he has seen and that he examines by showing it to you realistically."[98] Returning later to this conversation, he developed this idea: "He is neither a comic playwright, nor a tragedian, strictly speaking; his art is all his own, and his art is as psychological as it is poetic. He does not portray the consummately ambitious, jealous, or wicked man, but rather a certain jealous man, a certain ambitious man, less a type than a nature with its specific nuances. Macbeth, Othello, and Iago are anything but types; the details, or rather singularities, of these characters might make them resemble individuals, but they do not give an absolute idea of each of their passions. Shakespeare has such a power of reality that he causes us to accept his character by means of a portrait, as it were, of a man we could have met."[99] His strength, therefore, is not of the classical kind: Shakespeare does not move us in the way that Michelangelo or Beethoven do, but instead through disproportion, the gigantic and exaggerated aspect.[100] But that is exactly what makes him a painter's writer: "I infer that, in general, it is not the greatest poets that offer the most to painting; those who offer the most are those who are the most descriptive. The truth of the passions and characters are not necessary. Why is Ariosto, despite his very paintable subjects, less conducive to being represented in paintings than Shakespeare or Lord Byron? I believe it is because the two Englishmen, though they have a few prominent traits that strike the imagination, are often inflated, bloated. Ariosto, on the other hand, paints so much with the means of his art, so little abuses interminable, picturesque description, that there is nothing one can steal from him. One can take from one of Shakespeare's characters his striking effect, that character's sort of picturesque reality, and add a degree of finesse, according

to one's ability; but Ariosto! . . ."[101] The importance of Shakespeare's themes for Delacroix, therefore, stems as much from the painter's personal taste, as from the playwright's specific qualities, which make him particularly suitable for translation into images.

Beginning in 1828, Delacroix drew a lithograph of *Hamlet and Horatio in the Graveyard* (fig. 236), illustrating act five, scene one of *Hamlet*. The gravedigger has just handed Hamlet the skull of Yorick the jester. Hamlet, walking in the cemetery with his friend Horatio, is about to speak the famous "Alas, poor Yorick . . ." monologue. Ophelia's funeral procession is passing in the background. The atmosphere is very like that of *Faust*, which Delacroix had just finished: the theatrical attitudes of the three figures, the mannerism of the positions, the picturesque costumes, and the expressive richness of the very detailed setting. He may have made a painting of this subject at the time; it is now lost, but one may imagine it as close to the lithograph and to a contemporary watercolor with the same elements—Hamlet and Horatio contemplating Yorick's skull, the gravedigger halfway into the grave, the procession in the background, and the church tower—but in a vertical format.[102] In any case, seven years later he simplified and refined the composition (fig. 238). Hamlet is seated on the edge of the gravestone, Yorick's skull in his hand; Horatio is standing; they are alone in the cemetery, which extends into the distance. The sky, which takes up half the painting and which sets off Horatio's upper body, contributes to the scene's funereal atmosphere. But is it Yorick's skull? In the play, Hamlet handles several skulls before he meets the gravedigger, or rather gravediggers. Delacroix, abandoning the exaggerated expressiveness of the lithograph, here insists on Hamlet's solitary meditation and the two friends, each withdrawn into himself, not talking. The painting was rejected for the Salon of 1836, which provoked strong feelings among Delacroix's supporters. This rejection is difficult to understand, since the painting looks far more "finished" than other works that the jury accepted. The jury's antagonism toward the painter might have been coupled with a desire to make a pointed example on an extremely sensitive subject, Shakespeare being, at the time, a symbol of the gulf between classicals and Romantics, and *Hamlet and Horatio* being the first Shakespearean subject that Delacroix had submitted. This rejection did not prevent Delacroix from returning to it. The painting exhibited at the Salon of 1839 (fig. 237), was very successful, as we have seen. The composition is very different from the two previous versions: the two gravediggers are in the foreground, and one of them shows Yorick's skull to Hamlet and Horatio. The attitudes are more precise, and the scene more expressive because it is more descriptive and less vague. The subtle graduation upward, which more effectively brings the viewer into the scene, still allows the skull, standing out against the sky, to be the true center of the painting.

Delacroix did not stop with this success. Working intermittently, after 1834, on his *Hamlet* series of lithographs, he obviously had to include the cemetery scene. His print of 1843 (fig. 239) altered the painted version of 1839 somewhat, as well as reversing it. The setting is more explicit, with the cross in the right background and the castle walls on the left. The two gravediggers are slightly different (the arm of one, the tilt of the other's head). Hamlet sets one foot on the grave, and Horatio, instead of also leaning over, turns in an opposite movement that introduces an additional tension. Fifteen years later, Delacroix produced his last interpretation (fig. 235), which, paradoxically, repeated the first lithograph, of 1828. Once again, he conflated two successive episodes of the scene —Ophelia's burial and the monologue over Yorick's skull— adding a curious inversion of the conventional representations of Horatio and the now-bearded Hamlet that he had previously followed. But he connected the two groups—a connection lacking in the lithograph—by means of the second gravedigger, who is waiting for the coffin, but looking at the grave. The funereal atmosphere, rendered in a color range that is both warm and muted, is another unifying factor. For thirty years Delacroix continually rearranged the various elements of the scene, from the settings to the characters; without ever straying from the text, he produced a different interpretation each time, by emphasizing one or another aspect. He extended this process to other scenes from *Hamlet* as well. For example, Delacroix treated Ophelia's death four times: first in 1838, in an almost monochrome painting, "neither a grisaille, nor a work entirely in color," according to Villot, to whom it belonged; it seems that the painter was so satisfied with it at that point that he deliberately did not push it further, despite its unfinished quality. In 1844, immediately following the lithograph from the *Hamlet* series of 1843 (fig. 242), there was a new painting, like that of 1838 except that he "finished" it,

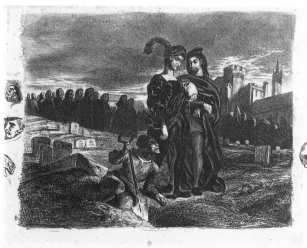

235. *Hamlet and Horatio in the Graveyard*, 1859

Exhibited at the Salon of 1859.
Oil on canvas, 29.5 × 36 cm
Musée du Louvre, Paris

236. *Hamlet and Horatio in the Graveyard*, 1828

Lithograph (first of three states, with remarks in the margin), 34.7 × 26.1 cm
Bibliothèque Nationale de France, Département des Estampes et de la Photographie, Paris

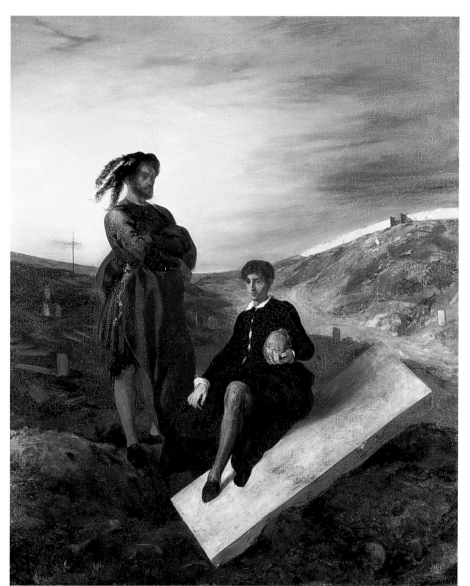

ABOVE

237. *Hamlet and Horatio in the Graveyard*, 1839
Exhibited at the Salon of 1839. Oil on canvas, 81.5 × 65.4 cm
Musée du Louvre, Paris

LEFT, TOP

238. *Hamlet and Horatio in the Graveyard*, 1835
Rejected by the Salon of 1836. Oil on canvas, 100 × 81.3 cm
Städelsches Kunstinstitut, Frankfurt

LEFT, BOTTOM

239. *Hamlet and Horatio in the Graveyard*, 1843
Lithograph (second of three states, with letter
and Villain's name), 28.3 × 21.4 cm
Bibliothèque Nationale de France, Département
des Estampes et de la Photographie, Paris

and, then, a last version in 1853.[103] In these works, the variation is even more subtle, for the composition is practically identical in each case, aside from the inversion of Ophelia in the last painting, where she drifts to the left, not the right. The slight differences concern the framing of the image, the position of the body, a few elements of the landscape, the paintings' more-or-less finished look, and their tonalities. For both *Hamlet and Horatio* and *The Death of Ophelia*, the importance of the lithographic series should be noted: it became integrated naturally into the process of reinterpretation and redoubles it with the transition from color to value. For example, in 1848–49, Delacroix virtually replicated three prints from this series (*Hamlet about to Kill Polonius*, *Hamlet and the King at His Prayers* [fig. 241], and *Hamlet and Ophelia*) in paintings of the same format, probably following specific requests on the part of dealers.[104] In the case of *Hamlet Has Just Killed Polonius*, of 1855–56, the last painting on a subject from *Hamlet*, he introduced a number of modifications with respect to the lithograph of 1835, entitled *Hamlet and the Body of Polonius*

(fig. 240), most apparent in Hamlet's position and the presence of Queen Gertrude.[105] The *Hamlet* series turns out to be a point of departure for Delacroix and, later, a point of reference. In 1834, it was the beginning of Delacroix's illustration of the play, a project that he pursued until 1843. Three sheets date from 1834 (*The Queen Tries to Console Hamlet*, *Hamlet and the Queen*, and *Ophelia's Song*); three from 1835 (*Hamlet Sees the Ghost of His Father* [fig. 243], *Hamlet Causing the Players to Perform the Scene in Which His Father Is Poisoned*, and *Hamlet and the Body of Polonius*); and six from 1843 (*The Ghost on the Terrace*, *Hamlet and the King at His Prayers*, *The Death of Ophelia*, *Hamlet and Horatio in the Graveyard*, *Hamlet and Laertes in Ophelia's Grave*, and *The Death of Hamlet*). Four are undated (*Hamlet and Polonius*, *The Murder of Polonius*, *Hamlet and Guildenstern*, and *Hamlet and Ophelia*). The execution of the lithographs, interspersed with the actual pictorial work, must have now and again invigorated and supported it. Unfortunately, it is impossible to know more specifically the extent to which they affected each other, given the

240. *Hamlet and the Body of Polonius*, 1835
Lithograph (second of three states, with letter and Villain's name), 25.5 × 17.7 cm
Bibliothèque Nationale de France, Département des Estampes et de la Photographie, Paris

241. *Hamlet and the King at His Prayers*, 1843
Lithograph (first of two states, with letter and Villain's name), 26.3 × 18.1 cm
Bibliothèque Nationale de France, Département des Estampes et de la Photographie, Paris

uncertainty that surrounds the exact chronology of the prints. The published series (thirteen of the sixteen plates, since Delacroix set aside *Hamlet and Ophelia*, *Ophelia's Song*, and *Hamlet and Laertes in Ophelia's Grave*) was not a bestseller.[106] It is very different from *Faust*, however, in that Delacroix demonstrated a much more sober, substantially less expansive style. The tension is entirely within the characters themselves, and they are drawn very realistically. The line has become simpler, the contrasts, often, less marked. Here, Delacroix very clearly distanced himself from his traditional Romantic prints, *Faust* being an obvious example. This shift is quite evident in the two ghost scenes from *Hamlet*, which have very little of the uncanny about them.

Delacroix treated other plays by Shakespeare more intermittently. For example, he twice drew from *Romeo and Juliet*,[107] in a small painting exhibited at the Salon of 1846, *Romeo Bids Juliet Farewell* (fig. 244), and around 1855 in a painting now lost, *Romeo Lifts Juliet from the Capulet Tomb*. The first was violently attacked for the lack of idealism in the treatment of the lovers' faces and attitudes, and for the laxity of the brushstrokes. But in 1855 Charles Perrier praised it for those very qualities in *L'Artiste*, on the occasion of the Exposition Universelle. His remarks could have applied to many of Delacroix's paintings, especially those he was painting at the time: "There is in this work some vaguely poetic and harmonious quality, arising from the halting effect of the figures and the indecisiveness of the contours. . . . If the forms had been precise and firm, they might have produced a poem perfect in its delicacy, but would never have managed to render the mysterious aching in the touching love between Romeo and Juliet as Shakespeare revealed them to us."[108] The critics were for the most part quite harsh about another small Shakespearean painting, *Othello and Desdemona* (fig. 245), presented at the Salon of 1849. Delacroix had been familiar with the play *Othello* since his youth. He had seen two of the most famous actors of the day, Kean and Kemble, in the role, and had later had the opportunity to hear Rossini's opera.[109] He had drawn inspiration from it only once before he returned to the subject in several paintings, *Desdemona Cursed by Her Father* (fig. 246), *Desdemona and Emilia* (now lost), and *The Death of Desdemona*, which he left unfinished. The influence of the stage is evident in both *Othello and Desdemona* and *Desdemona Cursed by Her Father*. The harp in the former, for example, is a direct

242. *The Death of Ophelia*, 1843
Lithograph (second of three states, with letter and Villain's name), 18.1 × 25.5 cm. Bibliothèque Nationale de France, Département des Estampes et de la Photographie, Paris

243. *Hamlet Sees the Ghost of His Father*, 1835
Lithograph (second of three states, with letter and Villain's name)
Bibliothèque Nationale de France, Département des Estampes et de la Photographie, Paris

reference to Rossini's work. But its manifest theatricality derives from the painting itself: the expressiveness of the attitudes, dramatic chiaroscuro, and strong contrasts emphasized by the use of red are found, throughout the painting in *Othello and Desdemona* and are concentrated on Brabantio in *Desdemona Cursed by Her Father*.

Shakespeare, Goethe, Byron, and Scott: both before 1830 and after, Delacroix found his essential "literary" inspiration in only a handful of writers. He was never very close to the French Romantics, who provided subjects for only a few paintings: Hugo, perhaps, for *African Pirates Abducting a Young Woman*, more likely Dumas and George Sand, Dumas for *Queen Christina and Sentinelli*, taken from the epilogue of his drama *Christine*, and Sand for two versions of *Lélia Mourns over Sténio's Body*. Delacroix had been very impressed by a performance of Dumas's play in March 1830. "I am preoccupied with choosing a project from your *Christine*, to serve you a dish in my style," Delacroix wrote him shortly after. "You have given me very keen feelings, the kind one is no longer used to finding at the theater. I hope only to reproduce a portion."[110] He almost certainly had an engraved frontispiece in mind. We do not know why he waited some fifteen years to paint the final scene, in which Christina of Sweden, in her death-throes, on her deathbed, calls for Sentinelli, her former captain of the guards, without knowing his identity—he has become a monk to atone

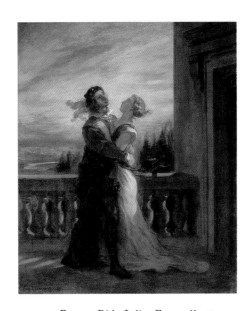

244. *Romeo Bids Juliet Farewell*, 1845
Exhibited at the Salon of 1846. Oil on canvas, 61 × 50 cm
Private collection, United States

245. *Othello and Desdemona*, 1847–?49
Exhibited at the Salon of 1849. Oil on canvas, 50.3 × 60.7 cm
The National Gallery of Canada, Ottawa

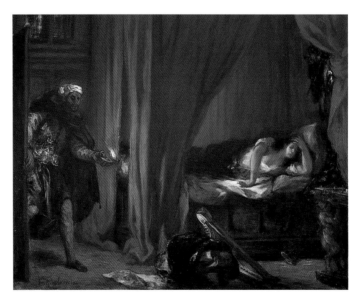

for the murder of his squire, Monaldeschi, perpetrated at the queen's command. The scene from *Lélia* is equally dramatic: the poet Sténio finds again his lover, Lélia, who had entered a convent after being betrayed. She tells him that she no longer loves him. In despair, he drowns himself. Lélia then cries out her love to his dead body, in a cave inhabited by a monk, Magnus. Delacroix immediately sold the first version, of 1847, a very small painting that may have been commissioned, to Beugniet, a dealer. He painted the second expressly for George Sand, to whom he gave it as a New Year's gift in December 1852.[111] *Lélia* and *Queen Christina* are thus clearly unrelated, occasional works, which, unlike Delacroix's other literary subjects, are not part of a logical, continuous thematic development. The case of the more classical subjects to which he turned at the end of his life is very different. Not surprisingly, he returned to Dante, with *Ugolino and His Sons in the Tower*,[112] which in certain ways recalls *The Prisoner of Chillon* and—following his decorative works—to classical mythology: *Perseus and Andromeda*, *Hercules Resting from His Labors*, *Hercules and the Horses of Diomedes*, *The Education of Achilles*, and *Ariadne Abandoned*. Some of these paintings borrowed more or less from the compositions of the Hôtel de Ville and the library of the Palais-Bourbon, others denote a new direction for the painter, like the three versions of *Perseus and Andromeda*.[113] But what is most surprising is his

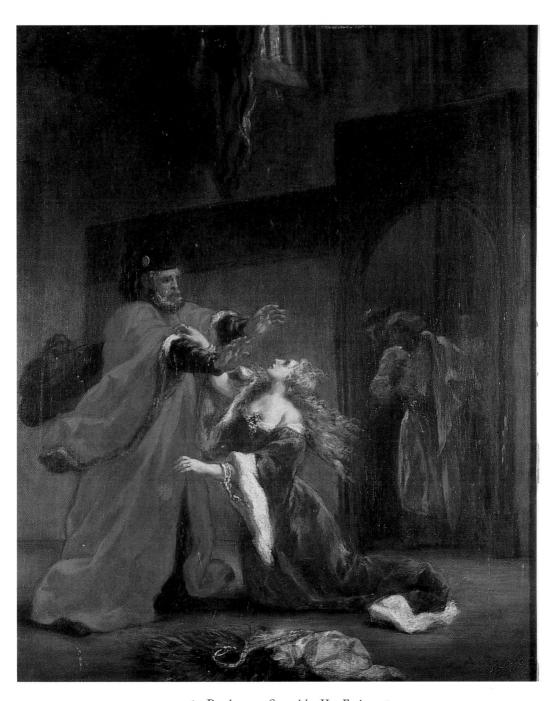

246. *Desdemona Cursed by Her Father*, 1852
Oil on canvas, 59 × 49 cm
Musée Saint-Denis, Reims

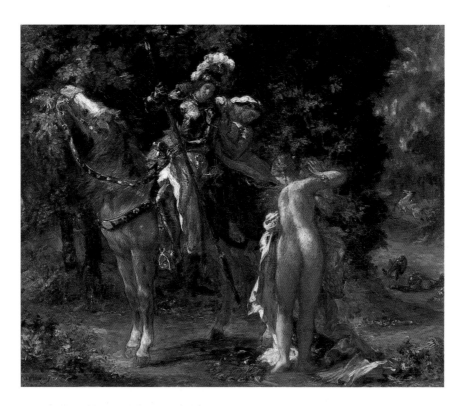

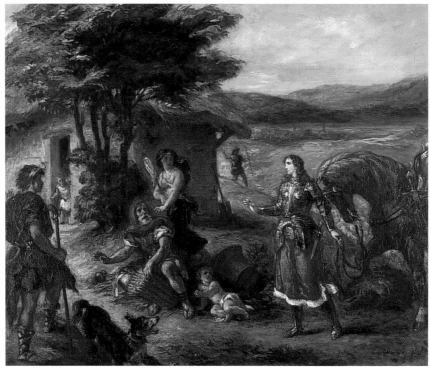

247. *Marfisa and Pinabello's Lady*, 1852
Oil on canvas, 82 × 101 cm. The Walters Art Gallery, Baltimore

248. *Erminia and the Shepherds*, 1859
Exhibited at the Salon of 1859. Oil on canvas, 82 × 104 cm
Nationalmuseum, Stockholm

taking on such traditional subjects, from Ariosto and Tasso, which had been very popular among painters of the Renaissance and the Classical age, but which in the nineteenth century seemed utterly unfashionable. From a strictly literary point of view, Delacroix esteemed them very highly indeed (we have already encountered his opinion of Ariosto). How could paintings add to such finished, perfect texts? The weight of pictorial tradition came close to inhibiting Delacroix completely—he did not attack *Jerusalem Delivered* and *Orlando Furioso* until very late, when he had reached maturity and was fully confident in his craft and his talent. However, the fact that he did not paint several versions of these works may also be evidence of a persistent reluctance on his part. Furthermore, we may point out that he exhibited only one, *Erminia and the Shepherds*, at the Salon, and as late as, in 1859. The first, *Marfisa and Pinabello's Lady* (fig. 247), dates to 1852. The subject is taken from *Orlando Furioso*.[114] Marfisa, a female knight, is riding with an old woman, Gabrina, mounted behind her. She meets Pinabello, with his lover, who mocks the old lady. Marfisa forthwith fights Pinabello, whom she fells with a lance stroke, and forces his companion to give all her clothes to Gabrina. We can see Pinabello on the ground, to the right, and his horse rearing on the path, a little further on; the middle group illustrates Ariosto's poem perfectly. But isn't this a pretext, a pretext for the sumptuous female nude that Delacroix obviously painted with the greatest care, in order to give it the desired tones and transparency,[115] or for the quivering horse, and the copse that sets off the scene? The painter multiplied the harmonies and delicate contrasts, especially in the red, white, and green clothing that Gabrina snatches up—which set off the stripped body of the impertinent young woman—and in the horse's trappings—the colors of which play against her dress. Illustration yields to poetic evocation, as in the other paintings that Delacroix later regularly derived from Ariosto and Tasso, and sometimes found difficult to finish: *Clorinda Rescues Olinda and Sophronia* (1853–56), *Ruggerio Rescues Angelica* (1856), and *Erminia and the Shepherds* (1859) (fig. 248).[116] Erminia, a Syrian princess, has fled Jerusalem dressed as Clorinda, to find Tancred, whom she loves. Drawn by music and singing, she discovers a group of shepherds: "Upon suddenly seeing unknown arms, they are disturbed and frightened; but Erminia greets them and reassures them: 'Happy shepherds,' she says, 'continue your games and your labors; these arms are not in-

tended to disturb your work or your songs.'"[117] Symbolically, the painter of *Scenes from the Massacres of Chios* and *Entry of the Crusaders into Constantinople* relinquished the sorrows of war and celebrated peace in this last pastoral scene.

Following his trip to Morocco, Delacroix continually expanded his thematic field: to the subjects that he had taken on in his youth and still explored in a parallel development, he added Orientalism, mythology, ancient history, and classical literature, as well as sacred history, which posed a particular problem. In nineteenth-century France, religious painting was undergoing a period of intense renewal, as much from an aesthetic as from a purely theoretical point of view, that is, the relationship of the work to dogma, the expression of faith, and the sensibility of the faithful.[118] Delacroix, however, remained isolated, outside this movement.[119] Yet, a few of his key works are on religious subjects, from his first two important paintings, *The Virgin of the Harvest* and *The Virgin of the Sacred Heart* in the Chapelle des Saints-Anges in Saint-Sulpice, to *The Agony in the Garden*, *Christ on the Cross* of 1835, the *Saint Sebastian Tended by the Holy Women* of 1836, the *Lamentation* of Saint-Denis-du-Saint-Sacrement in 1843, the *Lamentation* of 1848 (fig. 250), and the continuous flow of numerous small paintings. By 1832, Delacroix had made some fifteen religious paintings. Between 1835 and his death, he would execute more than seventy, most of them in his last years, while he was painting at Saint-Sulpice. Does this impressive production, increasing over time (even allowing for the small size of many of the works), mean that Delacroix was a religious painter, or, more specifically, a Christian painter? In other words, is there a meaningful connection to his convictions, and ought we explain one in terms of the other? Nothing really permits us to do so. The famous passage from his journal is often quoted in the context of his beliefs: "God is within us: he is the inner presence that causes us to admire what is beautiful and to feel joy when we have done right, and consoles us for not sharing in the malicious man's happiness. It is surely he who creates the inspiration of men of genius, and who excites them at the sight of his own creations. There are men of valor as there are men of genius; both are inspired and favored by God. The opposite would therefore be true: there would be natures upon which divine inspiration has no effect, who coldly commit evil acts, who will never feel joy at the sight of honesty and beauty. There are, therefore, some

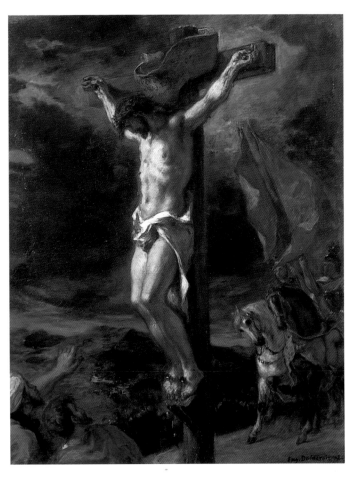

249. *Christ on the Cross,* 1846
Exhibited at the Salon of 1847.
Oil on canvas, 80 × 64.2 cm
The Walters Art Gallery, Baltimore

who are favorites of the Eternal Being. The misfortune that often, indeed, too often, seems to beset these great hearts does not, fortunately, cause them to give in during their brief passage: the sight of the malicious being showered with fortune's gifts must not defeat them. . . . Their inner satisfaction in obeying divine inspiration is reward enough."[120] Delacroix's spirituality was never circumscribed within the strict beliefs of any church or practices of any religion: it extends, in a vague and diffuse way, to the whole world. He was not a materialist; as heir to Voltaire and eighteenth-century philosophy, he was perhaps a deist, but not a believer. Why then did he paint so many religious pictures? First of all, because some of them were commissioned from him during the general movement to restore the churches that followed the Revolution; this was the case with his three major religious paintings during the Restoration, as well as with the Saint-Denis *Lamentation* and the Chapelle des Saints-Anges. This was also true of many of the small pictures of his last years, painted at the request of collectors and dealers. As for the rest, they emerged from a personal initiative, including the large Salon paintings. But these are, precisely, paintings, not devotional objects. What happened to the three paintings by Delacroix that the State sent to places of worship is very illuminating on this point: *The Agony in the Garden* was damaged by dampness in the church of Saint-Paul-Saint-Louis, where it was also hard to see, and had to be restored in 1855.[121] *Saint Sebastian*, which the church council of the parish of Nantua wanted to sell in 1869 (the transaction was called off when the city council intervened, upon public protest), was in equally poor condition. As for *Christ on the Cross*, it suffered an even worse fate.[122] Exiled to Vannes, to a dark chapel in the church of Saint-Paterne—indeed, according to local tradition, relegated to the belfry—its very existence was in jeopardy. When Delacroix was informed of this, he was upset. The letter that he wrote to the Minister of State at that time reveals how he viewed religious painting, and also shows, incidentally, the limits of his reputation: "I have learned that this work, placed long since in a dark, damp chapel of this church, is now threatened with complete destruction if the situation continues any longer." He then requested that the painting be sent back to Paris, because the city of Vannes had no museum where it might be kept safe after it was restored, and the church had demonstrated how little care it was receiving. "It has further

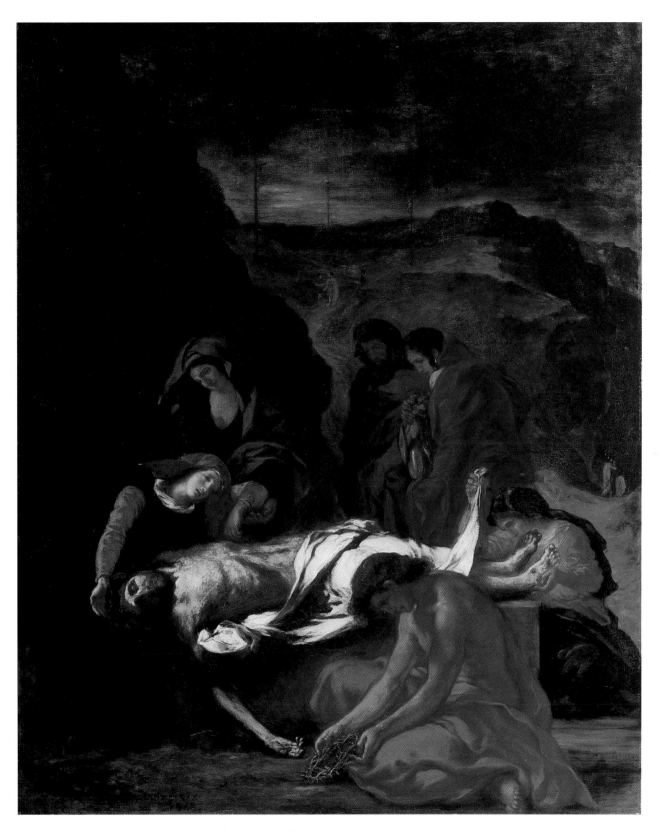

250. *The Lamentation*, 1848

Exhibited at the Salon of 1848. Oil on canvas, 161.3 × 130.5 cm
Museum of Fine Arts, Boston

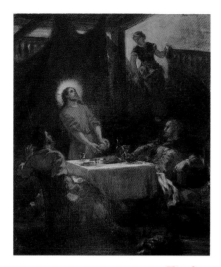

251. *The Supper at Emmaus*, 1853
Exhibited at the Salon of 1853. Oil on canvas remounted on wood, 56 × 46 cm
The Brooklyn Museum, New York

252. *Saint Stephen Borne Away by His Disciples*, 1862
Oil on canvas, 46.7 × 38 cm. Barber Institute of Fine Arts, Birmingham, England

been suggested to me that the reason for the unfavorable placement of my painting might have been a figure of the Magdalen that could have appeared insufficiently draped to the clergy. This might appear to Your Excellency to be another reason why this painting, which I composed with no intention of seeing it appear in a church, should obtain a new site after it has been properly repaired."[123]

The reception of *Christ on the Cross* at the Salon of 1835 is equally revealing. The two most favorable reviews saw very clearly that Delacroix had set out to make a painting, rather than express any particular religious sentiment, and that the viewer's feeling is evoked essentially by the artist's talent as a painter.[124] *L'Artiste* insisted upon the paradoxical novelty of the subject: "Where is religious belief? Where is the Christian faith today? . . . We must be grateful to M. Delacroix for this, for not having given up on the Gospel. *Christ on the Cross,* the recurring subject of numerous masterpieces during the ages of faith, did not frighten the creator of *The Prisoner of Chillon.* Now, this endeavor, which one may call new after eighteen times one hundred years, has been a fortunate one for M. Delacroix. He chose for his Passion the instant in which the sky became covered with clouds, the earth quaked, the veil of the temple was rent in twain from top to bottom; a somber, funereal color envelops the mountain. . . . This Magdalen is

wonderful in her effect, the pose is entirely new; that is the beautiful hair that once dried the feet of Our Lord; that is the Gospel's beautiful Magdalen, that grain of ungodly incense burnt upon the Savior's altar; in short, in its overall effect, in that movement, in the arrangement of its figures, M. Delacroix's Calvary is both grand and solemn; it may not be a Christian Calvary, but there is no doubt that it is the Calvary of a great artist."[125] And Decamps, who was also sensitive to the innovation that Delacroix was introducing, concluded with the latter's relationship to the classical tradition: "The Minister of Public Worship requested of M. Delacroix a Calvary destined for some provincial town, and M. Delacroix has made a painting that is more religious than all the paintings of the modern religious school. . . . The entire scene is stamped with grave emotion, a solemn sorrow, and all with the richest, surest, most brilliant palette of the Venetian school. When the eye stops on this Calvary, after perusing the glittering garishness throughout the gallery, the viewer's thought naturally turns to the painting of the masters; that is because M. Delacroix indeed has a touch of the master; not that he copies or imitates them, but because he is in sympathy with them in the noble sentiment and powerful execution that he displays in his art."[126]

In *Christ on the Cross,* Delacroix scrupulously followed traditional iconographic conventions. The Salon brochure

253. *Saint Stephen Borne Away by His Disciples,* 1853
Exhibited at the Salon of 1853. Oil on canvas, 148 × 115 cm. Musée Municipal, Arras

254. *Saint Sebastian Tended by the Holy Women,* 1858
Exhibited at the Salon of 1859. Oil on panel, 38 × 50.8 cm. Los Angeles County Museum of Art

255. *The Education of the Virgin*, 1842
Rejected by the Salon of 1845. Oil on canvas, 95 × 125 cm
Private collection

described the precise moment he had chosen: "Then he cried out and said: My Father, why have you forsaken me?" Christ has just died: he bears on his side the lance wound no doubt delivered just now by the knight on the right; on the left, a man presses into a basin the sponge full of the vinegar drink. The sky is becoming covered with black clouds, the people in the crowd look at one another questioningly. Mary Magdalen cries at the foot of the cross, while the Virgin and Saint John console each other. In the foreground are the bones—according to tradition, those of Adam and Eve—that designate the place as Golgotha. The serpent coming away from them is another reference to original sin. The only twist on the Gospel's account is that Christ is dying before one of the two thieves has been put on his cross, which is just being raised on the left in the background. Another slight contradiction is the man on the right, raising his ladder; we are quite aware that he is there to accentuate the parallel verticals of the two crosses. A certain static quality could have otherwise resulted, made more so by the positions of Saint John and the Virgin.

With this studied and meticulously laid-out painting, Delacroix certainly intended to compete with the great masters, particularly Rubens, whose influence is obvious here. A personal reinterpretation of a well-known subject, emulation of the old masters—might one not extend these motivations to all his religious painting? In the last analysis, they appear to be less the expression of a personal mystical theology, a particular doctrine, or even of the faith of his contemporaries, than new links in a continuous pictorial tradition to whose survival Delacroix was contributing. The different Crucifixions that he subsequently painted introduced as many variations to the painting of 1835. A small panel that he gave to Mme de Forget and that for once looks almost like a devotional object (enclosed within a Gothic frame, it was kept in a case) no longer shows anything except Christ, full-face and haloed with light, and therefore represents an abandonment of the previous painting's realistic depiction.[127] More important was the painting of 1846 (fig. 249), which was particularly noted at the Salon of 1847. On his first trip to Antwerp, Delacroix had been able to admire Rubens's *Lance Wound*, which influenced this work. It is likely that either then, or shortly after, he did a pastel of it, an intermediate work then followed by the sketch on panel, before he ended, logically, with an original painting.[128] Here, Delacroix concentrated the dramatic interest by reducing the number of figures and by framing Christ more tightly. The body—the only bright patch—is violently set off against a uniformly dark but animated background: the green of the clouds and hills is broken only by the veiled sun, which also illuminates the distance in a narrow,

256. *The Education of the Virgin*, 1853
Oil on canvas, 46.5 × 55.5 cm
National Museum of Western Art, Tokyo

brown-orange band. Once again, Delacroix avoided frontality, in order to make the composition dynamic, sometimes in very subtle ways: the diagonal that goes from the two men on the left toward the two horsemen on the right, is emphasized as much by the movement of both groups as by the muted color references—the white of the turban and brown-green and red of the mantles, on one side, and the white of the horse and the brown-green and red of the flag on the other. Delacroix subsequently painted the Crucifixion several more times, combining several elements of the earlier paintings and even introducing references to others of his works—for example, to the *Lamentation* in Saint-Denis-du-Saint-Sacrement, sometimes following the traditional iconography closely, other times displaying his originality, as when he represents Mary Magdalen drying Christ's feet with a cloth.[129] But just as *Christ on the Cross* of 1846 was different from that of 1835, so does each painting remain unique, even as it takes its place within a single iconographic series.

This ongoing process of reinterpreting the same subject, in which the continual variation in the use of the formal means attempts to express a different feeling each time, characterizes the majority of Delacroix's religious paintings, as if the choice of themes treated prolifically before him became, in the end, secondary. The only thing that really mattered was what is most material in the painting—composition, color, and brushstroke—but always in the service of the expression of a particular idea. This was how Delacroix renewed his older compositions, for example, his *Saint Sebastian Tended by the Holy Women*, in a painting that he repeated once more, and which was remarked upon at the Salon of 1859 (fig. 254).[130] He also did a number of double versions of a single composition,[131] such as *Saint Stephen Borne Away by His Disciples* (figs. 252 and 253) in which the most noticeable difference lies in the changed setting: the ramparts of Jerusalem, themselves a reference to those of Tangier, disappear. Similarly, there exists a second version of *The Education of the Virgin*, a painting that he had begun in 1842, during his stay in Nohant, to keep busy, for he could not stand being idle: "No sooner was I settled in, than I realized that my plans to do nothing would not hold, and that I would be horribly bored if I did not start something. I will amuse myself with the son of the house [Maurice Sand] to begin something for the local church."[132] The specific idea for the painting came to him by chance, when he encountered in the park "a superb motif for a painting, a scene that touched him deeply:" George Sand's farmer giving her little girl a reading lesson.[133] After the painting was rejected by the jury of the Salon of 1845, George Sand kept it (fig. 255) (her son's copy had been given to the Nohant

church). Ten years later, at Champrosay, Delacroix treated the same subject again (fig. 256), repeating his composition in a smaller size and making a number of changes (the landscape became more prominent, the attitudes of the two women and their faces were altered, a dog was added). He explained in his journal: "During the day, worked rather slackly, yet with some success, on the little *Saint Anne*. The background, redone with some trees I drew two or three days ago at the skirt of the forest going toward Draveil, changed the whole painting. That little bit of nature caught in the act, and that still squares with the rest, gave it character. For the figures, I also reused the sketches made from nature in Nohant for Mme Sand's painting. I gained by it some artlessness and firmness in their simplicity."[134] The clues left by the painter here allow us—and it is not always the case—to evaluate accurately his motivations and the meaning of his repetitions.[135] The latter could take the form of actual cycles, such as *Christ on the Sea of Galilee* (six versions, between 1841 and 1854)[136] and the various *Lamentations* (seven versions, from 1843–44 to 1857). The first group (figs. 260 and 261), which breaks down into two groups, depending upon whether or not the boat is masted, offers in addition a clear connection with *The Shipwreck of Don Juan*, and through it with *Castaways in a Ship's Boat*. Delacroix had painted a shipwreck as well as the calmed storm, as some of his contemporaries were well aware.[137] More generally, the critics also enjoyed searching Delacroix's religious paintings for more-or-less explicit references to the old masters, especially Rubens, whose mark here is more evident than ever. Sometimes this worked against the painter, for example, as in *The Supper at Emmaus* (fig. 251), exhibited at the Salon of 1853. The painting, which is very Rembrandtesque in its facture, was attacked for its anachronisms, in particular for the disciples' and the servant's modern clothing. What was permitted in Rembrandt was unacceptable for a modern artist . . .[138] These audacities, however, were actually the exception for Delacroix, who was always preoccupied with the accuracy and realism of his costumes and setting.

The correspondences among his various religious paintings sometimes extended to compositions with different subjects. *The Raising of Lazarus* (fig. 258), *The Road to Calvary* (fig. 259) (which Delacroix had conceived much earlier for a large format in Saint-Sulpice, in the chapel with the baptismal fonts), and *The Entombment* (fig. 257) are practically the same

size. But their compositions are also based upon an identical principle, an ascending and descending spiral that gives dynamism to a painting, and the latter two paintings, which are exactly contemporary, could work perfectly well as pendants. The same is true of *The Raising of Lazarus* and *The Entombment:* even though a period of eight years separates these paintings, Delacroix used the same colors, the same chiaroscuro effects, and the same golden light to open up the paintings' backgrounds. Yet, each composition has its own internal coherence and effect. We are well aware that these parallelisms—which could as easily be explained by the nature of the genre or the mere resemblance between subjects—are not due to the repetitive application of formulas perpetually rehashed. Delacroix's last years, in fact, were marked by a continual return to the same themes, and similar compositions, not only to religious paintings, but to all the genres he had undertaken over the last twenty years of his life. For example, there are three repetitions of *Medea about to Kill Her Children* (fig. 262)[139] and two of *The Sultan of Morocco and His Entourage,*[140] and these are not isolated cases. Collectors and dealers, whose commissions multiplied during the 1850s, were responsible in part: the *Medea* that is in the Louvre today, to take only one example, was sold to Émile Péreire, with Haro serving as intermediary.[141] But that did not keep Delacroix from taking the opportunity to vary one or another element. There are few virtually identical replicas, like the small version of *The Death of Sardanapalus*, which Delacroix painted in 1846, when the 1827 painting was sold to the banker John Wilson, not to repeat it, but to preserve the memory of a work that was always dear to its maker's heart.[142] Nor was it the case with all the second versions, which often present significant variations (*Moroccan Chieftain Receiving Tribute*[143] and *Ovid among the Scythians*[144]), and sometimes are entirely changed in terms of compositions (*Castaways in a Ship's Boat,*[145] *Cleopatra and the Peasant,*[146] *The Fanatics of Tangier*[147]). Delacroix was able to return to an early idea that circumstances had obliged him to abandon, such as in the second version of *Entry of the Crusaders into Constantinople*, which is closer to the original concept, as he had noted it in the sketch and which he had to adapt to the specific circumstances of its exhibition in the gallery at Versailles. Here, the frontality is less marked and the central group of crusaders less emphasized: by expanding the setting and reducing the size of the figures, Delacroix was able to

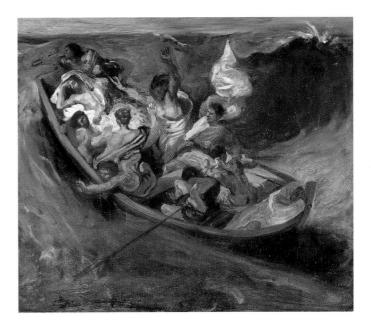

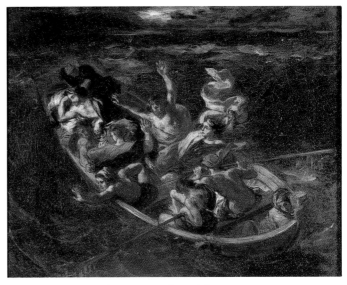

260. *Christ on the Sea of Galilee*, c. 1841
Oil on canvas, 45.7 × 54.2 cm. Nelson-Atkins Museum, Kansas City

261. *Christ on the Sea of Galilee*, c. 1841
Oil on canvas, 46.1 × 55.7 cm. Portland Art Museum, Portland, Oregon

OPPOSITE

257. *The Entombment*, 1859
Exhibited at the Salon of 1859. Oil on canvas, 56.3 × 46.3 cm
National Museum of Western Art, Tokyo

258. *The Raising of Lazarus*, 1850
Exhibited at the Salon of 1850–51. Oil on canvas, 61 × 50.2 cm
Öffentliche Kunstsammlung, Kunstmuseum Basel

259. *The Road to Calvary*, 1859
Exhibited at the Salon of 1859. Oil on panel, 57 × 48 cm
Musée des Beaux-Arts, Metz

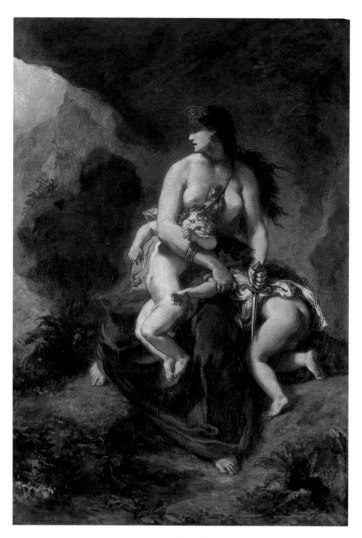

262. *Medea about to Kill Her Children*, 1862
Oil on canvas, 122.5 × 84.5 cm
Musée du Louvre, Paris

263. *Tasso in the Hospital of Saint Anna, Ferrara*, 1839
Rejected at the Salon of 1839.
Oil on canvas, 60.5 × 50 cm
Oskar Reinhart Foundation, Winterthur

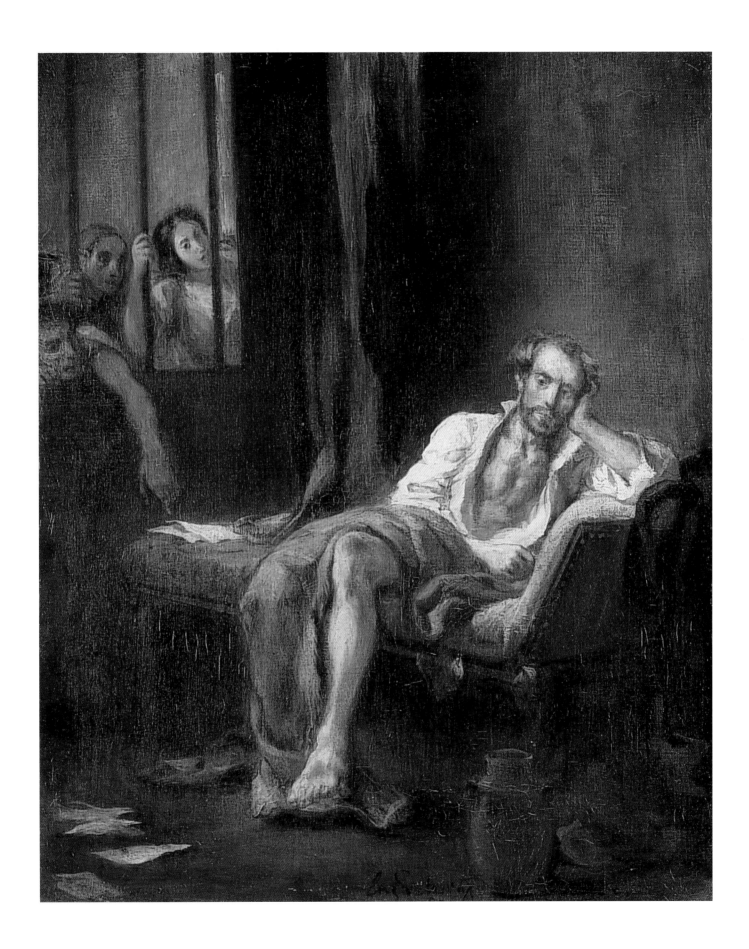

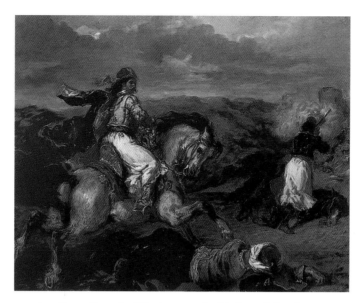

264. *Scene from the War between the Turks and Greeks*, 1856
Oil on canvas, 65.7 × 81.6 cm
National Museum, Athens

introduce other episodes and integrate the elements better. At times, the path from one work to another was more circuitous, as was the case with his *Odalisque* of 1857 (fig. 265). This small oil on panel, in which Delacroix painted a subject he had already treated many times, appears to belong in line with *Women of Algiers*. But we also know, from his journal, that Delacroix worked on it at Champrosay from a daguerreotype of a nude.[148] These ongoing reinterpretations, whatever their origins, do not address only paintings done after the trip to Morocco. At the very end of his life, Delacroix also returned to the works and plans of his youth: in 1856, for example, he painted a new version of *Scene from the War between the Turks and Greeks* (fig. 264), and returned to the idea of a large composition of *The Death of Botzaris during an Attack from the Turkish Camp*.[149]

His work of the last years also included new compositions, such as a group of four decorative paintings commissioned by Hartmann, a banker, on the theme of the seasons,[150] and *Collection of the Arab Tax*, one of his last paintings, and unlike anything he had ever done. Thus, Delacroix never stopped painting until his strength utterly failed him, nor did his career end with the completion of the Chapelle des Saints-Anges. He continued to progress in new drawings, as far as his condition would allow. "Oh! If I get well, as I expect to, I will do

amazing things; I feel my brain boiling," he is believed to have confided to Jenny during his last, terminal illness. In reality, his health was in decline. "The last time I saw him," wrote his paint-shop owner, Mme Haro, to her son Étienne, "he told me, smiling, that he was happy, that he no longer went out among people, that he intended to live only for himself, that he felt his health deteriorating, alas! I urged him to take good care of himself, and he replied, 'It is too late, I have stayed up too many nights, I am burned out. Well, if we cannot be cheerful, let us at least not give it too much thought. I confess, Madame, that, if I really think about it, death is so natural that it does not frighten me. Yet I never talk about it.' I felt a certain premonition that he would not live long." In fact, he suffered from a severe and lingering cold during the entire winter of 1863. In late May 1863 he went to Champrosay to rest. After much back and forth, due to a sudden worsening, he returned to Paris for good, taking to his bed in early July, and slowly failing until 13 August. "My poor dear master had been sick for three months; his illness began with a cold as always, and his poor chest was affected; I looked after him the whole time, never leaving him for a single moment," wrote Jenny to one of Delacroix's former students. "He kept a calm and peaceful state of mind to the very end, pressing my hands but unable to speak, and he breathed his last like a child."[151]

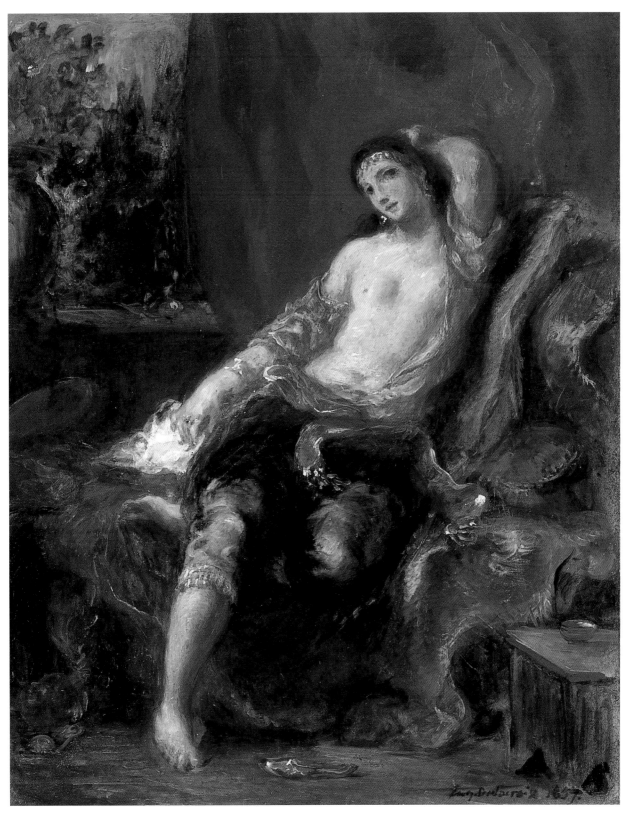

265. *An Odalisque*, 1857
Oil on panel, 35.5 × 30.5 cm
Private collection

266. The Delacroix exhibition organized in 1864 by the
Société Nationale des Beaux-Arts

Oil on canvas, 67 × 100 cm, by E. D. Albertini
Musée Carnavalet, Paris

One can identify *Entry of the Crusaders into Constantinople* and *Women of
Algiers in Their Apartment* in the first gallery, *Jewish Wedding in Morocco*
and *The Death of Botzaris during an Attack from the Turkish Camp* in the
second, and *Scenes from the Massacres of Chios* in the third.

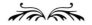

Delacroix after His Death

Delacroix's funeral was held with little pomp. A delegation from the Institute accompanied the coffin to the Père Lachaise cemetery. The pallbearers were Nieuwerkerke, the superintendent of the Beaux-Arts; the sculptor Jouffroy, president of the Beaux-Arts; Gisors, the architect of the Palais du Luxembourg; and, by a twist of circumstances, Flandrin, one of Ingres's favorite pupils. There were also close relations, other family members, and friends: Silvestre, who later grieved that Paris did not honor Delacroix as Antwerp did Rubens; Gautier, furious at the conventional speechifying he was hearing; and Paul Huet, who spoke a few warm words—the only ones. It would be several years before Delacroix's eulogy would be spoken at the Institute—by Delaborde, who was hostile rather than laudatory, and who attacked rather than defended the artist's memory. Yet, people's thinking had already changed. Delacroix, who was still being disparaged in 1859, at his last appearance at the Salon, very soon after his death entered the pantheon of the great glories of French painting.

The first phase was the post-obit auction. Ten days before he died, Delacroix had made his will.[1] Piron was named sole legatee, and executor of the estate according to the dying man's wishes. Jenny le Guillou received fifty thousand francs, some pieces of furniture, and the *Self-Portrait* of c. 1837; Delacroix's cousin and friend Léon Riesener, twenty thousand francs, the house at Champrosay, and several family portraits. Other similar but smaller bequests, such as paintings, frames, objects, and souvenirs, were distributed among more distant relatives and the close friends who survived him: Soulier, Rivet, Louis Guillemardet, George Sand, and Joséphine de Forget. Carrier, Huet, Chenavard, and Schwiter inherited souvenirs of the Romantic years, when Delacroix had met them—sketches by their comrade Hippolyte Poterlet and drawings by Monsieur Auguste. The inventory made in Paris and Champrosay after his death dovetailed perfectly with these provisions. Delacroix was no

collector. He owned only some portfolios of engravings, a few paintings by friends and relations, and, in greater number, souvenirs of his youth, in particular, studies by Géricault that he had bought in 1824. The most important part of the estate was the stock of paintings in the studio, the sale of which he had arranged for and organized, concerned as he must have been for his posthumous reputation. He wished it, "without making a law of it," to be directed by "MM. Petit and Tedesco," assisted in the sorting of the drawings by "MM. Pérignon, Dauzats, Carrier, Baron Schwiter, Andrieu, Dutilleux, and Burty."

Petit and Tedesco had been his dealers in the final years, at the same time that he had become friends with the painter Constant Dutilleux, a native of Arras and Corot's famous friend. It was as natural for Delacroix to entrust a final task to the companions of his last years, as to bring in his oldest friends, Dauzats and Schwiter. But the bulk of the chore actually fell to Philippe Burty, who had been, in 1859, one of the founders of the *Gazette des Beaux-Arts*, where he had made his name as an expert in prints, and who was an acknowledged presence in the art market, as editor of a number of catalogues. He was principally responsible for the auction, which took place in February 1864, six months after Delacroix's death.

The only paintings that Delacroix had kept that were both finished and known to the public were *The Cumaean Sibyl* and the flower paintings exhibited in 1849 and 1855, along with a handful of other works and a large number of painted sketches for the mural decorations. These made up the first part of the auction, and brought in the most money. But the most important part, the real discovery, were the boxes of drawings, six thousand in all. Burty knew all about them: "No one should be surprised by either the number or the perfection of Eugène Delacroix's studies. . . . We should examine these studies in pen and pencil, the successive versions, ever approaching closer to perfection, with which he clarified his thought and corrected his draft. . . . It was like a rigorous exercise that he continually imposed upon his intelligence, eyes, pencil, and brush, and to which he owed the serene abundance of his compositions as well as their charm and their brilliance. Delacroix valued these boxes most highly, and with good reason; he opened them only for his pupils and most intimate friends. He never emptied them for profit. He wanted them to come as an impressive argument after his death, to challenge the criticisms of improvisation and facileness constantly leveled at him, and to prove that such facility in expressing an idea, without the most persistent previous practice, would have been a phenomenon unprecedented in the history of art."[2]

People came pouring in on the first day of the exhibition, which was by invitation only;

among the attendees were friends of the artist, enemies, fans, and society people: "Because the distinctive quality of these works made indifference impossible, the visitors were quite animated. . . . To be sure, one must be fairly well versed in art to feel and understand the attractions, or if you will, the potential attractions, of these unfinished paintings." The next day was the same, at the exhibition open to the public, and yet again on the first day of the bidding: "Everyone felt that this was a master whose name and oeuvre would live on. If Eugène Delacroix had ever known such a triumph during his lifetime, he would have fallen ill from pleasure."[3] The triumph, however, was the auction itself. Prices went through the roof: people argued over every sketched scrap, regardless of Burty's sometimes dubious attributions, which, apparently in all good faith, passed off the work of students as originals.[4] Applause interrupted some of the bidding, for example, when Duchâtel, a highly respected collector and former minister under Louis-Philippe, bought *The Sea at Dieppe* for the large sum of 3,650 francs. The prices that were reached contributed to the impact of the discovery of a new, hitherto unsuspected aspect of Delacroix's work: "When, after his death, in the auction rooms of the Hôtel Drouot, they saw that prodigious pile of drawings, studies, and sketches, which describe the master's daily, indefatigable labor, a cry of admiration arose from every heart. All at once, we understood both the greatness of the man and of the work. It was like a revelation! For their weight in gold, at any price, the least lines from this glorious pencil were disputed. Everything was bought, and carried away with an intoxicated fervor; one would have said that the public was taking revenge upon itself for its past disdain, making it a matter of honor to pay insane amounts: every bid was an homage. This fanatical fever did not let up for an instant. Art-lovers, rich people and poor devils alike, bid against each other to the end. . . . The faithful let their radiant joy explode freely, and greeted the higher bids with outbursts of frantic applause: it really was a magnificent sight, one of those one cannot forget."[5]

The implications of the sale went beyond the public's acknowledgment, now unanimous, or nearly. Delacroix's work was being reevaluated, and it is interesting, from this standpoint, that Piron attributed the auction's unexpected success to the opinion of artists, as much as to the actual worth of the man.[6] Although he was critical of a sale that he felt ought to have been drastically weeded out, and was far from sharing in the general enthusiasm (perhaps because Delacroix had favored Dutilleux over him), Silvestre pointed out that, "what truly amazed everyone at this auction of Delacroix's watercolors, drawings, and rough sketches was the master's inexhaustible abundance, the variety of his motifs, and the passion that he brought to rendering under in all their forms the subjects that struck him. One easily saw

that he was a man who produced continuously, to ease his mind and his heart, and who condemned his hand to constant struggle. When Delacroix wrote these lines, he was only telling the simple truth: 'As for the compositions that are set, perfect fair copies, and ready to be executed, I have enough to do for two human lifetimes, and as for every kind of project, that is, the subject matter to occupy mind and hand, I have enough for four hundred years.'"[7]

The exceptional event was extended shortly after by a retrospective exhibition organized on the boulevard des Italiens by the Société Nationale des Beaux-Arts. Even more than the Exhibition of 1855, this show helped to confirm in the public's mind the image of a prolific and multifaceted artist. "Delacroix lives again in glory there. Everything had been piously gathered [at the exhibition] that was not permanently fastened to the walls, such as mural paintings on the walls of monuments and churches, and these galleries that he fills all by himself offer the most various samples of his manifold genius," wrote Gautier in his article for *Le Moniteur Universel*, in reality an overview on the painter and his work.[8] Further along in the article, he emphasized the difference from Delacroix's earlier situation: "Now that all is calmer around that great name—one that posterity will not forget—it seems impossible to recall what an uproar surrounded him, in what a passionate dust of battle he lived. Every one of his works aroused deafening clamors, storms, furious discussions. The artist was abused with invectives that could not have been more vulgar or shameful if they had been addressed to a robber or a murderer. Critical courtesy no longer applied, and when the critics ran short of epithets, they borrowed more from the gutter. He was a savage, a barbarian, a maniac, a wild man, a madman who should have been sent back to his birthplace, Charenton. He favored the ugly, the ignoble, and the monstrous; and couldn't draw besides: he broke more limbs than a bonesetter could reset. He threw buckets of paint onto canvases, he painted with a drunken broom—that drunken broom looked quite nice and was enormously impressive in its day. . . . This is how geniuses are greeted at their dawning: a strange mistake that surprises every generation in retrospect, and that they ingenuously repeat."

The catalogue, including supplements, totaled 315 numbers, of which nearly 200 were paintings and 120 drawings and prints (certain numbers grouped several works together).[9] Most of Delacroix's large paintings were together (*Sardanapalus*, in the smaller format that Delacroix had made when he sold it). Of course, one could regret the absence of *The Prisoner of Chillon*, *The Fanatics of Tangier*, *The Murder of the Bishop of Liège*, *The Death of Valentine*, *Hamlet and Horatio and the Gravediggers*, *The Shipwreck of Don Juan*, and especially of *Medea about to Kill Her Children*, *The Sultan of Morocco and His Entourage*, and *The Justice of Trajan*. But the exhibition was more balanced than that of 1855, which had privileged the

Salon paintings, and all in all better represented Delacroix's work. And, again, there were the drawings—easier to see than during the posthumous sale some months earlier—which revealed a new Delacroix: "All these great pages, all these masterpieces [the large paintings] have found ardent apologists and are accepted today by those who so long repudiated them. Those are, I dare say, Delacroix's great works. But there is another Delacroix, less imposing and more intimate; the Delacroix of the drawings, the sketches, and the small formats; the Delacroix of the rough outline, the draft, and the sketch, and I find him so interesting, curious, instructive, surprising, and extraordinary, that we will pause to concentrate on him," wrote one of the reviewers of the exhibition. "The sketch is Delacroix's triumph," he continued. "No one had a livelier hand for capturing genius's blazing ideas in rapid lines. His burning brush seems to fly across the canvas, and the composition comes together all at once, without hesitation, without cooling off, as palpitating as life. Light, perspective, depth, movement, everything is there in those swift strokes whose assurance astounds you. The harmony emerges directly, as it were, and the finished work, slowly painted, deeply studied, adds only material perfection to this miraculous first impulse. Certainly, many details will be altered in the course of its execution in the large format, but what will remain is this overall quality, achieved at the first attempt."[10]

The catalogue's preface addressed these points, with the author, d'Arpentigny, insisting especially on the new perception and the revision of premature and summary opinions brought about by the presentation of the drawings: "Delacroix is also a great draftsman, not in the common sense of the word, but in its real meaning. Only the most narrow-minded of judges would consider drawing to be merely defining a contour with a thin line created by with the point of a sharpened pencil; giving movement, neglecting detail in favor of shaping a living mass that seems to palpitate with active thought—that, too, is drawing. When Delacroix dislocates a limb, or seems to break a torso, one would have to be poor in spirit indeed to believe that he does so out of ignorance; like Michelangelo or Raphael himself, he exaggerates so as to force the eye to grasp his thought. He gives life to the beings that he creates in the fire of his genius, his enthusiasm overflows on every side. It is life, a soul given to each of them. He could have done the patient work, drawn the line; he knew his craft perfectly, he had studied nature and the old masters, everything had been revealed to him. Let no one speak of ignorance before such genius, a rigorous genius that can be understood only by those capable of boldness and grandeur."[11]

At the same time, Delacroix's writings very soon began to be published. Piron previewed them in his *Eugène Delacroix,* which he started writing in 1865 (and dedicated to

the painter's friends), and which circulated privately after his death. The volume comprised a biographical introduction, for which Piron had relied largely upon his recollections and those of his friends; the artist's manuscripts; a catalogue essay on the principal paintings; reprints of articles published by Delacroix during his lifetime; and excerpts from his correspondence and journal. Delacroix's letters were published sporadically, until Philippe Burty issued a first edition of the artist's correspondence in 1878. It was expanded in 1880,[12] and would remain the sole reference for fifty years, until André Joubin's efforts, which recapitulated all the discoveries since then. The only obstacle Burty encountered in his task was the dispersion of the letters, but the journal was another story. As we have seen, Jenny entrusted Delacroix's notebooks to Dutilleux;[13] at his death, his son-in-law, Robaut, returned to Jenny what originals he had been able to copy (Jenny then passed them along to Verninac's family), kept the rest, copied them, and turned them over to Andrieu. A comprehensive edition was finally published in 1893, overseen by René Piot, Andrieu's pupil; he worked with a scholar, Paul Flat, who seems to have used Andrieu's originals and Robaut's copies.[14] Hence, the erroneous readings and omissions, where the editors deleted certain passages, in particular where Delacroix entered excerpts from his readings. In the end, however, the journal appeared, for the first time, and in a form that was quite close to the original, no longer a series of excerpts: Delacroix's image was being filled in with a new and extremely important contribution.

A short time previously, in 1885, another retrospective had been held, a benefit to raise funds for a monument (a bust by Dalou was planned for the Luxembourg). Although it was along similar lines as the exhibition of 1864, it was more complete.[15] The catalogue included 242 numbered paintings (250, counting paintings not in the catalogue); 211 drawings; 32 prints; 13 travel albums and notebooks; some 50 manuscripts selected by Charavay to show the evolution of Delacroix's writing—and, to quote the catalogue, "[to present a] writer whose style is so clear, so alive; this great-hearted man; this sincere and faithful friend," thus completing "the physiognomy of this illustrious artist"—some 20 portraits of the master; together with prints, photographs, drawings, sculptures, and, finally, a palette that Delacroix had used, and on which Andrieu had noted the range of colors employed by him. In the end, the inclusion of major paintings—*Medea, Marcus Aurelius, The Battle of Nancy, The Sultan of Morocco,* the *Entry of the Crusaders into Constantinople*—was less significant than the comprehensive view that this very successful exhibition sought to give of Delacroix, who was now truly a part of history, as evidenced, during this same period, by the publication of Robaut and Chesneau's catalogue. This work, which followed the first similar

267. Two pages from Delacroix's *Journal*, 28–29 January 1857,
showing preparatory notes for the *Dictionnaire des Beaux-Arts*, with
a number of references to other passages in the *Journal*
Bibliothèque d'Art et Archéologie, Fondation Jacques Doucet, Paris

endeavor (by Adolphe Moreau of twelve years earlier), was flawed: Robaut's method was sometimes unscientific, and he was sometimes less disinterested than one has believed him to be.[16] Nevertheless, his achievement was a virtually exhaustive collection that incorporates the drawings into the study, even if he often simply repeated the descriptions of the lots from the auction catalogue. His book, more complete than Moreau's, would gradually—it sold very poorly—become the ultimate reference work. Chesneau's role in the catalogue tends to be forgotten. It is a mistake to underestimate his part: besides editing the commentary, he recorded in the process a number of facts and interpretations that he knew either directly from Delacroix himself, or from his close friends and relations. The strength of these various efforts resides first in their intrinsic value, but also from the fact that the authors knew Delacroix and the milieu within which he developed and so were recording a still living tradition. The case is unique among the great nineteenth-century French painters. Neither David, nor Ingres, nor artists as revered in their day as Decamps and Horace Vernet benefited from such *post mortem* devotion: thirty years after his death, Delacroix's works were catalogued and his most important writings published, as were the recollections, memoirs, and critical studies of those who had been close to him. In this way, his image was captured for posterity.

His historiography has, of course, expanded considerably since then, but always from these foundations, and what differences have arisen deal essentially with the place assigned to Delacroix within the Romantic movement and the interpretation of that movement, since the two questions are closely related. Even though Delacroix did not head a school, he remains one of the artists who represented best the new tendencies in French painting around 1830, in the subjects of his works, their facture, the sensibility that they express, and the intensity of the emotions that they manifest.[17] From this point of view, it is significant that the first large-scale retrospective to be organized after the exhibition of 1885 was held in 1930, one of a number of events marking the centennial of Romanticism.[18] The 1963 exhibition, on the other hand, focused on the painter as such, and in particular on the paintings shown at the Salon.[19] This is the other major analytical direction, which privileges Delacroix in isolation, separating him from his contemporaries as far as possible, and insisting especially upon the irreducible expression of individual feeling that lies at the heart of every Romantic work of art, and his in particular. The definition of a Romantic movement governs this analysis. Does it mark an irremediable break with the classical tradition, and therefore usher in every subsequent development of modern painting, or, on the contrary, must it be resituated within a continuum, as suggested by a closer analysis of Neoclassicism, one that puts

forward, especially with regard to late eighteenth-century British and German art, the idea of Romantic classicism? In fact, Delacroix seems to be independent of all these categories, and removed from what is necessarily arbitrary and simplistic about them. To say that he was a Romantic during his youth, but returned to classicism, in part as a result of his trip to Morocco, accounts for only one aspect of his development, which, as we have seen, was equally determined by his very traditional conception of painting, which he acquired during his years with Guérin. The opposite is equally true: it would be just as absurd to deny the ways in which he was innovative, even revolutionary, even though his position and his ideas on the question may be difficult to pin down specifically and precisely. The apparent contradiction finally dissolved with the passage of time, which has clarified to what extent Delacroix simultaneously extended, pursued, and renewed the classical tradition, in a personal synthesis that also foreshadowed a subsequent number of far more radical upheavals. For an understanding of Delacroix's place in art history, we must turn once more to Baudelaire, who had perceived all these facets and expressed them wonderfully, summing up an entire career and giving it its deep meaning in a few sentences that have lost nothing of their force and insight. For example, this is how he began Delacroix's obituary: "Flanders has Rubens; Italy has Raphael and Veronese. France has Lebrun, David, and Delacroix." He continued: "A superficial mind might be shocked at first glance by the linking of these names, which stand for such different qualities and methods. But a more attentive spiritual eye will see immediately that there is a family resemblance between them, a kind of brotherhood or *cousinage* arising from the love of what is great, national, immense, and universal, a love that has always expressed itself in so-called decorative painting and in large *productions*. . . . Who is the greatest of these very different men? One may decide as one pleases, depending upon whether one's temperament leans toward Rubens's prolific, radiant, almost jovial abundance, Raphael's sweet majesty and harmonious order, Veronese's paradisiac, afternoon colors, David's taut and austere severity, or Lebrun's dramatic, almost literary fluency. None of these men is replaceable; they all aimed at similar goals, but employed different means, drawn from their individual natures. Delacroix, the latecomer, expressed with wonderful vehemence and fervor what the others conveyed in a necessarily incomplete manner. . . . So what is that mysterious something that Delacroix, to the glory of our century, conveyed better than any other? It is what is impalpable, dreams, nerves, the *soul*. . . . Delacroix was the most *evocative* of all painters, the one whose works, even the secondary, inferior ones, most prompt us to think, to recall to memory the most emotions and poetic thoughts, which we already knew, but believed to be buried forever in the night of the past."[20]

❧ *Notes* ❧

Introduction

1. Paul Jamot in *Centenaire du romantisme. Exposition E. Delacroix*, exh. cat. (Paris, 1930), 11.

2. Letter from Frédéric Villot to Alfred Sensier, 27 July 1869, in Maurice Tourneux, *Eugène Delacroix devant ses contemporains. Ses Ecrits, ses biographes, ses critiques* (Paris, 1886), 124–25. Villot specifically attacks Delacroix's supplier, Haro. The question has been studied by N. Sauvaire, *Le Rôle de la famille Haro, marchand de couleurs, dans l'oeuvre de Delacroix et les techniques picturales du peintre* (master's thesis, University of Paris IV, 1978). Various students of Delacroix left notes on the techniques he used: see chap. 5, nn. 44–48 for references to these partially edited texts; see also David Liot, "La Technique d'Eugène Delacroix: Une approche historique," in *Delacroix. Les dernières années*, exh. cat. (Paris and Philadelphia, 1998–99), 384–93. On Delacroix and Haro, see André Joubin, "M. Haro entre Ingres et Delacroix," *L'Amour de l'Art*, no. 3 (Mar. 1936): 85–93.

3. The affair can be followed in Delacroix's correspondence. See *Correspondance générale de Eugène Delacroix*, ed. André Joubin, 5 vols. (Paris, 1936–38), 4:133–34, 151, 232–33, 239–40. Delacroix delivered the retouched painting to the administration in February 1861.

4. See Eugène Delacroix, *Journal, 1822–1863*, ed. André Joubin (1931–32; rev. ed by Régis Labourdette, 3 vols. in 1, Paris, 1980), 436, June 1854.

5. See J. Gasquet, *Cézanne* (Paris, 1926), 179. The consequences of the move from Versailles to Paris, which provoked enormous cracks that were later repaired but had irremediably damaged "the marvel that we knew," are reported by Alfred Robaut in the fundamental critical catalogue of Delacroix's work, in an annotation in the margin of his personal copy, today in the Bibliothèque Nationale.

6. Cited by Lee Johnson, *The Paintings of Eugène Delacroix: A Critical Catalogue*, 6 vols. (Oxford, 1981–89 [vol. 4 rev. 1993]), 5:60. This work is hereafter referred to as *Crit. Cat.* See also *Eugène Delacroix à l'Assemblée Nationale, peintures, murales, esquisses, dessins*, exh. cat. (Paris, 1995), 47–48 (chronology established by Arlette Sérullaz).

7. The words are those of the journalist Alfred Sensier. Johnson, *Crit. Cat.*, 5:99.

8. See the report by Nathalie Volle on the last restoration done in 1991–92, in *Eugène Delacroix à l'Assemblée Nationale*, 55–72.

9. I refer here to the André Joubin edition revised by R. Labourdette, cited in n. 4, a one-volume edition of the original in three volumes, hereafter cited as *Journal*.

10. The edition of reference for the correspondence of Delacroix is *Correspondance générale de Eugène Delacroix*, ed. André Joubin, 5 vols. (Paris, 1936–38), hereafter cited as *Corr. gén.* The first volume covers the years 1804–37, the second 1838–49, the third 1850–57, the fourth 1858–63, and the last contains supplements and tables. Alfred Dupont published a group of letters, mostly from Delacroix's youth, drawn from his collection of manuscripts: Eugène Delacroix, *Lettres intimes* (Paris, 1954; 2nd ed. 1995). Lee Johnson has gathered letters that have appeared since the preceding publications in *Eugène Delacroix: Further Correspondence, 1817–1863* (Oxford, 1991).

11. A recent edition of these writings, François-Marie Deyrolle and Christophe Denissel, *Eugène Delacroix, Ecrits sur l'art* (Paris, 1988), is available, but the older, two-volume edition is preferred: *Oeuvres littéraires, I. Etudes esthétiques, II. Essais sur les artistes célèbres*, ed. Elie Faure (Paris, 1923), cited hereafter as *Oeuvres littéraires*.

12. Adolphe Moreau, *E. Delacroix et son oeuvre* (Paris, 1873), a work still useful today, especially for the engravings by and from Delacroix. On Moreau and Delacroix, see *De Corot aux impressionistes, donations Moreau-Nelaton*, exh. cat. (Paris, 1991).

13. Alfred Robaut et al., *L'Oeuvre complet de Eugène Delacroix. Peintures, gravures, dessins, lithographies* (Paris, 1885). I return in the conclusion to the importance of this catalogue and to that of Moreau's.

14. Lee Johnson, *The Paintings of Eugène Delacroix. A Critical Catalogue*, 6 vols. (Oxford, 1981–89 [vol. 4 rev. 1993]). I am greatly indebted to the irreplaceable publications of Lee Johnson, which synthesize a life of research entirely dedicated to Delacroix, and which are an indispensable source for those who study Delacroix.

15. Loÿs Delteil, *Le Peintre-graveur illustré, III: Ingres–Delacroix* (Paris, 1908). The translated and revised edition by Susan Strauber, *Eugène Delacroix: The Graphic Work. A Catalogue Raisonné* (San Francisco, 1997), brings together the previous research. In addition, there is Barthélémy Jobert, ed., *Delacroix. Le Trait romantique*, exh. cat. (Paris, 1998), which, within the framework of the bicentennial of the artist's birth, analyzes the different aspects of Delacroix's relationship to the reproducible image, including prints and photography. The bibliography is completed by a special issue of *Nouvelles de l'Estampe* (Mar. 1998)

16. Maurice Sérullaz et al., *Musée du Louvre. Cabinet des dessins. Inventaire général des dessins. Ecole française. Dessins d'Eugène Delacroix*, 2 vols. (Paris, 1984), cited hereafter as *Dessins*. For the pastels, see Lee Johnson, *Delacroix Pastels* (New York, 1995), hereafter cited as *Pastels*.

17. The basic bibliographic list is given in Tourneux, *Eugène Delacroix devant ses contemporains*. It also contains several extracts, such as the letter of Frederic Villot cited in n. 2.

18. See, for example, *Journal*, 22 May 1855, 508, and the letters to Dumas and Mme Cavé, Apr.–May 1859, *Corr. gén.*, 4:96–98. Dumas used them several times: first in *Mes Mémoires*, especially chap. 220, "Eugène Delacroix," 30–37, and chap. 229, on the "bal romantique" that is considered in-depth in chap. 1 with regard to the *King Roderick*. (The chapters may be found in the edition of the complete works, ed. P. Josserand, 5 vols. [Paris, 1968], 30–37, 82–84.) In a lecture that he gave in 1864 on the occasion of the posthumous exhibition organized on the boulevard des Italiens by the Société Nationale des Beaux Arts, later published, Dumas expanded his remarks. It is this more complete text that I have used: A. Dumas, *Causerie sur Eugène Delacroix et ses oeuvres faite par Alexandre Dumas le 10 décembre 1864 dans la salle d'exposition des oeuvres d'Eugène Delacroix* (Paris, 1865). (The text had first appeared serially in *La Presse* between 29 Dec. 1864 and 12 Jan. 1865.) The text was reedited by J. Thibaudeau as Alexandre Dumas, *Delacroix* (Paris, 1996), hereafter cited as A. Dumas, *Delacroix*.

19. Achille Piron, *Eugène Delacroix. Sa vie et ses oeuvres* (Paris, 1865).

20. A first list of these Salons is given in Tourneux, *Eugène Delacroix devant ses contemporains*, to be completed, picture by picture, with the precise references given in Johnson, *Crit. Cat.* The purely rhetorical aspect that such literature can assume is treated by Anne Larue, "Delacroix and His Critics: The Stakes and Strategies," in *Art Criticism and Its Institutions in Nineteenth-Century France*, ed. Michael R. Orwicz (New York, 1994), 63–87, but that does not change the reality that it represented for the painter and his contemporaries, or the influence that it had as a whole, or the information that, taken as a whole, it gives as to the reception of the works by their first public. An approach to these problems can be found in the work of Richard Wrigley, centering on the period before the first years of Delacroix but nevertheless rich in information, *The Origins of French Art Criticism, from the Ancien Regime to the Restoration* (Oxford, 1993). See also M.-M. Dujon, "A la Recherche du regard sur l'oeuvre de Delacroix" (thesis of the *troisième cycle*, University of Paris-I, 1979).

21. Most of the articles that appeared then are in Maurice Sérullaz, *Les Peintures murales d'Eugène Delacroix* (Paris, 1963).

22. Thoré's articles as well as some of his critiques (especially one that appeared simultaneously in *La Loi*, devoted to the Salon du Roi in the Palais-Bourbon), were published by Maurice de Seigneur, "Eugène Delacroix et Théophile Thoré," *Le Journal des Arts*, 24 Oct.; 14, 21, and 28 Nov.; and 5, 12, and 19 Dec. 1890. Delacroix found the articles a little too favorable, agreeing, however, with the "nervous ardor" that according to Thoré characterized it: see two letters to Thoré, 18 Feb. and 2 Mar. 1837, *Corr. gén.* 1:427–28. Nevertheless he thought very highly of Thoré and in vain recommended to François Bulot, director of the *Revue des Deux-Mondes*, that he be given the Salon criticism (letter to Buloz, 2 Mar. 1837, ibid., 1:429).

23. Baudelaire Dufaÿs, *Salon de 1846* (Paris, 1846), in Claude Pichois, ed., *Baudelaire, Oeuvres complètes* (Paris, 1976), 2:427–42 et passim.

24. Articles that first appeared in *Le Moniteur universel*, 19 and 25 July 1855, and in *Les Beaux-Arts en Europe* (Paris, 1855), 1:166–93.

25. Théophile Silvestre, *Histoire des artistes vivants français et étrangers*, 2nd ed. (Brussels and Leipzig, 1861), 5–37.

26. He reprints an article of *La Revue européenne* of 1 Dec. 1861, which also appeared in *La Peinture française au XIX siècle. Les chefs d'école. L. David, Gros, Géricault, Decamps, Ingres, Eug. Delacroix* (Paris, 1862), 313–92.

27. I refer here to Jean-Paul Bouillon

et al., *La Promenade du critique influent. Anthologie de la critique d'art en France, 1850–1900* (Paris, 1985).

28. See, for example, the invitation to a tour of the Chapelle des Saints-Anges in Saint-Sulpice, 29 June 1861, and the letters addressed at the same time to various friends, critics, and journalists, *Corr. gén.*, 4:253–67.

29. See especially René Jullian, "Delacroix et Baudelaire," *Gazette des Beaux-Arts*, 1953, 311–26; L. Hornet, *Baudelaire critique de Delacroix* (Geneva, 1956); and A. Moss, *Baudelaire et Delacroix* (Paris, 1973); and also J. Starzynski, "Delacroix, Baudelaire et l'art du XIXème siècle," *Revue des Expressions Contemporaines* (summer 1963): 94–116; A. Brookner, "Art Historians and Art Critics–VII: Charles Baudelaire," *Burlington Magazine*, June 1964, 269–79; L. J. Austin, "Baudelaire et Delacroix," *Annales de la Faculté des Lettres et Sciences de Nice* (1968): 13–23; Philippe Berthier, "Des images sur les mots, des mots sur les images: A propos de Baudelaire et Delacroix," *Revue d'Histoire Littéraire de la France* 80, no. 6 (1980): 900–915; E. Abel, "Redefining the Sister Arts: Baudelaire's Response to the Art of Delacroix," *Critical Inquiry* 6, no. 3 (1979–80): 363–64; and the anthology by Stéphane Guégan, *Charles Baudelaire.*

Théophile Gautier: Correspondances esthétique, sur Delacroix (Paris, 1998).

30. T. Silvestre, *Eugène Delacroix. Documents nouveaux* (Paris, 1864), 55.

31. Etienne Moreau-Nélaton, *Delacroix raconté par lui-même*, 2 vols. (Paris, 1916); Raymond Escholier, *Delacroix peintre, graveur, écrivain*, 3 vols. (Paris, 1926–29). See also the very factual work by Maurice Sérullaz, *Delacroix* (Paris, 1989); and Timothy Wilson-Smith, *Delacroix: A Life* (London, 1992), with a similar approach but less exclusively dependent on facts.

32. Maurice Sérullaz, *Eugène Delacroix 1798–1863. Mémorial de l'exposition organisée au musée du Louvre à l'occasion du centenaire de l'artiste*, exh. cat. (Paris, 1963), hereafter cited as *Mémorial*. The year 1963 saw various commemorative exhibitions and the publication of several important works: see the reviews of André Chastel, Lee Johnson, and Daniel Wildenstein. Several exhibits devoted to Delacroix developed one point or another; references will be given as these points are covered. Among the retrospective exhibitions, in addition to the first two of 1864 and 1885, which are discussed in the conclusion, an important one occurred in 1930 at the Louvre, on the occasion of the centenary of Romanticism (cited in n. 1) and two in

Frankfurt in 1992. No retrospective of the whole was organized for the bicentennial of the artist's birth in 1998, but several exhibitions on complementary topics have allowed for a deeper understanding of some essential points and have thus made a productive contribution to the research on Delacroix. Among them are *Delacroix. La naissance d'un nouveau romantisme*, exh. cat. (Rouen, 1998); *Delacroix. Les dernières années*, cited in n. 2; as well as the exhibition at the Bibliothèque Nationale de France, cited in n. 15.

33. Among monographs on Delacroix are Julius Meier-Grafe, *Eugène Delacroix. Beiträge zu einer Analyse* (Munich, 1913); Lucien Rudrauf, *Eugène Delacroix et le problème du romantisme artistique* (Paris, 1942); Jean Cassou, *Delacroix* (Paris, 1947); Lee Johnson, *Delacroix* (London, 1963); René Huyghe, *Delacroix, ou, Le Combat solitaire* (Paris, 1964; repr. 1990); Philippe Jullian, *Delacroix* (Paris 1963); Corrado Maltese, *Delacroix* (Florence, 1965); Kurt Badt, *Eugène Delacroix, Werke und Ideale* (Cologne, 1965); Tom Prideaux, *The World of Delacroix* (New York, 1966); Frank Anderson Trapp, *The Attainment of Delacroix* (Baltimore, 1971); Guy Dumur, *Delacroix, romantique français* (Paris, 1973); Alain Daguerre de Hureaux, *Delacroix* (Paris, 1992). I was not able to con-

sult for this study the latest work, Peter Rautmann, *Delacroix* (Paris, 1997).

34. Readers who want to know more about the preparatory works for a particular work can consult Johnson, *Crit. Cat.*, which gives the list of conserved sheets, and especially Sérullaz, *Mémorial*, which reproduces many of them. For the paintings at the Palais-Bourbon, see the catalogue of the exhibition *Eugène Delacroix à l'Assemblée Nationale.*

35. The particularly well-developed example by Catherine Krahmer, "Meier-Grafe et Delacroix," *Revue de l'Art* 99, no. 1 (1993): 60–68, which deals with the reception of Delacroix in Germany, suggests the possibilities of such an approach. Lee Johnson, in *Crit. Cat.*, gives a first series of indications, useful but still fragmentary. On the reception of Delacroix in the United States, see J. Rishel, "Delacroix et l'Amérique," in *Delacroix. Les dernières années*, 60–72. See also Arlette Sérullaz, "Delacroix vu par ses contemporains," ibid., 34–45.

36. *Journal*, 31 Jan. 1850, 219.

37. "Des Variations du Beau," in *Oeuvres littéraires*, 1:52 (the article appeared first in the *Revue des Deux-Mondes*, 15 July 1857).

Chapter One

1. On Delacroix's self-portraits, see André Joubin, "Delacroix vu par lui-même," *Gazette des Beaux-Arts*, May–June 1936, 305–18; see also J. Starzinski, "En quête des auto portraits de Delacroix entre 1849 et 1853," *Gazette des Beaux-Arts*, Apr. 1964, 245–54. Among the drawings are various sheets conserved in the Louvre: they correspond to the years 1818 (RF 9574 and RF 9142 fol. 14v), 1823 (RF 9200), c. 1823 (RF 10650), 1832 (RF 1712 bis fol. 89v), 1842 (RF 10251), and c. 1842 (10365); see Sérullaz, *Dessins*, nos. 567–71, 1747 fol. 14 and 1756 fol. 89.

2. Besides the *Self-Portrait as Ravenswood* and the *Self-Portrait* of c. 1837, there are two other paintings: the *Self-Portrait* today in Zurich, at the Fondation E. Bührle (1823, perhaps c. 1819, Johnson M5), left unfinished by Delacroix and largely repainted by his friend Constant Dutilleux (see Johnson, *Crit. Cat.*, 1:231), and the *Self-Portrait* in the Uffizi in Florence (c. 1852? See ibid., 1:237).

3. But according to Robaut, on condition that the Orléans take the throne (see Robaut, *L'Oeuvre complet*, 82, no. 295). It is also possible that Delacroix wished to leave to the Louvre the *Self-Portrait* of the Uffizi. On the circumstances of the Le

Guillou legacy and the evidence of retouching on the *Self-Portrait* of c. 1837 after Delacroix's death, see Hélène Toussaint, "A propos de Delacroix: Le legs Le Guillou au Musée du Louvre," *Revue du Louvre*, no. 3 (1982): 181–87.

4. See Lee Johnson's synthesis of the different hypotheses in *Crit. Cat.* 1:41–42. On the identification with Hamlet (which goes back to 1907, when the portrait was in the Chéramy sale), see Paul Jamot, "Eugène Delacroix en costume d'Hamlet," *Bulletin de la Société de l'Histoire de l'Art Français* (1935): 41–44; the identification with Childe Harold was proposed by George Heard Hamilton, "Hamlet or Childe Harold? Delacroix and Byron," *Gazette des Beaux-Arts*, July 1944, 365–86.

5. Reproductions of these various portraits are conveniently grouped in Huyghe, *Delacroix, ou, Le Combat solitaire*, pls. 8–12, and in Pierre Georgel and Luigina Rossi Bortolatto, *Tout l'oeuvre peint de Delacroix*, ed. Henriette Bessis, rev. ed. (Paris, 1984), 83.

6. Baudelaire, "L'Oeuvre et la vie d'Eugène Delacroix," appeared originally in *L'Opinion Nationale*, 2 Sept. and 14 and 22 Nov. 1863, then in *L'Art romantique* (Paris, 1868), cited in Claude Pichois's

edition, *Oeuvres complètes*, vol. 2 (Paris, 1976), 759.

7. In this, as in the question of the paternity of Charles Delacroix, I follow the synthesis, to my mind certain and complete, of Paul Loppin, *Delacroix père et fils*, rev. ed. (Paris, 1972), which includes the preceding publications by the same author. See also "Compte-rendu de la conférence du médecin général A. Camelin . . . le jeudi 31 mai 1979: 'Charles Delacroix, père et préfet contestés,'" *Bulletin de la Société Aixoise d'Etudes Historiques*, no. 61 (July–Oct. 1979), n.p., and A. Camelin, "La Naissance controuvée d'Eugène Delacroix," *Mémoires de l'Académie de Lyon* (1981): 82–83.

8. Eugène Delacroix was born at Charenton-Saint-Maurice, in a house that still stands, although the neighborhood has changed drastically.

9. See especially Raymond Escholier, *Delacroix, peintre, graveur, écrivain*, 3 vols. (Paris, 1926–29).

10. For details, see chap. 3 (the competition for the Chambre des Députés, in which Delacroix participated), and chaps. 5 and 6 for the successive links among the different major decorative

works. I give there the circumstances of each commission.

11. Especially at the very beginning of the *Journal*, 7 Sept. 1824, 23–24. Delacroix praises the courage and firmness of his father in regard to some Dutch rebels and during his operation.

12. Delacroix's mother complained, on 19 April 1798, of still suffering from an overly strenuous effort she had made to get into a carriage. One can imagine another hypothesis, that Charles Delacroix fathered the child *before* his operation, which some physicians think possible. In any case, he could have been capable of it fifteen days after the operation, given the known rapidity of healing, which would make possible a seven-month gestation.

13. See the account of his mother's death that he gave three years later to his friend Jean-Baptiste Pierret, in a letter of 29 Oct. 1819, *Corr. gén.*, 1:61–64.

14. Piron, *Delacroix. Sa vie et ses oeuvres*, 36.

15. *Journal*, 13 Sept. 1822, 25. Delacroix much later copied a passage of *La Rabouilleuse* in his *Journal*, 15 May 1850, 252. It is a passage that has nothing to do with the two brothers but describes the sentiments of the *rabouilleuse* herself.

16. See especially *Lettres intimes*, 183–210, and the letters written to his relatives and friends after the death of the general at Bordeaux in January 1846, in *Corr. gén.*, 2:248–61. Delacroix brought the graves of his brother and father together and took it upon himself to erect a suitable monument. On Charles-Henry Delacroix, see J.-L. Stéphant, "Chili ou le frère 'oublié' d'Eugène Delacroix. Documents inédits," *Bulletin de la Société de l'Histoire de l'Art Français*, 1990 [1992], 173–205.

17. Letter to Jean-Baptiste Pierret, at the end of December 1817, *Corr. gén.*, 1:14. Delacroix's letters to his sister Henriette, from 1819 to 1822, give a great deal of information on their relations, in which questions of money play a large role (Delacroix also being responsible for his nephew Charles de Verninac, who remained in Paris after his mother left for Charente). See especially ibid., 5:3–143.

18. On the Delacroix fortune, see André Joubin, "Documents nouveaux sur Delacroix et sa famille," *Gazette des Beaux-Arts*, Mar. 1933, 173–86. In spite of the difficulties caused by the inheritance, Delacroix spent several vacations in Charente: see A. Dupuy, "Eugène Delacroix en forêt de Boixe," *Gazette des Beaux-Arts*, Feb. 1968, 117–22. On Delacroix's vacations in Touraine, especially at the home of his brother Charles, see the catalogue of the 1998 exhibition *Delacroix en Touraine*, at the Musée des Beaux-Arts, Tours.

19. See the letter to Joséphine de Forget, 31 Aug. 1858, *Corr. gén.*, 4:43–44. The archives preserved by Achille Piron and then by his descendants, which were sold in Dec. 1997 (the sale was held at the Théâtre de Caen, 6 Dec. 1997, by Tancrède and Lo Dumont) and acquired by various public institutions, have allowed for close reexamination of Delacroix's financial situation throughout his career. See Vincent Pomarède, "Eugène Delacroix, l'Etat, les collectionneurs, et les marchands," in *Delacroix. Les dernières années*, 46–59.

20. On the life and portraits of this beloved nephew of Delacroix, see Lee Johnson, "Eugène Delacroix and Charles de Verninac: An Unpublished Portrait and New Letters," *Burlington Magazine*, Sept. 1968, 511–18.

21. Letter to Charles Soulier, 20 July 1834, *Corr. gén.*, 1:376. See also the letter to Pierret of the same day, 377.

22. On Delacroix's sojourns at the Abbaye de Valmont, see Annie Conan, "Delacroix à l'abbaye de Valmont," *Art de France* 3 (1963): 271–76. More generally, on Delacroix in Normandy see the catalogue edited by Arlette Sérullaz for the 1993 exhibition *Delacroix et la Normandie*, at the Musée National Eugène Delacroix, Paris. One finds there the genealogical tree of Delacroix, already given by André

Joubin in a supplement to the *Journal*, corrected by Lee Johnson, 25–27.

23. See *Journal*, 1–8 Oct. 1856, 591–94, and the letter to Joséphine de Forget, 25 Oct. 1856, *Corr. gén.*, 3:340–41.

24. See Raymond Escholier, *Delacroix et les femmes* (Paris, 1963). See also Julien Cain, "Lettres inédits d'Eugène Delacroix," in *Etudes et documents sur l'art français du XIIme au XIXme siècles* (Paris, 1959), 372–82; and Camille Bernard, "Une liaison orageuse. Correspondance inédit entre Eugène Delacroix et Eugénie Dalton," *Nouvelles littéraires*, 9 May 1963 (special issue devoted to Delacroix), 8.

25. Letter to Charles de Verninac, 1 May 1830, *Further Corr.*, 14–15. On Delacroix and Joséphine de Forget, see Raymond Escholier, *Eugène Delacroix et sa 'consolatrice'* (Paris, 1932).

26. See André Joubin, "Deux amies de Delacroix. Mme Elisabeth Boulanger-Cavé et Mme Rang-Babut," *Revue de l'Art Ancient et Moderne* (Jan.–May 1930): 56–94, and P. Angrand, *Marie-Elisabeth Cavé, disciple de Delacroix* (Lausanne, 1966). On a worldly and artistic relationship, see H. Bessis, "Delacroix et la duchesse Colonna," *L'Oeil*, no. 147 (Mar. 1967): 22–29.

27. Baudelaire, "L'Oeuvre et la vie d'Eugène Delacroix," 766.

28. *Lettres intimes*, passim.

29. Today in the Louvre, RF 1940 (Sérullaz et al., *Dessins*, no. 1739). The last New Year's Eve gathering commemorated in the album is that of 1842–43.

30. Letter of Villot published in René-Paul Huet, *Paul Huet* (Paris, 1911), 386. On the relations between Delacroix and Villot, see *Le Roman d'une amitié. Delacroix et Villot, le petit journal des grandes expositions*, ed. Catherine Adam et al. (Apr.–July 1998).

31. See Michel Florisoone, "La Mort d'une amitié: Delacroix et Villot," *Nouvelles Archives de l'Art Français* (1959): 382–99.

32. See chap. 6.

33. Manuscript memoirs of Delacroix, cited in Piron, *Delacroix. Sa vie et ses oeuvres*, 61. Delacroix may have posed as the man in front of the boat, head bent forward and arms extended (ibid., 57).

34. *Journal*, 27 Jan. 1854, 50. A week later, 2 Feb., ibid., Delacroix goes back to his friend's death, but in the abstract and without precise reference to Géricault.

35. Ibid., 30 Dec. 1823, 44.

36. On the sale after Géricault's death, and the purchases that Delacroix may have made, see Germain Bazin, *Théodore Géricault, étude critique, documents et catalogue raisonné* (Paris, 1987), 1:92–100. The imprecision of the extant documents and of the information that one can draw from the sale after the death of Delacroix himself, prevents our knowing precisely all the pictures by Géricault that Delacroix bought. But they almost certainly included

Polish Lancer Standing by His Horse (private collection, Paris), *Assumption of the Virgin*, after Titian (Kunsthalle Bremen), *Death of Saint Peter the Martyr*, also after Titian (Öffentliche Kunstsammlung, Basel), the *Equestrian Portrait of the Marquis of Moncade*, after Van Dyck (Amsterdam Historical Museum), the *Portrait of Marie Serre*, after Rigaud (Musée des Beaux-Arts, Dijon).

37. See Piron, *Delacroix. Sa vie et ses oeuvres*, 61–62. See also Camille Bernard, "Delacroix admirateur et critique de Géricault," *Bulletin de la Librairie Ancienne et Moderne*, no. 166 (Aug.–Sept. 1966): 133–39. The relationship of Delacroix to Géricault and their role in the Romantic movement are at the heart of a line of inquiry developed by the 1998 exhibition at the Musée des Beaux-Arts de Rouen, *Delacroix. La naissance d'un nouveau romantisme*. See in particular Lee Johnson, "Delacroix et Géricault: Liens et divergences," 17–37; B. Jobert, "Delacroix et la littérature: Une nouvelle dimension du romantisme," 39–59; and C. Pétry, "Le héros romantique," 83–103.

38. Chap. 3 deals with the English connection characteristic of Romanticism in general and of Delacroix's in particular.

39. Letter to Théophile Thoré, 30 Nov. 1861, *Corr. gén.*, 4:286–89.

40. *Journal*, 9 June 1823, 40. Among his painter friends of the Romantic years, Delacroix especially appreciated Hippolyte Poterlet and Paul Huet. He also had a relationship with Paul Chenavard.

41. On George Sand and Delacroix, see André Joubin, "L'amitié de George Sand et d'Eugène Delacroix," *Revue des Deux-Mondes*, 1 May 1934, 832–65; A. de Rothmaler, "Les portraits de George Sand par Delacroix," *Gazette des Beaux-Arts*, July–Aug. 1926, 70–78; J. Pueyo, "Les portraits de George Sand par Delacroix," *Présence de George Sand*, 27 Oct. 1986, 21–29; B. C. Chambaz, "George Sand et Delacroix," ibid., 29–34. All the letters from Delacroix to George Sand, from April 1835 to July 1863, have been conserved, with no censorship, as seems to be the case also with those of his other great female friend, Joséphine de Forget. The opposite is not true, with some very rare exceptions. George Sand also spoke of Delacroix in several texts, of which some were published during the life of the painter without his contradiction or objection. The sessions of posing for the portrait in men's clothes are recorded in her *Journal intime* (Paris, 1926), 3.

42. Letter to George Sand, 19 July 1855, *Corr. gén.*, 3:278. On the double portrait of Chopin and George Sand, see René Berthelot, "Histoire et vicissitudes d'un portrait célèbre: Le *Chopin* de Delacroix," *Musica* 117 (Dec. 1953): 27–34.

43. *Journal*, 31 Mar. 1824, 59.

44. Manuscript remembrances cited in

Piron, *Delacroix. Sa vie et ses oeuvres*, 78–79.

45. Baudelaire, "L'Oeuvre et la vie d'Eugène Delacroix," 757.

46. Ibid., 756.

47. Théophile Gautier, *Histoire du Romantisme* (Paris, 1874), 202–3.

48. Théophile Silvestre, *Histoire des artistes vivants. Les artistes français. Etudes d'après nature* (Paris, 1861), 9–10.

49. Robaut et al., *L'Oeuvre complet*, 1. By way of comparison, the catalogue of Lee Johnson counts 504 paintings known or located (not including the decorative works), and 214 lost paintings; the critical catalogue of drawings conserved in the Louvre, by Maurice Sérullaz, shows 1,760 entries (but the number of drawings is higher, since the albums are counted as one entry); the last critical catalogue of engravings and lithographs, that of Loÿs Delteil, counts 131 known items and 12 more on the list, mentioned by Moreau or Robaut, of which no prints are known.

50. Letter to his brother Charles Delacroix, 20 Sept. [in fact 4 Oct.] 1820, *Corr. gén.*, 1:72–73, and *Lettres intimes*, 186–87.

51. He was staying with his Riesener cousins, at Frépillon, near Paris; he speaks then of a "rather serious illness that overtook me" (letter of 27 Feb. 1835, *Corr. gén.*, 1:393).

52. Letter to George Sand, 10 Apr. 1842, *Corr. gén.*, 2:97. Delacroix had lost Félix Guillemardet in 1840, and in 1839 his Bataille cousin, who lived in Normandy and to whom he was also close. He continued to feel the effects of the death of his nephew Charles de Verninac.

53. Letter to George Sand, Apr. 1842, ibid., 2:98; the letters written by Delacroix during his stay at Frépillon and on his return to Paris give comparable indications (ibid., 2:91–103). It was at this time that the first daguerreotypes were taken of him, his first photographic portraits.

54. Letter to Gisors, 13 Apr. 1842, ibid., 2:99.

55. Silvestre, *Histoire des artistes vivants*, 5–6.

56. Piron, *Delacroix. Sa vie et ses oeuvres*, 20–21.

57. *Journal*, 3 Oct. 1855, 549.

58. Letter to Jenny Le Guillou, 30 Aug. 1859, *Corr. gén.*, 4:119.

59. In 1819, Delacroix had fathered a child named Caroline, by a servant of his friends the Pierrets. The mother has sometimes been identified as Jenny, and the portrait of her daughter in the Louvre identified with that child. Nothing is less certain, and the last archival discoveries in no way confirm this dubious assertion, which goes back to Delacroix's student Lassalle-Bordes, with whom he broke ties and whose recollections are for that reason to be handled with caution when they touch on Delacroix's private life. See Johnson, *Crit. Cat.*, 1:84–85 and 3:54.

60. See, for example, a discussion resulting from an assertion made by Chenavard, *Journal*, 12 Oct. 1854, 484.

61. Baudelaire, in an obituary on Delacroix, reports having seen him explaining to her the Assyrian statues of the museum. See Baudelaire, "L'Oeuvre et la vie d'Eugène Delacroix," 763.

62. Letter from George Sand to Théophile Silvestre, 5 Jan. 1853, in George Sand, *Correspondance*, ed. G. Lubin (Paris, 1976), 11:534–35.

63. Piron, *Delacroix. Sa vie et ses oeuvres*, 39. Delacroix thought the music teacher was a friend of Mozart. On Delacroix and music, see the synthesizing article of R. Jullian, "Delacroix et la musique du tableau," *Gazette des Beaux-Arts*, Mar. 1976, 81–88 (with a complete bibliography on the question). See also G. P. Mras, "*Ut Pictura Musica*: A Study of Delacroix's Paragone," *Art Bulletin* 45 (1963): 266–71; and Georges Liébert, "Les mots et les couleurs et les sons se répondent," in *Rigueur et Passion. Hommage à Annie Kriegel* (Paris, 1994), 251–70.

64. Letter to his sister Henriette de Verninac, 1 Mar. 1820, *Corr. gén.*, 5:34.

65. See, for example, the echo of his conversations with Chopin: *Journal*, 2 Feb. 1849, 174; 7 Apr. 1849, 189–90; 25 Jan. 1857, 634; 13 Apr. 1860, 779.

66. Lassalle-Bordes, cited by Burty in *Lettres de Eugène Delacroix*, ed. Philippe Burty, 2nd ed. (Paris, 1880), 2:xvii.

67. Letter to Dessauer, 23 Mar. 1847, *Corr. gén.*, 2:308.

68. Letter to Berryer, 12 Nov. 1859, ibid., 2:308.

69. Letter to George Sand, 10 Dec. 1859, ibid., 4:131–32.

70. Letter to George Sand, 20 Nov. 1847, ibid., 2:331.

71. *Journal*, 7 Apr. 1849, 190.

72. Ibid., 19 Feb. 1850, 224.

73. Ibid., 23 Apr. 1849, 193.

74. Ibid., 3 Mar. 1850, 226–27.

75. Ibid., 21 Apr. 1853, 331.

76. Ibid., 29 June 1853, 357–58.

77. Synthesis in Juliusz Starzynski, "Delacroix et Chopin," in Académie Polonaise des Sciences, Centre Scientifique de Paris, conférences, fascicule 34, which summarizes previous articles by the same author. I take up below some of his conclusions, notably on the importance of music in general and Chopin in particular in the elaboration of Delacroix's aesthetic conceptions. I would, however, be careful not to overestimate the Chopin connection and remain skeptical about certain specific points (the 'Orphic' inspiration of the Luxembourg cupola, and the identification of his contemporaries with certain personages: George Sand with Aspasia, Chopin with Dante, Mme de Forget with Sappho, and Delacroix himself with Virgil or Cato of Utica). See J. Starzynski, "La pensée orphique du plafond d'Homère de

Delacroix," *Revue du Louvre*, no. 2 (1962): 73–82.

78. George Sand, *Impressions et souvenirs*, 3rd ed. (Paris, 1873), 80–81 (article initially appearing in *Le Temps* in 1871–72).

79. Letter to Pierret, 7 June 1842, *Corr. gén.*, 2:108.

80. *Journal*, 29 June 1853, 358. The remark comes just after the one on Mozart and Beethoven cited previously.

81. *Journal*, 28 Feb. 1851, 271–75.

82. Letter to George Sand, Mar. 1838, *Corr. gén.*, 2:6–7.

83. Adolphe Moreau, *E. Delacroix et son oeuvre* (Paris, 1873), xiii–xiv.

84. A mural painting representing *The Lamentation* (see chap. 6).

85. *Journal*, 24 Dec. 1853, 394.

86. Moreau reports a conversation with Delacroix also pertaining to *The Lamentation* of Saint-Denis (the artist having attributed "the pose, so woefully abandoned" of the Magdalen to the "religious chants of the month of Mary"). Moreau, *E. Delacroix et son oeuvre*, xiv.

87. *Journal*, 22 June 1863, 808–9. This passage, which ends the *Journal*, is in fact a note made by Delacroix on 22 June, conserved, according to A. Joubin, in a notebook now lost.

88. George Sand, *Impressions et souvenirs*, 81–82.

89. See *Journal*, 30 Nov. 1857 ("On the comparison of the work and the finished sketch" ["De la comparaison de l'ouvrage à l'ébauche fini"]), 701; 9 Jan. 1859 ("On the *sketch* and on *finish*" ["Sur l'*ébauche* et sur le *fini*"]). The improvisations of Chopin are bolder than the work: one does not spoil by finishing, when one is a great artist"), 736.

90. *Journal*, 20 Apr. 1853, 330.

91. Ibid., 15 Apr. 1853, 327–28 for the (harsh) appreciation of Courbet; 328 for the cited phrase.

92. Ibid., 26 Mar. 1856, 405–7.

93. Ibid., 12 Dec. 1856, 600.

94. Silvestre, *Histoire des artistes vivants*, 31.

95. Notebook of manuscript memoirs of Delacroix, cited by Piron, *Delacroix. Sa vie et ses oeuvres*, 40. On Delacroix's studies, see Y. Hucher, "Eugène Delacroix au Lycée impérial," in *Louis-le-Grand 1563–1963. Etudes, souvenirs, documents* (Paris, 1963), 117–30. A. Joubin published the school notebooks of Delacroix, "Etudes sur Eugène Delacroix," *Gazette des Beaux-Arts*, Mar. 1927, 159–82.

96. Letter to Pierret, 2 Oct. 1818, *Corr. gén.*, 1:26.

97. On the relations between Hugo and Delacroix, see Jean Gaudon, "Hugo juge de Delacroix," *Gazette des Beaux-Arts*, Sept. 1966, 173–76, and Pierre Georget, "Delacroix et Auguste Vacquerie," *Bulletin de la Société de l'Histoire de l'Art français* 1968 (1970), 163–89. Delacroix took inspiration from Hugo for only one of his

paintings, and he did not do it openly (see the article cited in chap. 7, n. 63).

98. See Delacroix's letter to Hugo, July 1828, *Corr. gén.*, 1:221.

99. The anecdote is reported by Alexandre Dumas, who dated it to 1836: see Dumas, *Delacroix*, 63–68.

100. Philarète Chasles, *Mémoires* (Paris, 1876), 1:341.

101. The anecdote, taken from a letter of Alfred de Musset (4 Aug. 1831), is told in Tourneux, *Eugène Delacroix devant ses contemporains*, 64. Horace de Viel-Castel reports a similar fact; see Raymond Escholier, *Delacroix, peintre, graveur, écrivain* (Paris, 1927), 2:117.

102. Besides *King Roderick*, Dumas possessed several other works of Delacroix: the first versions of *Tasso in the Hospital of Saint Anna, Ferrara* (Johnson 106, 1824, Collection Bührle, Zurich), and of *The Combat of the Giaour and Hassan* (Johnson 114, 1826, The Art Institute of Chicago), *Hamlet Sees the Ghost of His Father* (Johnson L99, 1825, Jagellon University Museum, Krakow), *Queen Christina and Sentinelli* (Johnson 279, 1844–45, private collection). Delacroix also painted for Dumas in 1854 a *Hamlet and Polonius*, often identified with a picture in the museum at Reims, but Johnson refutes this: *Crit. Cat.*, 3:139–40. On the question of relations between the two men in general, see Lee Johnson, "Delacroix, Dumas, and Hamlet," *Burlington Magazine*, Dec. 1981, 717–21; Feb. 1982, 128.

103. Dumas, *Delacroix*, 97–99.

104. *Journal*, 5 Feb. 1847, 128.

105. Ibid., 20 Mar. 1847, 145.

106. Ibid., 2 Oct. 1852, 310.

107. Ibid., 17 Oct. 1853, 370–71. The remark applies equally to Dumas and to George Sand.

108. Letter to Pierret, 22 June 1842, *Corr. gén.*, 2:112.

109. *Journal*, 22 July 1860, 785–86. On Delacroix and Balzac, see N. Javosrkaja, "Delakrua i Bal'zak," *Spvetskoe Isskustvosnanie*, no. 1 (1979): 156–96 (summarized in English at the end of the Russian article).

110. Manuscript memoirs of Delacroix, in Piron, *Delacroix. Sa vie et ses oeuvres*, 80.

111. See n. 114 for Silvestre's passage; for Baudelaire, "L'Oeuvre et la vie d'Eugène Delacroix," 757–58.

112. Three of his earliest literary endeavors are known: *Alfred*, a novel set in the time of William the Conqueror; *Les Dangers de la Cour*, set in modern times and heavily influenced by Rousseau; and *Victoria*, which seems to be later than the other two. See Jean Marchand, "Eugène Delacroix homme de lettres d'après trois oeuvres de jeunesse inédites," *Le Livre et l'Estampe*, no. 3 (1959): 3–14. André Joubin published some of Delacroix's youthful verses in the *Gazette des Beaux-Arts*, 1927, 165; see also A. Fontaine, *Delacroix poète* (Paris, 1953).

113. See, for example, reflections on the continuation of the article on Poussin, destined for the *Moniteur*, in the *Journal*, May–June 1853; 6 May, 338; 8 May, 339; 10 May, 342; 13 May, 343; 14 May, 344; 25 and 29 May, 352; 5 and 7 June, 355; and the remarks to his cousin Joséphine de Forget written at the same time: letters of 11, 16, and 29 May, and of 16 June 1853, *Corr. gén.*, 3:155–57, 159–60, and 162.

114. Silvestre, *Histoire des artistes vivants*, 32.

115. On this point, as more generally on Delacroix as a man of letters, see Michele Hannoosh, *Painting and the "Journal" of Eugène Delacroix* (Princeton, 1995); Eugène Delacroix, *Dictionnaire des Beaux-Arts*, ed. Anne Larue (Paris, 1996), especially xvi–xvii (hereafter referred to as *Dictionnaire*); and Anne Larue, "Fragments ou pensées détachées? Etudes de quelques romantiques," *La Licorne* 21 (1991): 239–53; see also Larue, *Romantisme et mélancolie. Le Journal de Delacroix* (Paris, 1998). More generally, see C. Sieber-Meier, *Untersuchungen zum "oeuvre littéraire" von Eugène Delacroix* (Bern, 1963).

116. Letter to François Buloz, 25 Nov. 1853, *Corr. gén.*, 3:181.

117. See André Joubin's introduction to the *Journal*, 5–8, and the conclusion.

118. *Journal*, 3 Sept. 1822, 19.

119. Ibid., 19 Jan. 1847, 118.

120. One can get the clearest idea of this theory in Anne Larue's reconstruction of the *Dictionnaire des Beaux-Arts*, which regroups the different passages (separated in those editions of the *Journal* that list them chronologically) around themes chosen by Delacroix himself and following his references.

121. Note published by Hannoosh, *Painting and the "Journal" of Eugène Delacroix*, 203, following Thierry Bodin, *Lettres et manuscrits autographes* (Hôtel Drouot, Paris, 23 Apr. 1993).

122. *Journal*, 24 Oct. 1853, 374. For an analysis of the question of the difference between the arts in Delacroix's writings, see Hannoosh, *Painting and the "Journal" of Eugène Delacroix*, 23–54.

123. *Journal*, 21 July 1850, 253–54.

124. Ibid., 5 Jan. 1857, 606.

125. Baudelaire, "L'Oeuvre et la vie d'Eugène Delacroix," 745–46.

126. Letter to Jules Allard, 25 Aug. 1813, *Corr. gén.*, 1:6.

127. Letter to Achille Piron, 11 Nov. 1815, *Lettres intimes*, 39.

128. The notebook is today in the Bibliothèque d'Art et d'Archéologie, Fondation Jacques Doucet, Paris.

129. Extract from the manuscript memoirs of Delacroix, cited by Piron, *Delacroix. Sa vie et ses oeuvres*, 50 (like the extracts cited above, ibid., 49–51). On Guérin's studio, and on the relationship between the painter and the beginnings of

Romanticism, see Bruno Chenique, "Le meurtre du père, ou les insensées de l'atelier Guérin," in *Le Temps des passions. Collections romantiques des musées d'Orléans* (Orléans, 1997), 37–71.

130. Letter to Gaultron, 5 Sept. 1844, *Corr. gén.*, 2:191.

131. See Delacroix's letter to Villot, 14 June 1842, *Corr. gén.*, 2:111, where he explains his difficulty in "organizing a canvas for painting" at Nohant, where he is staying.

132. *Journal*, 11 Jan. 1857, 608.

133. On Delacroix's drawing, one relies principally on the catalogue of the traveling exhibition of 1963, *Le Rôle du dessin dans l'oeuvre de Delacroix*, ed. D. Milhau and S. Savanne, which included a useful introduction; Maurice Sérullaz, "L'Oeuvre dessiné d'Eugène Delacroix," in *Dessins*, 7–23; ibid., in the catalogue of the 1986 exhibition *Ingres et Delacroix. Dessins et aquarelles*, 127–41, at the Palais des Beaux-Arts, Brussels; and Günter Busch, "Delacroix dessinateur," ibid., 288–93, initially published in 1964 (in German) in the catalogue of the exhibition *Eugène Delacroix*, at the Kunsthalle Bremen. The pastels have been studied by Lee Johnson, *Pastels*. As early as 1864, Robaut gave the first facsimiles of the drawings, when that aspect of Delacroix's work was being discovered: *Fac-similés de dessins et croquis originaux d'Eugène Delacroix*, 2 vols. (Paris, 1864). See also G. Janneau, *Le Dessin de Delacroix* (Paris, 1921); H. Graber, *E. Delacroix: Zeitnungen, Aquarelle, Pastelle* (Basel, 1929); K. Badt, *Delacroix. Drawings* (Oxford, 1946); Maurice Sérullaz, *Eugène Delacroix. Album de croquis* (Paris, 1961); V. Price, *The Drawings of Delacroix* (Alhambra, Calif., 1966); C. Roger-Marx, *L'Univers de Delacroix* (Paris, 1970); E. Petrova, *Delacroix und die romantische Zeichnung* (Hanau, 1989); Ivan Bergerol and Arlette Sérullaz, *Eugène Delacroix, aquarelles et lavis* (Paris, 1998); and Arlette Sérullaz, *Delacroix, Le Cabinet des Dessins* (Paris, 1998). Among the numerous Delacroix exhibitions that include the drawings, especially notable is that organized by Margret Stuffman in 1987 at the Städtische Galerie im Städelschen Kunstinstitut, Frankfurt, *Eugène Delacroix. Themen und Variationen. Arbeiten auf Papier* (Frankfurt, 1987), which analyzes designs and engravings thematically, and that of the Bibliothèque Nationale de France, *Delacroix. Le trait romantique* (Paris, 1998). On Delacroix's early drawings, see Lee Johnson, "The Early Drawings of Delacroix," *Burlington Magazine*, Jan. 1956, 22–26, followed up by D. Backhüys, "1822–1840: Delacroix et le dessin," in *Delacroix. La naissance d'un nouveau romantisme*, 113–27. Some particular studies include the article of A. Joubin (cited in n. 95 above), which examines two notebooks of sketches and notes);

J. Bouchot-Saupique, "Some Drawings by Delacroix in the Musée de Besançon," *Master Drawings*, no. 3 (1963): 40–43; R. Ionescu, "Dessins de Delacroix au Musée d'art de l'Académie," *Revue Roumaine d'Histoire de l'Art* (1966): 107–8; S. Lichtenstein, "An Unpublished Portrait of Eugène Delacroix and Some Figure Sketches," *Master Drawings*, no. 1 (1966): 39–45; Maurice Sérullaz, "Unpublished Drawings by Eugène Delacroix at the National Museum, Stockholm," *Master Drawings*, no. 4 (1967): 404–6; L. Eitner, "A Sheet of Figure Studies by Delacroix," *Stanford Museum* (1976–77): 2–9; L.-A. Pratt, "Un ensemble de dessins de Delacroix au Musée de Picardie à Amiens," *Revue du Louvre*, no. 2 (1979): 100–107; "Dessins inédits de Delacroix à Dijon," *Revue du Louvre*, no. 2 (1981): 103–8; L.-A. and Véronique Prat, "Dessins de la Collection Chennevières et dessins de Delacroix," in *La Donation Suzanne et Henri Baderou au Musée de Rouen. Etudes de la Revue du Louvre* 1 (1980): 103–8; *Eugène Delacroix 1798–1863. Ausgewählte Graphik und Zeichnungen aus de Sammlung der Kunsthalle Bremen* (Kaiserlauten: Pfalzgalerie, 1983); E. Batache, "Delacroix in Australia," *Art and Australia*, no. 2 (1986): 235–38 (drawings and paintings); and "Eugène Delacroix dans les collections du Musée Condé à Chantilly [dessins et peintures]," *Le Musée Condé*, no. 54 (Apr. 1998).

134. The same words are also used by Frédéric Villot, *Catalogue de tableaux, aquarelles, etc. par Eugène Delacroix, provenant du cabinet de M. F. V[illot]* (Paris, 11 Feb. 1865), vi.

135. Baudelaire, "L'Oeuvre et la vie d'Eugène Delacroix," 763–64.

136. See chap. 4.

137. Piron, *Delacroix. Sa vie et ses oeuvres*, 53–54.

138. These words are reported by Baudelaire, "L'Oeuvre et la vie d'Eugène Delacroix," 747.

139. Silvestre, *Histoire des artistes vivants*, 12.

140. *Journal*, 13 Jan. 1857, 616; *Dictionnaire*, 40.

141. See Arlette Sérullaz, "Delacroix copiste," in the exhibition catalogue *Copier créer. De Turner à Picasso: Trois cents oeuvres inspirées par les maîtres de Louvres* (Paris, 1993), 234–38; for various painted copies by Delacroix and others attributed to him, see ibid., 239–48. There is also a dossier on "Delacroix copié," in ibid., 250–71. For examples of copies drawn by Delacroix, see M. Sérullaz et al., *Dessins*, especially 2:7–77 (classification by sources, from antiquity to various European schools).

142. Thus in 1863 he asked the photographer Pierre Petit to sell him, "at the artist's price," the collection of reproductions of frescos of Raphael in the Farnese, which Petit finally gave him. See the two

letters to Petit, 1 and 4 Mar. 1863, *Corr. gén.*, 4:366–67. The relationship of Delacroix and the photographer poses numerous problems, which are articulated with regard to an album of photographs done under his direction by Eugène Durieu in June 1854. It concerns not only photography but also drawing and more generally the aesthetic theory of Delacroix. After the pioneering study of F. A. Trapp, "The Art of Delacroix and the Camera's Eye," *Apollo* (Apr. 1966): 278–88, one should see the most recent clarification by J. Sagne, *Delacroix et la photographie* (Paris, 1982), as well as the review by P. Vaisse in *Photographies*, no. 3 (1983): 96–116; and the article of H. Zerner, "Delacroix, la photographie, le dessin," in *Quarante-Huit-Quatorze, Conférences du Musée d'Orsay* (1992) no. 4, 7–14. Various research projects, conducted most notably around the collections of the Bibliothèque Nationale de France, have clarified and renewed this question. See especially Sylvie Aubenas, "Un album de photographies d'Eugène Delacroix," in Jobert, ed., *Delacroix. Le Trait romantique*, 51–55, and also her article "La collection de photographies d'Eugène Delacroix," to appear in *Revue de l'Art* in the fall of 1998. To situate Delacroix in a broad context, see the catalogue for the 1997 exhibition at the Bibliothèque Nationale de France, *L'Art du nu au XIXe siècle, le photographe et son modèle* (Paris, 1997).

143. Musée des Beaux-Arts, Rouen, reproduced in *Delacroix et la Normandie*, 52, fig. 95.

144. See, for example, Delacroix's letter to Pierret, 26 Mar. 1830, *Corr. gén.*, 1:251–52, in which he recommends to him that he go to see, before its sale, the collection of drawings of the dealer Constantin; and the pages of his journal written on the occasion of the sale of the inheritance of Louis-Philippe, which included the tapestries of the *Life of Achilles*, after Rubens, *Journal*, 26 Jan.–1 Feb. 1852, 283–86. On a visit to the Galerie Espagnole of Marshal Soult, see the letter of request to Schwiter, c. 1833, *Corr. gén.* 1:362; on a visit to the collection of Eudoxe Marcille, see the letter to Pierret, 6 Oct. 1846, ibid., 2:288. For Delacroix at Bordeaux, see the letter to George Sand, 25 Jan. 1846, ibid., 2:260. Y. Sjöberg has studied the views of Delacroix on the dispersion of the Campana collection bought by the State under Napoleon III, "Eugène Delacroix et la collection Campana," *Gazette des Beaux-Arts*, Sept. 1966, 149–64.

145. Silvestre, *Histoire des artistes vivants*, 18–19. On Delacroix and Rubens, see L. Hourticq, "Delacroix et Rubens," *Revue de l'Art Ancien et Moderne* (1909): 215–28; E. Lambert, "Delacroix et Rubens. La *Justice de Trajan* et l'*Elévation de la Croix* d'Anvers," *Gazette des Beaux-Arts*, Nov. 1932, 245–48; P. Fierens, "Eu-

gène Delacroix admirateur et copiste de Rubens," *Pictura* 2 (1946): 5–9; L. Rudrauf, "Imitation et invention dans l'art d'Eugène Delacroix. Delacroix et Rubens," in *Mélanges Georges Jamati* (Paris, 1956), 277–84; B. E. White, "Delacroix's Painted Copies after Rubens," *Art Bulletin* (Jan. 1967): 37–51; R. Floetemeyer, "Das Bild des Zweifelnden Thomas bei Delacroix und Rubens: Eine vergleichende Studie zur religiösen Malerei des 19. Jahrhunderts," *Zeitschrift für Aesthetik und Kunstwissenshaft* 35 (1990): 95–130. Floetemeyer also intepreted the entirety of Delacroix's work in relation to Rubens in *Delacroix's Bild des Menschen. Erkundungen vor dem Hintergrund der Kunst des Rubens* (Mainz, 1998). Other examples of links between Delacroix and former artists are discussed in the following: A. Linzeler, "Une source d'inspiration inconnue d'Eugène Delacroix," *Gazette des Beaux-Arts*, June 1933, 309–12 (a Flemish print of 1573 used for the *Entry of the Crusaders into Constantinople*); L. Rudrauf, "Imitation et invention dans l'art d'Eugène Delacroix. Delacroix et Le Rosso," *Acta et Commentationes* 43, no. 1 (1938): 1–10; H. Bessis, "Deux sources d'inspiration d'Eugène Delacroix," *Bulletin de la Société de l'Histoire de l'Art Français* 1969 (1971): 175–80 (Charles-Nicolas Cochin and the English engraver Henry Alken, a contemporary of Delacroix); F. Mellinghoff, "Eugène Delacroix copiert nach Jacob van Oest d'Ä," *Museum Folkwang Essen Mitteilungen*, nos. 5–6 (1971–72): 29–38; C. Ganeval, "Delacroix et les maîtres allemands du XVIme siècle," *Panthéon* 25 (1976): 40–48; S. Lichtenstein, "Delacroix *Emblematicus*: His Unknown Studies after Bonasone," *Journal of the Warburg and Courtauld Institutes* (1976): 275–80; Maurice Sérullaz, "Eugène Delacroix: l'Italie de la Renaissance, les maîtres de l'école de Fontainebleau," in *Hommage à Hubert Landais* (Paris, 1987), 190–96.

146. See Sarah Lichtenstein, "Delacroix's Copies after Raphael, Part 1," *Burlington Magazine*, Sept. 1971, 525–33; Part 2, ibid., Oct. 1971, 593–603; "More about Delacroix's Copies after Raphael," ibid., July 1977, 503–4; and *Delacroix and Raphael* (New York, 1979).

147. Robaut et al., *Oeuvre complet*, 11.

148. On Delacroix's "youthful sins," (the phrase is Jean Laran's, in an article of 1930), see Nina Athanassoglou-Kallmyer, *Eugène Delacroix: Prints, Politics, and Satire, 1814–1822* (New Haven, 1991). Care must be taken not to confuse Delacroix with a man of the same name, whose troubles with the police have led some to think that the painter was a *carbonaro*: see Camille Bernard, "Eugène Delacroix et le lithographe sans scrupule," *Bulletin de la Librairie Ancienne et Moderne* (Apr.–May 1975): 129–40.

149. Spanish influences on Delacroix

have been studied, especially by Michel Florisoone: "Comment Delacroix a-t-il connu les *Caprices* de Goya?" *Bulletin de la Société de l'Histoire de l'Art Français* 1957 (1958): 131–46; "Moratin Inspirer of Géricault and Delacroix," *Burlington Magazine*, Sept. 1957; "En Busca de Goya Pintor, Siguiendo a Delacroix," *Goya*, no. 61 (1964): 1–10; "La genèse espagnole des *Massacres de Scio* de Delacroix," *Revue du Louvre*, nos. 4–5 (1963): 195–208. See also J. d'Elbée, *Le Sourd et le muet. Notes parallèles sur Goya et Delacroix* (Paris, 1932), and the clarification by Maurice Sérullaz, "Goya und Delacroix," in *Goya. Das Zeitalter der Revolution*, exh. cat. (Hamburg, 1980–81), 23–27.

150. See Charles de Tolnay, "*Michel-Ange dans son atelier* par Delacroix," *Gazette des Beaux-Arts*, 1962, 43–52; J. Spector, "Towards a Deeper Understanding of Delacroix and His Art: An Interpretation of *Michelangelo in His Studio*," *Gazette des Beaux-Arts*, Jan. 1984, 19–28. A synthesis of interpretations and their sources appears in Johnson, *Crit. Cat.*, 3:127–28. The same reasoning has sometimes been proposed for another composition of Delacroix, *Tasso in the Hospital of Saint Anna, Ferrara*: see A. Joubin, "A propos du *Tasse dans la maison des fous*," *Gazette des Beaux-Arts*, Apr. 1934, 247–49.

151. "Michel-Ange," *Revue de Paris* 15–16 (1830), reprinted in *Oeuvres littéraires*, 2:51–52.

152. *Journal*, 11 Jan. 1857, 614 (article "Decadence" for the *Dictionnaire des Beaux-Arts*).

153. Ibid., 615 (article "Classic").

154. Silvestre, *Histoire des artistes vivants*, 24–25.

155. Examples of studies after the Persian miniatures in the Louvre, Département des Arts Graphiques (see no. 1475 in *Dessins*, 2:84–86; RF 10043, no. 1480; RF 3971, no. 1484; RF 10031); see D. A. Rosenthal, "A Mughal Portrait Copied by Delacroix," *Burlington Magazine*, July 1977, 505–6, and Lee Johnson, "Two Sources of Oriental Motives Copied by Delacroix," *Gazette des Beaux-Arts*, Mar. 1965, 163–68. Khmer and Indian motifs appear on two sheets also conserved at the Louvre, the exact sources of which are not known, RF 9841 and RF 32667, nos. 1481–82 in *Dessins*. One can also discern the influence of Hokusai on Delacroix: N. Finlay, "Japanese Influence on a Lithograph by Delacroix," *New Mexico Studies in the Fine Arts* (1979): 5–7.

156. See Lee Johnson, "The Etruscan Sources of Delacroix's *Death of Sardanapalus*," *Art Bulletin* (Dec. 1960): 296–300; B. Farwell, "Sources for Delacroix's *Death of Sardanapalus*," *Art Bulletin* 40 (1958): 66–71; W. A. Steinke, "An Archeological Source of Delacroix's *Death of Sardanapalus*," *Art Bulletin* (June 1984): 310–20.

157. *Journal*, 23 Apr. 1854, 414–15.

158. Ibid., 8 Oct. 1822, 29.

159. Ibid., 21 July 1850, 252–53.

160. Ibid., 25 Jan. 1857, 625; the passage cited previously is recopied by Delacroix *in extenso* before this extract, except for his two last sentences. For the whole of his remarks on effect, see the *Dictionnaire*, 79–83. On the aesthetic theories of Delacroix, see the synthesis of George P. Mras, *Eugene Delacroix's Theory of Art* (Princeton, 1966). The question has been broached in many articles, from various angles. See George P. Mras, "Literary Sources of Delacroix's Conception of the Sketch and the Imagination," *Art Bulletin* (Sept. 1963): 266–71; L. Rudrauf, "De la Bête à l'Ange. Les étapes de la lutte vitale dans la pensée et l'art d'Eugène Delacroix," *Acta Historiae Artiium, Academiae Scientiarium Hungaricae* 9, nos. 3–4 (1963): 295–341; K. Herding, "Kunst aus hochgemuter Düsternis. Uber Delacroix 'Paradoxien,'" *Städel-Jahrbuch* (1989): 259–78.

161. The jest is reported by Dumas, *Delacroix*, 64. Before the studio of the quai Voltaire, Delacroix had occupied several others, as well as different lodgings, among others, rue de la Planche, rue de Grenelle, rue de l'Université, rue Jacob, rue de Choiseul, and the passage Saulnier. Then came the rue Neuve-Guillemin (1838–44); he lived at the time in the rue des Marais Saint-Germain (now rue Visconti), then rue Notre-Dame-de-Lorette (1844–57), before the studio at the place Fürstenberg, where he died, and which is today the Musée National Eugène Delacroix. The glass passageway that allowed him to go from his apartment to the studio in any weather has disappeared, but his quarters have kept their bourgeois character, intimate and orderly. See André Joubin, "L'appartement et l'atelier de Delacroix rue de Fürstenberg," *Gazette des Beaux-Arts*, June 1938, 293–304, and "Logis et ateliers d'Eugène Delacroix," *Bulletin de la Société de l'Histoire de l'Art Français* (1938): 60.

162. The fact is emphasized by Gautier, *Histoire du romantisme*, 204, and by Silvestre, *Histoire des artistes vivants*, 10–11.

163. Silvestre, *Histoire des artistes vivants*, 7.

164. Baudelaire, "L'Oeuvre et la vie d'Eugène Delacroix," 163.

165. Silvestre, *Histoire des artistes vivants*, 6 (for the first citation), 8 (for the second).

166. Maxime Du Camp, *Souvenirs littéraires*, ed. Daniel Ostier (Paris, 1994), 493–94 (the *Souvenirs* first appeared serially, in the *Revue des Deux-Mondes*, in 1881–82).

167. Silvestre, *Histoire des artistes vivants*, 13.

168. *Journal*, 1 Mar. 1859, 736. Delacroix, after six months' interruption due to the works at Saint-Sulpice, took up regular writing in his journal by a series of pre-paratory notes for the *Dictionnaire* begun in 1857. This one ("Tableau") is the first.

169. See, on this point, ibid., and the testimony of Jean Gigoux, *Causeries sur les artistes de mon temps* (Paris, 1885), 12–13.

170. George Sand, *Impressions et souvenirs*, 77–79.

171. On Delacroix and color, see Lee Johnson, *Delacroix* (New York, 1963), which takes up the conclusions of his thesis, "Colour in Delacroix: Theory and Practice" (Cambridge University, 1958). See also J. B. Howell, "Eugène Delacroix and Color: Practice, Theory, and Legend," *Athenor* 2 (1982): 37–43. The topic has been revisited by John Gage, *Colour and Culture: Practice and Meaning from Antiquity to Abstraction* (London, 1993), especially 173–74, 185–87, and 235–36; and by Georges Roque, *Art et science de la couleur. Chevreul et les peintres, de Delacroix à l'abstraction* (Nimes, 1997), especially 197–214, whose conclusions I treat here. As Gage has emphasized, the preliminary color arrangements of Delacroix circulated in the studios beginning in the 1850s. One of his students, Pierre Andrieu, transmitted them to one of his own students, René Piot, who published them in *Les Palettes de Delacroix* (Paris, 1931).

172. Delacroix had noted, from Léonor Mérimée, the triangle of complementaries.

173. Maxime Du Camp, *Souvenirs littéraires*, 492–93.

174. Villot, *Catalogue de tableaux, aquarelles, etc.*, vi.

175. *Journal*, 2 Jan. 1853, 318.

176. First fragment, *Journal*, 11 Jan. 1857, 615–16; second, 5 Mar. 1857, 643–44; third, 30 Jan. 1860, 759. I follow here the *Dictionnaire*, which puts the original text in order, 189–90 and 103–4.

177. *Journal*, 11 Jan. 1857, 614–15 ("Mer," "Marines," of the *Dictionnaire*)

178. Delacroix, something of a homebody, never systematically took sketching tours like a Turner always looking for new landscapes. He was satisfied to sketch various studies there where he found himself during his rather rare departures from home, England in 1825 and especially Morocco in 1832 being quite exceptional: see R. Escholier, "Delacroix voyageur," *Revue de l'Art Ancien et Moderne* (Jan.–May 1930): 13–48. For some examples, see C. Ganeval and P. Lamicq, *Eugène Delacroix aux Pyrénées, 1845* (Lourdes, 1975); A. Dussert, "Eugène Delacroix aux Pyrénées," *Pyrénées*, no. 104 (1975): 291–93; J.-O Bouffin, "The Tours Sketchbook of Eugène Delacroix," *Metropolitan Museum Journal* 29 (1994): 135–50 (on the sojourn in Touraine of 1828; there, Delacroix also prepared *Quentin Durward*). See also *Delacroix en Touraine* (cited in n. 18 above). It is more than likely that some of the twenty-three landscapes sold at his posthumous sale were wrongly attributed to him. As Lee Johnson rightly points out in the short synthesis that he devotes to this problem, the study of Delacroix as a landscapist is complicated by two problems: attribution (the corpus of his landscapes not having really been established with precision—many have disappeared or have not been identified), and the identification of the places he painted (see Johnson, *Crit. Cat.*, 4:251–57). See also Bernard-Louis Derr, "The Landscapes of Eugène Delacroix" (Ph.D. diss., Ann Arbor and London, 1982).

179. *Journal*, 14 Sept. 1852, 308.

180. Examples in A. Sérullaz, ed., *Delacroix et la Normandie*, with the watercolor *Sunset on the Sea* (1854?), fig. 66, 44; and in *Ingres et Delacroix. Dessins et aquarelles*, with the watercolor and gouache *The Sea at Dieppe* (1852 or 1854), no. 138.

181. See, for example, *Journal*, 5 Oct. 1822, 27. One counts not less than thirty-six painted studies of horses at his sale, but about half are lost today. The situation is the same as for the landscapes, and for similar reasons: the study of the animal painting of Delacroix, especially of equestrian subjects, remains to be done (on this point, see Johnson, *Crit. Cat.*, 1:29–34). Also see Nancy Ann Finlay, "Animal Themes in the Paintings of Eugène Delacroix" (Ph.D. diss., Univ. of Michigan, 1984).

182. See François-Raphaël Loffredo, "Des recherches communes de Barye et Delacroix au laboratoire d'anatomie du Muséum d'Histoire Naturelle," *Bulletin de la Société de l'Histoire de l'Art Français* 1982 (1984): 147–57, and *La Griffe et la dent. Antoine Louis Barye (1795–1875) sculpteur animalier* (Paris, 1996), passim. On another common source for the two artists, an illustrated English publication, see Lee Johnson, "Delacroix, Barye, and the 'Tower Menagerie': An English Influence on French Romantic Animal Pictures," *Burlington Magazine*, Sept. 1964, 416–19.

183. Hippolyte Taine, *Philosophie de l'art* (Paris, 1985), 478 (the citation is taken from a study on Leonardo da Vinci that originally appeared in 1865). See also E. Kliman, "Delacroix's Lions and Tigers: A Link between Man and Nature," *Art Bulletin* (Sept. 1982): 446–66, and "Delacroix's *Jeune Tigre jouant avec sa mère*," *Gazette des Beaux-Arts*, Sept. 1984, 67–82. For Delacroix's horse paintings, see Lee Johnson, "Two Exotic Horse Paintings by Eugène Delacroix," *RACAR* 9, nos. 1–2 (1982): 74–77. On Delacroix as a painter of cats and tigers, see E. Kliman, *Eugène Delacroix: A Study of Selected Paintings, Watercolours, Pastels, Prints and Drawings of the Feline* (Toronto, 1978).

184. Louvre, Département des Arts Graphiques, RF 9293; see M. Sérullaz, *Dessins*, 1:118, no. 169.

185. See Hamilton, "Hamlet or Childe

Harold? Delacroix and Byron" (n. 4 above).

186. *Journal*, 28 Apr. 1853, 332–33; Delacroix, following this text, develops an analysis of Poussin and Lesueur that anticipates his article on Poussin.

187. On the *Sheets of Antique Medals*, see Joyce Bernstein Howell, "Delacroix's Lithographs of Antique Coins," *Gazette des Beaux-Arts*, July–Aug. 1994, 15–24. See the catalogue for the exhibition *Delacroix. Le trait romantique* (cited in n. 133

above) and especially "Les sources des lithographies de 'médailles' d'Eugène Delacroix," *Nouvelles de l'Estampe*, Mar. 1998, 12–20, and Jean-Luc Gail, "L'Empreinte de l'antique," 7–11, in the same issue.

188. See Bruno Chenique in the catalogue of the exhibition *Géricault* at the Grand Palais (Paris, 1991), especially 301–2. On interpretation of the picture, see J. Spector, "The *Vierge du Sacré Coeur*: Religious Politics and Personal Expression

in an Early Work of Delacroix," *Burlington Magazine*, Apr. 1981, 200–206.

189. Lee Johnson has reconstructed the history of the commission and proposed a hypothetical reconstitution on the basis of very fragmentary documentation, in particular several preliminary drawings. It is very probable that Delacroix executed four and perhaps five lunettes, with subjects *à l'antique* (the iconographic program cannot be determined more precisely). See Lee Johnson, "Some Early

Murals by Delacroix," *Burlington Magazine*, Oct. 1975, 650–58, and *Crit. Cat.*, 1:199–200.

190. On this commission see Lee Johnson, "Delacroix's Decorations of Talma's Dining-Room," *Burlington Magazine*, Mar. 1957, 78–87. Delacroix returned to the theme of the seasons several times in his career: see Julia Ballas, "La Signification des saisons dans l'oeuvre de Delacroix," *Gazette des Beaux-Arts*, July 1985, 15–21.

Chapter Two

1. See the remarks of Oskar Bätschman, who introduced this idea in "Géricault artiste d'exposition," in R. Michel, *Géricault* (acts of the colloquium held at the Louvre in 1991), vol. 2 (1996), 679–99. His remarks apply perfectly to Delacroix's entries in the first three Salons. On the other hand, I am far from sharing the interpretation of R. H. Brown, which at first glance is so seductive. Brown has tried to show in Delacroix's work of the 1820s— from *The Barque of Dante* to *Boissy d'Anglas at the National Convention*—the formation of the central personage of the painting as a disengaged hero, as opposed to the *engagé* heroes of his Neoclassical predecessors, whose new mentality corresponds to an ethic shared by the firmest patrons of the painter, the bankers and liberal journalists. This last idea appears dubious to me, and it seems that the argument does not take sufficient account of the constraints of the artistic life that Delacroix had assumed. It is still true that his paintings broke with the principle of the exemplary hero and virtuous death typical of Neoclassicism, as has been shown by T. Gaethgens, subverting the traditional codes to introduce an original vision of the destiny of humankind and an equally new conception of history and its representation. See R. H. Brown, "The Formation of Delacroix's Hero between 1822 and 1831," *Art Bulletin* (June 1984): 237–54, and T. Gaethgens, "L'Artiste en tant que héros. Eugène Delacroix," in *Triomphe et mort du héros* (Lyons, 1988), 120–29.

2. Letter to Henriette de Verninac, 26 July 1821, *Corr. gén.*, 5:91.

3. For the works sent to the Salon by Delacroix and those rejected by the jury, see Johnson, *Crit. Cat.*, 3:xxi–xxiv, and also "Delacroix et les Salons. Documents

inédits au Louvre," *Revue du Louvre*, nos. 4–5 (1966): 217–30, for the complete list established from the record of the sessions of the jury, conserved in the library of the Louvre.

4. 1824, Johnson 77; see Eric Moinet, "Une étude pour les *Massacres de Scio, Tête de vieille femme grecque* (1824) par Delacroix," *Revue du Louvre*, no. 4 (Oct. 1996): 21.

5. The installation of the Salon, which opened in autumn 1827, was continued during the winter. Delacroix thus presented in November *The Agony in the Garden, Two English Farm Horses, Young Turk Stroking His Horse, A Mortally Wounded Brigand Quenches His Thirst, Head of an Indian, Scene from the War between the Turks and Greeks*, and *Still Life with Lobsters*. *Justinian Drafting His Laws* was on view in January 1828; *The Death of Sardanapalus, Mephistopheles*, and *Milton Dictating "Paradise Lost" to His Daughters* were installed only in February.

6. 1826–27, Winterthur, Oskar Reinhart Collection (Johnson 115); the composition was greatly reworked and improved by Delacroix in a canvas done in 1856 (see chap. 7).

7. 1827–28, private collection (Johnson 128).

8. About 1826, Musée J. P. Pescatore, Galerie Municipale de Peinture, Luxembourg (Johnson 38).

9. Lost today but known through various documents (1826, Johnson L80). Bonington also painted the count, at the same time as Delacroix. On the very complex question of the authenticity of the different versions and their attribution, see Johnson, *Crit. Cat.*, 1:195–98, and Patrick Noon, *Richard Parkes Bonington. "Du plaisir de peindre"* (Paris, 1992), 168–69.

A. Daguerre de Hureaux has suggested the identification of the lost painting with a work conserved in the Národni Gallery in Prague, *Delacroix* (Paris, 1992), 60.

10. 1827, private collection, on loan to the Philadelphia Museum of Art (Johnson 88).

11. Perhaps a portrait of Mme Bornot, 1826–27, private collection, on loan to the Philadelphia Museum of Art (Johnson 87).

12. No doubt the canvas shown in 1827 at the Salon de Douai, location unknown (Johnson 53).

13. These exhibitions include the Greek benefit organized at the Galerie Lebrun in 1826, where he sent *The Execution of the Doge Marino Faliero, Greece on the Ruins of Missolonghi*, and *The Combat of the Giaour and Hassan*; the exhibition organized in the same gallery in 1829 for the elimination of begging, where he showed *Tam o'Shanter*; as well as the ones at the Galerie Colbert between 1829 and 1832, where he showed *The Murder of the Bishop of Liège* and *The Combat of the Giaour and Hassan*. On the exhibits at the Musée Colbert, see B. S. Wright, "Henri Gaugain et le Musée Colbert. L'entreprise d'un directeur de galerie et d'un éditeur d'art à l'époque romantique," *Nouvelles de l'Estampe*, no. 114 (Dec. 1990): 24–31. Delacroix regularly exhibited in the provinces, usually choosing works that had already been presented in Paris or were about to be. Two of these provincial showings have been more specifically studied within the framework of more general studies of the Salons of northern France (Lille, 1822; Douai, 1823, 1827, 1837) in *Les Salons retrouvés. Eclat de la vie artistique dans la France du Nord, 1815–1848*, 2 vols. (Pas-de-

Calais, 1993), passim; and that of Bordeaux, dealing with a later period, in Dominique Dussol, *Art et bourgeoisie. La Société des Amis des Arts de Bordeaux (1851–1939)* (Bordeaux, 1997), especially 131–37.

14. See P. Grate, "La critique d'art et la bataille romantique," *Gazette des Beaux-Arts*, Sept. 1959, 129–48, and, more generally, on the context of artistic life in France under the Restoration, Léon Rosenthal, *La Peinture romantique. Essai sur l'évolution de la peinture en France de 1815 à 1830* (Paris, 1900), passim.

15. See, besides the letter previously cited, his letter to Pierret, 30 July 1821, *Corr. gén.*, 1:128.

16. Location unknown (Johnson 99).

17. Letter to Soulier, 15 Sept. 1821, *Corr. gén.*, 1:132.

18. See his letter to Pierret, 23 Aug. 1829, ibid., 1:41.

19. Letter to Soulier, 15 Apr. 1822, ibid., 1:140.

20. *Journal*, 24 Dec. 1853, 394.

21. Manuscript memoirs of Delacroix reported by Piron, *Delacroix. Sa vie et ses oeuvres*, 50–51. The professors of whom Delacroix speaks are those who taught at the Beaux-Arts, heirs to the traditions of the former Academy.

22. Ibid., 51. The episode is pleasantly recounted by Dumas, *Delacroix*, 33–41, who also reports the remarks that Guérin made. Gros also, according to him, had a frame made for *The Barque of Dante*, which the impecunious Delacroix had presented in a frame composed of four flat boards gilded by himself.

23. C. P. Landon, "Salon de 1822," *Annales du Musée et de l'Ecole Moderne des Beaux-Arts*, 1 (1822): 87.

24. E.-J. Delécluze, "Salon de 1822," *Le Moniteur Universel*, 18 May 1822.

25. A. Thiers, "Salon de 1822," *Le Constitutionnel*, 11 May 1822. The last phrase is suppressed in the volume edition, Paris 1822.

26. For a precise recension of the iconographic sources of Delacroix, see Lee Johnson, "The Formal Sources of Delacroix's *Barque de Dante*," *Burlington Magazine*, July 1958, 228–32, edited and enlarged in Johnson, *Crit. Cat.*, 1:75–76. See also K. Schwager, "Die *Dantebarke*. Zur Auseinandersetzung Eugène Delacroix," in H. Brunner, R. Kannicht, and K. Schwager, eds., *Wort und Bild. Symposium des Fachbereich Altertums-und Kulturwissenschaften zum 500 jährigen Jubiläum der Eberhard-Karl-Universität Tübigen 1977* (Munich, 1979), 313–39; J. Rubin, *Eugène Delacroix. Die Dantebark. Idealismus und Modernität* (Frankfurt, 1987); and "Delacroix's *Dante et Virgil* [*The Barque of Dante*] as a Romantic Manifesto. Politics and Theory in the Early 1820s," *Art Journal*, 52, no. 2 (1993): 48–58.

27. See Johnson, *Crit. Cat.*, for the precise references for some of these critiques. On Delacroix's relationship to Géricault, see *Delacroix. La naissance d'un nouveau romantisme* (cited above, chap. 1, n. 37), which addresses the matter from various perspectives, particularly in terms of style and theme, within the framework of the artist's "Romantic years."

28. See the letter of Delacroix to the Count de Forbin, the superintendent of the Beaux-Arts, 1 June 1822, *Corr. gén.*, 1:142–43, where in response to the count's inquiry, he suggests a price of two thousand four hundred francs; the canvas finally brought two thousand francs.

29. *Journal*, 23 May 1823, 39.

30. Ibid., 41

31. Letter to Félix Guillemardet, 1 Dec. 1823, *Lettres intimes*, 148.

32. *Journal*, 12 Jan. 1824, 47.

33. References in M. Sérullaz, ed., *Mémorial*, 29–30; see also Johnson, *Crit. Cat.*, 1:87. To the numerous bibliographic indications given by Johnson, ibid., 83–84, add G. Busch, "Ikonographische Ambivalenz bei Delacroix," *Stil und Uberliefung (Actes du 21me Congrès international d'histoire de l'art, Bonn, 1964)* (1967), 143–48.

34. *Journal*, 12 Jan. 1824, 47.

35. Private collection, Germany (Johnson 102).

36. Private collection, Switzerland (Johnson 103).

37. Rijksmuseum H. W. Mesdag, The Hague (Johnson 104).

38. Private collection, Paris (Johnson, 21).

39. Montpellier, Musée Fabre (Johnson 79); private collection, Zurich (Johnson 80 and Johnson 81). I rely for the dates on references given by Johnson, drawn mostly

from the *Journal: Crit. Cat.*, 1:50–54 and 78–82, passim.

40. See M. Florisoone, "La genèse espagnole des *Massacres de Scio* de Delacroix," *Revue du Louvre*, nos. 4–5 (1963): 195–208.

41. *Journal*, 25 Jan. 1824, 49.

42. *Journal*, 7 Mar. 1824, 56.

43. See M. Florisoone, "Constable and the *Massacres de Scio* by Delacroix," *Journal of the Warburg and Courtauld Institutes*, 20 (1957): 180–85, and the clarification by Johnson in *Crit. Cat.*, 1:89.

44. The rue des Grès, next to the Sorbonne, probably in a former chapel of the Couvent des Jacobins: Lee Johnson, "Where Delacroix Painted the *Massacres de Scio*," *Burlington Magazine*, Aug. 1990, 583–89.

45. *Journal*, 7 May 1824, 78.

46. On the philhellenic movement in the arts, see N. Athanassoglou-Kallmyer, *French Images from the Greek War of Independence, 1821–1830: Art and Politics under the Restoration* (New Haven, 1989); and *La Grèce en révolte. Delacroix et les peintres français, 1815–1848*, exh. cat. (Bordeaux, 1996). On Delacroix in particular, R. Huyghe, *Delacroix et la Grèce* (Athens, 1971); R. Hollenstein, "Delacroix und der grieschiche Freiheitskrieg," *Artis*, no. 6 (1987): 10–17.

47. I follow here the indications of the booklets.

48. *Journal*, 12 Jan. 1824, 46.

49. A. Joubin first called attention to this, citing a passage from the *Memoires* of the colonel that is perfectly illustrated by this detail of the painting: "Delacroix au Salon de 1824," *Bulletin de la Société de l'Histoire de l'Art Français* (1937): 150–52.

50. *Journal*, 19 Aug. 1824, 91.

51. Gérard's statement is recalled by Dumas, who goes on to report Gros's remark and the episode of his encounter with Delacroix. Dumas, *Delacroix*, 45.

52. Unpublished article of Rivet, cited by Piron, *Delacroix. Sa vie et ses oeuvres*, 66–67.

53. See, for example, Auguste Chauvin, *Salon de mil huit cent vingt-quatre* (Paris, 1825); and Adolphe Thiers, *Salon de mil huit cent vingt-quatre* (Paris, n.d.).

54. Manuscript memoirs of Delacroix, cited by Piron, *Delacroix. Sa vie et ses oeuvres*, 66–67.

55. Théophile Gautier, *Les Beaux-Arts en Europe en 1855* (Paris, 1855), 1:175.

56. See Dumas, *Delacroix*, 43–44.

57. See Rosenthal, *La Peinture romantique*, 94–101.

58. Today in the Musée des Beaux-Arts in Nimes. See the notice dedicated to this painting and to Sigalon by Jacques Foucart in *De David à Delacroix. La peinture française de 1774 à 1830*, exh. cat. (Paris, 1974), 604–8.

59. Thiers, *Salon de 1824*, 15–16.

60. Chauvin, *Salon de 1824*. The first remark is cited on p. 51; the following citation is on p. 92; the definitions of classic and romantic are on pp. 22–23.

61. Ibid., 13–15.

62. C. P. Landon, "Salon de 1824," *Annales du Musée et de l'Ecole Moderne des Beaux-Arts*, 1 (1824): 54.

63. E.-J. Delécluze, "Exposition du Louvre," *Journal des Débats*, 5 Oct. 1824, 3.

64. Thiers, *Salon de 1824*, p. 18.

65. See also the anonymous critiques in the *Journal du Commerce*, 4 Sept. 1824, and in *Le Globe*, 28 Sept. 1824.

66. Dumas, *Delacroix*, 50.

67. Thiers, *Salon de 1824*, 18–19.

68. M., *Revue critique des productins de peinture, sculpture, gravures exposées au Salon de 1824* (Paris, 1825), cited by Johnson, *Crit. Cat.*, 1:92.

69. Notebook dating from the beginning of the 1820s; text edited in the *Journal*, 814.

70. Letter to Pierret, 22 Sept. 1819, *Corr. gén.*, 1:54.

71. Article appeared in the *Journal de Paris*, reprinted in *Mélanges d'art et de littérature* (Paris, 1867), 179.

72. Pierre Angrand, "Liste alphabétique des peintres d'un talent remarquable, 1824," *Gazette des Beaux-Arts*, Nov. 1982, 178–82. The price of the *Massacres of Chios* is not exceptional, but a bit above the average, if one were to judge by the sums indicated in this list for purchases or commissions.

73. Thiers, *Salon de 1824*, 19.

74. Letter to Soulier, 11 Mar. 1828, *Corr. gén.*, 1:213.

75. Letter to Soulier, 6 Feb. 1828, ibid., 1:211.

76. L. Vitet, "Beaux-Arts," *Le Globe*, 8 Mar. 1828, 253.

77. Unpublished article by Rivet reported by Piron, *Delacroix. Sa vie et ses oeuvres*, 69–70.

78. Thénot, *Les Règles de la perspective pratique* (Paris, 1853), 18, cited by Johnson, *Crit. Cat.*, 1:118.

79. Vitet, "Beaux-Arts," 253.

80. Rivet, cited by Piron, *Delacroix. Sa vie et ses oeuvres*, 70–71.

81. See, among others, the pastels conserved at the Louvre, Département des Arts Graphiques, RF 29665, RF 29666, RF 29667; Sérullaz et al., *Dessins*, nos. 134–36; as well as those of The Art Institute of Chicago (see Johnson, *Pastels*, 36–43, nos. 1–4). One could also refer to the articles by G. Bazin, "Pastels de Delacroix pour le *Sardanapale*," *L'Amour de l'Art* (July 1945): 15-21, and by A. Swanson Honore, "A Pastel Study for *The Death of Sardanapalus* by Eugène Delacroix," *Museum Studies [Notable Acquisitions at The Art Institute of Chicago]* 21, no. 1 (1995):

6–23, 70–73. For the genesis of the painting, see in addition to the references given in chap. 1, n. 156, Lee Johnson, "An Early Study for Delacroix's *Death of Sardanapalus*," *Burlington Magazine*, May 1969, 296–99. See also indications in R. Jullian, "Delacroix et la thème de Sardanapale," *Connaissance des Arts* (Apr. 1963): 82–89; G. Doy, "*The Death of Sardanapalus*," *Burlington Magazine*, June 1976, 773–75; and syntheses, as of their respective dates, in J. Spector, *Delacroix: The Death of Sardanapalus* (London, 1974), and in V. Pomarède, *Eugène Delacroix, "La Mort de Sardanapale,"* (Paris, 1998).

82. E.-J. Delécluze, "Exposition au Louvre," *Journal des Débats*, 21 Mar. 1828, 1.

83. A. Jal, *Esquisses, croquis, pochades ou tout ce qu'on voudra sur le Salon de 1827* (Paris, 1828), 312–13.

84. Ch., "Beaux-Arts. Salon," *Le Moniteur Universel*, 27 Feb. 1828.

85. Delacroix speaks of this in his letter to Soulier of 11 Mar., previously cited.

86. L. Vitet, "Salon de peinture de 1827, *Le Globe*, 10 Nov. 1827, 505.

87. E.-J. Delécluze, *Journal des Débats*, 20 Dec. 1827, 1.

88. F. Trapp, "An Early Photograph of a Lost Delacroix," *Burlington Magazine*, June 1964, 267–69. The most complete study of the picture remains that of Johnson, *Crit. Cat.*, 1:110–13, from which most of what follows is drawn.

89. T. Gautier, "Exposition universelle," *Le Moniteur Universel*, 25 July 1855, reprinted in *Les Beaux-Arts en Europe* (Paris, 1855), 191; Maxime Du Camp, *Les Beaux-Arts à l'Exposition Universelle de 1855* (Paris, 1855), 110.

90. See for example Delécluze, *Journal des Débats*, 14 Jan. 1828; the articles of *Le Moniteur Universel*, 29 Jan. 1828; and of *L'Observateur des Beaux-Arts*, 24 Apr. 1828.

91. Notice in the catalogue of the exhibition at the Galerie Lebrun, probably by Delacroix himself.

92. See the review by Victor Hugo in *Oeuvres complètes* (Paris, 1967), 2:984.

93. See the letter to Soulier,11 Mar. 1828, *Corr. gén.*, 1:213–24.

94. Letter to Silvestre, 31 Dec. 1858, *Corr. gén.*, 4:59.

95. E.-J. Delécluze, *Journal des Débats*, 20 Dec. 1827, 1.

96. See Louis Vitet's article in *Le Globe*, 3 June 1826.

97. Burty, ed., *Lettres de Eugène Delacroix*, 2:xxiii.

98. Manuscript memoirs of Delacroix in Piron, *Delacroix. Sa vie et ses oeuvres*, 71–73.

99. Baudelaire, *Revue anecdotique*, first two weeks of Jan. 1862, in *Oeuvres complètes* 2:733–34.

1. Manuscript memoirs of Delacroix, cited by Piron, *Delacroix. Sa vie et ses oeuvres*, 67.

2. Article "Classic," *Dictionnaire*, 34 (Jan. 1857).

3. Gautier, *Les Beaux-Arts en Europe en 1855*, 1:169–70.

4. Painting lost today (Johnson L105). Its composition is known by the description of a preliminary drawing in the Villot sale in 1865: "Young Raphael in his studio. He is seated on a stool, elbow leaning on a table, head resting on his hand, in an attitude of meditation." See Johnson, *Crit. Cat.*, 1:208–9.

5. The watercolor is in the Louvre. For the circumstances of its execution and the conversation reported by Paul Huet, see René-Paul Huet, *Paul Huet (1803–1869) d'après ses notes, sa correspondance, ses contemporains* (Paris, 1911), 381–83.

6. On the context of Delacroix's relations with the British art of his time, see my doctoral thesis, "La Reception de l'école anglaise en France, 1802–1878. Un aspect des relations artistiques franco-britanniques au dix-neuvième siècle," 3 vols. (Université de Paris-Sorbonne, Paris IV, 1994). On the contacts between French and English artists under the Restoration, see C. Shaw Smith, "From Francia to Delacroix: The English Influence on French Romantic Landscape Painting," 3 vols. (Ph.D. diss., University of North Carolina, 1982); M. Pointon, *The Bonington Circle. English Watercolours and Anglo-French Landscape, 1790–1855* (Brighton, 1985); and the exhibition catalogues *Louis Francia, 1772–1839* (Calais, 1988); and P. Noon, *Richard Parkes Bonington, "Du plaisir de peindre"* (Paris, 1992). Delacroix's trip to London has been studied by S. Lodge, "French Artists Visiting England, 1815–1830" (Ph.D. diss., London University, 1966), to which I have added some information; see Jobert, "La Reception de l'école anglaise en France," 1:51–53. On Delacroix as seen by an Englishman, see Lee Johnson, "Géricault and Delacroix as seen by Cockerell," *Burlington Magazine*, Sept. 1971, 547–51.

7. Note published by André Joubin in the *Journal*, 820.

8. Letter to T. Silvestre, 31 Dec. 1858, *Corr. gén.*, 4:57–58.

9. Letters to Pierret, 27 May 1825, 18 June 1825, 27 June 1825, 1 Aug. 1825, and 12 Aug. 1825; and to Soulier, 6 June 1825; all in *Corr. gén.*, 1:153–71. One can add the letter sent to Etty in which Delacroix expresses his regret at not having seen him again before his departure from England, *Further Corr.*, 92.

10. The notebook used by Delacroix during his trip to England, which is today in the Louvre (RF 9143; no. 1751 in Sérullaz et al., *Dessins*, 2:343–45), shows this activity. See also K. Garlick, "Delacroix's Drawings in London," *Master Drawings*, no. 1 (1965): 52–54.

11. Letter of 27 May 1825, *Corr. gén.*, 1:15.

12. Letter of 6 June 1825, ibid., 1:158.

13. An album in the Louvre contains the dates of opening of the principal London exhibitions as Delacroix noted them down (RF 23355; no. 1749 in Sérullaz et al., *Dessins*, 325).

14. Notebook today in the Louvre, Département des Arts Graphiques, RF 6234; no. 1760 in Sérullaz et al., *Dessins*, 2:400–402). See also G. Reynolds, "Newly Discovered Drawings by Constable in a Louvre Sketch-Book," *Burlington Magazine*, Mar. 1966, 138–41.

15. These are the terms used in the *Journal*, 17 June 1855, 515. Delacroix there returns to "the English School forty years ago," after having seen the works of their successors at the Exposition Universelle, especially the Pre-Raphaelites.

16. Letter to T. Silvestre, 31 Dec. 1858, *Corr. gén.*, 4:60.

17. Ibid., in the same paragraph as Constable. The qualifications cited are being applied to both painters.

18. See G. Finley, *Landscapes of Memory. Turner as Illustrator to Scott* (London, 1980), 194–95 and 259n. 75.

19. *Journal*, 24 Mar. 1855, 504.

20. Delacroix received a copy in payment for *Faust*.

21. E. Delacroix, "Portrait de Pie VII de Thomas Lawrence," in *Oeuvres littéraires*, 2:157–58 for the first citation, 2:159 for the second. The article appeared in the *Revue de Paris*, 4 (1829): 109–13.

22. Letter to T. Silvestre, 31 Dec. 1858, *Corr. gén.*, 1:59.

23. Johnson, *Crit. Cat.*, 1:171.

24. Nancy Ann Finlay, "Animal Themes," 35–41. See also R. J. Bantens, "Delacroix's *Still Life with Lobsters*," *Southeast College Art Conference Review*, no. 2 (1977): 69.

25. Annotations on a drawing in the Maurice Sérullaz collection, shown in the 1963 exhibit, *Delacroix*; see no. 146 in *Mémorial*, 105. John Trumbull (1746–1843) was famous for his pictures representing events of the American Revolution; Benjamin West (1738–1820), whose permanent exhibit Delacroix had seen in London, was considered one of the most important painters of British history, having in particular illustrated numerous episodes of English history of the seventeenth and eighteenth centuries.

26. On the studies of Greek costumes by Delacroix and Bonington, see N. Athanassoglou-Kallmyer, "Of Suliots, Arnauts, Albanians and Eugène Delacroix," *Burlington Magazine*, Aug. 1983, 487–91; Noon, *Richard Parkes Bonington*, 168–73; and Musée des Beaux-Arts, Bordeaux, *La Grèce en révolte*, 120–21. See also P. Joannidès, "Colin, Delacroix, Byron, and the Greek War of Independence," *Burlington Magazine*, 1983, 495–500; and Lee Johnson, "Toward Delacroix's Oriental Sources," *Burlington Magazine*, Mar. 1978, 144–51. The common activities of Delacroix and Bonington have been treated by A. Daguerre de Hureaux, "Delacroix et Bonington dans les années 1824–1827: à propos de la *Femme caressant un perroquet* du Musée des Beaux-Arts de Lyon," *Bulletin des Musées et Monuments Lyonnais*, nos. 1–2 (1994): 24–35. See also J.-L. Stephant, "Une aquarelle de Delacroix au Musée Bonnat de Bayonne," *Revue du Louvre*, no. 4 (1994): 64–67. On 'Monsieur Auguste,' so called by his young painter friends, including Delacroix, who thus showed their regard for him, see C. Saunier, "Un artiste romantique oublié: Monsieur Auguste," *Gazette des Beaux-Arts*, June 1910, 441–60; July 1910, 51–68; Sept. 1910, 229–42; and the catalogue of the exhibition *Delacroix au Maroc 1832, et exposition rétrospective du peintre orientaliste M. Auguste* (Paris, 1933).

27. On the problem posed by the *Portrait of Count Palatiano in Suliot Costume*, see Johnson, *Crit. Cat.*, 1:195–98 (Johnson L 80) and 1:233–35 (Johnson R 33 and R 34).

28. The painting by Bonington, done in 1826, is one year later than Delacroix's, but it is doubtless inspired directly by it, as Delacroix kept it in his studio, a studio that the two men then shared. It is today in the Yale Center for British Art. See Noon, *Richard Parkes Bonington*, 176–79.

29. Johnson 127 for the first painting (1826–27, private collection), Johnson 128 for the second (1827–28, private collection, R.F.A.). On the paintings of the historical genre by Delacroix, see Lee Johnson, "Some Historical Sketches by Delacroix," *Burlington Magazine*, Oct. 1973, 672–76.

30. On the development of the "historical genre," see two essays by Marie-Claude Chaudonneret, "Du genre anecdotique au genre historique," in *Les Années romantiques. La peinture française de 1815 à 1850*, exh. cat. (Nantes and Paris, 1996): 76–85; and "The *Genre Anecdotique*, or the Evocation of a Dream-Like Past," in *Romance and Chivalry. History and Literature Reflected in Early Nineteenth-Century French Painting*, ed. N. Tscherny and G. Stair Sainty, exh. cat. (New Orleans, New York, and Cincinnati, 1996–97). These two catalogues also furnish the best illustration of the more general context to which the "historical genre" belongs. See also *De David à Delacroix. La peinture française de 1774–1830*, exh. cat. (Paris, 1974). The painting of history during the Restoration is the subject of a recent synthesis: Beth S. Wright, *Painting and History during the French Restoration: Abandoned by the Past* (Cambridge, 1997).

31. The painting (Johnson L 102) disappeared after its exhibition at the Salon in Douai in 1827.

32. 1817–28 (?), private collection (Johnson 128). On the *Rabelais*, see M. Garcia and M.-F. Lettereux, "Le Portrait de Rabelais d'Eugène Delacroix," *Bulletin de la Société des Amis du Vieux Chinon*, 9, no. 3 (1989): 343–50.

33. On the painting, see the synthesis by G. Tinterow, *The Metropolitan Museum of Art Bulletin*, 43, no. 2 (autumn 1990): 41–42.

34. V. Schoelcher, "Salon de 1835. Deuxième article," *Revue de Paris*, 16 (1835): 58.

35. About 1825, Wildenstein, London (Johnson 107); there is another large version, done probably at the same time, location unknown today (Johnson 108). On Delacroix and Shakespeare, see the references on *Hamlet*, chap. 7, nn. 102ff. in this book, and E. G. Dotson, "English Shakespeare Illustration and Eugène Delacroix," *Essays in Honour of Walter Friedlaender* (1965): 40–61. I was unable to consult G. A. Rodetis, *Delacroix; The Romantic Sensibility Visualized through the Poetry of Shakespeare and Byron* (Urbana, 1981).

36. The first two (Johnson L 98 and L 99a) are lost; the last, of 1825, is in the museum of Jagellon University in Warsaw (1825, Johnson L 99).

37. About 1826–28, formerly in the Claude Roger-Marx Collection (Johnson 117).

38. On the Faust lithographs, see the synthesis of U. Sinnreich, "Delacroix, Faust-Illustrationen," in *Eugène Delacroix. Themen und Variationen. Arbeiten auf Papier*, exh. cat. (Frankfurt, 1988), 56–99; also R. Escholier, "Le Faust d'Eugène Delacroix," *Gazette des Beaux-Arts*, Sept. 1929, 174–84; J. O. Kherli, *Die Lithographien zu Goethes Faust von Eugène Delacroix* (Berne, 1949); and G. Doy, "Delacroix et Faust," *Nouvelles de l'Estampe*, no. 21 (May–June 1972): 18–25. See also Nathalie Darzac, "Delacroix illustrateur de Goethe et Shakespeare," *Signes et Scribes*, no. 3 (autumn 1987): 32–33. More generally, and dealing with both prints and pic-

tures, P. Jamot, "Goethe et Delacroix," *Gazette des Beaux-Arts*, Dec. 1932, 279–98; J. Lüdecke, "Goethe, Delacroix, und die Weltliteratur," in *Goethe*, vol. 33 (1971): 54–74; U. Fischer, "Il mondo come litteratura: Goethe e Delacroix," *Annali della Scuola Normale Superiore de Pisa*, no. 2 (1976): 569–605.

39. See *Journal*, 28 Feb. 1824, 52.

40. Letter to P. Burty, 1 Mar. 1862, *Corr. gén.*, 4:303–4; see also *Journal*, 29 June 1855, 520, and K. Lochnan, "Les Lithographies de Delacroix pour *Faust* et le théâtre anglais des années 1820," *Nouvelles de l'Estampe* (July 1986): 6–13.

41. He copied long passages of the text, with marginal sketches anticipating the lithographs, in the manuscript notes in the Bibliothèque d'Art et d'Archéologie, Fondation Jacques Doucet, MS. 250.

42. *Journal*, 17 Feb. 1824, 51.

43. Letter to Motte, Dec. 1827, *Corr. gén.*, 1:209.

44. Letter to P. Burty, 1 Mar. 1862, ibid., 1:304.

45. Eckermann, *Conversations de Goethe avec Eckermann*, trans. J. Chuzeville (Paris, 1949; rev. ed. 1988), 171–72 (the conversation is dated 29 Nov. 1826).

46. Johnson 116a, *Crit. Cat.*, 3:314–15, dates it c. 1826.

47. Johnson L 97.

48. 1824, Cairo, Mahmoud Khalil Museum, Johnson L 104. See Lee Johnson, "Mazeppa in Giza: A Riddle Solved," *Burlington Magazine*, Aug. 1983, 491–94. On Mazeppa in romantic painting, see D. Marcink, *Mazeppa: Ein Thema der Französischen-Romantik. Malerei und Graphik, 1823–1827* (Munich, 1991).

49. Letter to F. Feuillet de Conches, Mar. 1831, *Corr. gén.*, 1:277–78. The original text is, in fact, "Weel done, Cutty Sark!"

50. The version of the Salon of 1831 is probably the one in the Bührle Collection, Zurich (Johnson 139), the two others being respectively those of the Castle Museum in Nottingham (Johnson 109) and the Kunstmuseum in Basel. The two citations, which I take from Johnson, *Crit. Cat.*, 1:136–37, appeared respectively in the *Journal des Artistes*, 12 July 1829 (when the painting was shown at the Galerie Lebrun) and in the *Gazette de France*, 14 July 1831.

51. *Journal*, 11 May 1824, 79–80. On Delacroix and Byron, see G. H. Hamilton, "Delacroix and Lord Byron," *Gazette des Beaux-Arts*, Feb. 1943, 99–110; "Hamlet or Childe Harold? Delacroix and Byron, II," ibid., July–Dec. 1944, 364–86, and "Delacroix, Byron, and the English Illustrators," ibid., Oct.–Dec. 1949, 261–78. To place Delacroix in the larger movement, see E. Estève, *Byron et le romantisme français* (Paris, 1907).

52. Private collection, Zurich (Johnson 138).

53. National Gallery of Victoria, Melbourne (Johnson 256).

54. Musée National des Beaux-Arts, Algiers (Johnson 296). On Delacroix and the theme of the *Giaour*, see K. J. Smith, "Contours of Conflict; the Giaour in Byron and Delacroix," *Athanor*, 10 (1991): 39–43.

55. The hypothesis of such a source is convincingly argued by Lee Johnson, who cites the relevant passage from Brantôme (*Crit. Cat.*, 1:8–9). The picture is still above all a female nude. On the identification of Delacroix's models, see A. Joubin, "Modèles de Delacroix," *Bulletin de la Société de l'Histoire de l'Art Français* (1936): 135–36.

56. On the reception of Scott's work in France, see K. Massmann, *Die Rezeption des Historischen Romane Sir Walter Scotts in Frankreich (1816–1832)* (Keidelberg, 1972). On subjects treated in paintings, see B. S. Wright, "Walter Scott and French Art: Imagining the Past," in N. Tscherny and G. Sainty, eds., *Romance and Chivalry*, 180–93, which synthesizes B. S. Wright, "Scott's Historical Novels and French Historical Painting, 1815–1855," *Art Bulletin* (June 1981): 268–87, and B. S. Wright and P. Joannides, "Les romans historiques de Walter Scott et la peinture française, 1822–1863, I," *Bulletin de la Société de l'Histoire de l'Art Français*, 1982 (1984): 118–32 and ibid., 1983 (1985): 95–115, as well as B. S. Wright, "Walter Scott et la gravure française: A propos de la collection du Département des Estampes de Paris," *Nouvelles de l'Estampe*, no. 93 (July 1987): 6–18. For a study of the topic within the European framework, see C. Gordon, "The Illustration of Sir Walter Scott: Nineteenth-Century Enthusiasm and Adaptation," *Journal of the Warburg and Courtauld Institutes*, 24 (1971): 297–317.

57. *Journal*, 28 Oct. 1853, 377. On *Rebecca and the Wounded Ivanhoe*, see Lee Johnson, "A New Delacroix: *Rebecca and the Wounded Ivanhoe*," *Burlington Magazine*, May 1984, 280–82.

58. *Journal*, 28 Oct. 1853, 377–78; see a similar development on 24 Dec. 1853, 395–96.

59. Ibid., 30 Aug. 1859, 744–45; on the "longueurs" and the overabundance of detail in Scott's novels, see also ibid., 10 Jan. 1857, 606, and 25 Jan. 1857, 623. In a much earlier passage, in which Delacroix copied extracts of T. Medwin's *Journal of the Conversations of Lord Byron* (1824), he records Byron's judgment of Scott, which emphasizes his borrowings as well as his originality (ibid., 15 July 1850, 251).

60. Notice in the Salon booklet of 1831, when the painting was exhibited.

61. A *Leicester* of 1824 existed (location unknown, Johnson L 96), and also a *Richard in Palestine*, perhaps inspired by *The Talisman*, painted c. 1825, mentioned only in the catalogue of the posthumous exhibit of 1864 (Johnson L 100). On *The Murder*

of the Bishop of Liège, see M. Toupet, "*L'Assassinat de l'évêque de Liège*," *Revue du Louvre*, no. 2 (1963): 83–94.

62. Salon booklet of 1831, when the picture was shown.

63. Gautier, *Les Beaux-Arts en Europe en 1855*, 1:177.

64. G. Planche, "Salon de 1831" (Paris, 1831), reprinted in *Etudes sur l'Ecole française* (Paris, 1855), 1:178.

65. See the examples cited in Johnson, *Crit. Cat.*, 1:132–33, from which I take the references that follow.

66. *Le National*, 20 Jan. 1830.

67. Gautier, *Les Beaux-Arts en Europe en 1855*, 1:178.

68. F. Villot, intro. to the catalogue of the F. Villot sale, 11 Feb. 1865, 1.

69. Letter to T. Gautier, 11 May 1860, written to thank him for his article on the exhibition at the Galerie Francis Petit, *Corr. gén.*, 4:174–75.

70. G. Planche, "Histoire et philosophie de l'art. IV. De l'Ecole française au Salon de 1834," *Revue des Deux-Mondes*, 1 Apr. 1834, reprinted in *Etudes sur l'Ecole française* (Paris, 1855), 1:246.

71. T. Gautier, "Salon de 1834," *La France industrielle* 1, no. 1 (Apr. 1834): 19.

72. The anecdote is reported in Robaut et al., *L'Oeuvre complet*, 96 (no. 351). See also G. Dubosc, "Le Palais de Justice de Rouen dans l'oeuvre d'Eugène Delacroix," *Journal de Rouen*, 7 Sept. 1902.

73. *Journal*, 11 May 1824, 79.

74. 1824, Rijksmuseum H. W. Mesdag, The Hague (Johnson 104).

75. *Journal*, 19 Apr. 1824, 69.

76. 1826, Bührle Foundation, Zurich.

77. *Journal*, 12 Apr. 1824, 66; see also 1 May 1824, 74.

78. 1826–27, Oskar Reinhart Collection, Winterthur (Johnson 115).

79. J. Vatout, *Histoire lithographiée du Palais-Royal* (Paris, [1825]), pl. 3.

80. F. P., "Salon de 1831," *Le Moniteur Universel*, 4 June 1831.

81. Letter to F. Guillemardet, 4 Oct. 1828, *Lettres intimes*, 151, and letter to Soulier, Oct. 1828, *Corr. gén.*, 1:222. The two following quotations on the commission of *The Battle of Nancy* are drawn from the same letters.

82. On the circumstances of the commission, see T. Charpentier, "A propos de *La Bataille de Nancy* d'Eugène Delacroix," *La Revue du Louvre et des Musées de France*, no. 2 (1963): 95–104; and "*La Bataille de Nancy* d'Eugène Delacroix. Musée des Beaux-Arts de Nancy," *Cahiers-Musées*, no. 1 (1988). The work was the subject of the 1997 exhibition *La Mort du Téméraire*, at the Musée des Beaux-Arts (catalogue ed. François Pupil). The letter to Soulier, Oct. 1828, is in *Corr. gén.*, 1:222–23; the one to F. Guillemardet, 4 Oct. 1828, in *Lettres intimes*, 150–53.

83. Letter to Pierret, 5 Nov. 1828, *Corr. gén.*, 1:143.

84. On this point, see Charpentier, "A propos de *La Bataille de Nancy*," 103–4.

85. This is suggested by J. Thuillier in *Delacroix et le romantisme français* (Tokyo, 1989), 77–79.

86. See the catalogue of the Musée Colbert of 1829, when the painting was exhibited: "Greece. (Allegory) She is represented as a young woman crying on the ruins." See also the catalogue of the exhibition in Bordeaux in 1851; the letter sent on this occasion by Delacroix to Dauzats, Oct. 1851, *Corr. gén.*, 3:84; as well as the letter of thanks addressed to the Mayor of Bordeaux after the purchase by the Musée des Beaux-Arts of that city, 31 Mar. 1852, ibid., 3:112.

87. Sérullaz et al., *Dessins*, vol. 2, no. 1750 (RF 9145), especially 336–43. The annotations are on folio 16r, p. 337.

88. "Seconde exposition en faveur des Grecs," *Journal des Débats*, 2 Sept. 1826.

89. "Exposition au profit des Grecs: la nouvelle école de peinture"; this text remained unprinted until its publication in Victor Hugo, *Oeuvres complètes*, vol. 2 (Paris, 1967), 984.

90. The date 28 July appears in the Salon catalogue of 1831, but the manuscript register of entries to the Salon, written from the dictation of the artists, has 29 July: see the Louvre's catalogue of the exposition dedicated to the painting, "*La Liberté guidant le peuple*" de Delacroix, 1982 ("Les dossiers du Département des Peintures, 26"), completely revised by H. Toussaint, here p. 45; it usefully completes the extensive bibliography on the painting, to be found in Johnson, *Crit. Cat.*, 1:144–45. See also G. H. Hamilton, "The Iconographical Origins of Delacroix's *Liberty Leading the People*," in D. Miner, ed., *Studies in Art and Literature for Belle da Costa* (Princeton, 1954), 55–66; G. Busch, *Eugène Delacroix. Die Freiheit auf den Barrikaden* (Stuttgart, 1960); S. Ringbom, "Guérin, Delacroix, and the *Liberty*," *Burlington Magazine*, May 1968, 270–75; A. and M. Sérullaz, "Dessins inédits de Delacroix pour *la Liberté guidant le peuple*," *Revue de l'Art*, no. 14 (1971): 57–62; W. Hofmann, "Sur la *Liberté* de Delacroix," *Gazette des Beaux-Arts*, Sept. 1975, 61–70. See also the more recent E. Newman, "L'image de la foule dans la Révolution de 1830," *Annales Historiques de la Révolution Française*, no. 242 (1980): 499–509; E. Warren Hoffman, "A Footnote to Delacroix's *Liberty Leading the People*," *Source* 9, no. 3 (spring 1990): 24–30; J. Traeger, "L'Epiphanie de la Liberté. La Révolution vue par Eugène Delacroix," *Revue de l'Art*, no. 98 (1992): 9–28, and G. Schneider, "Die Allegorie der Freiheit der Caricature 1831–1834," in *Die Karikatur Zwischen Republik und Zensur: Bildsatire 1830 bis 1880, eine Sprache der Widerstands?* (Marburg, 1992), 91–112.

91. See the letter of 6 Dec. 1830 to F. Guillemardet, *Corr. gén.*, 1:262, and that of 12 Oct. to Charles Delacroix, cited in n. 94.

92. Dumas, *Delacroix*, 80–81.

93. Letter to Charles de Verninac, 17 Aug. 1830, *Further Corr.*, 18.

94. Letter to Charles Delacroix, 12 Oct. 1820, *Lettres Intimes*, 191.

95. P. Gaudibert, "Eugène Delacroix et le Romantisme révolutionnaitre: A propos de *La Liberté sur les barricades*," *Europe*, no. 408 (Apr. 1863): 4–21. On Delacroix's political opinions, see also J.-P. Chimot, "Delacroix et la politique," *Cahiers d'histoire* (1965): 249–74; and H. Lüdecke, *Eugène Delacroix und die Pariser Juli-Revolution* (Berlin, 1965).

96. Dumas, *Delacroix*, 79–80.

97. Charles Lenormant, *Les Artistes contemporains. Salon de 1831* (Paris, 1833), 195.

98. I follow here Toussaint, "*La Liberté guidant le peuple*" *de Delacroix*, rev. ed., 43–51, without, however, always agreeing with her conclusions as to the meaning of certain details, particularly the man in the beret, to whom I think she gives a much too precise significance.

99. H. Toussaint, noting the black velvet beret of this figure, the "faluche" traditionally worn by students, suggests that he is Jehan Frollo, the student in *Notre-Dame de Paris*, published in Sept. 1830, ibid., 47.

100. Lenormant, *Les Artistes contemporains*, 197.

101. Stratigraphic analysis has revealed five successive layers of paint: vivid red, rosy beige glaze, a second purplish glaze, then two layers of orange of which the second is a glaze (study done in the laboratory of the Musées de France by Lola Faillant-Dumas and Jean-Paul Rioux). See Toussaint, "*La Liberté guidant le peuple*" *de Delacroix*, rev. ed., 72.

102. On the reception of the canvas, see especially N. Hadjinicolaou, "*La Liberté guidant le peuple* de Delacroix devant son premier public," *Actes de la Recherche en Sciences Sociales*, no. 28 (June 1979): 3–26; see also N. Heinich, "Lettre à propos de l'article de N. Hadjinicolaou," ibid., 27–28.

103. H. Heine, "Salon de 1831" (repr. in *De la France* [Paris, 1833]), in *Oeuvres complètes* (Paris, 1860), 340.

104. T. Thoré, "Artistes contemporains. M. Eugène Delacroix," *Le Siècle*, 25 Feb. 1837.

105. On the circumstances of the purchase and its payment, see H. Toussaint, "*La Liberté guidant le peuple*" *de Delacroix*, rev. ed., 59–60.

106. Letter registered 11 Apr. 1855, Archives du Louvre, cited in ibid., 62.

107. Letter to Varcollier, 11 Apr. 1855, ibid.

108. Dumas, *Delacroix*, 88.

109. See the well-known studies by Maurice Agulhon, especially *Marianne au combat. L'Imagerie et la symbolique républicaines de 1789 à 1880* (Paris, 1979).

110. Some examples in H. Toussaint, "*La Liberté guidant le peuple*" *de Delacroix* rev. ed., 63–69.

111. Liberty followed the figure of Hersilie from the *Sabines* of David. In the autumn of 1997, a Cézanne replaced the Delacroix.

112. The subjects are taken from *Le Moniteur Universel*, 30 Sept. 1830; Guizot's explanation of his report to the king was published in ibid., 29 Sept. 1830. On the competition of 1830, see M.-C. Chaudonneret, "Le concours de 1830 pour la Chambre des Députés: Deux esquisses d'A.-E. Fragonard au Louvre," *Revue du Louvre et des Musées de France*, no. 2 (1987): 128–35, and M. Marrinan, "Resistance, Revolution, and the July Monarchy: Images to Inspire the Chamber of Deputies," *Oxford Art Journal* (Oct. 1980): 26–37, revised and enlarged in *Painting Politics for Louis-Philippe. Art and Ideology in Orleanist France* (New Haven and London, 1988).

113. Delivered 1 Mar. 1831, also published in *Corr. gén.*, 1:268–76; my citations are from the latter.

114. *Journal*, 4 Oct. 1854, 481–82.

115. L. Boulanger, "Un des cinquante Boissy d'Anglas," *L'Artiste* 1 (1831): 122.

116. Silvestre, *Histoire des artistes vivants*, 23.

Chapter Four

1. The most recent full treatment of the subject is the catalogue of the 1994–95 exhibition *Delacroix. Le Voyage au Maroc*, at the Institut du Monde Arabe, Paris (catalogue ed. Brahim Alaoui). See also Maurice Arama, *Le Maroc de Delacroix* (Paris, 1987); Guy Dumur, *Delacroix et le Maroc* (Paris, 1988); André Joubin, *Delacroix. Voyage au Maroc, 1832. Lettres, aquarelles et dessins* (Paris, 1932); and the catalogue of the 1993 commemorative exhibition at the Orangerie, Paris, *Delacroix au Maroc, 1832, et exposition rétrospective du peintre orientaliste Monsieur Auguste*. See the brief synthesis in A. Sérullaz and V. Pomarède, "'Rome n'est plus dans Rome,' ou la poésie de l'Orient," in *Delacroix. La naissance d'un nouveau romantisme*, 62–81. Delacroix's notebooks of the voyage were published in facsimile by Maurice Arama, *Eugène Delacroix, le voyage au Maroc. Facsimilé des carnets conservés au Musée du Louvre et au Musée Condé à Chantilly complétés par deux volumes de notes et de documents*, 6 vols. (Paris, 1992). The Bibliothèque Nationale de France has recently acquired an unpublished but unfortunately incomplete manuscript edited by Delacroix. Here he relates, more than ten years after his voyage, some of the salient episodes. A fall 1998 publication, under the direction of Laure Beaumont-Maillet, is anticipated. See also I. Goffitzer, *Der Orient in der Kunst und den Schriften von Eugène Delacroix* (Vienna, 1983). To place Delacroix's experience in a more general context, see Christine Peltre, *Les Orientalistes* (Paris, 1997); Jean Alazard, *L'Orient et la peinture française au XIXme siècle, d'Eugène Delacroix à Auguste Renoir* (Paris, 1930), and by the same author, "L'Orient, thème romantique," *Revue de l'Art Ancien et Moderne* (Jan.–May 1930): 277–92. I have most often followed modern spelling for Arabic names (Abd el-Rahman instead of Abd-err-Rhamann). Europeans spoke of either the sultan or the emperor of Morocco; I have thus used both terms.

2. Letter of Jan. 1832 to his friend Randouin, sous-préfet of Dunkirk, in *Lettres intimes*, 193–94n. 1.

3. See Delacroix's letter to Duponchel, 23 Feb. 1832, *Corr. gén.*, 1:315–16. On Henri Duponchel, then architect, decorator, designer of costumes and scenery, and later director of the Opera, see Anne Dion-Tenenbaum, "Multiple Duponchel," *Revue de l'Art* 116, no. 2 (1997): 66–75.

4. *Corr. gén.*, 1:315.

5. Cited by Arama in *Eugene Delacroix, le voyage au Maroc*, 6:12. The two other references found by Arama are of little importance: one alludes to the painter's sunburn on his return to Tangier, and the other, which appears later in correspondence to Delaporte about the trip to Spain, says that Delacroix would go alone to Cadiz. Arama found no mention of Delacroix elsewhere in the private papers of Mornay or Mlle Mars.

6. See *Journal*, 18 Jan. 1850, 218.

7. See his letter to Villot, 8 Dec. 1831, *Corr. gén.*, 1:302.

8. We owe the most exact chronology of the trip to Arama, *Eugène Delacroix, le voyage au Maroc*, 6:12 ("Journal de route") and 6:235–51 ("Le calendrier").

9. Letter to Pierret, 24 Jan. 1832, *Corr. gén.*, 1:305.

10. It is not known whether the painter, with the rest of the mission, was invited to all the festivities, which, according to custom, lasted a whole week.

11. Letter to Pierret, 25 Jan. 1832, *Corr. gén.*, 1:305.

12. Letter to Félix Feuillet de Conches (who had recommended to the minister that Delacroix be included in the mission), 25 Jan. 1832, ibid., 1:308.

13. Letter to Pierret, 8 Feb. 1832, ibid., 1:310–11.

14. Letter to Gudin, 23 Feb. 1832, ibid., 1:313.

15. Letter to Duponchel, 23 Feb. 1832, ibid., 1:314–15.

16. Letter to Pierret, 16 Mar. 1832, ibid., 1:320.

17. Ibid., 1:321–22.

18. Ibid., 1:323–24.

19. Ibid., 1:322.

20. Ibid., 1:323. Considerations on Moorish architecture in the same letter, ibid., 1:322, and in the one to Duponchel cited in n. 15 above, ibid., 1:315.

21. Letter to Pierret, 2 Apr. 1832, ibid., 1:325–26. The whole sojourn in Meknès is summed up with similar ideas (and sometimes in the same words as those used in the correspondence with Pierret), as expressed in a letter to Armand Bertin, 2 Apr. 1832, ibid., 1:327–29.

22. Letter to Pierret, 2 Apr. 1832, ibid., 1:326.

23. On the Spanish trip, see A. Joubin, "Quinze jours en Espagne avec Delacroix, 16–30 mai 1832," *Revue de l'Art Ancien et Moderne* 57 (Jan.–May 1930): 49–56; and E. Lambert, "Delacroix et l'Espagne," *Revue des Arts* 3 (1951): 159–71.

24. All these details are studied in the article by Joubin, cited in n. 23.

25. Letter to Pierret, 5 June 1832, *Corr. gén.*, 1:331–32. See also his letter to Villot, 7 July 1832, ibid., 1:335.

26. See the study by E. Lambert,

Delacroix et les femmes d'Alger (Paris, 1937), especially 9–11, which relies on Philippe Burty, "Eugène Delacroix à Algers," *L'Art* 32 (1883), 1:76–79 and 94–98, the first to have reported the episode. Burty doubtless took it from two different sources, Mornay (although this appears unlikely) and Charles Cournault. Cournault, curator of the Musée Lorrain in Nancy, was a friend of the painter, who made him one of the executors of his estate and left him "two chests from Morocco and all [his] objects from Algiers." The text cited here comes from the letters of Cournault edited by Burty without indication of date or addressee. They include an obituary also by Cournault, cited by Lambert, *Delacroix et les femmes d'Alger*, 11. On Cournault, who is also the source for what we know of the origin of the *Women of Algiers in Their Apartment*, see Lee Johnson, "La collection Charles Cournault," *Bulletin de la Société de l'Histoire de l'Art Français* 1978 (1980): 249–62.

27. Preface to Burty, *Catalogue de la vente qui aura lieu par suite du décès de Eugène Delacroix* (Paris, 1864), xiii.

28. Executed in May 1832 and now in the Musée National des Beaux-Arts, Algiers (Johnson 215).

29. Private collection (Johnson 349). The work was recently shown in the exhibition *Delacroix. Le voyage au Maroc*, no. 50, 176–77. On Delacroix's fantasias, see Lee Johnson, "Delacroix's *Rencontre de cavaliers maures*," *Burlington Magazine*, Oct. 1961, 417–23; P. Joannidès, "Delacroix, the *Choc des cavaliers arabes* and the Galerie des Beaux-Arts," *Journal of the Walters Art Gallery*, no. 35 (1977): 93–97; T. Loer, "Ästhetik im Ausgang vom

Werk. Eugène Delacroix: Fantasia Arabe, 1833, Exemplairsche Überlegungen," *Zeitschrit für Ästhetik und Allgemeine Kunstwissenschaft* 36 (1991): 154–70.

30. There were more than a thousand Moroccan drawings in the posthumous sale. But it is likely that there were many more if the small sketches are counted. Elie Lambert proposes that three or four thousand sketches were brought from Africa. Some studies on Delacroix's Moroccan drawings include: A. Mongan, "Souvenirs of Delacroix's Journey to Morocco in American Collections," *Master Drawings*, no. 2 (1963): 20–31; and "Watercolors from Delacroix's North African Journey in American Collections," in *Jean Alazard. Souvenirs et Mélanges* (Paris, 1963), 187–94.

31. Three of these notebooks are in the Louvre, one is in the Musée Condé at Chantilly. These are the four notebooks that were reedited in 1992 in the facsimile edition by Maurice Arama, *Eugène Delacroix, le voyage au Maroc*. It is possible that Delacroix used more than seven notebooks (the only ones extant at the time of the sale), but the question remains open (see A. Sérullaz in the catalogue by Arama, 128–29).

32. See Piron, *Delacroix. Sa vie et ses oeuvres*, 90.

33. Letter to Pierret, 29 Feb. 1832, *Corr. gén.*, 1:319.

34. Letter to Villot, 7 July 1832, ibid., 1:334.

35. Lambert, *Delacroix et les femmes d'Alger*, whom I often follow on the development of the painting from the preliminary studies.

36. Alfred Bruyas said he had seen the costume worn by the black servant:

A. Bruyas, *La Galerie Bruyas* (Paris, 1876), 279.

37. Joachim Gasquet, *Cézanne* (Paris, 1921), 108.

38. Gustave Planche, "De l'Ecole française au Salon de 1834," *Revue des Deux-Mondes*, 1 Apr. 1834, reprinted in *Etudes sur l'Ecole française, peinture et sculpture, 1831–1852* (Paris, 1855), 1:247–48.

39. Charles Blanc, "Eugène Delacroix, II," *Gazette des Beaux-Arts*, 1 Feb. 1864, 111–12.

40. *Journal*, 7 Feb. 1849, 175.

41. A. Bruyas, *La Galerie Bruyas*, 280.

42. On this question, see the clarification by Johnson, *Crit. Cat.*, 3:177–78. On the *Jewish Wedding in Morocco*, see also Clara Brahm, "Two Copies of Delacroix's *Noce juive dans le Maroc*," *Gazette des Beaux-Arts*, Nov. 1952, 269–86.

43. Philippe Burty, "La collection du Lau," *Gazette des Beaux-Arts*, 1 May 1869, 474–75.

44. The sketch done on-site is in the Louvre (RF 10069). The drawings done in Morocco that later served for the *Jewish Wedding in Morocco* are well known: see, for example, Alaoui, ed., *Delacroix. Le voyage au Maroc*, passim. A watercolor representing the wedding guests' visit to the bride, a watercolor taken up again in part in the etching falsely named *Jewish Woman of Algiers*, was recently published by Lee Johnson in "Delacroix's 'Jewish Bride,'" *Burlington Magazine*, Nov. 1997, 755–59.

45. Cited in the *Journal*, 21 Feb. 1832, 97–98.

46. G. Planche, "Salon de 1838," *Revue du Dix-Neuvième Siècle. Chronique de Paris*, reprinted in *Etudes sur l'Ecole française* (Paris, 1855), 2:109. The rest of the text is very critical of the painting.

47. Gautier, *Les Beaux-Arts en Europe*, 1:181–82.

48. Ibid.; cited in Johnson, *Crit. Cat.*, 3:178.

49. On this painting, see E. Lambert, *Histoire d'un tableau. L'Abd el-Rahman Sultan du Maroc de Delacroix* (Paris, 1953); and L. Johnson, "Delacroix's Road to the Sultan of Morocco," *Apollo* (Feb. 1982): 186–89.

50. *Journal*, 22 Mar. 1832, 105.

51. Charles Blanc, "Eugène Delacroix, II," *Gazette des Beaux-Arts*, 1 Feb. 1864, 118.

52. Handwritten notes adressed to Philippe Burty, Paris, Bibliothèque Nationale, Département des Estampes et de la Photographie, 31–32.

53. T. Thoré, "Salon de 1845," in *Salon de T. Thoré 1844, 1845, 1846, 1847, 1848* (Paris, 1868), 118.

54. Baudelaire-Dufaÿs, "Salon de 1845," in *Oeuvres complètes* (Paris, 1976), 357.

55. Letter to Pierret, 8 Feb. 1832, *Corr. gén.*, 1:311.

56. *Journal*, 17 Oct. 1853, 369.

57. Letter to Villot, 29 Feb. 1832, *Corr. gén.*, 1:317.

58. Ibid.

59. Letter to Pierret, 29 Feb. 1832, ibid., 1:319.

60. Letter to Armand Bertin, 2 Apr. 1832, ibid., 1:327–38.

61. Letter to Jal, 4 June 1832, ibid., 1:330.

62. On this point, see especially the note by Claude Allemand-Cosneau on Vernet's painting *Hagar Banished by Abraham*, in the catalogue of the exhibition *Les Années romantiques. La peinture française de 1815 à 1850* (Nantes, Paris, and Plaisance, 1996), 442–43.

Chapter Five

1. On Delacroix's decorative paintings in general, see Maurice Sérullaz, *Les Peintures murales de Delacroix* (Paris, 1963), which reproduces most of the original documents and extensive excerpts of the contemporary criticism, and Johnson, *Crit. Cat.*, vols. 5 (text) and 6 (plates), which concerns specifically the artist's public decorations and the sketches for them. To restore Delacroix's works to their context, see L. Rosenthal, *Du Romantisme au réalisme. La Peinture en France de 1830 à 1848* (Paris, 1914; reprint Paris, 1987), 298–344 (chap. 7: "La Peinture monumentale"); P. Vaisse, "La Machine officielle. Regards sur les murailles des édifices publics," *Romantisme—Revue du Dix-Neuvième Siècle*, no. 41 (1983): 19–40;

St. Germer, *Historizität und Autonomie. Studien zu Wandbildern in Frankreich des 19. Jahrhunderts* (Hildesheim, Zurich, and New York, 1988).

2. Delacroix's work in the Chambre des Députés was the subject of a recent exhibition, *Delacroix à l'Assemblée Nationale. Peintures murales, esquisses, dessins*, held on-site in 1995. On the program of the Salon du Roi, see J. J. Guiffrey, "Le Salon du Roi au palais de la Chambre des Députés. Peintures décoratives d'Eugène Delacroix décrites par l'artiste," *L'Art* (1878), 2:257–68. See also Alfred Robaut, "Peintures décoratives d'Eugène Delacroix au Salon du Roi ou Salle des Fleuves," *L'Art* (1880), 1:107–12; reprinted with revisions in *Peintures décoratives par Eugène Dela-*

croix: Le Salon du Roi au Palais législatif (Paris, 1880).

3. The orders and notifications are in the Archives Nationales, F21584, stored at the library of the Palais-Bourbon, cited in Sérullaz, *Les Peintures murales*, 27.

4. Letter to Cavé, 30 May 1833, *Corr. gén.*, 1:358.

5. Letter to Lelong, 27 June 1833, ibid., 1:360.

6. Letter to Guillemardet, 27 July 1833, ibid., 5:164.

7. Manuscript memoirs of Delacroix, as reported in Piron, *Delacroix. Sa vie et ses oeuvres*, 62–63, both citations.

8. Glassed-in and today containing a chandelier.

9. Guiffrey, "Le Salon du Roi," 259.

10. Letter of 27 Dec. 1836, *Corr. gén.*, 1: 419–20. I am following here the corrected version given in Sérullaz, *Les Peintures murales*, 35.

11. Manuscript memoirs of 1848, published by Guiffrey, "Le Salon du Roi," 263.

12. Delacroix began with the ceiling, then, in late 1834, started work on the frieze, which was completed in January 1836; the piers were finished the following year. In January 1837, however, Delacroix was considering certain "important modifications," and he retouched his work over the course of the year 1837 and perhaps even into 1838. On the chronology of the execution, see Johnson, *Crit. Cat.*, 5:7–8; Sérullaz, *Les Peintures*

murales, 27–40, cited in *Delacroix à l'Assemblée Nationale*, 22–30.

13. Letter to Villot, 23 Sept. 1834, *Corr. gén.*, 1:381–82.

14. Letter to Villot, Oct. 1834, ibid., 1:386–87. On Delacroix's experiments at Valmont, see Maurice Sérullaz, "Les Premières Décorations murales de Delacroix," *Art de France* 3 (1963): 265–69.

15. On Delacroix's experiments and the techniques he ultimately selected, the most precise and complete overview is the study by Nathalie Volle, in collaboration with K. Kzrzyzynski and Y. Ogrodnik-Mendili, "La Restauration des peintures du Salon du Roi," in *Delacroix à l'Assemblée Nationale*, 25–72, which I have followed here.

16. See Villot's statement below, concerning the library of the Palais du Luxembourg.

17. The program was explained by Delacroix himself in the memoir cited in n. 11, above.

18. Horace's *Ars poetica* and *Odes* are the sources for the first two quotations, and Virgil's *Georgics* and Ovid's *Fasti* for the last two. Delacroix cut Virgil's verse short; in full it reads: *Plenis spumat vindemia labris* (the grape harvest foams up in the full vats).

19. Théophile Gautier, "Peintures de la Chambre des Députés. Salle du Trône," *La Presse*, 26 Aug. 1836.

20. Gustave Planche, *Revue des Deux-Mondes*, 15 June 1837, reprinted in *Portraits d'artistes. Peintres et sculpteurs*, vol. 2 (Paris, 1853), 28–29, 37.

21. On this point, see Maurice Sérullaz, "Eugène Delacroix: L'Italie de la Renaissance, les maîtres de l'Ecole de Fontainebleau," in *Hommage à Hubert Landais* (Paris, 1987), 190–96.

22. On this point, see Johnson, *Crit. Cat.*, 5:25–30.

23. On the preparatory drawings, consult, besides the general works, Jacqueline Bouchot-Saupique, "Some Drawings by Delacroix in the Musée de Besançon," *Master Drawings* 1, no. 3 (1963): 40–43; Maurice Sérullaz, "Delacroix's Drawings for the Decorations of the Salon du Roi," *Master Drawings* 1, no. 4 (1963): 41–43; H. Bock, "Zeichnungen zum Salon du Roi im Palais Bourbon von Delacroix," *Wallraf-Richartz Jahrbuch* 28 (1968): 105–15.

24. Letter to Rivet, 23 Feb. 1838, *Corr. gén.*, 2:4.

25. Memoir stored in the Archives Nationales, F21752, published in Sérullaz, *Les Peintures murales*, 49–51, as are all of the following passages not otherwise attributed. The memoir itself arose from a reflection retraced by Pierre Angrand, "Genèse des travaux d'Eugène Delacroix à la bibliothèque de la Chambre," *Archives de l'Art Français*, new ser., 25 (1978) (*À travers l'art français, hommage à René Jullian*): 313–35. See also G. L. Hersey, "A Delacroix Preparatory Drawing for the Library Ceiling in the Palais Bourbon," *Bulletin of the Yale University Art Gallery* 29 (Dec. 1963): 5–21, and R. N. Beetem, "Delacroix's *Lycurgus Consulting the Pythia*," *The University of Michigan Museum of Art Bulletin* 4 (1969): 10–23.

26. On Vernet's paintings in the Palais-Bourbon, see R. Beetem, "Horace Vernet's Mural in the Palais-Bourbon . . . ," *Art Bulletin* 66, no. 2 (1984): 254–69.

27. Letter to Villot, 13 Sept. 1838, *Corr. gén.*, 2:24.

28. Review in *Le Constitutionnel*, 31 Jan. 1848, published in Sérullaz, *Les Peintures murales*, 66–68. I quoted from this review the unattributed explanation below of the subjects of the two hemicycles. For the subjects, I have preferred to use the titles inscribed in the library itself, sometimes clarifying them with excerpts from the review.

29. Louis de Ronchaud, "La Peinture monumentale," *Revue Indépendante*, 25 Nov. 1847, 48–49.

30. Clément de Ris, *L'Artiste*, 9 Jan. 1848, 154–55.

31. Prosper Haussard, *Le National*, 18 Oct. 1850.

32. Paul de Saint-Victor, *La Presse*, 22 Sept. 1863.

33. Elements of comparison may be found in André Masson, *Le Décor des bibliothèques du Moyen Age à la Révolution* (Geneva, 1972), and *The Pictorial Catalogue: Mural Decorations in Libraries* (Oxford, 1981).

34. G. L. Hersey, "Delacroix's Imagery in the Palais Bourbon Library," *Journal of the Warburg and Courtauld Institutes* 31 (1968): 383–403.

35. A. Hopmans, "Delacroix's Decorations in the Palais Bourbon Library: A Classic Example of an Unacademic Approach," *Simiolus* 17, no. 4 (1987): 240–69. See also Beetem, "Delacroix's *Lycurgus Consulting the Pythia*," 10–23. See also two very different interpretations of Delacroix's works in the Palais-Bourbon and in the Luxembourg, one related to the iconography of the law in nineteenth-century France: Jonathan Ribner, *Broken Tablets: The Cult of the Law in French Art from David to Delacroix* (Berkeley, 1993), especially 80–82 and 98–137; the other from a much more literary perspective, following a "structuralist and poststructuralist" analysis (but quite debatable from a strictly historical point of view), Norman Bryson, *Tradition and Desire from David to Delacroix* (Cambridge, 1984), 176–210.

36. On this point, see Michele Hannoosh's pertinent analysis, *Painting and the "Journal" of Eugène Delacroix*, 128–60.

37. For a detailed chronology, see Johnson, *Crit. Cat.*, 5:38–41.

38. Letter to George Sand, 11 Sept. 1841, *Corr. gén.*, 2:85.

39. See the anonymous review published in *L'Artiste*, 25 June 1843, 412.

40. Louis de Planet, *Souvenirs de travaux de peinture avec M. Eugène Delacroix*, ed. André Joubin (Paris, 1929), 98.

41. On this point, see the memoirs of Lassalle-Bordes, published in Burty, *Lettres d'Eugène Delacroix*, 2:x–xi.

42. Letter to Jules de Joly, 23 July 1844, *Corr. gén.*, 2:187.

43. Invitations to David d'Angers, Préault, Diaz, Théophile Gautier, Villot, and Couture, 21–22 Dec. 1847, *Corr. gén.*, 2:333–35.

44. On Delacroix's studio, see Henriette Bessis, *Les Elèves de Delacroix*, Mémoire de l'Ecole du Louvre (Paris, 1967), and Paul Duro, "Les Elèves de Delacroix au Musée du Louvre," *Archives de l'Art Français*, new ser., 26 (1984): 259–65. On Mme Rang-Babut, see André Joubin, "Deux amies de Delacroix. Mme Elisabeth Boulanger-Cavé et Mme Rang-Babut," *Revue de l'Art Ancien et Moderne* 57 (Jan.–May 1930): 56–94.

45. On Andrieu, see, among others, Lee Johnson, "Pierre Andrieu, le cachet E. D. et le château de Guermantes," *Gazette des Beaux-Arts*, Feb. 1970, 99–110, and "Pierre Andrieu, un polisson?" *Revue de l'Art*, no. 21 (1973): 66–69; Henriette Bessis, "Décorations murales de Pierre Andrieu," *Gazette des Beaux-Arts*, Feb. 1967, 183–86; "Pierre Andrieu," *Médecine de France*, May 1971, n.p.; Suzanne Damiron and Henriette Bessis, "Journal de Pierre Andrieu (1821–1892). Un document inédit conservé à la bibliothèque d'Art et d'Archéologie de Paris (MS 426)," *B.S.H.A.F.* 1975 (1976): 261–80; and, Susan Strauber, "Delacroix's Drawings and the False Estate Stamp, II: Topography and Chronology of the *Faux cachet*," *B.S.H.A.F.* 5, no. 2 (1993): 129–63. On Lassalle-Bordes (who played a very important part in the Luxembourg library), see Robert N. Beetem, "Delacroix and His Assistant Lassalle-Bordes: Problems in the Design and the Execution of the Luxembourg Dome Mural," *Art Bulletin* 49 (Dec. 1967): 305–10.

46. Burty, *Lettres d'Eugène Delacroix*, 2:iii–xvi; there follow some remarks by Lassalle-Bordes, pp. xvii–xxxv. Burty, most certainly out of reverence for Delacroix, suppressed a part of what Lassalle-Bordes had written him. The latter seems not to have minded and to have expatiated on the facts in another letter. Maurice Tourneux, who knew about this, copied this long new letter, in a transcription given by Etienne Moreau-Nélaton to the Cabinet des Estampes in the Bibliothèque Nationale, with the rest of his documentation on Delacroix. It is kept there at present. Anne Larue appears to have relied on these documents for an interpretation, which I do not entirely share, of the relations between Delacroix and his pupils. She seems to me to give too much weight to Lassalle-Bordes's accusations, which should be completed by and checked against more neutral sources before being taken literally. See A. Larue, "Delacroix et ses élèves d'après un manuscrit inédit," *Romantisme* 93, no. 6 (1996): 7–20.

47. See n. 40, above.

48. Planet, *Souvenirs de travaux*, 95. In his introduction, André Joubin clearly lays out the participation of Delacroix's pupils in the body of his work.

49. Prosper Haussard, "Peintures de M. Eugène Delacroix au Palais législatif et au Palais du Luxembourg," *Le National*, 20 Oct. 1850.

50. Paul de Saint-Victor, "Eugène Delacroix," *La Presse*, 22 Sept. 1863.

1. See his letter to Gisors, 4 Apr. 1840, *Corr. gén.*, 2:52–53.

2. On Delacroix's works in the Palais du Luxembourg, besides the general works cited in chap. 5, see A. Hustin, "Les Peintures d'Eugène Delacroix au Sénat," *Les Arts*, no. 191 (1920): 1–19; N. Sandblad, "Le Caton d'Utique de la bibliothèque du Sénat," *Figura, Uppsala Studies in the History of Art*, new ser., 1 (1959): 181–203; a hypothetical interpretation (debatable, see chap. 1) in J. Starzynski, "La Pensée orphique du plafond d'Homère de Delacroix," *Revue du Louvre*, no. 2 (1963): 73–82.

3. Notes preserved in the Bibliothèque d'Art et Archéologie, MS 250, fol. 11, cited and analyzed by Johnson, *Crit. Cat.*, 5:89, which I follow here.

4. Bibliothèque Nationale de France, Print Department, R.39 papers, portfolio 15, 1845, repr. in Beetem, "Delacroix and His Assistant Lassalle-Bordes," fig. 14.

5. The excerpt is from a letter from Villot to Alfred Sensier, who in 1869 had written a letter on the restoration of Delacroix's works in the Palais du Luxembourg. In it, he describes the genesis of the composition (in the passage cited here), and then analyzes the strictly technical problems that had caused the cupola, detached from its support, to collapse. The letter, published in the *Revue Internationale de l'Art et de la Curiosité*, was later republished in Tourneux, *Eugène Delacroix devant ses contemporains*, 123–27 (the passage cited here is from 124–26).

6. See Lassalle-Bordes's letter in Burty, *Lettres d'Eugène Delacroix*, 2:viii. The question of Delacroix as a "classical" painter in the Senate is discussed in Sandblad, "Le Caton d'Utique."

7. In *L'Artiste*, 4 Oct. 1846, 221.

8. *Phaedo*.

9. In a manuscript collected by Philippe Burty, published in E. Moreau-Nélaton, *Delacroix raconté par lui-même*, vol. 2 (Paris, 1916) 18–19.

10. Delacroix uses almost the same words in a letter to the director of *L'Artiste*, Arsène Houssaye, in Jan. 1847, *Corr. gén.*, 2:298.

11. On this debate, see Hustin, "Les Peintures d'Eugène Delacroix au Sénat," quoted in Sérullaz, *Les Peintures murales*, 90–91. Riesener's ceilings fill the left side, Roqueplan's (not yet in place in early 1843), the right.

12. Letter to Gisors, 15 Dec. 1844, *Corr. gén.*, 2:205. On Delacroix's preparatory works for the Luxembourg library, see M. Sérullaz, "A Rediscovered Sketch by Delacroix for the Library of the Luxembourg Palace," *Burlington Magazine*, June 1970, 378–81.

13. See his letters to Thoré of 25 and 27 Oct. 1845, *Corr. gén.*, 2:243–44.

14. The most complete list is in Johnson, *Crit. Cat.*, 5:102–3. To be noted in particular are the first, Léon Joubert's (*Le Moniteur des Arts*, 8 Feb. 1846), Gautier's (*La Presse*, 1 Apr. 1846 and 31 Jan. 1847), Gustave Planche's (*Revue des Deux Mondes*, 1 July 1846), Thoré's (*Le Constitutionnel*, 10 Jan. 1847), and Paul Mantz's (*L'Artiste*, 7 Feb. 1847).

15. Paul Mantz, "Bibliothèque de la Chambre des Pairs. Coupole de M. Eugène Delacroix," *L'Artiste*, 7 Feb. 1847, 218.

16. Théophile Thoré, "Revue des Arts. Les peintures de M. Eugène Delacroix à la Chambre des Pairs," *Le Constitutionnel*, 10 Jan. 1847.

17. Mantz, "Bibliothèque de la Chambre des Pairs," 220.

18. Ibid.

19. E. Thierry, "Beaux-Arts: Peintures de M. Eugène Delacroix dans la bibliothèque de la Chambre des Pairs," *Revue Nouvelle* 12 (15 Dec. 1846), 296.

20. On this point, see Lee Johnson's summary, *Crit. Cat.*, 5:92–96.

21. Mantz, "Bibliothèque de la Chambre des Pairs," 220.

22. Théophile Gautier, "Feuilleton. La Croix de Berny (bibliothèque de la Chambre des Pairs)," *La Presse*, 31 Jan. 1847.

23. Ibid.

24. Gustave Planche, "Peintures monumentales de MM. Eugène Delacroix et Hippolyte Flandrin à la Chambre des Pairs et à Saint-Germain-des-Prés," *Revue des Deux Mondes*, 1 July 1846.

25. Paul Mantz, "Bibliothèque de la Chambre des Pairs," passim.

26. Ibid., 218.

27. Thoré, "Revue des Arts."

28. See the *Journal*, 19 Jan. 1847, 116.

29. Ibid., 1 Mar. 1847, 137.

30. See ibid., 23 Jan. 1847, for the subjects that Delacroix was considering.

31. On the Louvre works: M. Rousseau, "La Commande du plafond de la Galerie d'Apollon à Eugène Delacroix," *B.S.H.A.F.* 1935, 293–98; Jennifer Montagu, "Le Brun et Delacroix dans la Galerie d'Apollon," *Revue du Louvre*, no. 5 (1962): 233–36; M. Hesse, "Eugène Delacroix (1798–1863): Deckenbild in der Galerie d'Apollon des Louvre: Realitätsstruktur und Bildaussage," *Zeitschrift für Ästhetik und allgemeine Kunstwissenschaft* 25 (1980): 88–107; and F. Matsche, "Delacroix als Deckenmaler: Apollon vainqueur du serpent Python," *Zeitschrift für Kunstgeschichte* 47 (1984): 465–500. See also L. Johnson, "A New Oil Sketch for *Apollo Slays Python*," *Burlington Magazine*, Jan. 1988, 35–36. J. de Caso published the cor-

respondence between Duban and Delacroix, which clarifies the former's intentions and the latter's attitude, in "Neuf lettres inédites de Delacroix à Duban au sujet des travaux de la Galerie d'Apollon," *Bulletin de la Société de l'Histoire de l'Art français* 1966 (1967): 283–90. On the ceiling's iconographic context, Marie-Claude Chaudonneret, "Historicism and 'Héritage' in the Louvre, 1820–1840: From the Musée Charles x to the Gallery d'Apollon," *Art History* 14, no. 4 (Dec. 1991): 488–520.

32. See Emmanuel Jacquin, "Le Chantier du Louvre," in Sylvain Bellenger and Françoise Hamon, eds., *Félix Duban (1798–1870). Les couleurs de l'architecte* (Paris, 1996), 100–107.

33. On Duban's part in the Galerie d'Apollon, see Geneviève Bresc-Bautier, "La Galerie d'Apollon," in ibid., 107–11.

34. See the *Journal*, 13 Apr. 1849, 192.

35. Letter to Constant Dutilleux, 5 Oct. 1850, *Corr. gén.*, 3:36.

36. *L'Automne (Triomphe de Bacchus)*, by Hugues Taraval (1769); *L'Eté (Cérès et ses compagnes implorant le soleil)*, by Louis-Jacques Durameau (1774); *L'Hiver (Eole déchaîne les vents qui couvrent les montagnes)*, by Jean-Jacques Lagrenée le Jeune (1775); and *Le Printemps (Zéphyre et Flore couronnant de fleurs Cybèle)*, by Antoine Callet (1780).

37. See the *Journal*, 5 Oct. 1847, 164; 15 Dec. 1847, 168; and 16 Mar. 1850, 229.

38. David R. Slavitt, trans., *The Metamorphoses of Ovid* (Baltimore, 1994).

39. There are several, slightly different versions of this text. I am following *Corr. gén.*, 3:89–90.

40. Gustave Planche, "Le Plafond de M. E. Delacroix au Louvre: Triomphe d'Apollon Pythien," *Revue des Deux-Mondes*, 15 Nov. 1851, reprinted in *Portraits d'artistes*, 2:49.

41. On this point, see the *Journal*, 10 Apr. 1850, 231, and Johnson, *Crit. Cat.*, 5:117.

42. Letter to Constant Dutilleux, 10 Apr. 1851, *Corr. gén.*, 3:64.

43. See his letters to Théophile Gautier, 10 Mar. 1851, ibid., 3:61; and to Mme Guyot-Desfontaines, 14 Mar. 1851, ibid., 3:62.

44. Letter to George Sand, 10 Oct. 1851, ibid., 3:86.

45. *Journal*, 8 June 1850, 241.

46. Ibid., 10 Aug. 1850, 263.

47. E.-J. Delécluze, "Plafond central de la Galerie d'Apollon peint par M. E. Delacroix," *Journal des Débats*, 17 Oct. 1851.

48. Charles Tillot, "Beaux-Arts. Plafond de la Galerie d'Apollon. M. E. Delacroix," *Le Siècle*, 30 Oct. 1851.

49. See Johnson, *Crit. Cat.*, 5:117–18;

A. Vacquerie's review, "L'Apollon d'Eugène Delacroix," appeared in *L'Avènement du Peuple*, 18 Oct. 1851.

50. On this particular point, see Matsche, "Delacroix als Deckenmaler."

51. Letter to George Sand, 20 Oct. 1851, *Corr. gén.*, 3:90–91.

52. The only recent summary of the subject is Lee Johnson's account of the paintings in the Hôtel de Ville, *Crit. Cat.*, 5:133–57. See also M.-C. Cauboue, "Deux dessins de Delacroix pour la décoration du Salon de la Paix à l'ancien Hôtel de Ville de Paris," *Bulletin du Musée Carnevalet* 5, no. 1 (June 1952): 11–17. Michele Hannoosh discovered in the Bibliothèque Royale in Brussels a copy of the explanatory text that Delacroix distributed to the critics; its existence had been suspected but it had not hitherto been found. This has recently made it possible to identify the order and arrangement of the lunettes: see Lee Johnson and M. Hannoosh, "Delacroix's 'Hercules Cycle' in the Salon de la Paix," *Burlington Magazine*, Apr. 1997, 256–57.

53. Letter of 2 Sept. 1852, *Corr. gén.*, 3:122.

54. *Journal*, 19 Oct. 1851, 312.

55. Ibid., 20 Oct. 1851.

56. Ibid., 23 Oct. 1851.

57. Letter to Andrieu, 3 Aug. 1853, *Corr. gén.*, 3:122.

58. Letter to George Sand, 7 Dec. 1852, ibid., 3:130–31.

59. See his letter to Andrieu of 6 Jan. 1853, ibid., 3:134.

60. Théophile Gautier, "Le Salon de la Paix," *Le Moniteur Universel*, 25 Mar. 1854. Here, Gautier develops the text cited in n. 52, and found, among others, in Victor Calliat, *Hôtel de Ville de Paris . . . Supplément* (Paris, 1856), 4, but Gautier's text gives an idea of the colors and the luminous effect of the ceiling. I also excerpted from it the description that follows of the lunettes with the life of Hercules.

61. For the drawings and sketches, see Cauboue, "Deux dessins de Delacroix," 11–15; J. Wilhelm, "Une esquisse de Delacroix pour la décoration du Salon de la Paix," *Bulletin du Musée Carnevalet* 28, no. 1 (1975): 27. The authenticity of certain sketches in the collections of the museum of the Petit Palais in Paris is still open to question: see Lee Johnson, "Pierre Andrieu, un polisson?" *Revue de l'Art*, no. 21 (1973): 66–69, and *Crit. Cat.*, 5:145–57.

62. Gautier, "Le Salon de la Paix."

63. E.-J. Delécluze, "Peintures de M. E. Delecroix à l'Hôtel de Ville," *Journal des Débats*, 17 Mar. 1854.

64. L. Clément de Ris, "Plafond de M. Delacroix à l'Hôtel de Ville," *L'Artiste*, 1 Mar. 1854, 44.

65. This hypothesis is neither countered nor confirmed by any document.

66. See, for example, Gustave Planche, "L'Apothéose de Napoléon et le Salon de la Paix: Les Deux écoles de peinture à l'Hôtel de Ville," *La Revue des Deux-Mondes*, 15 Apr. 1854, 305–21.

67. *Journal*, 10 May 1854, 422.

68. This point is developed further in the following chapter.

69. On *The Lamentation* in Saint-Denis-du-Saint-Sacrement, see Johnson, *Crit. Cat.*, 5:79–85.

70. *Journal*, 30 Jan. 1855, 498.

71. Letter to Thoré, 17 Nov. 1844, *Corr. gén.*, 2:200.

72. Charles Baudelaire, *Salon de 1846*, reprinted in *Oeuvres complètes*, Bibliothèque de la Pléiade, vol. 2 (Paris, 1976), 435.

73. Letter to Charles Blanc, 23 Aug. 1861, *Corr. gén.*, 4:266–67.

74. An outstanding summary among the plentiful bibliography concerning the Chapelle des Saints-Anges in Saint-Sulpice is Jack Spector, *The Murals of Eu-*

gène *Delacroix at Saint-Sulpice* (New York, 1967); see also J. Schultze, "Voir Jean Duvet pour les anges," *Kunstgeschichtliche Studien für Kurt Bauch . . .* (Munich and Berlin, 1967), 277–86; and E. Kliman, "The Figural Sources of Delacroix's *Jacob Wrestling with the Angel*," *RACAR* 10 (1984): 157–62.

75. Invitation printed with explanatory text, sent by Delacroix on the occasion of the opening of the chapel, June 1861, *Corr. gén.*, 4:253–54; I have also excerpted from it the explanation of *Jacob Wrestling with the Angel*.

76. Gen. 32:23–33.

77. *Journal*, 20 Mar. 1856, 572.

78. Letter to Auguste Lamey, 25 June 1860, *Corr. gén.*, 4:184.

79. Letter to George Sand, 12 Jan. 1861, ibid., 4:228.

80. Letter to Charles Rivet, 23 Feb. 1861, ibid., 4:241–42.

81. Letter to Auguste Lamey, 2 Oct. 1860, ibid., 4:200–202; see also letters to Léon Riesener, 7 Oct. 1860, and Antoine Berryer, 14 Oct. 1860, ibid., 4:202–4.

82. Letter to Auguste Lamey, 13 Aug. 1860, ibid., 4:189.

83. *Journal*, 1 Jan. 1861, 796.

84. First published as "Le Testament d'Eugène Delacroix," *Revue Hebdomadaire* 6 (3, 18 June 1921): 249–60, reprinted in 1927 in *Le Mystère en pleine lumière*; I am quoting here from the P. Barrès and J. Dutourd edition, *L'Oeuvre de Maurice Barrès*, vol. 12 (Paris 1967), 231, 234.

85. Readers will be reminded of René Huyghe's 1964 monograph, *Delacroix, ou, Le Combat solitaire*.

86. Discussed in detail in Spector, *The Murals of Eugène Delacroix at Saint-Sulpice*, 108–38, and completed by Johnson, *Crit. Cat.*, 5:159–64.

87. Schultze, "Voir Jean Duvet pour les anges."

88. E. Kliman, "The Figural Sources of Delacroix's *Jacob Wrestling with the Angel*."

89. Schultze, "Voir Jean Duvet pour les anges."

90. Summary in Spector, *The Murals of Eugène Delacroix at Saint-Sulpice*, 138–53.

91. Thoré on *Heliodorus* in "La Chapelle des Saints-Anges à Saint-Sulpice," *Le Temps* 9 (Aug. 1861).

92. This analysis is further developed in L. Fournier, "Eugène Delacroix et ses peintures décoratives à Saint-Sulpice," *Revue des Arts Décoratifs* 21 (1901): 221–30.

93. Expressed especially in *Le Musée de Montpellier* (Paris, 1876), 375–76, from which the quote following is excerpted.

94. Thoré, "La Chapelle des Saints-Anges à Saint-Sulpice."

95. Spector, *The Murals of Eugène Delacroix at Saint-Sulpice*, 47–51, and figs. 23–28 and 42–44.

96. For the general context, see Bruno Foucart, *Le Renouveau de la peinture religieuse en France (1800–1860)* (Paris, 1987), passim (on Delacroix at Saint-Sulpice, p. 249).

97. Letter to Léon Riesener, 1 Sept. 1861, *Corr. gén.*, 4:269–70.

98. On this point, see Léon Rosenthal's summary, "La peinture monumentale," cited in chap. 5, n. 1, above.

Chapter Seven

1. The three watercolors were *Interior of a Guardhouse of Moorish Soldiers, Jewish Family*, and *Costumes of Morocco*. The portraits of Desmaisons and Petit de Beauverger are in private collections in the United States and France (Johnson 218 and Johnson 211, respectively; see Johnson, *Crit. Cat.*, 3:37 and 32–33). Delacroix had wanted to exhibit *The Knight and the Hermit of Copmanhurst* (lost; Johnson L 141).

2. *Clash of Arab Horsemen* (private collection, Paris; Johnson 355) and—once again—*The Knight and the Hermit of Copmanhurst* had been rejected by the jury.

3. *Christ on the Cross* is today in Vannes, in the Musée de la Cohue; *The Prisoner of Chillon* is in the Louvre (I will analyze the implications of *Christ on the Cross* later; for *The Natchez*, see chap. 3). *Arabs of Oran*, a painted version of a watercolor by Delacroix, is in a private collection in Paris (Johnson 357, Johnson, *Crit. Cat.*, 4:170); the location of *Portrait of Guillemardet* is unknown (Johnson 227, ibid., 4:45–46).

4. H. Trianon, "Salon de 1835," *La Romance* 2, no. 18 (2 May 1835): 72, cited in Johnson, *Crit. Cat.*, 3:69, from which I have borrowed this excerpt.

5. *L'Artiste* 9, no. 8 (1835): 88–89.

6. See Hervé Robert, "Le Destin d'une grande collection princière au XIXᵉ siècle:

l'Exemple de la galerie de tableaux du duc d'Orléans, Prince royal," *Gazette des Beaux-Arts*, July–Aug. 1991, 37–51; and *Le Mécénat du duc d'Orléans, 1830–1842, Délégation artistique à la Ville de Paris* (Paris, 1993); and "Une prestigieuse galerie de tableaux," 88–109.

7. Fabien Pillet, "Salon de 1835," *Le Moniteur Universel*, 13 Apr. 1835, 829 (?).

8. A., "Salon de 1835," *Le Constitutionnel*, no. 115, 26 Apr. 1835.

9. The jury had rejected the first version of *Hamlet and Horatio in the Graveyard*.

10. Gustave Planche, "Beaux-Arts. Salon de 1836," *Chronique de Paris*, 24 Apr. 1836, reprinted in *Etudes sur l'Ecole française*, vol. 2 (Paris, 1855), 21–22 and 23–24.

11. "Salon de 1836" (anonymous article), *L'Artiste* 11, no. 7 (1836): 78. *Saint Sebastian Tended by the Holy Women*, sent to the church in Nantua, was there subjected to inadequate conservation conditions. In 1869, it was almost sold by the church council, which disliked the painting, but the mayor and the town council succeeded in blocking the sale. In 1899–1900, when the painting was being restored in Paris, the possibility was also raised of keeping it in the Louvre, but in the end it was sent back to Nantua, where it still is today. See P. Angrand, "Les malheurs d'un *Saint*

Sébastien," *Gazette des Beaux-Arts*, Nov. 1984, 189–92.

12. Letter to the president of the Académie des Beaux-Arts, 4 Feb. 1837, *Corr. gén.*, 1:425–26.

13. Letter to F. Villot, 20 July 1836, ibid., 1:416.

14. On the Musée Historique de Versailles, the Galerie des Batailles, and the originality of Delacroix's work in this context, see T. Gaethgens, *Versailles. De la résidence royale au Musée historique. La galerie des Batailles dans le Musée historique de Louis-Philippe* (Paris, 1984), especially 146–52. See also Michael Marrinan, *Painting Politics for Louis-Philippe: Art and Ideology in Orleanist France, 1830–1848* (New Haven and London, 1987).

15. Brochure for the Salon of 1837.

16. F. Pillet, "Salon de 1837," *Le Moniteur Universel*, 2 Mar. 1837.

17. L. Viardot, "Salon de 1837," *Le Siècle*, 19 Mar. 1837; see Johnson, *Crit. Cat.*, 3:75, for an analysis of the reviews.

18. Théophile Gautier, "Salon de 1837," *La Presse*, 9 Mar. 1837.

19. Louis Batissier, *L'Artiste* 13, no. 7 (1837): 81–82.

20. G. Planche, "Salon de 1837," *Chronique de Paris* 4 (12 Mar. 1837), reprinted in *Etudes sur l'Ecole française*, vol. 2 (Paris, 1855), 56–57.

21. G. Planche, "Salon de 1838," *Revue*

du XIXᵉ *Siècle*, reprinted in *Etudes sur l'Ecole française*, 2:107–8.

22. No. 459 in the brochure: "Interior of a courtyard into which some Moroccan soldiers have brought horses. One of them is busy setting pegs into the ground that will be used to hobble them, as is their practice." The whereabouts of the painting is unknown (Johnson 354; *Crit. Cat.*, 4:163–64.

23. On this painting (private collection), see ibid., 1:206–7 (L 101), and L. Johnson, "The Last Scene of 'Don Giovanni': A Newly Discovered Delacroix," *Burlington Magazine*, Sept. 1996, 605–7.

24. See *Journal*, 4 Mar. 1824.

25. "Salon de 1838," *La Quotidienne*, no. 70, 11 Mar. 1838, quoted in Sérullaz, ed., *Mémorial*, 184.

26. Planche, "Salon de 1838," 107.

27. See his letter to Cavé, 10 July 1838, *Corr. gén.*, 2:13, and the letter of the Minister of the Interior to Josson, deputy for the North, 4 Aug. 1838, published in M. Sérullaz, ed., *Mémorial*, 185.

28. Letter from Sand to Delacroix, Apr. 1838, *Corr. gén.*, 2:8–9.

29. The rejected paintings, besides *Tasso*, were *Arab Soldier by a Grave* (Johnson 362, Museum of Art, Hiroshima), and *Encampment of Arab Mule Drivers*, c. 1839 (Johnson 364, Milwaukee Art Museum).

30. Letter to George Sand, 28 May

1848, *Corr. gén.*, 2:349. On this painting, see J. C. Sloane, "Delacroix's *Cleopatra*," *Art Quarterly* 24 (Summer 1961): 124–28.

31. Prosper Mérimée, "Salon de 1839," *La Revue des Deux-Mondes*, 1 Apr. 1839, 98.

32. See Johnson, *Crit. Cat.*, 3:82–83.

33. T. Thoré, "Salon de 1839," *Le Constitutionnel*, 16 Mar. 1839.

34. See chap. 6, and the letter to Gisors of 4 Apr. 1840, *Corr. gén.*, 1:53.

35. The first one to mention it was A. Tardieu, in his "Salon de 1840," *Le Courrier Français*, 10 Mar. 1840. This was then unquestioningly repeated, until L. Johnson settled the matter by referring to the records of the deliberations, in "Eugène Delacroix et les Salons. Documents inédits au Louvre," *Revue du Louvre*, no. 4 (1966): 224; the painting received eleven votes in favor and seven opposed. On the reception of the painting, see Michèle Bundorf, "La *Justice de Trajan* et la critique," *Art de France* 4 (1964): 336–39, and S. Guégan, "A propos d'un cheval rose. Note sur le 'Trajan' de Delacroix au Salon de 1840," in *Delacroix. La naissance d'un nouveau romantisme*, 106–11.

36. See, for example, A. Tardieu, "Salon de 1840," *Le Courrier Français*, 10 Mar. 1840, quoted in Johnson, *Crit. Cat.*, 3:92.

37. G. Planche, "Salon de 1840," *Revue des Deux-Mondes*, 1 Apr. 1840, reprinted in *Etudes sur l'Ecole française*, 165–66.

38. Quoted in Philippe Burty, *Corr.*, 1:xxiii.

39. Brochure for the Salon of 1841.

40. R., "Beaux-Arts. Salon de 1841," *Le Constitutionnel*, no. 81, 23 Mar. 1841.

41. Théophile Gautier, *Revue de Paris*, 3rd ser., 28 Apr. 1841, 160.

42. G. Laviron, *Le Salon de 1841* (Paris, [1841]), 46, for the first part of the quote, 48–49, for the second.

43. Charles Baudelaire, "Exposition Universelle. 1855. Beaux-Arts," *Le Pays*, 3 June 1855, reprinted in *Oeuvres complètes*, vol. 2 (Paris, 1976), 592.

44. Stanzas 74 and 75, which are also quoted in the catalogue of the exhibition organized at the Galerie Martinet in 1860.

45. Eugène Pelletan, "Salon de 1841," *La Presse*, 16 Mar. 1841, quoted in Johnson, *Crit. Cat.*, 3:102.

46. Laviron, *Le Salon de 1841*, 45.

47. Baudelaire, *Salon de 1845* (Paris, 1845), reprinted in *Oeuvres complètes*, 353.

48. Letter to Thoré, Mar. 1845, *Corr. gén.*, 2:212–13.

49. This chronology and Planet's collaboration are based on and confirmed by the *Correspondance* and Planet's *Souvenirs de peinture*. Summarized in Johnson, *Crit. Cat.*, 3:307.

50. T. Thoré, "Salon de 1845," *Le Constitutionnel*, 18 Mar. 1845.

51. See Delacroix's letter to Cavé, 30 June 1845, *Corr. gén.*, 2:219, and *Journal*, 5 Mar. 1849, 182. The State did not pur-

chase the painting and send it to the Musée des Beaux-Arts in Lyons until 1858, an acquisition that Delacroix had been urging since the Exposition Universelle of 1855, where the painting had been shown again.

52. Brochure of the Salon of 1845. The painting in fact dates to 1838 (see Johnson, *Crit. Cat.*, 3:82–83).

53. Letter to Thoré, 14 Apr. 1845, *Corr. gén.*, 2:213–14.

54. 1845(?), private collection (Johnson 372).

55. 1847(?), private collection (Johnson 179).

56. Baudelaire, *Salon de 1846*, 427–31.

57. About 1829(?), Wildenstein, New York (Johnson 348).

58. For a summary on the flower paintings of 1848–49, see Johnson, *Crit. Cat.*, 3:261–65 (Johnson 501, 502, and 503; the three paintings exhibited during Delacroix's lifetime) and 3:294–95 (Johnson L 213 and L 214; the last two, location unknown). See also D. Ternois, "Un tableau de fleurs d'Eugène Delacroix: *Le Vase à la console*," *Revue du Louvre*, nos. 4–5 (1965): 233–36.

59. Letter to C. Dutilleux, 6 Feb. 1849, *Corr. gén.*, 2:372–73.

60. Letter to L. Riesener, 9 June 1849, ibid., 2:380–81.

61. Théophile Gautier, "Salon de 1849," *La Presse*, 1 Aug. 1849.

62. T. J. Clark, *The Absolute Bourgeois: Artists and Politics in France, 1848–51* (Princeton, 1973; new ed., 1982), 131. Clark analyzes the flower paintings within the broader context of Delacroix's attitude toward the revolution of Feb.–June 1848; see ibid., 126–41.

63. On all these points, see L. Johnson, "*La Chanson de pirates* de Victor Hugo interprétée par Delacroix," *Revue du Louvre*, no. 4 (1981): 273–75.

64. To borrow Moreau-Nélaton's terms, in *Delacroix raconté par lui-même*, 2 vols. (Paris, 1916), 2:110.

65. On the context of the Exposition Universelle of 1855, see P. Mainardi, *Art and Politics of the Second Empire: The Universal Expositions of 1855 and 1867* (New Haven and London, 1987), especially 39–96.

66. Letter to Frédéric de Mercey, 26 Mar. 1855, *Corr. gén.*, 3:250–51. Delacroix finally succeeded in having his work placed in the small gallery reserved for the French School; letter to same, ibid., 3:251–52.

67. Johnson 87; *Crit. Cat.*, 1:59–60.

68. Johnson L 150; see *Crit. Cat.*, 3:277–78.

69. Brochure of the Exposition Universelle of 1855; Delacroix alluded to no specific source, nor does he mention Byron.

70. On the various stages of the execution of the painting and an overall hypothesis on the modifications that Dela-

croix made to his original composition when he returned to the painting in 1854, see Johnson, *Crit. Cat.*, 3:136–37.

71. *Journal*, 25 Jan. 1847, 121.

72. Pierre Petroz, "Exposition Universelle des Beaux-Arts. III. M. Eugène Delacroix," *La Presse*, 5 June 1855.

73. Maxime Du Camp, "Exposition Universelle. Beaux-Arts," *Revue de Paris*, reprinted in *Les Beaux-Arts à l'Exposition Universelle de 1855* (Paris, 1855), 115–16.

74. Gautier, *Les Beaux-Arts en Europe*, 1:166–67.

75. Letter to C. Dutilleux, 13 Jan. 1857, *Corr. gén.*, 3:363. On Delacroix and the Institute, see L. Hautecoeur, "Delacroix et l'Académie des Beaux-Arts," *Gazette des Beaux-Arts*, Dec. 1963, 349–64.

76. Letter to C. Dutilleux, 2 Apr. 1859, *Corr. gén.*, 4:91.

77. Brochure for the Salon of 1859.

78. L. Jourdain, *Les Peintres français, Salon de 1859* (Paris [1859]), 35, for the first quotation; Théophile Gautier, "Exposition de 1859," *Le Moniteur Universel*, 21 May 1859, for the second. The painting's reception has been analyzed by H. Loyrette, "Delacroix's *Ovid in Exile*," *Burlington Magazine*, Oct. 1995, who also proposed a new interpretation of the painting, "as a subtle reflection on civilization and barbarism," rather than a meditation on "the sorrowful exile of the poet, the solitude of a misunderstood artist in a perpetually foreign land." See the response of L. Johnson, "Delacroix chez les Scythes," *Burlington Magazine*, Jan. 1996, 31, which points out that this aspect was evinced by Delacroix on the subject of *Ovid Among the Scythians* as early as 1835.

79. On the context of the Salon of 1859, see H. Loyrette, "Le Salon de 1859," in *Impressionisme. Les origines, 1859–1869* (Paris, 1994), 3–27.

80. Maxime Du Camp, *Le Salon de 1859* (Paris, 1859), 34.

81. Letter to Paul Huet, May 1859, *Corr. gén.*, 4:100.

82. The limitation of three paintings per artist may have also played a part in his decision. Because of it, Delacroix might have decided against finishing the four paintings of the seasons (commissioned by the banker Hartmann) in time for the exhibition. They could not have appeared as a group at the Salon.

83. Johnson 269; see Johnson, *Crit. Cat.*, 3:269.

84. *Catalogue de la vente de San Donato*, Paris, 21 Feb. 1870, 24.

85. *Journal*, 28 Feb. 1824, 52. On Delacroix as illustrator of *Goetz*, see G. Rouchès, "La suite lithographique de Delacroix pour le *Götz de Berlichingen*," *Pro Medico* 1 (1938): 32–42.

86. Notebook preserved at the Louvre, RF 9150 fol. 25v, see no. 1753 in Sérullaz et al., *Dessins*, 2:354, which L. Johnson

completes with a drawing from the 1820s, a sketch for *Weislingen Captured by Goetz's Men*, on which Delacroix wrote out a passage from the play in French (the drawing was put up for sale in New York in June 1982, reproduced in Johnson, *Crit. Cat.*, 3:135).

87. 1846, location unknown, Johnson 285.

88. Gustave Planche, "Salon de 1846," *Revue des Deux-Mondes*, 15 Apr. 1846, reprinted in *Etudes sur l'Ecole française*, 2:199–200.

89. Brochure for the Salon of 1848. On the painting, see the monograph by Günter Busch, *Eugène Delacroix. Der Tod des Valentin* (Frankfurt, 1973).

90. Planche, "Salon de 1846," 199.

91. *Journal*, 29 Dec. 1860, 794–95. The following quotation is of 31 Dec. 1860, 795.

92. T. Thoré, "Salon de 1848," *Le Constitutionnel*, 17 Mar. 1848, reprinted in *Salons de William Bürger*, vol. 1 (Paris, n.d.).

93. Brochure for the Salon of 1850–51.

94. Summarized in Lee Johnson, "Delacroix and the Bride of Abydos," *Burlington Magazine*, Sept. 1972, 579–85.

95. See Soulier's note following a letter that Delacroix sent him in Dec. 1818, *Corr. gén.*, 1: 37–38; Delacroix's letter to Soulier of Sept. 1820, in which he tells him of *Richard III*, ibid., 1:76–77; and the recollection of a conversation with Achille Ricourt, the founder of *L'Artiste*, in *Journal*, 28 Nov. 1853, 387. We should remember that Delacroix's trip to London had allowed him to see Shakespeare performed in English, notably by Kean.

96. *Journal*, 12 Apr. 1860 [continuation of a passage written in July 1855].

97. *Journal*, 16 Apr. 1856, 577.

98. *Journal*, 27 Dec. 1853, 396.

99. *Journal*, 25 Mar. 1855, 505.

100. See *Journal*, 9 May 1853, 341.

101. *Journal*, 17 Sept. 1846, 880.

102. See Johnson, *Crit. Cat.*, 3:274, with a reproduction of the watercolor. On Delacroix's different versions of this scene, see R. Jullian, "Delacroix et la scène d'*Hamlet au cimetière*," *Bulletin de la Société de l'Histoire de l'Art Français* (1975 [1976]): 245–59. The small version painted by Delacroix in 1844 for E. Boulanger-Cavé, after the canvas of 1839 (Johnson L 148), has just been rediscovered in a private collection and exhibited at the Musée des Beaux-Arts in Rouen (*Delacroix. La naissance d'un nouveau romantisme*, no. 62, p. 52, repr. p. 53).

103. The first version (Johnson 264) is in the collection of the Neue Pinakothek in Munich, the second (Johnson 282), in the Oskar Reinhart Collection at Winterthur, the third (Johnson 313), in the Louvre.

104. When they were finished, in Feb.–Mar. 1849 and Jan. 1850, Delacroix sold the three paintings—Johnson 293

(Metropolitan Museum of Art, New York), Johnson 294 (location unknown), and Johnson 298 (Musée du Louvre, Paris; it repeats the lithograph, but reversed)—to two dealers, Bouquet and Beugniet.

105. Johnson 319, location unknown, reproduced in Johnson, *Crit. Cat.*, 4:118. There is a copy in the Musée Saint-Denis in Reims, reproduced ibid., 3:139.

106. The lithographic stones have been kept intact and are today in the Musée National Eugène Delacroix. See also R. I. Edenbaum, "Delacroix's *Hamlet* Studies," *Art Journal* 26 (1966): 340–51, and 27 (1967): 373; Yves Bonnefoy and Arlette Sérullaz, *Delacroix et Hamlet* (Paris, 1993).

107. For a list of subjects that Delacroix had considered taking from *Romeo and Juliet*, see the *Journal*, 29 Dec. 1860, 793–94.

108. Charles Perrier, "Exposition Universelle des beaux-arts," *L'Artiste*, 10 June 1855, 72.

109. L. Johnson called attention to this very probable source; see *Crit. Cat.*, 3:117–18.

110. Letter to Alexandre Dumas, 4 Apr. 1830, *Corr. gén.*, 1:253–54.

111. See Delacroix's letter to George Sand, 7 Dec. 1852, ibid., 3:130–31. The first version of *Lelia* (Johnson 289) is on loan to the Stanford Art Museum; the location of the second (Johnson 310) is unknown.

112. Johnson 337, in the Ordupgaard Museum.

113. The first dates to 1851–53 (Johnson 306) and is in the collection of the Baltimore Museum of Art; the second, of 1853 (Johnson 314), is in the Stuttgart Staatsgalerie; the third has disappeared (Johnson L 153) but was executed before 1854. There is also the *Andromeda* of 1852 (Johnson 307), in the Museum of Fine Arts, Houston.

114. Canto 20, stanza 15. On Delacroix and Ariosto, see E. Lambert, "Une scène du *Roland furieux* traitée par Delacroix," *Bulletin de la Société de l'Histoire de l'Art Français* 1936 (1937): 146–52.

115. See the *Journal*, 13 May 1851, 278.

116. *Clorinda Rescues Olinda and Sophronia*, Neue Pinakothek, Munich (Johnson 321); *Ruggerio Rescues Angelica* (often confused with *Saint George Slaying the Dragon* or *Perseus and Andromeda*), Musée des Beaux-Arts, Grenoble (Johnson 324). The subject of *Erminia and the Shepherds* is drawn from *Jerusalem Delivered*, canto 7, stanzas 7–8. On one of these "classical" subjects treated by Delacroix, see L. Johnson, "Erminia and the Wounded Tancred," *Apollo* (Dec. 1992): 379–83.

117. Brochure for the Salon of 1859, which also gives the reference for the poem.

118. On this point, I refer the reader to the analyses of Foucart, *Le Renouveau de la peinture religieuse en France*.

119. Summarized in *Delacroix: peintures et dessins d'inspiration religieuse*, exh. cat. (Nice, 1986), especially in the chapter by Maurice Sérullaz, "Delacroix et la peinture religieuse," 11–31. See also François Fosca, "Delacroix et l'art religieux," *La Vie et les Arts Liturgiques* (July 1920): 359–66; and especially R. P. Régamey, *Eugène Delacroix. Epoque de la chapelle des Saints-Anges (1847–63)* (Paris, [1931]). Thematic examples are treated in Camille Bernard, "Saint Jérôme dans l'oeuvre de Delacroix," *Les Amis de Saint François*, nos. 4–5 (1966): 176–80; J. Cooper, "Delacroix's *Christ on the Lake of Genesareth* in the Metropolitan Museum of Art," *Vassar Journal* 21 (1968): 48–55 (see especially, concerning this group, Johnson, *Crit. Cat.*, 3:232–38); and L. Johnson, "Delacroix's *Christ at the Column*," *Burlington Magazine*, Nov. 1979, 681–85.

120. *Journal*, 12 Oct. 1862, 804–5.

121. See his letter to the parish priest, 5 Apr. 1855, *Corr. gén.*, 5: 194–95, and Dumas, *Delacroix*, 70–74. The painting had to be restored again following World War I.

122. See J.-L. Debauve, "Heurs et malheurs d'un tableau d'Eugène Delacroix et son entrée au musée de Vannes," *Bulletin de la Société Polymathique du Morbihan* (1965): 109–18.

123. Letter to Minister of State, 1860, *Corr. gén.*, 4:222–23. His request was turned down, and not until 1865, upon Rivet's pressing petition, was the painting finally restored in Paris by Haro and copied by Andrieu. It was returned to Vannes, where it was hung in the mayor's office before finally going to the Musée Municipal in 1908.

124. Most of the criticism was published in *Autour de Delacroix. La peinture religieuse en Bretagne au XIXᵉ siècle* (Vannes, 1993), 90–93; (review by Philippe Bonnet).

125. "Salon de 1835," *L'Artiste* 9, no. 8 (1835): 89–90. (the anonymous article may be by Jules Janin).

126. Alexandres Descamps, "Salon de 1835," *Revue Républicaine* 5, no. 13 (10 Apr. 1835): 70–71.

127. Johnson 427, Louvre, Paris. The observations on the frame and case are given in the sales catalogue in which the painting appeared in 1890, before it was purchased by Thomy-Thiéry and given by him to the Louvre.

128. In the Louvre, RF 9457; no. 1352 in Sérullaz et al., *Dessins*, 2:53, reproduced in 1:10. The work is traditionally dated 1850. Delacroix would have done it from memory after his trip through Antwerp, in August. I prefer to follow Johnson's hypothesis, which seems to me to account better for Delacroix's relationship to Rubens in the process of working out his painting. See Johnson, *Crit. Cat.*, 3:220–21.

129. This representation occurs in the panting in the Kunsthalle Bremen, painted around 1853–56 (Johnson 462); the other versions are of 1853 (Johnson 457, location unknown, and Johnson 460, National Gallery, London). Marie Magdalen is depicted drying Christ's feet in Johnson 457 and 462.

130. Johnson 450 for the first version (1847[?]–53, private collection, Great Britain) and Johnson 467 for the second (1858, Los Angeles County Museum of Art). There is an intermediary version, which appears to be just a replica of the first (Johnson 465, c. 1854–55, location unknown).

131. One example, among others, *The Good Samaritan* (1849–51, private collection, Johnson 437; 1852, Victoria and Albert Museum, London, Johnson 446); *The Agony in the Garden* (1847, no. 34 in Johnson, *Pastels*, 128–29; 1849[?], location unknown, Johnson 438; 1851, Rijksmuseum, Amsterdam, Johnson 445); *Christ at the Column* (1853–56, Kunsthalle Bremen, Johnson 462; 1852, Musée des Beaux-Arts, Dijon, Johnson 447—on this painting, see Johnson, "Delacroix's *Christ at the Column*").

132. Letter to Pierret, 7 June 1842, *Corr. gén.*, 2:106–7; see also his letter to Villot of 14 July 1842, ibid., 2:110–11.

133. This anecdote is told by Robaut et al., *Oeuvre complète*, 201; George Sand recounted that her maid and her goddaughter posed for the painting while she read novels to the painter and while Maurice copied accordingly in order to study his methods (letter to Edouard Rodrigues, 25 Feb. 1866, cited in Sérullaz, ed., *Mémorial*, 234).

134. *Journal*, 12 Oct. 1853, 365. See above J. Lethève, "George Sand et la *Sainte Anne* de Delacroix," *Bulletin de la Bibliothèque Nationale*, no. 2 (1977): 39–43.

135. See also *Journal*, 12 Oct. 1853, 366–67.

136. See Lee Johnson's discussion of the different versions in *Crit. Cat.*, 3:232–38.

137. Gautier's review appeared on the occasion of the 1860 benefit exhibition for the Artist's Relief Fund, in which appeared the version that is today in the Fondation Bürle in Zurich (1853, Johnson 455), and which he compared to the *Raft of the "Medusa"* (quoted in Johnson, *Crit. Cat.*, 3:237).

138. See especially H. Delaborde, "Salon de 1853," *Revue des Deux-Mondes*, 15 June 1853, 1137, reprinted in *Mélanges sur l'art contemporain* (Paris, 1866), 72–74.

139. 1859, destroyed in World War II Johnson 333; 1862, Musée du Louvre, Paris, Johnson 343; 1862, formerly Collection Noailles, Paris, Johnson 344.

140. 1856, Norton Simon Foundation, Pasadena, Johnson 401; 1862, Fondation Bührle, Zurich, Johnson 417.

141. See the letters from Delacroix to Haro and Emile Péreire, 13 Mar. 1862, *Corr. gén.*, 4:306–7.

142. The painting is today in the Philadelphia Museum of Art, McIlhenny Collection (1846, Johnson 286).

143. 1862, formerly Collection Noailles, Paris, Johnson 416.

144. 1862, private collection, Bern, Johnson 345.

145. This painting could be considered a variant of *The Shipwreck of Don Juan* (1840–47[?], Pushkin Museum, Moscow, Johnson 277).

146. 1848, private collection, Johnson 292.

147. 1857, Art Gallery of Ontario, Toronto, Johnson 403.

148. *Journal*, 15 Oct. 1854, 485, and 22 Oct. 1854, 486. See also A. Scharf and A. Jammes, "Le Réalisme de la photographie et la réaction des peintres," *Art de France* 4 (1964): 183; and A. Scharf, *Art and Photography* (London, 1968), 94.

149. Sketch later cut into pieces, around 1862, Toledo Museum of Art, Johnson 346, and private collection, Johnson (M)6. For more information on Delacroix's work after 1850 and especially on the reinterpretation of subjects from the antique, see the catalogue for the exhibition *Delacroix. Les dernières années*. The majority of the artist's important works (except the large decorative works) from this period are studied here. See also the introductory essay by Lee Johnson, "Les dernières oeuvres: continuités et variations," ibid., 26–33.

150. On these paintings, begun in 1856 and left unfinished at Delacroix's death, see Johnson, *Crit. Cat.*, 3:62–67. There is another instance of a work that Delacroix left unfinished; see L. Johnson, "Delacroix's *Christ Healing the Blind Man of Jericho*: Poussin Reviewed," *Burlington Magazine*, Sept. 1986, 672–74.

151. Letter from Jenny Le Guillou to Mme Rang-Babut, 20 Aug. 1863, *Corr. gén.*, 4:382. Mme Haro's letter was published by André Joubin, "M. Haro entre Ingres et Delacroix. Documents inédits," *L'Amour de l'Art*, no. 3 (Mar. 1936): 89–90.

1. The transcription is in Maurice Sérullaz, *Delacroix* (Paris, 1989), 453–58. The post-obit inventory was published by H. Bessis, "L'inventaire après décès d'Eugène Delacroix," *Bulletin de la Société de l'Histoire de l'Art Français* 1969 (1971): 199–222.

2. Philippe Burty, *Catalogue de la vente qui aura lieu par suite du décès de Eugène Delacroix . . .* (Paris, 1864), xiv–xv. The auction took place from 16 to 19 February, and began with three days of public exhibition. For the prices of the paintings, sketches, and watercolors, as well as the total sales, see A. Moreau, *E. Delacroix et son oeuvre* (Paris, 1873), 301–26. The prices of the drawings are recorded in a copy in the Bibliothèque Nationale de France, Département des Estampes (Yb³ 945a.8º). On Philippe Burty and Delacroix, see H. Bessis, "Philippe Burty et Eugène Delacroix," *Gazette des Beaux-Arts*, Oct. 1968, 195–202.

3. T. Silvestre, *Eugène Delacroix. Documents nouveaux* (Paris, 1864), 3–4 for the first passage, 10 for the second. Silvestre gives a very lively report of the auction, in the form of brief notes probably written on the spot, and in any case amply confirmed by the accounts in the press. See also Thoré's letter to Louis Viardot, published by Bruno Chenique in the exhibition catalogue for *Géricault* (Paris, 1991), 323.

4. See T. Silvestre, *Eugène Delacroix. Documents nouveaux*, 11. Andrieu, who was involved in organizing the drawings, apparently filched some of the original boxes (selling them later on his own account), replacing them with works by students that he passed off as Delacroix's. It is also known that he counterfeited a stamp like the one used for the auction, and used it to sell his own drawings (see chap. 6). The sale brought in a little more than 360,000 francs (see Moreau, *E. Delacroix et son oeuvre*, 305–6). Burty himself analyzed the sales, "Vente Eugène Delacroix. Peintures," *La Chronique des Arts et de la Curiosité*, no. 54 (28 Feb. 1864): 66–67.

5. Henri de la Madelène, *Eugène Delacroix à l'Exposition du boulevard des Italiens* (Paris, 1864), 8 (this study originally appeared in *Revue de Paris*, 1 Sept. 1864).

6. Piron, *Delacroix. Sa vie et ses oeuvres*, 101.

7. Ibid., 43.

8. Théophile Gautier, "Exposition du boulevard des Italiens," *Le Moniteur Universel*, 17 Nov. 1864. A second article, published ibid., 18 Nov., was reprinted in *Histoire du romantisme* (Paris, 1874), 200–17. The second passage quoted is taken from ibid., 200–201.

9. *Exposition des oeuvres de Eugène Delacroix* [at 26, boulevard des Italiens] (Paris, 1864).

10. Henri de la Madelène, *Delacroix à l'Exposition*, 11–12.

11. D'Arpentigny, preface to the *Exposition des oeuvres*, 10.

12. *Lettres de Eugène Delacroix (1815–1863) recueillies et publiées par M. Philippe Burty*, 2 vols. (Paris: 1878, vol. 1; 1880, vol. 2).

13. On the complicated problem of the publication of the *Journal*, the reader is referred to André Joubin's introduction, *Journal*, 1:3–16, and to Delacroix's own writings. The surviving manuscripts are today in the Bibliothèque d'Art et Archéologie, Fondation Jacques Doucet. The others, now lost, are known only from Robaut's copies, which are far from exhaustive. M. Hannoosh is currently preparing a new critical edition of the *Journal*, which should constitute a notable improvement over the Joubin edition, but will inevitably remain incomplete in relation to the original.

14. Paul Flat and René Piot, eds. [*Journal*], 3 vols. (Paris 1893). Note that Maurice Tourneux, in the seminal work that appeared in 1886, only indexed the editions of the correspondence and does not mention the journal, which was really only made public thirty years after Delacroix's death.

15. *Exposition Eugène Delacroix au profit de la souscription destinée à élever à Paris un monument à sa mémoire*, at the Ecole nationale des Beaux-Arts, Quai Malaquais, Paris, 1885 (6 Mar.–15 Apr.).

16. On this subject, see Louis-Antoine Prat, "Alfred Robaut, une âme d'apôtre?" *Bulletin de la Société de l'Histoire de l'Art Français* 1977 (1979), 265–70.

17. Readers might refer to the catalogue for *Delacroix et le romantisme français*, the exhibition organized in 1989 by Jacques Thuillier, at the National Museum of Western Art in Tokyo and The City Museum of Fine Art in Nagoya; and to the catalogue [edited by Isabelle Julia and Jean Lacambre] for *Les Années romantiques. La peinture française de 1815 à 1850*, an exhibition held in 1995–96 at the Musée des Beaux-Arts in Nantes, the Grand-Palais in Paris, and the Palazzo Gotico in Piacenza. Both catalogues provide useful points of reference. See also *Delacroix. La naissance d'un nouveau romantisme*.

18. See the catalogue for the exhibition, including the preface by Paul Jamot, whose first sentence I quoted at the beginning of my introduction; and the collective work, *Le Romantisme et l'art* (Paris, 1928), which gathers a series of lectures sponsored by the administration of the Musées de France and the Ecole du Louvre, in commemoration of the centennial of the artistic events of 1827, especially Paul Jamot, "Delacroix," 93–134; André Joubin, "Les manuscrits d'Eugène Delacroix," 135–60; G. Rouchès, "Les peintres romantiques et la peinture étrangère," 205–28; Léon Rosenthal, "La gravure romantique," 229–49; and René Lanson, "L'Orient romantique," 250–74. Readers might also consult the catalogue for *Le Romantisme*, the exhibition held in 1930 at the Bibliothèque Nationale. All works on Romanticism discuss Delacroix. To choose only one, I refer the reader to W. Vaughan's short, specific, and synoptic, but very useful, essay, "The Visual Arts," in D. G. Charlton, ed., *The French Romantics*, vol. 2 (Cambridge, 1984), 308–52, with bibliographical references (this two-volume work, in fact, provides one of the best current introductions to the various aspects of French Romanticism).

19. See Sérullaz, ed., *Mémorial*, xix–xx.

20. Baudelaire, "L'Oeuvre et la vie d'Eugène Delacroix," 743–45.

❧ *Selected Bibliography* ❧

The Delacroix bibliography is considerable. The following list includes the most important editions of Delacroix's writings, catalogues of his works, monographic books and articles, and exhibition catalogues. Additional bibliographic information on specific topics may be found in the notes.

Delacroix's Writings

Delacroix, Eugène. *Correspondance générale de Eugène Delacroix*. Ed. André Joubin. 5 vols. Paris, 1936–38.

———. *Dictionnaire des Beaux-Arts*. Ed. Anne Larue. Paris, 1996.

———. *Eugène Delacroix: Further Correspondence, 1817–1863*. Ed. Lee Johnson. Oxford, 1991.

———. *Journal, 1822–1863*. Ed. André Joubin. 3 vols. Paris, 1931–32. Revised ed. by Régis Labourdette, Paris, 1980. Reprint, Paris, 1996.

———. *Lettres intimes*. Ed. Alfred Dupont. Paris, 1954. Reprint, Paris, 1995.

———. *Mon voyage au Maroc*. Ed. Laure Beaumont-Maillet. Paris, 1998.

———. *Oeuvres littéraires, I. Etudes esthétiques, II. Essais sur les artistes célèbres*. Ed. Elie Faure. Paris, 1923.

Deyrolle, François-Marie, and Christophe Denissel. *Eugène Delacroix. Ecrits sur l'art*. Paris, 1988.

Piron, Achille. *Eugène Delacroix. Sa vie et ses oeuvres*. Paris, 1865.

Catalogues of Delacroix's Works

Delteil, Loÿs. *Le Peintre-graveur illustré, III. Ingres-Delacroix*. Paris, 1908. Revised and translated by Susan Strauber as *Eugène Delacroix. The Graphic Work: A Catalogue Raisonné*. San Francisco, 1997.

Georgel, Pierre, and Luigina Rossi Bortolatto. *Tout l'oeuvre peint de Delacroix*. Paris, 1975. Revised ed. by Henriette Bessis. Paris, 1984.

Johnson, Lee. *The Paintings of Eugène Delacroix: A Critical Catalogue*. 6 vols. Oxford, 1981–89. *1816–1831:* Vol. 1, *Text;* Vol. 2, *Plates.* Oxford, 1981. *1832–1863:* Vol. 3, *Text;* Vol. 4, *Plates.* Oxford, 1986 (revised ed., 1993). *The Public Decorations and Their Sketches:* Vol. 5, *Text;* Vol. 6, *Plates.* Oxford, 1989.

———. *Delacroix Pastels*. New York, 1995.

Moreau, Adolphe. *E. Delacroix et son oeuvre*. Paris, 1873.

Robaut, Alfred, Ernest Chesneau, and Fernand Calmettes. *L'Oeuvre complet de Eugène Delacroix. Peintures, dessins, gravures, lithographies*. Paris, 1885. Robaut's annotated copy, now in the Département des Estampes de la Bibliothèque Nationale de France, was published in New York, 1969.

Sérullaz, Maurice, et al. *Musée du Louvre. Cabinet des dessins. Inventaire général des dessins. Ecole française. Dessins d'Eugène Delacroix*. 2 vols. Paris, 1984.

Monographic Books and Articles

Athanassoglou-Kallmyer, Nina. *Eugène Delacroix. Prints, Politics and Satire 1814–1822*. New Haven and London, 1991.

Badt, Kurt. *Eugène Delacroix. Werk und Ideale*. Cologne, 1965.

Bergerol, Ivan, and Arlette Sérullaz. *Eugène Delacroix, aquarelles et lavis*. Paris, 1998.

Busch, Günther. *Eugène Delacroix. Der Tod des Valentin*. Frankfurt, 1973.

Cassou, Jean. *Delacroix*. Paris, 1947.

Chastel, André. "L'année Delacroix." *Art de France* 4 (1964): 332–33.

Courthion, Pierre. *Delacroix*. Geneva, 1943.

Daguerre de Hureaux, Alain. *Delacroix*. Paris, 1992.

Daix, Pierre. *Delacroix le libérateur*. Paris, 1963.

Derr, Bernard-Louis. *The Landscapes of Eugène Delacroix*. Ann Arbor, 1982.

Deslandres, Yvonne. *Delacroix*. Paris, 1963.

Diehl, Gaston. *Delacroix*. Paris, 1967.

Dumur, Guy. *Delacroix romantique français*. Paris, 1973.

Escholier, Raymond. *Delacroix peintre, graveur, écrivain*. 3 vols. Paris, 1926–29.

Finlay, Nancy Ann. "Animal Themes in the Paintings of Eugène Delacroix." Ph.D. diss., Univ. of Michigan, 1984.

Fischer, Uwe. *Das literarische Bild im Werk Eugène Delacroix*. Bonn, 1963.

Florenne, Yves. *Delacroix*. Paris, 1963.

Florisoone, Michel. *Delacroix*. Paris, 1938.

Fosca, François. *Delacroix*. Bern, 1947.

Gauthier, Maximilien. *Delacroix*. Paris, 1963.

Gillot, Hubert. *E. Delacroix. L'homme, ses idées, son oeuvre*. Paris, 1928.

Graber, Hans. *Delacroix*. Basel, 1919.

———. *Der junge Delacroix*. Basel, 1938.

Guégan, Stéphane. *Delacroix. L'Enfer et l'atelier*. Paris, 1998.

Guillerm, Jean-Pierre. *Couleurs du noir. Le Journal de Delacroix*. Lille, 1990.

Gysin, Fritz. *Eugène Delacroix. Studien zu seiner Künstlerischen Entwicklung*. Strasbourg, 1929.

Hannoosh, Michele. *Painting and the "Journal" of Eugène Delacroix*. Princeton, 1995.

Hourticq, Louis. *Delacroix. L'Oeuvre du maître*. Paris, 1930.

Huyghe, René. *Delacroix, ou, Le Combat solitaire*. Paris, 1964.

Huyghe, René, et al. *Delacroix*. Paris, 1963.

Johnson, Lee. *Delacroix*. London, 1963.

———. "The Delacroix Centenary in France." *Burlington Magazine*, July 1963, 297–305; June 1964, 259–67.

———. "Recent Delacroix Literature." *Burlington Magazine*, Feb. 1968, 102–5.

Lambert, Elie. *Delacroix et les Femmes d'Alger*. Paris, 1937.

———. *Histoire d'un tableau, l'Abd-er-Rahman, Sultan du Maroc, de Delacroix*. Paris, 1963.

Lichtenstein, Sara. *Delacroix and Raphaël*. New York, 1979.

Maltese, Corrado. *Delacroix*. Milan, 1965.

Marchiori, Giuseppe. *Delacroix*. Florence, 1969.

Mauclair, Camille. *Eugène Delacroix*. Paris, [1909].

Meier-Grafe, Julius. *Eugène Delacroix. Beiträge zu einer Analyse*. Munich, 1913.

Moreau-Nélaton, Etienne. *Delacroix raconté par lui-même*. 2 vols. Paris, 1916.

Mras, George P. *Eugène Delacroix's Theory of Art*. Princeton, 1966.

Piot, René. *Les Palettes de Delacroix*. Paris, 1931.

Pomarède, Vincent. *Eugène Delacroix, "La Mort de Sardanapale."* Paris, 1998.

Prideaux, Tom. *The World of Delacroix, 1798–1863*. New York, 1966.

Régamey, Raymond. *Eugène Delacroix. L'Epoque de la Chapelle des Saints-Anges (1847–1863)*. Paris, [1931].

Roger-Marx, Claude. *L'Univers de Delacroix*. Paris, 1970.

Rubin, James Henry. *Eugène Delacroix. Die Dantebarke. Idealismus und Modernität*. Frankfurt, 1987.

Sagne, Jean. *Delacroix et la photographie*. Paris, 1982.

Schawelka, Karl. *Eugène Delacroix. Sieben Studien zu seiner Kunsttheorie*. Mittenwald, 1979.

Sérullaz, Arlette. *Delacroix*. Collection "Le Cabinet des Dessins." Paris, 1998.

Sérullaz, Arlette, and Annick Doutriaux. *Delacroix, "Une fête pour l'oeil."* Paris, 1998.

Sérullaz, Maurice. *Les Peintures murales d'Eugène Delacroix*. Paris, 1963.

———. *Eugène Delacroix*. New York, 1969.

———. *Delacroix*. Paris, 1989.

Sjöberg, Yves. *Pour comprendre Delacroix*. Paris, 1963.

Spector, Jack J. *The Murals of Delacroix at Saint-Sulpice*. New York, 1967.

———. *Delacroix. The Death of Sardanapalus*. London, 1974.

Tourneux, Maurice. *Eugène Delacroix devant ses contemporains. Ses écrits, ses biographes, ses critiques*. Paris, 1886.

———. *Eugène Delacroix, biographie critique*. Paris, 1902.

Trapp, Frank Anderson. *The Attainment of Delacroix*. Baltimore, 1971.

Vallon, Fernand. *Au Louvre avec Delacroix*. Grenoble, 1930.

Wildenstein, Daniel. "L'année Delacroix." *Gazette des Beaux-Arts*, Sept. 1963, supplement, 1–3.

Exhibition Catalogues

Centenaire du romantisme. Exposition E. Delacroix. Musée du Louvre, Paris. 1930.

Delacroix. Art Gallery of Ontario, Toronto, and The National Gallery of Canada, Ottawa. 1962–63.

Eugène Delacroix, 1798–1963. Musée du Louvre, Paris. 1963. Two catalogues were published for this exhibition: the gallery guide, and the more substantial *Mémorial de l'exposition organisée à l'occasion du centenaire de l'artiste*, ed. Maurice Sérullaz.

Delacroix. Dessins. Musée du Louvre, Paris. 1963.

Delacroix, ses maîtres, ses amis, ses élèves. Musée des Beaux-Arts, Bordeaux. 1963.

Delacroix et la gravure romantique. Bibliothèque Nationale de France, Paris. 1963.

Delacroix. Royal Scottish Academy, Edinburgh, and Royal Academy, London. 1963–64.

Eugène Delacroix (1798–1863). Kunsthalle Bremen. 1964.

La Liberté guidant le peuple de Delacroix. Musée du Louvre, Paris. 1982.

Ingres et Delacroix. Aquarelles et dessins. Kunsthalle, Tübingen, and Palais des Beaux-Arts, Brussels. 1986.

Delacroix. Peintures et dessins d'inspiration religieuse. Musée National Message Biblique Marc Chagall, Nice. 1986.

Eugène Delacroix. Kunsthaus Zurich and Städelsches Kunstinstitut, Frankfurt. 1987–88.

Eugène Delacroix. Themen und Variationen. Arbeiten auf Papier. Städelsches Kunstinstitut, Frankfurt. 1987–88.

Eugène Delacroix (1798–1863). Paintings, Drawings and Prints from the North American Collections. The Metropolitan Museum of Art, New York. 1991.

Eugène Delacroix à l'Assemblée Nationale, peintures murales, esquisses, dessins. Assemblée Nationale, Paris. 1995.

Delacroix. Le voyage au Maroc. Institut du Monde Arabe, Paris. 1995.

Delacroix. La naissance d'un nouveau romantisme. Musée des Beaux-Arts, Rouen. 1998.

Delacroix. Le trait romantique. Bibliothèque Nationale de France, Paris. 1998.

Delacroix. Les dernières années. Galeries Nationales du Grand Palais, Paris, and Philadelphia Museum of Art. 1998–99. An English edition of this catalogue is forthcoming.

❧ *Acknowledgments* ❧

The inspiration for this book goes back to Jean-Loup Champion: I thank him for his patience, which I put to the test. My gratitude goes equally to his whole group: Laurence Peydro, who followed the work step by step; Giovanna Citi-Hebey and Gwenaëlle Bégat; Caterina d'Agostino, who assembled the illustrations; Jacques Maillot and Anne Lagarrigue, who did the layout; Claire Marchandise, who made the index; and Christian Delval. I owe a particular debt to Isabelle Loric, who supervised production, and Patrizia Tardito, who was responsible for the plates: they have gone well beyond what one has a right to expect in working out with me in situ comparisons between the photographic documents available to us and the works of Delacroix in various French (especially Parisian) collections, notably at the Louvre, the Palais-Bourbon, the Palais du Luxembourg, and Saint-Sulpice.

Princeton University Press has done a remarkable job in very little time, which has allowed access to an English-language edition only one year after the original publication in French. I thank the entire team responsible for this project, in particular Patricia Fidler and Curtis Scott, who handled the production with great enthusiasm, as well as the translators, Alexandra Bonfante-Warren and Terry Harris Grabar. I must add that even though the general bibliography and notes include the most important articles and works that have appeared since the French publication, the original text has not been modified. The numerous bicentennial exhibitions have afforded scholars the chance to fine-tune certain points, but have not fundamentally changed the general thinking previously held on the artist and his career.

My reflections have been enriched by numerous meetings, conversations, and discussions. I cannot cite all those who have been helpful to me in differing degrees at one time or another, but I wish to thank particularly Jacques Thuillier and Bruno Foucart, as well as Laure Beaumont-Maillet, Christine Flon-Granveaud, Marianne Grivel, Alain Mérot, and Christine Peltre. François Monfrin was good enough to take time from his work on paleochristian art and with kindness and competence read the entire manuscript. The courses and lectures that I have given at the University of Paris-Sorbonne, Paris-IV, have also allowed me to clarify my ideas. I thank my students and assistants for their observations, from which I have often profited.

One does not go into an enterprise of this kind, which stretched over several years, without the support of family and close friends. They have not failed me. I dedicate this book to my parents, with special remembrance of my grandmother, who died just before the book appeared, and who always encouraged me by her manner and by her example. I also thank Pauline, who knew how to bring me down to earth when I needed it, and also numerous rugby players, students at the Ecole Normale Supérieure, and others, who from now on will know how to recognize the house of Delacroix's birth at Charenton-Saint-Maurice, on the road to the Pershing Stadium and the Polygon of Vincennes.

❧ Index of Proper Names ❧

❧ *Index of Works* ❧

Illustrated works are referenced by figure number. Paintings are further cross-referenced to their corresponding number in the catalogue raisonné by Lee Johnson, prints to that of Loÿs Delteil, and drawings to the inventory number of their collection. Works in the *Faust* and *Hamlet* series are grouped under those general headings.

Abduction of Rebecca, The (fig. 232; Johnson 284), 257, 274, 275

Abduction of Rebecca, The (fig. 231; Johnson 326), 268, 274, 276

Adam and Eve (fig. 164; Johnson 556), 194, 200

African Pirates Abducting a Young Woman (fig. 217; Johnson 308), 260, 263, 284

Agony in the Garden, The (fig. 47; Johnson 154), 66, 70, 83–84, 85, 238, 242, 263, 287, 288, 316n. 5, 326n. 131

Agriculture ceiling (fig. 153; Johnson 508), 184–85, 188

Agriculture frieze (fig. 154; Johnson 516), 184–85, 188

Alexander and Homer's Poems (fig. 165; Johnson 558), 195, 196

Alexander Preserves Homer's Poems (fig. 175; Johnson 570), 198, 208, 209–11

Alfred Bruyas (fig. 33; Johnson 239), 59, 60, 98

Amin Bias, Minister of Finance to the Sultan of Morocco, (fig. 110; RF 4612), 149

Anacreon and a Girl (Johnson 241), 181

Apollo Slays Python (fig. 178; Johnson 578), 10, 214–18, 233, 236; final sketch (fig. 177; Johnson 576), 214, 216

Arab Cavalry Practicing a Charge (fig. 139; Johnson 351), 169

Arab Horseman Practicing a Charge, watercolor, 147, 148, 257

Arab Horseman Practicing a Charge, 1832 version (fig. 109; Johnson 349), 147, 148

Arab Horsemen Resting Near Tangier (fig. 112; inv. 1951-35), 149

Arab Horses Fighting in a Stable (fig. 135; Johnson 413), 167, 168

Arab Players (fig. 132; Johnson 380), 165, 258

Arab Saddling His Horse (fig. 140; Johnson 398), 170, 171

Arab Soldier by a Grave (fig. 138; Johnson 362), 169, 171, 324n. 29

Arab Woman Seated on Cushions (fig. 114; RF 4185c), 150, 152

Arabs at a Market, 150

Arabs Playing Chess (fig. 137; Johnson 379), 168, 171

Arabs of Oran (fig. 143; Delteil 20), 172, 174, 175

Arabs of Oran (Johnson 357), 236, 324n. 3

Arabs Skirmishing in the Mountains (fig. 133; Johnson 419), 166, 168, 171

Archimedes Killed by the Soldier (fig. 161; Johnson 545), 192, 194, 270

Archimedes Killed by a Roman Soldier (Johnson 287), 270

Ariadne Abandoned (Johnson 301 and L 149), 284

Aristotle Describes the Animals Sent by

Alexander (fig. 161; Johnson 543), 192, 194

Arrival at Meknès (fig. 107; RF 1712bis fols. 17v–18r), 145, 146

Assemblée Nationale. *See* Palais-Bourbon

Attila and His Hordes Overrun Italy and the Arts (fig. 166; Johnson 541), 196–97, 198, 199

Babylonian Captivity, The (fig. 164; Johnson 557), 194

Bacchus with a Tiger (Johnson 243), 182

Banks of the River Sebou, The (fig. 134), 56, 166, 168, 268

Barque of Dante, The (fig. 39; Johnson 100), 6, 9, 20, 25, 62, 66, 67, 68–70, 71, 75, 78, 92, 128, 136, 174, 217, 238, 242, 246, 262, 263

Basket of Flowers Overturned in a Park, A (fig. 215; Johnson 502), 259, 261

Basket of Fruit in a Flower Garden, A (fig. 214; Johnson 501), 259, 261

Battle of Poitiers, The (fig. 92; Johnson 141), 88, 120, 121, 124, 126–27, 136, 242, 245, 252, 263; sketch (fig. 91; Johnson 140), 124, 127

Battle of Nancy, Death of Charles the Bold, Duke of Burgundy, The (fig. 94; Johnson 143), 9, 88, 120, 121, 123, 125, 126, 127, 136, 236, 242, 245, 252, 306; sketch (fig. 93; Johnson 142), 123

Battle of Taillebourg, The (fig. 198; Johnson 260), 120, 126, 178, 238, 242–45, 246, 251, 252, 254; sketch (fig. 197; Johnson 255), 242

Battlefield, Evening, A (Johnson 104), 70, 120

Blacksmith, The (fig. 35; Delteil 19), 61

Boissy d'Anglas at the National Convention (fig. 99; Johnson 147), 10, 116, 118, 120, 133–34, 136, 137, 179, 263

Bouquet of Flowers (fig. 18), 41, 42

Bride of Abydos, The (Johnson 297, 300, 311), 276

Bride of Abydos, The (fig. 234; Johnson 325), 276, 277

Bride of Lamermoor, The (Delteil 83), 274

Brother Martin Clasping Goetz's Iron Hand (fig. 229; Delteil 119), 272–73

Bruyas. *See Alfred Bruyas*

Camp at the Town of Aliassar-el-Kebir, 149

Capulet Ball, The (Johnson 117), 104

Cardinal Richelieu Saying Mass in the Chapel of the Palais-Royal (Johnson 131), 8, 27, 88, 120, 121, 123, 133

Cardinal Richelieu Saying Mass in the Chapel of the Palais-Royal, lithograph (fig. 89), 121, 122

Cardinal Richelieu Saying Mass in the Chapel of the Palais-Royal, variant (fig. 90; Johnson 132), 121, 122

Castaways in a Ship's Boat (fig. 206; Johnson 277), 254, 258, 294, 295

Chaldean Shepherds: Inventors of Astronomy, The (fig. 162; Johnson 547), 193, 194

Charles V at the Monastery of Yuste, lost original (Johnson 149), 102

Charles V at the Monastery of Yuste (fig. 62; Delteil 92), 101, 102

Charles V at the Monastery of Yuste, small version (fig. 63), 101, 102, 236

Charles VI and Odette de Champdivers (fig. 60; Johnson 110), 100, 102

Charles VII and Agnès Sorel (Johnson L 102), 102

Christ on the Cross (fig. 249; Johnson 433), 257, 264, 288, 290, 292, 293

Christ on the Cross (Johnson 427), 292

Christ on the Cross (fig. 196; Johnson 421), 236, 238, 239, 240, 241, 246, 254, 287, 290, 292, 293

Christ on the Sea of Galilee (fig. 260; Johnson 451), 294, 295

Christ on the Sea of Galilee (fig. 261; Johnson 452), 294, 295

Christopher Columbus at the Monastery of La Rabida (fig. 225; Johnson 265), 270–71

Cicero Accuses Verres (fig. 163; Johnson 552), 193, 194

Clash of Arab Horsemen (Johnson 355), 168, 324n. 2

Clash of Moorish Horsemen (fig. 144; Delteil 23), 172, 174, 175

Cleopatra and the Peasant (fig. 201; Johnson 262), 248, 250, 254, 295

Cleopatra and the Peasant, 1848 version (Johnson 292), 295, 326n. 146

Clio (fig. 185; Johnson L 229), 222, 223, 225

Clorinda Rescues Olinda and Sophronia (Johnson 321), 47, 287, 326n. 116

Collection of the Arab Tax, 298

Combat between Two Horsemen in Armor (fig. 75; Johnson O 10), 110, 114

Combat of the Giaour and Hassan, The, 1826 version (fig. 77; Johnson 114), 67, 110, 112, 136, 273, 276, 313n. 102, 316n. 13

Combat of the Giaour and Hassan, The, 1835 version (fig. 78; Johnson 257), 111, 112, 263, 276

Combat of the Giaour and Hassan, The, lithograph (fig. 76; Delteil 55), 110, 112

Copy of a Portrait of Charles II of Spain (Johnson 21), 70

Costumes of the Kingdom of Morocco, 150

Costumes of Morocco, 150, 172, 324n. 1

Coulouglis and Arab Seated at the Door of a House, 150

Count Charles de Mornay and Count Anatole Demidoff (fig. 30; Johnson 220), 56, 60, 236

Count de Mornay's Apartment (fig. 31; Johnson 219), 57, 60, 99

Courtyard in Morocco, A (Johnson 354), 245

Courtyard in Tangier, A, or *House of the Jewish Wedding* (fig. 118; RF 3375), 156

Cromwell at Windsor Castle (fig. 84; Johnson 129), 92, 115, 116, 133

Crucifixion, The. See Christ on the Cross

Cumaean Sibyl, The (fig. 209; Johnson 263), 209, 248, 255, 257, 262, 264, 302

Dante and the Spirits of the Great (figs. 170–74; Johnson 569), 204, 207–9

Death of Botzaris during an Attack from the Turkish Camp, The (Johnson M 6), 298, 300

Death of Desdemona, The, 283

Death of Lara, The (fig. 233; Johnson 290), 258, 276, 277

Death of Lara, The, 1858 version (Johnson 328), 276, 278

Death of Marcus Aurelius, The (fig. 210; Johnson 281), 8, 49, 175, 255, 256–57, 262, 264, 306

Death of Pliny the Elder, The (fig. 161; Johnson 542), 192, 194

Death of Sardanapalus, The (fig. 46; Johnson 125), 7, 8, 47, 66, 78, 80–84, 85, 86, 88, 107, 112, 116, 121, 123, 128, 136, 150, 172, 198, 242, 255, 263, 295, 304, 316n. 5; sketch (fig. 45; Johnson 124), 80

Death of Sardanapalus, The, 1846 replica (Johnson 142), 295, 326n. 142

Death of Seneca, The (fig. 162; Johnson 548), 193, 194

Death of Valentine, The (fig. 227; Johnson 288), 258, 264, 272, 273–74, 304

Demosthenes Declaiming by the Seashore (fig. 163; Johnson 553), 193, 194

Desdemona Cursed by Her Father (fig. 246; Johnson 309), 283–84, 285

Desdemona and Emilia (Johnson L 98), 104

Desdemona and Emilia (Johnson 304), 283

Doctor François-Marie Desmaisons (Johnson 218), 236

Don Quixote in His Library (Johnson 102), 70

Education of Achilles, The (fig. 165; Johnson 560), 195, 196, 284

Education of Achilles, The, easel painting (Johnson 341), 284

Education of the Virgin, The (fig. 255; Johnson 426), 292, 293, 294

Education of the Virgin, The (fig. 256; Johnson 461), 255, 293, 294

Eloquence (Johnson 571), 208

Encampment of Arab Mule Drivers (fig. 129; Johnson 364), 164, 168, 324n. 29

Entombment, The, after Titian (fig. 20; Johnson 12), 44, 45

Entombment, The (fig. 257; Johnson 470), 268, 294, 295

Entry of the Crusaders into Constantinople (fig. 205; Johnson 274), 7, 9, 120, 178, 198, 217, 250–52, 253, 254, 264, 287, 295, 300, 306; sketch (fig. 204; Johnson 273), 253

Entry of the Crusaders into Constantinople, variant (fig. 203; Johnson 302), 252

Erminia and the Shepherds (fig. 248; Johnson 331), 268, 286, 287

Eugène Berny d'Ouville (fig. 55; Johnson 75), 96, 98

Execution of the Doge Marino Faliero, The (fig. 49; Johnson 112), 36, 66, 83, 84, 85–87, 112, 116, 120, 229, 242, 262, 263, 316 nn. 5, 13

Fanatics of Tangier, The, 1838 version (fig. 122; Johnson 360), 155, 158, 159, 160, 168, 245, 254, 262, 263, 295, 304

Fanatics of Tangier, The, watercolor (fig. 121), 148, 156, 158

Fanatics of Tangier, The, drawing (RF 10069), 156

Fanatics of Tangier, The, 1857 version (fig. 123; Johnson 403), 159, 172, 295

❧ *Photographic Credits* ❧